THE REAL DRAGON

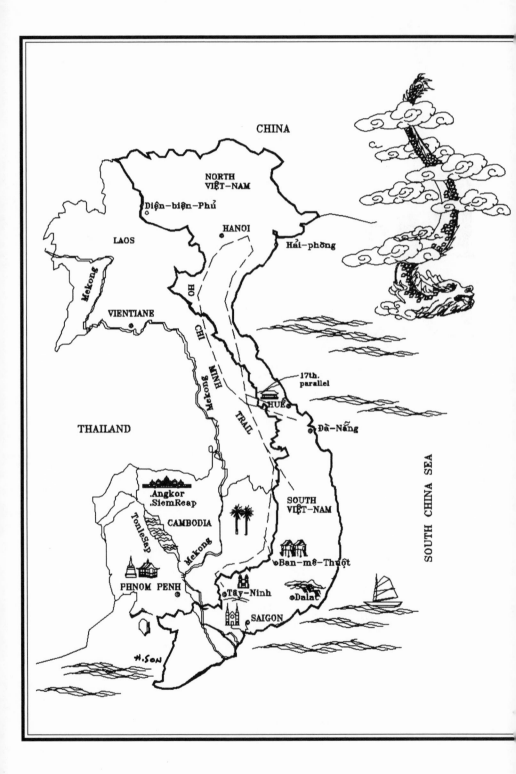

The
Real
Dragon

a novel of
Vietnam

Louisa Hagner Trigg

illustrations by Ruth Boynton

FITHIAN PRESS
SANTA BARBARA, CALIFORNIA
2001

Published by Fithian Press
A division of Daniel and Daniel, Publishers, Inc.
Post Office Box 1525
Santa Barbara, CA 93102
www.danielpublishing.com

LIBRARY OF CONGRESS CATALOGING-IN-PUBLICATION DATA
 Trigg, Louisa Hagner, (date)
 The real dragon : a novel / by Louisa Hagner Trigg.
 ISBN 1-56474-352-7 (alk. paper)
 1. Vietnam—History—1945–1957—Fiction. 2. Americans—Vietnam—Fiction.
 I. Title
 PS3570.R4586 R43 2001
 813'.6—dc21 00-009130

For the people of Vietnam and their land,
with love

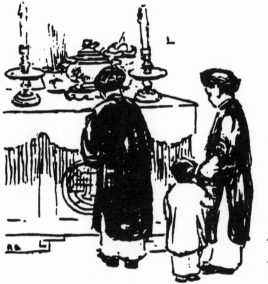

ACKNOWLEDGEMENTS

My first thanks go to Mrs. Shirley Yarnall who, in a creative writing class at American University, suggested that a story I wrote for her might well become a novel, and, as it did indeed grow, helped with the editing.

I am grateful to Renni Browne, Editor, of the Editorial Department, Grandview, New York. She and her staff did a great job in helping me revise and shape the Dragon.

Warm thanks to our friend Dotty Eisenhour. She gave me so much encouragement by always claiming she enjoyed typing the novel!

My appreciation to Dr. James L. Hall of Community Medical Care for giving me permission to use his poem on studying medicine in Part IV, Chapter 23.

Loving thanks to our Saigon foster children, who bravely escaped by boat and built new lives as Americans. Son and Thuy, Van and Hai and Tu Ba have inspired in us a love and admiration for all things Vietnamese. Special thanks to Son for the map and the dragon drawing, and for helping me choose the right names for my Vietnamese characters. In the Vietnamese language your name has a special meaning!

The following are dear and honored friends who helped me to love and understand their country: General and Mrs. Truong Quang An, Dr. and Mrs. Tran Ngoc Ninh, Dr. and Mrs. Trinh Van Tuat, Admiral and Mrs. Nguyen Duc Van, and their daughter Danielle.

Much appreciation goes to Ruth Boynton, who was my friend in Saigon, and whose gifted illustrations always catch exactly what I am trying to convey.

I feel gratitude to a host of books and their authors named in the appendix. They helped in my research, so that I could build a factual and authentic background for my story.

Thanks to my friend Dick Barrows, who read the novel, and helped me find the publisher.

Loving thanks to our four children, who always supported and never scoffed at Mom's creative efforts. Special thanks to our son Randy, who,

down the years, with kindest effort and understanding, moved me from the ancient typewriter into the new age of high tech. He was not *entirely* successful, but, in a pinch, can often be reached at the other end of the phone in Palo Alto. Heartfelt thanks also to son Jon, who brings to the project the invaluable practical help of a successful businessman. For this effort all four of our children, Robin, Randy, Jon and Mary, filled in wherever I was lacking, and so did their generous mates, Michelle Babitz, Timotha Trigg and Gordon MacArthur.

And now with the thanks I can never adequately express—to my beloved husband, William R., co-creator. He, along with our over-lighting angels, never let me give up on the dream that we would someday see the Dragon in print.

FOREWORD

Once there was a Vietnam rarely seen on television. Life and even war was more simple, more idealistic, than can be imagined from our recent perspective of bombs and napalm, highly technical, organized military forces, concentrated power. Those of us there in the late 1950s and early '60s were captured, hooked, by the challenging problems of a people waking to the idea of freedom from tyranny, from foreign occupation.

This story is based on historical fact. The fictional events may not have happened, but they could have happened in the Vietnam of those days. And the characters resemble the many kinds of people who lived there then. In later years if someone could have asked Americans like Allison or Kate or Joe or Colonel Don, "What happened to us there—how did we get so badly involved?," they might have said, "It all really started at the time of the Coup."

But if someone could have asked the Thanhs or Kiem or other Vietnamese, they might have answered, "It all started long before."

L. H. T.

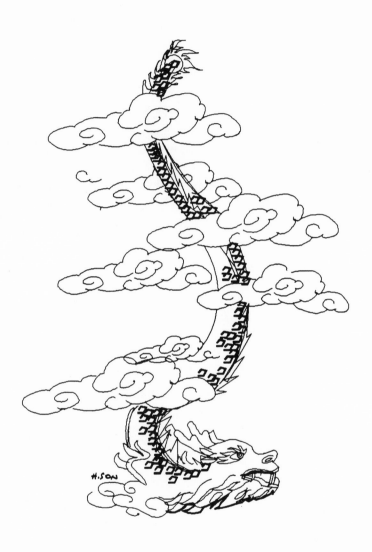

People who come out of prison
can build up the country.
Misfortune is a test of people's fidelity.
Those who protest at injustice
are people of true merit.
When the prison-doors are opened,
the *real dragon* will fly out.

Ho Chi Minh
The Prison Diary, translated by Aileen Palmer

Perhaps all the dragons of our lives are princesses
who are only waiting to see us once beautiful and
brave. Perhaps everything terrible is in its deepest
being something helpless that wants help from us.

Rainer Maria Rilke
Letters to a Young Poet

THE REAL DRAGON

PART I
Setting the Stage

With Vietnam a non-issue in the 1960 campaign, President-elect Kennedy undoubtedly paid little attention to a seemingly trivial event in Saigon that occurred three days after his election: a...coup d'etat against South Vietnamese President Ngo Dinh Diem. Lost in the shuffle between administrations, the...1960 Coup was a symptom of serious sickness within the South Vietnamese body politic, the base upon which Kennedy would build his counter insurgency effort.

"It was a firebell warning which few noticed," reflected CIA's George Carver many years later. "Its not being heeded made probable, if not inevitable, much tragedy that was historically soon to follow."

William Rust and the editors of
U.S. News Books, 1985, Kennedy in Vietnam

The Coup—November, 1960

Some people, like Katherine Gregory, who cared about Vietnam and were there for the Coup, saved the following report. It was circulated by the United States Information Services around American offices in Saigon after that revolutionary weekend. Compiled from newspaper headlines and radio reports, hastily translated from the Vietnamese, its staccato immediacy punctuates with renewed intensity memories of the Coup.

```
USIS REPORT
Press and Radio Highlights
for November 11, 12, and 13, 1960

Please destroy this file
when no longer of use.

Saigon Newspaper Buoi Sang in Vietnamese
November 11, 1960
(Headline : Uprising in Saigon)
(Text)
...At 3 three a.m. people were awakened by shoot-
ing. No one knew anything. Shooting continued to
be heard...from rifles, mortars and so forth....
There was more shooting than during the war
against the Binh Xuyen (Pirates) in 1955.
```

In the darkness about 2:30 that morning, little disturbed the silence of the sleeping city. On the corner near the Gregorys' house at the crossing of Ba Huyen Thanh Quan Street and Ky Dong, like a shadow a pedicab passed, shush, shush, on rubber-tired wheels under the branches of the monkey-pod tree. Was there a moon?

Katherine Gregory, wife of the USAID Program Officer, paused for a moment on an upstairs porch, looking down through the great tree which

reached out beyond their garden wall, almost covering the intersection. It was not supposed to be good luck to look at the moon through the branches of a tree. Her eyes followed the hooded vehicle passing in the empty Saigon street, while her four-year-old son weighed down her arms with drowsiness. Hal was much too heavy to carry, but he had screamed out of some nightmare, bringing her up two stairs at a time. Now he was afraid to stay in his own bed. When both his brothers were soundly asleep, Hal felt abandoned.

Damn. Katherine sighed. It must be Friday, Armistice Day already. And there was no moon. Tossing her long hair back over her shoulders, she lugged Hal downstairs, half-dragging a quilt she used at times like these to bed him down on the floor between her own and Jeff's twin beds. On their arrival in Saigon, Jeff Gregory had enjoyed a good laugh as that heavy quilt was unpacked at 90 degrees in the shade.

While she was settling Hal into the irrational but useful comforter, Katherine suddenly thought she heard a gun boom, and not too far away either. From her bed, arms around her knees, she listened. At first there was only the hum of the ceiling fan or *ventilateur* overhead. Then: *belom belom belom boum tactactac.*

Jeff roused, leaned on his elbows. "What's going on, Kate?"

"It's one of Hal's nightmares, a tiger this time. But Jeff, something else.... Listen! Do you hear guns?" Into the silence a soft, heavy fall of mortars was punctuated again by sharp rifle fire.

Jeff said, "It could be the Vietnamese army detonating some old French ammo at the dump in Cholon," but she knew he was wearing his skeptical look.

After one more big explosion and several rapid fusillades, Kate whispered, "They warn people in advance when they're going to do that, don't they?"

"So far they always have." Jeff's mind turned to the office, only five blocks down the street, the U.S. Operations Mission (USOM), where he was the Program Officer for AID, the Agency for International Development. As far as Jeff knew there had been no Intelligence warnings about any kind of attack for today.

Since Saigon was considered relatively secure, the effort nowadays was all concentrated out there on the defense of the provinces. Everybody lay awake nights trying to think of effective ways to stop the Communist infiltration. The latest suggestion had been a defensive *wall* winding through the jungles, up and down the mountains and across the watery delta of

Vietnam's long, meandering border with Laos and Cambodia! Jeff laughed silently. He couldn't begin to imagine either the appearance or the cost of such a wall.

However, he could easily imagine and had outlined in detail an effective land reform program, plus tax reforms, to strengthen the government's position. But why bother, when politics and military security were always put before economic development? And lately, the stubbornness toward change of President Diem and his family seemed almost as powerful an enemy as the northern forces of General Giap.

Wouldn't it be interesting if others had come to the same conclusion and were turning on Diem to tear him down? Jeff listened to the bombardment. It might well be true that "the Beast" is more often found within than out there someplace.

At Kate's urgent whisper, he left his speculations to follow her upstairs for a look. Recently, on their upper porch the Gregory family had watched the fireworks shooting up from the Presidential palace grounds on Vietnamese Independence Day. These guns also sounded from that direction, though nothing much could be seen. Possibly the Palace *was* being attacked. Jeff felt Kate gripping his arm with excitement. She had never wasted any love on the administration of Ngo Dinh Diem.

He couldn't resist teasing her. "Did you ever get around to making that household inventory list?"

"You're so brainy; why didn't you remind me? Oh Jeff, if we should be evacuated tomorrow, we could lose everything and be stuck with no basis for a claim!"

"Hey, slow down, honey. This may be nothing more than a mutiny of the Palace Guard, or an isolated strike by the VC to flex their muscles." Taking a fistful of her moon-blonde hair, he tugged at it absently. "I can't believe they'd risk anything like that yet. Still—"

From below, Hal let out a yell of wild distress. Kate flew down to their room and stumbled onto the floor beside him. He was sobbing, "Mummie, it's guys wif weal, weal wifles!"

"Hal's old subconscious is right on the beam this time." Jeff went into the bathroom to get the aspirin bottle and a glass of boiled water from the thermos pitcher. "Why don't we take a couple of these and try to get some sleep, Kate? We won't find out anything for several hours, and we'll need the rest for tomorrow."

"Well, at least try the USIS radio station first!"

Shrugging, he flipped the switch. For a while they sat listening to a repeated warning to stay off the streets except in genuine emergencies. When Hal moaned sleepy objections, they turned off radio and light.

"Do you think they really could be getting rid of Diem?" Kate leaned eagerly on her elbow.

"God knows," Jeff muttered, hungry now to dodge away, at least into pretended sleep.

"But you're bound to care! I've heard you complaining over and over how he never holds any budget reviews and hasn't got any overall economic plan. Only yesterday you were telling me, if a department runs out of funds, they just come to us, and we make up the deficit, without any solid guarantees on how they will spend our money. Wouldn't you love to change all that?"

Jeff turned over, discouraged. She always took such a lively (and critical!) interest in what was surely his proper sphere. He had his doctorate in economics from Harvard and yet she seemed to care more about the whole problem than he did. Next thing she would remind him that ninety percent of the AID budget was said to be spent on the army and the military bureaucracy. Politics, like Kate, was emotional and had the same frustrating way of clogging the works in a reasonably constructed program.

Now that she had thoroughly alienated him, Kate was probably lying over there wanting to make love! Jeff yawned. There's a time for everything, and a change in leadership on the Vietnamese side certainly might help. He determined to leave for the office at first light. May the best man win, was his last thought; he will anyway.

"You could at least answer when I ask you something!" As Kate lay there, tense with excitement, hearing Jeff's breathing grow slow and heavy, she felt like starting her own private revolution. The firing continued without a single long pause. Tossing on the tumbled bed she considered how great it would be if there really were a Coup under way; if some aggressive "good guys" were throwing that stuffy old Mandarin out! And wouldn't it also be great if her own husband reached for her, instead of the aspirin bottle, at moments like this? Sometimes he seemed more like a mind than a man!

Restless, Kate moved again, tired of always wanting Jeff. She was still normal and young and attractive. What about that Captain at the Sheerings' dinner on Wednesday? He had taken one look at her...well, they *exchanged* a look, and then he turned up beside her all evening. Consoling, but

somewhat frightening too. Claiborne DeWitt was not only good-looking, he was also a hot-headed southerner. To play games with him would be fooling with fire, her own—the one kind of fire Kate was afraid of.

Belom belom tactactac. Stretching all the way out until every muscle was taut, she stared up through the darkness to the flicker of the gecko's tail across the white ceiling. Those lightning lizards were supposed to bring luck and happiness and fulfillment to a home. So much for all wishful superstitions.

On this night without a moon, she did eventually fall asleep. In her dream, war had come to Saigon while she galloped off on a wild horse, scattering the notes for her household inventory into the dust behind her. And standing safely at one side of the road was the Mission Director's wife, Mrs. Harrison, shaking her head.

```
Friday 3.30 a.m.
What is strange is that during the shooting,
people continued to circulate in the streets, but
they were rather scarce.
    From time to time, taxicabs and private cars
drove through the streets. They met no difficul-
ties.
```

Allison Giraud had never been this close to gunfire. In a Renault taxi between two American army officers, she was being taken home after a late dinner and a long visit to the night club, Cicade. Both men, especially the Captain, were beginning to feel their drinks. Allison hadn't minded until the raid, or whatever it was, started. Now she felt cold sober and couldn't think of anything except getting home to her children as fast as possible. A big explosion behind them made her gasp.

Captain DeWitt quickly put his arm around her. "Curses," he said mildly. "These North Viets are no better than Yankees. What a mistake it was, ever letting them cross the Potomac! They ruined the South, and now they want to do the same thing to South Vietnam." Allison stared at him, the amusement she might have felt replaced by exasperation.

But Colonel Altbacher laughed heartily. "Hold on there, Clay, you're all mixed up, boy! I'm a Yankee myself, from Ohio. You know that. We're all Americans now."

Slumping for a sodden moment, DeWitt pondered this and decided to

be gracious. "Colonel, I'm willin' to give you the benefit of the doubt, and if you *are* a real American," his dark eyes flared, "let's stop this attack, stop 'em dead in their tracks!"

"Damn right!" exclaimed Altbacher with enthusiasm before Allison caught his eye. Then he laughed again. "But let's take the lady home first." Elation flooded Don Altbacher's veins like the good French wine. Long years in a job he never liked under his father, living with a wife who refused to let him join the regular army, had not given him much experience of adventure. Thank God for the Reserves, for here he was, crowded against the lovely American widow of a French planter, in a little Saigon taxi running just ahead of some serious action!

"That was damned close!" he declared cheerfully.

"Women and children to safety!" DeWitt lifted his young profile with its stubborn chin. Then, bowing his dark head over Allison's hand, he kissed it. "Fair flower of the Confederacy...."

Allison couldn't believe him. "Clay, you nut, don't you realize this is really happening? We could all be killed right here in the street!"

"'Dead on the field of honor, sir!'" he stiffened, quoting in a clear ringing voice from the roll call of noble cadets sacrificed at the battle of Newmarket.

"What's he saying, Allison?" Altbacher was fascinated.

Both officers reminded her of her six-year-old son, James Giraud, playing war. "Oh, it's something to do with VMI where he went to military school." Her feeling of wild impatience was just under control.

"The West Point of the South." Altbacher looked wise as his elation expanded. "A good man to have with you in combat!"

When their cab stopped stupidly in the empty street for a traffic light as machine guns ripped through the hot darkness, Allison thought she would jump right out of her skin. The children would be terrified. One parent was all they had now, and that one gone out on a silly date! She felt perspiration on her upper lip. Was it possible once again that she could be off playing, not even really enjoying herself, when another disaster came to threaten everything she loved?

Don Altbacher looked to see if Allison was afraid and found it hard to be sure. More angry, he thought. One of the attractive things about her was that air of mystery. Her cloudy gray eyes, flecked with green, always seemed to be keeping secrets. And some of these were fun. He knew, because her eyes might suddenly light up and one dimple would deepen in her cheek, though he didn't always grasp the joke.

Now they were careening toward the Hotel Majestic, tearing past deserted quays along the river. Didn't know these little taxis could go like this! Clay DeWitt was still making speeches, something about courage totally wasted behind a desk in the MAAG Compound. No mystery as to what Allison thought of that.

"Well, you two have all the fun you want being brave. I'm scared to death, and I want to get home to my kids!" The Colonel was amazed at this outburst from one who was always poised and ladylike. Allison's voice trembled with relief and haste while she was telling the driver where to stop.

And almost before they halted under dark trees in front of the small apartment building, she had reached across, wrenched the cab door open, slipped out, and was on her way up the stairs to her flat on the top floor.

When she saw her familiar, middle-aged servant Chi Nam scolding at the open door in anxious French and Vietnamese, Allison pulled herself together. "Hush, it's all right now, Chi Nam. Here I am. Let's take the children down to the ground floor until the firing is over." She let the heavy teak door slam and lock behind her.

But no one was following. Below in the street the two officers had descended from the taxi and were staring up after her. Clay put a hand on Colonel Don's shoulder to steady himself.

"Frightened as a deer!" He shook his head in wonder. "Not much of a compliment to us, do you think? Lady surrounded by courageous army officers (solid as the rock) runs off into the night like a bat."

Don Altbacher was thoughtful. "Well, Allison's had some bad times, Clay. Her husband was murdered by the Viet Minh in '54. She seems to be well off, but still it's been rough on her, bringing up two kids out here in Saigon on her own. Doesn't look more than twenty-nine or thirty to me."

"Should have gone home to the States! Why didn't she?" Altbacher didn't know.

"Still," Clay straightened courteously, "ought to see her safe in."

"She *is* in, I think." The Colonel rocked back on his heels, watching more lights come on in the highest apartment.

Clay yawned. "Women can be a bore when the fighting starts." At the sharp stitching of bullets somewhere both men brightened. "Well, now she's safe home, shall we work our way over toward the action?" They groped for their cab to topple back into. Nothing, however, was there. The taxi had left them cold, and they didn't even remember paying. So, leaning

together, singing fitfully, the two wandered off down the empty street toward the firing.

By this time Allison was already sitting on a rug in the lower hallway, her back against the wall, Katrine's and James's hard heads in her lap. Holding one hand between kept them from bumping each other. Gradually the other residents and their servants talked out their excitement, made themselves less uncomfortable, and wearily dropped off to sleep around her. She was left awake, thinking, in the sounding dark. The men's reactions had surprised Allison.

Don Altbacher was a serious, responsible person, much admired by his own men and the Vietnamese, who called him Colonel Don because his last name was hopeless to pronounce. The Giraud family had met him on the wide beach of the South China Sea at Langh Hai. One Saturday Allison raised her hand against the blinding glare of sunlight on the grayish-yellow roll of tame breakers, to see the children approaching happily with a new friend. They always brought her any interesting creature they found. He was tall, solid, and redheaded with skin that burned and freckled easily in the cruel sun. She liked his kind blue eyes. Don was a man's man, somewhat shy with women but very much at home with James. Standing there in the incessant wind from the sea, Allison thought he must be forty-something. Amusing how he managed to avoid even one glance at her new bikini, at least when she was looking.

Later on in Saigon she and Jamie's Colonel Don saw quite a bit of each other, usually with the children along. Already she knew he was a West Point graduate who had just made it into action before the end of World War II. Although he had eventually left the regular army and gone into the electronics business in Marietta, Ohio, with his father, Don always kept up his status in the National Guard. Then, she gathered, because of an unhappy marriage, he applied for active duty and was sent to Vietnam. Allison really liked him, though she didn't find him exciting.

Claiborne DeWitt, on the other hand, definitely vibrated. Younger, about twenty-six, she thought, the Virginian worked for Don, who had brought him by the apartment once or twice. Clay read a lot of books and quoted from them, told funny stories with a dead-pan face and a slow drawl. He rode horses in a devil-may-care way. Allison had watched him taking jumps when she went to the Cercle Hippique for the children's lessons. Clay had a fierce, sensitive manhood, as if he were too highly bred. She had felt the

heat of his temper when she happened to be standing nearby while he scorched a *sais* for neglecting his horse. Clay could be a throwback to Jeb Stuart, someone like that.

During one of the deceptive breaks in the firing, Allison considered how, once this thing started, her two dates had acted like dopes. It wasn't just the drink—Don Altbacher hadn't drunk all that much. More likely he was intoxicated by the promise of action. In a way Allison could understand their feelings. In spite of all her fears since Maxim's violent death, one side of her was bored, frustrated, deadened by this comfortable life. Her inheritance from North Carolina textile mills had even made it unnecessary to find a job. In that moment of rushing up to get the children, Allison had felt a part of purpose and movement. Now she was once again outside the action that seemed to create meaning for other people. Sometimes she longed to be swept out of her passive self by some force! At the same time knowing she was afraid.

Does action, any action, Allison wondered, really have the power to liberate? Or do those of us who are cowards only hope so? By now, she thought, her companions of the evening must be risking their all in the most satisfying adventures, having forgotten all about her.

But Altbacher and DeWitt were still making their way quietly up Catinat Street (now named *Tu Do* for Independence) when Clay suddenly grasped the iron grill over a store front they were passing. He stopped, looking dazed, while the firing grew louder.

"What's wrong, old buddy?" the Colonel asked.

Clay slowly shook his head to clear it. "I was wondering…," he glanced up, slightly arching his nostrils, "just where in hell we're headed?"

"Right toward the action!" Don responded. "That's where we're headed. No more paper-shoving, ass-numbing, in-and-out boxing…."

"Yeah, but action toward where?" Clay was looking around as though to pierce some heavy fog. "I mean, action for what? Does General Jackson stand in need of cavalry?"

"General…? Will you listen at him?" The Colonel's grammar slipped with his patience. "Damn it, Clay, you know it don't matter to *where* or to *what*. They're firing! Can't you hear? It's what we've waited for, trained for, action at last!"

The younger officer pulled himself upright, straight and slender. "Wait, Colonel, an important thought has occurred! It just may be that we are both

crazy—completely and totally insane. Have you thought of that?" Clay's drawl was curiously low-key, but his eyes burned like dark wine, and his face was flushed. In slow motion he shook his friend by the shoulders.

Don shrugged him off. "Aw, Clay, come on, will you? We're missing the whole show!" His tone changed suddenly. "Captain, you *march!*"

Clay's eyes went blank. "Sir, well…," he slumped a little. "'Sno help for it I guess." Flourishing one arm in a debonair wave, again he draped it around his Colonel. "'Slong as you understand we're both nuts." Weaving slightly they continued their slow but definite progress up Catinat toward the mind-stopping explosions.

Friday 6:00-8:00 a.m.
The Saigon market, at 4 a.m. refused to open its doors to traders; later they were allowed in. Traffic was blocked at many streets.
 At this moment, all the people in the capital knew that the shooting they heard came from the area surrounding the President's Palace.

In a one-room thatched house tightly squeezed along an alley beyond the market with many other tiny houses, the barber, Tam, was discussing the situation for the benefit of his young woman, Chi Hai. They had been living together during the last several months in this house of her aunt. The young couple were sitting on a straw mat laid upon the low wooden bed; Tam in striped shorts and singlet, Hai in black silk trousers and half-buttoned tunic. She was a round-faced girl, tempting and plump as a pigeon. Tam's handsome, regular features and his cold black eyes were illumined.

"We are not to be frightened at such times as these, Hai! Haven't I taught you carefully about everything that must happen, before we can see the great General Uprising of the people to which we are all struggling?"

"But Tam," she suggested timidly, "they were saying outside when I tried to visit the market for our rice, that it's not the Viet Cong attacking the Palace. People think it's part of the army, turned against the President."

Roughly he pushed her aside with the flat of his hand and got up. "How many times have I told you not to use that word Viet Cong? This name for our liberating forces comes from the Diem clique and their militarists!" Immense patience was necessary in order to deal with someone of Chi Hai's limited mentality. Tam sighed, remembering that according to his brother

Thom, who was a leading member of the Party working out of Dalat, such people as Hai are the very ocean from which the fish of the revolution must draw nourishment!

There were sudden tears in her eyes. Chi Hai really did not know what other name to use than "Communist person." However, it seemed that Tam had already forgotten her mistake as he strode up and down in the narrow space before the heavy, and dusty, ancestral altar.

"Our movement for the liberation and unification of all Vietnam is bigger than such imperialist military squabbles." He raised his head to listen. Somewhere mortars thudded down. "But we, in our constant Struggle, are able to use every happening for the advantage of our Cause. You will see! The military elements will do our work for us; then the people will arise and take over the power!"

Hai, who stayed where she was, pushed back against the wall, felt not so much stirred as dazed by the sight of her lover striding fiercely up and down, strong in the right of destiny. When a round of machine gun fire stuttered through the babble of noises in their neighborhood, she cried out, "Oh Tam, do I have to go out to work for Madame today? I'm so afraid!"

Ordinarily he drove her out whenever she was lazy and pled for a holiday. The money from Madame Giraud was very useful, but today Tam felt heady with the excitement of change. The eternal aunt with her everlasting brats was out on the streets gabbling foolishly with the neighbors. Turning his sinewy back to Chi Hai, he pushed the small bolt across the door.

There was a giggle from the bed. "Won't you be expected on your usual corner to shave and clip your regular customers? Maybe they will be angry and look for another barber?" She was afraid to mention his important work as a spy.

Tam came and knelt above her, ripping the last feeble buttons from the strained tunic. "To hell with them," he said seriously, his black brows drawn together. "Let this be a day of freedom!"

> Friday 7:00 a.m.
> Shooting continued to be heard.... Many govern-
> ment buildings were occupied and guarded by the
> army.... The private houses of different govern-
> ment leaders were also guarded by the army men.

The Minister of Education, Nguyen Tan Thinh, had been warned only just

in time to escape from his villa before the revolutionary forces (paratroopers?) surrounded his compound. He and his wife, Quyen, were now sitting in acute discomfort upon fat chintz-covered chairs. The blinds were drawn in the library of the American Ambassador's Residence where they had taken refuge. Although congratulating himself upon this quick and clever move, Thinh did not look at his wife, whose hands nervously turned her valuable rings, an irritating habit which became evident in any moment of tension.

Quyen could only be worried about the younger children, since all the older ones were attending good schools in France. Such anxiety was not intelligent. Their servants at home were completely reliable, having served Thinh's family for generations. The servants here, on the other hand, glanced up slyly, gazed at one with rude curiosity. He closed his eyes. It was well known that the servants of Americans were not only over-paid but over-indulged in every way. Opening his eyes, he saw that the houseboy had placed refreshments on the low table and left the room.

Minister Thinh cleared his throat. "My dear Quyen," he said in French, "we will drink some tea. This is not only for politeness, but also it is appropriate to show that we remain serene in times of difficulty, preparing ourselves with confidence for any eventuality."

Madame Thinh gave a woeful look at the cheerful modern paintings on the crimson brocaded walls, the high rows of books beginning to blur before her eyes. Her feet did not touch the floor from this large American chair; her sandals were dropping off at the heels. Thinh's pomposity was a further trial, although she could not have given it a name and had long ago grown used to suppressing her irritation.

"Tea," she agreed vacantly, smoothing the silk of her dress, a stark print in black and white, not pretty, but the first thing her hand had touched in her armoire.

"Be assured," went on Minister Thinh, handing his wife a cup, "our President will not be intimidated or defeated by any revolutionary riffraff, be they Viet Cong or other subversive elements. Our personalized, idealistic government will easily override this minor upset."

When his words sounded like quotes from Ngo Dinh Nhu, the President's brother, Madame Thinh did not attempt to listen. She accepted the teacup, and managed to still her trembling, so that it would not chink against the saucer. She thought her own Limoges cups were much older and in a more pleasing pattern.

The bursts of gunfire continued outside. How strangely they seemed to ignite fiery sparks within Quyen's submissive spirit. Patiently she had borne many children, thirteen. Bitterly she had suppressed her knowledge of her husband's young mistresses. Now at thirty-nine, still beautiful, Quyen's possessive love was all for her children, her ambitious concern chiefly for their futures.

Politics was Thinh's province. When her lawyer husband decided to throw in his lot with President Diem, she had not opposed this, although she had pointed out that the Ngo family was from the Center, and that she had known for years a great deal of reliable gossip about them which was not to their credit. Gossip was her province. Still, supporting Diem, they had done well financially, so far. And Quyen would know, since, like most Vietnamese wives, it was her duty to keep the books. Very well indeed, she considered. Until now. Irrational anger at the general stupidity of men, and her husband in particular, shook her whole body. The tea scalded her mouth.

With only a slight cry, she was putting the cup away from her, when the white paneled door opened. This time the big American Ambassador himself appeared with friends, another Vietnamese Cabinet minister, and his wife. The Thinhs rose; everyone spoke at once in French. The two women rushed together.

Towering over his guests, Douglas St. John showed only well-mannered concern on the broad, sun-burned face below his graying hair. Harriet St. John, who had followed them all into the room, knew that her husband's kind expression would soon grow stiff because of his anxiety to get downtown. With practiced ease she welcomed her early and very unexpected guests, saw them comfortably seated near the tea, and somehow made an opportunity for the Ambassador's polite exit.

Crossing the black-and-white tiled floor of the hall with his wife, St. John picked up his briefcase from a chair. Dropping a kiss in the thick red hair behind her ear, he raised humorous eyebrows at the closed door of the library.

"I'm off; can you manage?"

Harriet laughed. They both knew she adored to manage. Her quick brown eyes glanced beyond the open front door to where the new young FSO, Mark Gardiner, was waiting with Toan near the black limousine, its motor running quietly. Harriet had come to think that every moment they were even nearly alone was a small miracle. She refrained from asking him to be careful, reaching up to give him a sound kiss instead.

As he hastily patted her shoulder, she said, "Doug, do let me *know* something from time to time. I can bear anything except slow death from curiosity!"

He grinned, head on one side, the laughter lines radiating out from his eyes. "I'll send messengers if the phone doesn't work—that is, if it's safe," and he grew sober.

She knew he wouldn't remember, and shook her head, but her eyes were full of pride. "To think how right you've been all along, dear. Now Washington is bound to see how accurate your warnings were!"

Settled back in the smooth-running car, Douglas St. John thought his own assessment of the situation probably *was* being confirmed by events today. And he had to admit to some elation, though he had never considered himself a prophet. Of course the intelligence available to him had almost always been good. But the man Diem was an enigma, with his holy vision of himself, his family, and his government as the only bastion against Communism. Such fanatical convictions could be useful; they bred power. But the French had never liked or trusted him. And back in '55 the first American General out here had never been quite satisfied with Diem, had almost persuaded Foster Dulles not to back him. However, just at that point, news came that, with the help of Col. Lansdale and the CIA, Diem's forces had defeated the piratical sects warring for power in the South. So Diem had received American support, although somehow he was never able to relate to his own people.

Outside the car window, the Vietnamese soldiers guarding the streets in the early morning light were paratroopers and marines, as the Ambassador had been informed. They saluted his car, smiling. Everyone certainly looked very happy!

"Well, you got here just in time, Mark." He nodded to young Gardiner, son of a Harvard classmate, who had arrived the week before, and so far looked like becoming a good Foreign Service Officer.

"It would have been a shame to miss this, sir." Mark glanced down a side street to their left. "Those are the first tanks I've seen this morning."

"I understood most of the tanks were proceeding down Hong Thap Tu." St. John turned toward the back window. "But it looks now as though they are ringing the Palace area." Would today actually see the fall of the President? Since the beginning of last year all intelligence had concurred that discontent with the government was rising fast and must eventually cause the collapse of Diem's regime. St. John thought about his cable to the

Department back in the middle of September. He didn't believe he could have put it more strongly. Still had it almost by heart.

First there was the danger from demonstrations or a coup attempt in Saigon: "Likely to be predominantly non-Communistic in origin but Communists can be expected to endeavor infiltrate and exploit any such an attempt. Even more serious danger is gradual Viet Cong extension of control over countryside which, if current Communist progress continues, would mean loss free Vietnam to Communists."

St. John had pointed out that the dangers were related, because the temptation for the non-Communists to stage a coup against the government was partly motivated by a sincere desire to prevent a Communist takeover. If it was hard to convince the Department that opposition could be genuine and non-Communist, it was absolutely impossible to convince Diem.

"How joyful the people seem!" Mark turned from a group of students gleefully waving flags at the liberating troops. "This kind of feeling against the government, has it been obvious for some time?"

"Under wraps, until today," Douglas St. John said. "People were afraid to express themselves, but there've been signs." He guessed the young man was wondering whether his Ambassador had correctly informed Washington of the dangers in advance.

St. John leaned his head back against the white linen seat cover with his eyes closed. Now and then it amused him a little to see people jumping to the wrong conclusions. After all, one day everything would be in the record. He remembered that blonde young woman who had tackled him on the subject of Diem's failings the other night. She must have had one too many. It had happened at the Sheerings' buffet dinner on Wednesday. (Jim Sheering was a damn good intelligence officer. Too good. Might not be able to keep him much after today. Depended of course on which way the ball bounced.) Now who was that smart young woman? Was she Gregory's wife? That was it, Katherine Gregory, wife of the USOM Program Officer. Attractive, athletic-looking girl with strong opinions. Asked audacious questions about matters that were not her responsibility.

How one's ego always longs for personal justification! He would have given a lot to have seated that young woman with a typescript of his September 16 cablegram. Opening the briefcase on his knees, St. John found the place:

I realize some measures I am recommending are drastic and

would be most improper for an ambassador to make under normal circumstances. But conditions here are by no means normal. Diem government is in quite serious danger. Therefore in my opinion prompt and even drastic action is called for.... While Diem obviously resented my frank talks earlier this year and will probably resent even more suggestions outlined below, he has apparently acted on some of our earlier suggestions and might act on at least some of the following:

And again he went over his ten very explicit recommendations, including cabinet changes, even the appointment of Nhu and his head of Secret Service to ambassadorships abroad!

His conclusion had been bold enough:

We believe U.S. should at this time support Diem as best available Vietnamese leader, but should recognize that overriding U.S. objective is strongly anti-Communist Vietnamese government which can command loyal and enthusiastic support of widest possible segments of Vietnamese people, and is able to carry on effective fight against Communist guerrillas. If Diem's position in country continues deteriorate as result failure adopt proper political, psychological, economic and security measures, it may become necessary for U.S. Government to begin consideration of alternative courses of action and leaders in order achieve our objective.

As Ambassador you go dangerously out on a limb with Christian Herter, the Secretary of State, while keeping a poker face in Saigon, so that most of the members of your own mission remain unenlightened and unimpressed.

Hell, Katherine Gregory is not my type of woman anyway. St. John closed his briefcase, wincing inwardly at the taste of sour grapes. Mrs. Gregory did appeal to him quite a bit, as she had to that young Captain the other night at the Sheerings. He remembered passing them where they sat together on a sofa, untouched plates on their knees, laughing with delight into each other's eyes. Youth. Young people could afford extravagant emotional excitement about a flirtation, about politics, about anything!

The artillery was deafening as they passed behind the Palace through almost festive streets. The people were just too excited to stay home in safety.

Mark turned from the window back to his boss. "Makes you wonder what the President is doing and thinking right now, doesn't it, sir?"

The Ambassador chuckled. "If Ngo Dinh Diem is not in urgent contact with his support forces out in the provinces at this very moment, then he's trying like hell to be!" The car slowed, and stopped in front of the Embassy doors where two Marine Guards stood at attention. "Well, Mark, let's hop to it."

A black guard held the door as the Ambassador got out. "Good morning, Pete. Morning, Harry. Looks like a warm day." He heard them both laughing behind him as he and Mark went in to work, their footsteps ringing in the nearly empty building. From an inner office radio static broke through.

<div align="center">

Friday 9:00-10:00 a.m.
Saigon voice of the Republic of Vietnam
in Vietnamese
to Vietnam Nov. 11 1960 9:30 GMT

</div>

(Text)
To all comrades-in-arms in the capital and throughout the country: The historic hour has struck...our army has taken control.... Ngo Dinh Diem and his clicque have surrendered. All generals are supporting orders from the supreme revolutionary committee.

Let all of you—our friends—collaborate with us...so far, you have lived in a cheating...atmosphere of the Ngo Dinh Diem government.

Now the Supreme Revolutionary Committee is supported by the entire world and all our people....

Place your entire confidence in the supreme committee's tasks of national reconstruction and extermination of the Communists. We greet you with the determination to triumph.

The Supreme Revolutionary Committee

In the pause before the staccato radio message dissolved into Oriental music, Kate looked up, eagerly questioning. Standing behind chairs at the long

dining table, her cook and houseboy glanced at each other doubtfully. Then the boy translated the sensational news for her into French and broken English. Kate drew a deep breath of satisfaction. It really was a military coup then! They looked at each other in amazement—the young American mistress seated at the foot of the mahogany table by the small radio, the thin, middle-aged Vietnamese she called Monsieur Bep, or Mister Cook, and the lively Vietnamese houseboy, An.

Jeff Gregory's chair at the head was empty, pushed hastily aside, its white linen seat cover crooked. He had gone to USOM about 7:30 and had not yet returned. The Vietnamese radio message was the first to give any political news. Earlier, the USIS station had continued to order everyone to stay at home. The American School was closed anyway for Armistice Day. Second grader Pete Gregory had rushed back upstairs after breakfast to put on his cowboy suit.

"You're going to be much too hot in that outfit," Kate called while four-year-old Hal was led off in tears to his French Nursery School by Ut, the maid.

Now Kate felt uneasy about having let them go, even though the Croix Rouge School was only two blocks away. Outside the closed shutters of their big cool house the day shone bright and sunny at the beginning of the dry season.

"What were you saying, Monsieur Bep?" she asked in French.

"Madame, I said I am afraid of the cannon. Very much afraid." He bent seriously above the table, pale, his hand trembling a little.

"Well, that's okay." Katherine felt expansive, in a holiday mood. "Go on home; today's your afternoon off anyway, isn't it? We'll make out. You have your family, after all, and the others here are not married."

"Merci, Madame!" He gave his first wan smile of the morning. "The drinking water is boiled, and I have told An about the meals." An nodded, heading for the kitchen.

"Thanks, Monsieur Bep, we'll see you tomorrow, I hope!"

"Without fail, Madame, without fail." His tall figure ambled off at once through the swinging door and the pantry down the steps to the outside kitchen.

Pushing back her chair, Kate saw with relief that Ut and Hal were returning through the living room. Ut told Madame that the French Sisters had given the children holiday today.

"On account of the firecrackers!" shouted Hal.

"That's wonderful!" Katherine reached out for him, but Hal wriggled away and pounded up the stairs yelling to his brother Pete in triumph.

"Hush, crazy, you'll wake the baby!" Kate said. Ut grinned and ran two steps at a time in her white trousers and jacket to catch and silence him. Fat Andy, almost two, still took a morning nap to the great convenience of his Amah, who was out in the back yard washing diapers. There was a warning crackle from the radio which had been turned way down.

"An, wait, come back! I think they're about to announce something else." Kate bent over the radio, whacking it firmly across the top.

> Saigon voice of the Republic of Vietnam
> Nov. 11 1960 0935 GMT
> After the victory, the Supreme Revolutionary
> Council has collaborated with all army units....
> The whole people are assembling on Boulevard
> Thong Nhut, applauding the Supreme Revolution-
> ary Committee.

After An's enthusiastic translation, Katherine snapped off the repeating message and leaned back. "I wonder how many people have been hurt." It was hard to believe in injury or death with the sun shining brightly and excitement running high.

"No many. Peoples very happy, say goodbye bad President!" An chuckled with glee, his eyes shining.

Katherine felt as though she had never known her servants before. Until now they had always dropped their eyes, replied vaguely, looked embarrassed if she asked political questions.

"But An, I don't think I ever heard any of you say a word against President Diem before."

An nodded. "Until this day, no know. Peoples no talk."

"Well, how do most people really feel about Diem?"

"No much like." He bent his head in smiling embarrassment.

"Why is that, An?"

He looked uneasy. "Many peoples finding no work; very difficult. Also Madame Nhu. Very bad lady."

Having met Madame Nhu at a reception only the month before, she remembered mostly the hard glitter; from her eyes, from her jewels, from her smiling teeth. Thoughtfully Katherine rose from the table, smoking a

last after-breakfast cigarette. In her orange cotton housecoat she wandered over to the shaded verandah, crossing brown forearms, looking into the brilliance outside with curiosity.

There seemed to be quite a lot of activity across the street at the villa of their neighbor, a prominent lawyer. Was his name Tu or Tho? Something like that. Men were coming and going, singly and in groups, their white shirts catching the light. Tu must have something important to do with all this. I wonder which side he's on? Suddenly Kate became absolutely still.

A small, not unfamiliar brown sedan had driven slowly by the Tu villa and turned into the nearby alley. Jim Sheering must have parked somewhere around the bend, because he appeared for only one moment at the mouth of the alley. Glancing quickly up and down, he disappeared like magic through Tu's gate, which closed instantly after him. Well, Kate thought, intrigued, how furtive! That's the first time I've ever seen one of the cloak-and-dagger boys in action, outside of a movie. Sheering was CIA. They had just been there for dinner on Wednesday.

Time went by. Artillery continued to dominate all the Saigon noises, though more and more sporadically. Katherine did not see Jim Sheering come out again. No doubt there was a back gate onto the alley. Elated, she went in to dress. When Kate came out of their downstairs bedroom in a loud print shift, carrying a notebook full of papers, Jeff Gregory ran up the porch steps and across the living room.

"You're back! What's the news?"

Jeff grinned at her papers. "Is that the inventory?"

His wife lifted one shoulder, her pleasure abated. "Shutting the gate after the cow has gone. Come on, Jeff, what did you hear?" Behind him the servants were gathering in the pantry door.

Jeff said he had been directly over to see the Chief of Mission, Alec Harrison, in his home. "As far as we understand now, there's been a military coup all right, against President Diem. The Palace is surrounded and being fired on. Whether they've got him yet or not, no one knows. Nor do they know for sure who's at the head of the Coup. There is some kind of announcement going around by the grapevine that foreigners are perfectly safe." Jeff threw himself down on the sofa. "Lord, I'm hot. An, get me a beer, will you please, and turn on that ceiling fan."

While he leaned back and swallowed a good part of a frosty bottle of Saigon's "33" beer, Kate began to tell him at once about the visit of their CIA friend Sheering to the villa across the street.

Jeff whistled. Then he said, "These fusillades you keep hearing in the neighborhood are the revolutionary troops rounding up the wealthy cabinet members and other high-ranking government officials. The Harrisons live right next to the Secret Service Chief and saw him being taken away. A couple of the luckier government members made it either to the Harrisons' or the Ambassador's and are hiding out there."

"No!"

Jeff smiled at his wife. "You're really enjoying yourself, aren't you, Kate?"

"Well, why not? You know it had to happen; the people are out of their minds with joy. I love the excitement, but I can't bear sitting around here doing nothing!"

"Get on with the inventory!" She groaned. "Kate, you have an appetite for everything but duty!" He put a casual hand on her brown knee. "What are the kids doing?"

"Playing cowboys and Indians, something violent."

Jeff's hand dropped. "While they're home from school, you could get that young man in the street to give them a haircut. I need one myself."

"He's not there; didn't you notice? I sent An out earlier to get news and he said none of the regulars are there, not the bicycle man or the cart-restaurant man or the barber or any of them. Either they're home scared, like Monsieur Bep, or downtown watching, I guess. Shall I try the radio again?"

Jeff shook his head and finished the beer. "It's only about ten. Wait 'til there's something new. By the way, Kate, I wouldn't mention to anyone seeing old Jim sneaking around across the street."

"Of course not." She pushed back her hair impatiently. "Oh Jeff, you always sound so objective. I won't be able to stand it if we don't win!" Her voice was rough with feeling.

He shook his head against the sofa back, studying her, troubled. He was thinking of the way she took on the Ambassador the other night. "Honey, in our business we've got to keep our cool, no matter how things turn out."

"I prefer to have a little passion, for one side or the other. Cold objectivity is bloodless and dead."

Jeff shut his eyes.

Excerpt from Saigon newspaper
Buoi Sang in Vietnamese
Nov. 11 1960 (uprising in saigon)

(Text)

At the President's Palace, more shooting was
heard. Dense smoke rose into the air. At ten 10
A.M. the people heard the President's voice, giv-
ing orders to commanders of military zones.... At
the same time, the President appealed to Colonel
Khiem--commander of the My Tho zone--to come to
Phy Lam with a tank division and a special bat-
talion and wait for orders. The President's appeal
was repeated again and again by the radio....

At half past ten, shooting from the President's
Palace stopped. At 11 eleven, calm prevailed in
the entire capital. One did not rpt not know what
this calmness meant at the President's Palace.

A boy, running through the swarm of bicyclists, motorcyclists, and pedes-
trians, dodged to one side of Thong Nhut Boulevard in front of the
President's Palace and flung himself down under a tree in the park. People
streamed past, almost stepping on him, but the streets were his home, and
he was too comfortably tired to move. Eleven-year-old Phuong lay there on
the dusty grass grinning and blinking his eyes. It was the most exciting day
he could ever remember. He hadn't the least idea what had caused all the
shooting, nor was he curious. In addition to the thrill of guns and danger
there had been side benefits. That morning when he had finally gotten into
the Central Market to fool around close to the booths as usual looking for
plunder, he found the peddlers and traders grown careless beyond belief.
They crowded into groups, talking excitedly, while Phuong lifted whatever
he wanted, almost free of the blows and curses he was used to.

When he had eaten his fill and stuffed his pockets, Phuong let himself
be flowed along by the crowds of people, mostly students and kids, moving
through the streets. At one point along the Palace fence, he stationed him-
self right behind a machine gunner, touching the shiny ammo belt, jamming
his fingers in his ears and screaming whenever the gun was fired. The sol-
diers were friendly. In the pauses some marines even let people examine their
weapons!

Gradually the shooting stopped. Phuong couldn't see very well, so it was
hard to tell what was happening. Often he rubbed his somehow clouded
eyes. But the people around him were wondering out loud if the President

had given up, if the paratroopers had won. Not only were the guns quiet now around the Palace, they said, but also further down Boulevard Thong Nhut where fierce fighting had taken place around the barracks of the Palace Guard.

When Phuong saw the soldiers beginning to eat food brought to them by women in the crowd, he withdrew to the shade of a tree and reached into his own full pockets. What a day! While he kicked his bare hard heels in the warm dust, a shadow fell over him. Squinting up, Phuong saw the shape of an older boy who often came around. So he sat up on an elbow, scenting business, throwing the banana skin over his shoulder.

This older boy squatted down to talk with Phuong in the friendly intense manner he always adopted. This time there was a chance to fly a kite, of very pretty paper in red and blue and gold. There was a star in the center when it was unrolled. Beautiful. It would be fun to fly on such a day, but Phuong had learned how to deal with this person. So he giggled doubtfully, pulling at the faded grass and complaining. He was very tired. Also he did not know where the kite could be flown; everywhere was too crowded....

The boy looked over his shoulder, then sharply around on all sides. "Go over in front of the American Embassy where the black guard stands," he urged. "It's not crowded there!" Phuong frowned with uncertainty and squinted into the sun. Eventually, by the time the boy left, he had handed over to Phuong eight grimy piasters as well as the kite.

What a day! Phuong hugged himself and scratched under his arms. Soon he would fly the kite in the wide street where he had often teased the smiling black man. When he was sure the shooting had really stopped, when he saw the soldiers even stretching themselves full length along the ground, Phuong went off with the bright paper rolled up under his arm, the little ball of string cupped in his palm.

Pete Jackson was standing outside the Embassy doors in his Marine Guard uniform enjoying himself. "O happy day," he hummed under his breath. Everybody who went past looked pleased to death, and Pete felt the same. From what he had read, the President and this Nhu family were a bunch of killjoys. Newspapers were censored and shut down, free meetings weren't allowed, police were constantly watching the bars, the gambling houses, and the street girls. Lately there was even a new law against certain popular music and against *dancing*!

If there was a change coming, Pete would have no objection. None in the world. He winked at a cocky little boy who swaggered past. The American

marine could hardly tell one of these kids from the other. He was friendly with them all. It hadn't been that long since he was a kid himself. Although Pete had never had to hustle on the streets in those days, he knew plenty who had, so he gave out a few piasters here and there when he could. The kids were sometimes a nuisance, swarming around, but they didn't give him any real trouble. He never allowed that from anybody.

Pete tried out his Vietnamese. "What you got there, huh?"

Phuong squinted up happily at the tall man, waving the kite in a flash of color.

Pete squatted down. Something wrong with the kid's eyes. They had a funny bluish filmed-over look, some disease.

"Now let's see what you got," he began in English, while thinking something ought to be done about those eyes.

Phuong unrolled the kite and displayed it. *"U bai?"* he asked, his head on one side. Anything was possible today!

The big man's face went stern. "Hey, boy! That looks like a Commie flag." He reached out. "Where'd you get that thing?"

But Phuong had twisted away like a lizard and was running off down the street laughing. When people got that serious look, he ran fast. He wasn't going to be cheated out of flying his kite for anybody.

The marine looked after him without smiling. "Charley" (Viet Cong) could be anywhere, using little kids like that. If he could put *what* he wanted *where* he wanted it, the possibility was that "it" wouldn't always be just a North Vietnamese paper flag. Tomorrow it might be a bomb or a hand grenade.

<div align="center">

Friday 11:00 A.M.-3:00 p.m.
Saigon voice of the Republic of Vietnam
in Vietnamese
to Vietnam November 11 1960 11:00 GMT.
(Appeal of Dr. Phan Quang Dan, Political Com-
missioner of the Revolutionary Committee)

</div>

(Text)
...The army has overthrown Ngo Dinh Diem's feu-
dal government and mastered the situation....
During the past six dark years, justice was
trampled on, human rights violated, thousands of

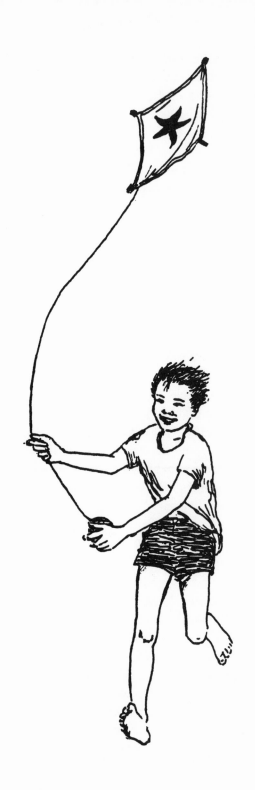

```
nationalist fighters and...democratic believers
were illegally arrested and imprisoned.... The
press was guided, elections were fraudulent, the
national assembly was a puppet, justice was un-
just.... In town, business was bad, unemployment
increasing.... In the countryside, peasants were
living in fear, taxes were heavy.... They were
forced to construct roads and agrovilles.
    ...In the past six years, with...warm support
from the free world, Vietnam should have been
strong and...growing in democracy, ...and the
Communists should not have been able to infil-
trate the South.... Because of the backward and
feudal policy of Ngo Dinh Diem's family, ...the
Communist danger has become extremely grave. Com-
patriots! Thanks to the army's patriotism and hero-
ism, the future of Vietnam begins to be brilliant,
our dream of exterminating the Communists and
reconstructing the country, ...of enjoying demo-
cratic freedoms, ...of living in peace and happi-
ness has become true.
    Compatriots! Support the Revolutionary Commit-
tee with all your heart.... Tear up all Ngo Dinh
Diem's portraits, ...write and stick on your doors
these slogans "Down with Ngo Dinh Diem."
```

It was high noon. Kate lay on a wicker sofa in the shady porch playing with the baby. Andrew gurgled his response to her elation as she tossed him up, her hands under his fat arms. When he drooled on her, chortling, she dodged laughing, pressing him against her shoulder and breast, struggling to sit up. Her mind was roused by the ringing radio message from Dr. Dan.

Suddenly she felt a poke in the back. Andy's Amah, come to get him for lunch, was pointing to something outside. Drawing in her breath, Katherine handed over the baby and waved them both back into the house. The street beyond their wall was rapidly filling up with jeeps and trucks full of soldiers. A big machine gun mounted on a truck covered the whole situation. Katherine stared at the proudly grinning gunner with his shiny ammunition

belt slung over his shoulder. U.S. helmets, U.S. fatigues, U.S. jeeps, U.S. guns!

"My God, what an incredible day! I've got an orchestra seat for every event." And what a feeling of liberation filled the air!

Across the street the door opened. Her lawyer neighbor emerged in a natty blue suit. Obviously he was the one they had come for. No wonder Jim Sheering of the CIA had found the man interesting. Tu must be some high-up member of the Revolution, and was probably being escorted downtown (to the Palace?) where he would now come into his own in the sun of influence and prestige!

Kate checked the whole scene over to be sure the military escort was not a threat. No, his beaming wife had distributed fruit to all the soldiers, and they were eating with enthusiasm. This man's star had risen. Kate got up to see better as the jeeps began to move. A soldier riding a truck caught sight of her blondness and waved over the tailgate. She waved back, smiling. Hooray, she thought, down with Ngo Dinh Diem and all tyrants! To hell with Jeff's cautious approach, his warnings to keep her cool. Freedom was being realized today—for once!

<div align="center">

Saigon voice of the Republic of Vietnam in
Vietnamese
to Vietnam Nov. 11, 1960 12:30 GMT.
(Order from General Le Van Ty, Chief of Staff
of the Vietnam Republican Army)

</div>

(Text)
Officers, noncommissioned officers, and men of the Vietnam Republican Army, during the serious uprising taking place in the prefecture today, I have conferred with President Ngo Dinh Diem and he has agreed to the following measures to maintain the unity of the army: 1) The President--with the agreement of the Revolutionary Council--entrusted officers of the Vietnam Republican Army with the responsibility to form a provisional military government which will continue the anticommunist struggle to protect the country; 2) Immediately after receiving this order, all units

```
must stop shooting, resume their former activi-
ties, and be constantly calm to prevent sabotage
by the Viet Cong....
    After the victory...the whole people are assem-
bling on Boulevard Thong Nhut..., applauding the
Supreme Revolutionary Committee.... Thousands of
ovations are rising in a lively atmosphere.
```

The courtyard of Foster Parents Plan's offices was empty. For once there were no children with relatives waiting eagerly, squatting in the shade. Most of the staff, having been dismissed, had gone to join the many Saigonese who were visiting their pagodas, not only to celebrate and give thanks, but also to see friends and gather the latest news. Mrs. Thanh, a case worker for Plan, came out of the office compound onto Cong Ly Boulevard, putting on her wide hat, pressing its velvet band across her round chin. She waved to a coolie for his cyclo and seated herself carefully, keeping the silk skirts of her long dress out of the black and oily wheels. She directed him to the Xa Loi Pagoda.

At first the euphoria rising from the city did not penetrate Mrs. Thanh's awareness, for she had just been studying an unusual medical report on one of her cases. Recent x-rays had revealed that the little girl's headaches were caused by an actual hole in her skull. Since Mrs. Thanh was a nurse as well as a case worker she pondered the causes of this as she was pedaled down the broad Boulevard Cong Ly. It might be due to a lack of calcium, or infection, or both. Only last week during her routine home visit, the child's mother had again refused to spend money for milk and fruit, explaining anxiously that she must save for medicine, in case one of the children fell ill! Frowning faintly at this irony, Mrs. Thanh put aside her thoughts and looked around.

People were streaming by, dressed for a festival. Her eyes widened as the crowd grew, approaching the Xa Loi Pagoda. By the time she had descended and paid the coolie, she felt her own spirits lifted by the waves of excitement, and couldn't help smiling. Her smile was reflected with radiance on all the surrounding faces. In wonder she thought, only those who have known repression can understand this merry ecstasy, this release!

The first familiar person she recognized in the shadow of the pagoda was Dr. Le Van Thien. As Mrs. Thanh watched his slender, boyish figure moving politely through the jostling crowd, she thought again how little he

resembled one's idea of a well-known and successful orthopedic surgeon. And yet, in the operating theater, she had often seen him wield the heavy orthopedic tools with effective force. The doctor's glance met hers; his serious look became one of real pleasure.

"Ba Thanh!" he exclaimed as they bowed. "What a good thing to see you on such a day of—excitement." She laughed at the expression. Dr. Thien was always careful to be exact.

They had been inexorably pushed into a backwash of the crowd behind some feathery Australian pines. Observing their momentary privacy, he began with a tentative, "And your husband, the Major…?"

"He is in the United States, attending the Command and General Staff School at Fort Leavenworth." She had really come to give thanks that Thanh was not here, not forced to take sides.

"I congratulate you," Thien said. "Thanh will soon be a Colonel. What will he think of today's events, being himself part of the Airborne troops?"

She responded in a rush. "I'm ashamed to tell you how relieved I am that he's missing all this!" She looked for his reaction to her perfidy. "But of course, if there really is success, he will be crushed not to have been here. You know, Thanh is ambitious to be one of the leaders, to help our country find herself." She stopped and looked down so as not to shine too brightly with pride in her strong young husband.

Dr. Thien noticed that Yen Thanh wore a black silk dress printed with magnolia blossoms, very flattering to her ivory skin. Loving her for the past several years, he was not sure whether or not she knew this.

"*If* there is really success?" he teased. "You are not completely confident that our gallant paratroopers have safely defeated our tyrant, Diem?"

Her warm dark eyes, so widely set, met his. "If only they have!"

He told her of the recent broadcast from General Ty, announcing that the President had agreed to the formation of a provisional military government, and to declaring a victory. Both were silent then, staring at the faces of the excited crowd.

"Even with a victory today," she murmured, "do you believe all our divided selves can truly be united?"

"Or have we perhaps removed the best barrier to a Communist takeover?" Thien shook his head. "It does seem too easy, the magic of this day. So much distrust and fear removed with just one blow? But look, there comes my optimistic friend Duong Quang Minh and his adoring students. He will cheer us up. Do you know him?"

"The Professor of Anthropology? Yes, he and my father are close friends." Minh was also prominent in Psychology at the University of Saigon, she remembered, watching his approach. Professor Minh, about five feet eight, was tall for a Vietnamese, and very much on stage. He was thin, his long neck and prominent Adam's apple partly covered by a dark silk scarf. As he turned his head in many directions, his hair stood up stiffly in a cockscomb. Minh had hollow cheeks and a pointed chin; his eyes were brilliant with intelligence, humor and curiosity. Along with noticing that his skin was brown, his nose somewhat beaky, she decided that the electric smile was either on or off. Some of his expressions were certainly for effect, as in most teachers, but Yen Thanh knew that Minh's enthusiasm for his academic subjects and for the cause of political freedom in Vietnam was genuine. Was that a dark shadow in his eyes when he was suddenly not smiling? Surely not; the Professor had obviously come rejoicing to the pagoda, surrounded by excited young men, and some girls, too.

Dr. Thien was saying to her, "He is full of idiosyncrasies and a favorite with the students because he is always anti-system, anti-government."

Yen smiled. "I like him."

"I too. I hope he will survive."

Before she could question his meaning, Minh had seen them and come over at once. "Hello, my friend! So, how does a rational skeptic view the happy arrival of our liberty?" After the men shook hands, the Professor turned with warmth to Mrs. Thanh. He patted her shoulder and inquired after her father. Then, eyes twinkling, "Well, Doctor?" he asked.

With his rueful smile Thien admitted, "Professor, I am afraid my rational doubts do somewhat tarnish the golden moment."

"Tut-tut, dear Doctor, you limit yourself too narrowly with your intellectual viewpoint! I too am a scientist, but we must go beyond that—even into our instincts and idealism, into myths and ancient fables! Through these gates we will find healing for the nation and full life for those of us who are now barely existing."

His friend said, "This is an old argument we always pursue, Mrs. Thanh. Now it is my turn to say, 'but without rational control, there is no harmony.' And today I will add that following our instincts impulsively can be a dangerous business."

"I understand you, Thien," the Professor said. "You see me as a fanatic risking my everything for a fable of freedom. And you are right about me. I say, reason for guidance, yes, for paralysis, no. We must go *with* our deepest

instincts, not against them! Look, I have an analogy for you, Thien. Your critical reason is your tyrant, worse than Ngo Dinh Diem!"

Minh turned toward the young people who were pressing closer. "Carl Jung said, 'The more critical reason dominates, the more impoverished life becomes, while the more of the free unconscious, of myth, that we can make conscious, the more we integrate our lives. Under the dominion of overvalued reason, an individual is made poor!'" Some of the students sighed; some took notes.

Dr. Thien returned the Professor's bright gaze steadily. "A certain poverty results, yes, but with it some measure of security."

Minh said to his students, "Do not assume that my friend is a coward. Dr. Thien and his wife fought alongside the Viet Minh in the North for years, and only left when the Communist movement became dominant." He turned back. "Yet you must forgive me, Thien, as your words suggest, our chief flaw in South Vietnam today could be that each one of us is too closely wedded to his own and his family's security!"

At this Thien remained silent, though politely smiling, while still the banners flapped and tumbled, purple bougainvillaea cascaded off the porches of the pagoda; sunshine blazed back from the spectacles of Duong Quang Minh.

"But come, we must move on." The Professor waved toward the temple. "Buddhism offers us one way to transcend the limitations of society and reach a higher truth. Remember," and he quoted an ancient seer, "'life smiles upon this day. She is free, even when we drag our chains!'" Then he swept off, a kite with its tail, veering toward the dim doorway of the Xa Loi Pagoda.

Yen Thanh stood with the doctor, looking after him. "I don't think I understand your differences."

"Conscious mind versus the unconscious? Or perhaps, just some words." He lifted his hands and let them fall at his sides.

"But is he a Communist?"

Thien laughed. Suddenly for a moment they were as intimate as husband and wife. "Don't you see, Yen, it is just the other way? I seem to be more the Communist, with my rational, scientific dialectic." She looked up, puzzled. His eyes were still full of light, of tender amusement. "No, no. Minh is not a Communist. However, he is an idealist, and like many idealists he can play into their hands. I once did."

She nodded. "He is like an American with his ideals and enthusiasm, isn't he?"

"We could say a mixture of French and American, *n'est-ce pas?*"
Yen laughed. "Okay."

"It's funny, but serious, too." Looking depressed, Thien explained. "The influence of other societies on us and our ways is beyond debate. Exposed as we are to their ideals, theories, and methods, things happen," he gestured at the happy crowd, "and then, for better or worse, our society and our ways will never be the same again."

Yen did not like to see him sorrowful. "You are a philosopher like my father. Maybe I see things too practically, but anyway, I think Dr. Minh's ego is big, much bigger than yours, for instance." She smiled at him with affection. "Maybe Professor Minh is still too much attached by his ego to the ten thousand things of this world!"

"Or is he taking a short cut, by his extremism, to deprive himself very quickly of them all?" Realizing how much he hoped not, Thien recognized his deep appreciation for his flamboyant friend. "I think he believes that truth is not truth unless you become deeply involved with it in action. As for me, in spite of what you heard me say about reason, like most Vietnamese, I wait to see what is the mandate of Heaven."

She touched his wrist. "I don't know about all that, Thien. My father would say that you and Minh are just a pair of northerners and hotheads. It is *your* fight within the Viet Minh, Nationalist versus Communist, that has spread to us down here! We are southerners in our family, more inclined toward patience, collaboration. My father says about the war against the French, if we had just exercised a little patience, if you northerners hadn't led us astray, the French eventually would have left Vietnam, without bloodshed, the same way the British left India."

Thien closed his eyes for a minute to damp the blaze her touch wakened, and heard the Professor's words again, "We must go *with* our deepest instincts, not against them." To disaster? Firmly he directed his mind to her argument. "I was young when we fought with the Viet Minh, Yen. Now I am older. But the thought that your father may be right certainly doesn't console me. Each faction is struggling to show that it has the way for all the people, when there can be only one way. One nation and one way."

Yen did not ask, and what is that way? No one knows, she thought, and it is getting late. Calmly she glanced at her watch, unaware that with her touch she had aroused the tiger of his senses. "Well, let's console ourselves with hoping for the unity that today may bring! Are you going in?" She nodded toward the temple doorway.

"I think not." His gentle smile did not quite hide irritation. "For me it is somewhat too late in the day. But go in yourself. Follow Minh and his students. They are meditating at the source of life and oneness, are they not?"

At the bitterness in his voice, she turned. "I don't understand you, Thien; why are you kind and tolerant with everyone except yourself?"

Her innocent look embarrassed him. From the vise of his unhappy marriage, he wanted to flash out that miserable people always hate themselves. "It is only that I think too much," he said. "With you everything is love and action, very simple and beautiful."

It was her turn to be embarrassed. They bowed formally and went their separate ways through the afternoon in a city waking to release and relaxation.

Friday 4:00–6:00 p.m.
Saigon Moi in Vietnamese [New Saigon News]

(Text)
At about four...P.M...people saw a plane flying over Saigon which dropped the following leaflet:
To all combatants: for over ten years, we have struggled against the Communists for the country. Now we are determined...not to approve of...a coup d'etat by force, because this is a Communist solution.
All nationalists resort onto political solutions, such as negotiations and discussions.
Friends, ask your commanding officers...not to give orders to shoot at President Ngo Dinh Diem's palace and at friendly units, because they represent the national sovereignty and the blood of our great military family. Calmly judge the situation.
[Signed] The High Command

The flecks of these tiny leaflets were almost invisible against a pale blue sky. As though aimless, they descended lightly. People could see them flicker against tall trees or walls, dipping within possible reach. What was the word? Adventurous boys climbed up to catch them. Those who couldn't read saved them for good luck.

Two or three were drifting slowly toward the tennis courts of the Cercle

Sportif at five o'clock when Mark Gardiner of the American Embassy and Pierre Lemont, his French Embassy counterpart, came out of the Club in whites for a match. Mark felt good. It had been an exciting day already, and somehow he still expected something else to happen. Stretching up with his racket in both hands above his head, Mark saw a few of the leaflet flakes turn through the air and subside under a nearby bench. Dropping his things, he picked one up.

"What's this all about, Pierre?"

Lemont was lightly built, with narrow hips, and the carelessly assured virility which Mark associated with the French. Tossing down racket and towel he squinted at the mimeographed paper.

"Poof, Vietnamese." Pierre wrinkled his nose laughing. "Can't be much. Looks like a desperate plea from the Palace. Since they've lost control of the radio station, this is the only way they can use the air waves! That would be my guess." And he twirled the screws of his press, cocking his head for the location of the sun.

Mark studied the paper before he put it in the back pocket of his shorts. "It's okay for you to be casual, Pierre, but this is my first experience with a coup d'etat, and I don't want to miss anything. Also, whether or not he *gets* help is important, dammit."

Glancing at Gardiner's serious expression, Pierre shrugged. "All right. After the match we go up for a beer." He gestured toward the trellised swimming pool above the long expanse of courts. "And I'll find someone to translate for you." He grinned. "You people have taken so much trouble with your precious Ngo Dinh Diem, I can understand how you feel today at the prospect of a fall."

Mark smiled patiently. "*Touché*. Still, you don't want to be too sure you understand how we're feeling." He crossed over, taking the sunny side. "Now, let's play tennis, instead of politics, huh?"

"*Allons!*" The flicker of his grin disappeared when Pierre stretched up into his hard serve.

The singing of well-hit balls was part of the pleasantly familiar atmosphere of the Cercle as Allison Giraud and her children arrived in two cyclos with Chi Nam. Allison's mood lifted. "I'm glad we came as usual. The whole thing seems about over."

"Well, I sure *hope* not," said six-year-old James. "This is the best fun we've had for years."

His mother only raised her eyebrows. "So? Well, you two, run and change for your lesson; Monsieur DuVant won't be late because of a little Coup!"

"No, he's just always late, period!" retorted eight-year-old Katrine. "Don't be so slow yourself, Mummie. You gossip too much while you're changing; I want you to watch me race." The tan little girl with brown pigtails disappeared into the right side of the lower regions followed by Chi Nam. Allison gave James a little pat toward the left side, and went thoughtfully in after her maid.

Eventually she emerged into the golden afternoon light by the aquamarine of the pool. Allison didn't really like swimming in the evening. Having lived six years in the tropics, a few degrees difference in temperature had begun to matter. Hot mornings were best for the pool. But, shivering, she had put on her bikini anyway. After the harrowing night a swim should be bracing.

Monsieur DuVant was down at her end of the pool. He greeted her at once in his characteristic bellow, gesturing fiercely with his quite unnecessary megaphone.

"M'dame M'dame! You are here, I see! You and a few others have decided to be *courageuse*." The hoarseness of his voice came booming out of the sunburned swell of his grizzled chest. Bright blue eyes admired her extravagantly before they clouded with rage. "These American parents—weaklings! Allowing their children to employ any excuse to miss a lesson!" His mighty roar, his flourishing gesture dismissed the Revolution as he would swat a fly.

Allison enjoyed him, laughing. "But Monsieur, you are a bear without manners. After all, you know, I am American too!"

The big man stiffened, embarrassed for her. *"Pardon, M'dame!"* He cut her off, dismissing the possibility. "Your accent is without fault; your children *bien élevés, et alors,* as Giraud's wife you are one of *us*. No one could say you are not *française!"*

Allison, laughing into his eyes, said, *"Merci."*

Brusquely DuVant moved off into his act, the pool his stage, the laughing club members his appreciative audience. *"Allons, mes enfants!"* he roared, while Allison turned to sit down beside her friend Madeleine Beaufort, who had achieved a very dark tan.

Madeleine moved her lean body slightly to make room. "He is marvelous, Monsieur DuVant."

"A touch bitter, don't you think?" Allison arranged herself against a pillar,

gingerly crossing her long legs in the oblique sunlight on the damp yellow tiles. Perhaps she wouldn't swim after all.

"But yes," Madeleine agreed, "full of passionate hatred."

"Poor man."

"My dear, see how he enjoys it!"

"Ummm." They chatted about the night's experiences while the afternoon mellowed. Gunfire had been replaced by the tuning up of the cicadas. All the children splashed furiously, urged on in throaty magnificence by DuVant, himself a former Olympic star. Allison wandered over to the bar for a lemonade, pressing one elbow on the mahogany, perching on a tall stool. She saw herself in the mirror behind the white-coated men, cloudy hair, brown breasts, curved torso. Not bad at all for thirty. Idly she glanced out over the tennis courts as two men in whites ran up the steps.

"Allison!" Pierre Lemont called out with pleasure. "You are obliged to help us, but first, let me introduce Mark Gardiner, American Embassy."

Giving the stranger her hand, she felt herself isolated in the concentrated focus of his near-sighted blue eyes. *Alors,* someone new.

"Madame," the waiter was handing out a frosted lemonade as Mark Gardiner said, *"Enchanté,"* firmly keeping her hand.

Allison drew it away, smiling, to receive her glass. "Why don't you both have something to drink? How was the game?"

"We are well matched," Pierre crowed. "He's not bad at all! But Mark, see, you can speak English. She's an American…*widow.*" Mischief lighted his narrow face.

Looking up from her glass, Allison watched Mark thinking it over. His expression remained seriously attentive, waking her interest. As a diplomat he would be steadily successful, she thought. Would never rush his fences.

"Lemont tells me you're a linguist," he was pulling something out of the back pocket of his shorts. "Can you translate this?"

Allison slipped down from the stool. When she took the paper in brown fingers, Mark saw the flash of an emerald. "But I'm not an expert; Pierre, you know perfectly well…." Lemont had gone. They were alone at the far end of the bar.

Teenagers were teasing, joking, playing on all the bar stools, ignoring them totally. Her eyes looking up at Mark seemed to be a mixture—blue, gray, green. Strange coloring, might be the shadow.

She was saying, "but surely you have someone who could do it better for you at your Embassy."

Annoyed with her "your Embassy," Mark crossed his arms. "Try it," he said. "Let's see how you make out," and he began wiping his forehead and neck with a handkerchief.

"Well," lifting brown shoulders in resignation, Allison looked down at the bottom of the leaflet. "It seems to be signed by the High Command...." She studied the sentences, much aware of his direct gaze, feeling herself on the spot. "Well, they do *not* approve of the military coup d'etat. 'This is a Communist—uh—solution.... It is better to talk...and negotiate. Friends, do not shoot at President Ngo Dinh Diem's Palace....' And so forth. 'Judge calmly,' they advise. 'Support friendly troops.'" Allison looked up. "That's about it."

"Well, thanks!" Mark was impressed.

"You're welcome. Still, it doesn't seem to be very important, does it? So little that's printed here really says anything."

Mark frowned. Turning, he ordered himself a beer. Then, "Do you care very much about which way things turn out today?" There was a dimple in her right cheek that deepened from time to time.

Allison was longing to say, "Not in the least!" just to catch his reaction. Her honesty spoiled a lot of her fun. "I guess I would care if I thought there was some hope of real improvement, toward more freedom, more peace, more safety."

"But you don't think there is." She heard that unmistakable Boston flatness in his speech.

Allison shook her head, feeling the soft hair move behind her neck, wondering if she had flunked or passed. To him it seemed important what she *thought*. A man from New England. Allison decided that for her it was important to make him smile.

With the voice of Monsieur DuVant booming out behind her she said, "You are a new arrival; have you seen the pool yet?"

Mark shook his head, glancing around. "It looks big."

She turned to lead him toward its shimmering Olympic length, surrounded by shady arbors and trellises, the whole towered about by trees, dark and massively green. But Mark was looking at Allison as he followed, noticing the smooth poised way she moved her body in the printed bikini, seeing the wide-spaced pair of dents in her lower back, just above the upper edge of the tiny pants. American women did not wear bikinis back home. Mark began at once to appreciate the fashion.

Allison showed him her children sitting on the edge of the pool, very wet,

thin arms around thin knees, waiting their turn to race. When Mark smiled, she called his attention to Monsieur DuVant exhorting his star pupil, a cherub of two and a half.

"Allons, Bébé!" he thundered to the delight of his audience, while the infant churned the water mightily.

But Mark gave all this an absent glance. "Are you free to have dinner with me tonight?"

After she had laughed a little at his abruptness, Allison shook her head. "I don't want to leave my children yet; not until we see if the shooting is all over."

Had she shivered in all this heat? "How about Monday?"

"Fine." When she smiled, the dimple came out full. Seeing this, his face brightened with a boy's enthusiasm, and Allison thought what beautiful American teeth he had.

"Let me have your phone number...." They looked at each other's bodies, quite free of pens, pads, pocket books, and wallets. Mark borrowed a pencil from the waiter and wrote her address and telephone on the propaganda leaflet which had urged them not to fire at the Palace.

Suddenly cool, where they stood in the shade, Allison realized they were being regarded. When sudden interest flares between two people, it never goes unnoticed. Madeleine would be watching, and Chi Nam waiting with the towels.

"It's late. I must get my children out and take them home. Glad to have met you, Mark."

He felt her first use of his name. "See you Monday, Allison!" Elated, Mark leaned on the railing and watched her collecting her children, without hurry, gracefully. He exulted in the new place, the strange day. By Monday he would see her again, and by Monday they would know whether the provisional government of the coup d'etat was really going to make it.

Stealthy afternoon shadows were claiming the whole city. Night fell, leaving everyone in suspense. But not for long. The decisive events of the following day began in the darkness before dawn.

Saturday and Sunday, November 12th and 13th
Saigon voice of the Republic of Vietnam
in Vietnamese
to Vietnam Nov. 12 1960 0220 GMT

(Text)

"Obeying orders from President Ngo, we of the Republican Army have reoccupied the Saigon radio station in a very easy manner.... We are combatants of the Republican Army. We only recognize President Ngo who is the supreme commander.... We are ready to shed the last drop of our blood to protect President Ngo who is the clearsighted leader of the Vietnamese people."

Dear listeners, you have just heard Major Nguyen Minh Man..., commander of the First Military Zone, who has...come back...to liberate the capital in collaboration with many large units of the Republican Army....

Following is a short interview with a high-ranking officer, who has just fulfilled his responsibility: reoccupation of the national radio station:

Question: My major, how did you receive orders from the President?

Answer: We were maneuvering...when we heard over the radio that hooligans were attempting to create disturbances to kill the people. We received orders to unite under the command of the brigadier general commanding Thu Duc Inter-Arms School,...(and) a number of other units--(we) came to the capital and reoccupied various places very easily.

Question: Have the forces under your command suffered any casualties?

Answer: No one of our men has been injured. Being hooligans, they are cowards and they have left behind many corpses and all their weapons. Some of them ran away, but we have arrested them.

A sun like Friday's blazed down again on Saturday morning, November the twelfth. And gunfire was still heard occasionally. However, the people of Saigon were silent, most of them remaining at home. The revolution had been defeated. Evidently President Diem still retained the mandate of Heaven.

Saigon voice of the Republic of Vietnam
in Vietnamese
to Vietnam Nov. 12 1960 1050 GMT
(Commentary: "The Vietnamese people despise the
maneuvers of political speculators")

(Text)
On the afternoon of Nov. 11 eleven, 1960 nineteen
sixty, after...rebel paratroopers occupied the
national radio station, the people could hear a
group of political speculators disclose...their
national salvation and reconstruction plans--
plans they will never apply, as they are people
who only think of their own interests and who
only wanted to seize power to fill their pockets
in order to escape abroad some day, abandoning
the fatherland and the people to the Commu-
nists....

The people believe that President Ngo will be
very just in rewards and punishment. He will be
lenient with respect to misled people, but very
strict with respect to hooligans and traitors to
the fatherland.

The Vietnamese people are convinced that Presi-
dent Ngo will do away with all the hooligans and
political speculators who want to help the Commu-
nists and Colonialists carry out their maneuvers.

So that was that. Monday morning Mark Gardiner in his office at the U.S. Embassy laid down the report of the weekend feeling depressed and tired. He might have known from the start how it would come out. Mark reread the last declaration, probably worded by Brother Nhu. Funny how much his language resembled the propaganda of his enemies, the Communists. So the whole blazing weekend had come to absolutely nothing. Even the thought of his date that evening with the intriguing Allison Giraud didn't restore Mark's equilibrium.

His anger and disappointment surprised him. Though newly arrived in Saigon, he had been caught up Friday in all the fever of excitement over the

sudden possibility of freedom for South Vietnam. Maybe from a Boston Tea Party ancestor he had inherited this ready response to a peoples' desire to throw off a tyrant. Would the Ambassador, the Department, the President —would they all just let this happen without a protest? As the typewriters outside his door began their daily chatter, business as usual, Mark wondered what people back in the States thought. Were there headlines about the Coup in the newspapers back home?

Thousands of miles around the earth's curve a special interest in the abortive Coup was felt in one home in western North Carolina, where premature dusk closed down on that rainy November Sunday. A young man had been snoozing away in his favorite easy chair underneath section A of the Greensboro *Daily News*. Over by the fire his dad, Boyd Ruffin, looked up from his chess game, took the pipe out of his mouth and reread the large type tented over his son: SAIGON COUP ATTEMPT FAILS—DIEM RESTORED TO POWER.

The doctor shook his head. "Joe better get his sleeping in while he can. That place he's determined to head for doesn't sound restful."

Hissing, sighing, a log broke on the hearth, and at the other side of the small table, Sanford Ambler advanced his knight with a firm, thin hand. Then he drummed his fingers impatiently.

"There's no dissuading him, Boyd. His heart is set on this. And, since you and I have been giving him his head ever since his mother died, it's rather late in the day to think of opposing him."

"Who wants to oppose him, San?" The stout doctor had a fringe of graying hair around his rosy bald head. Blue eyes behind spectacles stared out of the window where he didn't see the rain smothering dark red fields, an old tobacco drying shed, and the winter woods around the clapboard farmhouse. "You know me better than that. It's just that I'd like to understand the boy, his motivation, I mean."

The newspaper heaved and slipped to the floor, uncovering his thirty-two-year-old son, dark hair tousled, brown sweater rumpled. Joe sat up, stretching, while the two older men looked at him in thoughtful silence.

"Now, Dad, what's the problem? Ever since I came home from Korea you've both known I wanted to go back to the Far East to practice medicine."

Boyd Ruffin knocked out his pipe carefully. His tone was mild. "Well, I can't help thinking there are plenty of isolated areas in our own country

where we don't have enough doctors to go around. Right here in North Carolina there're lots of folks, sick in body and mind, who are not getting the help they need. I just hate to see you go so far away. With your Harvard Med degree plus all that psychology and counseling skill you've added on to it, you're equipped like I never was, to help people right here, and no language problem either." His eyes twinkled, remembering Joe's struggle with French in high school.

Irritation thoroughly woke Joe up, and he frowned. "Dad, the kind of medicine I want to practice is just one part of the thing. You understand me on that. You've always said we've got to learn how to treat the whole person."

Gently his father persisted. "You can do that right here, son."

"I don't know, Dad. I'm beginning to see sickness as a kind of revolt from the status quo. People protest through their illness and nervous breakdowns and drinking and drug addiction. But we doctors in this country are in the habit of just patching them up, so they can go right back into their old unbearable ways and do themselves more harm."

"You've always been a maverick, Joe." Sanford Ambler was Joe's godfather, a long-time family friend, and minister of the nearby Episcopal church. "Your Dad and I have gotten a great deal of vicarious pleasure out of that fact down the years." In his gray suit with its turned-around collar, Ambler had the look of an intelligent, humorous ascetic.

Joe found his "Uncle San" attractive as always. Middle age was beginning to frost his blond hair, paling the blue of his eyes. Ambler's long legs were casually extended before the fire, which warmed his olive skin and well-cut mouth. That expression of cool amusement usually made Joe wonder what he himself was being so passionate about.

But his father said, "That maverick business is not exactly the point for me, Sanford. I can accept the boy's notions about setting people free. Hell, they're our notions too, yours and mine." He turned directly to Joe. "But why can't you stay here and do your liberating?"

Joe linked square hands between his knees, blowing out a whistle of air. "Gosh, Dad, do you really want to go into all that again? It only makes you feel bad."

"Just go ahead, son, you know you can't hurt my feelings."

Joe didn't know anything of the kind. He sighed, pondering the design of the old rug while rain dripped and fell about the peace of his home.

Then he looked up suddenly. "You're both in the healing professions.

Knowing you two, watching you work, has got me where I am. But being proud of you doesn't keep me from seeing the way you've each been hamstrung at times. Dad, look at the AMA. We know what that important club is like! I don't want to have to be part of a group like that—overly protective of its legal rights, political power, financial benefits, all reaped out of human suffering and need. The whole thing has gotten way out of proportion. Why, nowadays the AMA is so conservative it's often a stumbling block in the way of finding new and better methods of healing."

Boyd Ruffin sucked on his pipe. "You haven't mentioned the worst thing that's happened to doctors; we've come to think of ourselves as more like God than other people."

"I think Joe was saving that for the clergy." Sanford Ambler still leaned back in amused negligence.

Joe's thick dark eyebrows seemed about to meet above the bridge of his nose. "Well, you've got to admit, San, the hierarchy and liturgy and wealthy organization of the traditional church are a trap. How can a person be a free, creative individual in that set-up?"

"Now, Joe, every idealist has to learn to work inside the limitations of reality. You will too."

"God forbid," Joe said, "that I should be responsible for putting a millstone around anyone's neck." At this Ambler's thin cheeks flushed, his eyes kindled, but Joe was under way.

"And what about this pietistic morality that wasn't a part of Jesus at all? Think of all these religious people who've got to pretend to be freed from the very sins and passions they're still slaves to. You and Dad see these cases all the time here in the 'Bible belt'; people making like saints out front, while they're torn with inner conflict all the time. The ordinary guy outside the church, seeing us, doesn't need a psychologist to get the message, so he isn't about to join. Is Christ's own church going to stand between the man in the street and the joy and peace and healing that's supposed to be part of the Kingdom? I don't know much about joy and peace, and I've been going to church off and on all my life."

The Reverend Sanford Ambler winced and crossed his legs. "I'm convinced you're a preacher, Joe." The younger man shrugged and bent his head. Ambler sat up. "No, no. Don't be embarrassed. It's a fine sermon from a text out of Luke, the physician. We church leaders have the keys of the kingdom, but we refuse to go in, and won't let others in either." He allowed both his

hands to fall with grace. "After all your years of sitting below my pulpit, I owe you more than one sermon of your own."

Joe grinned. "That's for sure. If you ministers weren't so hidebound, you'd give the congregation a chance to answer back right along. Liberation, that's what we need!"

His father moved heavily in his seat. "I don't have any objections to revolutionaries, Joe. We can use them. If you feel like a rebel, why don't you stay right here, practice your own type of medicine and Christianity, and try to change the system? God knows it's got faults."

Joe took a breath. "Well, one reason is because I feel spoiled, you know, over-indulged. Not by you two. I really needed this crazy freedom you always give me to say and think what I like, you and Aunt Hester. But it's all the soft good pleasures. I think I've got to go where it's harder, like it was in Korea, to find out more about who I am, to peel off some more layers. And to go where I'm desperately needed, where I can work long hours every day, knowing that my being there makes the difference between life or death."

When he paused they were quiet. Ambler looked into the fire. Boyd Ruffin scratched his bald head with the stem of his old pipe, remembering what it was to be young.

Joe went on more slowly. "I want to help other people get free. Isn't that what the real Christianity is about, not legalism and moral judgments? But how can I help anyone else, until I first get free myself?"

His father thought about it. "Well, they say there's something to be learned from these Asian religions, like the Buddhists, and some of the others…whatever their names are."

Encouraged, Joe said, "Yes! That's one of the magnetic things about the East for me."

"'Oh the temple bells are calling,…'" Ambler always found the apt quotation hard to resist. "But getting down to the practical, Joe, as I understand it, you're going out there attached to a CMA mission. I find it hard to believe that the Christian and Missionary Alliance would send a medical missionary out there under their auspices, even though he was a layman, if they knew he felt the way you do about religion."

"Right." Joe drooped. "You've hit on what's been my biggest difficulty all along. How to get out there and serve as a doctor with enough to live on, but without being too tightly bound by some group or system. Of course I didn't want to be part of our military, or even our civilian government. I did

apply to the World Health Organization, but there's a lot of red tape involved. And they seem to want public health doctors and sanitation experts rather than GP's like me. However, that could still work out. I also think the Tom Dooley group could give me a job. I'm on their waiting list for the Cambodian team. You remember I met Dr. Dooley before he died. Still, I'm not sure what they're doing is my kind of thing either. Since they're just beginning to build an organization, there's too much salesmanship involved. They have to depend on fund drives in the States in order to keep going."

"What about this project with the ship, the Hope Project?" his father asked.

"They move around too much. Don't have the continuity in one country that I'm looking for."

Sanford Ambler neatly dropped a small apple log on the fire, dusting off his hands. "And what about the work of your own church overseas?"

Joe turned toward him. "I've thought about that too, San. It seems as though most of the pioneer mission work in our church is about over. It's funny that our work nowadays is in countries like Japan or southern Brazil where the people are comparatively well off. Of course there's Africa, but I'll admit I don't know a thing about the Episcopal church there. You see, it's Vietnam that seems to draw me, and in South Vietnam our church, as you probably know, has no permission from the present regime to evangelize in the country. We are allowed one man to minister to the American-British congregation in Saigon. The Baptists have a new group of active missionaries, but so far they are not doing any medical work. The Seventh Day Adventists already have doctors who are trained members of their own church.

"Now CMA has the most extensive work in Vietnam of any religious group, and of course, originally, they were formed of several denominations, Presbyterians and Episcopalians among them, to do mission work for all the Christian groups." And he stopped, brow wrinkled, before light broke across his face. "Right now they need another doctor pretty bad!"

Both older men laughed. Sanford Ambler shook his head. "I'm afraid I foresee theological difficulties, Joe. Friction, anyway."

"Yeah, well, you're right of course. So I've put all my cards on the table, the best I could. They know at their headquarters in New York about the sympathy I feel for Asian people. They know how I've wanted to go out and work with these people ever since I was a medic in Korea. With CMA I wouldn't have too much trouble getting my license to practice medicine in

Vietnam. And I've tried to explain to them that my religion is personal and changing, getting worked out in experience. They understand that I want to try to follow Jesus' way, see if it's possible to *do* the things he said and did. Maybe the biggest difficulty for me is this strong notion they have of good and evil. Like the devil and his troops are on one side, and the children of light are on the other. For them it's a fight to the finish. This bothers me. Resisting 'evil' like that feels wrong to me somehow."

"And how would you explain evil?" Ambler couldn't help asking.

Joe shifted uncomfortably. "You all are giving me a hard time." But they were silent. "Well, I keep noticing how something good so often develops out of something that might be called evil. People always seem to be mixed bags. Maybe God wants you to be genuinely where you are, even if you're not so nice or so moral. At least not yet. To me any man who's honest about his failings can't be all bad."

"Maybe that's the way the CMA feels about you!" His dad chuckled.

Joe shook his head. "If they could find a more conservative type who was as well-qualified a doctor as me, who was willing to go, they'd take him like a shot! This one guy in charge in New York keeps asking me what I think my *ministry* is going to be. And I have to admit I'm not sure I have a ministry. My purpose is something like working toward wholeness. That's the best I could say to him."

"And did he actually accept you on that basis?" Ambler looked disbelieving.

"Well, he wasn't upset, just thoughtful. Said I had no idea of the sacrifices missionaries have to make in the field, and he doubted that my motivation was strong enough to carry me through. Admitting that he didn't see it working out, he still said he had better pray about it and meet me again the next day.

"So I waited around, thinking it was all over. The next day he came in, still serious, said he had prayed about it, and I would do! Gave me a weird feeling he knows something about me that I don't know." Then his hopeful smile erased the cloud. "Well, aren't you two going to give me your blessing?"

"I am." Sanford Ambler was definite. "It sounds to me as if God is saying to you what He said to Abraham, 'Go forth from your country and your kindred and your father's house to the land that I will show you.' To obey is an act of faith, no matter what comes of it."

"Thanks, San." Joe cocked his head toward his father. "Dad, look, if I go

out there now, then later on maybe I can come back and help change things here. Right now I just feel if I can work out in the East, I may get freed up, or at least make a start. I know I sound self-centered; that could be one of the things I need to get free of."

"Well," Boyd Ruffin said, "you're right to try to change yourself, because you won't be changing anyone else. Not so's you'd notice it. And frustration, you'll find, is not limited to the practice of medicine and/or Christianity here in the U.S.A." He waved aside Joe's beginning protest with his pipe stem. "All right, son." There was a pause while the doctor remembered how he had let his young wife go to New York to have her operatic career and how she had died there. He wondered if man is always fated to be a repetition of himself, right or wrong, come what may.

"Well, I understand you a little better all the time, Joe. And you know I want you doing what *you* think is right...." Looking around, he was relieved to see his sister coming into the room with a loaded tray. "Here's your Aunt Hester, Joe. Pick on her a little. Doesn't she need liberation?" All three men had risen.

"If southern women don't need it, no one does!" her nephew replied promptly.

"Nonsense!" Miss Hester paused, resting the tray against the sofa back, puffing a little, looking them through with her sharp dark eyes. "All I need is some help from a bunch of lazy men. Boy, come set up that card table! We'll have our supper here by the fire."

And as Joe obeyed, he thought, I'll certainly miss all this. I guess they won't have hearth fires in the tropics—revolutionary fires, more likely.

Saigon and Dalat, 1961

Inevitably times would change: rich and secure, the dynasty would isolate itself from the people and grow corrupt—the image of degeneration, the stagnant pool. Then revolution would come—the cleansing fire to burn away the rot of the old order.

Frances Fitzgerald, Fire in the Lake

A Happening

Albert Camus writes, "The aim of life can only be to increase the sum of freedom and responsibility to be found in every man and the world. It cannot, under any circumstances, be to reduce or suppress that freedom, even temporarily."

Bruce Larsen, Setting Men Free

Indochina in the dry season is baked hard. Elsewhere in the world April may break with the spring of a tiger into a green change, but South Vietnam drones under monotonous heat as usual. In dusty Saigon the soaring trunks of mahogany and tamarind trees, planted fifty years ago by the French, still drop their deep shade over the Cercle Sportif, in spite of other changes. There on weekday mornings around the turquoise pool French women share the illusion that the private club is still their own while recently admitted Vietnamese and American members are busy. In bikinis, improving their tans, the French women gossip lazily. Discussing the Americans, the situation, they use exclamations like *incroyable, effroyant.* One lifts on an elbow with sudden animation to scold René or Françoise, splashing up glittering showers in the shallow end, while overhead cicadas whir onto a higher note.

Outside this charmed circle lies another, the Saigon of 1961. With graceful complication the city seems to pursue life as usual. But the French way of life has gone, and new ways uneasily supplant the old. Since the paratroopers' revolution of the preceding November, a coup that failed, the political silence felt in Saigon is not one of apathy. It is rather the quiet after a purge, the silence of repression and deadlock. Under blossoms of flame tree and jacaranda, like an oasis sheltered by her exposed provinces, the city somehow preserves a hot-house peace. Saigon inhabitants are not yet even aware that they owe their temporary security to a strategy made in Hanoi: "Win the countryside first, and the cities will fall like ripe plums."

Meanwhile, along the Ho Chi Minh Trail from the North, through the jungles of Laos and Cambodia, weapons for the hidden guerrilla are coming down on coolie back, ox cart, or swinging elephant. Dangerous realities build up slowly like the thunderheads that mass day by day for months before the rains.

Below the heavy clouds Saigon life is feeding streams of people in and out of myriad patterns every instant. The sandals of decorative Vietnamese girls skim the hot pavements as they sit poised behind their white-shirted, narrow-waisted men on motor scooters. At the corner of Le Loi Boulevard near the flower market two carts and four white oxen have caused a noontime traffic jam. Everyone is on the way home, impatient for his lunch and his siesta. Doors open as little Renault taxis pile up; drivers gesticulate angrily. A stout matron, enthroned in her hired cyclo among wicker baskets of quacking ducks, urges on her stalled coolie with queenly motions. Seated high up behind her on the halted bike, one muscular leg stretched to the lowest pedal, he scowls over the hood and the heads of the crowd, looking for a break in the traffic.

Seeing there is little danger of a sudden start, Yen Thanh passes on foot, smiling, in front of the noisy ducks, their white heads and necks weaving in and out through the open basketwork. In her brown silk dress flecked with gold, Yen moves easily through the stalled traffic. This is her own milieu, rich fields of energy interchanging at a thousand different speeds. Here she is perfectly at home. Yen slips through still open doors into the Abraham Lincoln Library of the American Information Service. Later, after leaving the dim stacks with two books in her string bag, she stands outside again, dazzled in the sun. The streets are almost empty now and quiet. She walks smoothly along Le Loi Boulevard, turning left on Ham Nghi. Yen's cousin runs a pharmacy on the corner opposite the American Embassy. A tonic is needed for younger daughter My Linh who is badly run down after the measles. Entering the shop from the side door because the pharmacy is closed during the lunch period, Yen wrinkles her nose a little at the acrid smell of many drugs meeting her nostrils from the dark-shelved interior.

Across the street the Marine Guard named Pete Jackson is leaning against the concrete wall of the unpretentious U.S. Embassy building. He is not black, more bronze, with the blood of Cherokee as well as African ancestors. Under the overhang, in its narrow band of shade, Pete is joking with the dusty bare-legged children come to admire his pistols. Lunchtime. Nobody much around. He pushes off from the wall gracefully when a dark-

haired man of about thirty comes out of the Embassy stuffing a passport into his hip pocket. From his six feet he grins up at Pete's six-four.

Pete grins back. "Get a visa to a good R and R spot, mister?"

"Cambodia—Angkor Wat." The stranger was stopping.

Pete winced. "All them pyramids and tombs slo-o-owly suffocating in the jungle. Not for me. I take Hong Kong or Singapore. Like some night life with my sightseeing."

"Bored with the Saigon nights, Sergeant?" This guy had a teasing gleam in his light eyes. Pete thought he looked familiar. Kind of rough-hewn. Thin cheeks. Hard chin. Could be from North Carolina, too.

"Saigon night life? Hell, man, where you been? We got this President Diem and his whole family working overtime to straighten up the town. Try a little dancing or holding hands in a movie, you could end up in jail!"

"Yeah? I've heard something like that, haven't been here too long." He put out his hand. "My name's Joe Ruffin."

"Pete Jackson." They shook hands.

"You must be the Ambassador's special aide or something." Ruffin indicated the heavy loop of white braid at Jackson's shoulder.

Pete laughed some. "I'm not that special." Then he winked. "Fact is, I play a pretty good game of basketball, catches attention from the top brass." He greeted some secretaries passing in to work after lunch, and turned again to his casual acquaintance, who didn't seem in any hurry. "What outfit are you with?"

"I'm a medical missionary," Ruffin said.

"You gotta be kidding!" Still, he looked okay. "Well, it takes all kinds," Pete said largely and watched the missionary break up laughing. He had to wipe away the tears. Pete gave a sheepish grin. "Okay. What I know about missionaries you could...."

"Forget it. Since New Year's I've been shut up in four walls studying the Vietnamese language. What I know about Southeast Asia you could put in a thimble. My two weeks off begins today, and I'm planning to see what I've missed, learn everything I can. After this first trip to Cambodia, I'm going up to Dalat. They tell me that's the highest place around here. I'm going partly on business to look at a medical clinic for the mountain tribes people but also to get a little cool air."

Pete closed his eyes. "Dalat is high all right, five thousand feet. Man, how I could use some of that air conditioning!"

Joe leaned the muscles of his shoulders against the concrete wall. It felt

like an oven. He stared up at the massed clouds through a haze of heat and dust, raising one eyebrow. "Well, it looks like it might rain here today. That would cool things off."

"Saigon day," said Pete. "Don't let those clouds fool you. We going to have those same clouds and this heat and all that dust for a month more—at least—before the rains."

Ruffin shook his head at the weight of the thunderheads. "My first dry season in Saigon, and already I'm imagining the day when it finally starts to rain. That really must be something!"

Pete laughed. He kind of liked the guy's enthusiasm, his curly dark hair, and stubborn chin. "You just think that, man. Lemme warn you right now, keep out of that first downpour. When all that water meets all this dust and dirt, you get a bath all right, but you don't get clean!"

"Yeah. I see what you mean." Joe's smile flashed. "Just the same, when those clouds finally do break, it'll be a wonderful change!"

Pete remembered back. A rising wind, the flying dust, banging shutters, and somewhere an excited scream. A kind of wild thrill running, leaping up, into the crash of the rains at last. At last that steady drumming roar and the new smell of wetness.

"Yeah. You got something." Pete looked out over the shimmering, crowded street. A woman was chewing out a peddler in high squawks like a parrot. "Yeah. And people around here get plenty uptight the last days before that monsoon breaks." He glanced routinely down the street toward the gleam of the river and up toward the main part of the city. Traffic was beginning to thicken again. Lunch hour was about over.

Suddenly Pete moved out into the sun. "Hey, what's going on up there?"

Joe Ruffin joined him, squinting at a clotted mass of people beginning to surge down the middle of the street toward them. A few small figures could be seen running, well out in front. Police whistles shrilled.

"What is it, Sarge, cops and robbers?"

Pete narrowed his eyes. "Look like it." He waved an arm at the other Marine Guard seated just inside the Embassy doors, which were standing open. As he joined them, so did a young Vietnamese woman just crossing the street from the pharmacy. The four stood gazing toward the commotion, hearing shouts and more police whistles, the howl of sirens. For a few long moments they were frozen spectators of a drama.

The running figure in the center quickly became a Vietnamese man, not young, with a stiff brush of hair, shiny glasses, a sharp chin, and beaky nose.

Close on either side of this man were white-shirted younger men (students?) looking frantically over their shoulders. They were all striding, pelting down the street as though headed right for the doors of the Embassy behind Pete and Harry, the other Marine Guard. Pete felt the fleeing man's gaze fixed on him, as though he were the Statue of Liberty or something. Behind this first group, police officers in their cream-colored uniforms and puttees were spilling out of jeeps, coming after, pistols at the ready. Just as the man in the center got near enough for them to see the hopeful anguish twisting his face, the four watchers by the open door saw the end coming.

Action speeded up, the officers closed in. When the first policeman seized the older man's shoulder, two young men jumped to his defense, rolling with the officer to the ground, where they were easy targets for the gun butts of the other onrushing police. At this the older man stopped, pain creasing his face. Quickly he said something to the frantic students and then gave himself up. Even while the police were thrusting his arms behind him, shoving him bodily toward one of the jeeps, the man still spoke calmly to the students, telling them to fall back, to clear out.

Joe, who understood that much, heard the Vietnamese woman standing beside him murmur with distress, "Dr. Minh!" The following crowd had caught up. They made an angry circle around the scene as the older man was booted roughly into the first jeep, and the two students who had attacked the police were flung into a second vehicle. The people muttered ominously. Joe felt his nails biting into his palms. He was even near enough to see the older man's glasses knocked off, flying into the street. When the prisoner bowed his head, the woman beside Joe Ruffin sighed. He almost missed it in the rising murmur of protest.

"What is the crowd saying; what are they shouting?" he asked her in Vietnamese, looking down, seeing tears on her lashes.

She answered in English. "They say, 'It is Dr. Minh who is being arrested, Duong Quang Minh!' I think many of them are his students." Then she added, as though to herself, "And the last time I saw him we thought we were celebrating the coming of freedom."

Joe was watching the prisoner now, his head up, his eyes flashing, as he was carried on past the American Embassy. The Vietnamese words *Canh Sat* (Police) were painted on the jeep, as was the clasped-hands symbol of the U.S. Operations Mission, USOM.

Joe turned to Pete. "Isn't that our AID emblem on the jeep?"

The guard answered impatiently. "We supply the Saigon police with their

vehicles. Hey, you know something, I don't like the looks of this crowd." He raised his voice. "Now move back there, people!" With both arms spread wide Pete was pushing those near him back against the shelter of the building when something whizzing by struck one of the passing policemen. His black-visored cap was smacked into the gutter by a flung papaya, which burst open across the paving stones. Infuriated, the officer turned and fired into the crowd on the sidewalk. There was a horrified gasp like the backwash of a wave.

When a child fell to the pavement nearby, Pete instinctively looked over his shoulder and saw the bullet had buried itself in the wall of the Embassy. "My God!"

Dimly aware that others were bending at once to help the child, Pete stalked after the Vietnamese officer, who was furiously retrieving his hat, brushing futilely at the pulpy stain. His hat!

"What the hell's wrong with you, man? Are you crazy? You must be some kind of maniac shooting into a crowd of people like that!" The words were English but the message was getting through. The policeman held Pete's gaze in truculent silence and carefully spat, before he turned to walk after the jeep. Pete followed on, sputtering belligerence, knowing the English words were thrown away but too excited to find Vietnamese. "Why you bastard, how come they let you carry a weapon? Stupid, untrained nuts like you...." Enraged and frustrated, seeing that he was wasting his energy, Pete stopped and took down the license number of the jeep.

Sweating, he turned back. A Vietnamese woman who was kneeling with the missionary, Joe Ruffin, on the pavement by the injured boy, raised her head. "Sergeant Jackson," she said in a clear steady English, "will you please call for a doctor?"

"Mrs. Thanh! For Christ's sake, what you doing here?" Pete pushed through to them, as Harry, the other guard, was urging people to move back, give them room. Pete heard Ruffin tell her he was a doctor himself and would be glad to help.

"Fine; I am a nurse myself." Mrs. Thanh smiled. "This boy has fallen on good hands." Both their heads bent to examine the child's leg intently, oblivious to being the focus of attention for half the Embassy staff out on the sidewalk, as well as the milling crowd drawing in from the street. While the Marine Guards pushed people back (young men in dark glasses with bicycles, coolies in black trousers peering out from under straw hats with baskets of papayas and mangoes swinging from their shoulders), Joe only

saw that a tibial artery was slowly pumping blood onto the street and onto the dark silk trousers of the Vietnamese nurse. Swiftly he began to make a firm tourniquet out of his handkerchief for the thin leg just above the knee. Looking up from the dusty bare legs and feet, he saw a boy with screwed-up face wearing only a T-shirt and cotton shorts in faded blue stripes. Mrs. Thanh supported the child's black head, smoothing the rough spears of his hair. She had calmed his thrashing and was also trying to reassure his brother, or pal, who squatted close by, terrified, rubbing in some tears with a grimy fist. Tightly in his other hand he still held a worn-out gray tennis ball.

Doctor and nurse looked at each other as the bleeding began to slow. His hand on the thready pulse, Joe said, "This boy should go to a hospital." One of the secretaries offered to call an ambulance, but Joe glanced around in the crowd. "If we could get hold of a motor cyclo, that would probably be quicker."

At once Pete beckoned to a self-assured young man in a pork-pie hat who shoved his vehicle right up against the curb. Now that the tourniquet was secure, Joe realized he had accomplished the small job fiercely, adrenalin way up, enraged by the whole incident. Yet in all the noise and excitement the Vietnamese nurse had been as calm as the eye of a storm. Still, there had been those tears for the prisoner.

Feeling his look she glanced up. "Children's Hospital, Doctor?" When Joe nodded she spoke to the victim's little pal with several firm sentences. But he shook his head, answered sharply and ran off. She said, "I told him to go for the boy's mother and bring her to Nhi Dong Hospital, but he says there is no mother, and no relatives at all. I think he calls the boy Phuong." And she held up a restraining hand to show the impatient driver that they were not yet ready to take off.

The large shadow of Pete fell over them. "Good thing you two were here; this kid was really bleeding." He pushed his hat back off his sweaty forehead. "Dr. Ruffin, this lady is Mrs. Thanh, a friend of mine, a nurse *and* a social worker."

Joe nodded and stood up, his black eyebrows drawn together as he looked down the street to where the jeep with its sad prisoner had vanished. "Sergeant, what will happen now about this? Surely the local police are not free to shoot down civilians right in front of our...."

Pete interrupted him then, his expression suddenly hard. "All right, Doctor, you take care of your job and I'll take care of mine. Our first duty

is to see this kid on his way to the hospital." He picked up the boy carefully in his arms. "Mrs. Thanh, just get into the cyclo with the doctor, now, please, and give the driver some directions...." Obediently Yen Thanh and Joe Ruffin seated themselves on the broad padded bench in front of the driver sitting behind them on his attached motorcycle. Pete placed the small limp body across their laps as Mrs. Thanh gave brief directions and pillowed the spiky head in the crook of her elbow. Joe saw the child's eyes flicker, squint momentarily, and close again. Slowly their three-wheeled vehicle sputtered off, maneuvering through the curious crowd, gathering speed.

When Joe looked back he saw the tall African American moving easily to confront some official who had just come out of the Embassy door. "That Sergeant is quite a guy." And he turned, dejected, to Mrs. Thanh. "I guess he was right. But still," Joe felt the tide of protest rising again, "it's hard to take that kind of crazy injustice lying down."

Mrs. Thanh studied his face. "Have you been here for a short time only, Dr. Ruffin?"

"That's right." Hazel eyes searched her dark ones. "Are you trying to tell me I better get used to this kind of thing?" She looked down. "Well, that Sergeant did the best he could, I guess."

Her voice brightened as she said, "Pete Jackson is a very kind man."

Joe felt irritated with the big Marine. Was it because of his assertion of authority or for the warmth he stirred in this lovely woman? "Have you known him long?"

"Since last Christmas, when he and his Marine Guard friends gave a big party for the children of Plan. You see, I am a caseworker at Foster Parents Plan Headquarters. Since we met and worked on that party, now Pete always consults me if he finds an ill or abandoned child." She looked down at the boy whose eyes were closed, thick black lashes on an olive cheek shadowed with down.

Joe reached for his pulse again. "I wish we had something to put around him. Does his color look all right to you?" Joe was well aware then that her hand touched his arm in light reassurance. Yet he sensed a definite aura about Mrs. Thanh—womanliness held in reserve.

"He looks okay, and we will be there quickly now," her eyes widened, "if we are not killed first." With crisp confidence she spoke over her silk shoulder to the driver as they swerved onto a wide boulevard and roared toward the Chinese city of Cholon. Growling, the driver modified his speed.

Mrs. Thanh turned serenely back to Joe. "By luck I was already coming

to the hospital this afternoon to visit two of our foster children who are patients there. The personnel are good. Nhi Dong is run by the government especially for children of the poor. You will see, Doctor. They will take care of us at once."

Joe repressed his bitter question, "And is your government often busy treating its own victims?" Instead he smiled at her. "That's great, Mrs. Thanh." She was obviously used to taking charge in a capable, pleasing way. They had certainly "fallen on good hands."

When Mrs. Thanh glanced down at the boy again, Joe took the opportunity to look at her in her Vietnamese dress, the *ao dai*, smoothly fitting her rounded shoulders and arms, her compact short figure. This dress was of brown silk, patterned in small yellow flowers like forsythia back home. Its high collar came up almost to her ivory chin. The long skirts of this light material, divided to the waist at the sides, blew back in the wind of their passage. So did her loose black silk trousers, hardly showing the bloodstains. Beside his own loafers on the vibrating footrest, she had braced the black painted soles of her wooden sandals. Wide black velvet beaded straps crossed the short bareness of her feet below her even toes.

"Doctor, this is a funny boy. He does not relax. His eyes are closed, but tightly, you know? His little body feels ready to spring up and run off again!"

"He better not! Shall I hold him?" Mrs. Thanh shook her head. He liked her hair, cut in a soft, pageboy bob, falling only to her shoulders, rather than to her waist in the traditional style. Joe thought Mrs. Thanh a nice mixture of the old and the new, with her straightforward, friendly ways, yet still wearing the graceful dress and this occasional quiet reserve. From her poise and dignity, from her well-cared-for hands (she wore a wedding ring and a small diamond set with jade), he got the impression that she was a person of some importance, yet she was not at all repelled by the dirty street urchin she held in her arms. Somehow Joe doubted whether high-born ladies in Vietnam often were trained as nurses and social workers. He sighed. Unless he felt free to come right out with his questions, it was going to take forever to learn all he wanted to know about these people. Exercising what he thought of as Eastern courtesy was going to take more patience than he had.

Joe stared out between the marching blocks of white apartment buildings across a field of thatched huts toward the light blue horizon. "This looks like a new area."

"No, is old, but was badly devastated in 1955. Here in Cholon there was a four-day battle between the forces of the Binh Xuyen, led by Bay Vien, the

river pirate, and the soldiers of President Diem. The President won with some help, it is said, from your Colonel Lansdale of the CIA. You can still see the scars of fighting on the trees." She pointed to the pits in the bark of the chop-limbed sycamores along their route.

Joe thought her calm self-control might have come from living through times like those. But also, maybe Mrs. Thanh had to overlook the wrongs of the establishment if she happened to be the wife of one of its important officials. How could a humane woman become patiently inured to happenings like this morning's adventure? Angrily Joe reviewed in sharp detail and full color that brief flight and capture, ending with the shot in front of the U.S. Embassy building.

Outside the Embassy doors in Ham Nghi Street, Pete Jackson had turned to meet a well-built blond man, healthily tanned, who wore glasses. "What's been going on out here, Sergeant?" His voice had the flat accent of Boston.

"Damned if I can understand it, Mr. Gardiner."

"Just give me the facts." Mark Gardiner looked hot. "The press is about to descend, and I have to brief the Ambassador the minute he gets back."

Pete frowned. "Well, there was this Vietnamese being chased by the cops. He was running down the middle of the street, out in front of a crowd, but older and dignified—a professor maybe, you know—not the type to go out for track. They caught him right off, half a block away, up there just a couple doors beyond the pharmacy. I got the feeling he was heading for us, for the Embassy door, to get clean away. But he never made it."

"And the crowd?"

"Yeah. Well, the crowd was full of students. Seemed to know who he was and maybe were trying to help him. Couple of them got beat up some and carried off too. People were angry. Somebody threw a fruit that hit one cop right in the head, knocked his hat off!" Pete grinned and then sobered. "This bastard cop got so mad, he fired right into the crowd and hit a skinny kid standing on the pavement. Of course I chased after him, but what could I do? All I got was the number of the police jeep." He reached into his breast pocket, tore a leaf off his pad and handed it over.

"It's hard to believe," Mark Gardiner said, frowning at the square of paper.

"It happened."

"So what became of the kid?" The keen blue eyes flashed up through his glasses.

"That was a coincidence, like. This nurse and social worker I know, Mrs. Thanh, just happened to be standing right here with a Dr. Ruffin, said he was a medical missionary. They examined the boy, stopped the bleeding, and took him off to Children's Hospital. They must be there by now."

"Quick work. Know anything more about this Mrs. Thanh?"

"You've probably met her. She's a lady, and I mean the genuine article. Her husband is a jump officer. Could be he's also a Province Chief; I think I heard that."

One of the Vietnamese secretaries came forward out of the group still clustered around the door. "That was Mrs. Truong Vinh Thanh, Mr. Gardiner. Her husband attended the U.S. Command and General Staff School at Fort Leavenworth last year. Now he is a Lt. Colonel and the Chief of Tuyen Duc province where Dalat is located. Mrs. Yen Thanh herself is a case worker at Foster Parents Plan."

After a glance registering her prim rectitude, Gardiner was writing it down. "Thanks, Miss Van. Who was the man they arrested?"

As the secretary hesitated, dropping her eyes, a messenger boy spoke up boldly. "It was Professor Minh, who signed the Manifesto against the President!"

"Duong Quang Minh, you mean?" Some of the Embassy people were nodding. "But he didn't actually sign the Caravelle Manifesto, did he? I understood he was just a part of the general quiet protest against the government."

Miss Van kept her eyes down. "At the University Dr. Minh's views on the need for reforms are well known." Silence.

Without expression Pete said in an undertone to Mark Gardiner, "And ever since our little Revolution last November that failed, everybody with any 'views' seems to have disappeared from around here, or turned up in jail; maybe Con Son Island?"

Frowning, Mark changed the subject. "But you think the injured child is in good hands, do you Sergeant?"

"The best. We worked with Mrs. Thanh on a couple of the Guard charity projects. You see a lot of women trying to help people, but I never see anybody as cool as she is. She's good, and she enjoys it."

Mark raised his eyebrows. For Pete that had been quite a speech. "What about the missionary?"

"He was a Dr. Ruffin, in here for a visa, stranger to me. Seemed okay."

"I'll check him out in the Visa Section. And we'll send someone over to

the hospital in the next hour. Well, I guess that's it." He turned to get out of the heat. "Sergeant, let's get these kids off the pavement now, and have the staff return to work, okay?" Mark gave a back-to-normal smile and started through the door.

Pete caught up with him just inside. "Uh, one more thing, Mr. Gardiner." His voice was low. "Those bastards going to get away with this? I mean, right here in front of our door?" The two men looked at each other uncomfortably.

"Hell, Pete, you know we'll do our damnedest." Gardiner turned away, suddenly tired.

"Yeah." Pete muttered to himself after he went back out on the street. "I know the answer to that one. We're so busy advising them how to save freedom out in the provinces, we don't notice how they're crushing it in Saigon—and with our jeeps!" He moved toward the children, breaking into a few syllables of the Vietnamese language. At this they crowded even closer, laughing. However, a few minutes later when he saw the Ambassador's sleek limousine returning from lunch, American flags rippling, Pete had cleared the sidewalk of everything except a dull stain.

Children's Hospital

*We live our lives inscrutably included within the streaming
mutual life of the universe.*

Martin Buber, I and Thou

By the time they pulled up under the porte cochère of the modern hospital
building, Joe had noticed some coagulation in the small wound on Phuong's
leg. Before getting out of the cyclo he released the tourniquet for a few
moments and then retied it less tightly. Then he lifted the boy with distressing
ease and stood in the welcome shadow of the overhang while Mrs. Thanh
settled with their driver. Picking up a green string bag of books and closing
her pocketbook, she led the way down the wide hall into an office on the left.

A slender nurse rose at once from behind a neatly cleared desk and came
forward, her eyes rounded with surprise. In Vietnamese she asked, "An ac-
cident, Yen?"

For Joe's benefit Mrs. Thanh answered her friend in English. "Hoa, this
boy was just shot—on Ham Nghi Street outside the American Embassy. An
American doctor has happened to be there to help. Miss Luong, this is Dr.
Ruffin and our patient, Phuong. Dr. Ruffin, Miss Luong is the head nurse
here at Nhi Dong."

Miss Luong bowed and glanced at the boy's leg. "Excuse me," she said
in clear English, "I will call to Dr. Khanh of pediatric service, and will also
bring a stretcher. Please be seated." They sat down in straight chairs, of
necessity close together because Phuong, still in Joe's arms, had grabbed a
piece of Mrs. Thanh's dress. The head nurse came back for a moment to take
the patient's pulse. As she reached over, Joe saw that her thin olive forearm
was covered in the faintest black hairs. Modern short-sleeved uniforms
might be practical, he thought, but they would never be as becoming as Mrs.
Thanh's *ao dai.*

The three waited in the green-painted office. Several times Phuong struggled to get down, frowning up at Joe, who held on firmly while he tried to read the titles of the worn library books lying with a wrapped packet in the string bag on Mrs. Thanh's lap. One seemed to be *Walden* and the other a life of Clara Barton. He was about to comment when an orderly shuffled in pushing a stretcher on rollers.

Joe and Mrs. Thanh arranged Phuong on the flat surface as well as they could, since he was still in running position and wouldn't let go of her dress. They were both leaning over the stretcher as a white-coated doctor entered with a polite cough. When Joe straightened up, Phuong almost escaped, and was seized in the nick of time by Mrs. Thanh and the orderly. The doctor barked out a sharp order. Miss Luong, coming in behind him, helped the orderly strap Phuong down. While Joe rubbed his freed arms, Miss Luong adjusted her cap and introduced the American to Dr. Khanh, who was inspecting the small leg wound.

"Very happy to make your acquaintance, Doctor." Khanh bowed, glancing at Joe with bright curiosity. Then he bent his gaze upon Mrs. Thanh, whom he seemed to know. "Please to explain me, Ba Thanh, how persons are shooting children by U.S. Embassy building?" Phuong whimpered while the doctor felt his forehead and the glands in his neck, pulling out his lower eyelids, muttering something about eye disease.

Mrs. Thanh took a breath. "There was much confusion in the street, but I believe this boy was shot accidentally by the police during the capture— and arrest—of Dr. Minh."

"That shot was no accident!" Joe broke in, looking directly at Mrs. Thanh, who glanced away. Miss Luong's eyebrows went up. When Joe saw Dr. Khanh give her a meaningful look, she turned to close the door.

Only then did Khanh ask, "Duong Quang Minh was shot?"

Mrs. Thanh said, "He was running away from the police. Some people in the crowd, students, I think, were trying to save him. One police officer was hit by a fruit, and in his anger, he fired into the people. Only this boy was hit."

Phuong wriggled against the straps. Dr. Khanh turned to the American. "Doctor Minh was not escaping?"

Joe shook his head. "The older man we saw running toward us was overpowered and carried off in a police jeep."

Cautiously Dr. Khanh released the makeshift tourniquet, his eyes on the wound. Then he cleared his throat and made formal pronouncement. "As

we can see, Doctor, from rapid examination, this wound is not of extreme gravity. The bullet is not remaining in the body. But I think it was passing a tibial artery. Is it not?" Joe nodded. "He was losing many blood?"

"I doubt if he lost half a cup—ninety to a hundred cc."

"You were quickly." With that Dr. Khanh gave up the struggle to practice his English and spoke in fast Vietnamese to the two women.

Mrs. Thanh turned to Joe. "The doctor will have this boy taken to the operating room for cleanup and some stitches. He would be happy to have you assist."

Joe smiled. "Thanks, Doctor, I'd only be in your way. But I would like to look around the hospital, if that's okay."

Relieved, Dr. Khanh assigned Mrs. Thanh to show him around, and bowing, left. When the stretcher rolled, Phuong began to wail. Mrs. Thanh leaned over, whispering in his ear, removing her dress from his fist. Joe saw that Phuong was not at all resigned to his fate. The wild, somewhat cloudy eyes stared back at them still, until the stretcher had turned the corner.

"Poor kid." They left Miss Luong and started down the corridor toward the out-patient clinic and the labs. Joe added, "You're really good with children."

Yen smiled. "Well, I like them. But also they are my job, Dr. Ruffin, at work and at home. My husband and I have two little girls of our own."

"What does your husband do, Mrs. Thanh?"

She looked up puzzled. "Oh, my husband's work. He is a Lieutenant Colonel of the Airborne Forces."

Joe had painted a picture in his mind of an older military type, chosen for her by her parents. An enthusiastic young intern showed them the out-patient section and exercised his English with daring and imagination. Joe could use his Vietnamese only on the patients, who waited, leaning against the walls, squatting on the tiles.

As he glanced through the doors of the lab where technicians looked up to stare, Joe said, "In Korea I was a medic attached to the Airborne myself."

"You have jumped?" Her eyes shone.

"A few times."

"A few times," Yen echoed. "We also."

Joe laughed in disbelief. "Mrs. Thanh, you are not going to tell me that your husband lets you jump with him?"

"No more jumping for me I'm afraid, not since the children have arrived. But," she gave him a mischievous smile, "that is how we met!"

Joe scratched his portrait of the distinguished old officer as they reached the crowded Social Welfare Office where a painfully thin middle-aged lady in a white silk dress and trousers rose eagerly to meet them. Her black lacquer hair was strained into a tight bun on top of her head, which seemed to pull the thin eyebrows up anxiously. She wore a small gold cross on a chain and no other decoration. Mrs. Thanh was explaining that all these people who jammed her tiny office were parents, unable to afford the prescriptions doctors had written for their children. No money, no medicines and transfusions.

As the people melted back into the hall, Joe was introduced in French to Miss Lanh, who said she did not yet speak English, though she was studying at night. When Joe told her his French was much worse than his Vietnamese, Miss Lanh was amazed. In her own ordinary language then, they began a conversation which Joe determined to come back and continue later. He was drawn to this single-minded woman, so delighted over his interest in "the poor." Watching, Joe saw that her outward severity was only a cover-up for her intense drive to be of service. It kept her thin, never resting.

He gestured toward the neat account books open on her desk. "Where do you get the money to help these people?"

Miss Lanh looked even more worried. Her allotment from the government's Bureau of Social Welfare would take them only part way through a month. Until the American ladies came, she had to ignore requests after the allotment was spent. Thin hands met with finality.

"Children would actually die for lack of transfusions?"

She nodded. "And for glucose or the very expensive antibiotics." Then her plain face lighted. "But now, with the American ladies, we perform many miracles! We are even thinking of setting up a few worthwhile individuals in small businesses of their own, selling soup or shining shoes, so they become independent. See, Doctor, I am keeping very careful records for the American Women's Association to be sure their money is never wasted." She turned the pages of spidery figures and script, entered in straight columns.

It almost hurt to see how conscientious she was. "You know, Miss Lanh," Joe said, "I envy you. You are so badly needed! I sit all day studying the language and wishing I were involved in work like yours. Would you mind if I came back again?"

Pleasure brought a little red to the sallow skin tight across her cheekbones. "*Xin loi, Ong Bac Si.* [Please do, Doctor.] Already you speak our language so well that I can understand you! I am told Vietnamese is very

difficult for foreigners, although it seems easy to us. Would you not prefer to speak French?"

Joe was tired of being asked that. "I like your language."

"Then please be patient, Dr. Ruffin. You will soon speak much better, and I know our Lord will give you great opportunities to serve His poor, for I can see you are a very kind person."

As they went on down the hall, Joe looked back and saw Miss Lanh straight and white and anxious in the clamoring crowd of her poor. She was trying to single out who was next.

Mrs. Thanh smiled up at him. "You liked her."

"You knew I would."

Yen looked away. "Miss Lanh and I both graduated from the same nursing school of the Daughters of Charity in Tu Xuong Street." She led him toward the elevators.

"And you went to the same school of social welfare?"

"The Sisters run the only school for social workers in Vietnam."

"Your friend Miss Lanh must have second sight. I mean, she really had my number when she warned me to have patience."

Yen said, "I have not noticed your so little patience."

"Mrs. Thanh, you see before you the most frustrated man in Saigon. I have *always* got to be *doing* something, and I don't mean sitting in a room with a book all day." Joe shoved his hands in his pockets.

Always polite, she murmured, "I understand."

Joe laughed. "Excuse me, Mrs. Thanh, you aren't about to understand. Here you people are all trained in patience, I guess, from the time you are infants. I'm not sure whether it's Confucian or Buddhist or what, but you are not going to disturb the social harmony, even if this elevator should never come!"

She giggled with pleasure as the door opened and they got in. "I understand better than you think, Dr. Ruffin. My American boss at Foster Parents is like you, and he does many good things. Maybe too much patience is not okay. Also, I'm not sure our religion is the cause of our quiet ways. I think Americans have many energies because they are healthy. We are not so healthy as you."

Joe thought of the generally high incidence of dysentery and malaria and TB. Looking around any hospital a person would certainly conclude that patient resignation was one of the results of poor health. Still, walking through Nhi Dong Hospital, he had a good feeling about the place. They

passed the post-operative recovery room with its huge plate glass window through which concerned relatives stared at little waxen figures in cribs receiving glucose or plasma. They went by the screened-in ward for children who had been severely burned, the only room with screens so far.

"Who are all those people crowding the wards and on the balconies?" Joe asked. "Is it visiting hour?"

Mrs. Thanh looked apologetic. "These are the relatives. We must have their help because we are badly understaffed."

She shook her head as they passed the bobbing, smiling people, often in ragged, soiled clothes. "It is very hard on the staff to have them here. Of course we try to teach the mothers hygiene, and how to help their children in right ways, but it is very difficult."

"Great for the kids, though. I bet they feel much more secure in the strange place."

They looked into green operating theaters. As one was being cleaned up, bloody cloths were carried out in buckets while sun poured in through the skylight. Glass cases of instruments lined the corridors outside, probably kept sterile enough. In the general ambience of casual informality, however, on the same hall some three- and four-year-old ambulatory patients were happily splashing Chinese soup together around a small table.

"Hey, these kids really feel at home. That's great, and I like these balconies, too." He stepped outside. There were no doors and no screens. "Don't you have trouble with flies?"

"Not up here on fourth floor, but downstairs."

Joe leaned against the railing and looked out over the bright city, extending further than they could see. "We Americans would be horrified at the thought of a hospital with flies, but we sometimes separate a child from his mother at the worst crisis in his life." After a pause he went on. "Sometimes I've thought that in trying to cure someone, efficiency without caring is not efficient; it may even be counter-productive. On the other hand," he turned on her his intent gaze, "is caring without efficiency really caring? What do you think?"

She drew back. "Dr. Ruffin, are you always so...disturbing?"

"Usually." He smiled, thinking how very undisturbed and poised she looked. Smooth hair, smooth dress, warm expression and smile. "Are you a Catholic, Mrs. Thanh, like Miss Lanh?"

"No." Her limpid gaze met his.

"But these schools you mentioned were run by the Sisters?"

"Oh yes."

"And you were never interested...?"

"Interested, yes. But you see, I am a Buddhist. And after some study I find it is all one! There is the Buddhist Nirvana, the Taoist secret of the Golden Flower, your Kingdom of God, the treasure hidden in a field...." She laughed merrily at the expression on his face. "Dr. Ruffin, I can see your own interest is not just for medicine and hospitals!"

"Mrs. Thanh, everything and everyone in Vietnam interests me. I want to learn it all so fast it's pitiful."

"No patience?"

"Didn't I tell you?" Starting to put his hand on her shoulder to draw her closer, Joe stopped. "I'm afraid if you know all the rude, impatient questions I'm crazy to ask, you might not want to be my friend."

"I am your friend already, Dr. Ruffin. Please to tell me some of the questions."

"Well—great. Of course in America friends would call each other by their first names, but let's waive that for the moment. I'm curious about so many things. Like what you said about Buddhism and Christianity being much the same. I'd love to know what you mean and how you got there."

"But to talk things like that takes some time, doesn't it? And you see," her hands opened out, "I guess I am more a person for doing, than for so much thinking about those things."

His light glance examined her. "That explains how you could have met your husband jumping from airplanes, but not what you're doing with Thoreau's *Walden* in your bag." Yen's eyes widened; she opened her mouth, but Joe was going on. "I'm loaded with questions about that tragedy we happened to take part in this noon. These may be political questions, though I've hardly had a chance to formulate them. Mrs. Thanh, after an experience like that I feel a strong protest rising inside me. I couldn't understand you. You weren't that upset. You just seemed to accept the whole sorry thing, even with a smile, and go right on." Yen turned away in silence. "Have I hurt your feelings?"

"Not—exactly." But she did not meet his eyes.

The impatient spurt of his anger took a moment to die. Then something in her withdrawal touched Joe. He came a step nearer. "I'm sorry. Look, why don't we figure out what we could do about this together? We might be able to make some kind of formal protest to your government. Or I could stir up something through my own Embassy and the American press. That might

help Dr. Minh. Well, don't look so shocked; a little publicity could be very healthy for the Saigon police!" Searching her horrified face, trying to read her thoughts, Joe saw appearing the serious, older-sister look she had when making arrangements for Phuong.

Her eyes were still troubled, however. "Dr. Ruffin, you frighten me, even though I know you are right for trying to understand. Only, please do not take actions before you are understanding. It could be dangerous." When he frowned, Yen continued firmly, glancing at her watch. "Okay. I think I see how we do. I will go now to visit my two cases from Plan. Also to check up with our boy Phuong, if he is fine, and anything like that. In the meantime, you will be meeting Dr. Thien for discussing political questions."

"Hold on now, Mrs. Thanh." Joe felt uncomfortable. "I don't think...."

She put her light hand on his arm, a sister's reassuring hand. "Dr. Thien is Orthopedic Surgeon here. He is also former Minister of Health and knows many foreigners. For our Foster Parents Plan cases, he operates free of charge! Dr. Thien will know how to talk with you about this. Believe me, Dr. Ruffin, we Vietnamese are also unhappy over bad situation in our country, even if we may not show it, but I think Dr. Thien is best person to explain you our problems—and dangers."

Joe shrugged. "Okay."

"For the rest," Yen looked warm, eager, and less sure of herself, "I invite you to eat dinner in our home this week or at the weekend."

"Thanks!" He thought about it. "Well, I'm going to Angkor Wat this week, but I'll be back on Saturday. I'd love to come then."

"Very good. Seven o'clock. At home we can talk in freedom, and I think my husband will be asking questions to you! He is also very curious man. And my father—it was he who asked me to bring from your U.S. library the book of *Walden*. He wants me to translate it for him slowly!"

Joe decided that the Buddhist father who wanted to read Thoreau would be interesting to meet. And the Colonel who had chosen this woman for his wife could not be all bad.

"Mrs. Thanh, your husband is a very lucky man." He had to turn away from her responsive face shining with the joyful knowledge of her own happiness. There are some frustrations no older sister can help with. Looking down from the balcony through sharply rustling palms, Joe caught the flickering continual motion of vehicles and people below in the street. Resting his elbows on the rough, hot railing, he thought of himself as a spectator, a gloomy gargoyle fixed in concrete, watching life rapidly pass him by.

American Embassy

In Vietnam "the taint of Colonialism" had been removed, and now it was necessary to remove the taint of authoritarianism. For all these reasons Eisenhower, in the same letter to Diem promising American aid, stipulated that the Government of the United States expects that this aid will be met by performance on the part of the Government of Vietnam in undertaking needed reforms.

Eisenhower Papers, 1954

Vietnam was like a movie, a thousand pictures flicking by before you could catch them. The dark flow of hair down a young girl's back to her bicycle seat, the kid squatting there, grinning into the sunset shaking a fistful of yellow hibiscus. And the ovals of those downcast Vermeer faces, shadowed by the wide cones of their hats.

Mark Gardiner stood looking down on the involved street life below the Embassy windows. He liked it here, even had an urge to paint, something he hadn't felt since Harvard. But no one could ever paint the smells, from the rotting stench at the heart of the Central Market to the honey fragrance of frangipani over a wall. Or stinking *nuoc mam*, the fermented fish juice stored in innocent-looking piles of white ceramic pots. Behind plate glass he was effectively removed from the competing smells and the noises—a jangle of Oriental music, the raucous music of the Vietnamese language.

Something was happening to him here. Less than a year ago, he'd hated to leave all the advantages of a European post, and now Europe looked tame compared to the Far East. Could Allison Giraud be responsible? Was she calling to the exotic under his New England habit of reserve? Or had he himself, in another lifetime, put into this port before, as captain of a whaling fleet out of Provincetown? What pleased him most was the challenge

of this demanding post, where he could hope to make a difference.

An official throat was cleared behind him. Mark started. Although it was late, losing himself in the life down there always seemed to renew his appetite for the work. In a rumpled seersucker suit Mark was standing in the office of the U.S. Ambassador, after closing time, with a folder of papers still requiring the signature. Douglas St. John sat largely, solidly behind his heavy desk, reading and signing. He leaned forward.

"Now, Mark, let's have a look at that agenda for tomorrow's talk with Diem."

"Here it is, Mr. Ambassador, almost as we wrote it. For a wonder, General Curren was the only member of the Country Team who wanted any change this time. There—the third item, sir."

The Ambassador's trained eyes ran down the page.

"I think we can swallow that, though if Diem treats us to one of his monologues, we'll be lucky to get to the toilet sometime, much less to Item Three!"

Mark's responsive grin faded while he leafed through his folder to be sure he was not overlooking anything important. St. John shot a curious glance at the younger man across the typed page.

"This agenda is not exactly as you yourself would have written it, I daresay."

"Why, no sir."

"I just had a feeling, Mark, after our discussion of that unfortunate shooting incident in lunch hour, that you hadn't quite gotten everything off your chest before Homer Bigart and the rest of the press were on us. Is there something you want to add?"

"Well, sir, off the top of my head, I feel the Public Safety boys over at USOM should get the word that their protégés in the Saigon Police have got to straighten up, or do without."

"I agree," St. John said. "I've already told Howitzer he should require proof that the Vietnamese officer in question has been disciplined."

Involuntarily Mark pictured the American Chief of Public Safety, a former Marine and retired Police Chief, churning his way up and down the blue pool at the Cercle, arms flailing powerfully without a pause.

"I can see you're bothered, Mark, and certainly not just about Howitzer. He's a good sort, conscientiously doing his best according to his training. Since we're just about through here, why don't you sit down and spell out some of your own ideas, off the record of course. For once I see my calendar

allows me half an hour." He leaned back. "But you may be in a hurry your-self tonight."

If he should be late, Mark doubted that it would worry Allison. Anyway, such an opportunity was rare. He sat down uneasily, noticing in the French cuffs of the Ambassador's white shirt his crested, gleaming cuff links.

"Well, sir, I'm not too happy over our government's supporting a despotic regime like this. It came up again this morning in the orientation lectures. At the end of my usual talk on the political situation, some new arrival—usually from the AID program—always asks why we Americans are back-ing a tyrant in South Vietnam with no free press or religious freedom and rigged elections. Of course I try to tell them that in these emergency con-ditions a strong government is the only answer."

The Ambassador smiled. "And does that go against the grain of your revolutionary New England background?"

Mark grinned. "Somewhat, maybe. But I can live with compromise all right. It's just where to stick that I wonder about, sir." He paused and de-cided to push on. "Maybe we should stick more to our democratic prin-ciples—our only hope out here, would you agree? Of course, the big dan-ger in democracy is taking a chance on the ordinary people. Well, if we're afraid to do that here, because maybe the Vietnamese are different—if we sacrifice the means for the end in Saigon—are we any better than the Com-munists? Are we offering these people anything more valuable?"

St. John rubbed his chin. "Mark, we both know Diem isn't a democrat in our sense. Yet, while he is a Mandarin, he has stood out against the Com-munists, and he is respected, though I'll grant he doesn't generate any wild enthusiasm. Obviously the Saigon intellectuals are discontented, but what the government is concerned with right now is the Red menace.

"Essentially, Mark, it's the time element. With no democratic tradition—and because the country was exploited and is still underdeveloped—rigid discipline is needed for South Vietnam to move ahead rapidly enough to survive. After all, since Magna Carta it took eight centuries for our own democratic government to evolve. We simply don't have that kind of time here!" The Ambassador pulled on an ear lobe, watching Mark.

"Of course I agree that in wartime a strong central government is nec-essary." Mark frowned. "But this one seems more like a weak, corrupt au-tocracy, concerned only with staying in power. What can we say when we're asked about the bribery and corruption?"

"I have a favorite answer for that one," St. John said. "I use the word

'lubrication.' By the time-honored system out here, they put in oil so that the heavy machinery of the outdated bureaucracy works. We can't pretend this system is totally unknown in our country. If you lubricate up there a little, eventually down here will drop out the needed visa, license, job, or legislation. Otherwise, you can press levers as you will, and all you get is a lot of overheating and noise. I've heard a Vietnamese cabinet minister say that South Vietnam got self-government before they understood what government is." He shook his head. "We just have to deal with the government they have."

"I agree we have to deal with Diem for the short run. But shouldn't we be alert to the fact that every minute we keep a tyrant in power, we are just handing trump cards to the Communists? Their entire propaganda campaign is built around his mistakes or the mistakes of his relatives. And surely we don't have to brag about him or butter him up!" Mark decided not to name the visiting VIP who had called Diem "the George Washington of Southeast Asia."

He took a deep breath and went doggedly on; the Ambassador had asked for it. "In my view, sir, we ought to make clear to the President what we think of his forced labor, his involuntary Agroville plan, and his political prisons, somewhere in tomorrow's agenda and every future agenda. Frankly, Mr. Ambassador, I would rather not even think about the probable fate of Dr. Duong Quang Minh, who was arrested this noon. This only confirms my feeling that we should use the leverage we have to bring about some vital changes." Mark stopped. Maybe he had gone too far.

"Just how much leverage do we have, I wonder?" St. John said. "They asked us to come out here, they want our help—but not our dominance. This whole thing with Professor Minh brings back the mess over Dr. Dan. In the so-called elections of 1959 for the National Assembly, Dr. Phan Quang Dan was the only successful opposition candidate. On the day the new Assembly convened, Dan was arrested by Diem's police as he left his clinic to take his place in the Assembly. Naturally Dan was very bitter, and after his eventual release he said we Americans should have righted this wrong. Why, he asked, don't we intervene when moral issues are at stake, since we accept military and economic responsibilities?"

"What's become of him?"

"He had a big part in the unsuccessful coup last November—was arrested again, tortured, imprisoned, and hasn't yet been tried."

"My God. All that happened right after I came, and I never got the whole story."

"We presented a great many strong pleas for Dan with Diem," St. John went on, "which may at least have kept the doctor alive, but only added to the alienation of the President. Diem already suspected that many Americans would not have been displeased if the paratroopers' coup had succeeded.

"So Diem needs us in certain areas," the Ambassador said, "and we think what we need is a reformed Diem. But how democratic is it, you might wonder, to interfere in the internal affairs of a sovereign country? And beyond that, who's to say whether our idea of what's right for them actually is right? With our different history, culture, geography, do we really know what will work best in their set-up?"

The old one-two—Mark could have delivered it himself. Time now to bring out that realistic smile, but the pleasant rapport he had built up with his boss had begun to cost something.

"Mark, what I say and what I believe can't always be the same. In my position I don't have that freedom. But here in this office I can level with you, I think. I've always found you to be discreet."

Mark was silent.

"It's no secret that these months have been a time of crisis for our policy in Vietnam. The minute Kennedy was elected, the question before him was whether to give top priority to the military battle against the Viet Cong— or give it to the political reforms needed for winning popular support. You know how the VC are always working with the people—'the people are the water, the army is the fish.' But the South Vietnamese army has been exploiting the population.

"In spite of this, it seemed to me, since the National army was the only part of the government with a strong organization throughout the country and with good communications, it could still be the key to stabilizing the situation. If the army and the people could be brought together as a team, you would have your first strong weapon against Communism."

Mark lifted his eyebrows. Great idea if we could make it happen.

"Well, after the disappointment of the failed coup, as you know, I continued to report to the Department that the problems with Diem were growing even more serious. This present crisis in Laos is adding to our difficulties. If Washington should decide not to intervene there to help the right-wing fighters, then they'll be all the more determined to stick in Vietnam at least, so as not to lose prestige with our Asian allies, or run the risk of losing all Southeast Asia."

"Gives you a feeling of doom," Mark said.

"Well, I believe in keeping an optimistic outlook, but you hit the nail on the head when you said our present strategy depends on successfully prodding Diem to undertake political, economic, and social reforms that will 'win the hearts and minds of the people.'"

They exchanged painful smiles. This being Mark's first chance for any personal understanding of the Ambassador's views, he began to review what had been said.

"Are you feeling all right, Mark?"

"Why yes, sir...." He was surprised by the concern. Although his father and Douglas St. John had been friends and classmates at Harvard, Mark had tried to avoid taking any advantage of this.

"Getting plenty of golf or tennis?"

"Not nearly enough! I swim at the Cercle almost every lunch hour. Keep a riding horse over at the Club Hippique. I also tried water skiing with some French friends until I found out I couldn't stomach the river."

"You New Englanders always keep in trim—if your father ever missed his game of squash, I didn't know it. Of course it's doubly important to stay in shape in a tropical climate." He rested his hand on the bulge just above his belt line. "Well, you certainly look fit to me. However, Mrs. St. John has a notion you're getting tense, possibly overdoing things a bit. It's a compliment, really—she only gets these ideas about people she likes. So we're thinking of going up to our villa in Dalat weekend after next and would like to have you come along, if you're not busy."

"Thanks, Mr. Ambassador, I'd be delighted. I doubt there's anything wrong with me that a cool weekend wouldn't cure." And just how honest was that?

"Fine." Mr. St. John's eyes twinkled. "And be sure to bring your girl if you'd like—the pretty one who came with you to the tennis matches last week. We thought she was charming. All very informal, of course, Mark. No one but ourselves, I believe, or possibly a USOM couple and Minister Thinh with his wife."

"Thank you very much, sir." So Mrs. St. John was going in for matchmaking. Too bad her own children were all out of range back in the States. Still, at thirty-three he was a logical target. Mark frowned, hating his own indecision. Here was a perfectly good opportunity to see how Allison would fit into Foreign Service life. Mr. St. John was already signing the last document.

"Mr. Ambassador, Mrs. Giraud—Allison—the girl you suggested I

invite, is the American widow of a French rubber planter and has two children."

"Bring them along, bring them along. You know the size of that place. No problem there. Do us good to have some young life around." St. John got up. "But Mark," he turned back on his way to the door, "don't forget to check with Security if you plan to drive. Communist activity has been stepped up around Blao, I hear."

The lines on his forehead seemed deeper during these last months of day and night involvement with the fate of South Vietnam. The worst of it was, Mark guessed, the Ambassador sometimes felt he cared more about the situation than many Vietnamese.

"Mrs. St. John and I will probably fly. The Province Chief up there offered to take us in his own plane. We won't do that, of course, but he's a very likable fellow, a Colonel Thanh, has an attractive young wife. You may meet them. Well, Dalat is the capital of his province, Thuyen-Duc, which turns out to mean the 'Proclamation of Virtue.'"

Almost gone now, Mr. St. John paused, his large hand on the door knob, staring out on the congested scene below the windows. "I wish we were going tomorrow!" Then he gave Mark a blank stare. "But what the hell good will it do? Dalat with all her virtues, high up in the mountains? When we get back, the whole damn situation here will be just as hot and sticky as before, if it isn't worse."

"There's always some benefit from a change, sir." But the Ambassador had turned abruptly and left. That was his prerogative, and his half-hour must be up. Standing alone in the air-conditioned hum of the office with its American flag and signed photograph of President Kennedy, Mark began to feel a touch of optimism about the projected weekend. Something just might happen up in Dalat to break his own private deadlock.

Above the activity of Ham Nghi Street, he stayed to watch the evening light prettily gilding the red-tiled roofs of Saigon. Beyond the Majestic Hotel, along the river quay was Allison's charming apartment. Recently, from there her careless power had begun to draw him like a magnet. For a moment he imagined Allison sitting on her jade green sofa in her white Vietnamese dress, laughing at herself in the costume. Mark liked the high mandarin collar under her rounded chin. She was the only American girl he knew who had the figure for an *ao dai*. Long-waisted and small-breasted, she stood and moved in a way that caught your eye. Mark had considered how well Allison might decorate his future home and career with her poised

beauty, her fluent French and Vietnamese. Not that Allison ever seemed to study languages. It was just a knack, acquired, she said, because no woman could bear not to communicate. But whenever they met, Mark forgot everything except his delight over seeing her, being with her again.

His brown hand fell to the Ambassador's phone, dialing an outside number. *"Madame, s'il vous plait...."* "Hello, Allison—Mark here.... No, I'm still there. As a matter of fact I'm using the Ambassador's phone." His gaze roamed the spacious office. "You didn't forget our date?... Good. Sorry I'm delayed, but I'll be over in less than an hour." He glanced at his watch. "You haven't?" Mark exploded. "For Pete's sake, Allison, you know we were invited for eight!" He felt her gently mocking voice as half pleasure, half irritant. "No, I'm not excited, but you know how you are—some crazy thing like this always happens to you!... Okay.... All right; I'll make it a little later. Allison—no, I'll tell you when I see you. Go on and get started!"

Hanging up, he sank back to brood in the Ambassador's chair. Willpower, that's what was doubtful. Character and energy. Was she ever really serious? On the other hand, if Allison Giraud were reliable and predictable, would she be so much fun?

The door opened. The Ambassador's secretary, starting to come in, saw Gardiner's absorption and retreated with an apology. He got up and tramped through the other office without a word.

"What's eating Mr. Gardiner?" the new stenographer asked. "He's usually so pleasant."

"Probably nothing but ambition. You should have seen him just now, sitting in the Ambassador's chair!" She was locking the big safe with efficient whirls. "He's the keen-eyed, brilliant type from Hah-vahd. Rhodes Scholar too."

"I don't mind. I think he's cute."

"Oh, he's a catch all right."

Downstairs, going out, Mark ran against Pete Jackson. He left his hand on the powerful shoulder in the light khaki uniform. "About that trigger-happy police officer, Pete—I have official word he's going to be disciplined."

Pete looked away; his dark face expressionless. "Yeah, Mr. Gardiner, that's okay."

Dissatisfied, Mark went on out, pushing into the sudden weight of the warm soft twilight. Catching his wrinkled jacket at the neck he swung

it over his shoulder and looked around in case an Embassy car and driver were still available this late. Then, impatient for a shower and a drink, he took a cab.

Something after midnight Mark and Allison were sitting in his Peugeot curtained by the darkness falling from leafy trees around her small apartment building. It was brighter out on the river. Mark enjoyed the sweeping movement of a shadowy boatman who stood in the stern, propelling his sampan with easy rhythm toward the opposite shore, Viet Cong territory.

"Won't you come up?" Allison asked lightly.

"Thanks, but...."

"Nowadays you never accept." She turned to gather her things and get out of the car.

Mark drew her back, his hand on her neck. "I'm pretty sure you know my reasons." Then he caught the glimmer of her smile. "That pleases you, does it?" He had her chin in his hand, trying to read her expression.

"Well," she shrugged as if to say, doesn't everyone want to be wanted?

Mark sighed, letting her go. In some ways she seemed more foreign than American. After all, she had been married to a Frenchman for quite a few years. Frenchness could be catching. Even though it was a silly idea, it made him uneasy. Slouching back with his head against the seat and his hands in his pockets Mark thought, I decided to hang on like this until I'm sure of my own mind, and damn it, I'm sticking to my plan.

"What did you think of the Thiens' dinner?" he asked. It had been a private party in a Chinese restaurant in Cholon.

Allison sounded merry. "I'm always worried every time a new dish comes around for fear this time it's something I just can't manage!"

"After all these years in Saigon?"

"There are still a couple of impossible things—birds' nests and petrified eggs!" They both laughed.

"Allison, I saw you, you were stuffing! Still, you were lucky, sitting at the end by Dr. Thien. He would have kindly overlooked a graceful 'no thanks.' I was right under her eye—couldn't escape second helpings every time."

"She is formidable. But I love Dr. Thien. I can even chew on the bones of those baby birds for him. He has such a gentle smile, and I like the boyish way that lock of hair keeps falling across his forehead."

"That's enough about Dr. Thien." Mark turned his face into her silky brown hair.

Leaning her head against his, Allison looked out over the dark water. "How did you meet them? When he was Minister of Health?"

"Ummm. Not too long ago."

"Do you wonder why they ever married, Mark? She seems so hard, and he such an idealist. They must be miserable together."

"I don't know. Their parents would have made the match where they grew up in Hanoi. And when they were still in the North, fighting together with the Vietminh against the French, she must have been an asset to him. A real tiger."

Allison murmured, "A cowardly type like me would have been no use at all."

"Don't sell yourself short!" Mark felt impatient, even dogmatic. "You'd find in a crunch you're just as brave as the next person."

She didn't argue, only went on with a touch of envy. "When the Communists had taken over the North in '54, and the Nationalists had to flee south, can't you see her helping to organize the escape with their child on her hip?"

Mark smiled. "Like the Trung sisters, battle maids of Vietnamese history!"

"Ba Thien could have posed for the monument—the other sister, the one Madame Nhu didn't pose for!" Allison was thoughtful. "With Thien the Minister of Health, she must have had a splendid outlet for her ambition and energy. But, now…she looks so stout and sulky behind that made-up, jeweled shell."

He had stopped listening, watching the round of her cheek, the straight line of her nose, the extra fullness of her lower lip. As for the Thiens, when Mark tried to imagine them in bed together, and failed, he decided it was time to go home.

"Allison, I have an invitation for you—for us."

"Oh?" She turned.

"Mr. and Mrs. St. John enjoyed meeting you the other day at the Cercle. They asked me to bring you along up to the Ambassador's villa in Dalat for the long weekend. Will you come?"

She smiled. "Fine, Mark. That should be fun!"

"The children are invited too," he said, and heard her low laugh that was almost a chuckle.

"Not quite as much fun!"

"Allison!"

Still laughing, she opened the car door. "Don't worry, Mark. It will be great, a godsend in fact. We need the change terribly. And I'll be a picture mother—you'll see, a Mary Cassatt!"

"Allison, come back here!" But she had slipped away in the dark. Damn. She could always read his mind better than he could hers. His last glimpse of her face puzzled him—laughing, but wistful, too.

Viet Cong

*Choose individuals carefully, picking those who have the cour-
age to deal with the enemy, or who have the ability to win the
sympathy of enemy officials and troops.*

Douglas Pike, Technique and Organization
of the Viet Cong

Dalat is a mountain town where shadows flow in early to drown the light.
Up there on the same April day, as the earth turned from the sun, coolness
dropped suddenly into the little streets around Dalat's market place. No one
felt this change in the small, comfortably crowded bar, located between the
orchid seller's stand, bearded with gray-green parasites, and the corner *tabac.*
The bar was run by a stout businesswoman called the Tonkinese, because she
had come down from the North, formerly Tonkin, several years before to
make her living in the resort town. Keeping to herself, the industrious
woman had risen to being manager. Before long she intended to become
part-owner. Her customers were a mixture of farmers and small business-
men with a few members of the professions. Regularly now, Japanese who
were working on the Dai Nim dam project also came in. And of course there
was the stranger.

Known only as Le Tuan Anh, he was already sitting at his table in a cor-
ner of the room. The Tonkinese, Ba Le Thi Kieu, glanced at him sharply
from behind the bar when she brought in more glasses. Again she wondered
whether there was anything familiar about him. If so, it was something
unpleasant. Too beautiful for her taste, she had to admit that the stranger
added a certain *ton* to her establishment.

There he sat as usual, gazing with his half-smile through the blue swags
of cigarette smoke that always hung in the room. Like a handsome cat, he
stretched himself out in perfect relaxation, contemplating who could guess

what, secure as lord of the jungle. Physically he was well and evenly proportioned, not wiry or strung out like so many hard-worked Vietnamese. But his power did not lie in his physique. The Tonkinese studied his reflection in the mirror behind the bar. Le Tuan Anh had even features, full silky black hair, not cut too short, and a thick brush of moustache over his semi-smile. The eyes, in the smooth, gold-ivory face, were not to be deciphered. Perhaps his disturbing power lay there. After everything she had endured, this woman would not fail to recognize power.

Le Tuan Anh might be an alias, since by using this name she had been unable to learn where he was staying in Dalat. He didn't come here for the drinking; he drank very little. What he did was a great deal of meditative thinking behind that absent smile, sipping very occasionally at a little Cinzano or a vermouth perhaps. Sometimes men would stop to speak with him, but never the same man twice. Kieu, the Tonkinese, who bothered to know her clients thoroughly, felt piqued by the stranger's inaccessibility.

Le Tuan Anh also took pleasure in understanding people. He had not missed her curiosity. Let her decide that he was a lazy dreamer. Since coming down from the Central Committee of the Lao Dong party in Hanoi, ambassador-at-large to the emerging National Liberation Front, he had been active most of each day encouraging the build-up of the new organization's hierarchy and communications in the South, visiting committees and councils to check their arrangements and instill a corrective revolutionary spirit everywhere.

At certain hours, however, Tuan Anh had discovered that a seat in a bar or tea house was excellent for his purposes. Anonymous, he yet felt himself one with the masses, a nutritious situation. Here, while reviewing his earlier visits with a district, hamlet, or village committee—some section of the organizational pyramid—he could be alone with his thoughts and his non-thoughts, enjoying at the same time the feel of the place, its preoccupations, grievances, and jokes. Absorbing the local life renewed his own sleepy vitality. Often he expounded to new Front members how they should "live together, eat together, and work together with the people." For him this was more than an expedient doctrine.

Formerly there had been lighted within Tuan Anh some fervor for unity with life and nature. Even if it were only the longing for companionship of an essentially lonely man, he made great use of it in the drive for the oneness of Vietnam, whose villages and people and earth are sacred! Vietnam

whole, all splintered factions healed, putting down deep roots in its own earth again, free of foreigners. A dream? But the Party had already proved itself capable of making visions real. One had only to ask the French.

As he sat contemplating the councils, committees, and cells which would make up the future revolutionary structure of the South, Anh saw them as living organs of a growing whole, not to be forcibly manipulated like the ivory pieces in a game of mah-jongg. Being alive, they were meant to be carefully observed and then inspired to find their own related activity. He thought of himself as a physician who encourages the organs of a body to find their own proper balance in time and patience.

At that moment a good-looking young man came in and seated himself opposite the thinker. Tuan Anh felt himself being intensely scrutinized by this commanding young person. Here was Trinh Le Kiem, leader of a certain three-man guerrilla cell, a *To Ba Nguoi*, which had been formed with others some four months ago under his influence for the District Committee of Dalat.

Anh brought the bar woman to his side with a gesture. She stared at the newcomer while awaiting his order. But he, wanting nothing, dismissed her with indifference. Ah, how upright he was, how virtuous, this well-trained, perfectly indoctrinated son of the North. Each organism has need of bones, Anh thought, sipping his own vermouth.

Kiem could not hide his natural distaste for a person of seeming inactivity who yet wore the unmistakable aura of power. Le Tuan Anh went on smiling. Aware that his own androgynous beauty often offended the acutely male, he never allowed this to irritate him. Such men as Trinh Le Kiem were an essential part of the inevitable movement toward unity. One could think back over the history of Vietnam and observe a constant drive toward the fertility of the South by these rugged men from their barren valleys in the North, pushing on down, fearlessly penetrating further into southern richness.

Young Kiem, stiffly formal, gave his brief report. There was to be a regular meeting of his Cell Number Five this evening. He himself had just received word to come here for special orders beforehand. If the activity of the cell was not judged by the Party to be productive enough in the Struggle....

Le Tuan Anh raised a quiet hand. "On the contrary, Comrade, the work of your cell merits particular praise. The recent sabotage of the air strip was circumspect and created measurable anxiety and unrest among the enemy."

The young man bowed his head, becomingly unmoved.

In a low voice which did not carry beyond the table, Tuan Anh continued. "At this time it is desired to call the attention of your cadres to another matter, the matter of the new chief of this province, whose name is beginning to be generally known. Please observe, Comrade Kiem, there is no request for any specific action. Decisions as to the use of agitpropaganda and psychological methods versus more militant types of action are usually left to the autonomy of each cell. It is even possible that no action at all may prove to be the right course in this situation, which first requires study."

After a pause, Anh said, "A key question might be, 'Does this man wholeheartedly support the South Vietnamese government, or does he not?' I am authorized to pass on to you, Comrade, the desire of the Party—first, to commend your cadres for past action in the Struggle toward *Khoi Nghia*, the General Uprising, and also to indicate strongly that it would be fitting now for your particular cell, which has proved itself capable, to give consideration to this important matter of the new province chief."

At this Kiem was unable to veil the glint awakened in his intelligent eyes.

"*Chao*, Comrade Kiem. Please impart to your cell the commendation of the Front and the Party. Be assured that you are never alone in your efforts for the unity and liberation of our country."

Rising, Kiem bowed. Then he walked cleanly through and out of the smoke-filled bar. Tuan Anh looked after him somewhat as a father might follow with his eyes the progress of a tall son. He had a special feeling for this cell, recent flower of his passion for national unity.

In 1955 the Diem clique, lackeys of the Americans, had blocked the holding of national elections required by the Geneva conventions. Their propaganda ever since claimed an inevitable break in the unity of Vietnam. The Communist North was to be cut off permanently, on the assumption that any accommodation was impossible. This blatant offense against the wholeness of the nation which—Le Tuan Anh felt—could never be accepted by any true Vietnamese, had been a continual spur to his activities. And yet he was realist enough to know that his countrymen differed fiercely among themselves, and were often patriotic only to their section of Vietnam, be it North, South, or Center.

And therefore in his secret thoughts Anh had toyed with a possible experiment, the idea of using a southern farmer type, along with a teacher-scholar from the Center, from Hue perhaps, and a trained guerrilla cadre from Hanoi to form a three-man cell. Later, when he had actually brought such a cell into existence, Anh had not called anyone's attention to the

interesting combination. For the moment this was a private experiment, an application in miniature of what might someday be attained nationally.

Here one could observe how Marxist-Leninism in its Vietnamese form might be one method of erasing the decided differences among his countrymen. (Of course Anh scorned the strange Federalist notion cultivated by the West that differences should be reconciled in compromise. To a traditional Vietnamese, conflicting views must be dissolved, so that all parties unanimously follow the revealed Will of Heaven.)

Tonight this representative cell would meet, as they had many times already, led by the northern Trinh Le Kiem with his aura of strict sincerity and squared oval face, cheekbones high and all features well cut, his hair growing from the crown of his head in a well-fitting cap to the shape of his skull. Anh had noted, as Kiem was leaving, the graceful point of hair at the nape of his neck, his well-shaped ears.

The twenty-eight-year-old former soldier is tall and attractive with that glitter of self-confidence, of energy controlled. Since sincerity is demonstrated by the correct apparel and behavior for each role in the Struggle, when reporting to the District Committee Kiem wears khaki trousers and jacket over a white shirt to exhibit formal respect. When leading his cell he wears only the ordinary black tunic and pants, rubber sandals, or tennis shoes of any worker. In this way he projects for his cadres the way of simplicity. As Ho Chi Minh himself has shown, a leader must always manifest in his own person the way of the Party.

Since Kiem was an artillery officer at Dien Bien Phu, he is sprung from the victory of righteousness over French force. The young Lieutenant received an indelible impression: the Right, which is Nationalism, as demonstrated through the organized Communist way, will not fail to annihilate the Wrong, which is greedy Imperialism. Clearly this is the Will of Heaven. Tuan Anh reflects that their conviction of the moral correctness of their cause makes Kiem and every NLF supporter know himself superior to the enemy.

Le Tuan Anh closes his eyes. How well he has chosen! Here is an elite, hardcore cadre of General Giap's forces, a full-time guerrilla who has also been educated as a propaganda agent. He quotes easily from the training manuals and does not question the party dogmas.

Yet Anh is aware that a tree must not be too stiff or it will break in a monsoon wind. For this idealistic young man subtle shades may not exist, everything is black and white. Also he will not have much patience with the

doubts and slow deliberations of those older and less active than he. In Kiem the northern and Confucian virtue of filial piety has been transformed into obedience to the Party, the Lao Dong.

But Trinh Le Kiem is only one part of the cell. Leaning back, Anh knocks his glass with his elbow. It rolls to the floor. At his gesture the Tonkinese bar woman approaches stiffly, and somewhat grudgingly goes down on her knees by his feet to retrieve the glass. Being stout, she makes slow work of getting up again. Glancing down, he sees her eyes fixed on the seal ring which he always wears on his right hand, lying on his knee beneath the table.

The ring has a jade dragon, elaborately carved, set on a high gold crown in a rather unusual way, as though the dragon's scales are tipped with gold. He had received it somewhere in the Red River delta from a peasant whose land was nationalized by the Republic in 1956. This farmer had offered him the ring, hoping for a favorable response to his plea for the restoration of his land. At that time when Le Tuan Anh was serving as a judge in such civil disputes during the deplorably chaotic Land Reform program of Trinh Chuong, bribes were of course not approved by the Party. Anh had simply not been able to resist the charming ring with its dragon symbol for power and creativity. But of course he had not allowed it to influence his ruling in any way.

The bar woman was standing now, staring at him. "You are extremely slow," Anh remarked smiling. "Be so good as to bring me another glass of vermouth." He had not missed her sudden fierce animosity, like a beast baring its teeth! Interesting.... Her name had already been sent back to Hanoi. The results of the check would not be long in coming and might throw some light on her hostility. Hatred, the very stuff of the Revolution, was not to be feared, but understood, directed, and used.

While she was gone, he leaned into the almost palpable cushion of lively humanity around him and continued to reflect on his experimental cell. The second cadre, Bui Tang, was born in Hue in 1919, son of a civil servant. At that time in central Vietnam, resistance groups such as the Dai Viet, or Greater Vietnam Party, attracted government bureaucrats like Tang's father and created a tradition of anti-French activity. Only later did the Center give way to the North as the heart of resistance to French colonialism. Ho Chi Minh himself had come from Nghi An, a province not far from Hue. But Ngo Dinh Diem had also been born in the Center, Anh thought, amused by the irony.

Remembering the bitter pride stamped on the thin face of this member of his three-man cell, Anh did not think that Tang was often amused. After all, his patriotic father had given up his life in a French prison. The son is a slender man of middle height and age whose face is a pointed oval, made more so by a goatee. No moustache hides the thin, rather cruel mouth. On the high forehead his hair springs from a widow's peak, showing some distinguished gray at the temples.

What an interesting combination. On the one hand, the poor aristocratic scholar, educated in Hue, feeling himself the cultivated guardian of a treasured traditional legacy, and yet with much worldly shrewdness in his eyes. Those spectacles in the breast pocket may be window dressing; Tang's vision is probably sharp enough. He would see clearly that the old capital city of Hue and the court of the Emperor, left undisturbed by the practical French, have stagnated into a backwater. And in spite of his pride in culture and tradition, a man like Tang is unlikely to remain poor. As surely as this part-time journalist-teacher-political activist is motivated to avenge his father's patriotic sacrifice, it is also probable that he himself would never be caught and imprisoned.

Musing on the useful qualities of this second cadre, Tuan Anh thinks it curious how events have brought to Dalat each needed member of the cell. Naturally enough, an opportunist like Tang went to Dalat in early 1950 following the Emperor. The French had installed Bao Dai that January as the head of a new, hopefully national, government called the State of Vietnam. But, aware that he had no real power in Saigon, Bao Dai spent the next four years hunting, and otherwise enjoying himself, in the cool resort province of Tuyen Duc with its capital, Dalat. Later, however, when Bao Dai had resigned and a certain Ngo Dinh Diem ruled in Saigon, this Diem's brother Ngo Dinh Can assumed power in the Center where he ruled like a brutal warlord. Tang, already known for his political activities, was afraid to return to Hue, and sent for his family to join him in Dalat. Le Tuan Anh imagines that these family members are kept in their place and do not see a great deal of Tang, since they themselves are seldom in evidence. Very convenient.

For sundry opportunists like Bui Tang, the NLF presents a means for satisfying personal ambitions. Like many Vietnamese, like Anh himself, Tang feels at home in an atmosphere of intrigue and clandestine meetings. Out of the insecurities of the past, a romantic love for the devious has blossomed. But Tang is more than a romantic. With his strong intellectual grasp of the past and the present, he can quote Vietnamese history and

Communist documents equally well. Being weak physically, Tang has the powerful urge to manipulate. If one can control everything by cleverness, then one is never the victim of chaotic forces, never loses face. Tang's fears and hates, which can be guessed by the many nervous cigarettes he smokes, are for that which cannot be manipulated. These fears and the strengths they produce make for a useful organizer.

Yet Anh does not smile as he considers this member of his experimental trio. Perhaps Bui Tang, the manipulator, is more like himself than the others, too much so for proper detachment. The difference, Anh likes to think, is that Tang attempts to control outside events; but when standing apart from them, one is not in full control. The ideal of Le Tuan Anh is to become a part of everything, thus comprehending all, and in this way, becoming master.

The bar woman puts by his elbow a fresh glass of vermouth. "How he preens himself, that one!" and she turns away, sick with rage, unable to bear looking at him. Yet she *must* look to be sure the stranger is the one. With her hands on the bar rail, she closes her eyes tightly in the effort to remember. The inhuman one, the judge of those days, had worn shorter hair and no moustache. He had been a thinner, younger man. Naturally all those things could have changed in the time without difficulty. She opened her eyes again, and going behind the bar, began to wipe it down.

The important clue is the ring, the seal ring of her father-in-law handed down to her husband, Hong. How their little son Hai had been delighted to examine the carving of the tiny fierce dragon which he himself would someday inherit! The Tonkinese froze into stillness as she remembered the dragon had always had one flaw, a minute chip in the curl of its tail. Drawing in her breath, she took one more quick look at the stranger. Of course she still must check the ring for that tiny remembered chip in the dragon's tail. But, if this man were indeed the same cruel judge, then surely there lived, after all, justice and compassion among the gods. To think of the very man being given into her power! Deliberately she went on wiping the bar with downcast eyes, afraid to reveal her sudden terrible joy.

Le Tuan Anh was no longer concerned with the bar woman, who had ceased to exist for him. His attention was on the third member of his unusual cell, the southerner. For Anh the South had a unique mystical quality manifested in those strange southern religious sects, the Cao Dai and the Hoa Hao. As

Vietnamese made their way further and further into the South, somehow they left behind in Tonkin and Annam the influence of Mahayana Buddhism and of rationalist Chinese thought. Anh's father had come from Hanoi, but his mother, a southerner, had been a strong influence on her son. And so, for Anh there was a certain emotional charge in the study of Nguyen Van Thom, the last cadre of the cell.

In his mid-thirties, a sinewy part-time guerrilla, part-time farmer, Thom is extremely tall for a Vietnamese. Here is a big man who has done heavy work and would look better with more weight on him. Under his thick black hair, parted on the side, a dissatisfied frown creases the wide brow above eyes that often smolder with resentment. From his big mouth, once used to smiling, there are lines now, dragging down each side of his large nose, lines of disappointment and envy.

As a young man brought up in the South, Thom had believed in enjoying the simple things of nature, the good life. Anh imagined that Thom's broken front tooth, crowned with gold, had flashed many times in an easy grin. "Let it be" had been sufficient philosophy for him, until he was cheated out of his promised lands by the government.

During the resistance against the French, many rich landowners fearfully left the villages for the city. All those years then, the poor landless farmers tilled the earth and believed it would be theirs after the war. However, when peace came, and the landowners returned to the villages, local officials did not support the poor. Instead they helped the rich to get their land back.

By this time Thom had found a wife and started a family. Naturally he turned with interest toward anyone who offered to help peasants gain ownership of the land, and allowed himself to be easily indoctrinated by Viet Minh cadres left behind to do political work in the South. In fact, Thom had become a member in 1954 of one of the earliest Farmers' Associations in Ca Mau. For this he was soon arrested and put in prison by the new Diem government, busy jailing all dissidents whenever possible. In the detention camp Thom's disappointment over the land became savage disillusionment. When he was released after a year, he returned at once, over his wife's protests, to his Communist friends. Shortly afterwards he was sent North for training. Anh remembered that Thom had been indoctrinated at the camp called Xuan Mai.

Of course when he consented to leave for the North, Thom had no idea this would mean a total break with his wife and children and village. He went, believing that the Communists would win in the proposed 1956 elec-

tions, the South would be regained, and he reunited with his own in little more than a year. Le Tuan Anh stared back into the past. The fact that those elections never happened had resulted in wide frustration and discouragement among Party members. From 1954 to 1958 was the darkest period for the Communist cause.

Anh understood the painful disorientation which Thom had suffered. To the villagers their sacred spirits dwell in the particular earth of their village. If a man was forced away from his land and out of the village gates, he left his soul behind with the buried bones of his ancestors. And he left his own "face," the social position which gave him personal identity.

In the North, this sad peasant who could not go home to the Mekong delta because he would surely be put in prison again, became a "regrouped southerner," trained to continue the Struggle as part-time guerrilla, part-time farmer where needed. After two years' training he was infiltrated back, to work in a Diem government resettlement village near Dalat. And at this time, Le Tuan Anh, working on the organization of the Front around Dalat and studying files on all the cadres in the area, had chosen Thom as the third member for his Cell Number Five.

As with all the cadres he weaves into the organizational web, Anh feels it is important to understand Thom's motivation, and this is not difficult. Before he lost his land, Thom believed that he was the possessor of true happiness, which, to a southerner, is the leisurely enjoyment of simple pleasures and work in the pastoral harmony of nature's generosity. On leaving the South, his hopes of finding this state in the North under the Communist rule were disappointed. Although at Xuan Mai he was instructed that capitalism means poverty and slavery, while Communism means abundance and freedom, he did not experience the latter in the North. Right before his eyes the 1956 Land Reform Program in the Red River delta turned into a brutal mess, producing a peasant's revolt! Preoccupied, Anh rubbed the curly dragon on his seal ring, scratching his thumb on its tiny chip. The Land Reform Program had certainly been mismanaged.

To Thom's further shock, when he was sent back southward to work near Dalat, he found villages more prosperous than those in the North and people who did not feel the government pinch all that often, while the grasp of government on northerners was total. Therefore, doubt and disillusionment began to feed on Thom's mind, making him sullen and argumentative. He feels himself eternally victimized, the "good" man who is always mistreated, and unjustly so.

In farmer's black trousers and buttoned-down-the-front tunic, Nguyen Van Thom does not look like an asset to the cell. What he is good at is making things grow, knowing where fish jump in the canal, dragging behind him his water buffalo to cultivate the paddy. Thom's big hands are intuitive with earth and plants.

He likes children and a pretty woman to come home to in the lamplight, enough to drink on Saturday night. This man has become resentful and envious of others, because, in some way he does not understand, he has lost his rightful pattern. The years are passing. He is growing older and can rarely arrange to see his family, who hardly know him now. His old hopes of returning permanently to them and the land and the village never come any closer to being realized. Thom is willing to fight, eager to fight, but it is hard to be sure who is the enemy.

Anh does not hesitate to look at these facts realistically. He knows the force of envy and the associated power of hate, seeing in this the universal law of the equality of all beings. This law cannot be broken, as the French, or the new imperialists of the U.S.-Diem clique have broken it, without immediately producing opposition and discord. But Thom's kind of envious discouragement is difficult to satisfy and to harness. Anh admits to himself that the sense of lost opportunities in life is a great problem for the Cause. Revolution has to be a swift force, driving for immediate goals. There is danger of losing momentum when the goal seems years away.

And in Thom's case one cannot help but observe that a cadre who has been envious most of his life is not too useful in communal living. He likes to deprive others, having learned to blame others for his failures. This kind of cadre may end up a fighter and marplot who does not work well on a team. Of course the fact that he takes pleasure in the pain of his neighbor can be useful to the Front for situations requiring violence and torture. On the other hand, the renegade's inability to give himself to group effort, to relationships, is a decided drawback. Such a man must be kept in line by a leader, one with exactly the qualities of Comrade Kiem.

And so, the experimental cell has its virtues and weaknesses. Le Tuan Anh, patriot of wholeness, expects to have valleys as well as mountains, waste as well as production. Everything must be confronted, accepted, and used in any organizational shape. For a beautiful organism, created of interminable threads and lines of communication, is strictly amoral. And, like the physical body, made up of processes which are living and dying. All seems

very complex, yet everything works with the in-and-out simplicity of the pulse, the heartbeat.

His thoughts have come full circle. The cell is complete in the mind of its creator, but quite free to work out its own organic activities in tonight's meeting. Le Tuan Anh glances at his watch. It is six o'clock. There is a slight stir at the door as an American comes into the bar with an ARVN (Army of Vietnam) officer and two Japanese engineers from the Dai Nhim power project. The South Vietnamese officer who carries a swagger stick is looking about him severely. Anh studies the big lanky freckled American with more interest. Content to encourage others to hate and despise the Diem lackeys and their Yankee imperialists, Anh himself prefers to see them as mere agents, instruments, necessary spurs to the vital movement of the nation toward unity. Unthreatened, he sits on for a few moments more, musing in the onstreaming spirit, or *Tao*, of the inevitable Revolution.

Serving the so-important newcomers has claimed the attention of the Tonkinese for several minutes. It is irritating that her waitress-helper is off sick today. When finally she is free to look up, the stranger's place is empty. For one second her eyes blaze furiously, before the lids fall. Never mind, never mind, she urges her anxiously beating heart and shaking hands. He will surely come again. He always has. And the next time, when he comes, I will be ready.

The Three-Man Cell

*Below the village and hamlet level came the lowest most fundamental organizational unit, the liberation association cell, the same three-man cell structure that has served communism so well for the past fifty years. Referred to in various terms—the three-member cell (*to ba nguoi*), the glue-welded cell (*to keo son*) or the three-participant cell (*to tam gia*)—the unit was presented in terms of almost mystical unity: it "applies the principle of shared responsibility in fighting and performing all tasks...a three-member collective, glue-welded on the basis of comradeship and mutual life and assistance, stemming from a thorough revolutionary spirit, a noble class spirit, and good revolutionary virtues.... They must consider their [cell] as their home and their [cell members] as brothers...."*

Douglas Pike, Viet Cong

That evening in Dalat the sun, hours ago, had peacefully set over mountains and miniature lake. The whole resort was planted with flowers, producing the reassuring, holiday aspect of a Swiss village. On the outskirts of town, further down the mountain road, lived a French woman, owner of La Savoisienne restaurant-inn. She kept a huge garden, but carelessly. Everything—weeds, herbs, slugs, blossoms, blights, insects, fruits—was allowed to luxuriate there, and, even in the dark, gave an impression of bountiful wildness.

Madame Bruard was a realist. Quite satisfied with having been born in Vietnam, she had no nostalgia for life in France. Of course, intruders here were continually attempting to ruin the status quo; first the Japanese occupiers, now the Americans and their Ngo Dinh Diem with his crazy family. These she hated in an invigorating way. It amused her to know that her own

enemies had enemies too, even in quiet little Dalat. For this reason she appeared not to notice when one of her Vietnamese boarders, a subtle and cultivated gentleman from Hue, began to hold what might be called political meetings rather late in his room.

It was almost midnight now. Had he scorned her intelligence and tried to deceive her, Madame would have sent Monsieur Tang packing. Instead he let her know at once that he was well aware of her powers of observation. If his occasional late visitors should disturb Madame…? The note of inquiry was very casual as he bowed.

She looked at him hard before answering. "But no, Monsieur. Those who need it, sleep heavily. As for me, I am no longer young. You cannot disturb one who is already wakeful." Nor innocent, she did not need to add.

He returned her look, accepting the fact that they understood each other. To live and let live; the clandestine cell needed no more in order to flourish. How lively is the vivid flower of hate. Like a flame, once kindled, it nourishes itself easily upon any and everything in its path.

Bui Tang had carefully chosen his room, like the den of a badger, with two doors. One opened off the corridor, while the other gave onto a veranda descending by open stairs to the back courtyard at the far end, away from the kitchen. His room remained rather bare and countrified. There was a bed with mosquito net, a spindly rattan writing table and chair. In one corner three more chairs were standing about a circular table. A tall dresser stood in the other corner, arranged by Tang as a traditional altar. Centrally placed among the ritual brasses was a dimming photograph of his father, one of the leaders in the earlier movement for liberation from the French, and a hero to his son. Although Tang's father had died in a French prison, he would not remain unavenged!

Aside from the altar decorations, only a few things had been added to the whitewashed room; one was a print of the Emperor's Palace at Hue in central Vietnam and the other a sepia photograph of the Perfumed River in the old capital city. A small bookcase near the writing table was neatly stuffed with pamphlets and cream-colored paperback books. Through the unscreened windows night whispered with infinite life.

After consulting his watch, Tang went out by the veranda door. Moving without haste down the steps, he was hardly visible in his dark tunic and trousers until he was swallowed up by shadows at the back gate in the compound wall where he waited. Exactly at 12:05, after the signal knock, Tang unlocked the gate and opened it far enough to admit an erect young man,

who walked past him at once with silent assurance toward the flight of stairs.

Tang, still waiting, glanced from time to time at the luminous dial of his Japanese wristwatch. Gradually his expression became irritated. It was not good practice to extend the vulnerable time of waiting. Looking up at the back of the inn, Tang decided that all the windows were empty, staring down, and could not resist lighting a cigarette as he inwardly cursed all lazy, unpunctual southerners.

By 12:16 he was at last able to admit the tall bony figure of Nguyen Van Thom, shuffling somewhat. Giving him an angry look, Tang locked the gate and preceded Thom across the paving and up to the room. All three men wore quiet shoes; Kiem and Tang black tennis shoes, Thom rubber sandals. Inside the now locked doors of the room, they sat in the three chairs under the standing lamp. The silent men seemed to vibrate more intensely than the feeble light.

Trinh Le Kiem, leader of Cell Number Five of the National Liberation Front for Vietnam, opened his leather pouch of notes and directives, then raised his eyes to stare coldly at Thom.

"Before proceeding to the important business of tonight, we are forced by the lateness of Comrade Thom to devote some of our valuable time to *khiem thao*, the practice of self-criticism."

"Only a few seconds late! A man is not a clock." Thom, who was a great deal more comfortable squatting, had folded his long limbs uneasily onto the straight chair.

Kiem glanced away from the big farmer-guerrilla with some distaste.

"If it is necessary for each cadre, each member of the cell, to transform himself into a clock in order to arrive on time, he will perform this action. In the moments when Comrade Tang waited below he might well have been observed, endangering the secrecy of our meetings and the active work of this cell in the Struggle."

Thom gave a gusty sigh. "The other cadres do not have to come all the way from the village of Ich Thien at the mercy of a country bus. The Party should provide every working cadre in outlying districts with a Honda motorcycle or at least a bicycle. It's a miracle I got here at all!"

Kiem remained severe. "A Front cadre is self-reliant, self-sufficient! Perhaps if the comrade had not burdened himself with several beers along his way, the miracle would have been more spectacular."

Thom leaned back sulking, aggrieved. Trust a northerner to make an elephant out of an ant!

Tang decided to intervene. His thin mouth smiled above his goatee, his glasses glittered. "We must all work together to improve ourselves, and yet without discouragement. Comrade Thom is a farmer, not accustomed as others are to using a watch. Yet he is one of those peasant farmers who, our beloved leader has said, are the axle-tree of the Revolution. With their help, we can move anything." What Ho Chi Minh had actually said was, "If we control them...."

Kiem's nostrils flared. "This may well be true of *young* peasants who are open to change. Remember also, please, what Comrade Lenin said, 'The principal element of the Party is youth. Our Party holds the future, and the future belongs to youth.' If a cadre cannot remain young in years, at least he can stay young in alertness and zeal."

Thom was picking his teeth, unimpressed with ideology and touchy about youth. "I was part of the farmers' movement in the delta when other cadres were infants. With my years of struggle, imprisonment, and training, I have proved long ago that I am of use to the Party!"

Tang did not much care for the turn of the discussion, he himself being over forty, actually older than Thom. "Here in our country the wisdom of years has always been respected."

Kiem shrugged. "The old have had their chance. All through the 1950s in the South, cadres remained in total disorganization, often drifting into banditry and inaction." He rapped with the hard flat of his hand on the table. "Young and old must have organization and discipline, comrades! This is our hope for unifying the many diverse elements in our country, and in this very cell. Southerners especially must be on guard against the errors of tiredness and 'mountaintopism,' which is to lose connection with the Central Command and the correct Party line."

Out of his cool passion Kiem looked at each man. "We *will* unify and liberate Vietnam. Nothing and no one shall stand in our way, since this is the Mandate of Heaven. I, the leader of this cell, have reprimanded Comrade Thom for lack of punctuality. This will be included in his record by Comrade Tang. If Comrade Thom is late again, he will be punished."

Uneasy, Tang fingered his goatee. Although it was true that Thom, like most southerners, was rather boorish and unintellectual, Tang would have liked to warn their young leader, "Do not swat a fly upon your friend's head with a hatchet." However, under Kiem's eyes, he made the note for the record.

Kiem allowed a few moments for consciousness to refocus. "The self-

criticism session now being closed, I have a special message from the District Council." The others stirred. "Before I give you this, however, and before any discussion of new projects, let us look at the ongoing project of Comrade Thom to contact and subvert the members of the resettlement village being established by the Diem lackeys at Ich Thien. Have you anything to report tonight, Comrade?"

Although fed up with the stiff self-righteousness of their leader from the North, Thom felt somewhat mollified by the chance to report on the land development center not far from Dalat, which he was beginning to think of as his own.

"A few more families have arrived and all are beginning to clear the land for cultivation. It is planned that over two hundred families will be relocated here and allotted some hectares of land each."

"Are you able to practice the *Tam Cung*?" Kiem asked. "Eating with, sleeping with, and working with the people?"

Thom lifted bony shoulders. "Naturally, Comrade; this is unavoidable. I live with one of the farmers and give my labor in exchange for rice and shelter."

"Are these people who are arriving Catholics?" Tang asked.

"They are not," Thom said. "The Village Chief is bragging all around that his Center will *not* be for Catholic families."

"Too bad," said Tang. "In that case we could have spoken with justice about Diem favoritism."

"But it is much easier for me to work with non-Catholics, and there's no need to worry about lack of favoritism. I can already see the weakness of this Center Chief. He comes from the high-and-mighty office of the General Commissioner on Land Development in Saigon. At once he began using his power to distribute money and materials to favored families, refusing others for personal reasons. The people see that their fate lies in the hands of this man. For instance, you can only receive title to your land from the Center Chief. And to borrow money for fertilizer or seed, you must borrow against your land. But if you don't have title, you can't borrow. Great power lies in the grip of this man, Comrades." For Thom this was a very long speech.

Tang leaned forward. "Do you have any real proof that the Center Chief is biased and corrupt?"

"Coming from Saigon, what would you expect? Already the few settlers who have arrived are worried. Some have complained to me they can't get

proper identification cards or other papers without paying for the favor. It's easy to encourage them to hate the Center Chief." Thom grinned. "While this man remains in charge we'll have no trouble undermining the government's plans. And, if we in the Front should liquidate this traitor to the people, we will be heroes."

A large moth blundered against the electric bulb while they thought about assassination. Then Tang made a clucking sound.

"I doubt if there should be an effort on our part to remove such a man too soon. At the moment he is a positive asset, making the people smolder like hay which will blaze up when the right time has arrived."

"I agree with Comrade Tang, at least for the present," Kiem said. "Well and good. Comrade Thom is to be commended for his appraisal of the situation at Ich Thien and for his actions so far. Deferring the elimination of the Center Chief temporarily, Comrade Thom will go on to build a proper organization in the village as more settlers arrive."

Kiem looked at Thom. "Be ready, Comrade, for a long struggle in Ich Thien. To discover grievances against the government is only the first small step in the hard task of turning any village into a Combat Village. There is no short road from early discussion of complaints, and lectures on ideology, to such actions as the construction and laying of naily-board traps by the villagers themselves."

"Land is what matters," growled Thom. "Ownership of their land matters to these farmers, not ideology or booby traps."

"This is exactly our problem, Comrade. After we have helped them get title to their land, and this grievance disappears, then the force and drive of the Revolution in such a village often dies. Indoctrination and organization must be thorough from beginning to end." Seeing that Thom's eyes were not meeting his, and that his half-turned body expressed nothing but indifference, Kiem was not surprised. He could well imagine Comrade Thom drowsing comfortably through the political lectures of his past. It would probably be necessary for himself and Tang to lead the early meetings at Ich Thien until some enthusiastic young cadres could be trained. He made a note to this effect.

"Comrade Thom," Kiem said, "the people will support the Revolution *if* we can show them that their interests are the same as our Cause. We must constantly agitate them to prevent loss of enthusiasm. This will gradually turn them into men with initiative, who will act, and not merely react."

Tang could see some irony here. Perhaps he alone perceived the rather

dangerous fact that the interests of Comrade Thom himself might no longer be identical with the Cause.

"It may be the loss of their families, through dislocation," Tang said, "not only the loss of their land, which often disturbs our own cadres as well as the untrained villagers. The loss of opportunities, the lack of the female element for prolonged periods of time...."

Night noises were heard again when his voice faded. There they sat, three *yangs* without a *yin*. Thom's chest lifted on a sigh at the memory of his sturdy little woman suckling their youngest. And Tang's sense of his own power always swelled when he remembered his submissive wife and well-ordered household, though he seldom had time to visit them. Kiem hardly dared picture his own girl—warm, eager, enthusiastic—so recently his wife that he scarcely knew her. The other two were amazed to see the angles of their young leader's face soften, his right hand with its plain gold wedding band looked suddenly vulnerable, relaxed on the table.

Startled by the results of his attempt to relate to Comrade Thom, Tang cleared his throat. "It may, of course, be the very lack, temporarily, of the female element which is one of the factors driving us forward in the *Dau Tranh,* our indomitable Struggle."

Kiem did not make use of this opening. From time to time he felt Tang manipulating the group, while ostensibly only a modest subordinate to the leader. He dismissed thoughts of his emotional young bride, straightened his back, and pulled forward his notes on the meeting with Le Tuan Anh in the bar. That strange man possessed within his personality some element of the female. Could this conceivably be an asset? Le Tuan Anh was without doubt an actual member of the Central Committee of the *Lao Dong* party in Hanoi. To meet such a high person for the first time and to find him so oddly thoughtful...and passive, this had disturbed Kiem. Weak-looking attitudes were abhorrent to a man of action. In a rapid-fire voice he formally presented to his cell the commendation of the Front and the Party for their action in sabotaging the landing strip.

Tang smiled, and Thom slapped his knee with pleasure. "Now that's more like it! Cadres like us, efficient guerrillas, are wasted on this little holiday town!"

Although Kiem raised his head sharply, Tang spoke. "Dalat is not a backwater, Comrade Thom. It will interest you to know that the Chinese Marshal Peng Teh-Huai once advised General Giap to strike through this very mountain resort toward the coast of Phan Rang, if the French refused to sign

the Geneva Agreement in 1954. A future large-scale attack could still come along this line."

"When and where the attack comes is only guesswork," Kiem said. "*That* it will come is certain. And if you allow me to inform you about the important project which the Central Committee has decided to entrust to our cell alone, you will see they are concerned enough about affairs here in Dalat and Thuyen Duc province."

In ringing tones he spelled out their new responsibility for the fate of the Province Chief, which had been passed on to him in the deceptively gentle voice of Le Tuan Anh. Satisfied with the rapt attention of his two listeners, Kiem went on to explain the matter as he saw it, in its relationship to the Struggle.

"Here in Dalat we have a new Diem stooge in the person of the Province Chief, a Colonel Truong Vinh Thanh. Cadres will please remember that the Province Chief is the source of all power in his region. He may appoint all district chiefs, and, on their recommendation, even the village chiefs. A bad or corrupt Province Chief can make villagers suffer throughout his area. Our most effective policy in the NLF during this recent period has been to kill both bad and good officials, leaving only those who support our cause and those mediocre persons who do not interfere with it.

"Comrades can easily appreciate this policy. If we disembowel and decapitate a man for his well-known and cruel crimes against the people, we win many friends and supporters. On the other hand, if we execute some hard-working, honest government supporter, then we strike great terror into the hearts of such people who oppose the Front. Both policies are correct. As to which type of man our new Province Chief may be, information so far is not complete. In general we hear that he is well liked and well spoken of. Comrade Tang, do you have any knowledge of this Colonel Thanh?"

Tang seemed to be studying his hand. Its smallest finger wore a carefully preserved, long fingernail. "The Colonel does appear to be a person of so-called sagacity and force, the kind of man many fools will turn to for advice and leadership."

Kiem's eyebrows went up. "If further study bears out first impressions, we may then consider the liquidation of the Province Chief as our next important action!"

Tang and Thom exchanged a glance. The fervor of their chief for warlike action often seemed dangerous and somewhat exhausting. To assassi-

nate a small official in Ich Thien was one thing; to kill the new Province Chief in Dalat, quite another.

Tang said, "At present this man is spending more time in Saigon than here at his post in Dalat. He is said to be a very capable military officer, trained abroad, I have heard, by our American enemies. We might want to consider another possibility in his case. It could be excellent for our cell if we were able to convert this man into a useful cadre for the true Cause, intoxicate him with the Struggle for Liberation."

Kiem frowned. "The Colonel is a *My*-Diemist. They are all warmongers and aggressors, exploiters of the people! Cholera germs are cholera germs and do not change. Do you have any reason to doubt his loyalty to the *Mys* [Americans] who have trained him and their Diem lackeys?"

Encouraged by a nod from Tang, Comrade Thom produced a handwritten sheet and shoved it out on the table.

"Our leader will remember," Tang said, "that Comrade Thom has a brother Tam, outwardly only a barber, in Saigon, who is a loyal Party worker. Earlier, when the new Province Chief was appointed, you suggested that Tam's instructions from us should include the order to follow and investigate Thanh. As you will see from this report," Tang handed the paper to Kiem, "Tam did obtain the Colonel's address in Cholon. He has two small daughters and a wife who works for some American welfare organization. Since the Colonel's family are upright Buddhists, it is just possible the new Province Chief may not be too happy with the rank corruption of the Diem government.

"Perhaps, I only suggest perhaps, before elimination, some attempt should be made to offer him a more righteous role in the Cause of Vietnam." When Tang paused, Thom looked satisfied with the additional "face" acquired through the work of his younger brother, the barber.

"Why didn't you produce this at once in answer to my first question about Thanh?" Kiem studied the salient facts on the Colonel. Intelligent, well-educated, non-Catholic. Airborne training. Command and General Staff School at Fort Leavenworth, Kansas. Kiem ran a quick hand through his up-springing hair. A Province Chief as a secret but valuable member of the Liberation Front?

"This may be worth considering. As for your barber brother in Saigon, Comrade Thom, would he make a good propagandist for us, if we attempt to convert Colonel Thanh to the Struggle Movement?"

Thom sank into thought, seeing before him the handsome face of his

brother. "Tam is young, only twenty-five, the last child in our family. As the baby he was spoiled by my parents, who certainly did not spoil any of the rest of us." A strong note of envy in Thom's voice attested to the truth of this. "Also Tam has not received much Party indoctrination there in the South. As an observer for us, he is useful, but as an agitator—propagandist...." Thom pushed out his lower lip and shook his head.

Kiem's doubts about a "conversion" returned. "In my own opinion, comrades, it is most unlikely that Thanh would have been placed in this high position without being valued by Nhu, brother of the President, and the Ngo Dinh family. Especially as we all know that Diem is nervously suspicious of airborne officers since the November coup attempt. This man must have some close connection to the Ngos." Kiem tapped his white teeth with his pen. "We know well that Province Chiefs can only operate out of the very hand of Diem."

Bui Tang cleared his throat. Assassination loomed, threatening the waste of his own special talents. "It may be precisely this existence under the thumb of Diem which could become irksome to a man of Thanh's independence and foreign education. Look at the November coup by his brother airborne officers!

"I have learned from another source that what Comrade Kiem suggests is indeed true. Thanh is distantly related to the Ngo family, which gives him respectability in their eyes. And of course the Colonel is young, not yet thirty, and a non-intellectual. So far there would be nothing suspect for Nhu's secret police to uncover about him. He happened to be in America during the coup against Diem. Thanh is well liked by his superior officers. And, after all, comrades, even such an unpopular tyrant as Diem, who fears everyone, still must risk appointing *some* persons to positions of authority." Tang's thin mouth smiled above his goatee.

Kiem said, "Comrade! It is possible that you yourself are a cadre qualified to undertake this job—which might be defined as the intoxication of the Province Chief of Tuyen Duc with the Cause of Unity and Liberation. Do you think you could persuade Colonel Thanh that his future lies with us?"

"Or he won't have a future at all!" Thom chuckled and cleaned some wax from his ear.

Tang did not want to appear too eager, but one of the great charms of the Revolution was the opportunity for all types of persons at some time to be a hero.

"It would probably mean going down to Saigon, Comrade," he said.

Kiem nodded. "A brief journey of one cadre need not destroy the continuity of our work here. And, if successful, your expedition could add force to the Struggle and luster to the reputation of this cell." He studied Tang. "Do you think you can handle it?"

Behind his hooded eyes, Bui Tang reviewed different aspects of the project, weighing his chances of success or failure. It would be tricky, but fascinating. Down there he would keep his real identity secret. And even if he failed with Thanh, nothing much would have been lost.

"Of course," he said, "there's a certain amount of danger involved in getting close enough to the tiger to hold a conversation. However, I'm willing to make the attempt. But please, Comrades, do not be disappointed if such an inexperienced cadre as myself should fail."

Thom snorted. The old fox would handle it as well as anyone.

Kiem's eyes narrowed with the intensity of his thought. Tang would worry over every detail of the project. It was unlikely that he would be taken by surprise. Of course there was an element of risk, but this would be even more true if they should attempt assassination.

"Comrade Thom," Kiem said, "you will supply Comrade Tang with all information for contacting your brother, and through him, the Colonel."

Reaching into the breast pocket of his rusty black shirt, Thom brought out an old folded paper along with some newspaper clippings. These last puzzled him for a moment.

"Oh, Comrade Kiem," he said, "I was forgetting one other thing. My brother included with his report these news clippings about the shooting of a street boy in Saigon named Phuong."

"In what way can that concern us?"

Thom scratched his head. He was not sure. "It's hard to learn much from the censored news reports, but my brother writes the child was shot in front of the American Embassy by Diem's police while they were unjustly arresting a university professor named Minh."

Kiem seemed to be only half listening, but he paused gathering up his papers, allowing Thom to go on. "Well, my brother has been employing some children for different subversive activities, distribution of leaflets, etc. Phuong, this very boy who was shot, had already been useful sometimes to the Struggle as a messenger. Of course, he is only a tough street boy, delivers newspapers, but…."

Kiem raised his head. "You are absolutely correct, Comrade Thom, and so is your brother, to report such an outrageous shooting. Now the boy

Phuong has a true grievance against the government. Not to mention the jailed professor. Please commend your brother for this report and instruct him to contact the boy further, developing the situation as fully as possible. People in that area should be widely informed of the brutal action of the police against a mere child, as well as an old and weak professor." Kiem held up his hand to stop Tang from interrupting. "We in the Party see how the masses believe their unfortunate lot is determined by fate. They must be taught they are being deprived of their rights by their own government! The story of this boy can be useful in the political Struggle. Through this Struggle, Comrades, more important even than military victories, we must teach the people that the way of the Party is the one true and natural way for all Vietnamese to achieve justice and peace."

Since this sounded like a closing speech, Comrade Thom prepared to start for his distant bed, nodding with contentment over the praise of his brother.

"One moment!" Kiem gave Thom an impatient glance. "Please instruct your brother to give all possible help to Comrade Tang when he arrives in Saigon." Thom subsided again, covering a yawn.

Kiem turned to Tang. "Use caution on your visit to the South. In general, Comrade, remember, these are still early days in our Struggle. Now is the time for careful searching out of future leaders of our organization and true believers. Sometimes it will be necessary to work with non-Communists. You may even need to keep your own Communist identity a secret. Since our National Liberation Front is only a few months old, we must proceed with care."

Tang bowed. "I will remember your instructions, Comrade Kiem."

"See that you do. There is one more important point. When Thanh is approached, the object must not be for him at once to become a Communist. Such an expectation would be unrealistic. We are taught and must know only two things; one, that he possesses a genuine hostility toward the *My*-Diem government, and two, that he is characterized by personal dependability. Out of such material, strong leaders for the Movement can be developed. Comrade Tang, I see you as an opportunist. This is excellent. Be a patient one. Ahead of you lies a rich experience in the Struggle."

Bui Tang bowed again. Then, "What about expenses, Comrade?"

Kiem frowned as at the sting of a gnat. "This short trip should not be costly. Advance yourself from the treasury 1800 piasters, keeping strict account of it for the cell."

"Only 1800, Comrade? Why, this trip may take a week. As you yourself have suggested, time and patience may be necessary." Tang half shut his eyes so as not to expose his opinion of penny-pinching northerners who are always over-sharp in business deals.

But Kiem was closing the subject. "If 1800 piasters does not cover your expenses, use your own funds. When you bring a careful justification of these, we will allow a refund for what was properly spent."

Tang sat thinking that even for the radiant Cause of National Salvation, some things were almost too offensive to swallow.

He received a sidelong glance of sympathy from Thom. "If our cell was supplied with a motor bicycle or a small car even, all our activities could be extended, speeded up...."

"Comrade Thom," Kiem said, "at Dien Bien Phu we had one tracked vehicle, an old bulldozer, to keep supply routes open. Can you guess how many hundreds of vehicles the French had? How did we manage to win without all those modern vehicles? Because we were morally superior. Thus we were also politically and militarily superior to the enemy. All of us as Party cadres must continually demonstrate through our self-reliant way that heroism always wins out over material circumstances!"

It was getting late. Thom's face was almost paralyzed with the effort not to yawn. He and Tang well knew that their leader had been an artillery officer on the heights surrounding the plain of Vietnamese victory at Dien Bien Phu. Thom did have respect for Kiem's courage and ability, but he felt a shade of pity for the young man. To Thom there was something unnatural about so much moral rightness.

Tang, on the other hand, felt enthusiasm rise within him at Kiem's reminder of that glorious victory. Soon he himself would be playing a hero's role, no matter how quietly, how subtly. His chance now glittered before him down in the city. With the cleverest planning and the most careful use of his unusual talents, he, Bui Tang, might be the instrument for the intoxication of a Province Chief!

Looking at their faces, Kiem felt tired. Of course it was never possible to tell what Tang was thinking, which should certainly be an advantage down in Saigon. As for Thom and his vehicles, Kiem imagined that he saw reflected in Thom's eyes his own frustrated desire for a quick trip home. No vehicle except an airplane would bring him swiftly within reach of his young wife, and he had no other family. Back in 1947 when the French cruiser *Suffren* was ordered to bombard and bomb the densely peopled port of

Haiphong, six thousand had died in the ruins, Kiem's parents among them. Kiem was raised by his two older brothers, who were later killed fighting in the Viet Minh. The Cause was his family and his life; the thought of it renewed his strength when he tired.

But often he felt concern about the unity and dynamism of this cell which he led. Only rarely could he sense a spirit of unanimity. Was he using at all times the correct and creative line with these cadres? Kiem was moved to close with repeating the commendation of their cell by the District Council for the sabotage of the airport.

"This is a small victory, but, as the great General Giap has told us, all victories reflect the mountain-moving and river-filling power of our nation and people. As we separate now, let it be in the knowledge that our actions are worthy and in harmony with the Will of Heaven."

A few minutes later, from her dark window overlooking the gate, Madame Bruard watched her uninvited guests slip away through the wild and shadowy garden where she was content to let everything flourish.

Meetings

The situation grows more complex every day. The hope of free-dom sounds simple, does it not? But hope is a releasing force, and what it releases is not always simple.

<div align="right">

Pearl S. Buck

</div>

Next morning's sun shone hazy-white through Saigon's intensifying heat. Joe Ruffin, in a holiday mood, had started out early to shop through the choked alleyways of the Central Market for toys and fruit to take Phuong in the hospital. He resisted wholesome articles like soap or toothpaste which he thought Miss Lanh would recommend. Under the market roof it was dim, crowded, and sweltering. After only an hour Joe wilted, burdened with expensive toy planes and cars from Japan, fruits and candy he had been too hot and impatient to bargain for properly.

The last peddler woman, whom Phuong had often robbed, frowned when she was wrapping Joe's oranges in rough pink paper. Looking into the cheerful, perspiring face of the ignorant "long-nosed" foreigner, she felt guilty for having shouted him down, and salved her conscience over the lopsided deal by giving him too much change. Joe had to laugh in the pedicab on the way to Nhi Dong Hospital as he pocketed the piasters. She must have thought it was like taking candy from a baby!

Up behind on the bicycle, his peddling coolie also laughed politely un-til this brought on a violent fit of coughing. When they stopped at the hos-pital under the covered entrance to the green hallway, Joe took a good look at the hollow-chested coolie. From the visible signs, he was on his way to dying of tuberculosis. What would become of him when he could no longer peddle the cyclo? Did he have a family to support?

In Vietnamese Joe tried saying, "Man, I'm a doctor, and I think you are sick. Please come into the hospital for some tests and medicine to help you."

But the coolie, terror in his eyes, began to back off with his cyclo, even forgetting the fare. Frustrated, Joe followed and overpaid the man, hoping at least to give him a couple hours sleep in the shade, or a bowl of soup and rice from the nearby restaurant wagon. However, fisting the money without looking at it, his driver fled. Joe sighed. Trying to mop his forehead with a handkerchief while keeping a tenuous hold on his many packages, he entered the hospital for the second time.

Miss Luong glanced up out of her studied composure when Joe began to drop most of his things just inside her office door. Retrieving the oranges together in one corner, they bumped heads, and Joe saw her eyes disappear into half-moons of laughter.

"This is most generous of you, Dr. Ruffin," she began in a stifled voice. By the time they had caught the last rolling orange they liked each other very well.

Miss Luong emptied a carton of drugs, put his collection inside, and took the box in her thin arms. "I bring you now to see Phuong. Today he is doing very well already, only some little fever. Tomorrow was possibly going home, but since having no home, is staying until we are finding some place for him."

"Good." Joe took possession of the box and gestured with it for her to lead the way. Several times her slender figure turned back, and each time she could not seem to help smiling.

However, on the stairs she told him seriously, "I am sorry our elevator is not lifting; this part of city is having some hours without electric."

"Good grief! That must paralyze the hospital."

She considered as they were passing an old woman resting beside two large buckets of water on the landing. The seamed face under the gray hair grinned brightly at Joe.

Miss Luong said, "Yes, when the motor for the pump is not going, we have very much work." A slight movement of her hand just indicated the buckets. "And of course cannot operate for surgery unless very bad emergency." She shrugged. "There is nothing we can do about."

Joe shifted the box, the better to watch his feet on the stairs. "Of course you could call up and lodge a complaint with the utility authorities. I mean, you have to tell them, a hospital cannot function without power."

"Nhi Dong is public institution. We are not in position for influence such matters. We wait," she said with the lift of her shoulders that he began to see was characteristic. "Later the power is coming back."

"Yeah. Well, at least that means Dr. Thien will be free to see me. When I wanted to meet him yesterday, he was operating."

"Yes, this day Dr. Thien is expecting you."

He followed her into a big ward painted cream-yellow and floored with tiles in shades of brown. Confused by the empty bed near the doorway, Miss Luong checked the chart at the foot. This definitely was Phuong's bed.

Joe put the box down on it. "Well, our kid must be feeling okay!"

Miss Luong frowned. "It is doctor's orders: Phuong must remain in bed."

Joe smiled. By now he knew street boys though he didn't know many other Vietnamese. For months these kids had been part of all his comings and goings. They were the first with whom he had dared to try out his new language.

"I doubt if Phuong is much on obeying orders."

Miss Luong went over to question the children in other beds, surrounded by their relatives. She came back, disturbed. "Phuong is *never* remaining in bed!"

"That figures, he likes his freedom. Don't worry, Miss Luong. Once that scratch was sewed up, it was bound to heal quickly. He can't do himself a bit of harm." Before she could start a search, there came a shout from everyone on the ward. Miss Lanh, the social worker, was pulling the patient in question through the hall doorway and toward his bed. Phuong, of the spiky hair, dragged his feet, his swarthy face creased in a grin at the sight of the American bearing gifts. A fateful hunch hit Joe—he was going to be well acquainted with that gremlin smile before he was through.

Phuong sat meekly on the side of the bed, ducking his head under the torrent of urgent French from Miss Lanh. Phuong had been found in the hospital kitchens, hiding under the large table, stuffing himself with food! And already most of the morning she had spent on the telephone looking for an orphanage or a good home for Phuong.

"Mais vraiment, trop difficile!" Testing the child had only added to the difficulties. (Miss Luong was translating for Joe.) Eleven years old probably, and can neither read nor write his letters! Does not obey at all, and also, as you see, *"Il n'est pas beau."*

Joe winked at the one who was not beautiful. Phuong winked back. Miss Luong and Miss Lanh between them forcibly tucked him into bed, tightening the sheet across his thin chest. He looked dark and out of place against the white pillow, but his grin was pure happiness and his two hands grasped the box.

"Does your leg hurt?" Joe's jerky Vietnamese broke through the stream of French.

Phuong shook his head, the grin undisturbed, the grip steady. "This is for me?"

"All yours." Joe had no unrealistic hope that Phuong would share. He was like a fiercely content little animal.

"Il est sauvage!" exclaimed Miss Lanh. "What will become of him?"

They watched Phuong attack the candy. In painstaking Vietnamese Joe began to assure Miss Lanh that they would somehow find a home for the boy. He himself would help. His missionary friends would help. "Perhaps Mrs. Thanh at Foster Parents...."

"But no, Foster Parents does not accept cases where both parents are dead and there is no home at all. There must be one parent or someone to act as guardian at least."

A white-coated doctor of middle height had joined them. "Don't be so worried, Miss Lanh," he said. "You will surely find a home for him." This man, only a few years older than Joe, looked on in quiet amusement. Miss Luong introduced Dr. Le Van Thien. The two men bowed. Joe's first impression was that even when he smiled, Dr. Thien looked a little sad.

"What is wrong with the patient's eyes?" he asked.

"I'm not sure," Joe fell back into English. "Trachoma? Some infiltration of the cornea? Makes them look almost blue, doesn't it?"

"Dr. Khanh will certainly have his eyes examined before he leaves us."

"How can he leave us with no place to go?" Miss Lanh returned to French, in a lower key now that the doctor had joined them, but still persistent.

Ignoring this, Dr. Thien, with courtesy, in Vietnamese, invited Joe to come to his office. After bowing to the two women and rumpling Phuong's hair, which sprang right up again, Joe followed the slight man wearing the knee-length coat.

"Dr. Thien, Mrs. Thanh told me how well you speak my language. Don't bother to be polite about my Vietnamese. If we are going to have a real talk, it will have to be in English, because I'm not that good in your language; I'm still learning."

The Vietnamese doctor turned back, smiling gently, revealing a space between his two front teeth. A lock of hair fell over his clear forehead. "But you speak Vietnamese very well. Where are you studying?"

"At the Summer Institute of Linguistics."

"Ah," Dr. Thien opened the door of his office. "I understand their system is excellent."

"It's the only one I've tried." Joe took the worn leather chair indicated, near the wooden desk. "I'm afraid I'm not their best ad."

Looking extremely young, Dr. Thien sat down behind his desk with his back to the window. "You are living at the Institute with the other members?"

"At present, I am."

"You have had a tragic loss there recently, I believe."

"That's right!" Joe's head went up in surprise. "The Viet Cong ambushed a public bus last week on the road to Dalat. One of our Filipino doctors was shot, he and the infant son he was holding. For some reason his wife and the other baby—there were twins—survived."

Dr. Thien no longer looked so young. "Their policy of terror works by creating fear and chaos so that takeover is easier, also by removing trained workers and natural leaders from our communities. In my opinion this policy of Ho Chi Minh cannot be justified." He sighed. "I am sorry, not only for your group, but here in Vietnam we cannot spare a single doctor."

"I know. I understand this Filipino medical help is part of something called Operation Brotherhood."

Dr. Thien nodded. "It was started by the International Jaycees to provide medical service for our refugees from the North."

"Well, we all feel terrible about it," Joe said. "His wife has decided to stay on and continue their work, being an MD herself."

"So? That is commendable." There was a pause. "First, I must apologize not to see you sooner, Dr. Ruffin, as Mrs. Thanh suggested, but there were two operations yesterday afternoon."

"It's all right, Doctor. I have these days off, and I appreciate your giving me some time."

"Days off? What exactly is your medical work, Dr. Ruffin? Are you something like these doctors from the ship *Hope*, come to help us improve our surgery?" Dr. Thien looked down at his folded hands.

Joe winced. "Improve, no. For one thing, I'm not a surgeon at all. My work right now is to study Vietnamese. I'm a GP, preparing to do clinical work for a missionary group in the provinces."

"You are a missionary?" Thien's expression was open.

Joe rubbed his head. "It's like this—I came over with a religious group, and I'll be working under their auspices, but I have a great many doubts as to whether I qualify as a missionary."

"Your doubts are appealing," Dr. Thien said, "but you will surely qualify. It seems to me all Americans are missionaries." His smile disarmed. "You cannot help this. Not only for your churches, you see, but for technical progress, for democracy, for the free enterprise system, for a base of taxes, for birth control, for literacy, for health measures, for reform of corrupt bureaucrats, for agricultural...." Dr. Thien broke off to laugh with Joe.

"Okay, you win. I'm a missionary. Is that so bad, Dr. Thien?"

"Bad or good, it is a force, a power." The clear dark gaze above the smooth broad cheekbones met Joe's. "This is the way I have been thinking, when suddenly Mrs. Thanh comes to me, happy about her new American friend, eager for me to explain him our problems. So I think, I will see this man. First I will look, can he be trusted? If yes, then I will talk with him, because, just as he is wanting to understand our mysterious Oriental problems, I am wanting to tell some American what is in my heart.

"Once, I too was idealistic person, with many missionary and patriotic feelings. That was how we young people felt in the North after 1945 when we were serving with the Resistance against the French, who wanted to regain their power here after the Japanese were driven out. We were nationalists! Those were the years before the Communist organization seized full control."

"What exactly happened?"

"In 1951 the Viet Minh had shown its power by taking a group of French forts on the border with China. After that, in February, a Congress was held, and the Lao Dong or Workers' Party was formed. No longer was there any pretense that the Viet Minh was just a patriotic organization in which all could have a part. Non-Communists were dropped from every important administrative post in the government. The Communist cadres moved very fast and took over leadership of all groups—peasants, students, workers. Old-line intellectuals and nationalists like myself who had joined the Viet Minh in '46 were thrown out. Some of us were killed, some imprisoned. Many of us, like my wife and I, traveled south, sometimes for weeks only on foot."

Thien looked out of the window. "So nowadays I am disillusioned about trying to change our country for better. And yet the spark does not quite die. I find I still want to say what I feel to some friendly American who can hear, and whom I can trust." Then he gave Joe his not very happy smile.

Perplexed, Joe leaned forward, hands linked between his knees. "I guess it's as frustrating to be misunderstood, as it is not to understand. But how will you know you can trust me? And what exactly are you afraid of?"

"Do you think you should have to ask that last question, Dr. Ruffin, when you saw the fate of my friend Professor Minh yesterday?"

Joe sat right up in his chair. "Yeah. Okay. Damn it, how can you people live under repression like this? That's exactly what bothers me."

"Because we do want to live, sir. And we would also like for our families to live. Americans are always saying, 'You Vietnamese are so reserved, so unfriendly, how can we know you?' but we are wondering, 'Is this friendly person to be trusted? If he is a loose talker, the life of myself, my wife, my child will be in danger.' I know many Americans, and I feel badly to return your openness, your gracious ways with reserve, but I am afraid of my government. And also, of course, we are accustomed from many centuries of occupation to be careful, to trust chiefly within the family." They searched each other's eyes.

Joe drew his heavy brows together. "Well, about all I can offer in my favor is what I'm not! I'm not a reporter, I'm not working for my government, and I'm not part of the military. I'm not even married, for that matter, so I won't be talking things over with my wife in bed."

Dr. Thien's eyes brimmed with light. "You sound—ideal!"

Joe relaxed, laughing. "The perfect non-entity. Sometimes that's just the way I feel these days. Imagine spending at least eight hours out of the twenty-four trying to make your tongue and vocal chords do things they seem exactly designed not to do."

"Could you not omit all this suffering and use the French language in your work? Also, the Vietnamese people are rapidly learning English, as we did Japanese earlier and French before that and Chinese previously. We are very accommodating."

"Can't somebody else be accommodating too? Look, if my French was any good, and if I'd come here just to sell you something, that might be okay. But since I want to be a part of things, to learn from people and understand, then I've got to get your language."

Joe thought for a moment. "You've called me a missionary, and I think that means a person who serves. You could also say a person who gives or helps. And right there the trouble begins. The missionaries of the past were terrifying. I wonder which are worse, the ruthless givers, or the ruthless takers in life. To me there's got to be give and take if a relationship is going to be any good. So I'm trying out this missionary thing, sincerely. But I don't yet know whether I can stick it without doing violence to me—my own real self—whoever he is."

Dr. Thien's slim fingers rolled his black pen against one palm. "You are very convincing in honesty, Dr. Ruffin. Mrs. Thanh must be right when she believes we can trust your discretion."

"You won't run any risk through me, Dr. Thien. At least, not if I know it."

The Vietnamese leaned back. "*Alors*, where shall we begin?"

Joe felt encouraged by the boyish smile, the slightly humorous approach of Dr. Thien. His English was a wonder. "Well, I had thought we might discuss taking some kind of positive action, like a formal protest about the shooting to the proper authorities, or getting help from the American press."

Thien was amazed. "Now I can see why Mrs. Thanh was worried about you! Have you thought, if you should take up in public the cause of a so-called 'enemy' of the government like Professor Minh, you might find yourself unable to renew your visa, which permits you to live and work here with status of medical missionary? This would put in danger not only what you are doing but also perhaps the privilege of your whole organization to function here."

Joe remembered hearing about several missionaries of other sects who were cooling their heels in Hong Kong and Manila waiting for those precious entry visas to be granted by the government of South Vietnam.

"It is true," Thien said, "you would never find yourself in the political prison on Con Son Island, but still, to a small extent, you are one of us. You have something of value, possible to be lost, if you speak out against our repressive government. Of course, the repression grows out of fear and insecurity. Ngo Dinh Diem feels that any dissent is a crack in our wall of protection against a Communist takeover of the whole South."

"But you can't establish freedom by dictatorship!"

"And who is saying anything about freedom? National independence was our aim." Dr. Thien's smile grew fretful, disappeared. "When I was at *lycée* in Hanoi, we heard a great deal about '*Liberté, Egalité, Fraternité.*' In practice, however, these ideals were not always meant for Vietnamese persons. Now it is the American who mentions such upsetting words. We have never had freedom here. In your newspapers we do not read that you have perfect freedom at home, yet overseas you seem to expect and demand it everywhere.

"I, however, must face reality. Here in my own hospital the chief administrator is a spy for the government. Although there are certainly others, I must remain uneasy, not knowing who they may be. Dr. Ruffin, how can I

make you understand how dangerous you Americans are with your constant talk of freedom!"

"Dangerous?"

"Like a dragon breathing fire. Or for you and me, maybe better to say like persons with contagious disease. This constant expecting and hoping of freedom is catching. In us it works like yeast. Especially among our young people. Last fall your election campaign infected many with this fever. I remember dropping in your U.S. Information Service auditorium on Le Loi Boulevard next to Abraham Lincoln Library. It was first days of November, and the USIS held a big show for Vietnamese to see how American election can work. There were boards for the returnings from every state. The Voice of America program on the radio explained in Vietnamese. Your handsome modern hall was crowded with Vietnamese students and many others, putting down notes in much excitement.

"How exhilarating for us, Dr. Ruffin, is the wonderful way you Americans insult the opponent of your own candidate. Is it not a temptation to us, with so much encouragement, in such an atmosphere, to speak out what we have for so long kept locked in our hearts?"

Joe frowned, but Dr. Thien held up his hand. "And at the end of election, youth and idealism have triumphed, have they not? Your attractive Kennedy has promised to lead the entire world toward a new and better life for all. He wins! Saigon is full of joy and hope for the future, especially our intellectual persons and many of our leaders. Is it surprising, after this, that our old chains suddenly become unbearable to us?"

Joe felt troubled. "Are you saying we are wrong to inspire people with democratic ideals?"

"Right or wrong is not concerning me. I am only saying in a situation such as ours it is dangerous. Have you noticed that only a few days after this election of yours, in fact on your Armistice Day, November eleven, a Revolution broke out here against the government? It was led by young paratrooper officers, many trained in your country, demanding reforms—a free press, proper elections, and many other freedoms. When President Diem seemed to give in to their demands at the moment of victory, these leaders trusted him, while the whole city rejoiced for one day of freedom. You should have seen the people gathering on the street corners, at the pagodas, that Friday, speaking opinions freely just like Americans! However, by the next day our untrustworthy but powerful President had secretly called in his troops from the provinces, and the Revolution was crushed. Afterwards

there came such a thorough purge that many valuable leaders were lost, and our state was worse than before."

Joe felt hot.

"Please not to be angry," Dr. Thien said. "It is not my intention to accuse, only to make aware of real situation and dangers. I am almost more afraid of naive idealism than of cleverly planned tyranny. Explosions of violence more often result."

"So you and Mrs. Thanh are afraid that a naive idealist like me will react impulsively after yesterday's incident and cause trouble."

Dr. Thien met Joe's eyes steadily. "Some quality of openness, honesty, in you has made us believe you would understand our situation, if you knew the true facts. Otherwise, would have been no use to bother talking."

Joe leaned back, hands in his pockets. "Don't you think people should be dedicated to some ideals and convictions?"

"For oneself this gives unity and direction of behavior, yet what if one insists on forcing others to accept the same convictions? For this principle I had to leave the Viet Minh and my home in the North. Communist leaders believe their convictions are right for all and must be shared by any means. How are they knowing what is right for me?"

Joe sighed. "I get your point, Dr. Thien, and of course I agree with you about not pushing people around. Maybe that's one reason you and I chose the business we're in. Curing ills is not political."

His colleague looked doubtful. "But here in Vietnam, doctors have become involved with politics, chiefly because we do not have unlimited number of highly educated and respected leaders. Recently I accepted the appointment as Minister of Health, and survived for several months, since the job I did was neither very bad nor very good. My wife believes, if only I was having a little more ambition, I could have survived for longer period." He lifted his hands and dropped them. "So what about your own sideline, Dr. Ruffin. What is your religious philosophy?"

"Maybe it's all part of the same thing, Dr. Thien. I have this yen to help people some way. So far it has been the only purpose I could isolate for my life which satisfied me at all. You may have arrived at the same conclusion. But since I began my training, I learned how complex people are—each with a mind, a body, and a spirit. It doesn't seem to work, trying to help them on only one level."

"You have been reading Alexis Carrel." Dr. Thien's eyes lit up.

"You know, I'd forgotten about him. I believe I did read *Man the Un-*

known when I was still a medic out in Korea. Well, he said it, and healing the whole person, not just a piece of him, is what I want to learn how to do. You doctors trained in France may be further along toward some kind of synthesis than we are in the States. The biggest catch to my aim is this: how long does it take to be healed enough yourself to become a good physician on all three levels?" There was silence between them. "Still, I've got this dogged feeling that we are here to learn to help each other, and the only way we can learn is by trying."

Thien's voice was dry. "Let us hope what we offer is true help and not a mere desire to manage the fate of others as we think best."

"Would you say what you have been offering me here this morning is true help?" Joe had to tease a little.

Dr. Thien laughed out loud just as a peremptory double knock sounded on the frosted glass panel of his office door. Still laughing he said, *"Entrez!"*

His back to the door, Joe admitted, "You have helped me. At least you've stopped me from going down to beat my head against the Palace." And he turned then toward the woman who had just entered.

Dr. Thien rose. "Mrs. Gregory. Please come in, it is good to see you."

"I want to thank you for the wonderful dinner last night," she began. "Hope I'm not interrupting anything." She was a lean blonde with a dull huskiness in her voice.

"On the contrary, you two should know each other. Mrs. Gregory is the wife of an economist in your Embassy, Dr. Ruffin. Also she is my wife's English teacher and does good works for Nhi Dong through the American Women's Association."

"Oh?" Joe stood up. "She sounds like one of your American 'missionaries.'"

Katherine Gregory laughed. "Good God, no. You seldom catch me with those types—if I see them first. Is he kidding, Dr. Thien?"

Thien smiled with keenest delight. "It was only my joke, Mrs. Gregory, about the American—uh—zeal. And in your case my answer is, yes, most certainly you are such a type!"

"Okay. I know you think I'm the next thing to a Communist. Just the same, here are your medical books!" She dumped them on his desk. "They finally came, and they're damned heavy. At least you've got to admit I'm useful."

While Dr. Thien checked the titles, exclaiming, holding the big technical books with pleasure-taking hands, Joe looked at the woman who had brought them. She was fairly tall, athletic, and warmly tanned. Pale hair had

been knotted in a casual twist of toffee at the nape of her neck. Her sleeve-less, much-washed shirtwaist dress seemed a lighter color than the blue-gray of her eyes. Firm brown legs ended with bare feet in sandals.

"Madame, I have been wanting these books for many years." Dr. Thien smiled like a boy. "We shall declare a hospital day of celebration! Our thanks to you and your group of American ladies."

"Don't mention it, Dr. Thien. Sorry the order took so long to arrive." Her eyes were on Joe. "I wish I could ask what else you'd like for Nhi Dong, but they tell me the Welfare Committee budget is a bit curtailed for now."

Dr. Thien bowed to the inevitable. "Is there anything I can show you in the hospital today?"

"Thanks, no. I've got to be on my way. Perhaps your friend would like a ride back to Saigon." Again the cool eyes flicked over Joe, who shook his head.

"I better refuse. Didn't you say you don't associate with missionaries if you see them first?"

"So? Maybe you're the exception that proves the rule."

Thien seemed more amused than ever. "Go on with her, Dr. Ruffin, in spite of her bad manners. Mrs. Gregory and her husband are my old friends. They were here during the attempted Coup I was telling you about. This lady has critical views of both our governments which you might find interesting."

Joe rubbed his hand back over his curly hair. "I think I've had all the politics I can digest for today. But I won't say no if there's a chance to go off with a pretty woman."

Katherine Gregory put the leather strap of her bag over the tan round of her shoulder. "Are you a southerner or an Irishman, Dr. Ruffin?"

"A little of both." He turned back. "Thanks for your 'help,' Dr. Thien."

"Don't mention it, Dr. Ruffin. It was a relief to my mind—give and take, *n'est-ce pas*? Please come back when you have time."

"I'd like to." They shook hands.

"Perhaps I have disturbed you?" The dark Vietnamese eyes searched Joe's American face.

"Wasn't that what you intended?" The hazel eyes searched back.

Dr. Thien smiled. He put the fallen lock of hair away from his forehead and watched the two Americans walk off down the corridor, glancing at each other warily.

Once outside, they got into the blue metal oven of her Simca. Drawing

in her breath sharply, she pitched some toy soldiers and cars out of his side into the back. A baby's car seat was fastened between them.

"You seem to have a family, that's great."

"Three boys." Katherine was backing the car efficiently. "What's great about it?" On one smooth turn they were out of the gate and gathering speed down the boulevard toward Saigon.

When Joe did not reply, she smiled at him. "I'm sorry I'm bitchy. Some days the boys get on my nerves, but they're good kids. They might be a lot better if I bothered to make them behave. My husband and I usually go on the theory that kids ought to be free to express themselves. At least that's my belief. I'm not sure my husband has enough energy left over from his precious work to care."

This was like the restless discontent of a bad child who provokes attention, with bright watching eyes. "What does your husband do?" Joe stared out of the window. After his talk with Dr. Thien he felt put down. What he really wanted was time to mull over everything they had said, find out exactly where the sting lay.

"Jeff is an economist in the Program Office of USOM, United States Operations Mission. Actually he's good at development work, but I tell him there's not much chance of bringing Vietnam along with this reactionary regime in power."

Back to that again. As she shifted gears for a changing traffic light, Joe's eyes fell on the movements of her brown hand and slim brown knees. When he glanced up and met her gaze, a heady excitement filled the hot car. So that's how it was. This guy Gregory must be giving his total attention to economics.

"Mrs. Gregory...."

"Katherine."

"My name is Joe."

"Do they ever call you Holy Joe?"

He winced. "It's not the first time."

"Sorry."

Joe shrugged it off. "Katherine, Dr. Thien said you were in Saigon during the recent revolutionary attempt against the Palace. I wasn't around then, and I'm curious about it, especially since yesterday." He filled her in on the shooting outside the Embassy, feeling the pressure ease as her interest caught.

"My husband did mention it after work," she said, "and later on I took

it up with a political officer, Mark Gardiner, when we ran into him at Dr. Thien's dinner party in Cholon." She laughed with pleasure. "Mark was pretty uncomfortable about it."

"You make a habit of that kind of thing?"

"Well." Katherine had the grace to look a little guilty. "I guess I do with him, especially after a drink or two. He's pretty straight."

"Stuffed shirt?"

"That's a little strong. 'Dedicated' is the word we use in the Foreign Service." She smiled. "Anyway, he wouldn't tell me anything except that official assurance has been received, the policeman who shot the kid will be disciplined." Her eyebrows went up.

"I take it you don't have much optimism about the good faith of the Diem government?"

She laughed outright, producing his name as easily as if they had been childhood friends. "Joe, how can you use words like optimism and faith in connection with that autocrat? Diem's megalomania is ineffectively papered over with the lies of a controlled press. Everybody seems to understand the situation, except newcomers like you, plus our government in Washington."

For a moment he felt dazed by her fluent tongue. "Does everyone call you Katherine?"

She grinned. "My husband and my brother are the only ones I allow to call me Kate!"

Joe was strongly reminded of a tomboy he used to play with who had always dared him into some escapade, so he answered with a placidness bound to irritate.

"Katherine then. Isn't it true that Americans here have convinced Washington there *is* no alternative political leadership?"

"My God, how can any other leader be visible if no one is given the political freedom and safety to come to the surface?"

"You're pretty excited over all this, aren't you?" Joe asked, completely forgetting his own outraged reaction to the police incident of the day before.

She stopped at a red light and turned to study him, narrowing her eyes a little. Joe met the look frankly, letting her see exactly how much response her challenge aroused.

There was a cool twinkle in her eye when she shifted into low gear. "I guess Dr. Thien is right; we ought to know each other. I can help in your education." Katherine looked straight ahead with a poker face.

He burst out laughing. "That's for sure. Would you be willing to start with this Revolution I seem to have missed?"

Suddenly a motorbike flitted casually across their lane like a wild shadow, avoiding the Simca's bumper by inches. Katherine screeched to a stalling halt and screamed out the window, but the motorcyclist only waved a lazy hand in the distance. She closed her eyes. Joe could almost see her steaming.

Then, switching on the ignition again, she surprised him with a most engaging smile. "So far I haven't killed anyone, but I'm getting more and more eager. Where were we?"

"I think I was asking if you would fill me in on some of the political happenings, like the coup that failed."

"I don't know. I'm still laughing at myself in the role of English professor to Vietnamese doctors' wives. But honestly, Joe, political science instructor to a missionary!"

"So I'm unappetizing—or maybe your prejudices are showing." Joe knew he felt irritated because he himself could easily imagine playing almost any game with this woman.

"Okay, okay, you're attractive. And well you know it! But I am prejudiced. The only missionaries I've met think they're God's gift to the rest of us, who have ignorantly and stupidly chosen the lower road. They smell like hypocrites to me. I may be a bitch, but I'm honest about it."

Joe was beginning to like her. "Well, I'm at least as much of a bastard as you are a bitch. Will that help?"

Katherine looked at him carefully from the side. "Some. Now, we are almost to my house. Do you want to come in and have a late lunch, or shall I drop you somewhere downtown?" He saw curiosity in her slate-blue eyes and wondered what she was seeing in his.

Indecision, probably, because she added with a grin, "Well, are you sending up prayers for guidance?"

Joe laughed. "Maybe I ought to be." He looked around as she pulled the Simca up in a short driveway facing high gates. The world outside her walled compound was crowded and busy. At the left of the gate a young barber had hung his mirror by a nail from the wall. The barber himself was sitting in striped shorts with bare crossed legs in his wooden chair reading a frayed paperback while waiting for custom.

"You've got your own barber?"

"Isn't that something? Tam gives the kids haircuts for only ten piasters. Handsome too, I think."

A little too handsome. Joe followed the carved features below the blackbird's wing of hair that hid a high forehead. The young man looked up boldly, meeting the stranger's gaze. However, the eyes remained opaque, the expression revealed nothing. Joe felt uncomfortable.

"And who are those on the other side?"

"That's the bicycle repair man and his family. They keep that heavy wagon, with all the tools, locked inside our garden gates at night." She waved briefly. The bicycle man and his family, smudged with the black oil of their trade, grinned and waved back. The grimy children kept on working with fierce self-importance. The grimy mother was very pregnant, but she managed a complaining smile from where she sat on the hard-packed earth against the wall, holding a large sleepy toddler.

Beyond them the restaurant man behind his loaded cart bowed, murmuring *"Chao Ba"* to the American lady as he handed out bowls of rice and soup to three cyclo men.

"They seem to like you."

"Oh, they're used to us. We've been here a long time," she said with some pride. "It's our home." Katherine looked at him curiously, waiting. Clearly she was not going to make it easy for him.

The situation couldn't be real. An hour ago he hadn't even met her. But the attraction was real, and so was the heat.

"I don't believe I'll come in, Katherine."

"You're chicken!"

"That's right." He started to get out of the car. "You don't have to drive me home. I'll get a cyclo right here."

"And what about the November Revolution you were so interested in?"

Joe felt bad. Even the barber seemed to stare at him with dislike. "Hell, this country is so complicated, I must be nuts to try to understand any of it."

"No, I've got to admit you strike me as fairly open and surprisingly honest. You'll understand plenty. Wait a minute, I have an idea." She honked the light horn three times. A small man with a wizened but cheerful face under his straw hat came running out with eager bobbing movements to prop open both sides of the gate.

"Ong Coolie," Katherine said, driving into the green-shaded compound. Cutting off the motor, she turned to Joe. "You stay safely here in the hot car, and I'll be right back."

He caught her fleeting smile as she ran up the steps onto the wide

screened veranda roofed with red Chinese tiles. Joe could imagine how the ceiling fans would smoothly whir the shady air around the big rooms inside. Out in the garden Ong Coolie had been clipping the grass with hand clippers. Now he was sweeping the paths and the hard earth under the red hibiscus bushes. There were flame trees along the wall. In one corner a gray-trunked monkey pod tree lifted huge arms to shelter the whole compound as well as most of the intersection outside. Her boys would have a ball climbing that tree. Joe "stayed safely in the hot car," allowing discouragement to flow over him.

When he opened his eyes Katherine was there again, sun-flecked, warm and brown, oddly gentle. She handed him a manila envelope through the car window.

"Here's the USIS version of that weekend. Of course we're not supposed to save it but I did anyway. And also I put in the carbon of a letter I wrote my brother afterwards about our little Revolution that failed. I'm not the world's greatest writer. Still, the whole thing hit me pretty hard. It may help you feel as though 'you were there.'" He shook his head to clear it and fumbled with the string catch on the envelope.

"Not now, stupid," Katherine said. "Wherever home is, go there and get some lunch and have a siesta. Are you sure you don't want a lift?"

"I'm sure." Joe got out of the car. Standing on the bright pebbles of the drive, they stared at each other across the gap where heat waves shimmered.

"Thanks a lot, Katherine."

"For the reading matter?" She turned away to open the gate, waving with authority for one of the cyclo drivers at the dusty curb. "It's probably just a gimmick to get to see you again."

Before he could think of an answer to that, he was in the shady pedicab, cut right off from her vitality. As the motion started, Joe looked back, but she had closed the gate. Damn. What was wrong with him? Well, he was holding her envelope and would certainly see her again.

All you could ever do was live the moments as they came. And this had been a dayful: the market, that dying coolie, Phuong, Dr. Thien's words, Katherine Gregory. The old monotonous routine of study was behind him, at least for the time being! Giving directions to the driver, Joe abandoned himself to the soft wind of unmotorized motion. This had to be the greatest nickel ride in the world.

PART III
Complications

Novelty always comes as a threat, producing status quo rigidity versus fierce and rigid rebellion. But...freedom lies beyond conformity or rebellion.

Sam Keen, To a Dancing God

Phuong Means Any Direction

The war of liberation is fought by the...entire people.... Children too, for they also make the nation's heroic traditions more brilliant.... In the defense of one combat hamlet, a children's unit killed twenty-nine of the enemy.

Douglas Pike, Viet Cong

Joe read about the abortive revolution until late. When he finally woke up the next day, the first thing he saw was Katherine's USIS report lying on the floor, looking dead and powerless in a hot pool of the morning sun. Now he felt like forgetting the past. The future would be his trip to Angkor Wednesday—tomorrow—so what should he do with today?

Lying there lazy, perspiring, Joe saw a lizard, all its quickness poised, still, on the wall. While he watched the regular pulsing swell of the tiny throat, in and out, his mind wanted to run ahead to Angkor, or back to Katherine and Phuong. If he were the lizard, he would simply exist in the now. For himself, Joe thought, it would take a special kind of trick to manage this. But a street boy like Phuong might just naturally *be* in the present.

At that moment, on his stomach under the hospital bed, Phuong was passionately involved in the world of a large paper book which Co Lanh had given him, to keep, to belong to Phuong, to be his own. He had never seen a book like this before. There were no black dots and squiggles to bewilder and irritate. Each big colored picture had been cut out and pasted on a thick white page. With satisfaction his fingers ran around the slightly raised edges of one. Every page was a place he could enter. And yet there were mysteries, as in the dreams you have at night. What he couldn't understand kept him intent, concentrated, still. Also, he had to bring his eyes very close in order to see clearly. If he enjoyed his book up on the bed, other kids laughed at him with his face so close to the picture. They said he was trying to eat

it! And indeed there was a page covered with the most tempting food Phuong had ever seen. Although he could find no rice, he was sure he was meant to eat the bright shapes, because he recognized one prickly fruit, the pineapple, and large yellow bananas. Lowering his head as close as he could, Phuong devoured them with his eyes. Of course they would taste richer and sweeter than anything, even mangoes.

The dragon on the next page was familiar. Already several times Phuong had followed through the streets the dragon dance for celebrating Tet, the New Year. At first he had been frightened by the huge beast, Lao Long, with its glittering eyes, white-bearded jaw, and long bumpy tail swinging through the city to the beating of the drum, accompanied by the fat earth god, Ong Dia, with his permanently smiling face and his fan.

But later on, running with older boys, Phuong had peered under the dragon's long, scaly body, between his moving feet. The feet were the feet of many sweating men, prancing beneath the heavy sections of the body. It was not a true dragon! It was all fooling. Phuong scorned now to follow the dragon at the sound of the drum beat each year. That was for babies. As he looked at the picture in his book, he did not see the ordinary shoes of the men, but he knew all the same that the scary-looking dragon was not real, had no power to spread rich gifts. Phuong sniffed.

Never mind. There was consolation on the next page where a powerful tiger, lonely and free, paused for a moment, staring out at Phuong with golden eyes from the shadowy trees and vines. So completely was Phuong the tiger that he could not turn this page.

Just then someone poked rudely under the bed, calling his name. With fury he recognized the querulous voice of the thin Sister from the next ward. Always a little afraid of Phuong, she filled him with contempt.

"Phuong, Phuong," she piped, "come out from there! What are you do-ing under the bed? Come out, you bad boy; you have visitors!"

The American? He examined the legs and feet. Doubtful, still.... Clos-ing his precious book, Phuong put the pillow over it before rolling out into the glare and noise of the ward. Squinting up, he saw it was only that older boy, the same one who had brought him the kite that day of the fighting long ago. This time the boy had with him a strange man. It was hard to size him up while the Sister was tugging Phuong to his feet, making "tch, tch" noises, dusting off his shoulders. Shaking away her repulsive fingers, he heard the strange man thank the Sister coldly. Staring for a moment, she left, like magic.

The kite boy said proudly, "Phuong, I have brought with me an important friend, Ong Tam, the barber, who heard how you were shot the other day by those pigs the police!"

Phuong shrugged, gazing up at the stranger shyly.

Uneasy about his errand, Tam didn't know how to begin. He was unable to grasp how his brother's cell in Dalat could make any political capital out of such a small incident with a little nobody. Looking down, he saw a tough street kid, with horny toes and elbows, who could take care of himself. Probably without relatives. Well, so much the better. At least he could be trained to distribute leaflets and toss grenades.

"I brought you something," he said.

Brightening, Phuong moved a little nearer.

"Not here, let's go outside." Tam led him toward the balcony while giving a definite shove to the other boy, who walked away reluctantly, looking back.

Out in the sunshine of the empty balcony alone with the stranger, Phuong was frowning. "A present?" he asked with suspicion, looking for a package.

Tam realized the kid could be off like a hare in a second. His leg had only a small bandage; he didn't even limp. And yet the matter had seemed important enough to be included in the orders from his brother's cell in Dalat.

Feeling stupid, Tam declared, "Anh Phuong, the National Front for the Liberation of Vietnam has heard of the barbarous act of the government police to you, a brave—citizen—of our country!" Hastily he had substituted "citizen" for "child." Phuong was small, but fierce and unchildlike. What a restless one! Already he was losing his attention. Quickly Tam produced a small velvet box and snapped it open. On a sapphire bed glinted a pointed star of some silvery metal. Putting his rough head down close, Phuong gave out a delighted sigh. Dark little hands pulled at the magnificent star.

"Wait," said Tam, encouraged, lifting the box higher. "Of course this great prize is yours. You yourself have won this decoration for bravery, the medal of a hero of the Revolution!" Phuong was peering up, puzzled, half-smiling. "But first we must have a short talk together, so that you will understand what this honor means." When Tam squatted down on the warm concrete, Phuong crouched on his haunches, watching the little box.

"From us, your friends of the Liberation Front, you have nothing to fear, Anh Phuong. We are your brothers, and, together with you, we hate the mad dogs of the Saigon police who shoot at innocent and brave citizens like

yourself! So do not be afraid; we are behind you; we are your friends."

"I do well enough," Phuong said without interest. "I am not afraid of the stupid police bullies." Indeed he had probably run rings around them when they chased him at the market for pilfering.

Tam felt himself growing irritated. This boy was crazy. "The police may be stupid, but they can be very dangerous. You escaped easily this time, with only a small injury. Next time you may not be so lucky!"

Phuong's brow furrowed. "Next time?"

The barber made his mouth smile. "You are a clever boy. You can see the police must be your enemies, or why did they shoot at you? If they try to kill you once, and fail, do you think they will give up?"

Phuong looked surprised he had not asked himself this question before.

"No! Your enemies will not give up!" Tam said. "Once you leave this hospital, they will come after you again. And this time they may not fail; they may even put you in prison." Clearly the baffled Phuong did not understand. "Next time they will shut you up in a dark room like a box so you can never run free again!"

At this the boy fell right back on the balcony floor with a shudder of horror and disbelief. Tam saw he had made a lucky cast. Was the kid only afraid of being shut up? Phuong looked ready to cry, his elbow crooked in front of his eyes, like a real child.

Amazed at what he had accidentally accomplished, Tam rushed on. "Wait, Phuong, listen; remember, you are a hero!" Hurriedly he pressed the velvet box into the boy's limp hand. "With the help of us, your friends in the Front, you will not be caught. We will always save you from the police. We will never allow them to shut you up. Never."

But the terror did not leave Phuong's eyes. "I do not know this Front or who these men are."

"I, here with you, I am one of them. We are your friends. See," Tam opened the little box in Phuong's weak grasp, "this star is a sign that you are a part of the People's Revolutionary Struggle. You will never again be alone in danger. This star is a sign that the soldiers of the revolution will always protect you. Wear the star!"

Awkwardly Phuong began to take it out, trying to pin it on his shirt.

"No, no, wear it secretly, on the inside, like this." Reaching down the loose neck of the boy's grubby T-shirt, Tam fastened it for him. "There, that star is your magic protection. And I will come back to visit you from time to time, in secret, to prove that this is so."

The words "magic" and "secret" appealed to Phuong, although he would rather wear the star on the outside where everyone could see it shine and sparkle. On the inside, it pricked his chest. When the strange man had gone, Phuong's eyes began to cloud with doubt. His heart felt heavy. Delight in the star had faded easily, while some kind of nightmare smother remained.

Looking around anxiously, Phuong got up and went back inside to his bed, already planning to run clean away. But first he was trying to remember something. What had made him so happy before? The striped tiger! The heavy yellow bananas! He dived under the bed for the comfort of his book and lifted the pillow, but there was nothing on the floor. The book was gone. *Stolen!*

A terrible wail broke through the idle chatter of visitors on the ward. The whiplash of Phuong's savage little figure grabbed and shook each of the other children. Desperately, in fierce and husky growls, he demanded his treasure. Young and old made room, fell back, denied any knowledge of whatever it was he had lost. Whirling, Phuong scanned every unrevealing face. And then suddenly, wild with despair, he seemed to give up. The frenzied torpedo of his small body headed straight across the ward for the open door and the balcony rail. Everyone screamed. A man, standing by the door, turned just as the child launched himself toward the railing. Automatically his hand caught at the flying body. And, by a miracle, when the cloth of his shirt held, Phuong was dragged sobbing back into the pandemonium of the ward.

Joe had thought about Phuong that morning. And, lying there restless in bed, feeling very much alive, but incomplete, he also thought of Katherine Gregory. When he reviewed their meeting and their talk, Joe decided he had not come off very well. He told himself he was out of practice and wondered what he might have done differently, thought of several things, before remembering that she was a married woman, mother of three. Ouch. That didn't make her any less attractive. Well, it was unlikely that he would see her again soon. He could hardly go right back with her material on the Revolution the very next day. So it didn't take him too long to think of returning to visit Phuong in the hospital where he had first met Katherine.

Joe managed to wait until after lunch. By two o'clock he was entering the front door of Nhi Dong, almost hoping for a coincidence. The green hall was bare of people. So was Miss Luong's reception office. Wandering through the siesta quiet, Joe realized how very empty a doctor finds a hospital where

there is no work for him to do. Turning toward Miss Lanh's little room, he saw her there, absorbed, bent over a ledger, thin shoulders in pure white silk, lacquer hair drawn totally away from the bare, yellow-ocher forehead. What a strange combination of acute self-denial and intense self-giving. From inside his own solid body where the sap was rising, Joe saw Miss Lanh either as a reproach or a warning.

The black eyes had lifted and found him. *"Mon père!"* She looked seriously pleased to see him.

Joe said in Vietnamese, "You know, Miss Lanh, I'm not a priest." But he saw that he would be her "father" from now on. She would not notice his human irritation, only her noble projection on him. Still, she had given up the French, was responding with gladness in Vietnamese. Rising, she said that his visit was the answer to her prayers. They had had a terrible time this morning with Phuong.

Joe pulled up a wooden chair and straddled it, crossing his arms on the back. Miss Lanh sat down, very erect behind her desk, holding a sharpened pencil between her thin, clean, spatulate fingers. It seemed that the Boy Scout troop of Madame Gregory's (Katherine's!) little boys had pasted scrapbooks of bright pictures cut from American magazines for the children in the hospital. Several days before, Miss Lanh had taken such a splendid book from her locked cupboard and given it to Phuong for his pleasure and edification. At once Phuong passionately loved it and refused to be parted from it. Joe nodded, remembering his own affection for a well-thumbed scrapbook his aunt had made him. There had been a certain misty picture of an airplane high above a boy on a hilltop, flying a kite.

"Unfortunately," Miss Lanh said, "the scrapbook was stolen, and Phuong at once attempted suicide."

"Suicide!" Joe's chair thumped down. He was half-laughing.

But she was in earnest. "Phuong tried to throw himself off the third floor balcony. He was only saved by a miracle; a visitor caught at his shirt as he flashed past."

In English Joe said, "My God. To kill yourself for a scrapbook!"

"You see, *mon père*, he had never had any possession of his own, as far as we know, until your gifts. Perhaps never any lasting thing before in his life."

Joe thought about Phuong and about passion in general. But suicide? "No, there's got to be more to it than just this scrapbook. What in the world could have driven him crazy like that?"

"Even that craziness is not all, *mon père*. Yesterday afternoon, according

to doctor's orders, I sent Phuong with a young nurse over to Cho Ray Hospital for examination of his eyes. The tests were performed, although with difficulty. At the end the doctors explained to Phuong that he must now stay at Cho Ray for several days to have treatments. Could you believe that Phuong escaped from them all and ran away?"

Joe could.

"The name Phuong means any direction—no direction—you know?" Miss Lanh sighed. "By suppertime Phuong did return to us, very dirty. But the reports of his behavior were already sent to the Director's office by the pediatrician after listening to the hysterical complaints of the young nurse who had gone with Phuong. So, after the additional suicide happening of this morning, I am called to the office of Director just before lunch. I am told this situation cannot continue. Phuong is very bad, but he is basically healthy, and some home must be found for him at once. As nurse in charge of social welfare, I am responsible. He must not be allowed to disrupt the hospital routine further!"

"That I can understand," said Joe.

"But, *mon père*, I am not finding a home for Phuong! I have tried every orphanage. Of course they are overcrowded, and also they are not desirous to have Phuong, unless, as they say, I have absolutely no other means." After a pause she said, "Perhaps if someone from the Ladies' Welfare Committee of the American Women's Association would put in a word with Go Vap Orphanage or with Don Bosco...."

"How about Mrs. Gregory? Wouldn't she do it for us?"

Miss Lanh thought not. "Madame Gregory does excellent things for the hospital, but to take personal responsibility for a dirty street boy, a *gamin*...."

"Well, she has boys of her own, hasn't she? Here, Miss Lanh, I tell you what," Joe said generously, "I'll go over and ask her myself. She'll be sure to help us when I tell her that story about the Boy Scout scrapbook."

"It *is* a pathetic story, *mon père*."

Joe got up. "Miss Lanh, why don't you explain to the Director that you are making plans for Phuong and expect to have him placed by the weekend. That should satisfy him for the moment, okay?"

"Okay!" Her narrow chest lifted. The thin mouth smiled. The eyes shone. "I saw from the beginning, *mon père*, that you have great understanding for the poor!"

He felt only a little bit ashamed. "Hey, did you give Phuong another scrapbook?"

She hesitated. "But I have just the one left...."

"Please let me take it up to him, Miss Lanh. If worst comes to worst, I'll make you some more myself!" His smile was so engaging that she unlocked the cupboard and put the last precious book, stuffed out fatly, into his hand.

Upstairs Phuong was discovered teasing a charwoman with her own bucket and mop, but in a moment he dropped them and was all over Joe like a monkey. A hospital was certainly no place for this kid. Then Phuong saw the scrapbook! Both of them sat down close together on the hall floor and enjoyed it for a long time, although it was evident that for Phuong some important pages seemed to be missing. When Joe had to leave, the boy cried bitterly, fisting away the tears, but not losing his grip on the scrapbook. Was there something more desperate about him this time?

Leaving the building, Joe found that the sad squint of those cloudy eyes and the tight-hugging arms had almost driven away the thought of Katherine, though not quite. His idea that the two could be connected was cheering. Feeling some kind of scratch on his chest as he came out into the street, Joe wondered what in the world Phuong had pinned under his shirt. A sharp metal thing.

He started for Katherine's house at once before his nerve should fail, and only at her gate did it occur to him that she might not be there. However, the houseboy calmly showed him into a small air-conditioned study where Katherine herself looked up, startled, from behind a wide, messy desk. The sudden coldness of the room and the impact of her physical presence went straight to his head. She said absolutely nothing. Quickly Joe explained that he had come from Nhi Dong with a problem to talk over about Phuong.

"That kid who was shot?" Katherine got up from the desk, very tan in a white sleeveless dress, and asked him to sit down. While Joe settled into an old leather sofa against the shelves of books, she took the armchair nearby.

When they both started in to talk at once, Katherine gestured for him to go ahead, and listened to the story. "I never dreamed those scrapbooks would make such a hit," she said laughing. "That Phuong must be getting quite a name for himself over there!"

"He's notorious." Joe leaned forward. "The Director has given Miss Lanh 'til the end of the week to find a home for him. Already she's been refused by several orphanages and she's getting frantic. We both thought you might have some idea...."

Their eyes met. Chin in hand, Katherine seemed to be wondering about

him, though her words followed the line of their conversation. "Joe, have you thought that this boy of yours may never have had a roof over his head? I mean, anyway, only occasionally. Phuong may not *want* a home."

"Oh, I think when we find him one, if it's a good place, he's sure to settle down. He's bound to be glad for three squares a day."

Katherine was unconvinced. "Just think how free he's been," she said, while her eyes wandered. Then, looking back at Joe, she smiled. "Okay, I'll try, I really will. Whatever I find, we'll take him there together. I guess he would go where you took him, wouldn't he?"

Joe thought he would. There was silence except for the heavy hum of the air conditioner. Thick between them in the unnaturally cold atmosphere, below the surface of their talk, lay another level of communication.

"Can I give you a beer?" she asked.

"Thanks, if I'm not interrupting your work." Making a face at the desk, she got up to call the boy. Joe saw every detail; the soft toffee hair just above the lump of a vertebra, her slimly rounded upper arms, long back, smooth walk. Then while they drank the bright beer, he shared with her his immediate reaction to the USIS report of the coup—frustration that something great which was trying to happen hadn't come off.

"But I guess my chief reaction is something about the amazing complexity that lives just under the surface of any event, any problem."

"I don't know," Katherine said, "I see things pretty much as black or white."

Joe shook his head. "I have trouble with that. The deeper I get into something, the more gray it seems."

"This is the end of the dry season. You probably just need a vacation."

"Well, I'm going up to Angkor Wat tomorrow." Joe glanced around. It was odd how uneasy only a very attractive woman could make you feel.

"Really? You should take me with you." Joe laughed, but he couldn't have looked comfortable, because Kate added quickly, "Anyway, we're going up to Dalat soon for the long weekend."

Then she glanced at her watch. "Look, Joe, if you don't have anything planned for the rest of the afternoon, why don't we go out to Don Bosco and Go Vap right now? They're the two orphanages I would try first for Phuong. Maybe you'd like to look them over yourself."

"Why, that's great. I'd like to. Can you spare the time?"

"Well, the older boys are at their judo lesson, and An will pick them up. Just so I'm back by six-thirty."

Rising together, they were very close for a second before Kate went to get her bag. In the Simca, while they paused outside the gate, Joe saw the handsome barber to his right, working on a fat customer's head. One flick of his hard eyes, like a razor strap, was all he gave them.

"Strange fellow, your barber."

Kate had found an opening in traffic and was swinging the car out across the street to the left. "Strange because he doesn't like us?"

"Looks more like hate to me," Joe said, although he was losing interest in anything outside the car.

She shifted into third. "So? What reason does Tam have to like us? To heck with him, huh?" and they laughed. Sunbeams and leaf shadows were playing all over her light hair, brown skin, white dress. Joe didn't exactly see her. Like summertime, she enveloped him.

Outside the city in the direction of Bien Hoa, the first orphanage was Go Vap. Before they went in, Katherine braced him with an idea of what to expect, explaining that she had never become shock-proof. Even so, as a physician, Joe was horrified by the over-crowded condition of Go Vap, the unhealthy look of many of the "well" children, and the terrible state of the ill and malnourished. In the infirmary he could hardly keep his hands off the little patients, ached for his bag, and ended by making a lot of forceful recommendations that badly frightened the tired-looking Sister-in-charge.

Back in the hot car Katherine didn't start the motor at once. "My God," Joe said.

"I know how you feel. Sometimes when I get home, after I've bathed, and gone in to see my own boys, so healthy and rowdy, then later on in bed I can't get to sleep."

Don Bosco was better. This school for orphan boys was also run by a Catholic order. But here the fathers kept a disciplined, clean establishment with vocational training as well as basic education. Afternoon shadows were growing longer when they finished looking over the brick buildings set in wide brown fields. The children appeared to be healthy and clean, if somewhat regimented.

"This is it," Joe said. "Katherine, let's try to get Phuong in here."

"Well, it's too late to negotiate now, but I'll try tomorrow. The father-in-charge is a friend of mine, I believe he'll make room for Phuong."

"Thanks so much, Katherine. Oh, when you talk to the head father, be sure to tell him about Phuong's eye problem. Wherever he goes, he's got to

have treatment for those eyes." Joe looked at his watch. "You know, it's already six. Did you have a reason for wanting to get back by six-thirty?"

She started. "Yeah, a stupid cocktail party." They hurried to the little Simca, somewhat cooler for standing an hour in the shade of a big mahogany tree.

"Just let me off in front of your house, okay? I've got nothing to do but pack a few things for Angkor. Let me drift on home in a cyclo."

"All right, I will, thanks. These parties are tiresome after a while, but Jeff gets quite a bit of work done there, so we've got to attend." Although she looked a little hot and tired, Joe noticed Kate didn't miss many openings in the going-home traffic, and pulled the car up at the gate in about twenty energetic minutes. When she didn't honk, saying the coolie had gone home, they both got out of the car. All the usual people had left. The outside wall was bare of trappings, like the mirror which the barber usually hung up on the left. They met around the front of the car. Kate opened the gate and held it.

"Gee, Katherine, I can't thank you enough!" Joe said. " I wish I could go with you tomorrow to help make the arrangements; it's fun doing things together."

"We could always go to Angkor together...."

Joe hoped she was joking and tried for a laugh. "Maybe we'd better stick to social work, Katherine."

"You're afraid!" Her eyes were blue flames.

Stung, Joe grabbed her shoulders to shake her. Then he dropped his hands. "That's right, I am." He managed to keep looking at her. "I think we're both unhappy, maybe frustrated. And so we're attracted to each other, in my case more than a little." When she turned her head away, Joe went doggedly on. "I shouldn't have come back this afternoon, but Katherine, I can feel your vibrations all the way across town! Just the same, the way things are, I don't see any good coming out of it for either of us. So don't let's—"

"Happiness could come of it. Isn't that any good?"

"Maybe, if we manage to kid ourselves. I doubt if I'd have any real fun, because I'd be worried to death I would ruin my good name out here before I even begin to work. And temporary pleasure like that might not be much good to you either. Maybe what you really want is happiness inside your marriage."

When she started to speak, he hurried on. "Oh, you're mad at your husband now, and you've probably got plenty of problems to work out, but you're

inside a circle that I'm outside of. Yesterday you said to me, 'We've been here a long time; it's our home.' I can still hear you saying that. And what's more, Katherine, you want to hurt him so bad! Why, you could even be using me just to get back at him."

She didn't say anything further, concentrated on getting the gate open.

Joe wanted to go on, wanted to say, Katherine, I'm not a kid. Already I'm thirty-two. What I think I want is to find my own circle, with someone in it who cares enough to get that mad at *me*. But he had said too much already. With her back turned she was dragging one side of the green gate across the gravel.

"Katherine...."

She had slipped through, leaving the car standing. The gate clashed, and he could hear her feet inside, running over the little stones, setting them flying. He felt awful. There was no one around, not even a pedicab. Hands in his pockets, head bowed, Joe trudged off down the empty street of closed compounds and locked gates.

He tried to console himself by thinking of his coming trip to Angkor Wat in Cambodia. Eventually most of Southeast Asia would be drawn into threatening turbulence. But in the spring of '61 an American like Joe could still visit Cambodia, long-ago power center of the Dragon Peninsula.

Joseph: Chagrin d'amour

Tension is ecstasy in chains.

Sam *Keen,* To a Dancing God

Angkor, Joe thought. The name resounds in my mind like a gong. How strange to be sitting on the Air Cambodge DC-3, holding last year's *National Geographic* open to the exotic article on Angkor Wat. Last April it was all just a distant ruin. Now, he thought, I am almost there. But instead of dwelling on the romance of Siem Reap, of ancient temples half-submerged in the jungle sea, I'm wishing that somehow I had managed to bring Katherine along. Angkor. I should have guessed it would hurt to come here lonely, hungry for love.

Angrily shifting his weight, Joe let the magazine drop. Except for my own stupidity, he thought, she could be sitting beside me right now in the window seat. Vaguely bypassing the practical arrangements for such a trip together, I imagined Kate beside me, with her brown ankles crossed, knew her arm alive against mine on the armrest. Her dress was that gray-blue cotton, the first thing I had ever seen her wearing. And her eyes were not sad like yesterday but sparkling again with a dare. We would have three whole days and nights to take care of that.

Suddenly my dulled outward gaze met the bright spectacles of the man actually occupying the window seat. Bam.

Smiling light flashed across his face. "*Pardon,* you were looking for someone else perhaps?"

It wasn't easy to shift that fast. With an imaginary Kate laughing in my ear, I tried to focus on the stranger. He seemed to be an older man, maybe fifty-five? His was a thin, tanned face, not much hair above an intellectual forehead, and a lean, young body.

"Maybe I have a likeness to your friend?" The accent was French.

I had to grin. "No, no likeness. Sorry, sir, I must have been wool-gathering." (Apology to my fantasy Kate who angrily left the scene.)

The sharp eyes behind his glasses studied my face in an objective but friendly way. A hand advanced. "Edouard Monceau, archeologist."

"Joe Ruffin, doctor-missionary."

"I think you have just dropped your journal, Dr. Ruffin."

Easing my shoulders down, I grabbed it back up, and passed it over to him, the slick colorful pages falling open at the story of Angkor Wat. Smiling his interest, he read a paragraph aloud in his crisp English.

"In the tenth century, before the building of Europe's great cathedrals, a splendid capital took shape in the Khmer kingdom. Sacked by Thais in 1431, it lay forgotten for four centuries—cracked by the tropical sun, lashed by monsoon rains, torn apart by jungle roots. In 1860, French naturalist Henri Mouhot stumbled upon the ruins and wrote of Angkor's hidden wonders. Archeologists have since uncovered most of the city, including Angkor Wat—the intricately sculptured city temple designed as a symbolic abode of the gods and as a mausoleum for the ashes of King Suryavarman II."

It was the sure way he pronounced that king's name which clued me in. "You said you were an archeologist; are you working on this—uh—?"

"Dig?" he asked. I liked his smile. "Yes, I am associated with the Centre de Recherches Scientifiques Français as well as the Ecole Française d'Extreme-Orient. *En effet,* I have been working at Siem Reap most of the time for recent years." Noticing how impressed I was, "What a bore for you," he said politely. His mouth turned down on the escaping grin.

I laughed. "More like a bore for you; that is, if you're willing to let me ask questions." I thought of him at once as "the Professor," though I may not have begun to call him that for a while longer.

"On the contrary! *Voila, Monsieur,* I regard you, just as you may be regarding me, as a possible convert. Not so?"

Nothing could be less likely on my side, I thought, and watched him building a cathedral out of his firm brown fingers.

"Do you know," he went on, "I am like a child in my enthusiasm for the ruins of Angkor. Years ago in Paris I met the daughter of Henri Mouhot and was given the privilege of reading his diaries; in a word, miraculous! Since that time I have always been in love with the idea of this place."

"Ever since you were young...."

"No younger than yourself," he said. "At that time, I had just returned from your country. I am assuming you are American—one knows somehow.

I had been searching into your Indian mounds in Ohio and in Indiana. Very interesting! However, reading Mouhot's own story of his discovery changed my orientation. Ever since then, Kambuja, as they call it here, became the center for me. And yet, one does not feel limited at Angkor. One touches the globe with a finger, do you follow?"

I didn't exactly. But I was relieved to be free, for even a moment, from the growing power of my dreaming about Kate. It wasn't fantasy any longer, more like fever. Refusing her suggestion seemed only to have increased her magnetism. Edouard Monceau looked like a yellow life raft when you are out beyond your depth. While the seductive undertow continued, here sat the upright Professor, light blazing off his wire-rim spectacles, interfering, calling me back with his own fanaticism. He got me to loosen my seat belt and lean across toward the window.

"There sure is a lot of water down there."

"Exactly, Dr. Ruffin!" he said as if I had made a clever observation. "The whole Khmer civilization rested on the *barays*, or reservoirs, the dikes, and canals. A million people lived in the Angkor area, kept fertile by the water and soil and sun! The canals even made possible the temples, because they gave easy transport for the blocks of stone."

"Looks like a big lake...."

The Professor nodded. "So it is called, 'the Great Lake,' and it is fed by a branch of the Mekong, the Ton Le Sap. I will tell you an odd thing about it. The Ton Le Sap is unique in that it reverses its course twice a year."

"Flows backward?"

"Exactly that. During the rainy season, from June to October, its overflow runs up from the Mekong into the Great Lake which we are looking down on. But from November to May it flows in the opposite direction, toward the Mekong. Of course you are seeing the landscape now in the April dryness. During the rains the Great Lake overflows its banks and floods the whole area. From the air at that time the entire countryside is one vast shallow body of water leaving uncovered just the tops of the trees! Travel is only by pirogue. However, this is a source of great wealth, for the receding waters leave deposits of fertile soil and very much fish."

Kate, who was back, had begun tickling the lobe of my left ear with her light fingers. They slipped to the nape of my neck. Trying to be two men at once made me irritable.

"Well," I said, "I seem to be everywhere in the wrong season. When, if ever, do the rains actually arrive? The whole thing is very frustrating."

At this Monceau gave me a look of clinical interest. "Yes, you are right. It is a time of great tension. Here we cannot expect release until May or later. But, as to being the wrong time; everything has its own time, *n'est-ce pas?* 'For everything there is a season,'" he quoted peaceably, "'and a time for everything under the sun.'"

The Professor evidently had a gift for consenting to things. He also seemed to like himself, which put him light-years away from my present condition. What about *my* season? I wondered. Would my own time ever come, under the sun, or under the moon? The pretty Cambodian hostess was leaning close to check our seat belts. My eardrums tightened to the pressure of the descent as the wheels were let down, protesting. After the motors stopped, when we came out onto the hot field, I felt disappointed.

There was nothing exotic about the terminal, a simple, one-level building set down in the middle of silence and shimmering heat. The cleared field was edged with forest, too far away for suggestions of jungle life.

After a perfunctory passage through customs, while I stood staring around, a uniformed man came up to ask us something in French. Monceau introduced the chauffeur of the limousine for the Grand Hôtel D'Angkor of Siem Reap.

"It doesn't sound like my kind of place."

I received a sympathetic smile. "Unhappily, Dr. Ruffin, it is the only place. They are building a sort of 'motel' near the ruins. However, this is not yet habitable, may never be. Let me drive you to the hotel in my vehicle, if you like. I have left it to wait for me here while I was in Saigon."

"Well, thanks very much." As the limousine driver turned away toward three lady tourists, we picked up our bags. "You live in the hotel too?"

"Not now. For the last several years I have rented a bungalow in the town, but it will not be out of my way to drop you off."

"Thanks very much. Do you have family out here with you?"

The Professor shook his head, leading me around to the back of the terminal. "My family seldom come to Cambodia now. In these days Paris is more *convenable* for them. My wife, you see, has her own career as a designer, with a very large textile house. Our children also have demanding work in the city. My daughter is an architect; my son an artist. *Alors*, we are happy to make occasions when we can be together. When not, we also manage to be content!" With a cheerful gesture he indicated a dusty old Land Rover standing under a banyan tree. Throwing our bags into the rear seat, we

climbed in, and bounced off over one corner of the field before swerving onto a two-lane road through the forest.

"I could not manage without the good Land Rover," Monceau said, patting her tan metal door. "There are many places you cannot go without one, even in the dry season."

Kate did not seem pleased, sitting behind with the luggage. In fact, I didn't think she liked my Frenchman at all. Clearly it would be impossible to combine Monceau with heated reveries about Katherine. So, I gave her the back of my head, gripping my seat firmly against spine-jouncers. I thought he had just said something more about the dry season.

"Professor Monceau, could you explain the monsoon to me in very simple terms?" I had to pause to set my teeth against the jouncing. "I read—a long scientific—explanation—which didn't take."

He nodded cheerfully, going ahead with his talk in a relaxed way. His own teeth seemed to have no tendency to rattle. "Much of the cause of the movement of these winds is still not understood. I will only try to explain what I know." Again his eyes were twinkling at me in a fun-loving way. It looked like a break having met him. Unless he should suggest organizing my time too thoroughly for any dreaming.

"*Alors*, the monsoon. Obviously our climate in Cambodia is warm. The temperature doesn't fall below seventy-seven degrees Fahrenheit in December, and, as you are now beginning to appreciate, it often rises in April to more than ninety-six degrees. You will be rather warm here this week, I am afraid, but you must not let that keep you from exploring Angkor! Merely wear a hat and take plenty of salt.

"At home, Dr. Ruffin, in our temperate countries we welcome a reawakening in spring followed by other seasons, but in these tropical lands the change from one season to another is only marked by the bursting of heavy storms and the muddy rise in the waters of the great river. It makes a difference."

"Somehow I doubt if it bothers you much." Pointing across a field to where a tall wooden hut stood in a group of palms high above the earth, I asked, "Is your home built on stilts like that?"

"Literally, it is." He paused, enjoying some thought. Of what his home was built on? "Now, Doctor, in order to understand the movement of the monsoon winds, you need only understand one basic fact about nature. She is always seeking a balance in all her affairs." He checked to be sure I got that, so I nodded. "The monsoon is caused by the difference between the

temperatures of the sea and the land. Land always heats and cools more quickly than water. And cooler air always rushes in over warmer regions—to recreate the balance, don't you see? This causes a wind. In summer, beginning here in May, the monsoon winds travel from the cooler sea toward the warmer land masses, carrying with them heavy rains. In winter, beginning in November, they go from the cooling land mass of Asia back toward the warmer sea, carrying nothing. Do you follow?"

I was amazed by how quickly he had cleared up my confusion. "You should be a teacher. Maybe you are."

"No, no. *Mais enfin* I do have a certain facility with words—which I have exercised in writing a small guide book to Angkor. *Voila, Monsieur*, your hotel!" He stopped in a swirl of gravel before a large oblong of cream-colored plaster from which files of windows stared down upon us. To one side I saw some children getting rides on a gray elephant in the clearing that kept the jungle off the hotel, which did not seem to be near a town. But then, I had no idea where the town was. Jumping out, I reached behind for my bag and turned to stare back at the building.

"The feeling is bizarre, is it not? Such a large hotel in nowhere. Still one manages to be quite comfortable." He was digging something out of the glove compartment.

"Thank you very much, Professor Monceau," I said with feeling. "It's been great to meet you."

"My pleasure, my pleasure. Dr. Ruffin, I regret that my appointment this afternoon does not permit me to show you something of the monuments. However, I hope you will accept this pamphlet, which has been translated into English for tourists, and that you will use it to start your tour, perhaps with Angkor Wat itself."

"Well, thanks again."

"Of course Grolier is the best possible authority on the ruins, but one cannot be expected to carry that great volume everywhere. *Ça serait trop.* However, you will find that I have included many of his views in my own study."

Seeing that he was about to wave and drive off, I leaned on the top of the door. "Professor, if you are free tonight, how about being my guest at the hotel for dinner? I don't know how the food is...."

"The cuisine here is not too bad. Thank you, Dr. Ruffin! Shall we meet in the bar toward seven?"

"I'll be looking forward to it."

"In the meantime, please, not to drink the water of the hotel. Demand the bottled mineral water in your room. And do not forget, a hat for going out!" With a jaunty wave of the Professor's left hand, the good Land Rover took off, followed closely by the fat dust cloud it steadily boiled up from the road. Out of this, the limousine with its clutch of tourists was appearing, so I climbed the entrance steps at once.

Inside I found the building blessedly bare and shady. After registering (and ordering mineral water), I followed the slight bell boy up the wide wooden stairs to the "first" floor. My room was large and high. There were two big unscreened windows on the front and a small bath.

I found Kate, like a houri, already lying on the wide double bed, its mosquito netting looped clear for the day behind the headboard. The Cambodian boy turned on the ceiling fan which slowly began to rotate the air. As soon as I got rid of him I couldn't wait to throw myself down beside this woman who was haunting me. In my imagination our bodies came together on the hard flat bed like magnets. To the rhythmic creaking of the fan above us in the swirling air we began an introduction to love.

How long was it before there came a sharp, urgent knocking at the door? We froze. The knocking continued. *"Monsieur's Perrier; le voici! S'il vous plait, Monsieur, l'eau mineral!"*

The bottled water. To hell with all helpful advice. Sweating and aching, I went to the door, managed to take in the tray and tip him, surprised he didn't see Kate behind me on the bed in all her beautiful disarray. Perhaps he did. Anyway he gave me a very piercing look before he left.

Katherine was laughing while I closed the door and locked it, but I felt shaken. It didn't seem all that funny. Suddenly determined on action, I drank a full glass of the nasty-tasting gas water, went in the bathroom, took a sadly tepid shower and put on shorts with a clean sport shirt. Averting my eyes from the bed, I grabbed up my wallet and Monceau's guide book, almost running out of the room and down the stairs. When I reached the landing, I slowed to a walk.

And so I entered the dining room with an expression which must have been pretty grim, because the waiter with the small moustache offered me nervous smiles and did everything with extra flourishes to ingratiate himself. While my pepper steak and rice and cold tea were being prepared, glumly I examined the other guests. Aliens all. Finally I picked up Monceau's guide book. The only thing to do was to study up on Angkor Wat and spend the afternoon looking at it. Otherwise I would succumb. In the

languorous heat I'd be sucked down deeper and deeper into visions of my-self and Kate making love, in all kinds of ways, eternally. I shook my head like a dog coming up for air and started to read about the "Pressure of En-vironment on the Khmer Civilization":

> The credulous foreigner is apt to picture the Cambodians as living a happy, easy-going life in Arcadia. This is pure romance, and cheap romance at that. The luxuriant fertility of the tropics strangles far more life than it promotes. The soil is steeped in stagnant water, channeled by torrid rains, rotten to the core. Animal life is hostile to man. The atmosphere is charged with electricity, the skies leaden. Everywhere the damp heat drains men of their strength and will power.

I could witness to that.

The Professor gave credit to his friend Grolier for this discouraging pas-sage, which he offset at once by tracing the paradoxical rise of the fortunes of the Khmers to their highest historical point.

"Not only is Cambodia rich in natural resources, but also the Khmer lands were at the crossroads of all the land routes to Siam, Burma, and In-dia, even to Vietnam and China. The Khmers used the gifts of nature to build the most brilliant civilization which has ever flourished in Southeast Asia." So much for the negative effects of the rotten climate, I thought, baffled. However, finishing my spicy pepper steak and rice, I came to the eventual defeat of the proud Khmers by the Thais and the abandonment of the city with all her temples to the jungle for more than three hundred years. And, Monceau pointed out, the jungle is never slow to reclaim its former territory: "I have seen a stretch of paved road overwhelmed by forest growth after being neglected for a mere two years."

Rather than go back upstairs after lunch, I arranged to join the afternoon tour of the temple of Angkor Wat. The small bus was full of sightseers. There was an English family with children, one German couple, some European students with backpacks, and three American ladies of middle age. The leader of these last had a very keen expression. For her more plump, easy-going companion and herself, she chose the two seats opposite mine, indicating to the third lady the empty place beside me. This one slipped in quietly and, through shyness or good manners, left me alone. As the driver eased the bus away from the hotel, our guide talked enthusiastically over his

shoulder in what seemed to be both English and French. Since I caught very little of either, from time to time I resorted to the Professor's little book. Rolling through the afternoon forest I began to understand how the high places of Khmer architecture grew naturally out of the Cambodian flatness, out of their longing to have a hill to catch the eye in all the level monotony under the endless sky. Yet it was not in vertical lines, but in the horizontals they knew, that they had conceived their temples, building them up by level terraces into mountain monuments. The bus stopped.

When I looked up, there it all was; across a water-filled moat, a wide causeway led to colonnades of rhythmic columns, the long horizontals piling up, just as promised, to the lotus tower and all the lesser towers. The whole spread of Angkor Wat was much more gigantic than I had pictured. As we got out of the bus we were surrounded by vendors of souvenirs. Moving away from the swarm, I leaned against a balustrade and stared out through the vibrating heat, across the waters, broken by marsh reeds and heavy with lotus pads, while I listened for the first time to Cambodian chatter. It sounded dull to me. I missed the inflection of Vietnamese, with the rapid shifts in pitch and tone. Also, of course, I didn't understand a word.

In my isolation I read on, about the great influence of India on the Khmers. Siva was worshiped at Angkor, not for his destructive aspects, but for his creativity. "The common symbol everywhere is the linga or lingam, a phallus embedded in a pedestal representing the earth, or female energy, thus a symbol of creative force, of universal energy, and also the axis about which the world revolves." The God, the King, the phallus, united with the female, the earth.

Gloomily I looked out across the moat that was said to mirror the heavenly ocean and stared at the central towering pyramid, which was supposed to be a magic mountain, running through heaven and earth to hold the world stable, in place. We were to cross the rainbow bridge like pilgrims, walking toward heaven on earth, and we would be likely to find gods there, for surely gods would feel at home in a place so closely patterned after their own abode.

In shorts or rumpled skirts, with our cameras, we straggled out on to the causeway in the hot sun. My own humanity seemed particularly heavy. If I could have socked myself a hard right to the jaw, I might have felt some relief. Our guide, never silent, was leading us over the broad bridge from the level earth toward the looming "heaven." Out of the corner of my eye I had checked for Kate a couple of times. However, as I figured, she did not

crave heavenly sight-seeing. Anyway, she was probably mad at me for running off.

The monument, built of sandy laterite blocks, seemed even more mighty as we entered its shadow. Inside the colonnades, rhythm of light and shade was like a precision ballet. Almost at once we saw our first *apsaras*, playfully smiling dancers, nude to the waist, twined in twos and threes, sculptured along the length of walls.

Our guide recited, "These are the *apsaras*, the celestial nymphs whose full-blown charms gladdened the hearts of the gods!" I turned away from his knowing smile to their merry ones. Unashamed, they were displaying forever with seductive beat their own deliciousness.

Standing just behind the three American ladies, I shared their first impressions. The keen-eyed one, who seemed to be their natural leader, wore her hair in small gray curls. She had a long elegant nose, lips chiseled thinly, and a pointed chin.

After confronting the *apsaras* for a full moment she said, "In all these Eastern temples the emphasis on sex seems out of proportion."

"Now Hilary," said the one called Melba, plump with yellow hair. "They're beautiful, aren't they Alice?"

I felt a special interest in quiet Alice, the one beside me on the bus. But she looked about in a vague dreamlike way and murmured something I couldn't hear.

It was a miserable afternoon. Wherever we climbed (and every gallery seemed to end in a tower with stairs), there was endless perfection of sculpture, always suggestive, never satisfying. The views from the open embrasures as we ascended were of the roads radiating out from the four sides across the flat green-and-water expanse under clouds massing in the highness. From such a brilliant view, stumbling around one dark corner, I roused a student couple who had fallen together into a deep kiss. Once I caught myself humming, "They're writing songs of love, but not for me...." and broke off quickly, ashamed for anyone, even Alice, to guess my particular poverty.

Still, all the sexiness kept me from feeling totally alien. Disliking myself, I couldn't be a part of any country or people or monument. But I knew I was still alive when the blossoming sandstone raised flickers of desire, no matter how frustrating. It was the perfection that really bugged me. Here was a perfect song, carved in smugness; praise to themselves, their beauty, their life and ways.

Those secret lilting smiles seemed to shut me out. Even the Khmer king and all his warriors, arrayed (for battle?) against a background of feathery trees, were perfectly serene. And in the south wing, I found a very Christian version of the judgment of mankind. The saved were entering heaven in bliss in the upper section, and in the lower, devils were dragging the damned off to hell like buffaloes by cords passed through their nostrils! Which to identify with?

When our group began to clamber up the knee-high steps to the last height, I sat down to sweat quietly in the shade, looking out over the ancient tiled roofs on the wide landscape where nothing seemed to move. I read the last of the Professor's quotes on the temple: "It is no exaggeration to say that every stone of Angkor Wat and every building of this period bear the stamp of perfection. Henceforth no further progress is possible."

I was ready to go home to my wild dreams of Kate, tired from climbing all the way up where I couldn't belong. Here at famous Angkor, was this all the appreciation I was capable of? Then, just as I had given up, and we were leaving, passing out of the last arcade, I recognized in the smiles of the stone *apsaras* something of my own secret in-love-ness. And when our group of tourists started their return over the causeway, I hung back until last. For several minutes I stood there, allowing myself the luxury of acceptance. I might be frustrated, but at least I was in love, and the hell with it.

Only then, looking back, could I begin to imagine the city as Monceau described it. Angkor was a sea of roofs in those days, rooftops with gilded tiles, silk banners snapping in the little rise of evening air, processions with elephants, tall bronze weapons, crowds, dancing girls. And dominating the temple stood a tower with a huge gong on which the hours were struck. *Angkor* resonated across the marshy flatness from which a heron rose, flapping his awkward way off into the sunset.

When tropical night had dropped down over my hotel, I entered the bar, a man's room with leather chairs and no frills. On one wall a dim mirror repeated the heavy black bar with its reredos of bottles, the round tables and chairs mostly empty. A record had been put on, "La vie en rose," I think. They play that a lot out here. Coming toward me at once away from the bar, the Professor shook hands briskly before noticing my newly sunburned face.

He winced. "I see you insist on punishing yourself."

Weird point of view. "Sorry, Professor, I just don't own a hat."

Monceau shrugged. "Noel Coward should have included Americans with

his mad dogs and Englishmen." Somehow I had always thought that was a quote from Kipling. "What will you drink, Dr. Ruffin?" He had something in a glass on the rocks. Scotch? Vermouth? I looked to see if he was wondering whether a missionary ever drank. But he was waiting without interest for me to order. There wasn't any bourbon, so I took gin and tonic.

For a long time in Saigon I hadn't been drinking, except for an occasional beer. Mainly, I guess, because I was living with the Summer Institute people, who, when they gather before meals, simply go on in and eat. Now I felt a great need. And anyway, what was a drink compared to the hot love affair I was mentally carrying on with Kate. Might as well be hung for a lamb as a sheep.

As we settled at one of the small tables, I could see Monceau in the mirror considering me. "How was your afternoon, Dr. Ruffin?"

Suddenly I was glad I had asked him to come. "Professor, couldn't you call me Joe?"

"Your name is Joseph, is it not?"

"That's right." He made things interesting by being just a beat off the expected.

"*Bien*, my own Christian name is Edouard. However, since I see you are going to call me 'Professor,' I believe I shall call you Joseph, a name I like for you." We raised our glasses, looking seriously across them. "*Santé*, Joseph," he said, "your health!"

My health was okay. What seemed to be off was my brain, which had lost control over those inner fires so much further down. I looked at the Professor in his freshly ironed white shirt, a printed silk scarf at the open neck. His eye was bright and clear, his muscles firm, his body relaxed. All his obvious signs checked out good.

"You look healthy in spite of the sticky climate. How do you account for it?"

"Account? Oh, yes. How I explain this. Well, Doctor Joseph, I think I remain healthy, in any climate, because I am happy." His smile came on full. "I just always continue to follow my deep desires."

The two of us were mirrored faithfully, if dimly, along the wall. There was no happiness energy radiating from the image of me. This contrast between us, in spite of the difference in our ages, awakened my curiosity.

"How do you manage to be free to follow your desires? I mean with all the usual restrictions, social customs, religious taboos."

"But Joseph, I believe that the only forces which keep us from living as

we like are inside ourselves." He lifted both hands wide. "To learn to live as we like, we must stop living in ways that we dislike. And this takes practice. At first we must become conscious of our inner battle, the conflict between our own thoughts and feelings. After we have chosen what we really want, then it is necessary to rebel against oneself, one's old habits. It is war! But the enemy and the barricades are all here." He tapped his chest. "Not out there at all."

After a deep sip of my drink, I shook my head. "I don't know if I can agree with that. Or anyway, not right off. It would take some thought."

He was quite content to leave it there. Later on, however, his suggestions about how to live were what I remembered most from our evening. Over dinner, with a pleasant wine, we talked generally about Angkor Wat. He didn't seem disturbed by my negative reactions that afternoon. Monceau began to weave a background for me, explaining the Indian influence, the way the Brahmins had run everything. "Divine power" had even been delivered to the King by a Brahmin, power in the shape of a linga, which Siva himself was supposed to have given to the priest on a high mountain. I had seen plenty of linga that day, plus those undulant snake symbols called ragas, and a thousand bare-breasted nymphs. When I got back upstairs I was ready for bed. With Kate.

Or was it really Kate I longed for? At first with effortless relief I entered my room, closed the door, and let down the mosquito net to make a secret circle in the heavy dark. Once undressed and inside, it was curious that I found Kate's strong, definite personality getting in my way. So, mentally, I tried to abolish that side of her. Crossing my hands behind my head, I stared up into the blackness and imagined all kinds of adventures with her beautiful body. Of course she would have a waist like a wand, breasts like young pears, and long muscled brown thighs. But she kept on being just as demanding, fierce, hungry, and unsatisfied as me. In all the eager movements I envisioned, we only seemed to exhaust each other, and end up frustrated. After all, I told myself tightly, she wasn't really there! Still, my physical reaction to just thinking about her was really there. Sweating, I turned over and tried to extinguish my whole length against the mattress. There was no way to do it.

Whether Kate was my dream woman or not, she had thoroughly awakened me to my physical self, my own real needs. And remember how casual I had been about her real needs, which she had exposed to me with that breathtaking honesty. So what was the reason I had refused to get involved with her? I was afraid we'd be discovered, and I'd lose the prospect of work-

ing in Vietnam. Now I was just as lonely and hungry as she had been. Now I was facing it, as she had. What should I do? Loathe myself? Pray for fortitude? Call on Jesus? It was hot and dark and there was a dull pain in my very vital organs.

I remembered then what the Professor had said about where the enemy is to be found, where the war has to be fought. And I directed a challenge inward to the "noble" side of me, that precious one with the missionary complex.

"Get up here," I told him, "so I can knock you out of your would-be sainthood!" When he showed, I could see that stubborn jaw which I was so eager to land a right on. And the steely glint in his eyes.

"Don't forget," he said, "I'm tough, too. I can overcome any temptation with will power."

"And hurt other people who are willing to admit they're human? You're an inhibited bastard."

That only set him back for a minute. "All right, if I'm so mean, how come I traveled all the way out here just to try and help people?"

"Is that what you really came for? To me it looks like you did the whole thing to justify yourself. But *I* came out here to discover myself. And that's what I want, the freedom to do it!"

He was sore. "What *you* want is a license for any sexy violent act you feel like."

God, what a creep. "Brother, you always make me hate myself, even though I know it's just as sick to condemn me as anybody else. You actually tempt me to become a Buddhist. I've heard how they learn to get rid of all their painful desires and escape into Nirvana. I'll try that!"

He looked worried for the first time. "No, no, that can't be the way. Somehow we've got to make it in this material world. Maybe we're fighting the sex thing too much." For a minute there was quiet. "Even Jesus let the one he loved lean against his shoulder at the dinner table right in front of everybody. And what about that prostitute who was in love with him, the one who wet his feet with her tears and dried them with her hair? That was crazy, but he didn't fight it."

We both stood there together frowning. I didn't feel quite as lonely and separate as before. But, what to do?

He said, "I think the first thing is to face our weakness...."

"Hell, this is weakness? All this hardness and lift for some way to be complete? This is strength and power being denied! Maybe even love."

"It could be a power for evil...."

"Don't you believe it! There's something constructive here. After all the sightseeing we went through today," I grinned in triumph, "we've got to remember this lingam is a gift of supreme value to the life of the people, a gift from God!"

He flapped his hand wearily. "No, no. That's just the instinctive urge to perpetuate the race."

Thinking of Kate and me, I laughed. "Bullshit. Humans get a lot more than that out of sex. We get healthier, for one thing. Why, people make love even when they *know* they run the risk of perpetuating the race."

I thought I had tired him out; he was looking a little discouraged. But he rejoined with, "So you're clever with arguments—what are you going to do about your mighty creative force tonight?"

That knocked me back on the bed. In the sleepy darkness out beyond the fussy buzz of a mosquito, I could hear soft, living noises of the forest that I couldn't identify. Weary with fighting, I started in again to make up just one more adventure with Kate. Just one more situation where we were really boxed in; there was nothing else we could possibly do but make love.

Between waking and sleeping the words of Monceau snaked through my thoughts with his use of my name. Childhood and Sunday school hung around that name. Joseph and his brothers, Joseph and Potiphar's wife, Joseph and the dream, Joseph in prison. Did God get him out of there? Not for years, I remembered. A sentence floated clear, "And the Lord was with Joseph in prison." Was God really stuck here with me, sharing my frustration?

Well, I said to him, since this is such a powerful life force, you must have a use for it. I offered it back to him, and then I slept, exhausted, after only the first day at Angkor. Beautiful, somnolent, amoral, deep under the jungle sea, Angkor.

Nostalgia is supposed to be a sure indication that you're miserable where you are. When I woke up the next day it was so hot I was already sweating. I couldn't help thinking of how April comes on, back in Guilford County, North Carolina. There's the damp red earth. And a faint green mist over gray woods and hills. Flecks of white dogwood break through everywhere, with petal gold blowing out of the leaf-sodden ground. Cool freshness, and all the sounds of spring, like violin strings tightening, tuning up to life.

God, I was so fed up with frustration, I actually had tears in my eyes, and

I'd only been leading this celibate student life in Saigon since December. Maybe I could have adjusted better if I had been more controlled in my youth. Still, can anyone accept the possibility of a young male going through Harvard Medical School without a practical course in sex? Say it's April in Boston, out Huntington Avenue, where all the buildings are stone monuments to the austerity of science. In spring and in love, I even used to feel a fondness for the old mausoleum.

And when I passed that certain cornerstone with the deep-cut warning, "Life is short and the art long; occasion instant, experiment perilous, decision difficult," I smiled. It might be perilous, but it was better than being dead. In college I had already decided to be fully alive whatever the cost. The life juice inside said, "Do it, and don't worry any more than you can help. You'll make a lot of mistakes, but you'll get all this awareness and understanding. Plus, you'll be in there, alive, with everyone else."

However, in those days I never got interested in a married woman. And I wasn't even practicing medicine yet, much less stuck as a missionary! The only image I wanted to project was the successful med student. If I overworked because of the stiff competition and got a spell of mono when things seemed empty and meaningless, or if I felt sharply ashamed after a lonesome girl had been too easy, well, I told myself that was part of living too. I don't believe, being me, I could have handled the past differently.

I eased my watch off my damp wrist to squint at it. Eight-thirty. The Professor was planning to meet me on the front steps at nine o'clock. No time for breakfast. Abstinence was certainly the keynote of this trip so far. I got to my feet and took another one of those tepid showers. It was so damned uninvigorating that I ended up laughing and felt better. This is a vacation, after all! And the Professor, with his great enthusiasm, is sure to have a few interesting surprises in store. Kate didn't make a single move. I guess we had both given up.

Even so, my irrepressible subconscious thrust up a sex image as soon as it could. Have you ever seen bananas growing? Driving toward the first of the temples, Ta Prohm, we passed yellow-green banana plantations close to the road. A bunch of bananas grows curving up from the stem that points downward with its purplish cone-shaped head. How can people grow bananas right out in public like that? I must be feverish, I thought, just as Monceau pulled the Land Rover off the road.

Parking on the verge, he gave me a fatherly glance. "You have not slept well, Joseph? In any case, you have taken breakfast?"

I shook my head. "Let's go, Professor. I'm okay."

But, reaching over into the back seat, like magic he came up with a loaf of French bread and a bottle of red wine, still cool to my grip. "I have brought these for our lunch, but you must not start the tour on an empty stomach. Very bad for the liver. And there is plenty, after all."

He made a swinging gesture with his arm, so I took a long swig right out of the bottle and began to crunch on the bread. It was fantastic to have met this guy. Something might come of Angkor yet. When I had finished, the Professor still wouldn't start without providing us with hats! His was a soiled white panama, the hat of a tired southern gentleman; mine was a raffish brown straw, fraying at the edges, a hobo's hat. Putting mine on, I liked it, and followed him cheerfully into the jungle.

Just there, with the sunlight filtering down through the deep shadows under the canopy of the rain forest, I really began to understand the fascination of Angkor. French archeologists had allowed this temple, Ta Prohm, to remain as it was when first discovered. With a start I looked into a stone face being devoured by the jungle, blind eyes staring out between tough, warty roots.

The Professor made it more eerie by his occasional comments as we tramped around. "See here, Joseph, how the trunks of giant strangler figs have pushed up through the roofs of temple rooms. And here the roots are wrapping in a deadly embrace these *apsaras*, whose faces continue to shine, radiant!" He turned. "The feeling is bizarre, is it not?"

I shook my head, stunned. And we wandered on through roofless chambers green and lost, plundered by the tearing power of the jungle.

Once Monceau said, "The very splendor of Angkor, the part one always remembers, is this forced marriage of the natural and man-made wonders." High above in the light-starred gloom we heard monkeys chattering. The rank odor of bat droppings hung in those rooms which were still roofed. Outside, a parrot flashed one vivid curve up into an enormous white-trunked tree. Old walls, pointed arches, god-like faces were joined forever to roots and trunks and vines, in light and shade. When we came out into the hard, hot light again, I stumbled, looking back into that Eden where all life is one, and nothing has been rejected.

As we drove off, dust sharp in our nostrils, the Professor tried to tell me that a real person, a Khmer king named Jayavarman VII, had built Ta Prohm (now submerged) in memory of his father and mother. At the age of fifty-five ("my own age," said Monceau) he had ascended the throne in the year

1181, the period of Notre Dame Cathedral. Since this king had been a devout Buddhist, his reign saw a great religious revival combining Hinduism and Buddhism, using substitutes for the linga, often statues of Buddha-the-King.

"So you see the living monarch came to represent the God, the Deva Raj. And yet this monarch remained unusually human."

"What was he like?"

"Most different. He had great compassion for his people, did many charities. Some words of Jayavarman VII are carved into the stone of his city: 'It is the grief of the people that causes the grief of kings and not their own grief.' *Alors*, this unusual man built here, as well as the temple you have just seen, the huge capital city, Angkor Thom, or Angkor the Great. The center of the city is reached by four causeways crossing an outer moat at the points of the compass. Look, Joseph," he slowed the vehicle, "we are approaching one of the gates."

On the other side of the wide causeway an arched gate was topped by three rough towers carved with giant faces wearing those enigmatic smiles. The chin of one full-lipped mouth rested peacefully above the point of the crooked arch. And below, on each side of the bridge, like living balustrades, were stone giants grappling with huge naga-serpent bodies. I whistled. The impact was crazy.

"Perhaps you do not find it aesthetically pleasing?"

"No, I think it's great. What imagination those guys had!"

"You see, under this very human King they were more free. And to create, one must be able to let one's self go, unhampered. Is it not?"

Is it not. I stared up at the tip-tilted eyes, broad noses and generous mouths smiling their mysterious and happy smiles at the far horizon. Towers with human faces. Or god faces? They seemed not male or female, but both in one. Strange.

"*Tiens, mon ami*, reflect! It takes great courage to be original. The first time a thing appears, it shocks everyone, the artist too. But one must be free to leave it that way, and not retouch it. You are thinking, those towers are strange and clumsy; I have never seen towers with faces like that! For us the good is the familiar. The new arrives only by accident, by some mischance. It is a fault. And Picasso has said, it is only by sanctifying our faults that we create."

Sanctifying our faults? I fanned my head with my hat in the presence of the stone giants, battling furiously on either side with the great snakes.

"Gods to the left," the Professor said, "and demons to the right. Altogether, with the demons and gods of the other three gates, they are flailing the universe (the sea of milk) to let down the ambrosia of heaven here in this city for the people.... They saw it as a kind of churning, you follow?"

I was doubtful. Shouldn't the gods be on the right? And was the activity of demons necessary too in order to bring down heavenly abundance? The Professor had started up the Land Rover again. We swept across the causeway, through the irregular arch and into the jungle-occupied city. My mood was changing; I felt more at home, with no wish to puzzle over why. I was ready, in silence and wonder, to explore the vital remains of a city.

Monceau, however, was not silent. We saw the Bayon, the terrace of the Leper King, and the Elephant terrace, with all their realistic sculpture, like lusty music to the libretto of his knowledge and understanding. Quite a bit of the Professor's philosophy of life sifted down on the sun motes to me, following his purposeful trails among the messy piles of rock below the high trees. Nothing seemed alien to him. My nostrils almost dilated to the light but unmistakable smell of freedom. Did it come from Monceau? From the ancient Khmers? Picking my way unevenly among the fallen blocks with their robust signs of former life, I began to hope a little for myself.

We had paused on a shady open terrace before the confusing perspective of the Bayon, the central temple of the city. It was a forest of stone towers; on every tower four colossal faces were carved, staring out toward everywhere.

"Joseph, here where we stand was a glittering and happy world. Of course all power over these lives was still in the King." The Professor translated one of the inscriptions for me: "'The earth in intimate union with the passionate principle of this King brought forth untold riches.'" Sex on a cosmic scale. While I leaned against a living tree trunk, Monceau was gesturing toward the fantastic pile, ignoring a spell-bound group of tourists who saw that I had managed to corner the best guide.

"Figure to yourself, Joseph, there were tapestries and gilded bronze, brocaded silk banners from painted masts! All gone now. But so much remains. Jayavarman the Seventh was possessed by a mania for building. And all in haste so that gross faults abound. This is shocking to one who admires the serene perfection of the classical age you saw yesterday at Angkor Wat. But here, at Angkor Thom, everything is charged with human feeling...."

Turning suddenly, he confronted the staring group of tourists. As their Cambodian guide rushed up to herd them away, I saw my three American

ladies looking back in envy. It was a feeling of great privilege to have the Professor take my elbow and move me downwards around a sharp turn.

"Joseph, do you agree that artists and lovers are alike in one thing; they both know perfection is not really lovable? After all, it is the awkwardness of the fault that makes a person lovable. Do you not agree?"

I agreed as we squeezed past the out-sized breasts of a row of dancers, carved in such a narrow cleft between two walls and in such high relief that you could not keep your hands off.

"Ah, what storytellers these Khmers have been! Every sandstone surface is alive with sculpture. And look, Joseph, now the common people are here, because of this unusual Buddhist king. In the hasty carving, see the vitality, the human touch everywhere."

He showed me the King surrounded by his wives and courtiers being amused by clowns and a sword-swallower. A whole festival must be going on. There were bands and tight-rope dancers, fencers, an acrobat balancing a wheel with his feet, another lifting a pyramid of children. We came on a procession of animals which the Professor identified as a wild buffalo, a hare, a cassowary, and a rhinoceros! In one market scene I saw a peddler squatting with his shoulder pole supporting two baskets. Exactly like the Saigon market today except that the Khmer people seemed to have peculiar long ear lobes. Here a boy like Phuong is just about to steal some fruit. There a lady gathers water lilies; a cow suckles her calf. And the palace guards wrestle with each other. One hold certainly looked like a hammerlock to me. Then we came on the whole army storming home, victorious over the Chams. At their heels scramble camp followers and stragglers. They told it as it was.

"The squat figures with their merry faces always remind me of our Romanesque cathedrals in Europe. Clumsy, full of mischief. Delightful, *n'est-ce pas?*"

"The *apsaras* are not slender like the ones at Angkor Wat," I said. "These are more sexy...."

"Than celestial?" We both laughed.

Just at this point we came to some very explicit sculpture of the sexual activities of the inhabitants. It seemed a good place to rest, and the Professor took out his pipe. As we sat in the grass, leaning against the sun-warmed stone, I tried to follow the curves and convolutions of their lovemaking, carved out so frankly.

"One thing you've got to admit, Professor Monceau, you don't see this kind of stuff on Romanesque cathedrals!"

He gestured largely toward the relief with his pipe hand. "A pity that we don't, I feel. It shocks you?"

I shook my head. "But it certainly surprises me. On the walls of a temple, I mean."

"Ah yes. Coming from our culture, we must study the Eastern religions and point of view toward life, in order to understand the need for these erotic carvings along with those showing other everyday experiences. As a part of the Hindu way, for instance, the pilgrim is to accept all aspects of human life. Sex cannot be omitted. The Vedas say that joy is a fundamental element of creation.

"And further, Joseph, you want to understand that the Hindu path toward spiritual ascent is the way of the *dharma*. This means that a man must live rightly according to his station in life, or his caste, being faithful to his own inner self. Just as it is the *dharma* of light and water, wind and tide to maintain their inherent nature, so it is the *dharma* of man to be human. The pilgrim must quest his way through the many distractions of life; curious, intrigued, delighted, sated. At last, from the outward, he turns inward, to arrive finally at the balance of Truth in the heart. But all by experiencing to the full his own nature. A high Hindu belief is that man, fully human, is near the divine. And have we not said this also of our Jesus?"

I listened while my eyes absorbed one carving. The solid man stood with his legs spread wide, his woman a vertical column between them. The heat in my own loins tells me clearly what my *dharma* is. How can I be faithful to it?

Attack

"My only weapon is anger. I won't disarm my people until I trust you." (Ho Chi Minh to French negotiator Paul Mus)

Shaplen, Forest of Tigers

A sudden passion like Joe's, when frustrated, could become an obsession. For the Tonkinese woman in her bar in Dalat, long-time hatred and the desire for revenge were beginning to overcome reason. At the end of siesta on Tuesday afternoon, Ba Le Thi Kieu was clearing up and preparing to reopen for customers.

What if the stranger, the cruel judge of her past, should come in early this very afternoon? He, Le Tuan Anh, always sitting lazily in her bar, meditating on his secret affairs, was doubtless plotting against poor peasants near Dalat as once he had done in the North. What if, even for a few moments, she should be alone, or nearly alone, with him in the bar? There were still fifteen minutes before she unlocked the door at three o'clock. Feeling for the sharpened knife in her pocket, and praying to all the gods for her chance, Ba Kieu was still afraid she wouldn't have the courage. To strengthen her will she summoned up the images of her dead husband, Hong, and little son, Hai, her lost home, land, and village.

It was necessary to lean heavily on the counter and draw in deep breaths to avoid nausea. The cry of the Viet Minh in those days had been "Grab the land! Kill the Land Robbers!" She and Hong had never thought that such small landholders as themselves would be punished. Cruelly their own earth with its spirits had been snatched away, their rice, their very identity handed down from the ancestors, had been denied them, reduced to less than a quarter of a hectare. No man could make a living from such small paddy, the least arable of all their former land.

And so she had persuaded Hong to go to the District to ask for justice.

When, standing just behind Hong, she had looked upon the rather effemi-
nate young judge, she whispered to her husband to add the ring to their
bribe. Only in this had she been correct. The judge had liked their ring!
When the other valuables were haughtily returned, the dragon ring was not
among them.

What had it brought them, their precious ring? Bowed down, they re-
turned to their village, without hope after the judge's swift refusal to restore
a single square meter. With the high cost of fertilizer and the low selling
price of rice, how would they exist? Three days later Hong died of a heart
attack. He simply did not return from the field at sundown. After his funeral
she had struggled on with the help of their six-year-old son, beginning to
ail at the loss of his father. She could still see the constant anxiety wrinkling
his little forehead. Hai had not lived more than five months. There was not
enough rice anywhere to be had. He died, her only son, her immortality, as
others died all around them.

She should have died too—it would have been easier—but instead she
found a strength in hate and the growing idea of revenge. This precious
thought began to grow large and living in her stomach, like another child.
The problem was, whom to hate, to take revenge against? Never mind. For
the moment she would live on the pure flame of anger within.

And so she left their village, which was painfully dying to all they had
known, and not yet reborn into whatever shape it was to take. With the few
useful things she could carry, Kieu started walking southward, and eventu-
ally took up with the porters, many of them mountain tribesmen with black
skins, who in that year began in larger numbers to carry supplies from the
North down through the jungle for the guerrillas in the South. It was an
ordeal even to remember those grueling kilometers covered on foot, down
through Laos, hidden under a stifling tree canopy, nothing but mountain
and jungle tracks, scarcely wide enough for two abreast. But they had
brought her here.

Once the supply train reached a ridge above Dalat, through the dizziness
of exhaustion and illness, she looked out and saw how fertile the valley was,
high and cool, planted with fat green artichokes and cabbages and lettuces!
During that particular rest-break on their march, nothing moved but her
mind. Farmers here would have money to spend. In the town below she could
surely find some way to make a living. Before an hour passed she had let the
Montagnards move on, leaving her behind. She spent the night eating stolen
papayas, washing herself and her clothes in a mountain stream, and sleeping.

The next day down in Dalat she hired herself out as a waitress in this bar. Though she had written her full name on the job application, they always called her "the Tonkinese." No matter. Her old self had died. And, very recently, she had discovered a man to care for again, a man and his child. But now, for her vengeful purpose, the thought of them would be only weakness.

At three Ba Kieu unlocked the door to the bar and looked out into the street. With all her might she willed the stranger to come around the corner. No one was in sight except the owner of the *tabac*, raising the corrugated metal blinds over his shop window. She went back in, trembling, feeling the knife in her pocket, feverish with her overpowering desire. Somehow she believed he would come today. And the gods would give her one chance to avenge her loved family and rid the world of the destroyer, the self-satisfied one.

Five minutes later Ba Kieu almost loved him for being the first to come in by the open door and part the beaded curtain of the place. But when the stranger's eyes met hers, she felt fear, fear that giving way to violence now, she might never see the man Rau and his child again. Forcibly she put down the very thought of them. She could never be happy anywhere while this evil man lived.

Le Tuan Anh felt her fierce animosity, and was not displeased that another customer had followed him into the bar. Only yesterday he had received the report on Ba Le Thi Kieu from Hanoi. This woman had been deprived of most of her land when he was acting as judge in the Land Reform Program. As he sat down at his usual table Anh wondered how she had recognized him. She was waiting on the other customer first, a familiar old farmer.

When she came toward him for his order, Tuan Anh said, "It is early, why don't you sit down for a moment. I understand you are from the North too." His hands were on the table and he noticed her staring hard at the dragon ring. Could his ring have belonged to her or to her family? The woman hesitated. Then, with her gaze still fixed on the ring, she sat down.

"Where did you live up north—Hanoi?"

Her voice was gruff. "I am from the Red River delta." And she flashed one look at him.

"So—do you still have family there?" He made the question pleasant.

For a moment she could not answer. "Not any more," and her eyes burned into his.

Anh had seen enough. He must not come here again. Probably he should even leave Dalat, since his work was just about finished. It would be necessary to put a note for Kiem in the designated place to arrange one last meeting. There were a few loose ends, but, in any case, Dalat, a resort town, could never be a headquarters for the Movement.

"Perhaps you have brought your family down here," he said. "This seems a good enough place to settle." Abruptly the woman stood up. Was she trembling? He frowned. "Be so good as to bring me my usual vermouth."

Drawing a deep breath she left his table. Tuan Anh looked around. The bar was still almost empty. One more farmer had joined the other old man. They looked in his direction, nodding. That was the problem with staying too long in one place. It would not seem natural for him to leave before being served. Still, with the strong threat he perceived, Anh determined to look relaxed, but to watch the woman every second until he left the place. The sooner the better.

He saw her pouring from the green Cinzano bottle into a small glass. Then she opened a beer for the second farmer. Although there was no possible weapon in sight, Anh's muscles tensed as she stopped by his table to put down the glass of vermouth. When he looked up at her directly, she did not meet his eyes. Without turning he watched in the mirror behind the bar while she gave the farmer his beer and collected payment.

Now her hands were free. She stood for a moment staring at his back. The woman was about a meter and a half away across the room. Putting her right hand into the pocket of her tunic she started toward him. Even before she began to move faster and a knife flashed in the mirrored reflection, Anh knew his danger. With his eyes on the mirror he waited until she was almost upon him. Then he tipped his chair and himself over to the left just as she dived forward with the knife raised.

There was a crash. Le Tuan Anh rolled to the floor at one side, while the woman fell through the space where his chair had been, hitting the table with her body heavily. The two farmers rose, shouting. Anh did not wait to see what would happen next. He sprang to his feet like a cat and, parting the bead curtain, pushing aside two customers who were about to enter, ran off lightly down the quiet street. As he ran Anh was silently cursing himself for allowing such a thing to happen. Had it not been for the information from Hanoi and the mirror in the bar, his well-laid organizational plans and his careful cover would have been destroyed by a vengeful old woman! She would hardly have managed to kill him, but he would certainly have

been questioned by the police. And Anh judged himself harshly for the original mistake of accepting the dragon ring bribe.

Shocked and dazed, Ba Kieu pushed herself to her feet. Some customers were gathering. She saw that one of the men had picked up the knife from where it had slid on the floor and was coming over to her.

Holding one hand to her head, she moaned, "Water!" and tottered off behind the bar. She could hear the men exclaiming and arguing about calling the police as she ran through and out the back door of the place. Ba Kieu hardly knew yet what had happened. Running blindly through the alley and heading for the shortcut through the woods, she made for the cottage of Rau and his child on the broad grounds of the mission school. Inside, with her back to the closed door, Ba Kieu gasped with relief that no one was home. Then she realized—she had missed, failed, had not managed to kill him! Sobbing a little, she went slowly into the bedroom and threw her overheated body on the bed, thwarted of her passionate mission. Still, for the moment, she herself had somehow escaped and gone to earth.

There in Dalat, meanwhile, the three-man cell of Le Tuan Anh's creation had begun to carry out their new plot, either to convert or assassinate the Province Chief. Kiem was making contact with a young and needy clerk in Colonel Thanh's Dalat office. This clerk could be a source of valuable information about the comings and goings of the Province Chief. Tang, the second member of the cell, was about to leave for Saigon where he would arrange a meeting with the Province Chief and use all his persuasive powers to "intoxicate" him with the cause of the Revolution. For the moment there was nothing for Thom, third member of the cell, to do except return to his resettlement village and continue to foment discontent among the people. Thom was just as glad to be through with meetings for a while, leaving further action to the others. Sitting down on a bench in the cool of that evening after a day's work in the fields, he lit a cigarette and reflected with pride on the part in their plot his brother the barber would play down in Saigon. Snooty Comrade Tang would have to depend on his brother to arrange this important meeting with the Province Chief.

Plaisirs d'amour

*I cannot be liberated from anything I do not possess, have not
done or experienced.... A man who has not passed through the
inferno of his passions has never overcome them.*

Carl Jung, Memories, Dreams and Reflections

In Cambodia at Angkor Thom, we were eating our lunch on the Elephant
Terrace built by the king who had included in his city human and even pro-
fane things to make a richer whole. The grassy terrace where we sat was
supported by the famous wall, sculptured in a long line of elephants.

"Here on top, Joseph, were the light pavilions. From these the king
watched the great popular festivals." Looking out into the wide, open field
below, I imagined how the acrobats and processions I had seen in the carv-
ings might spring into living motion on the soft grass.

"A happy people! But that was the end of it, Joseph; after Jayavarman VII,
no more great monuments arose at Angkor."

While we ate I asked the Professor to tell me something about his job
as an archeologist here. Was he working for the French or the Cambodians?
The answer was both. After fifty years of study, clearing, and reconstruction,
France had handed over the whole site to the newly independent Cambo-
dian government in 1953. Cambodia then invited France to continue with
the job, so the Ecole Française d'Extreme-Orient was now working on be-
half of the Royal government.

"We are using the most exact and up-to-date techniques," Monceau said.
"Restoring so many temples spread over such a large area has become an
archeological feat. I am lucky to be part of it."

"I bet you're good—a real pro."

"Just as I am sure you are a very good physician."

We grinned at each other, and drank to our work and our pleasure in it.

Then we drank to the happy Khmers of the past; we drank a warm red wine that did nothing to diminish the heat. I saw the sense of it almost at once, however. Relaxed, sweaty, and peaceful, we were no longer bothered.

As I watched him busily arranging our good lunch, tearing into a chicken breast, I felt again how much I liked him. And I had a terrible craving to talk to him, my new friend, about my sorry condition. It would be satisfying just to drag Kate's name into the conversation, if I could figure out a way. Leaning back into the warm grass with my arms crossed behind my head, I frowned over it.

"What one thing has intrigued you most about our morning tour, Joseph?" He tossed me a banana.

I began to peel it. "Well, I can't get over the way sex seems to be woven pretty thoroughly into the religion out here. All those linga...."

"A lingam is more than a sex symbol, I think. Dr. Carl Jung has discovered through research into many religions and through the dreams of different people that the phallic symbol is an ancient one for divinity."

"But back home, if you think about religious people—I mean the Puritans, the Baptists, people like that—can you imagine a lingam on a pedestal set up in one of our churches?" The idea amused me in a scary way. I didn't think I would be happy with one of them in my church, if I had a church.

"You are speaking of recent times when human beings have been cut off from their deep primitive selves by the scientific age. But let us go back in our Western traditions, perhaps to the Greek. I believe it was Heraclitus who said, 'To God all things are good, beautiful, and right; men on the other hand deem some things right and others wrong.' And we remember the Greek gods as very natural beings. Here, it is the same with the Hindu gods. For example, Lord Krishna, one of the incarnations of Vishnu, was very passionate and prankish." Pressing tobacco into the bowl of his pipe, the Professor's blue-gray eyes shone into mine. "Very passionate. One time it is said he took sixteen thousand saris of maidens he caught bathing and climbed a tree with them. All those girls would have to come out, clothed only in their blushes! Charming." From my soft pillow in the tan grasses I gave out a hefty sigh.

"*Enfin*, Joseph, my poor friend. You are in love." Surprise made me sit right up.

He laughed. "*Tiens*, I have known this ever since you were so angry with me for occupying *her* seat on the plane!" Monceau held out open hands. "After all, was it my fault? You should have bought her a ticket."

I rolled onto my stomach. They always said French people were percep-

tive. Hell, this guy was a dangerous mind-reader. "I couldn't. She's married."

The Professor may have frowned a little. "What a bore for you." I turned over again, thinking this was the understatement of the trip. For a while we stayed quiet, me staring up at the dark green treetops against the blue-white sky. A tiny dry lizard, or something, ran across my hand. I sat up, resting my forearms on my knees, letting my hands hang loose. It was a huge relief to be known at last for my present self, the starved lover.

Monceau must have been thinking on steadily about me. "Joseph, what do you say to this? Perhaps you are simply in love with love. First I believe one falls in love with the idea of love itself, *n'est-ce pas?* Then, and not too long after, one falls in love with a certain woman in all her uniqueness."

Was I in love with love or with a woman? I pictured Kate, slim, tan, blonde. Bold, even rude—hungry. I didn't want to give her up. She was a real woman after all, and she wanted me. I stared off into apparent desolation.

"Come, Joseph. This is not the end of the world, eh? You are a doctor, and know there is a remedy." When I turned, he said, "But my friend, you simply follow your instincts. Your position is painful: you are in love with a married woman who is not here. *Alors,* without waiting about, you take to bed with you some more or less delicious girl in the place where you are. This is rudimentary."

"For a missionary?"

After rubbing his chin with his pipestem, he said, "For a missionary I would say this is even more important. We cannot put the pious lid down on some problem we have not faced. No, Joseph, that way lie terrible difficulties. Would you agree we must come to know our own urges before we can even consider sublimation?"

"Well, it sounds very sensible, but it could be rationalizing to justify doing whatever we want. Still, I've always had this feeling that I need to learn what's right and wrong for me through experience."

Monceau nodded encouragement. "Your mother; she would have taught you about the natural need for the expression of love."

"No, I never knew her. My father's sister helped him bring me up, and she didn't marry."

"*C'est malheureusement comme ça!*" he murmured.

I felt myself getting defensive. "Anyway, I'm not totally inexperienced. I was okay before. It's this religious business that's bothering me. Professor, you know damn well how it is. For a Christian missionary, a bachelor, there's supposed to be something self-indulgent, evil...."

"Evil? To exchange the energy of love, without which you will die?"

His fierceness bewildered me. "You must not be a Catholic." I had thought most French people were.

"Catholic? So I am," he sounded careless, "and also a scientist. Being acquainted with the laws of God's universe, I no longer make a habit of breaking myself against them! And as a doctor, you know even better than I, the constant exchange of this basic energy which is love, this is life, for cells, for people. Joseph, remember what I have already said; I am very fond of Edouard Monceau. So I am not intentionally cruel with myself, nor with others."

Great. Very humane. "But what about the teachings of your church?"

He shrugged. "You are thinking perhaps of the rule of celibacy for the clergy? This I consider to be one of our mistakes. It may well have been useful for certain individuals at one time. But as a general requirement, I find it a *bétise*, a stupidity which we have been practicing for many hundreds of years. We will outgrow this error, as we have others. Meanwhile we are sacrificing the divine ideal of love while adhering to the laws of a man-made institution."

"Okay. Forget the institution. I'll admit that nowadays Christianity, as represented by the church, no longer seems to meet the essential human needs. So let's leave the institution out of it. But what about Christ himself? He did without."

"Are we certain of that, Joseph?"

I reviewed the limited evidence. There was the disciple "whom Jesus loved" leaning on his shoulder. There was the extravagant, tearfully presented gift of the "bad" woman, Mary Magdalene. In one sentence hadn't he exalted her love forever? And later in the garden wasn't she the first person he chose to reveal himself to when he had risen? Almost his first thought had been to warn her not to touch his body yet. Would it have been so natural for her to throw herself right in his arms?

Our eyes met. "Also Joseph, by now I have more for guidance than the Roman Catholic interpretation of the meaning of life. The Orient has changed me. I still carry the Bible, but also the Teh King of Lao Tsu and some teachings of the Buddha. For instance, I am no longer constrained to believe that Jesus achieved his complete mastery of this material plane, including death, in just one lifetime. My wife says I have succumbed to the subtle influence of Eastern religion. This is one of the things we argue about when we are together." He frowned. "And she is right that I have accepted

the idea of reincarnation. This theory satisfies my experience of reality somewhat better than the 'one shot' explanation."

He had gone too far for me. "Professor, how in the world can you call yourself a Catholic without feeling like a hypocrite?"

Monceau laughed. "Because I must be at least as tolerant of the limitations of my church as I am of my own!" But his twinkling smile no longer seemed irresistible to me.

"Joseph," he consoled, "look around at the Bayon! To be human is to live. And to be whole, even to be truly Christian, is it not just the matter of being fully human?"

I had been looking at the Bayon all morning. Picking up the lunch basket I got to my feet. "Well, according to your theories, if I'm going to be any kind of Christian or human at all, I better be heading straight for the whorehouse." I thought it was a pretty feeble joke, but the Professor enjoyed it.

After he finished laughing and wiping his eyes, he put his glasses back on. "No, no, Joseph. We can do better for you than that. I will arrange something with the hotel if you wish." While I took that in, Monceau was leading the way down from the Elephant Terrace. I didn't feel enthusiastic about the idea of a call girl, but since I didn't answer, he went on.

"They will send a young woman you can trust. You have only to stay in your room after ten this evening. Lam will come, I think, and she will make you content."

Had he said a name? Something like Lam? With a long *a*. More a chord than a name, an opening chord. When we came back to the Land Rover the jungle all around us was steaming and vibrant with early afternoon. At once the heat seemed overpowering.

"Tomorrow," the Professor said as we climbed in, trying to avoid the searing metal, "I have to go down to the museum in Phnom Penh on business. It will please me very much if you will use the Land Rover to go out to Bantei Srei. There are no regular tours out there just now, and it is too beautiful to miss. If you agree, I will leave the keys and a map at the desk for you in the morning."

"Thanks," I said, not knowing anything about it.

"Bantei Srei," he repeated, "often called the Ladies' Temple. Not for today you understand, Joseph, but for afterwards. Now we will go home and sleep. The necessary arrangements for tonight I will make by telephone." The Professor gave me a keen look of inquiry. When I didn't say anything, I guess he had his answer.

And we were silent on the road back to the Grand Hôtel D'Angkor. After I got out, I turned to try to thank him, but he was already shifting into first. He gave me his jaunty wave, his fatherly smile, and was gone.

We had no common language, of speech, that is. Before she came I had been wondering how we would understand each other. There was no problem. Around ten-fifteen I heard a soft knock at my door. When I opened it, Lam stood there smiling. She was a Cambodian girl-woman, about five feet in height, rounded, shining, confidently anticipating pleasure. I took her by the shoulders and drew her inside, all her warmth steady and happy in my hands. She wore some kind of blouse, and over this her skirt-sarong was pulled tight across her breasts up under her arms. The soft heaviness of her hair curved back loosely from her wide face to a comb at the top of her dark head.

For a minute I stood there staring down at her in a kind of disbelief until she laughed. Reaching up, she took my face and gazed carefully into my eyes. Then she touched my mouth, my chin, and pushing me away, looked me over entirely. When, with her two hands, palms up, Lam gestured that it was okay, I was the one to laugh, the rising laugh of eagerness. We sank back on the bed, Lam letting the sandals slip from her bare feet, tucking her legs under her.

One of the delicious things was her smiling silence. She had a few French words which I don't believe we tried to use at all until the second night. Beginning with looks and smiles, we went on by touch until I completely forgot the wine I had ordered brought up to the room earlier. That night I remembered another language, the one that is heard only in nerve endings and runs on into their very core. I had never thought before how much ordinary talk gets in the way of love.

In the silence, how willingly I listened to her fluttering, caressing little hands. Peacefully, with purpose, Lam got rid of all the clothes that came between us. And everywhere she was rounded, dimpled. I pulled the comb out of her hair to let the black silk shower down. Only when I felt the teeth of her comb biting into my palm did I think to toss it away. Against my chest her full-tipped breasts did not feel large. It was like taking a playful child in your arms, and the mischief was magical.

That first time, when I couldn't wait at all, she was encouraging me not to. Fireworks of flowers seemed to explode softly in chain reactions out along my limbs. The climax felt as though thousands of silk strings which had been pulled up tight—those strings radiating out through my whole body from

the one excruciating center—all these were suddenly let go, and bliss poured down like rain. Later Lam's own climax blending into mine drew us on into unbearable relief. But words are not ecstasy. May there be no one in the world so deprived that he must substitute my words for the knowledge of oneness!

She was still there when I roused from sleep to want her again. Tender like a mother, fun-loving like a child, though hardly in sore need like a lover. By the light in the one small lamp, its shade knocked crooked, her huggable person filled my eye, complete and round in herself. She was a little goddess; I received her favors and offered her my upspringing libations, until it all became momentary, transient, when Lam firmly rewrapped her sarong to go home. She left me with what I hoped was her promise to return, and her happy smile.

Waking in the morning the first thing I saw was that unopened bottle of wine. So I lay there smiling and stretched up into the rightness of every-thing—expanding sunshine, rustling animal creatures, slow leafy growth. Almost at once my euphoria was put to the test. While shaving in the bath-room with a non-electric razor, I overheard the three women tourists next door having an argument. Maybe the bathroom partitions were thinner, being more recent, than the heavy walls of the rooms themselves. Anyway I could hear pretty well. Something was very wrong.

"But Alice, I don't understand. This…sculpture…your dresser, how did it…? …A gift?"

There was vague doubt in the response. "Well, …almost like a gift, lying…in the weeds."

Her questioner expressed horror. "Did…just pick it up…it off?" I stopped shaving and shamelessly listened.

"No one…to want it, Hilary. After all, …broken you see, not at all per-fect, and yet…"

In the silence I thought they all must be looking at it, when a third voice, warmer, offered, "…a beautiful carved torso! …a young Buddha…suppose?"

"Obvious…valuable…centuries old! No doubt Alice…planning… hand …to the guide…forgot."

"I don't really…was planning anything…so shapely and smooth. Maybe…just…having it with me…sunlight…desk at home."

Outrage sharpened Hilary's voice. "Good gracious, Alice…right there with us…guide explained…regulations…not…even a single pebble…the ruins!"

The mellow voice drawled lazily from a distance, "Come on, Hilary, …a Federal case.… Why shouldn't Alice keep the little statue…wants it so much?"

Hilary's voice now came through loud and clear. "Melba, I think you and Alice have gone completely out of your minds from the heat! Can you imagine the humiliation if we should be caught at the airport smuggling Cambodian art works out of the country? A poor, underdeveloped country with little enough to be proud of nowadays…"

Silence. I saw myself in the mirror, my lathered face screwed up with anxiety for quiet Alice. A person like Hilary would never let the thing be. Had she felt sorely tempted herself by all the treasures lying around?

"No indeed! When you both stop to think," Hilary was saying, "I know you'll agree we must concentrate on how to go about returning it, or somehow getting rid of it. And on our very last day, when we *still* haven't managed to get out to the Ladies' Temple, so highly praised in all the guide books. Oh, Alice, you've never done a thing like this before. What in the world possessed you?"

While the low voice was still murmuring, "I don't know, Hilary… sorry…" I retreated to sit on the edge of my messed-up bed with the bathroom door closed. For those few moments I had actually forgotten my paradise with Lam! But now I felt myself smiling as I rubbed some of the lather off my chin. Joe Ruffin, today you are a god. Go downstairs and perform a miracle for the lady with the anxious blue eyes! Still I moved slowly in the sweet lethargy of after-loving.

When I opened my door I bumped right into the three of them in the hall. They broke off their talk at once, staring.

"Good morning," I said cheerfully. "Looks like another hot day."

Pulling themselves together, they preceded me down the stairs, the one called Melba looking back to smile. While eating an enormous breakfast, I couldn't help noticing that my ladies ate little and talked less. Occasionally Hilary and Melba exchanged a few words. Alice looked down at her plate or out of the window. She had a halo of fair hair, possibly more silver than blond. Her features and bones were delicate, her mouth gentle. I thought she might have been lovely without that squashed look of timid anxiety. It was easy to tell which one was Hilary, because she matched her voice. Although her gray hair was too tightly set and her features too sharp for me, her dynamic energy and black eyes were attractive. Melba was sitting at the left, plump in body, lifting a pleasant, rosy-tan face with freckles and wide brown eyes. Whether her golden hair was real or not, it suited her exactly.

My happiness stretched to include them all, my ladies that day, for better or worse.

The food tasted so good that I dawdled. By the time I got out to the front desk and began idly turning over postcards, they were just about at the end of a futile discussion with the desk clerk. Very, very sorry, there were no more tours to Bantei Srei at this time. And no cars available with drivers. Very sorry, but... I didn't have the heart to wait and see what a defeated Hilary would look like.

"Excuse me; I'm going out to Bantei Srei this morning. If you don't object to a Land Rover, I'll be happy to give you a lift." They were completely surprised. Even Alice smiled a little. Hilary, who gave me one polite chance to change my mind, said they would be delighted. There was little to arrange. Melba ordered box lunches for us all, and we agreed to leave in half an hour.

It was a beautiful day. When we had introduced ourselves, I learned that Hilary, who would sit in front by me, was a Mrs. Cox. What was it about her? Even in my mood, next to her I felt I'd better keep my laughs down to chuckles; my baritone aria to a hum. I gathered she had married a judge who did not much care for foreign travel. Mrs. Lambert, the one like a peach, was a widow. My Alice, who also had another name, Mrs. Roger Hamilton, was the mother of four sons, almost grown, and the wife of a busy doctor. I imagined her men as overbearing and egocentric. The three women had known each other at college and been friends ever since.

Did I say what a beautiful day it was? For that one day I believe I loved Siem Reap and Cambodia and Angkor every bit as much as the Professor. If anything in Hilary's conversation struck a discord, I had only to think about the night that would surely fall, and I turned upon her such a look of warmth and interest as quite silenced her from time to time. Her thin chest rose and fell sharply. When she had thanked me for the ride (and I could tell she really appreciated being able to come more than any of them), I said something inane like, "No bachelor would feel right visiting the Ladies' Temple without any ladies." She looked at me very hard after this, so I tried to dispel any frivolous impression by discoursing on Angkor in imitation of Monceau. I think, back at the hotel, while the three were upstairs getting ready to leave, they must have decided that I could be trusted with their guilty secret, or Alice's guilty secret. However, Hilary was too cautious to confide in me right away.

The road to Bantei Srei on the Professor's map was little more than a track along the edge of the forest and across open grassy plains. Occasional

flowering trees, violent splashes of orange-red or purple, made my passengers exclaim. I told them that the dry season is the time of greatest flowering.

"Are you sure, Dr. Ruffin?" Mrs. Hilary Cox frowned. "That doesn't seem logical."

"It's true though. Maybe the trees flower now, so the new seeds will have the benefit of the rainy season coming on." Since she inclined her head receptively, I began to talk about the small temple buildings of Bantei Srei which I had read up on last night while waiting for Lam. Built of pink sandstone and hidden in a jungle glade, they have an important place in Khmer art. The founder of this temple was a cultured Brahmin who inspired his artists and workmen to create some of the most elegant and graceful sculpture at Angkor. It was a temple to Siva, the creator and destroyer. I said nothing at all about the linga, which I gathered were very much in evidence here too.

"What a lot you know about the architecture, Dr. Ruffin! I noticed yesterday that your guide at Angkor Thom was much more knowledgeable than ours."

"He's excellent." I thought of all the blessings provided by the Professor.

"You seem in very good spirits, Dr. Ruffin," Mrs. Cox said in a tentative way.

"Why not?" and I shifted into a higher gear, smiling out upon the sun-bleached expanses shimmering before us.

She sighed. "We, however, are somewhat concerned today over a troublesome problem." Sudden silence behind me.

"Oh? Can I help?"

Hilary sat up straighter, bracing herself more firmly against the jouncing. "It is only that we have—uh—accidentally—uh—acquired a small piece of the Khmer sculpture. We quite realize that this is against the law here. And even though this country does seem to be going rapidly downhill toward Communism, we do *not* want to break any laws." She looked toward me.

"No indeed. Of course not."

"Well, the problem is, Dr. Ruffin, what are we to do with the sculpture? We don't know exactly where it came from, and probably couldn't get back there on our last day to return it, if we did. We just can't throw it away, after all. What do you suggest we do?"

At first I frowned. "Well, that *is* something of a problem, but certainly not insoluble." After all, I had had plenty of time to consider the matter since

I overheard their argument that morning. "Of course you need to be abso-
lutely sure you want to give it back. Alice, I mean one of you, might prefer
to keep it and take it home." I looked in the rear view mirror for Alice's face.
It was clear she felt strangely frightened and certainly wanted to give the
carving back.

"Well, I have a suggestion which I hope will stop you all from worrying
about it right now." I glanced directly at Hilary Cox. "You see, my guide, the
one you saw yesterday, is one of the French archeologists working here at
Siem Reap. In fact, this Land Rover belongs to him. Professor Monceau is
out of town today, but I can talk with him tomorrow, maybe even this
evening. I'm positive he'll know what to do with the thing."

Hilary turned to me in amazed relief. "How extraordinary, Dr. Ruffin;
that exactly answers our problem!"

The pale madonna face in the back seat remained sad. Suddenly I felt
anger toward whatever had quenched her sparkle and subdued her whole
manner. I thought of Lam—mischievous, fun-loving, self-satisfied. Then,
of course, I forgot all about Alice.

We separated at Bantei Srei, since the three women allowed themselves
to be bagged by an English-speaking guide. Falling in love with the whole
scene (a sambar deer was browsing in the green brush springing up between
the old stones; a troop of leaf monkeys laughed through the trees above small
carved roofs), I wandered off with the Professor's little book. Walking first
at the edges of the cleared area, I peered up into the canopy, seeing how the
sunlight pulls the forest from deep and dark to high and bright where par-
rots and monkeys live. I read to myself that this jungle was inhabited by cobras
and lizards and many varieties of butterflies. "As in all forests, birds are more
easily observed than mammals. Tigers and leopards do, however, appear in
the Angkor National Park and wild elephants occasionally come to trample
the outer walls of the Bantei Srei temple." With a pleasant sense of danger,
I imagined in the shadows both the leopard and the trampling elephant.

Since my thoughts were never far from Lam, I wondered about the child-
like passionate qualities that are akin to nature, its beauty and violence. How
exquisite in its game of the hunt is a cat, perfectly poised to spring upon her
prey! Did the easy-going Cambodians have a savage force slumbering just
beneath their carefree ways?

Somehow I missed the picnic lunch. On purpose? Dimly I seemed to feel
that the grace of this particular temple was only to be understood through
the eyes of ecstasy, and in this the three women were lacking—needy—as

I had been that first day touring Angkor Wat. I hope they weren't disappointed when I didn't come. After all, I couldn't undertake to console all love-hungry women, could I?

One special opportunity was offered me. About two in the afternoon I found myself in a shady room inside a low door as I was following the ins and outs of the carvings. I sat down beyond the sun's reach with my back to the stone to read more about the life of the Khmers, the old Cambodians. If I should fall asleep, that would be okay too. But there was a wonderful description of the procession "as the king rides forth.... Next come the wives and concubines of the king, riding in palanquins or carriages, or mounted on horses or elephants: assuredly their gold-spangled parasols number more than a hundred. Behind these comes at last the king, standing on an elephant, his precious sword in hand. The elephant's tusks are likewise sheathed in gold. There are more than twenty gold-spangled parasols with handles of gold. Numerous elephants gather round him, and a guard of soldiers brings up the rear.... From this you may perceive that these people know full well what it is to be a King." My eyelids were drooping, when I heard what sounded like a sob. A woman seemed to be crying in the room beyond. As quietly as a jungle creature I rose and slipped toward the doorway, keeping my head somewhat down for the lintel. Not low enough! When the stars dispersed, I was not really surprised to find Alice sitting on a stone bench weeping.

Looking up, she saw me about to ask what was wrong. I hope some of the sympathy I felt showed in my face. Anyway it was too late for her to put on any kind of disguise. Alice was suffering, and she saw I knew it. At first, feeling stupid, I stood over her, rubbing my head where I had bumped it. When I sat down, firmly putting my arm around her, she turned her face against me and really let go. So I held her for a while without saying anything. Hadn't brought a single handkerchief to Cambodia. Never occurred to me I'd want one. Pretty soon she stopped shaking and began to search through her bag. I missed the feeling of her head on my shoulder.

Before she could start in with any apologies, I said, "Please don't be worried about the statue, Alice. I can promise you it won't be a problem."

She looked up then with a fierce, impatient expression in her very wet, blue eyes. "Oh for heaven's sake, Dr. Ruffin, I don't *care* about all that! The trouble is...." Alice cleared her throat, dabbed at her nose and eyes. "Seeing myself do something fantastic like that, steal something, it was like the last straw!" Looking into my eyes to see if I understood, and of course I didn't, her own welled full again.

Yesterday I might have been helpless in the presence of an irrational, crying woman. But this was today. First I took all her things out of her hands and set them on the ground. Then I stood her up and shook her a little, thinking that a long session of talk was in order but would have to be postponed. A shortcut was indicated. And so, before new tears could brim over down her cheeks, I had her in my arms and was kissing her well and thoroughly. She only resisted at first. And in the end, we sat side by side on the bench smiling at each other.

"You are an overpowering young man." Alice laughed in a shaky way.

"I've liked you since my first miserable afternoon at Angkor Wat."

She looked at me, but didn't ask why it had been miserable. "I'm old enough to be your mother...." Alice swallowed.

"Maybe. I doubt that. Is mothering all you think of?"

She looked surprised. "Just about all, I guess."

"Look, Alice, what is this? Are you unhappy with your life in general?"

"I think I must be, but I hadn't realized, hadn't noticed.... Something about the trip, this place, has made me feel strange, see things differently."

"Now you're afraid to go back?"

"I'm even afraid to go on." Her eyes looked suspicious again. When I moved to grab her, she fended me off laughing. "No more, Joe. I'm all right now. Thank you! And if I don't look too awful, we'd better find the others and start back. Hilary will be getting cross by now, the guide has been...difficult."

"Yeah." I grinned. "You look lovely."

Alice took a deep breath and gave me a proper smile. "I like that first-aid kit you carry around."

When we joined the others for the return journey, I saw to it that Alice Hamilton was sitting in front beside me.

Around five, while we were picking up our keys at the hotel desk, Monceau wandered over. So I introduced him to Mrs. Hamilton, Mrs. Lambert, and Mrs. Cox as the archaeologist who had lent us the Land Rover. They all thanked him; he asked about our day, and, after a little conversation, the ladies went on upstairs. Alice held back for a moment to give me a straight look, saying she would be right down with the statue.

While she was gone, I briefed Monceau hastily. He was watching for her when she ran quickly down again. Flushed and dusty after our long day, Alice looked very appealing, I thought. She offered him the small torso at once.

He held it in his brown hands gazing at her. "Would you care to join us for a cold drink, Madame?"

"Why yes, thanks, I would."

Her smile included me, but I decided it was time to bow out. Handing his car keys to the Professor, I told them I would see them later. Monceau and I exchanged one look. On the landing when I glanced back, they had disappeared. I was like an instrument which has been used, and is now laid aside by the surgeon in favor of another tool, better suited at this point to the operation. But then, heading for the shower, I began looking forward to my evening with Lam.

In taking her, I guess I had accepted my physical, passionate self, and nothing was about to bother me today. Everything was great.

I think I said she was fun-loving. As soon as I pulled her inside the room, we were laughing. But I had determined to think responsibly about her on this our last night. We were going to talk, in some language or other. But of course as soon as I saw her rounded self, head on one side, eyes bright with merriment, my whole perspective shifted. There were moments while we were making love when fantasies flew through my head. I was rebuilding my entire life around this little person.

About midnight with her head on my shoulder (I wasn't about to let her escape), I said in English, "Lam, what the hell are we going to do?"

She was disappointed in my tone. *"Monsieur pas content? Moi beaucoup content."* Wide smile. *"Pourquoi Monsieur beaucoup triste?"*

I could translate it! "Monsieur not happy? Me very much happy. Why Monsieur very much sad?" This was my kind of French, and I marshaled what I had of it. "No Lam. Not sad. Very much love Lam. Very much thank you!" Smile, kiss, long embrace. "But Lam," I struggled up on an elbow and into that impossible language, "me serious, understand? Not play. Tomorrow when I leave, what is Lam going to do?"

She pouted and shrugged. "Do like always. Return home like always." I pondered questions about her family and home life, but couldn't seem to put them into French. I had always been careful not to get seriously caught, or in danger of being hurt or rejected by a girl. But the very fact that she put no demands on me made me wonder. And every time I stopped to try to think rationally, Lam thought I was unhappy.

"Monsieur always again sad!" she said. "Why?"

I thought I saw a way. "Lam, regard. It is like this—I leave tomorrow, I think Lam very much alone. Maybe Lam very much cry!" I gestured waterfalls of tears from Lam's eyes.

At this she chuckled. "No, no. Lam never alone. Not cry. At the home of me, always very much persons—Lam's monsieur, Lam's babies, Lam's grandmother...."

My head reeled. "Lam already married?"

She nodded, very matter-of-fact. "Already long time." I considered my adulterous condition. Her husband would probably be angry if he knew about her sleeping around with strangers at the hotel.

"Your husband not know Lam come here like this?" She was absorbed in arranging her hair, and I thought she didn't get it.

She turned. "Oh, *oui*. Lam's Monsieur know. He very content Lam come here get much money!"

I couldn't grasp it; he must be a bastard. "Your husband say, 'Okay'?"

Lam sighed as though I was a very difficult type. "Monsieur no understand. Lam desire; Lam do." She folded her hands.

Nothing to do with her husband. She belonged to herself. But what about the other guys, the kind of man who might...."But Lam, it's not good, not always good. There are bad men who..."

Looking to heaven Lam sighed again. Sitting cross-legged she began to act out a story for her dumb lover. "See, *ami*, Lam is coming here, okay?" I nodded as she constructed the door opening with her flexible little palm bent backwards. "Maybe tonight Lam see here Monsieur French very much ugly, bad, very much old, very much fat like that!" Her little hands designed a huge paunch. She shuddered. "I *push* this Monsieur!" Unexpectedly she shoved against my chest with all her might, so that I fell back against the headboard. "And then I quit Monsieur, quit the money, sleep my house!" She smiled and shrugged. It was so simple.

Slowly I pushed myself back up. No use worrying about Lam. When I left tomorrow, she would be perfectly fine. Feeling sorry for myself, I drew her close.

"This Monsieur here, leave tomorrow, Lam not cry a little for him?" My tongue tangled up in the French. Hell, I wanted to be at least the greatest thing that had happened to her for years.

Lam turned up her roguish face. "Oh *oui* ! Me cry little bit. Monsieur very much good, very much strong, very much nice. Me very much love Monsieur! And maybe," coaxing tones, "Monsieur give very much money for

Lam?" She kissed me tenderly on the mouth. I felt great that night, everywhere except my ego. We should have left out the talking.

In the morning, as I shaved, I explored the emptiness of my unsentimental parting with the physical presence of Lam. Like poking with your tongue into the place where the tooth was extracted. And gradually I became aware that once again I was eavesdropping through the thin partition. I always seemed to tune in on a crisis.

This time there was a braver note in Alice's voice as she said, no, she was not packing. "I...decided to stay on...a while."

"What on earth for? We've seen...guide books recommend!"

"It's not so...sight-seeing, Hilary, though.... Monceau says he will... quite a lot I've missed."

"Indeed!" Poor Hilary.

The irony was lost on Alice. "No...realize suddenly I need... to think a little. Not...Angkor and our trip...my life at home...self. Taking...statue... a symptom, ...kind of warning...I guess. Something...bothering me! Or calling.... Here...peaceful...pause and think, figure out, if I can, what I've..." Alice's voice trailed away as though she were already following some thought.

"And what about your reservations, bookings?"

"I'm...cancel everything this...just...take a loss...deposits. And, later on, maybe...go ahead...wherever...want to go."

"All alone?"

Now I heard the fear and doubt in Alice's voice. "I guess so."

There was quite a pause while I finished shaving my left cheek accompanied only by the sounds of packing up. A suitcase lid slammed, followed by two firm snaps.

Hilary's voice was always perfectly clear. "I suppose you've thought, Alice, that people will say you only stayed on here to be the mistress of that Frenchman?"

"Why...hasn't even hinted...such a thing."

"But I suppose you would be delighted if he did?"

Then Alice laughed wonderfully. It was the first real laugh of hers that I had ever listened to.

Hilary put a stop to that. "What about Roger and the boys?"

This low blow brought Melba in. "Stop, Hilary. In our hearts...both know... should stay. And not just...Professor Monceau. As a...fact, you and

I have worried...how unhappy and afraid Alice has...said yourself... needed...on her own for years."

Without shame I put my ear to the wall. "The family will survive; it may even do them good," Melba said. "Now, please don't worry, Alice; I'll explain to Roger myself. It will be all right. We'll miss you, but you'll come home an entirely new person!"

"If you ever do come home," Hilary had to add.

That was the risk. Or one of them. But then Hilary conceded something. "There's certainly one thing, Alice; it will do that spoiled family of yours some good to be without you for a while!" I listened to the hurried sounds as they left the room. My own schedule was not so tight, since the Professor had insisted on driving me to the plane. What a wonder, Alice and Monceau. Not bad at all, I said to the co-creator.

No chance came to say goodbye to Alice and wish her well. When she didn't come to the airport, I was disappointed. There was something about her that I seemed to lack. And as for Lam.....

Standing in the hot sun on the tarmac I turned over an envelope in my hands. It was Kate's letter which I had left out for reading on the way back to Saigon. I had studied the USIS report on the coup that failed, but I had never looked at Kate's letter to her brother about it. Kate, Alice, and Lam. At least I wasn't starved for the female principle as I had been. Here at Angkor, I had found relief and escape from too much cerebration. Maybe in life we are not so badly entangled in our bodies, as we believe, but more trapped by our minds. A Monceau-like thought. It was time I thought my own thoughts again. I looked at him standing comfortably beside me.

Realizing how much I would miss him, I had nothing to say but, "Thanks."

"Thank *you, mon ami!*"

"Alice?" The Professor would know her gentle tenderness for a time.

We smiled, before he turned serious. "I like Madame Hamilton very much already, but I have the idea what she is wanting most is some time to be free."

I nodded, feeling very down. For me it was time to leave Angkor.

"And for yourself, Joseph, I wish that your work will start soon again. Not your studies, but your *medicine*. No one can live only in the future." My Professor took me by the shoulders, embracing me lightly on each side as the French do. "And of course, *mon cher ami*, I wish you love!"

Down in Saigon

The renegade is a conscientious objector to reality.

Carl Jung

Joe didn't wait to see Katherine again. He was afraid if he waited, he might never go. Best to take the plunge when you are afraid—just dive in and see what happens. So on the morning after his return from Cambodia, Joe was standing in a patch of sunlight at the gate of 127 Ba Huyen Thanh Quan holding Kate's manila envelope in his hand and waiting for An to answer the bell. He breathed in the drift of honey-sweet frangipani coming over her wall and thought about her outraged letter describing the November coup, the failure of the freedom forces to overthrow the tyrants. She really identified with that struggle.

Moving to ring the bell again, Joe saw coming toward him from the direction of the Catholic church the unfriendly barber, now deep in conversation with an older man who wore a wispy goatee. As they approached, this older person saw Joe watching. At once the conversation seemed to die. The barber helped the stranger into a handy cyclo and returned sulkily to set up his "shop" just as An opened the gate. Turning quickly, Joe forgot the barber and his friend with the goatee.

That morning Bui Tang had arrived in Saigon from Dalat. Without stopping to look for lodging, he had gone at once to find the barber Tam's place of business. On the way, Tang looked about him curiously in the pre-lunch-hour traffic jam. Impressed by the crowds, the machines, the noise, and feeling of excitement, he saw that the city did indeed "seethe with the struggle of the people" but not for the national salvation. It was each person for himself. Well, Tang thought, as General Giap has often said, it will be a long fight. And the longer the fight, the more mature our forces.

Maturity. Tang had decided that his first duty in carrying out his complicated mission would be to ascertain whether the agent Tam possessed a correctly developed revolutionary spirit. Up in Dalat when the cell had been discussing the barber, his own brother Thom had not made him sound very dependable. Now Tang's taxi was stopping on Ba Huyen Thanh Quan street. He took his time about paying to allow himself a careful look at the lively scene.

On a very busy corner, to the left of the closed gate numbered 127, some removable furnishings of the barber's trade had been set up. There was little more than a heavy wooden chair, a mirror hung by a nail from the wall, and an open box spilling out scissors and razors on the hard-packed earth. Upon this simple stage, the handsome barber was at that moment engaged in an altercation with a young woman. Folding a striped cloth with finality over the back of the chair, he explained coldly that he was fed up with the stupid aunt and her brats. No man could be expected to come home regularly to a menage with no privacy and, hence, limited pleasures.

The plump girl in the tight jacket angrily protested that he had the use of nearly all her earnings every week because the aunt provided a free roof over their heads. If Tam kept on spending everything in cafés, she, Chi Hai, would turn him out and use her money herself!

The barber only turned his back to stare at himself in the mirror, combing his hair critically. He did not bother to suggest that there were other women in Saigon who would be delighted to provide for such a desirable lover.

Rushing at him then, the girl pounded out her frustration on his back. As Tang dismissed his taxi, he saw Tam turning, enraged, to strike her hard. The girl broke through the circle of onlookers and ran off weeping. Only then did the blazing contempt in the eyes of the barber meet the appraising regard of Bui Tang.

Instantly Tam knew that here, in this person with the goatee, was the agent from his brother's cell in Dalat. Damnation. Typical of his luck that the very one he had been impatiently watching for should finally arrive right in the middle of one of Chi Hai's scenes. Tam started to pull down his rolled-up sleeves.

Without smiling Tang said, "I bring you greeting from your brother in Dalat."

"Chao Ong." Tam's voice was sullen over the way fate always treated him.

For a moment more Tang looked about, his hooded eyes registering no emotion at the life processes going on in the street. Then he turned back. "You are named...?"

"Tam," said the barber, returning the hard stare and beginning to recover. "Is there, perhaps, some more quiet place...?"

"I had thought of the church." Tam pointed across the intersection at a gray and white modern edifice under a bell tower set on a wide asphalt yard.

Tang assented. A Catholic church seemed a poor choice for a meeting place, but he must give the young man every chance to reveal the way he thought and acted. In order to control, one must first observe and understand thoroughly.

Quickly Tam removed the striped cloth, mirror, toolbox, and chair, carrying them back through a neighboring gate where he left them in a garage. As the two men proceeded toward the church Tang said nothing, leaving the barber to his restless thoughts.

Waiting nervously for the man's arrival had been one reason why Tam had blown up at Chi Hai. After all, it was a very important meeting. This person was a Party member. He had the power to advance a cadre in the Movement or throw him out. Tam did not want to lose the National Liberation Front. Belonging to it, even on the fringes, had given him a little fire in his life where he could warm his heart to vitality when boredom or inertia engulfed him.

As they entered the dim building, a bearded French priest coming out nodded in greeting. Tam did not bother to respond. Walking like a prince he led Tang to a shadowy bench almost behind the altar of one of the side chapels. A bank of candles in red glass cups flickered between this seat and passing visitors. Tang sat down in the shadows giving his first nod of approval.

With a thin smile he said, "Your corner out there is somewhat exposed for a meeting, although certainly you are correct to carry on your work in the midst of the people."

"I never have political meetings there," Tam said.

"So? And was that your young woman who was—uh—leaving as I arrived?"

The barber's eyes narrowed. "She is of no importance. Her money is useful at times, but she is too stupid to be helpful to the Revolution."

Tang studied him. "And yet she was clever enough to provoke you to anger in public."

"She was the angry one!" Tam shrugged. "I was not upset."

"That is well, *Dong Chi* [Comrade]. All our cadres must accept the warn-

ing to be careful in their relationships with women. Unless a cadre remains personally dependable, he is of no use to the Movement or the Party."

It was the first time Tam had ever been called "Comrade." This almost compensated for the moralizing. "Have no fears about the woman," he said. "Anytime she is no longer of use, Comrade, she will not know where I can be found."

The older man had placed his hands on his knees and was regarding the younger one from the side. "How is it that you are able to establish your barbering business right at the gate of this compound? The owners have no objection?"

"They are rich Americans. No problem."

"So? I find this curious. I doubt if a wealthy Vietnamese family would appreciate your presence at their gate."

"Of course. I know this. There are several rich Vietnamese across the street." Tam's lip curled with hatred.

Tang saw that the barber was properly imbued, as were most Vietnamese, with a passion for economic equality. The Party had little difficulty instilling this particular desire. For centuries in Vietnam, to survive economically (outside the city), villagers had to maintain some equality in wealth. In a village, where resources were limited, to acquire wealth meant just one thing, to deprive others of it. Anyone who did this was bound to be hated.

"And so you find rich Americans more generous than rich Vietnamese?"

"They only pretend in order to beguile the people." Tam was scornful. "They placate the poor with false gestures of kindness which change nothing really, while they themselves continue to lead the life of the rich."

"Adding hypocrisy to injustice." Tang nodded. "Just what one would expect from imperialist foreigners."

To dispel a fleeting memory of the American woman's frank expression, her husband's casual friendliness, Tam went on more fiercely, "Having everything they want, they live in our country as though it is their right to be here! We must get free of types like these who suck away our strength."

"Have patience, Comrade. That day is coming. In the meantime, you and I have been given an important role in the Liberation Movement. Now, through me, the leader of our cell in Dalat sends commendation to you, our courier in Saigon, for your work in shadowing Colonel Thanh. The information you sent has been well received."

Tam grew eager. "I stand ready, Comrade, to accomplish much more for the Movement. If provided with only a small gun, I—"

Tang interrupted. "The present plan is not to assassinate this important man as yet. My orders are to attempt to persuade the Colonel that ours is the only righteous cause for true Vietnamese to support. If we can bring this influential Province Chief out of his errors into our victorious Movement, we will add strength to the Cause!"

"That bastard?" Tam couldn't believe his ears. "Death is the only way to deal with a high-and-mighty military snob like Thanh. I have been working for him part-time in his compound and I know. He thinks he's too good for the rest of us."

"So?" Tang was interested in the emotional reactions of the barber. It was not hard to "read" a youth like Tam. Indulged by his family, he had been sure that society also owed him indulgence. When special privileges, which he had not earned, were denied, such a young person would seek to revenge himself against society for its injustice. And, of course, he would be furiously jealous of a successful man like Thanh, who was rapidly fulfilling his own potential. To tear this Colonel down would make Tam himself a hero! Tang, however, was aware that the hero in such a melodrama of destruction would have lost touch with reality. The Struggle Movement certainly could use the young man's grievances and hatred, but only under careful control. Here is an egocentric adventurer, wanting to own a gun, yet probably afraid of being drafted by the military. Tang had manipulated such a type before.

"In the future you may well be needed as an assassin, Comrade Tam," he said. "However, it will be necessary now to prove yourself a cooperative member of the Movement, capable of carrying out any orders." He did not use the word obedient; it was not necessary for Tam to see at once that he was substituting one dragon of authority for another.

"May well be needed as an assassin...." For Tam the phrase had a good ring, producing a fine flow of adrenalin. "I am fully capable of carrying out any orders!"

"Good. It is very well that you found work near the Colonel, and also you showed subtlety in recognizing that the lad Phuong, who was shot by the police, can be useful to the Party. Now in the case of Thanh, I believe our first step will be for you to approach the military guard who is placed at night before the Colonel's gate. Such a guard is regularly stationed outside the Thanh villa, is he not?"

"Of course, but I have already figured out how the Colonel himself may be directly approached."

"Tut, tut," said the older man, "'one does not attack a tiger before catching the deer.'" He reached into his wallet. "Using these funds, this is what I want you to arrange through the military guard...."

By the time the two men were pacing slowly back to the barber's corner, Tam had been clearly instructed. Beside the gate of number 127 an American was standing with something in his hands, obviously waiting for the bell to be answered. Tang sensed that the barber was recognized by this alert foreigner and that he himself was being examined with candid interest. It was time to leave.

To his own surprise, Tam found himself assisting the older man into a cyclo, even bowing slightly as the vehicle moved off. Ignoring the waiting American, he brought back his equipment and seated himself haughtily in his chair to think. The tight control of his visitor from Dalat had irked him. Tam was an eagle, not a silly hen to be pushed around the barnyard. And yet, he had been carefully entrusted with a risky piece of action. Fingering the piasters in his pocket, he caressed the thought of having a key part in the Struggle! And he could bring it off well enough. Tam knew just how to handle that guard in order to arrange a meeting between the old man and the Colonel for a late hour on the following night. It would have to be presented cleverly....

About to give up and leave, Joe Ruffin watched Tam's eyes fall shut. The barber had looked completely out of character kowtowing to the fellow with the goatee. What was all that in favor of?

Just then Katherine's houseboy finally opened one side of the gate. "No, Monsieur, very sorry. Madame go to Cercle Sportif before half an hour. Not likely come back very soon." Joe stood there holding the manila envelope, disappointed.

"Monsieur also go to Club," suggested the friendly boy. "Possibly seeing Madame at the *piscine*?"

Whatever it sounded like, Joe thought that *"piscine"* must mean swimming pool. "Okay. Thanks, I guess I will." Turning to follow the advice, he found that both barber and chair had again disappeared from the spot. That was quick. *Wonder what he does with his stuff?* Joe thought, as he started for the Cercle Sportif a few blocks away. Walking along he reviewed his experiences in Cambodia, as he had done on the plane, turning them over gently like special shells brought back from an island beach. Although he had been changed by those four days at Angkor Wat, he wasn't sure yet in what ways.

Of course the two nights with Lam had been great, a satisfying sexual exchange leaving no guilt feelings. At last he was a part of life again, a piece of the whole. Thinking about Kate Gregory now, Joe saw her smaller, as though through the other end of a telescope, but he saw her with more understanding. Today he regretted turning away from her because of his fears. Had he given any serious thought to her pain of being rejected? Remembering his own frustration that first night in Angkor, Joe felt ashamed. Maybe we've got to go down into our own shadowy self, find what's there, and even try it out in experience, before we can really feel for another human being.

On the plane he had finally read the letter she had written to her brother Harry about the failure of the Revolution. Katherine had described with deep disillusionment the events of that "lost" weekend. "Yesterday excitement of hope was in the air, like the moment in the Hungarian revolt just before the Russian tanks arrived. Tonight all that is dead." And at the end she had written, "You know what I feel like, Harry? Like one of those Saigon newspapers coming out too soon and too joyfully on Friday, only to have their presses smashed today by the police."

As he went on toward the Club, thinking about Kate, Joe wasn't sure he would feel comfortable if he found her. She was pretty militant. But hadn't he felt that way himself over the government police shooting Phuong? So what about the Professor's idea that all the barricades are really inside ourselves?

The short Revolution had been an actual battle in the real world. Joe considered how new things seem to come in as a threat, fierce rebellion against the status quo. In a fight like that, no matter who wins, do you ever get freedom? Is there some other way up and out?

As for Katherine, maybe he could have helped her somehow if he hadn't been so afraid and moralistic. Look how Lam had helped him! Joe kicked a stone in zigzags ahead on the pavement until it hit a tree root and bounced out into the street. Before I left, he thought, Kate was attracted to me, and I wanted her. Well, let's see how we feel today. If I don't get too tense and worried, if I follow my instincts, maybe in some way we can mean something to each other. Still, he felt pretty anxious as he turned in to the lush green premises of the Cercle Sportif.

She wasn't hard to find. Coming to the top of the steps leading to the poolside terrace, Joe saw her sitting at a green wooden table to his left by the railing overlooking the tennis courts. Two of her boys, who were eating

lunch with her, charged off as soon as they had been introduced. Pulling out a chair, he sat down opposite Katherine, smiling in a tentative way. Although she had very few clothes on and looked wonderfully natural, she was not disturbing.

Her smile was simply friendly. "Hi, Joe Ruffin! Did you have a good time at Angkor?"

The strangeness had something to do with his own feelings, which suddenly weren't there. Could Katherine Gregory be only another good-looking, interesting woman, nothing more?

"Angkor was great...."

She laughed. "Hey, I think you're blushing. Was it really that great?"

Katherine looked merry, interested, and not at all hungry. Had he made up the whole thing? "It was that great. I also read your stuff about the revolt against President Diem." He pushed the envelope toward her on the table cloth, avoiding the remains of the boys' Cokes and odd-looking hamburgers made with sliced white bread. "I'm really convinced about the need for more freedom here."

"Good." She was thoughtful. "I got Phuong over to my house after you left. We dressed him in some of Hal's clothes, and he spent the day playing with the kids. That evening I took him out to Father John at Don Bosco. But honestly, I don't know whether it will work or not, Joe. Keep your fingers crossed."

"Thanks so much, Katherine. That takes a load off my mind, and Miss Lanh's too, I guess. Phuong is bound to settle down after a while in a place like Don Bosco." Joe flicked away doubt. "I'll try to get out to see him before I leave for Dalat, or anyway, right after I come back."

Katherine shook her blond head. "Father John runs a pretty tight ship for a free spirit like Phuong."

"You know, I believe you are some kind of free spirit yourself, you understand him so well."

"A would-be one is what you mean." She looked away.

Glancing around, Joe saw there were plenty of other people eating lunch. However, the outside table at the railing gave them privacy. As the waiter appeared at his elbow, he ordered a shrimp salad and iced tea.

Then he said, "Somehow you do seem more free to be yourself than most people."

"So I'm outspoken." She lifted her bare shoulders. "And then I'm covered with stupid guilt afterwards. God, you're easy to talk to, Joe. How come you

relate to women so well?" Again he felt the odd, empty awareness that the strong pull between them had vanished. The fire was dead.

He heard her saying, "You must have had a pretty special mother."

"The fact is, I didn't really know my mother. She died when I was three, so instead I had lots of mothers. Being an orphan, half-an-orphan, I guess I appealed to all the women we knew. I got well mothered."

Kate looked puzzled. "But they were all southern women, weren't they?"

"Sure, North Carolinians. I'm from near Greensboro."

"Then how come you don't have a southern attitude toward women? Instead of the old flattering put-down, I feel sympathy, understanding, comradeship...." Katherine looked curious.

He laughed. "Maybe you don't have the right idea of how southern men feel about women."

"The hell I don't!"

Joe had to concede. "Okay. My Dad *is* a fairly unusual type. He's a small-town GP, and I don't know where he got his approach to females, but it's different. You see, for a short time my mother became a professional singer. I understand she had a beautiful, well-trained mezzo voice. My mother won a contest and was offered a small contract with the Met."

"Terrific!" Elbows on the table, leaning her chin on her hands, Kate was deeply interested.

"Yeah. Well, I think I must have been only around two years old at the time. My father encouraged her to go on to New York anyway and begin her career. To make a long story short, up there she contracted flu after a year. It went into pneumonia and she died."

"That's awful."

"Folks around home thought if she had stayed with her family where she belonged, it wouldn't have happened. But what my Dad remembers, and often tells me about, was the joy she had in her early successes. He was glad he had never held her back. That's a consolation to him. He saved all her pictures and programs and clippings for me."

In silence they sat for a while looking out on the tennis, Kate following with her eyes a couple playing singles on the near court. The man was young, well-built, and attractive. The woman.... Joe took a better look. Light on her feet, laughing and enjoying the game, she had loose brown hair catching the sun.

"French women are not free," Kate mused. "They are slaves to pleasing men. Spend all day on their figures, clothes, make-up." But Joe didn't hear,

being struck by the girl on the court, by her merry, elfin quality.

While Joe and Kate were watching, the couple finished their match, picked up their things, and started toward the high structure—pool and restaurant terrace above, dressing rooms below. The girl was listening to the young man's earnest talk, walking beside him in her short tennis dress. While they crossed the hotly bright driveway below, he laughed, and with flamboyant gestures was obviously using all his charm and persuasion. Joe saw the girl, not that much younger than himself, looking unhappy over whatever he wanted her to do. Suddenly she seemed tired. And when she turned, putting a hand on the man's arm to stop him, they were still too far below to be overheard. Whatever the girl said, changed things. The young man, even better-looking when viewed closer, was clearly disappointed. However, Joe decided, not crushed. They spoke together a moment longer before she offered her hand and left him. He stood there lighting a cigarette, looking surprised to find himself alone.

"Who's that?" Joe asked.

"Clay DeWitt," Kate said. "He's a Captain at MAAG."

"No," Joe was impatient. "I meant...." Their eyes met. They laughed together.

Then Kate touched his hand. "She's Allison Giraud, and it's damned nice of me to inform you."

"As you also just informed me that I've been beaten out with you by the military."

"Joe, you know you're relieved." Her eyes were on the Captain below who was beginning to look around.

Meanwhile, running up the stairs by the balustrade, Allison Giraud passed so close to Joe that their eyes met, he felt her agitation, caught her fragrance. If he had been standing, she could almost have run into his arms. And he did stand, but already she had slipped quickly through the crowd and was swallowed up by the stairs at the far end of the pool. Joe stared after her.

Kate was teasing, "Why, Doctor, I believe you're hit! Do you think she's going to matter?"

He looked into her quizzical eyes with amazement. "How can she matter when I don't even know her?"

"It's happened," and Kate patted his arm, just as Clay DeWitt appeared at the top of the steps.

"Say, Katherine Gregory," he exclaimed with relief, "how're you doing?"

Katherine smiled a welcome before she turned back to Joe for a moment,

shaking him gently. "In all honesty, Joe, she's too expensive for you. Pick another girl, huh? And have a good time in Dalat—who knows, we may get up there this weekend ourselves."

"Great." Joe hardly noticed when Katherine and Clay moved off together toward the bar. He stayed on at the table, but the girl didn't show up again. Later what remained with him was the light sound of her running feet on the stairs and the lost look he thought he had seen in her eyes.

The Dry Season

We feel restlessness, immobility, frustration. Yet there is an inherent quality of needing to grow, to move, to change. Life and energy must go somewhere.

Centerpoint: A Venture Inward with Carl Jung

Gingerly, Allison allowed herself to come awake one day further into the dry season. How she needed the planned holiday with Mark up in Dalat, but with this heat wondered if she had the energy to get ready and go! These mornings, Allison thought, are like filmy cocoons. Every day it seems harder and harder to force your way out and return to the living. Guilt made her stir under the cloud of her mosquito net. Already the children would have left for the park with friends, since there was no school during the hottest months of April, May, and June.

Allison could hear Nam, her cook-amah, scolding Chi Hai, the maid. Certainly Nam was too much of a perfectionist, but Chi Hai could be very provoking just now. In love with her young barber, she either floated about doing very little in a serious, glowing way, or, moody and despondent, did nothing. Six months ago Chi Hai could hardly enthuse enough over her Madame, her Madame's dresses, and every single thing in her Madame's elegant apartment. Now she talked only of her Monsieur. And probably, as she came in to work wearing that aura of warm fulfillment, Chi Hai might even feel sorry for her Madame, rich in every other way, but alone in her bed. Well, all right, Allison thought, if that bothers me so much, why did I refuse Clay's weekend invitation and accept Mark's? I know which one is more likely to end in love-making.

At this she sat straight up, angrily tugged the netting loose from the mattress. Sometimes she punished herself for wayward thoughts with the kind of scolding her mother used to give her back home in North Carolina. Allison's father had been the withdrawn, contemplative type who "never

amounted to anything," and her mother was always afraid Allison would turn out exactly like him.

"Allison James, are you going to sleep all day? I declare, I believe you would, if I let you. Anybody'd think you're *scared* to get up! Oh child, I'll never understand you; why don't you want to get busy, go out to people more? What good is just dreaming? Pretty as you are, you could have anything you'd ever want. Look at Mary Garland Henderson, as plain as a prune, but so easy, so enthusiastic and warm, the boys just flock around her. Do try to be a little more like Mary Garland!"

How clearly the sentences chimed, always driving her further into retreat, although her mother had been dead for two years. Why, Max, her own husband, had been dead longer than that. Dear old Max. Allison put on her coolest negligee. The sight of herself in the pale yellow, a fragrance of coffee enriching the air, and a wandering thought made her smile. Could people meet in heaven? Wouldn't easy-going, independent Maxim Giraud drive her bossy mother wild? And vice-versa! She had seen to it that they never met in life, but now they were quite beyond her.

Trailing out into the salon she found her friend Madeleine Beaufort smoking impatiently on the green sofa. "My God," Madeleine said, "I thought you were dead. Were you out late last night?"

"Not especially. When it's so hot, and everyone has left town, what is there to get up early for? Let's have coffee out on the terrace before the sun comes all the way around."

Her apartment was at the top of a small three-story building. Its open terrace hung in the branches of the trees overlooking the Saigon River and the shipping. Even inside an occasional bird flew right through the shady, unscreened rooms. And outside the sun was a dazzle from the water while red-orange bougainvillaea burned for attention against the bedroom wall. The two women sat down on the terrace, speaking in French since Madeleine had never bothered to learn English. When her friend cleared her throat with purpose, Allison felt herself growing evasive, letting her eyes wander.

"I thought it was today you were going up to Dalat." Frowning slightly into the glare, Madeleine put on her dark glasses. "It should do you a world of good."

"Tomorrow." Allison poured coffee as Nam slipped away.

Madeleine threw up her hands at her own forgetfulness. *"Ici en Indochine, on oublie tous, tous, tous! Ici ce climat fait perdre tout a fait la memoire!"*

"Don't be silly. Your memory is fine. I probably told you the wrong day."

And Allison changed the subject. "Darling, look at you, with those great glasses, your marvelous tan, and that apricot dress, you are just like an Italian film star."

Madeleine shrugged, only diverted momentarily. "Shall I look in on the children while you're gone?"

"Do you know, from the first, Mark said the Ambassador included them in the invitation!"

"How very odd."

"But nice...." Allison stretched and yawned.

"Sounds serious, like an engagement, to me."

"My Madeleine," Allison tried for ease. "What a loyal friend you are! I don't believe you'll have a moment's peace until I remarry or take a lover." Under the table she turned her rings.

"And why not? You know how Georges and I felt about Maxim; we are quite as fond of you."

"You're angels, both of you." One dimple showed.

"No, seriously, Alli*son*!"

"Must we be serious this morning, Madeleine?"

"*Enfin*, for once we must!" The dark girl plunged ahead with formidable determination. "All this intense social life—and yet you are unhappy—I can feel it. Thinner, too. You will lose your sex appeal!"

Allison turned her head away, one hand to her hair. Her visible cheek stained slightly. There was silence.

"Really, Alli*son*, don't be angry! For so long we have sympathized with your wish to be on your own. Also Georges and I have quite understood how you could not marry some of your recent friends like the so charming DeWitt or the somewhat older Colonel. But now we do feel you should thoughtfully consider Mark Gardiner."

At the way she said "Gar-dee-nair," Allison found she could smile.

Encouraged, Madeleine rushed on. "Georges says he is solid as a rock and very ambitious. *Alors*, he is tall; he is blond with blue eyes; well-built. Also he is very cultured and intelligent. For example, he speaks French, one must admit, really quite well. Of course, he is not a Frenchman!" She tossed away her expressive hands. "All the best Frenchmen are either gone or going. Georges says one must face reality; the Americans are everywhere." She laughed shortly. "Your own countrymen, after all! Alli*son*, we simply urge you to consider, and not do anything careless this weekend. Think of the children! Why, Georges and I are positive that Max himself might well

approve of this Mark."

Allison stood up too suddenly. "What makes you and Georges so sure that 'this Mark' is 'considering' me?"

Madeleine blew out smoke. "And what man we know hasn't?"

Touched, Allison walked to the railing and looked out over the river traffic. "*Alors*, Madeleine. I know you both mean well, and I am considering. Haven't I been seeing Mark often enough in the last weeks? But remember, you and Georges, with some men it is not enough for a woman to be pretty and amusing, with a good figure. This man is from New England. Perhaps he wants a—a pilgrim!"

Coming up behind her, Madeleine patted Allison's shoulder briskly. "Are you crazy? The cool mountain air in Dalat will put sense back into your head. Men are still men, thank heaven. The truth is, *chérie*, I will never understand why a woman as beautiful as you isn't just brimming with assurance. I've got a lot more confidence than you and only a tenth of your looks!"

Allison sighed.

"Well, it's true. I told Georges that, and he said you are the kind of woman who only knows who she is when she is in the process of loving or being loved."

"Georges thinks that about all women."

"Hummm. You may be right." Madeleine rose. "Well, I must run to my gymnastic class at the Cercle. Would you like to borrow my new cashmere sweater from Hong Kong for the weekend?"

"Good gracious!" Allison laughed a little, feeling embarrassed. "Such sacrifices are not yet in order." She allowed her cheek to be kissed and watched Madeleine's last wave as Nam let her out through the heavy teak door. Mission accomplished, Allison thought cynically in English, disliking herself.

Nam said, *"Bonjour, Madame."*

Allison turned. *"Bonjour, Nam, ça va?"*

"It goes, Madame," Nam was prim and neat as always in her starched white jacket.

Allison sat down outside again, staring at the coffeepot, before she realized that Nam was still there. Something to be said. "Yes?"

"If Madame will show Chi Hai what she wants to take to Dalat, Chi Hai can press the things before packing. And for the children too...." Nam swallowed. "Oh Madame, it is necessary to be very careful! Now in the west it

is no longer safe as before—very bad things are happening."

Allison heard the urgency under the hard tones of Nam's familiar voice. "Of course, Nam, we plan to be careful. Please don't start worrying."

But Nam had already started. "Best for Madame and the children not to go at all. It is very dangerous now in the provinces. I beg you Madame...." The murder of Monsieur Giraud by the Reds hung just outside mention.

Allison broke in sharply with the old fear gripping her diaphragm. "Nam, for heaven's sake! You are exaggerating the dangers. Of course we will go tomorrow, and of course we will be careful. Now please send Chi Hai so I can show her the clothes for pressing." She turned away quickly, knowing Nam was hurt. Must she appeal to the motherly in everyone today? First Madeleine, then Nam. Entering the bedroom, Allison pulled open her wardrobe door, feeling depressed and irritable. How heavy the heat seemed when you had anything at all to do.

Chi Hai, blue yesterday, looked radiant this morning. At least in her corner, all was right with the world. The girl bustled from cupboard to bed, exclaiming over how cold it must be up there if Madame could think of wearing the sweater, the coral coat! Madame would be *beaucoup jolie*. Before the mirror Allison held up her green wool dress, disbelieving that any place existed where you could be comfortable in such a thing. Suddenly she laughed with Chi Hai. After all, it was going to be a wonderful change! While Allison relaxed, her maid chattered on, making suggestions, quoting her Monsieur (the barber) on Dalat's climate. It seemed her Monsieur had a brother living up there.

"Madame and the children go to Dalat with Monsieur Gardeenair?" She was all innocence.

"Umm, Gardiner," Allison corrected, discovering a button loose on her tennis dress.

Chi Hai had piled all the clothes carelessly in her arms. She was standing quite close to Allison as she said, giggling, "Too bad it is the Monsieur Gardeenair—*beaucoup serieux*—no much good for Madame...." The resounding slap knocked Chi Hai's face sideways and silenced her. Allison and the maid faced each other for one instant in horror, Chi Hai's black eyes filling with tears as her ivory cheek reddened.

One angry threat burst from her. "Okay, Madame, *attendez*! One day will come—Madame *beaucoup* cry, Monsieur no come back!" And she ran from the room, her arms still full of clothes.

Chi Hai was little more than a child, and one who had already shown her

preference for Captain DeWitt without being reproved. Allison could not remember when she had so unreasonably lost control of herself. She dropped down on her bed in a dry despair too bewildering for tears.

Out in the kitchen Nam was just starting for market with her large satchel when Chi Hai threw down the armful of clothes and announced in tears that she was quitting. That very moment! Madame was a bitch. It was not safe to work for her. Chi Hai snuffed loudly, her head high. It was necessary to preserve one's pride. She was leaving now, and would never come back.

Nam stopped to take all this in, sighing hoarsely. "Yes, Madame is difficult today. But most unusual. Always Madame very tranquil person. We must use patience."

"She hit me!" Chi Hai rubbed the place, her eyes filling up again.

"You were probably impertinent." Shrewdly Nam paused to add up the factors. (She would do the same later in the market when bargaining for a live bird.) Something was crucially wrong with her mistress, and Chi Hai would be of no further use today. Better to do the ironing herself than listen to complaints and self pity. Let the air grow empty and still!

At the older woman's swift concurrence, Chi Hai felt hurt. True, Nam had only given permission for the one day off, but to this she had made no objection at all, adding to the burden of bitterness for Hai as she started off home in the unaccustomed light of mid-morning. To her further surprise, Tam was there, simply lying on the bed, doing nothing. For a moment she forgot her heavy grievance.

"What is wrong with you? Are you ill?"

Tam sat up, irritated. "Why should I be ill? I am *thinking*. I am using my head before I go out to perform a most important secret duty for the Party. And you, what are you doing home in the middle of the day? Have you been fired?"

At once Chi Hai poured out a tearful description of her Madame's selfishness. How bitter it was to be in the power of such a harpy! And she herself had done nothing but be a faithful and loyal maid for almost a whole year, believing and trusting that Madame also was fair and loyal. No! Madame was false and careless, without respect for her servant. Had Chi Hai no human feelings to be regarded? Evidently not!

Interested, Tam sat up. It was indeed a record that Chi Hai had stayed on one job almost a year. However, when he heard the whole of the brief tale, his mouth tightened. "Clearly this woman is a vicious imperialist exploit-

ing the working class!"

Chi Hai felt glad and hot. Tam agreed with her. Taking up a cloth, she began to wipe her eyes. "I hate her. I will never go back to work as her slave."

Tam kept his calculating gaze upon his angry girlfriend, weighing the loss of Madame's money. "But is she not leaving anyway tomorrow for Dalat?"

Chi Hai nodded, sniffing. "That's right. I forgot. She's taking all her beautiful clothes up there for a splendid holiday!" Tears flowed again.

Tam marveled at the injustice of the capitalist-colonialist system. "How wrong it is for spoiled foreigners like Madame Giraud to mistreat our hardworking people! Don't worry, her kind will be brought low, will be made to suffer for their misdeeds."

His high-sounding words always made Chi Hai impatient. "Oh well, the General Uprising, who knows if that day will ever come!"

"It will come, girl, you will see." Tam's eyes began to glitter with visions, near and far. There was tonight's meeting to be arranged between the agent from Dalat and the Colonel. This would be a golden success, justifying Tam's view of himself as a hero! And ahead in the future like a castle in the sky loomed the General Uprising, the natural result of many such brilliant arrangements by superior agents.

"The *Khoi Nghia* will surely come!" Looking for her warm response, Tam discovered on the round face only the martyred look of one who is wronged. "However," he said, "there is also the meantime. How is Madame Giraud traveling to Dalat?"

Chi Hai thought about it. "By car, I suppose, with Monsieur Gardeenair."

"And what kind of a car?"

Her voice grew doubtful. "It is a Peugeot, I think, a gray one."

Tam was satisfied. "Through certain forces on which I have the right to call, your Madame could receive punishment sooner than you think!"

Chi Hai looked frightened. "There are also the children...."

"So?" Tam was indifferent. He had begun to search for his shoes, for a shirt and necktie.

Chi Hai sat down on the edge of the bed. Her tears had stopped. Was it possible that Tam really did have mysterious forces at his disposal? Her cheeks grew pale. After all, it was the first time Madame had ever slapped her. And she herself had been somewhat bold.

"Tam, what kind of punishment do you mean?"

"Who knows?" He banged a drawer shut. "It is not for us to instruct the Party. Where are my socks?"

Chi Hai went to unpin them from the wire outside the back door. She came close to him, clutching the sun-warmed socks to her breast. "Tam, they must not do anything *bad* to Madame and the children! I was angry and overexcited. I see that now. It was nothing really...."

Tam sat down on the foot of the bed to put on his socks. "There is nothing to be afraid of, Chi Hai, not for simple honest working people like ourselves. Only such feudal rulers as your Madame need to be afraid."

Chi Hai stood over him, frowning with anxiety. "But Tam, I don't think Madame is so...feudal. I think she was more worried and upset."

Tam's sigh was a gust. "And her kind will become more upset! Chi Hai, your traditional values are impossible to correct! Your soft-hearted stupidity makes you unfit for an intelligent and dedicated cadre to waste his time on." He gestured with his chin for her to arrange his necktie, which she nervously did.

Eyeing himself in the mirror Tam pushed her away. "Don't concern yourself with these matters, Miss Goose. Others who are qualified will decide the fate of Madame and those like her. Now, I must go."

She saw as he left that his eyes were bright with some secret excitement. "By all the ancestors," Chi Hai wondered heavily, "has Tam truly got some hidden power to harm? It is a fact that I am not clever. In some stupid way have I accidentally put Madame and the children into terrible danger? Ai-yeeh...!" Chi Hai began to rock back and forth, crouched on the end of the bed. When the Aunt returned, she was unable to console the crazy girl.

Since Tam did not work as a barber that day, but rather occupied himself in the garden of the Colonel's Cholon villa until he could talk to the guard, he missed a small happening at 127 Ba Huyen Thanh Quan.

Monsieur Bep, the cook, returning from market about eleven o'clock, had to step over a small body before he could enter the gates of the Gregorys' compound. Not until An, the houseboy, had helped him put away the fine fruits, lobsters, and vegetables; actually not until the artichokes for lunch were boiling furiously in the biggest pot, did the cook remember to think of that child's body which had been lying in his way. There were always plenty of children about.

Across the threshold of his outdoor kitchen, shielding his eyes from the noon glare, Bep gazed past the ragged hibiscus bush down the yellow gravel drive toward the unrevealing gates. There had been something slightly familiar about that little body on the other side. Something about the shirt,

he thought. Had that shirt been one of Hal Gregory's? Clearing his throat, Monsieur Bep called An to open the gates and look outside. At once An ran back. A boy *was* still lying there, face down in the dirt.

So. Both men went together and stood, examining the silent form, black spiky head pillowed in the crook of one dirty brown arm. Inquiring glances directed toward the restaurant and bicycle repair men were answered only by shrugs. Monsieur Bep leaned down from his dignified height to make sure there was breath. Though the child did not move, he was unable to stifle his breathing. After Bep had pulled An back into the compound for a conference, they presented themselves to Madame.

Kate, busy in her room with the dressmaker, put on a robe and came out. While they told their story, her feelings of misgiving grew. It had to be Phuong. And out at the gate, it certainly was Phuong. How like him, Katherine thought, to just lie there in mute—mute what? Self-offering? She stood above the prostrate, grimy body dressed in the boys' outgrown clothes, now almost too dirty to recognize. Little Lazarus at her gate. Phuong still didn't move, though she knew he sensed her presence. She and Phuong had had some wordless understanding from the beginning. Kate gave up. So much for Don Bosco orphanage.

"Okay. Monsieur Bep, An, please bring Phuong inside. I'll ask the Amah to bathe him and give him some fresh clothes." They bent down in the warmth of general approval beamed by the circle of onlookers in the street. As Phuong was raised from the earth, Kate saw again the bleary squint, the gamin grin.

However, that afternoon when she went to consult Miss Lanh at Nhi Dong Hospital, Katherine did not feel reassured. Miss Lanh nodded seriously at the news.

"I see," she said in French, "Phuong has saved himself from the orphanage. At first he may have tried some days of his old life, but then, tired and hungry, he has surely remembered all the goodness of Madame." Subdued by a very final telephone conversation with Father John of Don Bosco, Miss Lanh and Katherine tried in vain to find another place for their orphan. It was going to be very difficult.

And, driving home, Kate thought about Joe Ruffin's high hopes for Phuong in a settled, secure life. Although she and Joe would certainly laugh together over how the kid had literally thrown himself on her mercy and "saved himself," it was not too funny. Who would now save them from the responsibility for a wild creature like Phuong?

Interlude

Strange is our situation here upon earth. Each of us comes for a short visit, not knowing why, yet sometimes seeming to divine a purpose.

Albert Einstein

The evening after his return from Cambodia, Joe was on his way to the Thanhs in a cyclo. It was hard to believe that only a week ago he had been hitting the books in quiet frustration. Now almost too much had happened. There was the world of Angkor with the Professor and Lam. Here in Saigon were Katherine and Phuong. Just before he left the house Kate telephoned to say Phuong had "freed himself" from that fine-looking orphanage, was back on their doorstep again! And only yesterday he had seen the strangely familiar girl by the pool. Tomorrow he would leave for Dalat. Grasping the padded armrests, Joe arched his back to let a little air circulate. Supper this evening with his new friend Yen Thanh, her officer husband, and their children might be just the peaceful interlude he needed.

When the cyclo slowed to a halt, his first sight of the sand-colored, one-level villa, clustered over with purple bougainvillaea, was pleasantly reassuring. The low wall of its compound seemed to cup and hold the draining light. A uniformed sentry at the guard box turned smartly away from someone in order to salute the newcomer. And as this other man, who was leaving, reached for the vacated cyclo, he faced Joe for one moment. It was Kate Gregory's street-corner barber! Dismayed as before by the shock of those cold eyes, Joe groped for the latch to the gate, while the sentry was already sounding a buzzer.

Mrs. Thanh came right out to the gate herself, shining with happiness to see him, lovely in a yellow silk dress with a single strand of luminous pearls. Joe shot a glance over his shoulder, but the barber and his cyclo had disap-

peared. Turning, he saw two little girls peep out giggling from behind their mother's white silk trousers. Yen Thanh swept them back with her hands while her husband, the stocky Colonel, came forward. The two men shook hands warmly, prepared to like each other. Joe noticed with relief that his host was wearing the simple Philippine evening shirt, open at the neck. He himself had not debated too long in that heat between sport shirt or coat and tie.

Yen's husband, though friendly, looked reserved and serious. Joe could imagine how well the military uniform suited him, this handsome man, about his own age, well-fed, but muscular, with plenty of vitality in his intelligent eyes. Entering the house, Joe wondered if he should tell the Colonel about his uneasy feeling at the sight of the Gregorys' hostile barber deep in conversation with Thanh's security guard.

In the living room, Yen introduced her father, Dr. Nguyen Trung Duc. He must be the one interested in Thoreau. Joe looked with curiosity at the clean-shaven, dignified old gentleman, seated by the big window, wearing the traditional black robe and turban not often seen on Saigon streets anymore. Bowing, Joe made his respectful greeting in Vietnamese. Yen also introduced an American, Colonel Altbacher, who wore tropical uniform, suntan trousers and short-sleeved open shirt. If he was surprised to see a fellow countryman, so was Joe.

As they all settled down to enjoy either a fruit punch or whiskey, Joe told himself to forget the barber for now. Accepting one of the appetizing little hot shrimp pastry rolls called *chiao giao*, he looked around, liking what he saw. Modern furniture in light wood was widely spaced on straw matting. There were yellow chrysanthemums in heavy pots. A tall carved wooden screen was placed in front of a doorway to the rest of the house, and an inlaid black desk stood against one wall. At the far end of the room hung a lacquer painting of warriors in black and red and eggshell, while nearest to Joe was a narrow Japanese scroll accenting with one long stroke the empty, cream-painted wall. The feeling in this bright uncluttered space was simple and happy.

Hearing Altbacher called "Colonel Don," Joe gathered that he had recently become Thanh's American military counterpart, U.S. Province Representative for Tuyen Duc where Thanh was the Province Chief. Colonel Don was telling a story about how he first met Thanh at a drinking ceremony over a ritual jug of rice wine with a mountain chieftain who kept passing a bamboo tube, making them both very drunk members of the tribe. They had matching bracelets to prove it.

Everyone was laughing, but Joe's mind wandered. It had to be an extraordinary coincidence, the barber appearing like that, both at the Gregorys' and here. The odds against it being an accident were enormous. Absently his eyes fell on the little girls playing what looked like jacks on the floor, dropping and catching a small rubber ball. Examining the long scroll near his chair, he saw it was a willow tree in spring brightness, blown against the threat of a storm.

Then he heard his own name spoken. Yen's father was asking him to tell how he met her during the street incident of the week before. While Joe told the story, whenever Professor Minh was mentioned, he noticed grief on the old man's face. But it all seemed a long time ago. Joe asked Yen to tell how she and her husband had first met.

With a merry glance toward her father, she explained they had married for love, very unusual in Vietnam. As a graduate nurse, working with paratroopers, Yen had volunteered for jump training. And in the aircraft, all excited before her first jump, she met her future husband, then a Captain.

"Love at first look," put in Thanh proudly, "just like Americans!"

"Love at first leap!" Joe grinned. They really were appealing, those two. Yen said she must "look over" something in the kitchen. Before slipping away behind the screen, she suggested that Joe might like to hear about Thanh's experiences in America when he was attending the Command and General Staff School at Fort Leavenworth.

Joe had a pretty good idea of what the lectures and training sessions would have been like. "Did you see anything of the rest of the country?"

"Yes. When my academic year at the Staff College comes to the end, I had a real good opportunity to go to Washington and New York for one week."

"What did you think of New York, Colonel Thanh?"

"Please to call me just Thanh, Doctor Ruffin."

"Thanks, Thanh, I'm Joe. Did you see much of New York City?"

"I had a chance to be at the Rockefeller Center and the Statue of Liberty."

"But for the U.S. itself, and our people, what did you think? Were you disappointed?"

The Vietnamese bent his cropped head. Raising impenetrable eyes he said, "It was a great opportunity to be in your country. I understand then that the Vietnam's problem is only small part of what the United States have now of the world. I also understand that majority of American people do not have

time to know what Vietnam is. So we are very glad, very happy to be with friends like you and Colonel Don who could understand us, comprehend our problem, and help us solve it."

"Hey, don't include me, Thanh. I'm no authority on anything here. I've got everything still to learn."

The stocky Colonel laughed. "That makes you and me both! To be a Province Chief for only one month is to find out how much I don't know."

And Thanh finally gave in to his little daughters who had been tugging impatiently at his sleeves from behind. "These young ladies think they can make better talk than father with Mr. Doctor."

At once they were against Joe's knees, unabashed. These girls certainly were pretty—moon-faced, with black bangs and straight silk hair slipping over their shoulders. Their short cotton dresses were peppermint colored and light green. Maybe the saucy one in pink, My Linh, was about five years old, while the shy prim one in green, My Hang, could be seven. It was hard to tell since Vietnamese children were small compared to Americans. Smiling at them, Joe dug into the pocket of his slacks for his much-worn pack of cards.

Dark was falling outside the windows, and the living room was a lighted island of love-in-the-family, security, and peace—almost too good to be true. While he showed them his ancient card tricks, the admiring little girls hung amazed, lightly laughing, at his side. But what about old Phuong, who also liked Joe's tricks? Was he still with Kate and her family, or had he already run away again in the dark? And the girl he had seen at the pool. Wherever she was out there, had she stopped running?

Joe could hardly stay preoccupied in the incredulous delight produced when the four robber jacks, which he had artfully buried, now leaped miraculously one by one out of the top of the deck! My Linh grabbed her mother to show her the fleeing robber cards, calling them Viet Cong. And Yen, who had come to lead the children off to bed, sat down momentarily to watch. Joe felt even closer to her, now that a spark had been struck in his own heart by the girl he had seen. With an arm around each child he told Yen of Phuong's ignominious return to the Gregorys' gate that day. And he watched her thinking this over. Many weird problems must come across her desk all day.

She pressed her lips together. "Maybe Don Bosco Orphanage has been too strict as first home for a wild boy like Phuong. I remind you, Joe, his name 'Phuong' means 'direction'—all directions—north, south, east, west.

So maybe it's not surprising we can't seem to get him settled in one spot."
Then Joe saw that elder sister smile. "But I will be thinking of some place
else, and, in the meantime, not to look worried! We will surely work it out."
Yen told the children in Vietnamese to say good night. Their merry bows
of thanks for *Ong Bac Si*, Mister Doctor, made bright ripples around him.
Flitting over to their grandfather, the two created more small feminine dis-
turbances before their final disappearance.

Then, as Joe saw the American Colonel getting up with his drink to ask
Thanh about the lacquer painting of warriors on the far wall, he himself
moved to a seat nearer the old man. Their eyes met.

Joe felt puzzled by a steady look of recognition from the other, who asked,
"Why are you here with us in Vietnam, *Ong Bac Si*?"

That was the question; and not to be passed off with a joke, not under
the gaze of this man. Joe looked at the scroll of the willow bowing before
the storm. "I want to help people who suffer, I believe I have to do it."

"Ah," the old man was nodding, the image of a Buddhist sage. "Some-
how this evening I thought it might be you. I have waited and watched, and
now you have come." Joe stared. "*Ong Bac Si*, my daughter has told me that
you are a missionary. Please forgive rude questions due to importance of
occasion. Are you a Christian? Priest or monk perhaps?"

The plain truth seemed essential. "No, I'm a physician, and a kind of
follower of Jesus. That's about it, sir."

Yen had rejoined them quietly. The old man touched her hand and be-
gan speaking in Vietnamese, as though they had reached a point beyond his
mastery of English.

She translated softly. "What my father says comes from the Bible, I think.
Your Christ became a master, but he was also a man of sorrows and accus-
tomed with grief."

Joe could only agree. Yen went on translating. "The Buddha also became
a master by the same path. There is one narrow road toward liberation from
sickness, suffering, and illusion.... Only one way back through the ten thou-
sand things to our true home.... All of us must find this difficult way of
service, the narrow path into eternal illumination."

That was pretty heavy. Joe tried to laugh. "Dr. Duc, it may be that we
don't understand each other yet. I'm just an ordinary guy, and I doubt if I
would make it in the way you mean. For one thing, I'm not looking for some
Nirvana, some kind of non-being. I want the whole of life."

Duc seemed undisturbed. "Yes, full experience is necessary. One cannot

be freed from something one has never known. As you say, you may not make it. Not in this lifetime, perhaps. And yet," he looked well satisfied, "your life purpose for this incarnation is remarkably clear. To have come such a far distance to this very place in order to alleviate suffering...." Soberly he added, "You have chosen well."

Joe was still fighting it. "But sir, I have no idea why I've got this urge to help people, or this special desire to come to Vietnam!"

Yen translated without emphasis both exclamation and response. "Do not disturb yourself, my son. The 'why' is not necessary to understand. This is developed through many past lifetimes, unnecessary to remember. But the purpose is strong and clear.... And also, in Vietnam, you have chosen the *place* with wisdom." He looked very sad while waiting for her to finish.

"But it could have been some other place; things just fell out this way, accidentally."

"No," Yen's father remained firm. "Your coming here was no accident. You will be badly needed in the terrible ordeal which I can see ahead for my country and my people.... As yet it has not been given me to know the fate of my own family," his glance encircled the room, "and I feel sure this cloud of ignorance is merciful." The eyes were very bright. "But, Dr. Ruffin, excuse me. I may be hasty in communicating to you what I see. It is not my wish to make you fear.... You who are strong, who have arrived to join your energies with ours, whatever the future holds for us all, I welcome you, and not as a foreigner. You are a son!" Bowing over his prayerful hands, Dr. Duc then opened them toward Joe, smiling radiantly. The translator was momentarily embarrassed, her own eyes misty.

Up to now, Joe had been thankful that the two officers were at the other end of the room. Now he forgot them. Suddenly Joseph Ruffin, M.D., allowed himself to become aware of the truth. He had come because he felt he was going to be needed right here in some extraordinary suffering ahead for human beings. He was "for it," and in a deep part of himself, seemed to have known it always. Once this was faced, Joe became as intent as the old gentleman. Stopping Yen with a raised hand, he went ahead in the new language on his own, freed into fluency if not accuracy.

"I'm afraid that I'm not good enough, don't have whatever I need to...."

There was a pause while the other searched Joe's face. "Technically—" but he dismissed this aspect. Either Duc assumed he was qualified as a doctor, or it wasn't that important. "Yes," he went on in Vietnamese, clear and slow, "there is still another kind of training and discipline which you are wanting."

He touched a sensitive spot just above and between Joe's eyes. "You have not yet acquired the art of meditation?"

"Well, off and on I've been trying to learn something about prayer...." Not with much success, he thought.

"Good," the old man said. "You will find the practice of meditation is also of use. Through this means, one is slowly transformed by a growing understanding of the many selves within. It has been said that, 'One who has never looked into his own nature, cannot be called wise.' So, my son, if you wish, we may explore together the art of meditation, with prayer. And, as you are able to attune to the Center, then all else needed for transformation will in time be added."

Some Christian echo stirred in Joe's mind, evaded him. "Well, I might like to learn how to meditate, though I'm not even sure what that means. When can we begin?"

Yen's smile broke through. "Dr. Joe, you are impatient again! Have you forgotten you leave for Dalat tomorrow, as Thanh and I do also? May we give you a lift in our plane?"

Joe tried to come back from wherever he had been. Dalat? He frowned.

Duc reassured him. "My son, there is no problem with the timing. You have come, we have met, and all is well."

"In that case," Yen said, touching her father's shoulder, "we can have our dinner?"

Joe didn't remember what they ate for the first course, although he was feeling more intensely aware all the time. There was an exhilaration of promise in what the old man had said, suggesting a purpose with deep meaning for his life. Strangely enough, the sight of the lovely but anxious girl at the pool had given him the same feeling. Now, eating away, he had no idea how long the conversation had been flowing past him when he heard Dalat mentioned several times.

Beginning to listen, Joe learned about the recent sabotage by fire of Dalat's airport by the Viet Cong. It seemed there were other possible VC targets up there, like the dam under construction by the Japanese, the nuclear power reactor given by the Eisenhower administration, or the Officers' Training School, also in Thanh's province. What was being said about the mountain tribes was more familiar to him. One reason for his own Dalat trip was to visit the clinics of the CMA missionaries to the Moi peoples.

Yen couldn't help smiling at the doctor, bending his man-sized head over

his soup bowl like a child in total absorption. How amazing if her father should be right about Joe! But then, hadn't she been drawn to him from the first, to his suppressed vitality, the eagle eye of his concern? Somehow tonight he seemed different. Not so unquiet as before, when she had felt compelled to explain things quickly before he misunderstood. After such a short acquaintance, it was odd that she had invited him here, where it now seemed so right and inevitable for him to be!

She asked if anyone would have more soup. Her father refused. After she had helped the Americans' bowls and reached for her husband's, he gestured an impatient negative. He was also looking different tonight. Had something unusual happened today? Here at home, Thanh usually wore a relaxed benevolent air; the generous mandarin, she liked to think, because he did come from a proud mandarin family. It wasn't easy for him to unbend with foreigners and those who were not his social equals. Yen thought tenderly that the slightly arrogant young Captain she married had been mellowed a good bit by life with a social worker-nurse, and by associating so much recently with the poor and with Americans.

However, this evening he was not in a relaxed mood. More alert, even sharp, she thought, watching him challenge Colonel Don, questioning him about the Strategic Hamlet program, sizing up his answers darkly, often disagreeing. Why does it matter so much tonight? Yen wondered. He's never cared that much before about Colonel Don's views. Thanh was even defending this Agroville program of Diem's brother Nhu, although she was sure he had grave doubts about the forcible methods being used. Was he arguing just to hear what the American would say? Don Altbacher was saying plenty, questioning the whole fortress-village concept.

Her husband leaned back casually, but his eyes gleamed. "It worked for Colonel Thompson in Malaysia."

Altbacher stopped eating. "Vietnam is no Malaysia! The guerrillas there were aliens, Chinese, who never got the full support of the Malays. And they had no Mekong delta to supply their rice. In Malaysia the Reds could be starved out. Thanh, you know damn well the VC may go a little short of food here, but it's just not possible to starve them out. More likely the South Vietnamese will get fed up with the war first!"

Yen watched her husband's face closing. Ordinarily Colonel Don was not so dogmatic, almost rude. Maybe the whiskey?

"As you know," Thanh said, "the important idea of the hamlet program is transporting our people from vulnerable open lands into more safe,

fortified places. Then guerrillas will be having no one to support them. Also the people are too afraid to stay with the government when unprotected. Without help, they give in to the terror and the VC. In our new hamlets they are safe, educated, and become government supporters."

"But Thanh, that's just giving the rest of the country to the enemy! Look, we tried it ourselves in the West. In our pioneer days, for fear of the Indians, we tried the fort system of settling the territories, and it failed. The only way we ever beat the Indians was by individuals having the guts to move out and live on the land, beyond the blockhouses and watchtowers. It was rough, but it was the only way. As long as we stayed in the forts, the land itself belonged to the red men."

Seeming unaware of a pun, Altbacher put both elbows on the table. "And what about the French? You can still see their guard towers standing deserted all over the country. That kind of thing didn't work for them either!"

After a pause, Thanh asked in a gentle voice, "I think there may be many ways you would disagree with our government's present strategy, Colonel Don?"

The large, sandy-haired man looked perplexed. "Well, I wouldn't say that, Thanh. You know I have some arguments with the way the ARVN is run, but then I'm not an ARVN General. And even if I was, I guess I wouldn't understand President Diem. I mean the way he often seems to hamper the army."

Thanh leaned forward. "Maybe you would be happier working somewhere else, Colonel Don, than here in Vietnam."

"No way, Thanh. I'd rather be here in Vietnam than any other post in the world!"

"Why is that?" Joe looked curious.

"Well, as I see it, it's the big challenge. The Commies want Vietnam more than any other place except Tokyo, and they know they can't get Japan, so they're going all out for Vietnam. No, I'd rather be right here with you, Thanh," and he grinned, "even though I don't always understand your President or the strategy of his General Staff."

Thanh was carefully turning over his china soup spoon. "If I were to come to your country and try to help in your affairs, I also might lack some understanding."

Feeling the strain, Yen glanced at Joe across the many dishes of the main course, which were being set out along the center of the white cloth.

Joe cleared his throat. "Uh, speaking of the government of President

Diem, I was wondering, Dr. Duc, if you could give me any news about your friend, Professor Minh. What has become of him since his arrest?"

"So far we can learn no news."

As calmly as she could, Yen ladled out the pungent fish sauce, *nuoc mam*, into small individual dishes, passing them down the table. "My father does not say he has been going almost every day to the prison where, rumor tells us, Minh has been taken. To sit waiting in this prison for so many hours, to inquire many times for someone the police have arrested, this is a dangerous risk." Her hand trembled a little, and she put down the china ladle, looking hard at her father.

Joe was shocked. "But surely they have to tell his family where he is? Plus he has a right to a lawyer and a trial, after all."

Ong Duc shook his head.

"No trial?" Joe couldn't seem to believe it.

"Well, there is a kind of a trial." Don Altbacher turned toward him. "It's like this, Dr. Ruffin, uh—Joe. Back in 1959 there were military tribunals established by President Diem to deal with 'infringements of national security.' That term has loosely covered a lot of so-called offenses. With these tribunals there is no right of defense and no appeal. The sentences are usually imprisonment or death."

"The idea," Thanh spoke softly into the silence, "was to catch Communists. Unfortunately, as you can hear, our prison camps are also containing other disagreeables."

Smiling in a funny way, Altbacher worked steadily with his chopsticks. Yen knew he could say a great deal more. Everyone was aware that uncooperative members of the press and trade unions had been jailed. Even elected members of the Assemblée Nationale. It was rumored that there were twenty thousand prisoners, although no one could be sure.

"Every government has bad sides; we hope that ours is not so bad for us as Communist form." Nervously Yen glanced at Thanh, who was not eating. His eyes brooded.

Colonel Don coughed. "You've got to understand, Doctor, uh—Joe—that in any country a near-dictatorship is often necessary in order to prosecute a war."

Perhaps Joe hadn't thought of it as a war. Yen watched him examining Altbacher's flushed face. Joe would see a big, kind person, a man's man who had found his niche in the army. The Colonel was shy with women, good with kids, and conscientious as an officer.

Joe looked from Altbacher to Thanh. "You military people, Vietnamese and Americans, are you pretty much in agreement on how to handle the situation out here?"

Yen saw Colonel Don glance toward her husband. It was possible to leave many things unsaid. But Thanh spoke—lazily, without joy. "You will hear some criticism about the Vietnamese, Joe. At first you might hear that only Catholics would fight, since most of the guns have gone to Catholics and not to Buddhist. I, however, am Buddhist, and not without gun. You will also hear of 'impossible bottleneck at the top' which sincere, capable young men cannot be getting through—more easy to do nothing than oppose the President. However, I am ambitious young man, and recently Chief of Province, although not being always in total agreement with our government."

When the Colonels exchanged a look, Joe saw that if other people got into the discussion, solidarity between the two officers was restored.

Colonel Don said, "Before I worked with Thanh here, I heard that Diem didn't trust his own officers, that every move had to await the personal approval of the President. And another thing I heard was how the ARVN was always trying to use substitutes for infantry, big guns like firecrackers to scare off the enemy and avoid the need for action, night patrols. Well, that stuff is certainly true in some sectors, but Thanh here, with my support, has already conducted maneuvers of hot pursuit which were plenty quick and plenty successful. Not always in the daytime either!" The Colonels grinned at each other like boys.

"There must be a lot of danger for you both out in the provinces." Joe's uneasiness had returned. "Is there any danger here in Saigon?" He laid his chopsticks down across his plate, still half-full of fried rice, juicy shrimp, and brown-skinned fowl.

When both officers only shrugged, Yen spoke up. "Yes, many dangers right here."

"Funny coincidence when I arrived tonight," Joe said. "This guy who was talking with your sentry is the very same fellow, a barber, that I've often run into on a corner in town near my American friends the Gregorys. Could be my imagination, but there's some kind of threat in the look he gives you. I felt it again outside your house tonight."

Yen turned anxiously toward her husband, who seemed unchanged, unless suddenly more careful. "It is an interesting coincidence," he said, without interest. "That may have been only Tam, who works in our yard part-time."

"He's got no special reason that I know of to dislike me," Joe went on almost to himself. "He just may not like people, but it is funny that he would turn up out here."

"Not very funny!" Yen exclaimed. "Those who do not like Americans, also do not like us."

Altbacher looked serious. "I've suggested before, Thanh, that you should have a heavier bodyguard here at home, and a thorough security check on any employees."

Thanh deliberately relaxed his broad shoulders and smiled. Looking at Altbacher he said, "In time of war all agree we must try to avoid the tendency, through natural fear of violence, to magnify significance of small, unpleasant happenings."

Joe realized he had not been thinking of this as a time of war. Evidently they did. Despondent, he decided there was some relief in having told them about the barber. Seeing Yen's worried expression, he turned at once to Dr. Duc.

"Sir, does your religion accept war as a necessity?"

Yen left the serving of the mangoes and lichee nuts for dessert to her elderly maid, while she concentrated on the delicate translation of her father's answer. "In the *Tao Te Ching* we learn that the Tao, or Way, opposes warfare. 'The Tao is like water, for water is soft, does not scramble, is content with the lowest place, yet it benefits all creatures and finally overcomes all.' So is the way of the Sage to act without striving. Thus power comes from complete harmony with nature and the self-defeat of fussy activity."

"Resist not evil," Joe thought. Fascinated as before by Yen's elegant translation, he grinned a little. "And violence is 'fussy activity'?"

The old man put his hands inside his sleeves. "Both the Tao and the Buddha recommend non-violence. Self-protective warfare *may* be justified; offensive warfare is against the whole interest of mankind."

Colonel Don cheerfully raised his sandy eyebrows as the old serving woman placed a bowl of fruit before him. "Well, there you are! What Thanh and I are engaged in, is the *defense* of South Vietnam."

Joe wasn't quite satisfied. "But isn't war itself bad, Dr. Duc? Any war?"

While her father pondered, the translator managed to eat two golden bites of the satin and velvet mango flesh. Then, "War, Doctor, is the common condition. It is sad, but true, that all things come to pass through strife. Out of opposition comes concord, does it not?" When Joe would have said something, the old man held up his thin hand. "I myself see war as a sick-

ness, a useful symptom that something is wrong. It can be a demand for change, for liberation from the ten thousand things. So how can it be all bad? In fighting a poison, one is healed."

Thanh said, "There will be need for the military until the millennium comes."

His father-in-law turned. "'Great is the general who conquers many armies, but he who conquers himself achieves a greater victory.'"

"Fortunate is he who is only a Colonel!" Thanh was gleeful.

But in the midst of their laughter, the old man still pursued the main question. "Perhaps it is not so much in war itself, but in the idea of victory and defeat that the greatest problem lies. Victory brings hatred, for the vanquished one is left bitter. Somehow men must rise above these opposing ideas of victory and defeat. Only then can there be happiness and peace."

Yen glanced around her table. The doctor looked fascinated, Colonel Don bored, and her husband, who had heard it all before, impatient. "Father," she suggested, "I doubt if our guests...."

"You are wise, my daughter," and Dr. Duc rose at once to his feet. "Nothing is ever to be forced; this is not the way of God. The Buddha has said, each must hold to the truth within himself as the only lamp."

And that lamp, Joe thought, could be the same one Jesus talked about. Chairs were pushed back; the party began to break up slowly. Joe was to be driven home along with Dr. Duc in Thanh's military car. It was arranged that the same driver would pick him up again at ten the next morning for the short flight to Dalat. Nice not to have to ride the bus.

"Thanks, Yen," Joe said warmly. "This evening more than came up to my hopes!"

"You are welcome, and I am happy."

"Aren't you tired? I get the impression your life is very busy."

"Well," she admitted, "pretty soon I will have to give up my job at Foster Parents Plan. I am always so busy now for Thanh on Social Welfare Committee of the Division. We must regularly visit the camps of military dependents around Dalat and elsewhere in Tuyen Duc province. And soon we may have to move to Dalat. Right now I am going back and forth all the time from there to here."

"What about the kids?"

"Ah, in that I am fortunate, since my parents live close by. They are overseeing the children and our home when we are away."

Joe saw a shadow on her face and was reminded of his uneasy feeling

about the barber talking with their sentry. "I'm afraid you face a lot of danger nowadays; I mean, not only Thanh, but perhaps all of you?"

"Dr. Joe, you see everything. Yes, some danger we must learn to live with."

Looking into Yen's open face, Joe could not resist kissing her.

In the car there was no further chance to talk with the old gentleman, who got out after only a few blocks. Helping him up to his door, Joe said, "I have a great admiration for your daughter, Dr. Duc."

The old man smiled. "Her name Yen has the meaning of light, as the light from a candle."

Joe stood still to enjoy that. "It has also been a blessing for me to meet you, sir."

"We will meet again, my son, before too long. And perhaps, later on, you will let me know what plan you have for helping my people."

Lying awake that night Joe wondered, "Is there some kind of plan in the works? And if there is, I surely hope someone will tell me! What terrible ordeal lies ahead? Is there any quick way to turn on that inner lamp the old man spoke of?" Joe rubbed his forehead in the sensitive spot just above the space between his eyes. In the darkness of now he told himself that he could always choose not to stay in Vietnam—before he thought again of the girl he had seen by the pool.

The Two

The rift between the conscious and the unconscious mind, between the individual and the group, between the world and God, is present in the two madmen who are mad because they are two. As long as they are two, they will act without correlation, each one in his separate insane way; nobody can induce them to cooperate. They will destroy everything and finally themselves.

Fritz Kunkel, Creation Continues

"Do you like him?" Yen asked her husband when they were alone.

Thanh looked up, half-smiling. "Your doctor? He's all right. Like so many Americans he seems boyish, almost naive, but there's a penetrating look in those light eyes of his."

"You felt it too...."

Throwing an arm over her shoulder, Thanh warned stoutly in English, "'Do not be carried off!' as the Americans say."

Yen giggled. "'Carried away!'"

"It is not the same?" He pretended to be hurt, but in the next moment she saw he had already forgotten their joke. "I wonder," Thanh murmured, "are the Americans the answer for Vietnam? It is a risk...."

Yen had started for the door behind the screen. Turning back she saw him glance at his watch and wander toward his desk. "Aren't you coming to bed?"

"Not just yet, I think." He stood with his back to her. "Please go ahead, Yen. I'll join you soon. Just one small piece of work.... Don't worry; I'll remember the lights."

She threw up her hands gently, leaving the room. If I worry, Yen thought, it will not be about the lights.

Almost twelve. Thanh did not open his inlaid desk. The small piece of work which remained was his appointment with the Communist agent. Alone, he sat in his heavy teak chair until there was a very light tap on the front door. Getting up, Thanh unlocked for his sentry, who closed the door behind him and saluted. "My Colonel, the agent of the NLF is here."

"He is punctual."

"Sir, the agent does not wish to meet with the Colonel inside the house."

Thanh found that he was not particularly eager to confront this man in his own living room. "Good, Corporal, arrange chairs on the side terrace. This is well away from the bedrooms, and the light falling from these windows will be adequate."

"My Colonel," the sentry paused, trying to find soldierly words for his sense of grave danger.

Thanh smiled. "He is alone?"

"Except for that fellow Tam who helped to arrange your meeting."

"That is satisfactory, Corporal. Just keep an eye on us from the guard post. But do not be anxious. The National Liberation Front has not yet decided to eliminate me."

The Corporal, who did not look comforted, saluted again, and, turning on his heel, preceded his Colonel into the midnight quiet. After pulling forward the chairs, he joined Tam, the go-between, who was waiting for him near the guard box.

On the side terrace in the semi-light, Colonel Truong Vinh Thanh faced Bui Tang, who seemed to have materialized out of the dark. They did not bow.

Thanh gestured. "Please be seated."

Tang picked the chair furthest into the shadow. Thanh seated himself with his back to the light, and for a few moments the two Vietnamese were silent. Physically, Tang felt somewhat tired. Here in Saigon, through caution, he had made a point of never eating or sleeping in the same place twice. This had involved much activity. Examining the husky Colonel against the background of his comfortable home, Tang felt his own weariness become a virtue. The flame within flared up and steadied.

Since he himself had initiated their meeting, he was not surprised that the other sat stolidly, waiting for him to open their discussion. Tang would let him wait a few moments longer, although there was no need for prolonged study of his adversary's appearance. Before him sat the mandarin type, clearly a man of power. And a natural leader. Tang had not missed the

defensive affection of the guard. These moments of waiting were useful to reassess his own purpose so that his aim would be true. He must be a propagandist who presents many ideas to one person, rather than an agitator presenting one idea to many.

The National Liberation Front has been formed, he thought, to bring the right strong men into power and keep them there. If someone like Thanh threatens your purpose in politics, you must either do him in, or bring him in. And their cell in Dalat had decided to try the latter course first.

Facing the Colonel's bulk, assessing his strength of personality, Tang thought how right they had been. (How right *he* had been.) Give this man some of the action on the winning side. Let him have a taste of the new kind of power, since power is what everyone wants. When the Colonel has the promise of it, he'll cooperate, and in this way his strength will become part of ours. The fact that Thanh was able to wait in patience without betraying any nervousness confirmed Tang's assessment. Now was the time to make his approach, which must be managed with respect and concerned interest.

"Comrade Thanh, I bring you the greetings of the National Liberation Front for a unified, independent Vietnam, our country. I do not greet you as a military officer, but as a man. To the present government of South Vietnam and its army, men are only cogs in the machine. But we, in the Front, work as friends and cadres, concerned over the wrongs and grievances of each person."

Thanh nodded in answer to the greetings. Then, "I have no grievance," he said mildly. It was his first word after the offer of a chair to his visitor. While he had felt himself being studied, Thanh also was examining the stranger. This man looked older than he, perhaps by ten years. Thin and wiry, he held himself controlled, tight. And even in the dimness, Thanh thought he perceived in the narrow eyes a bitter fanaticism beyond winning over by any use of charm. It would be force and power which this man understood. Contempt for any weakness would spring up strongly, he guessed, tangible as wind or fire.

"No grievance?" Tang's voice was light with disbelief. He paused, remembering how Kiem constantly admonished the members of their cell, "Keep and nourish your steady hostility to the Diem regime. Otherwise you are of no use to the NLF!" There must be some hostility in this man to nourish.

"How," he asked, "can a Colonel, a loyal patriot like yourself, not feel distress to see the obvious deterioration of the army?" Since Thanh simply

waited, his eyes rather wide, Tang went on. "It is clear to any observer that there is a near paralysis of the military effort when so many decisions have to await the personal approval of President Diem! Is he unable to trust his own officers? Perhaps not, since he promotes them, not on the basis of ability, but because of loyalty to his family! And the ARVN soldiers themselves, like their officers, have low morale. Americans have taught them to believe in firepower instead of in their own heroism. Firepower is their only soul! You know that your ARVN soldiers will not fight at night. Also they cannot live in the jungle for any length of time as we do. We are self-sufficient; we are self-reliant; the jungle will be ours by default!"

Thanh thought Colonel Don had said much the same thing in reference to the American Indians. "And yet, sir, recent facts of the military situation do not bear out your criticism of our fighting men," Thanh said. "The forces of the Viet Cong have suffered severe setbacks late in March and at the beginning of this month. I believe you must be aware of our engagement on the twenty-seventh of March near the Plain of Rushes. By exact count, one hundred of your cadres were lost to twenty-seven of our men. Then on the eve of our presidential election, your large force which gathered at Ben Cat, without adequate support and antiaircraft weapons, was scattered with heavy casualties. In addition, you not only lost an attack on the Fifth ARVN Division Headquarters east of Saigon, but also your attempt to seize Ben Tre, capital of Khien Hoa, was broken up with heavy losses on your side."

These facts might well be true. Tang decided not to question them since the NLF's communications network in the South was not yet complete. He shrugged. "Setbacks and hardships like these are always encountered at the beginning of any revolution in a just cause. They will only contribute to our maturity."

"And how can you be sure that it is your cause which is just?"

"Comrade, do not call the Revolution 'my cause.' Unity for our country and independence from foreigners; that is the goal of you and me and every true Vietnamese! But with the corrupt and inefficient government of President Diem, how can this goal be achieved? Because of the many wrongs of this cruel regime, the people are like a mound of straw ready to be ignited. We could not launch a movement in the South so easily, were it not for this dictatorship!"

Thanh rested his hands squarely on the arms of his chair. "These are generalities."

"Which I can readily support with facts. Please look at the land reform program so badly needed after we had driven out the French. Instead of redistributing land to the poor, the Diem lackeys ended up taking back what the peasants had rightly been given by the Viet Minh and returning it to the landlords! Only last year seventy-five percent of the land in the South was still owned by only fifteen percent of the people! And look at what your Mr. Diem has done to our villages, the precious heart of our nation. He abolished our ancient elected village councils, simply out of fear that *we* might gain power in them. Then he replaced our own popular bodies with appointed outsiders, northern refugees and Catholics, who are loyal to him. And can you deny that it is the Catholic refugees who have been given most of the agricultural credit for starting farm projects? I ask you, Comrade Thanh, how can you support a government that is both corrupt and biased? How can you live with so much injustice and wrong?"

The self-righteous tone was having its effect; Thanh could feel himself begin to simmer. "Do you imagine that your own government in Hanoi is absolutely pure and just? How many peasants died in the course of your drastic land reform program in the North?" He shook his head. "Society probably always needs changing; do you think the Communists are the only ones to see this? But sir, we are not Westerners, incapable of accepting both the good and the evil in life without losing face. No. I believe we Vietnamese can work patiently within the faulty system for gradual improvement, rather than having to destroy everything by force."

Tang did not allow himself to feel annoyed that the other would not call him "comrade," awarding him only an occasional "sir." Still smiling, he persevered.

"You are very loyal, Comrade, and loyalty is much treasured in the Party and the Movement. But take a moment to look at how your President treats his loyal friends. You have only to think of your patriot, Dr. Phan Quang Dan. Remember how, calling himself a nationalist, he refused to cooperate with our great leader, Ho Chi Minh, in 1946. It was Dan who persuaded the Emperor not to accept the overtures of the Viet Minh, whom your Ngo Dinh Diem also hated. And yet, where is your Dr. Dan now? For some disagreement with this same Diem, some minor disagreement perhaps, he lies in prison, tortured, it is said. This is how your dictator behaves to his loyal friends."

Thanh kept his voice steady. "I have not yet visited all prisons here in the South, nor have I visited any of those in the North. Rumor says there is little

virtue in either. I myself even doubt there is much difference between your methods and ours."

Tang decided on another smile. "As you say, Comrade, we Vietnamese on both sides are not very different in our methods, perhaps, although in my opinion, we in the Front are more careful to preserve justice. However, it is the goal, the cause, which is different. For example, our goal is independence from all foreigners, while you in the South are still allowing yourselves to be bullied and exploited by the capitalist and imperialist Americans!"

Thanh thought honestly about Altbacher, his often not-so-gentle pressure to do things their way, and his attempts to disguise his occasional scorn for Vietnamese methods, timing, fighting men. Also he considered what he had learned in the States about their way of life, their methods of warfare. He remembered his American friends.

"They have something to give us, which I believe we can make use of," Thanh said finally. 2

Bui Tang shook his head. "Comrade, only think how fiercely throughout our history we Vietnamese have struggled to get rid of successive dominations by foreigners—China, Japan, France! How can we bear to accept still another foreign overlordship?"

"And the doctrines of Karl Marx on which your whole ideology is based, you do not consider this European influence, brought through China, as foreign?" Thanh crossed his legs, feeling more relaxed.

Tang thought, this man is indeed intelligent, an opponent worth winning. "Once, Comrade, once these were foreign doctrines. But it has been the great work of our enlightened leader Ho Chi Minh to take Marxism and make a living Vietnamese doctrine out of it! A doctrine that suits us and our nation, no one else. As we have kept Chinese cultural advantages and driven out Chinese rulers, so we are shrewd enough to adopt some foreign values which may be useful, without submitting to foreign occupation and domination as your Diem clique is doing.

"Let me give an example, Comrade, of how we have incorporated some new values with Vietnamese custom and tradition. Once we had the Emperor, did we not? And also we had the Tao to follow. These gave us our style of leadership and our style of living, admittedly inherited from the Chinese. But now we have the Party. What Confucius once taught about the Emperor and the Way, we now teach about the Party. Our Party is as great as the immense sea, the high mountain.... Our Party is virtue, civilization, unity, independence, and a peaceful, comfortable life!"

Thanh thought about the way of the Tao. "Tao is the ultimate reality and the unity behind the diversity of things." They had substituted Party for Tao; thus reconciling the new with the old. Not bad. He himself felt a certain unity with this intensely rational man, this idealistic, power-loving fellow-countryman. Was there any important difference between them, important enough to die for? The question was necessary. It was clear that if Thanh did not accede to persuasion, powerful forces to eliminate him would be unleashed.

While the Colonel seemed to be reflecting on his words, Tang waited. Sudden hope made him eager. After all, it was only necessary to show possible cadres how their interests were identical to the Cause. "If you can be patient, Comrade, and listen with all your heart and mind, I can show you that our way is the one, true, natural way for all Vietnamese!"

Thanh smiled, looking suddenly quite young. "I can be patient, sir."

"Comrade, our Cause is just; come with us; add your strength to ours, for whether you do or not, we are bound to win eventually." Bui Tang felt himself becoming a poet, an orator. "We are the wave of the future, since all true patriots see that we are the only force attempting to unify North and South. The present regime of Diem only aims to maintain its feudalistic grip on the South. Our weapon is anger, righteous anger. And no matter how long we have to fight, we will fight. 'You will kill ten of our men, and we will kill one of yours, and in the end it will be you who will tire of it.' I am quoting our enlightened leader when he spoke to the French general at Fontainebleau!"

"In 1946. That was a long time ago." Thanh observed with appreciation how the Communist agent had become uplifted by his own effort to "intoxicate" another. Or was it "intoxify"?

"Time is not important," Tang said. "'The longer the fight, the more mature our forces, and the weaker the enemy forces.' In this I am quoting our great General Vo Nguyen Giap. 'All our people become increasingly mature by going through rich struggling experiences. So our maturity stems from our radiantly just cause. Ours is the all-people-great-unity bloc. It is our heroic spirit which will inevitably triumph over modern weapons!'"

Thanh looked skeptical. "We are a very small country, sir. If you had ever seen the United States...."

The light in Tang's eyes grew only brighter. "Indeed, Comrade, as you say, the territory of Vietnam is not vast, and its population is not large. Yet our people are indomitable and have a high spirit of self-reliance. We have defeated all aggressive enemies. In the past few decades, remember how our

people, relying mainly on their own strength, defeated the Japanese Fascists and the French Colonialist aggressors. It is only a matter of time before we get rid of the U.S. interventionists. These glorious victories reflect the mountain-moving and river-filling power of our nation and our people."

Thanh stirred, restless. "I am aware that we are courageous, a people of spirit."

Tang, who had been tapping one foot as he spoke, now rose and paced up and down the oblong of light thrown on the terrace from inside the house. "Add one more thing to our character and determination, Comrade, organization!" Thanh saw the man was uncovering his secret weapon, his trump card. "Through organization we are developing and launching a people's war that moves *with* our situation, moves *with* nature, and conforms to the characteristics of our own country. Only Westerners are so foolish as to move against the natural order. By the end of this year 1961, the National Liberation Front will have covered all of South Vietnam with administrative apparatus and military force, all directed through the Central Committee of the Lao Dong Party in Hanoi. And yet many of our principal leaders are southerners like you. Comrade, only imagine yourself as part of this great movement! If you take hold of a movement politically, you can form it, utilizing all the modern organizational techniques. Then you have indeed a powerful weapon, particularly when you work, as here, in a truly diverse, nonorganized society."

Thanh considered. For him this was the strong temptation; the exercise of power, plus the lure of the great crusade—Vietnam one and free! And also, like his fellow countrymen, he had a romantic love of the devious, was attracted by clandestine groups, secret arrangements. There was even the added appeal of virtue, of believing oneself morally right.

"For me," he admitted frankly aloud, "the greatest strength of your Movement is its power and organization, force applied with reason."

Was the fish about to swallow the hook? Tang did not allow sudden elation to remove the barriers of caution. He kept his mind focused. "A portion of this enormous power is now being offered to you, Comrade. Your natural leadership, fearlessness, and strength are needed in our righteous Cause, which Ho Chi Minh has declared is the Cause of national salvation!"

Here at the climax, Thanh was disappointed that he did not see at once, sharp and clear, what his choice should be. It seemed to him that a loyal Vietnamese could look at it either way. One could be a patriot and support the GVN or one could be a patriot and support the NLF. However, he

reminded himself, it was Ho Chi Minh's policy to murder thousands of patriotic Vietnamese who did not want to be Communists.

"Ho Chi Minh," Thanh murmured. "This name means the one who shines! But was it not the Buddha who said we must all be lamps unto ourselves? 'Be your own reliance,' he said. 'Hold to the truth within yourselves as the only lamp.'" At that moment his father-in-law seemed to be sitting beside him in the semi-dark.

"And in the light of this truth," Tang's relentless voice continued, "you will make your choice for the right and virtuous cause, the *only way* toward independence and unity and peace for our nation!"

The steady pressure reminded Thanh uncomfortably of Colonel Don. Suddenly he asked, "Why must I choose? Isn't it possible for you to go your way and me to go mine, each allowing the other to pursue his own path toward peace and unity and independence, giving to the whole our different contributions?"

Tang frowned. "But there *is* only one right path, superior to all others."

Thanh grew sad. Here might be the crux of the difficulty for him. He could not see only one path as right for his very individual countrymen. "Sir, you and others like you who are trained, you would manipulate and organize the many to force them into this one path." Seeing that Tang accepted this summary of his aims, Thanh sighed. "I don't believe I'm capable of enforcing this one path, this one type of government."

"Comrade, stop and reconsider. What you are expressing now is only fear and weakness."

"You may well be right," Thanh said. "I'm a fairly good, strong officer; I love my men, and I go with them into action. When I am single-minded like you, I can also be cruel, without heart. But politically, in my office of Province Chief, perhaps I'm not fully efficient, not fully adequate in the use of power. Democratic principles have a weakening effect I notice." He sank into reflection.

There was a long pause. Growing impatient, Tang forced the issue. "Am I to understand that you are giving me your decision? Is this your answer, what I can only call non-action?"

In the other's incredulous anger, Thanh sadly perceived that it was all over. He found no comfort in his father-in-law's words, "The way of the Tao is non-action, like water."

He straightened up. "I had thought, sir, of postponing my decision and giving you your answer after deliberation. However, we seem to have

emerged into a clear place already. I see that you are unable to live as you are, and still permit me to live as I am. This shows me something about your way, something I probably could not adjust to."

Tang could hardly believe the lack of intensity, the rational, almost casual tone. Coldly he said, "Perhaps the Colonel does not realize that this is a serious matter, a matter of life and death."

So now he was a Colonel and not a comrade. Thanh made his voice firm. "On the contrary, sir, I have been quite aware of that from the beginning. Am I blind not to have observed the murder and kidnapping of hundreds of our leaders in the last months, from school teachers and public health nurses to hamlet and province chiefs? I realize that, from your rather ruthless point of view, leaders like myself must either be persuaded or removed." He glanced around. "I have to admit that life is very dear to me. And, in addition, trained as I am in the military tradition, if I must die, I would prefer death in the field. However," he shrugged and smiled, "I must simply hope that you will not be successful in removing me. And if you are successful, then I must hope that, continuing to defend my way—more free, though perhaps not any more righteous than yours—I will somehow not have wasted my life." Interested himself to hear his thoughts expressed, Thanh held out his hand. "I believe we understand each other, Comrade."

But Tang found himself shaking with rage. It was impossible to keep from driving on to the end. "I can never understand such a weak and decadent choice, if it is a choice! How can there be choice where there is no conviction of right and wrong?" He ignored the extended hand. "We are totally in opposition."

Withdrawing his hand, Thanh considered this. "No, I don't believe that is true. We both want unity and independence for our nation. And also, have you noticed how much we each respect the uses of power? You and I see force as the way to set people on the road to independence. Our defending force may defeat you, or your attacking force may well defeat us." He thought of Yen's father again. Of his weird idea of somehow getting above victory and defeat. "In the long run, what if something else should defeat us both? Look, Comrade, it's just possible that the day of power and force, even defensive force, may be over, while we brothers are still struggling on, unaware of the fact! Can it be that we are both using hopeless and outdated methods for the same excellent goals?"

"Phu!" A scornful sound of disgust was the last thing Thanh heard from the Communist agent, who had already disappeared in the dark. So much

for his own oratory, which Thanh had begun to find more than a little intoxicating himself.

Reality descended. Thanh knew that he had revealed such a basic weakness, from the other's point of view, that the loss of such as he could only be gain for the Party. To think of himself as weak was unpleasant. He wondered wearily if all those words between himself and the Communist had made any sense. Had he been overly influenced by his father-in-law? Was either side right? Both used words of freedom and democracy, which were rarely practiced by either. In fact, he had once or twice thought before that, by the extent to which the South was democratic, by that very extent it was inefficient and would lose the war. Yen always grew angry when he said that.

Well, Thanh knew he was not a philosopher and not much of a politician. However, he was a pretty good Airborne officer in spite of all the frustrations of hierarchy and discipline, so he had proved he could submit to organization, adapt to it. Yet he did feel an inner longing for freedom. Would there ever come a day when the right of the individual to live by his own inner lamp would triumph over every outwardly imposed organization? And if it ever should happen, would it be a good thing?

He became aware that the sentry at his elbow could hardly contain his excited relief that the interview was safely over. Tomorrow would come after all! The Corporal reminded his Colonel of the hour of departure for Dalat in the morning. Thanh thanked him, and out of his stark loneliness, he reached over to touch the boy briefly on the shoulder before going slowly in to bed.

On the Way to Dalat

*And they moved upward. This is the urge forward, out of the
restless movement in the surrounding dark.... They made a
choice in favor of change.*

<div align="center">Centerpoint Study Group, "Navajo Creation Myth"</div>

In Vietnam there are several ways to travel from the engrossing heat of
Saigon up into the cool high of Dalat, some ways more dangerous than
others. The American Ambassador, Douglas St. John, would fly, of course,
to save time. On that April Friday he put aside for later the Air Vietnam
envelope which his secretary had placed on top of the loaded in-basket.
There would be work up there too, even in Dalat. He had invited Thinh, one
of Diem's cabinet ministers who had taken refuge in the Embassy residence
during the Coup. It would be good to get a feel for the man and how open
he might be to new ideas. Mark Gardiner would be on hand as needed,
along with his attractive girlfriend. No harm in indulging Harriet's
matchmaking tendencies when the girl is as charming as Mrs. Giraud. And
there would be other folks around. It was Embassy custom to offer remain-
ing places at the villa on holidays to members of the American community
who had put their names on a waiting list. Of course, he and Harriet couldn't
get away until after working hours. As he picked up the phone to set the
day's schedule in motion, the ambassador might envy people who were able
to leave sooner, but he certainly wouldn't want to change jobs with them.

The Thanhs were taking Joe Ruffin with them to Dalat in a Vietnamese Air
Force plane. Colonel Thanh sat in the cabin of the C-47 with the pilot, while
Yen and Joe were strapped into bucket seats along the wall beside one of the
window slits. Cargo was bolted to the floor down the center—heavy gray
mail bags and wooden crates stamped with military directions, mostly in the

Vietnamese language. There were a few other seats along each side occupied by men in uniform and one young woman, brightly made up and over-excited, holding a baby on her lap.

The Colonel's wife nodded and smiled to the young mother, obviously a military dependent. Turning back, Yen was glad to see that Joe was absorbed in the view falling away below his window. She didn't feel like trying to talk in English or even Vietnamese above the vibration of the plane. Yen was worried because Thanh seemed especially withdrawn. Last night, about an hour after she had left him standing by his desk, her husband had come quietly into their room. He undressed very softly and laid himself down beside her. Then she waited, listening for his deepened breathing and the little relaxing sigh with which he usually dropped off into sleep, but it did not come. Yen tried to lie without tossing, so he would think she was asleep. They had passed the night in strained silence, something unacknowledged between them like a wall.

Adjusting her safety belt, Yen wished she could turn the plane right around now toward home. While they gained altitude she swallowed, wiggling her ears to break the pressure. Nothing could relieve the pressure of fear. Whether what she feared lay ahead in Dalat, or behind with the children in Saigon, either way it would be better not to go! Yen pressed her lips together. She knew she must never pester Thanh with her questions and her anxiety. There were many things he did not, could not, share with his wife. She was trying hard to learn how to live with this separateness between them. But those very unknowns which he could not discuss were breeding the fear and anxiety, even anger, which she must not share with him. Nor with Joe, who was just turning away from the window.

He smiled. How happy he looked, holding his physician's bag on his knees like a treasure. Why, he was lit up like a child on the eve of the Tet festival! Dropping her eyes to the worn black bag, Yen realized she had not often thought of him as a doctor, since that first day when he had taken charge of the injured boy, Phuong.

She touched Joe's arm. "I think you are happy to be planning your medical work now in Dalat?" Either that, or he had fallen in love.

When Joe tried to respond, she had to smile and shake her head; it was too hard to catch the words above the vibrating noise of the motors. So he grinned and gave it up, staring at the gray ceiling. The old C-47 was stained with age and constant use. It reminded him of his days as a medic in Korea. That was all over, a long time now. And yet, without that experience he

probably would not now be on his way to meet his future fellow workers in the Christian and Missionary Alliance. Joe would soon see the School and the Retreat Center they were running in Dalat. He would visit the clinics CMA had begun to set up for tribal villagers in the surrounding mountains—his first professional activity in months and the fulfillment of his long-ago dream to come back to the East and practice tropical medicine.

So what would he find? Dysenteries certainly, malarial fevers, skin diseases, perhaps even cases of cholera or plague, and leprosy. He wondered if tribespeople had emotional and mental diseases as well? Hands on his bag and the tools of his trade, Joe thought about healing—that mysterious energy, the force of life, how to encourage and cooperate with it.

Also important was what these missionaries were like. Would they easily accept him along with his ideas about holistic medicine, or would they be stiff and resisting? Maybe his lack of their kind of sectarian religious training would disqualify him for service in their eyes. Soon he would know. In spite of the uncertainty, Joe's spirits lifted on a surprising feeling, like Christmas eve. He had better beware of exaggerated expectations. Christmas, in April, in the tropics? Never mind, whatever happened would be an adventure.

He leaned close to the little window again as they began their descent in a long slow circle. Joe could see a highway in the distance where a blue toy van was twisting its way along. He got Yen to look too, and she shouted in his ear that it was the highway up to Dalat from the coast, from Phan Rang.

Way down below, the blue van had *Tin-Lanh Bap-Tit* (Baptist Church) painted on its side in bold letters. Inside it, as they bounced along the narrow, increasingly curvy road, Charleen Tyson swallowed and found the courage to say to her husband, "Hank, you know, if I'd realized being a missionary would mean giving up our children, maybe I wouldn't have been one!"

The Reverend Henry Tyson surveyed the landscape sheering away on his left, while he firmly and steadily turned the wheel with the shoulder of the mountain. "Charleen, honey, we didn't *have* any children back then, when we decided to give everything to the Lord. Heck, we weren't even married yet. But I doubt very much if you would have decided on me—why, you'd hardly let me kiss you—unless I was committed to the Lord and this work."

She frowned a little, nibbling on a rosy thumb. "All that was back then, but now we are missionaries, and now we do have Gary and Beth and Amanda. I just can't feel satisfied about sending our own children away up

here to school. I'd still rather just go on teaching them myself—tiresome as it is!"

Hank stopped keeping a wary eye out for VC ambushes and asked the Lord for patience. "Now Charleen, we've gone over this whole thing so many times. We've prayed about it. And we know the kids need friends from other missionary families. They're getting bigger and harder to control. They need education that you and I can't give them, which they would have if we were living back home. And most of all, honey, you know the main thing is that I need you, and the Lord needs you, to get this new church started in Nhatrang. It's different for the CMA. They've been out here so long, they've even got Vietnamese pastors in most churches. We Baptists have been here such a short time. It's going to take all our combined energies to prove ourselves in the Lord's work!"

Charleen looked flushed. She was close to tears. That was one thing she had always especially liked about being missionaries. You both took on the job; you were partners. Of course she knew perfectly well that sending the children to Dalat was the right thing to do. She was at her wits' end trying to keep up with their extension courses *and* all the million things in the house and the church, church music, Bible school, Vietnamese language study. And every night Hank brought home new Vietnamese friends, possible Christians. He was so outgoing, he picked them up right on the beach. And they were so fascinated, they looked like never going home, no matter what time it was. And of course they had to eat! Not to mention all those newly arriving lonely American military advisers who were also attracted to them, their church, and their home. It was really demanding work.

But to send the children away! Gary was only twelve, Beth ten, and Mandy eight. She just wondered if life would be worth living without her own kids. Charleen wiped her eyes. "Well," she said, "when you promise your life to the Lord, He really takes you at your word."

Hank patted her knee covered by the new flowered dress she had made herself for the trip. "It's tough, but I know we can do it if we have to, Charleen. Look how brave you are about going into villages where the Viet Cong are known to come. You really do trust the Lord."

Charleen sniffed a little. "Oh well, dying is one thing, but giving up your children...."

"Now look," Hank said, "we're not even sure yet that we're going to do it. Remember, our plan was just to visit the Gordons and look at the school and catch a little holiday together. Do you think you could put off worrying

over it too much until we get there and see what it's like? Why, maybe it won't even happen."

Charleen longed to say, "Fat chance!" and felt ashamed of herself. But the arguments for it made such good sense, what hope did her feelings have against all that practical reasoning? She sighed, thinking of Gary, who even fought against going to church nowadays, and when Hank wasn't around, she had trouble getting him to mind her, much less study.

And Beth, their pride and joy, who had already made her own decision for the Lord, gone right up to the altar by herself when she was only seven, just a little thing, why Beth didn't seem like her own child anymore. Sometimes now she would lie on the bed for ages doing nothing, off somewhere. Maybe all that thinking and dreaming wasn't good for a child. If some of her own daydream memories were any indication, that was just encouragement for the devil!

Well, couldn't she at least keep her youngest? In honesty, Charleen had to face it; precious little Mandy was even more of a handful than the other two from the first. Too pretty, too teasing, too much the baby. She could get around her Daddy just by crying. It seemed as though your children never could be controlled, they could just be loved.

Charleen said, "The trouble with God is, He's always right. You know, it's hard to love somebody who's always right—it's too mean."

Hank took his hand off the wheel, put his arm around her warm plump shoulders and gave a squeeze. "Come on, honey, cheer up. We've been looking forward to this little holiday for a long time. Let's try to enjoy ourselves some, huh?"

Hank really was being nice. Of course, he didn't *care* like she did. But he was noticing how she felt, now, in the car, when he was far away from all his demanding church people. After all, he could have pronounced right out loud what she was trying not to think, "If thy right hand offend thee...."

Charleen felt grateful. "All right, honey, I'll try. Truly I will. Let's see what it's like in Dalat first. Everybody says it's a really pretty place, and goodness knows we deserve a little break in our routine. I'm glad the school is up here and not back in Saigon in all that heat!" Feeling the mountain shadow fall across her knees, she admired the roses and daisies on her new cotton dress. It was a right pretty print, if it had come in the missionary box!

So Hank was free to think about their colleagues in Dalat. He had met Bob Gordon and his wife, Amelia, some months ago at a conference in Saigon. The CMA missionary seemed to him very kind, rather low-key, not

exactly dynamic, but then, he was getting on in years, late fifties probably. Everybody loved and respected him—of course, he and his wife had been out here a long time. They had even been in a Jap prison camp.

A sudden movement on the high rock just ahead caught Hank's attention. Nothing but a big turkey buzzard slowly flapping away.

Charleen was smiling at him. "Hank, I think you're nervous about the VC too! I don't believe for a minute they pay any attention to what's written on a vehicle. And if they do read it, I doubt if they care about sparing missionaries. Maybe just the opposite."

"A lot of their experience has been with Roman Catholics. If they care about their country, they ought to respect Christian Baptists who come out here to work with the Vietnamese people and help them, rather than the government."

"Well," Charleen declared, "I wouldn't like to get in an argument with them about the difference between Baptists and Catholics. I just hope and pray the VC along here do their traveling at night."

The Viet Cong agent, Bui Tang, that same morning was about to leave Saigon for Dalat on a public vehicle, jammed with people inside, and piled with their bicycles, fruit, and other belongings on the roof. In near silence the young barber had walked his guest to the bus station beside the Central Market. Tam was irritated. He felt Tang's noncommunication as a lack of confidence in him. What had happened at the midnight interview, which he himself had arranged? Would he ever know? The young man glanced sideways. Results must have been negative, since his visitor's mood was like a banked fire, smoldering. But why had it been all talk and no action?

Late last night, almost running after this tight-lipped man as he stalked away from the Colonel's villa, Tam finally managed to get his attention with the story of Chi Hai's Madame Giraud and her arrogant imperialist behavior. He suggested, somewhat breathlessly, that the Party had an excellent opportunity today to right a wrong, for Madame would be extremely vulnerable to accident or ambush on the road to Dalat in the gray Peugeot of her American capitalist friend. The older man had even stopped, seeming to listen, subjecting Tam under a street light to the merciless scrutiny of his half-closed eyes. But who could tell if he would act?

And so the barber wondered in vain whether the agent had understood about Madame Giraud, had taken matters in hand, made secret phone calls, or sent ahead radio messages to arrange an ambush. Tam had little idea how

these things were managed. His cautious inquiries about this, as about the midnight meeting, were left to die unanswered. In the end, Tam felt nothing but relief to see the last of the important person, and turned away politely, carefully, trying not to show hurry, as though planting a time bomb with a lighted fuse on the overcrowded vehicle.

In order to mount the bus, Bui Tang was forced to step over and around baskets of squawking chickens, piles of bananas. Pushing his way firmly through the bodies in the aisle, he directed a woman with two small children to move over and take both of them on her lap, making room for him in the outside seat. Ignoring her sullen stare in the stifling wait for the bus to start, Tang continued his review of the meeting with Thanh. He was not worried about his own anger, which they were often reminded to keep alive. He was considering how best to present his performance of the whole mission to the cell, above all to Kiem, of the clear-cut profile, cool objectivity, and self-righteous idealism.

Bui Tang was tired now of the dream which had possessed him, and of all his efforts to make it real. This Province Chief would never, nor *should* he ever, be captured for the Cause. At least he had found out that much. But now, thoroughly fed up with Saigon and the impossibility of getting things to go as planned, sitting there on the bus in the sweltering stench of humanity, Tang gave in to a doubt. For just a moment he wondered if he was really a part of some wave of the future which could organize and unify in one great Struggle all these willful, pushy, demanding individuals. He was scarcely able to endure, much less master, the erratic human element, the irrational, the unexpected. Somehow the Colonel had completely escaped him, even though many of his crazy comments remained, burnt into Tang's brain. Thanh's murder, he thought with pleasure, would certainly offer a way out. And yet, he guessed, furious with himself, the loss would pain, like the death of a very irritating old friend!

Thanks to all the powers, at last the unmentionable bus began to roll forward...until the passengers were flung together suddenly by a hideous jolt. A little blue Simca full of Americans had dodged into the right of way and forced the swearing bus driver to shove on his brakes, stalling the motor.

In spite of the cries and heavy honking in the rear, Jeff Gregory, intent on getting out of Saigon, never noticed. The boys and Kate looked back to laugh, until she tried to imagine what it would be like to ride all the way on a bus like that, jam-packed with humanity. Feeling moody, Kate decided that

most of the passengers were happier about going to Dalat than she was. For one thing, she'd have the two older boys to look after for the whole weekend in a place where their behavior would be continually observed. Mrs. St. John had sons of her own, and probably knew just how boys should be raised. Still, in her dis-ease, Katherine thought it might be better to go someplace than stay home.

Was there any possibility of fun? Clay DeWitt wouldn't be up there to create excitement; she knew he had other plans. Joe Ruffin had said something about going to Dalat this weekend. However, he would surely hang out with his missionary friends, and they would never meet. So far there had been no chance to tell Joe of her new arrangement for Phuong, about this Vietnamese family she had once helped, who had agreed to take him into their home for a trial period. She was hoping against her doubts that this could be a way out for Phuong.

As for Dalat, Kate simply wasn't in the mood for a protocol holiday at the Ambassador's villa, and felt all the more irritated to find herself traveling up there anyway. Jeff had reminded her that having been on the waiting list for quite a while, they shouldn't let the chance slip when it came. Chance for what? Kate knew that Jeff planned to enjoy himself and also profit workwise by sharing a whole weekend with the St. Johns and their political guests. He would lap up the conversation, as invigorating to him as the cooler weather. She herself could have a little fun arguing with the Ambassador, but that would make Jeff furious. The outlook was bleak. Closed into the car, she felt larger than life, too wild or too strange in some way for the little Simca, her husband, her family, her life! He, on the other hand, seemed unusually relaxed, delighted to be getting away so early on a Friday.

Mark Gardiner was early, too, when he came to pick up Allison and her children. Incredibly, they were almost ready for him, and he took it as a good omen for the weekend. Katrine and James, neatly turned out in clean shorts, shirts, and sandals, climbed excitedly into the back, waving goodbye to their Amah, who seemed absurdly anxious and weepy for such a brief holiday separation.

"What's wrong with your Amah?" Mark asked, helping Allison in.

She looked embarrassed. When he had come around to the driver's seat, settled himself in, and was still raising an inquiring eyebrow, Allison said, "I'm afraid Chi Nam is the worrying type."

Not too concerned about the maid, Mark stopped to take a long look at Allison before turning the key. She was beautifully groomed, as always. Still there were shadows penciled on that fine white skin under her gray-green eyes. This weekend away together was a damned good idea.

Mark drove the Peugeot smoothly and surely out of the city over the Saigon River bridge and into the flat green countryside, softly squared by rice paddies. For a while Allison watched him weaving the car between oxcarts and over-burdened buses, bicycles, and motor cyclos.

"How well you drive in this traffic!" she said. "Would you like me to spell you later on?"

"Thanks, Allison." He flashed her an absent smile. "It's not really that much of a run, around a hundred and eighty miles."

On these roads that added up to a lot of kilometers, and five or six hours maybe. But he would enjoy it all, Allison thought. Her driving might only make him nervous. She rested the back of her hand against a painful little spot in the center of her forehead. So much can be decided by this weekend, if I measure up. Since she had lost her temper with Chi Hai in that uncontrolled way, she was no longer sure what she might do. Feeling Mark's occasional glance, Allison sat up straighter in her gray linen dress. A little blow-up with Chi Hai wasn't the end of the world! Lots of people feel edgy this time of year in the gradual build-up of powerful heat and humidity before the rains.

"Why so quiet, you two?" Mark asked the back seat. "What are you plotting?"

"*I'm* reading," Katrine replied with dignity.

"How she can read in the car...." Her mother glanced back at the glossy brown head with its two braids bent over *Riders of the Purple Sage*.

Mark laughed. "Mind over stomach, huh Katrine?"

Blue eyes were lifted from the page. "I always can do whatever I want to."

"I don't doubt it," Mark grinned, winking at Allison. "And what's with you back there, Jamie?"

"Well, I have this project, see?" Six-year-old James sounded excited. "Every time we pass a marker, I'm writing it on this little pad, see? I'm keeping track of how many kilometers to Dalat, and how far we've gone already!" James was blonder than Katrine and not as sturdy. His dark eyes peered out, anxiously intent, under tumbled light curls.

"That's great." Mark shifted into fourth gear. "Keep me posted how we're doing."

"Two hundred and twenty kilometers to Dalat, Mr. Mark! Two hundred and.... Now here comes another—two hundred and nineteen now, Mr. Mark, two hundred and nineteen!"

The children had hit on that name for Mark and it had stuck. He was really nice to them. With cheerful determination Allison looked out at the thatched farmhouses set deep in their fat green gardens of pineapple and banana and papaya. Palms sprang from the corners of the fields in bursts against the shimmering horizon.

"I love palm trees, Mark. Don't you think they look something like green comets, snatched back to earth by the tail just before they zoom off?"

Mark smiled. "A weird thought. I'm looking forward to some pine trees right now!"

"Me too!" shouted James from behind.

"Let's just hope we live to see a pine tree!" was Katrine's remark in her most adult voice. She looks like an eight-year-old, her mother thought; saucy round face, turned-up nose, and ginger pigtails. Allison knew very well what Katrine meant about living to see a pine tree.

Mark, however, frowned in a puzzled way as he stopped the car behind an open truck full of helmeted ARVN soldiers in camouflage battle dress, waiting under the sun for the on-coming traffic to cross a one-way bridge. Switching off the ignition, he turned with a whimsical look from the stolid, staring soldiers toward Allison.

"Katrine," he said over his shoulder, "I checked with Security yesterday and got a green light for driving up today. I think you can count on seeing a few pine trees, that is if we ever get across this bridge. I don't know how this country would function in a real war, with these totally inadequate roads and bridges."

As the beggars and peddlers began to swarm around the lined-up cars, Allison turned her back to the window, to the eagerly held-up crutches and stumps, to the juicy bits of sugar cane on bamboo slivers, the sections of *pamplemousse* on banana leaves, offered for sale, and to the flies. She told the children what they already knew—they couldn't have any. James and Katrine began to fight with each other over closing the window or leaving it open.

Allison said, "James Giraud, you know better than to touch that sugar cane! Close your window until we start."

"I'll suffocate and die!" But he rolled up the window, never taking his eyes off the face of the grinning beggar nearest the glass. James shook his head and shrugged his shoulders—no hope.

Allison saw Mark checking James in the rear view mirror. Then his steady blue gaze, intensified by his glasses, met hers. "What's with Katrine?" he asked. "Any particular reason why we shouldn't make it to Dalat?"

"Oh, Nam was full of stories yesterday about new threats from the Viet Cong, tried to persuade me not to go. I had to be quite cross with her." It was a light remark over an inner shiver. "Katrine is just being melodramatic."

"But it wasn't just Nam, Mister Mark," the little girl put both hands on the back of his seat, eager to explain. "Chi Hai came in this morning crying and all upset because Mummie had been bad to her, so Chi Hai told her Monsieur how bad Mummie was. Her Monsieur is very important, and he's going to get the Viet Cong to capture us all in an ambush on the way to Dalat!"

"That would certainly be a lesson to your Mummie!" Mark grinned. "Hey, this looks like being a pretty exciting weekend!" He stretched his muscular arms in their rolled-back blue shirt sleeves. "Scared, Allison?"

She glanced away from the attraction of him, from the golden hairs on his sun-reddened, solid forearms. He could be such a turn-on. But what if she should answer his teasing with her real fears?

"I'm just hot, as usual," and Allison smiled somehow.

Mark got out of the car to look impatiently ahead up the line of cars. "Nam may be exaggerating," he said as he got back in, "but I'm afraid she's not entirely wrong. Like these poor folks," he gestured at those still besieging the car, "we are going to have the Viet Cong with us for some time to come."

"What does Viet Cong mean?" Katrine inquired.

"It's short for *Viet Nam Cong San,* meaning Vietnamese Communist, and for the life of me, I can't see, if you are one, why you would object to the name."

"Do they object?" asked Allison.

"Robinson, the NBC correspondent, says a Vietnamese can be shot if he uses Viet Cong in referring to them. And I've also heard my friends in the military say, if they ever capture you, don't use the term Viet Cong or VC in talking to them. They don't like it!"

"But, Mark, I should think, once you were captured, you would have had it anyway."

"Not necessarily. Quite a few people have been ransomed so far, those two Australians most recently." He grinned at Allison's worried face. "You'd do best to pass yourself off as French."

"We *are* French!" Katrine said, leaning forward, crossing her arms on the front seat.

"Not me," James was scornful. "We can choose, and I choose American!"

"Well," Mark began, "we are none of us about to be captured. Foreigners are not the target of the VC at present. The ones they fear most are the potential leaders of South Vietnam, like hamlet chiefs, priests, teachers, public health workers throughout the provinces." He lowered his voice. "If they can steadily wipe out the natural leaders in this country, they will have inflicted a terrible loss on the South."

Allison stirred, recrossing her damp legs.

Mark's hand reached to cover hers in her lap. "I'm glad you decided to come in spite of what Nam said." He gave the three of them a warm smile. "And this is going to be a really great weekend! That is if these cars ever move!"

Getting Higher

There they were in the middle of the twentieth century on a tarmac road with bows and arrows and bare behinds and serious expressions.

Andrew Graham, Interval in Indochina

Motors ahead began to start up. Mark turned the key and shifted into first. "We're off, and we'll soon be up where it's high and cool!"

"Well, I don't know...." Katrine was still in doubt.

"It's going to be great!" Mark said while Allison thought how much she liked that sureness of his, making things right in a world of uncertainties. The road ahead was becoming familiar. Once, the way home had been like this, tunneling through the mottled shade of a rubber plantation where lines of trees filed off on both sides in a green twilight.

As they drove further into the dimness of the regimented rubber trees, Mark suddenly remembered that Allison and her husband had lived together on just such a plantation. Maxim Giraud had been the manager of a Michelin estate.

"What was it like living on a place like this, boring?"

"Not at first," she said, startled. "At first we used to think we were never alone enough. The social life in those days among the planters was very gay. I had lots of fun decorating the big house. It had wide verandas and plenty of ceiling fans. There were house parties and bridge and tennis tournaments. We had our own pool, and sometimes went skinny-dipping! We danced, we rode horseback. I could manage elegant dinner parties because I could even order from Saigon. The importer's delivery truck from the Rue Catinat came sixty kilometers twice a week!"

"You were happy." Mark looked straight ahead.

Well I was! Allison remembered with surprise. She hadn't managed her

hostess role too badly for a young bride. And we laughed at everything like children. Maxim's awful negative humor was such a refreshing antidote to her southern upbringing! What a relief and pleasure being married to someone so uncritical. Allison could always see in his merry brown eyes that he reveled in her just as she was. Once he had called her *"La Reine des Hévéars,"* the Queen of the Rubber Trees. Oh Max!

"Aren't French husbands somewhat arrogant and overbearing?"

"Max took charge." Allison smiled. He had certainly liked having his own way. But that was no real problem, since, living with her mother, Allison had always found it easier to "go along" whenever possible.

"Where did you first meet him?" Mark's hands were steady on the wheel.

"We were students together in Paris. He was in graduate school getting a business degree. I was mostly studying French and French literature." Where had she ever found the courage to leave Sweet Briar College after her second year to study abroad? It had been wonderful to get away! Every single thing was new and strange, especially feeling beautiful and loved. Together she and Max had tasted all the sensations, greedily or slowly, and Allison was glad to leave to Maxim's common sense any serious decisions, like getting married, or coming out to Indochina.

"So I never went back," she said.

"You found your great adventure." The gray rubber trees flipped steadily past. "Eventually did the life out here become boring?"

Allison cleared her throat. "After the second baby, I liked it better in Saigon. There was more going on...." Three young men had been in love with her. The French Ambassador himself always wanted the Girauds for his parties, arranging that Allison should be seated across from him, daring her to read what his black, black eyes might be saying across a lifted glass.

And so, like a coward, she had let Max make the last decision too, when danger outside from the Viet Minh grew more threatening, when the French, incredibly, seemed to be losing the war.

"Now wouldn't it be silly, *chérie*, for you to stay here courageous and devoted in the country with me, when you could all be safe—and happy—in Saigon?" Maxim's brown eyes had twinkled with pride. Of course he knew about the admirers.

"I'll come in nearly every weekend to put you in your proper place, don't worry!" And he had come, as long as he could.

With the old tightness gripping her diaphragm, Allison forgot Mark. Hadn't she kept telling herself that it spared Max anxiety to have his family

safe in Saigon? No one had looked out for his safety. Alone he was shot, routinely inspecting the trees, with his familiar intent frown, from the old jeep. And so her own husband became one of the statistics you read about in the newspapers: "In South Vietnam ample use is being made of terror and assassinations of key figures within and without the government."

She remembered protesting, "but Max *had* no political convictions." Nor really any particular convictions at all, she thought. "And he was tremendously well-liked in the rubber community, in the countryside."

People only shook their heads. "Perhaps he was too well-liked," they suggested. "Or he may have refused the Viet Minh something, some tax he may have thought exorbitant. No one will ever know." She could see they considered him some kind of martyr to his duty. Fun-loving Max? Maybe I never really knew him at all.

And Allison wondered if she even knew herself. Since Max decided for us both, why do I feel this endless guilt, convicted over and over again for my failure to *do* anything? Is there some secret person inside me, close kin to my mother, who believes in action, who deplores weak surrender? Just suppose we were ambushed, right this minute, as Katrine seems to hope, would I do anything to save my children? Or would I just...?

The sharp inner pain brought Allison back to the surface. Tactful of Mark to allow her the privacy of her own thoughts. However, she was thankful when the gray rubber trunks thinned, and they burst out into the power of the sun again. Katrine and James began to count the Roman Catholic churches built by resettled North Vietnamese refugees after 1954. An elaborate, pastel-colored church rose out of the huddled thatched huts along the roadside every few kilometers.

"Impractical, aren't they? One or two of those splendid pink churches would have done for the lot, at a considerable saving! But—are you a Catholic, Allison?" Mark looked surprised that he hadn't thought to ask before.

"The children are. I don't suppose I'm—anything. How about you?"

"My mother and father are Unitarians. Father finds it enormously stimulating. Intellectual discussions, writing things for the Beacon Press. I go to church with them occasionally when I'm at home. It's good neutral ground." They were passing the blasted shell of a once-pink church, and he glanced at it briefly. "Viet Cong."

"The churches here are not very neutral—more like fortresses against the Communists." It was the truth, Allison thought. "Some of the priests are quite...brave."

Mark nodded. "Extremists though. They almost seem to run toward their cruel destiny at times. Unnecessarily, perhaps."

"You may be right." She frowned a little, remembering the astonishment of the good Father Maurice at her unexpected stubbornness after Maxim's death. The Catholic funeral for Max she had conceded; interference about herself she had firmly discouraged. The only God Allison had ever met was her mother's bossy, intolerant Methodist one. From what she had heard, the Catholic God was not very different. So how could she share her honest feelings with a man of such a God? Impossible to put into words and hold up for his judgment those lovely "magic days" that she used to think had something to do with religion. And how could she tell a priest that what she frantically missed was the dear smell of Max, which was already beginning to fade from his clothes? Allison saw again the disappointment in the priest's flower-blue eyes, hot as he must have been in his long brown beard, that heavy brown serge cassock. Irrational attire for such a climate; irrational patience and understanding which had suddenly filled the deep blue of his eyes.

Allison looked up out of her uncomfortable memories, only to find a real present-day funeral just ahead. They were following an open army vehicle with four expressionless soldiers in uniform, seated facing each other across fixed bayonets. Between them on the bed of the jostling truck a coffin had been placed, under the orange-and-red flag of South Vietnam. And just inside the tailgate, squatting in unmilitary fashion, was a barefooted village woman with seamed brown face and laundered white tunic, patiently trying to hold down from the wind the bright flag flapping on her boy's coffin.

Neither Mark nor Allison commented. One glance and the picture was forever. Looking back Allison saw Katrine still absorbed in her book, while James had slipped into a nap in the seat corner. Mark put the truck behind them as soon as they came to an even stretch, entering the jungle. Allison stirred restlessly, unable to avoid the tangled vines of her thoughts. Set apart in the fast-moving car, still their ears were assailed by bird calls and the rising, throbbing friction of insects.

"The jungle is even more noisy than the city." She heard her own laugh, light as breaking glass and just as ineffective, curtained as they were in the scraping of millions of cicadas like the buzzing roar of a saw mill. The jungle rose, hot and steamy, towering close at each side of the narrow little road. Stifled, Allison even longed for something to happen! But only delicate flights of butterflies began to crowd the air through which they broke in Mark's car. An ambush of butterflies.

Crossly, James woke up, peering through the swarm of yellow wings. "There's another marker, Katrine! But I can't make it out; one hundred and what, Katrine? Mummie, *now* how many kilometers to Dalat?"

Blessedly James had missed quite a few markers in the last hour. Without thought Allison turned on the back seat. "James Giraud, will you shut up this minute with your everlasting kilometers? I don't want to hear another word out of either of you until I tell you. Let's have a little peace, okay?" In surprised silence they plowed on through fluttering butterfly wings, plastered against the windshield and then whipped off, leaving only yellow dust.

Mark lifted an eyebrow without taking his eyes from the flickering two-lane road. "It's okay, Allison."

She reached for dark glasses and put them on to hide the sudden tears. Through their dimming shield Allison stared at the cloud of yellow wings— some fluttering right into destruction, masses of others accidentally missed, lifting and falling in their aimless way on the surfaces of air.

"They seem so futile and silly." She had to clear her throat again.

"Probably migrating," Mark said. "Did you know that Southeast Asia is something of an insect melting pot? Think of everything it offers them; a tropical climate, rich vegetation, and all this at the crossroads between Asia, Africa, and Australia. I've heard there are more different species of insect here per square mile than in any other area of the world!"

Horrors! Allison couldn't think of a word to say. If they were migrating, what kind of a change could they possibly find in the thick hot reaches of the jungle? Were they trying for the mountains too? Were they mating? No, she decided, they are just fluttering foolishly about, looking pretty, doing nothing of any importance, always on the surface, easily destroyed. There, the next thing, I'll be snarling at the butterflies the way I snapped at the children. What a dreadful mother I am, what a stupid traveling companion!

Only a few inches from Mark's muscular body, she was almost afraid to look at him, his firm mouth, keen light-blue eyes, tall forehead, and springing sandy hair. Even his glasses seemed sensible, strong, and right. Could Mark possibly save her from this strange inner disquiet? What if she should suddenly burst out, "Oh Mark, I'm so fed up. I don't like myself; yesterday I actually hit my maid in the face!"

That would be madness, and she remembered Chi Hai's resentful threat, "One day Madame *beaucoup* cry, Monsieur no come back!" It had already happened once. Allison held her hands tight in her lap, trying to restrain her thoughts, terrified of letting go. Maybe she was going crazy. Madeleine

would certainly say so, if she blew her chances with Mark. Best to do nothing, just look out of the window.

And when she did, Allison saw with relief tall bamboo clinging to ever steeper slopes, changing to mountain walls. The Peugeot was at last climbing out of the jungle. Something had to give. Max would probably say, with Madeleine, that all she needed was to choose the right man and marry again. However, Allison was feeling a little angry with Max. Lately he seemed to have retreated to some far haven beyond death where earthly problems never penetrate the peace.

Her mother would thoroughly approve of her marrying Mark Gardiner, if he would have her. In the old days that would have been enough to kill the possibility. But then she had been innocent, dreamy, and daring. Now Allison was acquainted with life and death, knew fear. Qualities like good character, excellent brain, ambition to wield power where it would count for something, these traits suddenly looked valuable, even though she knew Mark paid for them with tension, an occasional headache. Maxim had been ambitious and energetic too, but with a lazy breadth, and relaxed humor— and a horrid temper! She smiled wistfully.

Never mind. The important thing now was to think of her children, hiding the shock of their father's violent death, yet frantic when she left them for more than a few hours. Sometimes in the night she panicked herself, wondering what would become of Katrine and James if anything should happen to her. What a sober word security was. "Monsieur Gardeenair is too serious for Madame!"

Well, he is serious. And he's very careful about what we "ought" to do. What's wrong with that? Couldn't I seduce Mark into more relaxed ways once we were married? A future as Mrs. Gardiner of the American Embassy was one she could handle, actually because it would be pretty much the same. The dry season had lasted too long.

But suddenly, incredibly, her bare arm on the window sill felt the power of the sun weakening. And then she saw a tree fern. Why does something miniature translated exactly into something big seem fascinating? If you stand under the huge fronds, you feel like *Alice in Wonderland* after she had shrunk small enough to creep through the keyhole into the magic garden.

Allison tried for a flash of her old joy. "Children look, there are the tree ferns Mummie always loved! Don't you remember the tree ferns?"

They peered down into the green chasm filled with funny elemental trees. James, reassured, began to beat on her back as he sang *"Joli tambour"* off key.

Up they came, out of the jungle and onto the broad consolation of the high plateau country. Spread out all around were the rolling plantations, neatly planted with rounded tea shrubs. Cloud shadows dropped and ran over the hillsides like dark water.

"Mummie, I'm hungry! Let's have the picnic now!" James implored.

"Wait for Mark to say where." Allison felt lighter, refreshed.

"Well, I had thought of Bobla Waterfall." She knew he would have thought. So they had their lunch in the shade at the edge of a leafy drop from which they saw across a valley the snowy white of Thac Bobla plunging down. Katrine, of course, scouted around suspiciously for VC before she felt comfortable enough to sit.

"You're not taking me seriously about this ambush." The little girl looked over her shoulder, kneeling on the edge of the blanket.

Allison felt that a real attack might have been almost preferable to those inner confrontations on the lower road. "Yes, we are taking you seriously, dear." As her eyes met Mark's, she didn't laugh, but she wanted to for the first time that day. "It's just that Mark has already checked very carefully about security. Chi Hai was angry, and so she made some rash statements that probably aren't true." While Katrine considered this, her mother began to bite into a crisp-edged chicken breast, and found herself enjoying Mark's eloquence on tree ferns.

"They can only flourish in the rain forest," he said, looking into a sandwich to see what kind it was. "Here in the wet and the warm, many of our own temperate zone plants grow to giant size. Look around you, kids, ferns here have woody trunks and stand fifteen to twenty feet tall. There is even a giant kind of grass, bamboo!" He gestured with his bitten sandwich down into the valley, feathered with bamboo, receiving the waterfall into its soft depths. "Here stands the forest, millions of years old, a dark place of warmth and mystery. Here we sit, Katrine and James, very small on the edge of the forest floor." He grinned. "We are dwarfed by giants, like those primordial ferns."

James was fascinated, staring upward. "What's primordial, Mr. Mark?" Katrine asked for a hardboiled egg. Allison passed one over with a packet of salt.

"That means very, very old. Those are the plants that once formed huge jungles, millions of years before any of the modern plants and trees evolved. Instead of reproducing by flowers and seeds, they produce tiny spores, and this is what sets them apart from the higher plants we see around us nowadays. You probably know all this, Allison."

She shook her head. Memories from botany class were faint.

"Well," Mark went on, "when we sit under the shaggy trunk of one of these monster ferns," he leaned against it, "and look up, then it's just as if we are transported back millions of years to a primordial world, the original paradise of innocence, the one we are supposed to have been cruelly driven out of."

"Why that's sad, and romantic," Allison said. Mark had his own version of *Alice* outside the magic garden.

To her further surprise, he leaned across to kiss her lightly, "Have you got any more of that chicken?"

And they went on up, all shouting together after another hour over the first pine tree. Once in a while on a ridge, they caught glimpses of the mountain people, the Moi tribesmen whom the French call *Montagnards*. They are almost black, often stunted-looking, the men wearing loincloths and carrying bows, the women with their breasts bare. These small primitive people, proud, at home in their hills, exchanged curious glances with the foreigners, passing in their machine.

"Oh, Mummie," cried James, "could I have a bow like that, could I?"

"With poisoned arrows!" his gleeful sister added.

Mark grinned back at her. "Wouldn't you like a handsome basket instead, the kind they carry their babies in?" Katrine sniffed. "Let's pay a visit to the market while we're here, maybe Saturday morning, and see what we can find." He was shifting back into third.

By this time they were finally climbing the mountain where Dalat lay, five thousand feet above sea level, Mark said. Allison felt light energy stirring in her veins. The last ten kilometers they wound steeply in second gear through hemlocks and pines with flashing views from the curves across space to other blue-green mountains. While Allison was happily reaching for sweaters to put on the children, she thought: in Dalat I will know. Max and I were here together plenty of times. Up here I will stop thinking and remember what it's like to be passionately in love!

They rolled through the town of Dalat along the broad, familiar boulevard, passing the chalk-tinted chalets, set in their pines and wild bright flowers, the lake below reflecting circled mountains like a miniature Geneva.

She heard Mark say, "The villa belonging to the Embassy is on top of another small mountain. Just wait 'til you see, Allison; it's pure Charles Addams!"

And she laughed, drenched through body and spirit with the ice-cool air.

In a few minutes they were turning into a drive between wooden posts where an old sign read faintly, "Property of the United States Government." Rocky ruts twisted through pine woods. That was all. Not even a security guard.

"Look, James," Katrine murmured, "that ditch, like a horseshoe in the pine needles; it's the very place to make our fort! We'll take turns watching for tigers, of course." Mark and Allison exchanged a look. Everyone was expecting great things from Dalat.

"I believe the Ambassador actually got his first and only tiger not too far from here." Mark seemed to know what city children would like to hear.

"Wait, I see some American children," said James. "I can tell by their blue jeans." Katrine peered anxiously. Tigers were one thing.

The car circled in front of a queer, tall house at the very top, set down brazenly on a great clearing of brown and treeless lawn.

"Mark, you are so right; Charles Addams was here! Is it haunted?" And Allison looked about for the monster or the lady with long black hair.

Turning off the ignition, he squinted up at the gables and turrets and chimneys, sharp and clear in the early afternoon sunshine. "We'll soon know."

Katrine was the first to get out. She stood staring around her in incredulous disappointment. "We got here, safe and sound."

James got down beside her, relieved, but understanding. "Well, anyway, Katrine, it does look something like a haunted house, if only it wasn't so white."

Slipping out of the car, Allison had to tilt her chin to see all of the vertical Victorian mansion. "The mountain just wasn't tall enough for them, whoever they were. But it's all so quiet!"

"Siesta time." Opening the trunk Mark placed the bags in a neat row while he explained who "they" were. "In the good old colonial days, Madame Barbier, sister of the last Vietnamese Emperor, Bao Dai, married a Frenchman and built this house."

"Didn't Bao Dai and his family retire safely to the Riviera during the war with the Viet Minh?" Allison smoothed James's curly hair down and took both the children's hands.

Mark was thinking about Bao Dai. "He was pretty corrupt. I think his behavior may have been at least partly responsible for letting a puritanical, mandarin type like Diem get hold of the power."

Allison's French friends would say that American money had gotten him

the power. "Mark," Allison whispered, "look at the servants coming out! They go with the house exactly."

As they approached, Mark introduced the thin, haughty cook. Behind him was his heavy, somber wife and a moon-faced, doubtful "boyesse."

"Monsieur Gardeenair," the cook gave a very slight bow, more like a nod, "will have the center room on the second floor. Madame Giraud and the children have been placed on the third floor."

With the stepchildren and amahs, Allison thought on a tremble of hysteria. How young and silly I feel. It must be the altitude. As they entered the cold hall, darkly paneled, the cook was already disappearing with the large bag containing their whiskey and cigarettes. Would they ever see the stuff again?

"The servants are probably all Viet Cong," Allison murmured to Mark, who seemed not to have heard.

A broad staircase led in majesty to the second floor, where Mark put down his things in the center room back. However, to reach their own assigned place on the third, a door opened at the end of the second floor hall onto a back stair which climbed steeply from the pantry to the top of the house. This staircase looked almost dangerous in places where the matting had come loose. As she saw Katrine consider the winding banister, Allison warned the children sharply to keep away from it. Upstairs the third floor corridor was dim, made narrow by two great wardrobes, one on each side.

Their rooms were a surprise. Built under a much higher roof than the low-ceilinged hall, at right angles to it, they extended across the front of the house, opening onto a long porch to the west with gingerbread balconies at each end. The white bath in the center looked old-fashioned and comfortable. The maid put down the children's suitcase in a room with French windows to their balcony, blue beds, cozy with bright blankets (blankets!), small-sized chairs and table painted the same light blue, and a built-in cushioned seat in one corner. Over the fireplace was a dazzling color photograph of Switzerland, the Matterhorn.

Mark, who had followed, smiled at her pleasure. "I thought you'd like it."

"I love it!" Amazed, she went eagerly across to her room, where the high walls and ceiling were stark white. The curving furniture of teak and mahogany had been upholstered in old blue. There was an ancient chandelier, a cold marble fireplace beneath a vast mirror, and a great bed, the wall at its head hung with a faded tapestry. In the austere grandeur of the room, lit by the high French windows, Allison felt quickened and rested to the bone. Running out

to lean with both hands on the dry-flaking porch rail, she saw miles of pine woods reaching to distant mountains, Dalat's small lake glimmering far to the left under an endless sky. As she turned back to the pure room, hard and cold, new energy welled and sparkled up impatiently. Saigon, warm and swarming with complicated life, had been cut cleanly away, fallen far below.

Mark was saying, "I guess you and the children might like a little rest and time for unpacking. I've got some work I can do, a few papers to go over before the Ambassador arrives. But after siesta we could all take a hike to look around. Shall we say four, four-thirty; how does that sound?"

"Ummm, that would be...nice," she answered doubtfully, meeting the children's affronted gaze. Siesta? Unpacking? When Mark had gone, Allison returned to the bare porch hanging over space. To the right were the roofs of villas, like chalets, peeping over their pine cushioning. Down to the left, she caught a glimpse of a tennis court with a backboard. Mark had spoken about this school on the next property, a school for the children of American Protestant missionaries. Visitors at the Ambassador's villa were generously invited to use the playground if they wished.

Turning back, she saw through the open door that James and Katrine were already stuffing themselves into their mail-order blue jeans. "Mummie, if we sneak out quietly, may we start on our fort? Honest, we're not a bit tired."

Prepared for argument, Katrine looked surprised when her mother answered hastily, "All right. Now, Kat, you have a watch. Don't leave the villa grounds. Go quietly, and be back in your room by 4:30 or else!" She was already kneeling, opening her suitcase. "Isn't it lovely here?"

"What are you going to do, Mummie?" Katrine turned back, curious.

"I think maybe I'll hit a few balls down there for a while. This air makes you want to do something," and Allison sat down on the cold parquet with her socks and sneakers.

On the way out in her tennis dress she smiled with pleasure, sneaking down the rather treacherous back stairway, carrying her racket and balls. Outside the still house, following a path down through the trees, drawing in on eager breaths the scent of sun-warm pine needles, she thought with terror how short a weekend is. If only the return to Saigon was not Monday. Then her wandering glance came to rest on the far-folded mountains. "What you must do, Allison Giraud, is use the time wisely; decide to be a different, happier person; meditate!" She almost giggled. Anything might be possible up here.

There Is Another Land....

For affliction does not come from the dust,
nor does trouble sprout from the ground;
but man is born to trouble
as the sparks fly upward.

<div align="right">

The Book of Job, Chapter 5

</div>

The Province Chief's aircraft had been awaited in considerable tension by the personnel of the small airport below Dalat. As soon as Thanh stepped off the stairs, he was surrounded by local authorities anxious to explain or excuse the recent sabotage by Viet Cong of the supposedly secure area. Brushing through, unsmiling, the Colonel at once requested a tour of the damage, leaving his wife and the doctor to the obsequious attentions of an embarrassed Second Lieutenant. Mrs. Thanh wrinkled up her nose. Since the terminal building reeked of smoke, she asked for two chairs to be placed outside in the shade and for Coca-Cola to be brought.

"I'm sorry, Joe. When you travel with us, delays often happen."

"Don't worry; I haven't got a tight schedule. Anyway, this is big trouble." He looked around in amazement at the scorched concrete runways, the blackened remnants of vehicles and aircraft lying about at unusual angles, their paint blistered and flaking. Even outdoors the acrid smell was powerful.

"Do they know who's responsible?"

"In Saigon my husband was just informed that VC cadres had set many fires here, destroying some planes on the ground and part of some hangars and a piece of the terminal building, as you see." She pressed her lips together.

"Wow. This kind of thing is frightening."

"You are very right!" Yen turned to him in a rush, a suspicious shine in her eyes. "Of course we already knew that more and more of the men in

black are coming from the North into these mountains, trying to settle among tribes like the Koho and the Roglai, to get help from them. After we heard of the attack on the airport, we could not come up right away, because Thanh must wait for consultation with the President." She gave a sigh. "My husband is strong military man, also honest, very valuable. More probably that is why the President appoint my husband to be Province Chief here."

"It's hard on you," Joe said. "I don't see how you can help being worried all the time. Hearing rumors about the terror policy of the VC is one thing. It's something else when you see what they actually do!"

Their eyes took in the destruction around them. This is guerrilla war, Joe thought. War. His most painful memories from Korea had not faded. Who could forget the feeling of desperation that grows after a week of constant rain and nothing dry anywhere, the intense longing that could build up until a man would pay anything for a woman, or a glass of milk? There was the kid with a testicle burnt off by a trip flare moaning, "Oh, Lord, why couldn't it have happened to the man in front of me?" There was the fear that made your whole body tremble as you waited at night in the rain, tensed, listening for the Chinks, knowing that five wounded men looked to you to bring them out of it. Thanh would understand—if this was really war.

It was warm down at the airport level. Joe and Yen sat on in the diminishing shade, sipping tepid Coke, while the small, stocky figure of Colonel Thanh moved about the field in the distance, inspecting the mess, examining new security measures and listening to officials. Eventually from the terminal a black Mercedes sped out across the asphalt to pick up the Province Chief, returning at a noticeably more moderate speed for his wife and the American doctor. Thanh sat in silence up front with the driver. As the fine car left the airport and purred up the mountain road between dark hemlocks toward the town of Dalat, Joe tried to distract Yen with things medical, and he couldn't help smiling to see how quickly she warmed to the subject.

"Dr. Joe, it is ignorance and superstition which are causing the most of our health problems in Vietnam! For example, since many of our women believe it is 'bad' to be eating papaya in pregnancy, one of our best and cheapest sources of Vitamin C is lost for mother and baby through superstition! A worse example still, cause of terrible malnutrition in babies, is the idea of our mothers that it is 'good' and very modern not to nurse your child, but to give him some bottle, which they do not rightly know how to mix."

Joe had already seen many of the skeletal babies with swollen stomachs resulting from such "bottles."

"But it's very good there are trained nurses and social workers like you here in Vietnam, Yen. Things will change!" He had noticed she didn't accept praise easily.

So Yen drew his attention to the town, the dimpling lake, the bright flowers they were passing. It's another world, he thought. Then he looked at the silent solid back of the Colonel. To Thanh is this a battlefront? There should be only pleasantness in the cool high atmosphere of such a charming place.

When they turned into a driveway, Yen touched his arm, pointing out the school building, a long, attractive two-story house with many shining windows. Beds of begonias and geraniums were planted close to the yellow plaster walls. There were green shutters and a red-tiled roof, its eaves curling upward in Chinese fashion. The whole place had a friendly, peaceful look. However, they pulled up behind a police car, and the four in the Mercedes saw at once that some kind of intense drama was taking place on the front porch. More trouble?

At first the "actors" were too absorbed to notice their arrival. On the porch stood a Vietnamese police officer and his sergeant who seemed to be questioning an older couple, probably American, while a younger pair, with suitcases, looked on, puzzled, from the steps. The doors of their blue van, parked ahead of the police car, were still open.

The officer was requesting permission to search the premises. His passing glance toward the newly arrived car made him pause in mid-sentence. It was an official black Mercedes, and, to his amazement, his boss, the Province Chief, was getting out. Without another word the Police Chief hurried down the steps to greet Colonel Thanh, whose driver had rushed around the car too late to open the door.

Thanh bowed to the missionaries and the police. "We have arrived at some difficulty?" he inquired politely in English, while his chauffeur was opening the back door for Yen and Joe. Thanh introduced them to the surprised Police Chief and to the Reverend and Mrs. Robert Gordon of the CMA Mission School. Bob Gordon then, on his side, presented visiting missionaries from Nhatrang, the Reverend and Mrs. Henry Tyson. Joe looked at his possible colleagues with open interest.

"May I be of any assistance?" Thanh asked Gordon, a kind-looking gray-haired man with a slight stoop, whom the Province Chief seemed to know already.

Reverting to fluent Vietnamese Bob Gordon thanked him. "Perhaps the Chief of Police, Officer Dinh, would be good enough to explain. We are not

quite clear ourselves about what has occurred. But we are very happy to see you again, Colonel and Mrs. Thanh, and we much appreciate your bringing Dr. Ruffin up to us." He had an appealing smile.

"No trouble, our pleasure." Thanh turned an inquiring glance toward the Chief. "Officer Dinh?"

"My Colonel, there was an attempted murder yesterday evening in a small bar near the market. It seems that the bar woman, a Tonkinese, tried to stab one of her customers. The victim may have been aware that such an attack was likely. We don't know. Witnesses report that the man might have looked into a mirror opposite him behind the bar. He could have seen the reflection of the woman approaching from his rear. Anyway he pushed his chair over just as the woman flew at him with a knife! According to witnesses, the bar woman sprawled on the floor while the knife slid away under the tables to be recovered by a Japanese customer." Dinh stopped for breath.

Thanh was frowning. "This is very serious, Chief Inspector. Still, I do not see how such criminal matters can concern these American missionaries, who do not frequent our bars." He smiled.

Uncomfortable but dogged, Le Ba Dinh explained further. "The bar woman escaped. She has not yet been found. People who were questioned in the bar believe that she lives with a Christian tribesman here on the property of the Mission School. The tribesman's name is Rau."

Joe saw that Gordon was looking thoughtful. His bright-eyed wife spoke. "It is true that Pastor Rau lives on our grounds with his little girl, Drim. He is a widower, a Christian convert, and for a long time has helped us by doing wonderful evangelical work among the tribes. I don't know of any woman...." She paused.

Her husband said to Thanh, "Although we are not aware that such a woman is living here, I had just told Officer Dinh he is welcome to institute a search."

Dinh turned a poker face toward the Province Chief. "Of course, my Colonel, since these people are your friends, there can be no question...."

"Who is this man who was attacked in the bar?"

Dinh ran a finger around the inside of his collar. "The intended victim has also disappeared suddenly. We are not yet able to establish his identity, even though he has been regularly visiting the bar. We are working on this, and at any moment the information...."

Thanh interrupted him. "Chief Inspector, your conscientious efforts are

to be commended. However, this seems to be a crime which was *not* committed, by one person who has disappeared, upon another person who has disappeared. Since there can be no charge in such a case, in my opinion more information is necessary before we disturb these people with a search. I will personally take responsibility for the delay while some knowledge about the victim is obtained. If the victim should appear and charge the bar woman with assault, it may well be necessary to search here—with your permission of course, Reverend Gordon."

"We are available to help the police at any time." The missionary gestured with open hands.

Dismissed by Thanh, Dinh returned stiffly with the sergeant to his car and left. Joe thought the Chief of Police must be seething inside, thinking that, by the time he was allowed to search, the woman could be anywhere. Still, Joe had understood enough to realize that it was a sort of non-case.

Into the fresh quiet after the departure of the police car, some tension evaporated, conversation returned to English, and the Tysons carried their bags around the house to a nearby cottage. The Gordons came down the steps to welcome Joe and chat with the Thanhs.

The Province Chief looked about at the school building and the grounds. "It is very pleasant here," Thanh said.

"Thank you. And thank you very much, sir, for saving us the inconvenience of a search just as our guests arrive. Of course I will look into this story at once with Pastor Rau, and if I should learn anything about the woman...."

"Do not worry yourself, Reverend Gordon." Thanh returned to English. "The matter is for the police. And they will not come back unless more facts are found. But indeed, your kind help is always appreciated." He bowed slightly before changing the subject. "And how is your work among the tribesmen in these days? I understand Dr. Joe here will be helping you. Are you finding more trouble now with Viet Cong cadres infiltrating Moi villages?"

Hearing his name mentioned, Joe joined the Colonel and the missionary. Mrs. Gordon and Yen had moved away, already discussing the affairs of the school and the community.

"Well, there has been some—uh—interference, yes," Bob Gordon said. "We are certainly aware that more of these men in black pajamas are slipping through the mountain passes at will, and, uh," he cleared his throat, "showing up among us."

"There have been incidents?" the Colonel asked.

"Oh yes." Gordon had thrust his hands deep into the pockets of a shabby pair of trousers. "A few of our people have been stopped, have identified themselves as missionaries, and were treated to propaganda lectures before being released." Then he looked up. "One of our fellows was shot at recently."

Thanh frowned. "Was the man in a vehicle?"

Gordon nodded. "A Rover, clearly marked *'Tinh-Lanh,'* which, as you know, identifies our evangelical workers. This man stopped his car at once, got out, and looked toward the area the shot seemed to have come from. He says it was suddenly very quiet in the village street. So he shouted in Vietnamese, 'I am your friend and an evangelical missionary! I am not here to fight anybody, but to help everybody. Suppose you had killed me, what good would that have done? The people would only hate you, for they know my work. Next time you see me, don't act so foolishly!' Then he climbed back into the Rover and drove on."

Although the Colonel smiled, he shook his head. "A brave man, but the situation is dangerous. You are not afraid, Reverend Gordon?"

"Sure." The gray-haired man raised his eyebrows. "We are not hoping to die, though we do recognize the possibility." He glanced at Joe's attentive face. "There are worse things than going to heaven a few years ahead of your three score and ten."

"Your faith is strong, Reverend sir, which is admirable, but fear, terror, this is the strongest weapon of the guerrilla. It is a part of your life and mine now, as the air we breathe. Even if we should keep our own courage, can we keep the courage of those around us?" The two men were silent, thinking about the responsibilities of leadership which they had in common. Thanh moved first, to extend his hand before leaving.

"Colonel," Amelia Gordon broke in, touching his sleeve. "Won't you all stay to lunch? It's just a simple meal, but there's plenty, and we'd love to have you." She had a vividness which seemed to Joe in strong contrast with the gentle, subdued quality of her husband.

Thanh turned toward his wife. After exchanging a look with him, Yen thanked Mrs. Gordon and apologized for their not being able to stay. "I think my husband is expected right away at his office."

Bob Gordon said, "Colonel Thanh, before you go, I'd like to extend a belated invitation. As it happens, I've been trying to reach you in your office, so your unexpected arrival with Dr. Ruffin is an answer to prayer."

The Province Chief looked pleasantly blank. Gordon quickly explained

that a new church was being dedicated on the road out of Dalat. It would benefit both town and tribespeople. The presence of the Province Chief and Mrs. Thanh at the opening service on Sunday morning at 10:00 would greatly add to the celebration of all those who helped to build the church.

"The American Ambassador is here this weekend. We are hoping he will also lend his presence to the occasion, which is important politically as well as in a religious way. Since the government of South Vietnam has finally awarded citizenship to the mountain tribespeople, as you know, we in the CMA believe that our once separated Vietnamese and tribal churches should now be united."

Thanh said they would be happy to come. "I must only check with my office first and confirm this to you later in the day."

With bows, smiles, and handshakes the Thanhs began to leave. Bob Gordon had moved quietly to Mrs. Thanh's side. "Maybe we will see each other out at the camp. It's terribly overcrowded nowadays with the military dependents plus families still escaping from the North."

"Yes, of course, I was planning a visit anyway while we are here this time." They smiled at each other.

Joe helped Yen into the car. "Thank you both so much for everything. I guess I'll see you on Sunday then." He put a little extra pressure into his grip on Yen's hand, but when seated in back by her husband, she seemed to him only polite and somehow lost.

Joe turned back to the Gordons, as the car pulled away. "It looks as though I've arrived on a busy weekend." He was thinking of the sabotage at the airport and the police visit.

But Robert put a friendly hand on his shoulder. "A festive one, certainly. We are hoping you'll take part in our service of celebration to dedicate the new church."

"Thanks, I'd like to, if there's not too much talking," and he grinned. "I can still understand Vietnamese a lot better than I can speak it." Then he realized that part of the service would probably be in a tribal language.

A buzzer sounded. Charleen Tyson had already closed the door of their van and come up to join the others on the porch. At once they were surrounded by chattering children pouring out of classrooms. Charleen watched Mrs. Gordon kidding with the ones who ran up to her and thought, well, they all surely do look cheerful and healthy, and the place is as pretty as anything!

Aloud she said to Amelia, "There are so many. Are they all separated from their parents?"

Understanding the note in her voice, Amelia urged the slower boys and girls on toward lunch, before turning back to her visitor with sympathy. "Yes; one of the toughest things about being a missionary is sending your children away to school." She put her arm lightly around Charleen as they followed the men inside.

Lunch was a lively meal in a large room, shining with cleanliness and sunlight, humming with children's voices, clattering with their knives and forks. Robert Gordon had pronounced a blessing before the chairs were pulled out, he and his wife presiding at the head table.

"We eat lunch with the children," she said, "but in the evening we have dinner privately in our own quarters. Robert and I hope you will join us tonight." Dispensing large helpings of a hot casserole topped with cheese, she paused to offer the salad to Charleen Tyson with a smile.

The Reverend Hank Tyson was sitting on Mrs. Gordon's right. "Well," he began unfolding his napkin, "that was a very mysterious matter with the Police Chief. What was it all about?"

Gordon said, "Rau is like my right hand. I want you all to meet him. He is doing miraculous work for Christ among his people."

"Is it possible that he *could* be living with this woman, and you wouldn't know it?" Tyson examined and firmly shook the salt cellar which was somewhat clotted.

Robert considered. "It's possible, I guess. Of course we seldom have any occasion to visit his home."

Charleen put down her fork, leaning forward, her rosy face anxious. "Here in the East almost anything is possible, don't you think, Reverend Gordon? Of course we haven't been out here very long, but we can see that the people are often not really open with us. They can cover up anything with a great big smile." Robert raised his eyes to hers. "Well, I mean, especially with so many Communists and soldiers coming in. Why, up in Nhatrang I went to my regular hairdresser's last week, and she sat me right down next to a prostitute! You can be sure I'll be careful not to go there again."

There was a silence until Amelia Gordon asked, "How did you know she was a prostitute?"

"Oh, she's famous!" Charleen's eyes were wide. "Major Hicks pointed her out to me on the street one day. And besides, you can tell; you know, by all that make-up and those *clothes*."

Joe had stopped eating to look at Charleen. Bob Gordon cleared his throat. "The matter of this police visit is disturbing. And I do feel, somehow, that there may be some connection with Rau. He has been alone for several years now, since his wife's death. Bringing up a little girl is not easy for a man by himself."

"And that Drim is mischievous." Amelia smiled, shaking her head.

"But Rau is a devout man," Gordon went on, "and very honest with me. I feel sure that a serious talk will clear the matter up. This woman, whoever she is, must have had some reason for attacking the man in the bar. It was a desperate thing to do in such a public place. The officer said she was from the North. There have been cruel wrongs which engender terrible hatred. I am realizing more and more in these days the power of hate." He looked down at his plate without seeing it.

"And this hatred must be overcome by the power of Christian love!" Hank Tyson said. Joe examined the man's strongly cut features, well-defined mouth and chin. There was vitality in the dark eyes under one streak of white in his upspringing hair.

"Truly," Gordon said.

Joe felt depressed. His earlier excitement seemed to be draining away. Then he saw the large salad bowl being passed to him. "Gosh, what beautiful lettuce! Is it really okay to eat the lettuce up here?"

"Yes," Amelia said with pride. "We grow it ourselves."

Joe helped himself lavishly. "After our lettuce down in Saigon is thoroughly soaked in bleach and water against amoebic, it just isn't lettuce any more."

"Maybe your servant doesn't know how to do it properly," Charleen suggested. "Before you go home, I'll be glad to write down the best way for you in Vietnamese." She smiled helpfully.

They had no servant but the cook. The young people in the house took turns at KP. "Thanks," he said and turned back to Amelia. "I've heard a lot about the Dalat vegetables, and it's one of the things I've been looking forward to!"

She put her elbows on the table. "What else have you been looking forward to, Reverend Ruffin?"

"Joe, please. Well, work first. I haven't practiced any medicine for months, just been studying Vietnamese all day." Everyone nodded. "Of course, I know I have to do it, if I'm going to be as fluent as the rest of you, but it's an awful job." His voice brightened. "And then, I've been wanting the

mountains and the cooler weather, a chance to exercise where it's not at least eighty-five degrees!"

"Take a walk around after lunch," Robert said. "You won't be able to visit the clinics until tomorrow. Stretch your legs!"

"I'd really like that."

"And you Tysons must do the same. There're some tennis rackets and balls down by the courts in the big chest. Help yourselves."

Amelia looked at Charleen. "Robert, I have a feeling what the Tysons would really like is to visit classes this afternoon while the children are still in school, since we don't have regular classes on Saturday."

"Oh yes!" Charleen passed along the pudding dishes. "Please, let's do visit the school!"

At the end of the meal, Robert Gordon sauntered down a path with Joe to show him his living quarters. There was a slow sleepiness in the sunshine under the pines. When Robert opened the door of a cottage at the top of the hill, Joe saw a small living room with a large view of the valley and further mountains. Wood was stacked neatly beside a stone fireplace. In the room beyond, the double bed was covered by a white spread, and a curtain hung over a closet alcove. Extra blankets were folded on a chair. There was a tiny bath with shower stall. Everything smelled faintly musty like old cabins he remembered from camp or from religious conferences. Joe set down his bag by the dresser and straightened up. The little house was all his.

"This is great!" And he turned to Gordon, meeting gray eyes with their twinkle of understanding.

"Good to have you with us, Joe. I hope you'll call me Bob. Amelia is the only one who insists on Robert."

"Thanks. It feels good to be here, Bob." There was a pause filled with stillness. Surely there could be no trouble here.

"I was wondering," Joe said suddenly, "what you meant about not being afraid to die. Something about your three score and ten."

The older man's habit of looking down made him seem diffident. "It would probably make a difference what kind of death. I'm afraid of pain, suffering, anyone is." Gordon had a gentle Virginia accent. He twisted his neck uneasily sideways as though to throw something off. "But a long time ago I discovered, there is another land, more real even than this one. And we can live in it now, if we choose. I believe it's the same land we will live in more fully after death. So it's all one. I admit, sometimes I even look forward to dying." And he smiled, his hand on Joe's arm. "We'll have plenty

of chances to share our ideas this weekend. You take some time now just to settle in."

"But if there's some way I could help this afternoon, Bob, I'd...."

"No," Gordon said. "Leave that 'til tomorrow. I've got plenty of use for you then. For today, you're on your own. Just relax, and do whatever you want. See you at supper time at our place, six-thirty." He waved a hand and left. Joe stood and listened to his footsteps going away before the cool silence flowed back again.

Dalat and Saigon

So on, endlessly, is the world divided between the creative and the receptive—motion and repose, man and woman, light and darkness, energy and inertia, active and passive, spiritual and material—yang and yin, forever opposed, forever united. Man's mystic need is to keep their harmony.

Hobart, Yang and Yin

Polarities

The rain forest, then, consists of much more than its three levels of trees. Long looping lianas, murderous strangler figs, brilliant epiphytic orchids glowing in the canopy, tiny saprophytes and parasites—all belong to the balanced community that is the rain forest.

Robert Silverberg, The World of the Rain Forest

Coming eagerly out on the asphalt, Allison slowed down at once when she saw the court was not empty. With one foot on the bench, a man in shorts was tugging fiercely at his shoe lace. He damned the thing as it snapped. Allison paused, already regretting her impulse to come out alone and use the backboard.

Too late. Her hasty glance had tangled with his direct, bright one. She just glimpsed rough eyebrows meeting over the bridge of a bold nose, a broad grin above a jutting chin as he saw her and came right over.

"Hello!" he said, almost as if he knew her. Then, "Joe Ruffin," and he held out his hand.

Allison gave him her name along with her hand. When the intense silence which followed didn't seem to bother him at all, or distract his gaze, she said hurriedly, "I thought I'd hit a few balls; the air up here is so...." The keen appreciation in his look was not steadying. "I didn't think anyone...."

Joe Ruffin said, "It's great you came; I was just wishing for someone to play with."

Something seemed familiar about him. Was it the South in his accent—North Carolina? Allison recovered her poise. "Do you play here often, Mr.—Ruffin?"

"I used to be pretty good, but I don't get many chances now. I doubt if I should ask you for a game."

"I'm probably no match for you, I just came down to use the backboard."

"Well, if you're sure you don't mind getting messed up." There was a spark in his eye as he banged a song from his racket against the heel of his palm.

"Why should I care if I get messed up?"

He smiled, looking her over. Allison could feel her careful make-up, short tailored dress, slim legs. Stubbornly she returned his look. "I'd better fix that shoe lace for you, if you're really going to try to beat me. I'd hate to have to give you a handicap."

And they both laughed as Joe handed over the sneaker. "You know, one minute you look like a swan, sailing in, and the next minute.... Is it Miss or Mrs. Giraud?"

"Mrs."

"That's life." His hazel eyes teased. "Will you play with me anyhow? Tennis, I mean."

"Well," and Allison noticed she was carefully reknotting the broken shoe-lace.

"Thanks a lot." He admired the knot. Then squinting at the sun, hopping on one foot, he said, "Let's rally some first. You better take that side." While he stamped into his shoe and tied it, she had a good look at his muscular legs, just hairy enough.

Allison attempted to concentrate on tennis, like trying to make serious conversation through the buzz of a second martini. The man was fast and powerful. She was better at placing. He wasted a lot of ferocious serves, and usually hit squarely back to her forehand, but he was way ahead in force and endurance. Also, he clearly loved to play! Having lost the set, not too badly, she collapsed, sweaty and happy, on the bench near a variety of children who had gathered at the edge of the asphalt to watch. Allison tossed back her hair and smiled at them.

Joe flopped down beside her. "These are some kids from the school here." A dark-skinned little girl, perhaps from one of the tribes, was squeezing between them. "This one asks millions of questions, sometimes even in English." He lifted her up and sat her on his knee. "Her name is Drim," Joe said. "Do you have any children?"

"Two." She could only point up the hill toward the villa, laughing, still breathless.

"Is your husband with the Embassy?"

Allison couldn't read the expression in that sharp gaze, but she was very much aware of his strong body on the seat close to her. Everything should

stay just where it was, light and free in the high cool air. Still, it was a fair and honest challenge.

"I'm a widow. My French husband, Maxim Giraud, was killed by the Viet Minh on our rubber plantation in 1955."

"That's bad." He regarded her now in a more gentle, if still probing, way.

"It was a good while ago." Looking down, seeing the watch on his broad wrist, Allison started up. "I have to be back by 4:30." Something heavy and familiar, tossed off for a while, was back again.

He considered, before handing over her can of balls. "You'd better run then; it's that now."

Allison hesitated. "Thanks."

Joe Ruffin stood up. "Do you want to play some more early tomorrow, before things start up over there?" He indicated the villa with his thumb. "I'd like to think I'd see you again."

"Well...." With a prick of irritation Allison saw the dark child clinging to his hand and the others watching.

"What about 6:30?" He studied her indecision, frowning. "Too early for you?"

Allison never got up early. "I'd love it!" They smiled at each other. And going away up the path, she skipped once, wiping with her upper arm the perspiring edges of her hair.

Running into Mark with her children in the dark hall, Allison felt like a child herself, a naughty one. He seemed surprisingly hurt that she had gone off by herself, looked at her as though realizing for the first time that she was capable of treachery.

"I'm sorry, Mark. I didn't feel like a nap."

"No, I see." At once she was aware of her flushed cheeks and sparkling eyes. "If you had just said something, Allison, I'd have been glad to play with you." The reproach in his voice was justified. How could it be so natural for other people always to do the proper thing?

Allison determined to make up for her defection during their walk. And yet she was unsettled. Finding everything beautiful, she wanted to run with the children hunting tiger, or lag behind to dream by the shaggy trunks of tree ferns. While Mark carefully briefed her on the other guests whom she would meet that night at the villa, Allison hummed an inner song. I must be happy, she thought. I'd forgotten how it feels!

"Monsieur Nguyen Tan Thinh, Minister of Education," she repeated

almost steadily, while her feet wanted dancing. Joe Ruffin, what a funny familiar name—what an oddly exciting unfamiliar…. Feeling guilt again, Allison asked Mark where the Ambassador and his wife had been posted before.

But suddenly Mark shouted at James: "Don't swing from that vine!"

Katrine and James froze, looking back with eyes darkly affronted. "We were playing Tarzan," Katrine said coldly.

Mark studied the vine, pulling on it, looking up. "This one might be all right. If it's a liana, it would hold a lot more than your weight, but you have to be sure."

Thank goodness for Mark. "Just don't swing on any vines," Allison said, "then you won't have a problem. Now Katrine, there's plenty for you and James to see. Race ahead; we'll catch you up." When James tugged at Katrine's hand, they both pelted off up the path.

Allison looked up high. "I know lianas are those long-looping vines, Mark, but I don't know a thing about them."

"Well, lianas compete with the forest trees for light and water. They're parasites, like orchids and strangler figs. They all belong to the balanced community that makes a rain forest."

Allison gazed into the canopy. Some of the vines had cables as big around as a man's arm. "I bet they don't do the trees any good."

"You're right. The host tree usually dies and rots away. As it rots, the strangler or liana will feed on its wood. By the time the original tree has disappeared, the parasite has moved on to other trees. See!" Mark pointed. "There's a big loop of a liana dangling in the air between two trees, rather far apart. That's probably the place where a third tree that once supported the vine has disappeared."

"How awful! In the end, they could kill the whole forest!"

But Mark shook his head. "That's the mystery. If the rain forest isn't interfered with too much, a kind of natural balance is kept."

"I didn't think this was a rain forest, up here, so high, and with all these pines and firs."

"It's only a mile above sea level," Mark said. "They call it sub—or semi-tropical with its mixture of things like orchids with conifers. You see, it may be cool up here, but they never have frost or snow."

"Well," Allison said, "I love the orchids, and that prickly plant over there may be an aloe vera, good for healing, but I don't think much of those murderous vines."

Mark laughed. "It's all one; you've got to have it all."

"Like life in Vietnam."

He walked more slowly, in his gray, hand-made sweater, hands behind his back, blond head bent. "Well, the politics here *is* a kind of a jungle. There'll be plenty of political talk at the villa this weekend. You know, sometimes I wonder, Allison, what your opinions are about this country." His gray-blue glance was serious.

She took a breath. This could be important to Mark. Would it upset him to know she had no strong views? Allison paused, remembering Madeleine's warning to be careful.

"Well, it all seems terribly complicated," she said. "I've never understood how a journalist can come out here for a week or a weekend and go back to write a book about Vietnam." Still, the girls Mark knew in Boston probably had strong opinions on Vietnam even from there.

Mark hunched his shoulders, shoving his hands deep in the pockets of his slacks. His brow wrinkled. "In your case, Allison, with your French and Vietnamese, it may be a matter of knowing too much."

She wondered. "Maybe that's right, Mark, maybe the more you know, the less you dare to say." Vietnam was like the inside of a shell, with its convoluted pattern of clandestine organizations, born of a long history of occupation by foreign powers. And nowadays there was the deep basic conflict between the Republican nationalist and the Communist nationalist—both Vietnamese—with each side's propaganda produced like ticker tape, careless of truth, chiefly concerned with grasping for political power. What could anyone say?

Allison turned toward him. "Mark, I don't know much about politics or economics. But I am interested in people and sometimes I can understand how they feel. Like there's an important South Vietnamese government leader I've known for years who's just hanging on from moment to moment with his money in Swiss banks. His main worry is the security of his family. And, because we lived out in the country, I've known peasants and farmers too. The thing they care about is the security of their families—on the land. Feelings are very strong. Since I often pass for French, I know first hand the bitterness Vietnamese can feel against the Colonial Frenchmen. And I've often gotten the sharp end too, of what a Frenchman feels about Americans!"

"You mean because we didn't give them enough support at Dien Bien Phu?"

"Well, they do think that was a betrayal. But mostly they just feel we're taking over the world that always belonged to them."

"I hadn't really thought before, what a singular position you are in, between the French and Americans. Here, let's sit down on this fallen tree and wait for the kids."

Allison slipped down on the log, clasping her hands around her knees, shaking back her hair.

He leaned on his elbows, stretching his legs, crossing his ankles. "Tell me some more; it's interesting."

"Well, let's see." Allison felt encouraged. "I sometimes swim with young Vietnamese students, Kennedy fans, who're wild to bring in American democracy and technology tomorrow! Or you and I go to dinner with their parents, educated in France, who think Paris is Mecca, and French ways are best.

"For northerners who left everything and came South, there is a clear right and wrong, Communism against nationalism. But the ordinary man is confused. He could be patriotic by supporting the Diem government, or he could support the new NLF and be called a brave patriot too." She shrugged. "Once, the Viet Minh offered the only route to nationalism. Since Communists took over the Viet Minh, the choice is not as clear. Many people are uncertain."

"It's confusing, all right," Mark said, "but after your experience, I'm willing to bet you have strong convictions about the Communists."

Is fear a conviction, Allison thought, or the desire for safety? Impatient, feeling driven, she said with sudden heat, "I do think the Communist strategy of guerrilla warfare is brilliant. So is their power to manipulate people—through propaganda and organization and terror. I love this country, and I'm afraid."

Mark took her hands and pulled her up. Smoothing away the frown between her eyebrows, he kissed her lightly. "Hey, don't be too pessimistic. We aren't planning to go the way of the French here. There's a tremendous amount of work to be done economically, we think, to improve the lot of the Vietnamese—politically to see they get some choice about their future and militarily to maintain enough peace for these improvements to happen. That's what we're here for." Mark held her hand surely and firmly in his as the sun dropped, and the shadow of the mountain engulfed them. "It's getting late and chilly; I'll call the kids."

His shouts rang through the trees. The tiger hunters came whooping

back down the path, James almost knocking Allison over, incoherent with excitement.

"What we did," he puffed out, "we threw rocks down the mountainside to make the tigers roar. We heard them, as loud as anything down there!"

"Scary!" Allison hugged him, glad to return to their world.

Katrine was watching. "Tomorrow we'll actually *see* one." Her eyes held a challenge.

Mark laughed. "You can't worry us, Katrine. You'd be a match for any tiger."

"Well, your mother certainly wouldn't!" Allison got up slowly, thinking about jungles, and about her own outspoken words. Mark had seemed surprised, even pleased. Why was it depressing to know she had done pretty well, may even have passed?

Never mind. A glimpse of the tennis court they passed on their way back to the villa reminded Allison that there are all kinds of delicious possibilities in the world! Impulsively she turned to Mark and told him how glad she was to be up here in Dalat.

The same afternoon seemed very long to Colonel Thanh, who had important matters to attend to before he could go home to his wife. Usually he didn't think of Yen while he was working. Today there was an uneasy feeling, as of something unresolved between them. Unless this could be settled, cleared right up, he knew he would not be completely free to devote himself to his job.

The Province Chief's offices were housed in a long, low building which had once accommodated the French mayor of Dalat, the *résident-maire*. There was a large central room full of male secretaries, some formerly French civil servants, now Vietnamese. The Colonel's private chamber held a handsome mahogany desk inherited from his French predecessor. Outside the open window was a frangipani tree. Thanh stared into the knobby branches, almost leafless, with their honey-scented, cream-gold flowers.

Having taken care of the most pressing orders and reports to Saigon regarding the sabotage of the airport, he fingered a summary by the Chief of Police about that attack in the bar near the market. This curious story had caught his attention mainly because he liked the Gordons and knew that his wife did. Then he remembered Pastor Gordon's invitation for Sunday morning. Getting up and stretching, the Colonel wandered into the outer office to study the wall calendar by his secretary's desk. This man, Vuong, was at

least sixty years old, prejudiced by long years of Colonial experience, and very protective toward his boss.

He stood up at once. "The Colonel did not ring...." Vuong was disapproving.

"I've been sitting around long enough. What have we got on for Sunday morning, Vuong?" The heads of the typists were raised.

"I don't believe there is anything scheduled, sir." Vuong moved toward the Colonel's office door.

But Thanh, motionless, was looking at the blank spot on the calendar for that Sunday morning. "In that case you had better accept an invitation for me and Mrs. Thanh to be present at the opening of the new Protestant church on the road to Phan Rang. Pastor Gordon has invited us to be there at 10:00. Be so kind as to call the CMA office and accept for us both." He glanced around the large room and the many desks. All the secretaries hastily returned to their typing. "You may also bring in the report of the Chief of Police on the bar incident."

Wandering back, he flopped heavily into his chair as Vuong followed quickly, closing the door carefully behind him. "You already have the police report on your desk, sir." His voice was prim.

"Oh yes." Thanh reached for the folder. Then he raised his eyelids. The secretary was rubbing his fingers together nervously. Thanh shifted his body. "What's the problem?"

"With the Colonel's permission, I feel—I must—I wish to suggest...."

"Out with it, Vuong!" He placed his elbows on the desk.

Vuong swallowed before speaking. "The Colonel's practice of openness, of making his movements, his plans for the week, public, is very dangerous."

Another warning bell. Thanh felt tired and cross. "To discuss my schedule in my own office is to make my movements public?"

Vuong raised his chin and his graying head higher. "Public!" Then he bowed himself over his clasped hands. "My Colonel, it is my shame to have to admit to the Colonel that I cannot positively account for the loyalty of some of the younger men. I have done my best. They are all carefully screened, and yet I see a kind of curiosity, a watchful alertness in one or two, which I do not remember noticing before. Please, my Colonel, let us take down the wall calendar outside, and let us arrange the Colonel's schedule privately."

With sorrow Thanh examined his own hands on the polished desk he

had been so proud of. "My friend, your suggestion is proper. The time has come to institute measures of security in all areas. From now on my schedule will be top secret."

Vuong looked at the bowed head with sad affection. "And perhaps the Colonel will not bother to attend this unimportant function?"

"What, the church thing on Sunday? No harm in that, and very important to the tribespeople, one of the first churches to unite them with the Vietnamese. This kind of thing will encourage them to turn to their church and our government rather than the VC. I hear the American Ambassador may also be present." Waving his secretary away, Thanh returned to his study of the police report. "Get Chief Inspector Dinh over here, *after* you have called the CMA."

The older man paused. To risk one's life for black savages…but when the Colonel glanced up impatiently, Vuong made his obeisance and left the room to call.

An hour later in the café across the street, Trinh Le Kiem was tapping his fingers on the checked tablecloth and swinging his crossed leg nervously. He had been waiting for Tang to return from his mission in Saigon all afternoon. The buses were never on time. If his three-man cell had a vehicle of their own…. Kiem recrossed his legs. Cadre Thom was beginning to influence him with his bourgeois ideas. Still, speed could often be an important factor. And now that he had received this extremely valuable tip from across the street, timing might mean everything.

From the window of the small French-run café next to the Post Office, Kiem could keep an eye on the imposing offices of the Province Chief. Here in the café he could meet, though rarely, with his contact who worked over there. A few minutes ago, over a cup of tea, he had extracted from the scared but very poor young clerk valuable information about the appearance in public at a church dedication this coming Sunday morning of Colonel Truong Vinh Thanh. The information had not been cheap, but he expected to be repaid by the Party through Le Tuan Anh.

Kiem did not worry that the French owner of this café might wonder about him, might report him to the Vietnamese authorities or to the Americans. The owner was a fat slob of a man with receding dark hair, whose big nose was reddened by drink. He had been born in Vietnam, had married a Vietnamese, and wanted nothing more than the freedom to pursue his

pleasant life as before. His wife cooked while his friends drank with him and played *vingt-et-un*. His spirited metisse children romped around the tables. Customers who expected something more from an eating place never returned. Old-timers were the right kind. Kiem had grown up near just such a down-at-the-heels café in Haiphong. He felt safe in the midst of negligence even while he despised it.

Suddenly the door was pushed open. Bui Tang appeared, frowning about like a near-sighted professor. As the languid waitress approached without interest, he waved her aside and joined Kiem, stilling his weary, trembling hands on the rough table cloth.

"You are late," said Kiem coldly.

"The bus had a breakdown. What can you expect from these ancient vehicles? It is no luxurious pleasure to use such transportation." Wanting a cup of tea, he looked around fretfully.

"I am well acquainted with the public buses." Kiem's tone was colorless. "Please explain, but quietly, what occurred in Saigon. Did you meet with the person?"

Tang clutched his hands together, forgetting tea. The flood of emotion that filled his being when he even thought of the Colonel astonished him. "That dog, that son of a dog, must die!"

Kiem leaned forward, light kindling in his eyes. "You were not able to persuade him, to intoxicate him with the righteousness of our Struggle?"

Tang straightened up, assuming some of his old rational dignity. "After contacting the barber, younger brother of our friend, I arranged a meeting with this person. Throughout the meeting I conducted myself correctly as a propagandist, presenting many ideas to one individual. First I extended a friendly greeting to him as a man, and explained that we are concerned over the wrongs and grievances of each person. He pretended that he had no grievance."

Kiem lifted his shoulders. It was what he would have expected. "I do not need to hear the entire discussion. You have been well trained to express correctly our way for bringing unity and independence to our country. He did not accept this?"

Tang felt his breath stop, like a river which is suddenly dammed. He had intended to go over the whole conversation held with his adversary, arriving in conclusion at full justification for himself. In fact, he had already rehearsed his speech many times on the bus. It would have been a great relief to recount everything with the proper emphasis. This northerner, Kiem,

had no proper feeling for the right conduct of events. His impatience was unmannerly, rough, un-....

Kiem repeated, "This person was unable to accept the correct way?"

Tang could hardly still his shaking when he remembered Thanh's calm hand reaching out at the end, his "I believe we understand each other, Comrade."

Kiem laughed. He could see that the formal, rational Tang was revitalized with the power of hate. "He is not for us, is that it?"

Tang spat. "We would never desire to have that one with us or for us. He is weak and reactionary, of no possible use to the Cause. He must be eliminated as rapidly as possible!"

Kiem smiled down at the table cloth. "Excellent," he said, still smiling. "This may be accomplished sooner than you imagine." As curiosity woke in Tang's fevered eyes, Kiem hurried to quench it. He himself as leader must be in contact with Le Tuan Anh before communicating this new information about Sunday to the cell members.

"Comrade, you have done well. Your trip was important and your business well handled. Submit your expense account to the treasurer."

"I myself am the treasurer," Tang said.

"Of course. The treasurer will report to the cell, and the amount, if appropriate, will be voted. Now, I want you to contact our friend in the country and have him meet with us tomorrow, Saturday, at noon in the hut of the old woman. This must happen without fail. Important actions need to be taken at once." Kiem rose.

The thirsty Tang rose more slowly. His older bones were not eager for further travel into the country. He had been looking forward to the ease and relaxation of home, of talking at length, to his wife at least.

Kiem read something of this in his expression. "Go on, old man, contact our other friend and then run to your bed. You will not be disappointed in the job which lies ahead of us." For just a moment he rested one hand lightly on Tang's elbow, communicating energy.

As they left the café together, the languid waitress leaned on the heavy shoulders of the proprietor, watching him choose a card. "Who are those characters?" she asked in French.

"Communists perhaps," he replied absently, rubbing his nose and laying out a card. "Those two smell of intrigue. So what, *hein*? Probably they cook up some trouble for our American friends!" Everyone in the little group around the table laughed comfortably.

"The young one is handsome," and the girl looked after him.

"Leave it," the café owner advised, plucking at a card. "That one will permit little room in his life for love."

Outside in the street, dusk had fallen. Kiem waited, picking his teeth, until Tang had disappeared around the corner. Then he began to move in the opposite direction, and quickly. This was the hour when Le Tuan Anh usually sat in the bar drinking his ridiculous vermouth.

In five minutes Kiem was putting aside the hanging beads at the door and glancing around in the blue haze of the room. There was no Anh and no bar woman. Curiously enough, there were several policemen, and a general interest in his arrival. One of the police was actually taking a step toward him, when Kiem melted backward into the darkening street, ran down an alley, and proceeded more calmly along side streets back again in the direction of the Post Office.

He was sharply annoyed with himself. Over-eagerness had caused him to disobey the rule Le Tuan Anh had laid down. "Never come for me. I will leave a message in your box when I want to see you." Kiem's quick action had saved him from involvement in whatever had been going on back there. But, in spite of everything, he felt justified in this case. He must see Anh. There was so little time for arrangements and preparation. What if there was no message in his box?

Feeling for the small key, he ran lightly up the steps of the Post Office. Only the outer lobby was still lighted. Kiem opened his numbered box. A thin flake of rice paper lay folded inside. The message was brief. "I will look for you by the Prenn Waterfall Saturday morning at 10:30." He sighed his satisfaction, and tore up the note, dropping the tiny white bits into the shadowy gutter as he strode away.

The headlights of a government limousine, turning from the official driveway into the street, briefly touched him with two white fingers. Casually the Province Chief glimpsed the upright figure, before it was left behind in the dark. It is not a joy, Thanh was thinking, to go home with this separateness lying between himself and his wife.

In the lighted hall when she came forward, as always, to meet him, he felt the strangeness more strongly—not only of the fine house, which they were slow to get used to, but of her doubt, her watchful waiting, her unhappy submission to the necessity for some wall between them. Thanh felt cross, perverse. Leaving her standing in the hall, he stamped up the elegant

staircase and took a shower, staying under the hot pelting water as long as he could.

When he came out into their bedroom in his old bathrobe, which she had unpacked that afternoon and thoughtfully hung on the bathroom door, Yen was sitting on the far side of the bed filing her nails. The straight fall of dark hair hid her face. Thanh toweled his head energetically, unable to think of something to say.

"I hope your afternoon at the office was satisfactory." She looked up then, so he turned away and opened the drawer with his underwear.

"It was all right." Thanh hoped he sounded bored. "No more news about that curious attack in the bar near the market." He looked for shorts and a clean pair of socks.

Yen brightened. "You handled that situation so well. I'm sure the American missionaries were thankful we arrived just then."

He dressed quickly, feeling the great difference in temperature between Saigon and Dalat. Thanh put on shirt and slacks and v-necked sweater. Still unwilling, or unable, to mention his all-important meeting with the Viet Cong cadre, he offered instead, "It's very odd; I can't shake off the feeling that this non-incident in the bar has some kind of importance." And he pretended to peer at himself, combing back his thick hair.

Yen leaned toward him with quickening interest. "Your hunches have often been very helpful."

"Ummm." He avoided her direct look. "Well, I'm starving. Can we have rice?"

She rose, disappointed. "It is waiting for you."

Both of them made a careful effort to create conversation as the houseboy served the many dishes of their excellent dinner. Thanh noticed that his wife was only pretending to enjoy the meal. And, after the first few bites, he found himself eating more and more slowly. He felt as though his head would explode at any moment, and if it finally did, he would be the better for it.

Night had scarcely fallen, and Robert Gordon was still working in his study in one of the smaller cottages, when he heard a very light knocking at the door. He was not completely surprised to see Rau, the Christian tribesman, enter, holding by one hand his little girl and by the other a stout woman of about forty who kept her head averted, her eyes lowered. She wore a white tunic and black trousers. Robert saw that she was Vietnamese. In the silence he felt what was coming, and asked God to be with them.

"Honorable Grandfather," Rau began in the tribal dialect, "I am bringing to you the woman the police were searching for here this noon. She and I have talked all the afternoon, and we have agreed," his voice strengthened, "we have agreed that we must come to the Grandfather to explain what has happened. This woman is Ba Le Thi Kieu." The woman bowed so that Gordon saw the satin of her black hair tightly drawn into a knot at the top of her head.

He nodded, feeling harassed. *"Chao, Ba."* Looking down, he moved some papers and cleared his throat. "All right, Pastor Rau. Please go ahead with your explanation. But let us speak in Vietnamese so that Mrs. Kieu will understand us."

Releasing his hold on the woman and his daughter, Rau put his hands together and regarded the rafters of the cottage. "As the Grandfather knows, this person has been sad and alone for many years since death of my wife, the mother of Drim." When the little girl wiggled self-consciously, Ba Kieu took her hand without raising her head. "But in the last few months, the Great Spirit in heaven, that I learned about from the respected Grandfather, this our God has rewarded me for faithful service to His name and to His Son's name among the tribes. He has looked down on my loneliness and has sent me this woman as a companion. For more than thirty days the woman has kept my house clean, has cooked rice for us after her work in the town, and has looked out for Drim, who was greatly in need of a mother."

"But Rau did not come and tell me of this new circumstance in his life."

The thin, intense black man hurried on with his story. "I am ashamed to admit to the Grandfather that, at first, I did not see the worth of this woman as a person. When we met, I had been drinking, and I considered that the whole matter was—uh—temporary only. I considered that it was wrong for a tribesman to have anything to do with a Vietnamese woman, and my intention was to drive her away. This I did do several times, but she always returned with some kindness for me and for my daughter. She seemed to have a love for the child, as well as sincere affection for myself. I began to see that the God in heaven was trying to give me a valuable gift. Difficult for me to understand, as the woman was only a refugee from the North and was also working in a bar near the market. Most important, she was not a tribesperson!

"But slowly I learned that Ba Kieu has been cruelly treated by the government in the North, her husband and son dead, herself forced to flee into these mountains. This work in the bar was the only means to keep her alive.

For the last few weeks I have allowed her to come at night and live in my house. We have talked together in the dark hours. It may be that she will come to love the God of heaven as I do, and then we can ask the Grandfather to marry us. My daughter will no longer be an orphan, and I myself will not be alone." Rau looked resolutely out of his clear dark eyes. He was as sure of the understanding and compassion of God as he was of these same qualities in the Grandfather.

Gordon crossed his arms and bowed his head in thought. Pastor Rau's confidence, his faith, had always been a rock to build on. He looked up.

"Rau, there is still the attack on the unknown gentleman in the bar yesterday. As you know, this matter concerns the police. What can you and Ba Kieu say about this?" He saw her look up then to exchange a savage glance with Rau who shook his head at her.

"This was not a Christian act," Rau said, "and only God has saved us from the evil. However, the man in the bar was a wicked judge formerly working for the government of the North. In the program that took away the farms, he stole the land of Ba Kieu and her husband, leaving them with so little, they could not grow enough rice to live. The husband and the child died. In her eyes they were murdered by this man, who accepted a bribe from them, and yet still took their land away. This very man, this Communist, has been visiting the bar where Kieu works. To her it was like a gift from her gods to avenge her relatives. She could identify him by the dragon ring which she and her husband gave him then, in the hope that he would help them. Ba Kieu hates this man with a hatred like fire."

Gordon stirred.

"Grandfather," Rau spoke even more earnestly, "you and I are Christians. We know about the love of God for us. We know that hatred is against our God, and will only bring misery. But this woman has not yet had the chance to learn what you and I know. If you let the police carry her to prison, she will never be changed. So far no crime has happened. Now I need the help of the Grandfather and Grandmother to protect Kieu so she can have time to understand the good news and stay here to be a Christian wife and the mother of my child."

Little Drim was staring round-eyed, gazing from face to face, trying to grasp the sense of this very important discussion. She clung to the hand of Ba Kieu and rubbed her head against the solid body in the white tunic.

Robert rested his eyes on them, and drew a long breath. "This is a very serious business." As Rau nodded eagerly, he added, "The most serious

business we have considered for many days. We must give it prayerful thought. It must be discussed with the other missionaries."

When Rau started to speak again, Gordon put up his hand and rose. "Please return quietly to your house now, and stay there tonight. Meet me here in the morning at nine to talk again. Good night, Ba Kieu." She did not lift her eyes, bowing twice. After the three had gone, Robert turned down the lamp. Having closed up, he started on the path for home, hands in his pockets and head bowed.

But Rau had run after him, was plucking at his sleeve urgently. "Grandfather," his voice was hoarse, "I have told her that our true God loves us and forgives us no matter what we do!"

Gordon turned and patted his shoulder. "All right, Rau, all right. Now go home, eat supper, and rest." He left the man standing there and went away along the dark path. Once he paused, and there was the sound of what might have been a chuckle, before he continued on home.

"God-followers"

For it seems that it is God's purpose now to replace an image of perfection with completion or wholeness.... Wholeness...combines the dark elements with the light.... Generally speaking the Christian striving has been toward goodness and perfection.... The movement toward wholeness...always involves us in a paradox; I am not at all sure that mankind is capable of that task right now, but it seems to be thrust upon us anyway.

Robert Johnson, He

Joe felt he had been coming all his life for this moment. Flat on his back, hands behind his head, blissful. Finally he had met the very girl he had seen by the pool in Saigon—and she was Allison! Joe stretched all the way out for pleasure.

Should he have asked about her husband that way? But he had to know. When she answered him with the fact of her widowhood, it was like the heart-stop in an elevator after a swift fall. Thank God she was free. Well— at least she wasn't married.

Joe went over their time together: the intensity of that first look exchanged, the slimness of her legs in motion, the lift of her body to the serve, her laughter chuckling out, her eyes retreating behind dropped lashes, the perspiration on her upper lip and darkening the edges of her soft brown hair. Had he been too on-coming? On-coming enough? Hell, however he had been, did she seem to *like* him? Joe sat up on his elbows, intent to remember. Allison had certainly agreed to get up and play with him tomorrow morning at 6:30, and she had smiled. She must be nuts—he must be nuts. Joe sank back amazed. He had expected a lot from Dalat, but never dreamed of anything like this. What had the Professor said at Angkor? At first you

fall in love with love, and then, later, you come to love a special, unique woman—Allison!

Some time later while he was still smiling foolishly at the gray ceiling, footsteps went by outside the cottage. He recognized the southern voices of the Tyson couple on their prompt way to supper at the Gordons' bungalow. The reminder of missionaries stirred his doubts as to whether he could gladly be one. In the medical world, a great disappointment had been the lack of openness to new ideas. Religious people could be narrow-minded too. This was his chance to learn what these people would be like to work with, and he had better not be prejudiced in advance. They were bound to discuss the interesting case of the woman in the bar, which would throw some light for him on the way they looked at things. He jumped up, unbuttoning his shirt, heading for the shower. But, as he shoved off one sneaker impatiently with the other, his shoe lace broke again. And he laughed for happiness.

Clean and comfortable in a warm flannel shirt, Joe felt deeply satisfied by the contrast between the darkening outside world ringed with solid mountains, and the bright, curtained living room at the Gordons. Flames sprang to life from logs on the stone hearth, burnishing Amelia Gordon's chestnut hair as she leaned down, passing mugs of a pungent hot drink to the Tysons, her husband, and Joe. Apple cider tasted like champagne!

Charleen Tyson turned toward Joe and teased him about the pretty girl he had been playing tennis with that afternoon. When his searching look met only twinkling encouragement, Joe began to like this missionary.

And Charleen raised her mug to him laughing. "You are some kind of a fast worker!"

"I think it's more like a miracle," Amelia pronounced, settling back into a deep chair. "Our beauties up here are mostly black and topless."

"They've got a lot to recommend them." Bob Gordon nodded soberly.

Joe laughed. "I did meet a cute little black girl named Drim."

"Pastor Rau's daughter." Joe thought a shadow crossed the older man's face. Rau, he remembered, was the evangelist who was supposed to be keeping the knife-happy bar woman. However, if there was a shadow, it had little effect on the occasion. Perhaps because of the great change of height and temperature, the visitors were freed up into pleasure while they enjoyed Amelia's supper of creamed chicken, rice, and garden peas. Bob Gordon's drollness almost fooled you. He kept a perfectly serious face while he told

his stories, like the hilarious one when he scared off his first tribal convert by trying to peer into the workings of throat and tongue as the strange sounds of the Chil language were being uttered.

Looking around, Joe saw that Charleen Tyson laughed and relaxed completely in the midst of simple social fun. Her husband, Hank, however, with his narrow, thrusting face, his close-cut curly hair the color of ginger, and the glitter of his eyeglasses, was pretty intense.

Charleen was asking, "Reverend Ruffin, when did you get here exactly? You must be one of the last missionaries allowed into Vietnam. A whole group of our Baptist people, who're badly needed here, are still held up—some in Hong Kong and some in Manila, because they can't get entry visas from the Vietnamese government."

"Yeah, it's lucky how that worked out," Joe said. "I arrived just a day or two after the Coup you had in Saigon last fall against the regime. I understand that President Diem was scared afterwards into tightening up a lot of regulations. But you see, by then I was already here."

"Whew, that was close, Reverend Ruffin! The Lord must really want you here in Vietnam."

Joe moved uneasily. "Mrs. Tyson, I hope you'll call me Joe. And please drop the 'Reverend' too, okay? Because I'm not an ordained minister." The Tysons looked puzzled.

Bob Gordon wiped his mouth with his napkin. "Joe here is with us because he's a doctor, a lay medical missionary for CMA. When he finishes his language training down in Saigon with the Wycliffe group, he'll be setting up tribal clinics in the mountains and also in the new villages down near the coast where, as you know, so many tribespeople have been resettled because of dangers from the VC."

Joe felt them taking another look at him. Mrs. Tyson, smiling, asked him to call her Charleen. Her husband's regard was steady. "Phuoc Long is one of those fortified villages near Nha Trang where many of the Moi people have been resettled," Tyson said. "I've been out there several times, and I can affirm your vocation. A Christian doctor would be a truly wonderful blessing to those people."

Joe's eyebrows lifted as he buttered another roll. "A doctor's a doctor." He said it lightly, but he couldn't help saying it.

Tyson frowned. "These people are ardent Christians, Dr. Ruffin—uh—Joe. They fled their mountains, their ancient homesites, and risked everything of value to them, just in order to keep the thing of most value, their

freedom to worship the one God!" When Joe returned the challenging look with a troubled one of his own, Hank leaned forward. "You are a Christian, yourself?"

"Well yes, in a way I think I am." Joe didn't see Gordon's smile.

"But are you saved? Have you committed your entire life to your Savior?"

Joe sighed. He had known the moment would come, but he hadn't expected it so soon. "I don't guess I can say I am, in the sense you mean. I'm a doctor, a healer. In the Bible Jesus seemed to be involved in a lot of healing, so you could say I'll be doing the Lord's work, at least in that area."

"And we're very thankful to have you." Amelia, who rose to clear the table, looked rather pointedly at her husband.

But Gordon was slow to intervene, and Joe had time to notice Charleen's bewildered face. She was a kind person who had given him a chance to let some of his wonderful excitement about Allison overflow.

"Look," he glanced around the circle, "I hope you all are going to help me learn my job. Bob just told you I'm supposed to be a 'lay medical missionary.' Well, maybe I'll get to be that, but I'll need help. I don't even know fully what it means, especially the missionary part."

Charleen sank back in her chair, forgetting to help Amelia clear off. She looked across with heartfelt sympathy. "Oh, Joe, I hope you'll get the right idea about missionaries from us! God's work always has to come first, and it's so hard to divide your loyalties, especially when your family's involved. I'm the child of a Baptist pastor and the wife of a missionary, and still I'm having the worst time giving up my children, even though I know they would have a fine education up here!"

Embarrassed, Hank Tyson reached over to pat her hand. "That's not exactly a problem for Joe at the moment, honey." Charleen took her hand away, wiping her eyes with a little handkerchief.

Amelia set the glass bowl of "Floating Island" in front of her husband. "Now, Robert," Amelia sat down, whisking her napkin back into her lap and handing him a big spoon, "why don't you tell them the story of how we came to Dalat? Maybe that's the best way to explain to Joe what being a missionary means to us."

Handing back the spoon, Gordon moved the pile of dishes firmly toward her. "In that case, you'd better do the honors with the dessert, Amelia. I may not be capable of managing both." And he smiled his very slow smile.

Not at all abashed, she reached for the big bowl of custard with its mound of egg white and started serving at once. "Well, go on!"

"I guess you all know," he began, "that in 1911 Robert Jaffray, a representative of the Christian and Missionary Alliance, crossed down from China to establish the first Protestant mission in what was then French Indochina. Many years later, before World War II in fact, Amelia and I, starting out Presbyterians from Virginia, got interested in CMA because of their goal of unity among the different Protestant missionary sects. That appealed to us. And so, as a young pastor, I volunteered my services to the CMA. Amelia and I were first sent to the southern delta region of this country. At that time we had never even heard of the Moi peoples of the mountain areas. Or, if we had, we heard them described by the French and the Vietnamese only as savages (which is what the word Moi means). Then one time, on a holiday here in Dalat where CMA was founding the boarding school for missionary children, I first saw the tribespeople—dark, erect, and at home in their mountains. I said to Amelia, 'These are fine people; they surely ought to know the Lord.'"

"And also you said, 'These people have as much to give us as we have to give them,'" Amelia added.

"It was something about their courage, their pride of bearing, I think. Anyway, Amelia and I went on back to the South and worked hard among the Vietnamese, but I kept thinking about those black people who were treated so badly and were so looked down on. It was like a shadow in my mind. In the end I got a fever, dengue it was, and the French doctor in Saigon thought it had affected my liver. He said I ought to live and work in a higher climate, so the CMA made it possible for us to come here. Nowadays Amelia pretty well runs the school, and I've been working for some years on getting the tribespeople to come to us, trying to learn their dialects, ministering to them. Nothing at all wrong with my liver now, that I can tell." He turned to Joe, who nodded with interest.

"Well, back in those days the French Commissionaire made it extra hard for us. He wouldn't allow us to evangelize out in the tribal villages, said we would make the savages think too well of themselves, so the French wouldn't be able to work them on the roads for nothing, as they did then.

"And the tribespeople did *not* think well of themselves, in spite of their straight posture. For example, they have a creation myth that the first tribesmen crawled out of holes in the ground. Their ancestors were so slow climbing out, the myth says, that when they did make it, they found all the good land already taken and settled by others. So only the bare highlands were left for the tribes."

When Gordon stopped to fill his pipe, Amelia got everyone to move on back into the sitting room. Joe felt the simple, friendly quality of the room again. On light gray-painted walls hung watercolors of Vietnam framed in a golden wood. He recognized the Marble Mountain and the harbor at Nhatrang from postcards he had seen. There was one of a tribal village with longhouses built across a violet mountainside.

Bob gestured toward the watercolors with his pipe. "That's Amelia's work."

Joe saw she had a quick, sure hand. The washes were clear and luminous.

"Well," Charleen said, settling into a rocking chair, "Amelia, you are a real artist!"

Amelia smiled. Hank sat down in a wooden armchair and tapped with the fingers of one hand on its armrest. He crossed his legs with energy.

Bob was looking into the heart of the fire while his wife put on another log and poked it into flame. "Of course, the tribes did not come out of holes in the ground. They came from the Polynesian Islands maybe three thousand years ago. At first they enjoyed life near the coast and in the rich river deltas until waves of the yellow race moved down from the North and pushed the brown men back up into the mountains. There are several descendants of these tribes near Dalat. Southward is the Chru tribe, northeast are the Chil, and further north are the Tring and the Roglai. The latter are the ones who use poison on their arrow tips."

Accepting her coffee cup, Charleen clucked with horror.

Bob took his pipe out of his mouth. "Am I boring you?" and he grinned.

"Oh, no…," Charleen began as her husband took over. "In my opinion, Bob, we need to hear more about these unusual people with their strong Christian convictions. Nowhere in the world," Hank said, "has Christian character, courage, and faith been more tested in our day than among these humble tribespeople!"

Joe let himself down on the rag rug in front of the fire, his arms around his knees.

"Well now, 'humble.'" Bob pondered the word. "I think I'd prefer 'oppressed.' Yes, you could certainly say that. Not only did the Vietnamese consider them savages and never allow them citizenship until year before last; not only did the French use them as forced labor on the roads; but the tribespeople themselves have had a cruelly hard time scratching a living from these mountains with their primitive 'slash and burn' method of agriculture. The soil is poor, plagues of rats or trampling elephants destroy their little

crops. Fierce gaur, a kind of wild ox, as well as tiger, threaten their lives. So they have been oppressed, not only by other people and by the wild animals, but also by their own ignorance and superstition."

Receiving his warm coffee cup, Joe took a good swallow. "But, Bob, don't we always hear that primitive people, who may be ignorant and superstitious, at least have a childlike fun and pleasure in life?"

"I'm afraid you couldn't say that about the Montagnards, Joe. Not that they were ever without faith. No; they were true believers, but the belief they held was a remarkably negative one. When we first came, we learned they believed they were surrounded by many spirits, demons if you will, who wished to work them harm. I couldn't discover that there were any friendly or helpful spirits. The only way a person managed to get on, was to spend much of each day trying to appease a crowd of hostile spirits, all devoted to his hurt and destruction.

"The only people to profit from this, as you can easily guess, were the sorcerers and witch doctors. Every time you were sick, there was no doctor to call in." He smiled at Joe. "Instead you had to offer your pig or chicken to the sorcerer to ward off the illness. The tribesmen were always in debt to their witch doctor for sacrificial animals. That's how desperately important healing is to suffering human beings! Jesus understood that."

Hank Tyson said, "'The blind see, the lame walk, the lepers are cleansed, the deaf hear, the dead are raised, to the poor the gospel is preached.' Luke 7:22."

Gordon thought about that. "It was certainly no accident that one of the gospel writers was a physician. I guess we can all agree on the importance of healing. And sacrifice is mighty important too. Amelia and I have been witness more than once to the sacrifice of a buffalo."

His wife looked around the listening group. "It's not pleasant. When a person is very bad off, perhaps dying, the tribal sorcerer demands the sacrifice of his buffalo. Everybody gathers around the poor unwitting beast, who is tied to a stake. In the light of the fire there's a kind of orgy of drinking and dancing which ends in the slow mutilation of the buffalo, starting with hacking at his legs!"

"I don't see how you could stand to be there!" and Joe saw Charleen's eyes widen with horror.

"The really sad part," Gordon said, "aside from the torture of the poor animal, is that the man has given up his working beast, so even if he recovers his health, he no longer has a means of livelihood, of tilling the soil."

Joe was powerfully seized by the story and thought of ways that civilized people also punish and deprive themselves, maybe through guilt.

Hank said, "Heathenism is an act of Satan blinding. It's up to us to turn on the light!"

"Is Satan the same as ignorance, Hank?" Joe asked.

Bob Gordon cleared his throat. "Now I don't want you to think we changed this tragic situation overnight. Since the French Commissionaire wouldn't let us go to them, we had to tempt them to come to us. I would visit the market where they came to sell their baskets and wild mushrooms and mountain fruits and orchids. I offered pay in piasters for construction work on our school, or for any kind of work. Slowly the word went out. The tribesmen came and worked, camped on our land, and began to trust us. Around their fires at night after a meal, I would talk to them about the one God, and I found that the sacrifice of God's son was readily understood.

"Rau, the man who was accused this morning by the police of harboring a criminal woman, was one of our earliest converts. Later he did dangerous missionary work among the Chil and Tring and Roglai. When you meet Rau, you will know him. His eyes have the look of fire.

"Well, slowly simple churches were built in the mountain villages, topped by a bamboo cross. People learned about the God of heaven and were released from slavery to the spirits and the sorcerers. A witch doctor actually became one of our strongest Christian missionaries. La Yoan, once a good servant of the demons, became a servant of God."

No one said anything. A log dropped. The fire sparked and then smoldered. "Many times we have seen that God works in mysterious ways," Bob went on. "You all probably know that the tribespeople enjoy sucking rice alcohol through long reeds from big green jars. Even the French began to appreciate the changes we had brought, when one of our brave converts escaped the sorcerers and came to warn the outposts at Dalat that the tribesmen, crazed by drink, were being urged into attacking Dalat—to kill all foreigners in white shirts.

"Thanks to the timely alert, many lives were saved, including the attackers themselves, who were diverted by K Sau and his brother. After warning us and the authorities, these two ran back and dared to stand, in the power of Christ, right in the path of the drunken tribesmen." Hank drew an appreciative breath. "The French changed their minds then about what Christianity would do to the Montagnards. So at last we were allowed to visit the new churches and work more freely among the tribes.

"That's the good news," Bob continued. "But that, unfortunately, is not the end of the story. Just at the time when many tribespeople were beginning to trade their fears for faith, a new enemy came on the scene. At the end of the Japanese occupation (which Amelia and I spent in an internment camp), a nationalist movement rose up against the French Colonial government. When we were able to come back to Dalat there were encounters beginning between the mountain peoples and the Viet Minh. The tribes called them 'jungle men,' these Viet Minh fighters who penetrated the forests wearing captured French legionnaires' jackets or combat boots with their black trousers. At first they only robbed the mountaineers of their rice, mushrooms, or fruits. Later Rau and others came back from preaching missions telling of greater demands, threats, and raids. Now, since the defeat of the French, the Viet Minh are known as Viet Cong. Village leaders who resist or even object have been killed, their villages put to the torch. 'God-followers,' as they are called, have been special targets, because they are leaders, and also because the Viet Cong do not admit there is a God."

Hank Tyson stirred angrily. "These men are enemies of the truth; they must, and will be overcome!"

"It won't be easy," Gordon said. "You can easily picture this shadowy war with the Communist guerrillas. All over our mountains, brother has been encouraged to fight brother. Trusted village officials in the daytime become enemy cadres at night. Young men are marched off into the jungle for indoctrination. Children wander innocently into mine fields and are blown to bits.

"By the time our situation got this bad, Pastor Rau had become Superintendent of the several tribal churches around Dalat. As far back as '56 the government at Saigon decided to move many tribal villages, to save them from the VC terror, and also to deny their support to the guerrillas. However, many tribesmen who were not Christians planned to die in their mountains by suicide rather than move to the strange hot lowlands and leave their familiar spirits. But Rau and other Christians began to organize the evacuation and resettlement of their churches. By now, many congregations have escaped to the coast. And, perhaps because of the heroism of the tribespeople, in 1959 the government of Vietnam finally gave them their citizenship.

"That's why we in the CMA felt that the once separate Christian churches of the Vietnamese and the tribes should be joined." Bob tapped his pipe on the hearth. "Like the new church you will be helping us dedicate this

Sunday." He glanced at their faces. "I hope you all will forgive me for handing you so much detail from the saga of the Moi people. You see, I have an ulterior motive."

He had their full attention. "I want you to have the background story of the tribesman Rau, because I need to ask your advice on the immediate problem of our heroic evangelical pastor and his woman friend, who is wanted for questioning by the police."

"Would anyone like more coffee?" Amelia inquired. No one did.

Hank Tyson leaned forward, placing his hands firmly on his knees. "Bob, are you saying there *is* a woman friend, who really lives with Rau?"

"They came to see me earlier this evening—Pastor Rau and his child, Drim, and the woman, Kieu."

"My goodness!" Charleen stopped rocking.

"Rau explained to me that he met the woman when he had been drinking, and only intended to let her come to his cottage temporarily. However, no matter how often he sent her away, she kept coming back to care for him and the child and their home. Remember that Rau has been very lonely since his wife died, and little Drim has been neglected, running wild, to a certain extent."

Amelia went around, taking up coffee cups. "It's what you'd expect from a child who has no mother, and whose father is either away on business, or over-indulgent, to make amends, when he can be at home."

There was a thoughtful pause. Joe leaned back on his elbows staring into the fire that reminded him of home. His father smoked a fragrant pipe like Bob Gordon's. He had hardly missed his mother, with his crusty Aunt Hester to bring him up in the way he should go.

Charleen said, "I feel really concerned about the child and her father. But I can't help wondering if this woman is the right kind of person to be an influence in a Christian home. Didn't the policeman tell us she's a bartender, and that she assaulted some man in the bar?"

"Not to mention," her husband added, "that she is living with the child's father even though they are not married."

Joe half-closed his eyes. What if he and Allison....

"It's a problem," Bob said. "I wouldn't mind hearing what you all think about it."

Hank was ready. "We should certainly pray for this woman, Kieu, but of course we cannot condone her attack on the unknown man. What kind of woman would be capable of such a violent act?"

Joe was surprised to find he was holding his breath.

"As to that," Bob said, "I should explain that this man whom Ba Kieu attacked, according to her, was formerly an unjust judge in the Communist government of the North. It appears that, during the Land Reform program of '54, he had the power to deprive Kieu and her husband of most of their land. Even though they gave him everything they had, including a certain inherited ring, he was not merciful. They were no longer able to survive from the small land left. Within months Kieu's husband and son were dead. She, however, was made of sterner stuff and escaped to these mountains, where she found the job in the bar.

"When she recognized one of the patrons, by her own family ring, as being the very man who had wronged her, Kieu was overcome with bitter hatred and tried to kill him. Fortunately she missed. The man has disappeared, and Kieu has taken refuge with Rau and the child, whom she has already become very fond of."

The room was silent. Only the fire spoke, gently.

Hank frowned. This changed things. "Clearly the man she attacked is a Communist and seriously wronged the woman. On her part, however, the police would certainly say there was intent to kill."

"There was that," Bob nodded.

Charleen looked very troubled. "It's such a sad story. And, after all, she didn't actually do anything criminal. But then of course she *is* an immoral person."

"Then so is Pastor Rau," Joe put in.

"He is," Bob nodded again.

Hank continued to think out loud. "Here is a dangerous, passionate woman. If someone wrongs her, she does not accept her fate humbly, she reacts like a tiger!"

Bob winked at his wife. "Well now, Amelia gets bored when I go on about this nation's past, but women of passion are not unusual in Vietnamese history. You remember the famous Trung sisters who turned back the Chinese armies, and then, when in defeat, committed suicide. Some years later, in the third century A.D., there was a notorious girl named Trieu-Au. She was an orphan who lived with her brother and her cruel sister-in-law. When she could no longer bear it, she killed the sister-in-law and took off for the mountains. There she raised one thousand troops with which she and her brother rose against the Chinese. At twenty-three Trieu-Au rode an elephant into battle. When her brother objected to her aggressive part in the

revolt, she said to him something like this: 'I want to sail against wind and tide, kill the whales in the Pacific Ocean, sweep the whole country to save the people from slavery! I have no desire to follow others and take abuse.'"

"Mercy!" Charleen breathed. "That's the very way Madame Nhu talks nowadays."

"Not very feminine," Hank commented. "Pastor Rau is headed for trouble if he loves a woman like that."

"There can be great potential in such a person," Bob Gordon said. "Outlaws like La Yoan, our former witch doctor, and this Kieu have a lot to offer." He chuckled. "The thing is, to get them on our side."

Hank began to look worried. "Of course, as a Christian, Pastor Rau can obtain forgiveness. Maybe even the woman can be persuaded to see her wrong-doing. Evil-doing is surely not too strong a word!"

Gordon leaned back, no longer laughing. "Rau has come to love Kieu, and much appreciates all she has done for him and for Drim. He says that Kieu has never had a chance to know the God of heaven. If I will only give them more time, Rau believes he can teach her about the true God. And then, when she has become a God-follower too, they can marry. That's his plan."

"Sounds good." Joe sat up. "The only thing—I wonder if it's possible to teach any of us to love and forgive our enemy. I can't quote chapter and verse on that...."

Hank's dark eyes flared. He was not going to be baited into an argument about loving Communists. "Of course the woman can receive forgiveness— if she repents, that is." He turned toward Bob. "But, in the meantime, aren't you, and the CMA, in a position of hiding her from the police and obstructing justice?"

"Hank, honey," Charleen said eagerly, "the legal part is not really important, is it, if there's a chance of Kieu getting to know the Lord? And think of that poor little motherless child...."

Hank's mouth was tight, his ears growing red.

Bob said, "It's helpful that so far Colonel Thanh, our Province Chief, seems to feel there is no case."

Hank was not relieved. "But Bob, we know the truth. That woman was willing to murder someone!"

Out in the kitchen Amelia rattled a few cups and saucers. Otherwise there was a heavy silence.

Joe thought, "The quality of mercy is not strained. It droppeth as the

gentle rain from heaven." He had never appreciated rain more than in this seemingly endless dry season of Vietnam.

"When I left Rau and Kieu and Drim," Gordon said, "I told them we would pray about this very serious matter and discuss it together tonight. He ran after me then, and pulled at my sleeve. 'Grandfather,' he said, 'I told her about the love of God! I have told her there is nothing we can do to separate us from the love of the one God, who can forgive anything.'"

Hank dropped his head in his hands, fingers running through his strong curly hair.

Charleen had tears in her eyes. "But she must truly repent!"

Joe grinned. "And give up killing." Tyson looked affronted again.

"Amelia, will you come back in here?" Bob called. "It's time for us to pray together about this. Joe, would you give the opening prayer? And then we'll all just be silent for a while."

Startled, Joe thought of his godfather, the minister, while Amelia came back and sat down. Then he heard himself begin an evening prayer from his own church liturgy, "'Lighten our darkness, we beseech Thee, O Lord, and by thy great mercy defend us, from all perils and dangers of this night....'" In the four or five minutes of quiet, a wind was heard to rise, moving the trees, lifting and dropping a loose tile on the roof.

At last Bob drew a deep breath. "Amen," he said, leaning his head back against the chair cushion. "Well, what is the sense of our meeting? Would anyone like to begin?"

Charleen clasped her hands, Hank looked away, and Amelia studied the fire. Finally Joe said, "Bob, you've been working with God longer than any of us, maybe you should go first."

Bob scratched with his pipe stem behind his ear. "Well, sometimes I get a feel for how He does things. For me the rule of thumb is something like this: first love, then allow. God always seems to give a person the freedom to do what He wants no matter what it is. Then He creates with what happens, somehow uses it in the Plan. So I would say: love, allow, create. God loves this woman, He lets her act, and He counts on us to help him create out of the situation."

Hank moved suddenly. "Begging your pardon, Bob. That sounds like pretty radical theology to me, and what's more, it evades some of the main issues."

Amelia looked at Hank with understanding. "How's this," she said, "maybe, even though our points of view differ, we all feel that Rau and Kieu

should have their chance—unless the police come back. Does that sound right to everybody?"

Slowly the members of the group agreed, but they had lost any merriment. Hank hurried Charleen through their thanks and goodnights.

Joe lingered with the Gordons for a moment longer. "'Blessed are the peacemakers,'" he smiled at Amelia. And Bob put his arm around her shoulders as they said good night.

Shadow People

There was a time, before the first of the iron-bound, man-made Moral Systems was set up, when men everywhere saw the whole of their limited world as a continuous sacred experience.... The destruction of those primitive values which went step by step with the development of that arrogant delusion, the sense of moral rectitude, is for some minds the greatest of all human catastrophes.

Dr. Alan McGlashan, "Psyche Unbound," Harvest, 1962

Outside in the sudden dark, Hank Tyson snapped on the flashlight he had brought with them. Charleen took her husband's arm, looking behind her in the blackness for Joe. When he didn't at once appear, Hank pulled her along toward home and bed. So Charleen came, glancing up from the white beam on the path to admire the stars and shiver deliciously in the fresh cold. But when they had closed the door of their little house and were alone together, she saw that Hank was upset.

Charleen thought it best not to notice while she spread a second brown blanket on the double bed and turned back the sheet. It looked so inviting. How perfectly miraculous to think of actually sleeping under so much cover! However, her husband still frowned, leaning his elbow on the tall dresser. Charleen wasn't exactly sure what he was fretting about and hoped they wouldn't have to go into it tonight.

"Don't you want to get ready for bed, honey? You can have the bathroom first if you want."

Hank didn't seem to have heard. "I don't feel altogether happy about things here, Charleen." He paced over to the window and back. "I just don't feel comfortable about that immoral, vengeful woman being allowed to run free here on the grounds of a Christian school for innocent children. After

all, she is wanted by the police! It makes me have second thoughts about trusting our own three to the Gordons."

Charleen considered. "But Hank, what they're hoping is to give that woman a chance to learn to know her Savior and be changed!"

"You don't have to tell me that! I was there; I heard the same stuff you did."

"Well…?"

"Well what?" Hank's voice was sharp.

Charleen was getting her old flannelette gown out of the suitcase. "Well, I guess that's the way it was decided, and we did pray about it."

Hank sat down on the bed, his hands on his knees. "But I still don't feel right! I didn't think Bob Gordon was at all forceful, and that new guy, the doctor, is very casual, not even a Christian. If I were running this place, I would see to it that a woman like that was brought to justice first, and then taught about Jesus after she understood her sin." Hank's demanding eyes met hers. "Charleen, they aren't really *fighting* against evil!"

Troubled, she could see how much all this mattered to him, and she remembered his understanding for her, earlier that day, when she had felt so desperate about letting the children go away to school. If only he could have waited till tomorrow!

"Well," Charleen returned his hot look with affection. "I see what you mean, Hank, and I'm really sorry you feel so upset about it all. The thing is, honey, I don't believe Bob and Amelia and Joe think of it as a fight, exactly. Still, if you decide everything is not right, then I'll start in to pray about it with you. And maybe God will help us figure out something different to suggest to them tomorrow.

"But for now, honey, I'll just run on in the bathroom first while you're undressing. It's getting late. And Hank," she turned, pink zipper bag in her hand, "I think it's sweet that the Gordons have turned out to be really kind people. It helps me so much when I think about the children coming up here to people like that." Charleen's smile was luminous.

"People like a would-be murderess!" Hank jerked at his collar button. "Indeed, they *don't* think of it as a fight. That's exactly it; they don't seem to realize you have to fight hard on the Lord's side, if you're going to win!" But the bathroom door had closed, and the water was already running.

Stumbling in the blackness on the unfamiliar path outside the Gordons'

cottage, Joe felt a hand at his elbow, heard a rough whisper, "Can speak Vietnamese, Mr. Doctor?"

He turned. "A little."

"Good. I am Pastor Rau, wanting to speak with you."

It was too dark to see the man at all. "Come along to my house then," Joe said. Once inside his cottage, he switched on the electric light and examined his visitor. This was the man Gordon had told of, with eyes like fire. In body Rau was thin and muscular. His black curly hair had been cut or shaved too high, revealing a broad stretch of forehead with two rows of deep wrinkles over level brows. The man's nose was wide, his upper lip long, the mouth full and generous, chin strong. Rau wore a white shirt with dark slacks and a brown knitted vest.

"Sit down," Joe gestured, "I'll light a fire."

But his guest held up a restraining hand. "I want only to ask quickly what the Grandfather and his friends have decided for my wife, Kieu." He used the word *nha* which could mean either wife or home.

"Wouldn't it be best to ask the Reverend Gordon himself?"

"Maybe not," Rau said. "The Grandfather is a very kind man. If the answer is bad, it is hard for the Grandfather to tell me, especially at night when he is tired. But he is an honest man; if Kieu must go to jail, he will tell me in the morning. However, in the meantime, my woman and I worry too much to sleep. I think the doctor can tell me now quickly without trouble."

Joe could see the sense in this. "Well, as I understood it, they will not give her over to the police."

"Thank God! And will they also let her stay by me and learn to become a Christian?"

Joe looked curiously at the broad, strongly carved face. "Aren't you satisfied that she escapes the police after such a crazy act? She sounds like a woman who cares for you and the child, why should she become a Christian?"

Rau looked belligerent. "I thought you were a pastor."

Joe felt suppressed anger rising. "I am a *doctor*. *Bac-si*. I am in the business of healing."

"Phu!" Rau blew through his lips. "No one heals without the power of God. God in heaven, He is the one who heals!"

Tired, a little ashamed, Joe indicated a chair. Now he saw the fire in those eyes. "Okay, Pastor Rau, please sit down. You're right, I guess."

Rau passed up the chair and squatted down beside it. "You can guess, *Ong*

Bac Si, but I know. A man may give pig or chicken or even buffalo, but he is not healed. If a man gives prayer to the true God, he can be healed. I know. This has happened to me and my people. If a man is right with God in his heart, he will be healed. So, if you are a doctor who can truly heal, then you are the hand of God!"

Joe had never dared to think that particular thought.

Rau said, "My woman, Kieu, is very lonely woman. And she is sick, sick from hate. Only the true God can save her, but not just from police. She can be cured from her sickness only by the hand of God. I and all of us here with the Grandfather, we are His hands; we can help to cure her." Rau leaned forward, two hands of power on his knees. "Mr. Doctor, you do not understand about hate."

"Pastor Rau, I survived the Korean war where I was wounded. You think I haven't felt the power of hate, both my own and others?"

Rau studied him. "If it is true that you do understand hate, then maybe you do not yet understand what it is to have God's Word stick in your liver, which you call heart."

Joe did not feel certain that either his liver or heart was stuck with the Word of God.

"You see," Rau hunched forward, "I know. In my tribe we used to take revenge on other villages with long daggers. If a village attacked ours and killed ten people, we would run to their village and kill more even than ten people. We would chop up everyone, women and children too, with long daggers, because of our sickness of hate, the same sickness of my woman, Kieu. But now we follow Jesus; we do not chop up our enemies. We let God take care of them."

Joe grinned. "That's a change all right."

"You bet! When God's Word sticks in many livers, we will have peace." He smiled broadly.

"So much for hatred," Joe said, studying the face of his visitor. "Pastor Rau, you almost make me believe there is a real need for missionaries."

Rau sat steadily on his strong bare heels, undisturbed. "It is not the doctor's fault that he is ignorant. I have already seen that many people from all nations, even America, do not know the good news of the God of heaven. But now you have met the Grandfather. It was because of him that my life changed, because he spoke my tongue and had such a heart for my people."

"He spoke my tongue…" Joe thought about how he had resisted learning the language without which he and Rau would not now be talking. And

Vietnamese was not Rau's first language either. He was almost as bad in Vietnamese as Joe. Truly, reaching out to another was not easy. Even in English it wasn't easy to understand another person. Would he manage to understand Allison, his sudden new love? Joe rested his head on his hand; questions crowding his mind.

But the pastor asked one first. "The Grandfather and the others, did they pray before they decide what to do for my wife?"

"Yes. They talked for a long time, and then they prayed."

"Is good." Rau's wide mouth closed firmly on his satisfaction. "Before, to decide a problem in our tribe, we used the water judgment. If two people disagreed, they were taken to a river, and their heads were put under the water. The one who had to come up first for air, he was wrong, and he who could stay under longest was right.

"But," Rau gave a dry chuckle, "that one who was right sometimes never came up to get his reward. Often drown."

"Not exactly justice."

Rau shrugged. "It was all we had for judgment custom. Before I heard of true God, I did not know a difference. Yet I was brave and very good with longbow. I kill as many tigers as any. I dig deep pit to trap wild elephants for tusks to sell in Dalat. I was strong, but not happy. I have to work so hard to keep the spirits from evil deed to me. I worry always, day and night.

"When I met the Grandfather, the first thing I can understand of his story around the fire at night, is that the God of heaven give his son for blood sacrifice. We can all understand why the God of the skies must do this to stop the evil ones. We also killed our animals for the power of their blood. Blood of son would have much more power!

"But I had many things still to learn. And most important, I had not yet grown a delicious ear toward the spirit of the skies. It take more than one year to learn to hear the voice of the one God in my heart and liver. Not only to hear, but to do what I hear, even if not seeming good to the tribe or our leaders. For example, once I find a girl I know is the right one for me. Do you understand, I know she is the one?"

"I understand," Joe said with joy.

After an approving grunt, Rau said, "But in our tribe, if you want wedding, man must have front teeth sawed off. It is always custom. Still have teeth, not yet married.

"But I learn from Grandfather, the true God does not want broken teeth for married man! I don't know what to do. Christian man still has same teeth

at wedding. At last after some time, I hear a clear voice in my heart, tell me not to let tribesmen saw off teeth. I wonder very much. After more nights of thinking, I obey voice. *Very hard!* Relatives angry. But my wife understand; we are different." He flashed a reassuring smile. "So I am married, and have teeth also, by grace of God who is kind, does not want cruel sacrifice. God's son already make blood sacrifice. Sacrifice finished for good."

Joe felt dazed. "How did you become a missionary?"

"After much learning and thinking, I see that me and my people, very sad people. Always slaving for evil spirits and evil customs. Very unhappy. So I must go everywhere in the mountains and tell all my people about the one spirit of the skies who is kind and loving. I explain such things as: if God make the frog, it is God we should worship, not the frog.

"Through many hardship I tell more and more people. How happy they are, now they do not believe in power of evil spirits! Many back in mountains become God-followers. We build small bamboo churches.

"But that is not all. Junglemen, Viet Cong from North, come down and try to make us serve them. No longer evil spirit, but junglemen. We serve them or they kill. Of our villages they say, 'Kill off the cocks, and the flock may be stolen.' So we must leave our mountains and move our churches and villages down to the plains to be safe. Very hard. Junglemen don't want villagers to move out of their reach. Also, many people cannot leave the place of their ancestors. They are afraid of dying in a strange village where they do not know the spirits. But Christians can do this."

"Don't Christians hate to leave their homes and possessions too?"

"It is hard for many. Never mind," he smiled suddenly with his unbroken teeth, "we take with us our things of spirit. We take our faith, our courage, our new freedom from fear, our new love-happiness! These things can go on small raft, take up no room in basket."

"Yet you yourself did not move away with the churches," Joe said gently.

Rau drew himself up with pride. "I go three times, but must return after. I am Superintendent for moving of all tribes—Chil, Tring, Roglai. More villages still not yet persuaded to leave dangers and go down to safer place for live and worship our God."

Tired, Joe leaned back in his chair, staring into the cold fireplace. "You are a happy man, Pastor Rau. I'd like to be that happy and sure too."

Still squatting, Rau said, "Do not be sad, Mr. Doctor. Something will happen. Maybe something has happened already. My brother Doi, very hard

to believe. Many years he cannot hear what I say, or what God says. But one day when he sees that the God of heaven gives me a wife, even though I will not have teeth sawed off, at last he believes! The true God is better than old law. At my wedding, my brother cry, 'I see it!' and before long Doi also develop delicious ear for the words of God. Wait, have patience, Mr. Doctor. Something will happen. The doctor has a wife?"

Joe shook his head.

"Maybe God will give the doctor a good wife, and then he will learn the kindness of God!" Rau stood up.

"That would be kind all right!" Joe rose too, smiling and stretching. Daring a long look into the man's light-filled eyes, he gripped both of Rau's hands. "Thanks! And sleep well!"

Rau nodded seriously. "I sleep well because I hear from you again what I learn before: the God of the skies is very kind. I go home and tell my wife the good news." Pastor Rau disappeared in the dark.

Joe leaned against the door jamb and lost himself in the stars. "I see it!" he repeated, testing the words. Maybe after all my wanderings, at last I am not a stranger. Now I'm among friends, in the right place, doing the right thing for me. Maybe something has already happened—Allison!

And later in bed with the warm covers up to his ears he wondered, if God is so particular in his kind attention, shouldn't we be as kind to ourselves? Even like ourselves, as Rau seems to?

The Ambassador's Villa

Come friends! How can you bear not to stay in these mountains
And savor that rich red wine with me!

Poem by Wang Wei, eighth century

Either something was just about to happen, or it already had, Allison
thought earlier that same evening. After their walk with Mark, the Girauds
quickly made a pleasant mess of their two rooms and bath. Familiar belong-
ings were everywhere, while Katrine and James romped across the beds as
though they were at home, with some added frisson of excitement. Mark
had said the children would have their supper early, at 6:30, in a separate
dining room, so she could send them down the back stairs in their night
clothes if she liked. That was customary with the younger ones.

Allison bathed and pajama-ed her kids merrily, bullied them out of an
argument, and sent them downstairs in outgrown flannel robes. Then she
went out on the high porch, drying her hands and arms with a towel. It was
still possible to see the little tennis court down below in the dusk. Would she
actually sneak out so early tomorrow morning and play with Joe again? The
cold gorgeous sunset above the black trees shivered her into soberness. The
mountains were there too, solid and timeless like a reproach. What she must
remember was the importance of this evening. Here was her chance to
impress Mark's boss and his wife, to show everyone what a good Foreign
Service wife she would make!

Back in the lighted room, there was an empty feeling with her children
gone from the floor. Odd old house. It's time for that drink, Allison thought,
beginning hurriedly to dress.

In her gray skirt, wine-red cashmere sweater, and the pearls Max had
brought from Hong Kong, she entered the drawing-room where other
guests were already drinking around the fire. It was a long room, with the

fireplace to her right and high curtained windows opposite the doorway. A beautiful Chinese rug spread from the hearth to the far end of the room where Mark was using a lacquer cabinet as a bar. Smiling, he came down to meet her, his obvious pride the best assurance that she looked just as she should.

To her left along the wall was a chintz-flowered sofa flanked by two stiff Chinese armchairs. From the nearest of these the Ambassador rose as Mark presented her. Allison had briefly met Mr. and Mrs. St. John one day at the Cercle Sportif. He was tall and heavily distinguished, with iron gray hair. A sense of humor had quirked his eyebrows, but his eyelids drooped a little, as though he had seen almost too much of the world. St. John gave her a smiling nod of appreciation before passing her with pleasant authority across the room to his wife. Allison thought it became a habit with ambassadors to keep people moving, not to devote too much of themselves at one time to one person.

Bright-eyed, red-haired Mrs. St. John was sitting in a flowered chair near the windows. Promptly pushing up from its depths, she reminded Allison of her mother because of her plumpness and energy. Allison willed herself not to retreat before so much female enthusiasm, and nervously overdid her own greeting. But Harriet St. John was introducing her at once to a Vietnamese couple seated together on the high-backed Chinese bench to her right.

Allison turned with relief to stout Mr. Nguyen Tan Thinh, coolly contained in his own satisfied ego. When she greeted him tentatively in Vietnamese, he answered firmly in English. Tiny, beautiful Mrs. Thinh seemed grateful, on the other hand, to find someone she could chat with in French and a little Vietnamese. Her eyes on Mrs. Thinh's exquisite jade and diamond ear drops, Allison heard the little lady explain that they had only brought the fourth of their thirteen children with them to Dalat.

"I can't believe you have that many!" she declared sincerely to the delight of the Thinhs.

For this Allison received a wink from the next guest, Jeff Gregory, an economist with the Foreign Aid program. A thin, tall intellectual, slumped deep in a comfortable chair by the grand piano, Gregory made only a casual gesture toward getting up, but signaled by his raised eyebrows that her arrival on the scene was an unexpected treat. His blonde wife, Katherine, looked stunning in a black knitted sheath. Their two boys were trying for attention by fighting over the popcorn bowl which they managed to over-

turn. As Gregory ignored it and his wife looked irritated, the butler appeared in cold disapproval and called the maid in to clean up the mess.

Pleasantly removed from that hassle at least, Allison sat down in a chair near the fireplace to sip the very dry martini Mark had put in her hand. Her own children must have gobbled down their supper at top speed. Now they were watching Mark as he showed them and the Thinh's daughter, who looked about seventeen, how to toast marshmallows brought from the Commissary in Saigon. It was a first for those three, though the Gregory boys were experts. Their delighted laughter seemed to fade while Allison leaned her head against the chair, looked into the flames, and listened to a secret inner singing. Could Joe be hearing it too? People said this sudden magic always pulled both ways. He had strange light eyes. Were they hazel? From memory she tried to read their expression.

"I understand you play tennis, Mrs. Giraud." Mr. St. John loomed suddenly above her chair.

Allison spilled more than a few drops of her martini over her wrist. "I play a little, Mr. Ambassador, but not very well."

"Still, you were out on the court almost as soon as you arrived this afternoon! I call that real enthusiasm," said Mrs. St. John from across the room. "I just happened to look down and saw you both. Mark, you certainly have a strong serve!"

Allison spoke quickly. "That was just someone from the school, Mrs. St. John, who gave me a quick set while Mark was working."

"Oh, one of the missionaries?" It was a bright question mark.

"I don't know." Allison was startled. "I didn't ask."

"If he was over there, he must be a missionary, perhaps one of the teachers."

Allison held back her impulse to say she had been over there, and she wasn't a missionary. What difference did it make anyhow? What was so awful about being a missionary? The very name had a lowly flavor. They should call themselves by a more elegant name. Horrors, was Joe really a missionary?

"Some missionaries are quite attractive," the blonde Mrs. Gregory drawled, as with a metallic whir the French clock under its glass cloche on the mantel struck eight. Mr. Thinh suggested that his daughter say good night, which she did, very gracefully, though surely she was too old for such an early bedtime. The Gregorys tried to persuade their children to go to bed,

failed, and "decided" to let them stay up longer if they would promise not to run in the dining room.

Catching Mrs. St. John's look of alarm as she glanced at her husband, Allison started Katrine and James on their leave-taking rounds. Mark looked proud as a father of Katrine's curtsies (however condescending and mechanical), of James's friendly handshake and candid gaze. With the warmth of approval at her back, Allison followed the children from the room. So far so good unless Mr. St. John could hear James crowing, "I shook hands with an Ambassador!"

And upstairs in bed they were not so easy. "We can't go to sleep up here, Mummie—it's scary! Don't leave us by ourselves," begged James. "There could be ghosts!"

"Don't be silly," but Allison glanced over her shoulder. "I'm right down-stairs if you want me. You've had your nice supper and marshmallows too, now it's Mummie's turn. I'll be up between courses to check on you. And anyway, I'm coming to bed soon myself, I feel so sleepy!" Allison convinced them, somewhat to her own surprise. There *was* a strange empty coldness about the third floor, so far removed by twisting stairs from the fire, her martini. She hurried down, trying not to catch her high heels in the frayed matting. Such a fall would be rather deadly.

At the dinner table Allison found herself on the Ambassador's left. I believe it's going to be our night, she thought, smiling over at Mark. His pleasant French to Mrs. Thinh was a modest triumph. The subjects he introduced now and then were interesting, amusing, and uncontroversial. Proud of Mark, Allison did her charming best with Mr. St. John, who, from his seat at the head, was establishing a holiday atmosphere of easy informality between the great and lesser beings. Although the oak furniture was heavy and ugly, the dinner was excellent, the service cold but impeccable. Allison deepened her dimple and her southern accent, enjoying the good life.

The number of people around the oval dining table was awkward for proper seating. If the Ambassador was to have Mrs. Thinh on his right and Allison on his left, if his wife was having Mr. Thinh on her right and Jeff Gregory on her left, then Mark would have a man, Jeff, on his right, and Allison would have a woman, Katherine Gregory, on her left. She turned in that direction while Mr. St. John engaged his lovely Vietnamese neighbor in conversation. Mrs. Gregory was already leaning back lazily, leaving Mr. Thinh to the gracious efforts of his hostess. Allison looked at Katherine

Gregory with respect. She always felt admiration for people who remained themselves right in the teeth of society's "oughts and shoulds."

Katherine returned the look with interest and said, "Your kids really behave well. How do you manage it?"

"That was sheer luck this evening. I think they were cowed by all the strangers."

"Come on. That little girl of yours doesn't look easily frightened."

Allison laughed. "You're absolutely right. It's a fight to the finish between us most of the time."

Katherine studied her sideways, sipping her wine. "Where do you get the motivation for it?"

Immediately uncomfortable without knowing why, Allison was glad to find the fat maid at her elbow with Hollandaise sauce for the asparagus. Busying herself with the ladle, she felt warmth rising in her cheeks. It was difficult to like someone who had such a knowing gleam in her eye as Katherine Gregory, and who obviously never made herself a slave to pleasing anyone.

Mrs. St. John's penetrating voice collected everyone's attention. "I want you all to know what I have just discovered: Minister Thinh is an orchid fancier, and has quite a collection in his greenhouses in Saigon!"

"That so, Thinh?" the Ambassador rumbled. "Are you planning to add to your collection while you're here in Dalat?"

"It has occurred to me, Mr. Ambassador. However, there are difficulties of which you may not be aware. First, of course, most of the orchids here will not bloom in the Saigon heat, and, in any case, one cannot go crashing into the jungle to gather orchids."

"No?"

"No, sir. One must make use of the orchid hunters. These men are those from the Moi tribes who understand the personality of the orchid."

"Orchids have personalities?" Mrs. St. John was intrigued.

"Indeed. They have an extreme sensitivity. For example, if you hunt orchids, you must go gently and quietly. And, on the day you will hunt, you must not speak of your search after midnight. If you talk carelessly of your plans, when you arrive in the rain forest, you will not smell the fragrance that leads you to the orchids. You will smell nothing, and find nothing." He seemed completely serious.

In the uncertain silence around the table he added, "Therefore, with no advance planning and little time, if I would acquire any of these beautiful

parasites which so nearly resemble butterflies, I can only hope to purchase a few ordinary ones at the orchid seller's stand located beside that little bar across from the market." Allison wondered if Minister Thinh was as devoted to his work for the Vietnamese government as he was to his hobby. Everyone seemed impressed, except Mrs. Thinh, who showed pointed disinterest in her husband's collection of parasite butterflies.

Mark leaned forward to ask a question, but the Ambassador spoke first. "So," he said, "the orchid hunt is a matter for intuition. If this is also true of tiger hunting, it would explain my many failures. I doubt if intuition is my strong suit." While Thinh disclaimed any knowledge of tigers, the rest of the company could not help smiling. Everyone knew how the Ambassador had struggled to bring back his tiger, going out many times with the famous "Lucky" Jordan.

Allison had heard one version down in Saigon of the Ambassador's desperate attempts. Finally, the story went, the nearest he came once was to a very moist spot where the tiger had urinated. This he dug up and took home! Seeing that the Ambassador came off no better, and even funnier, in his own version of the tale, Allison found herself warming to him. And, of course, someone is apt to like you if you like them. In the pleasant glow, her thoughts wandered away from tigers and orchids. "I'd like to think I'd see you again," Joe had said. To see him again!

As the wine went round, shy Mrs. Thinh asked some polite questions about the history of the villa. "Watch out," warned Mrs. St. John, "my husband is always waiting for an opportunity to tell our ghost story."

Allison responded to this only with her polite smile. All the others, however, murmured keen interest, and there was a sense of expectation in the candlelight. With his eye on his turning wine glass, Mr. St. John began to tell the ghost story of the villa.

"There was once a Madame Barbier, who lived in this house, and who was very beautiful." Solemnly he raised his glass to each of the women in turn. "One day, when she was expecting guests, Madame Barbier went up to inspect the preparation of the third floor rooms, where you are staying, Allison, I believe." There was a decided glint in his eye.

"Now, Douglas," his wife began, "and Allison, you mustn't take his stories seriously! He makes most of them up."

"It seems," the Ambassador went on unperturbed, smiling around on his listeners, "that one of her servant girls was young and recently arrived from the country. I imagine her, not only making tiresome mistakes, but, even

worse, being outspoken to her mistress. In any case, Madame Barbier became suddenly furious, and, at the very top of the back stairs, struck her maid! The unfortunate girl tumbled all of a heap, and was dead when they got to her on the landing." Someone gasped. Mr. St. John shrugged. "I suppose she broke her neck somehow. Now, of course, they say she haunts the scene of the crime."

Allison managed to keep her smile frozen in place. Of course the Ambassador knew absolutely nothing. He was simply creating conversation. It was pure accident that he had touched the nerve of her secret guilt.

Mrs. St. John finished up the story. "Of course Douglas tells it all for effect, but I must admit there's a certain amount of truth in it. You can't imagine the trouble I have getting anyone to work up there alone. They will only go in pairs, though they never explain why—just shut their faces, you know the way they do."

The thin butler-cook appeared at that moment with his shut face. "Well," Mrs. St. John smiled hastily at Allison, "poor you, sleeping up there! We are not a bit tactful. Do ghosts bother you?"

Before she could answer, "Sounds like an old wives' tale to me," Katherine Gregory commented in her husky voice, looking bored. "Anyway the maid was asking for it."

Allison felt a rush of appreciation, but Jeff Gregory, tipping back his chair, said, "Madame Barbier is faintly reminiscent of our own dragon lady, Madame Nhu, don't you think?" Possibly aware then that he might be embarrassing the Thinhs, Jeff let his chair down and suggested with relish, "I know what you can do about your ghost. Why don't you have an exorcism? You could get a Buddhist Bonza or one of those handy missionaries. It's supposed to work quite well."

Allison was bothered by words like "dragon lady" and "handy missionaries." She decided that Gregory had had too much to drink.

Mrs. St. John said, "Oh dear, Jeff, you make it sound exactly like calling in the Extermite people." While they were laughing, she rose. "Let's have our coffee in the drawing room."

Returning to the fireside, Allison found she could not recapture her pleasure in the charming world of ambassadors' villas, nor could she any longer hear the inner singing. Even the blending of East and West in the decor of the room no longer pleased her. Excusing herself to check on the children, she was surprised to see them sleeping soundly in their little blue beds, looking defenseless perhaps, but quite safe. No ghosts or goblins

disturbed their even breathing as Allison pulled their quilts higher and left them to dream.

And how could she keep them secure? By marrying Mark? Ashamed of her fears, Allison reminded herself stoutly of the daring things she had done when younger. But once you had kids, you were vulnerable. What was it her mother used to call children, "hostages to fate"? That was it, you had given hostages to fate.

Downstairs again, the Thinhs and Gregorys were missing, either gone out or gone to bed. The St. Johns were already finishing their coffee. Tasting hers, Allison found it tepid. Mr. St. John rose and left on an abrupt good night. His wife diplomatically praised the mountain air for her sleepiness, and, before following the Ambassador, smiled with maternal affection at Mark and Allison on the sofa. So they were accepted, and now they were alone together for the first time that day. Yet what were those disturbing thoughts to be brushed away as Allison settled back uneasily—the murder of a maid in anger, Joe Ruffin—a missionary?

Mark stretched out with his hands in his pockets, leaning his cropped blond head against the chintz flowers. He looked wonderful in his light blue shirt and tan cashmere jacket. Right behind him Allison could imagine the upstairs sitting room of his family house on Beacon Street; a few old ornaments brought on ships from China, some family photographs, silver-framed, his mother looking up from her writing desk to meet Allison some day, only politely, gently surprised. And off the Cape a wind-taut sail obedient to his experienced hand.

"They like you," Mark said contentedly. "Who wouldn't?"

Allison felt touched and guilty. "They don't know me very well yet. Sometimes," she suggested faintly, "I'm...awful."

Mark laughed indulgently. "You are perfect!" he said, "even when you run off to play tennis with strangers," and he emphasized it by a sound kiss. Allison kissed him back with sudden gratitude.

He sat right up then, aware of some difference. "What's wrong, Allison, is something bothering you? I can't think what—you clearly charmed them all."

Why could she never tell him what was wrong? They should be able to share important or even disturbing things, shouldn't they? Maybe she didn't know what was wrong. Suddenly she saw a perfectly clear picture of the back of Joe's head and the fiercely vital way his curly hair grew out of his neck. If Joe was what was wrong....

"Allison," Mark laughed a little. "Come here to me—come on! What's bothering you?"

She looked away. "Oh, I'm probably just scared by Mr. St. John's ghost story. After all, it did happen up on our floor."

Mark put a finger on the dimple beside her hesitant smile. Things were very quiet. There was a smell of wood ash from the dying fire. And the French clock whirred eleven strokes mechanically under its glass bell.

"Breakfast at 8:30!" Mark pulled Allison to her feet and went with her all the way upstairs, in case of ghosts. Before he left her outside her door in the dim corridor, Mark said he had ordered dinner the following night just for two at La Savoisienne. Leaning easily against the wall, he explained they would have to stay around the villa long enough for a drink beforehand, because the Ambassador always held Open House for Americans and their friends on Saturday nights when he was in residence. Since anyone could come, there might be a crowd, so he and Allison would be expected to help. But after that they were free to go off on their own. And he smiled down at her, warmly, privately.

Then, "Allison, speak up! Are you actually afraid of the ghost?"

She shook her head and smiled with determination. "I may be a little tired, that's all." Wasn't the cozy tête-a-tête Mark proposed for tomorrow night exactly what she had been hoping for? "Thanks so much, Mark. We are loving the weekend."

"Great, isn't it? And it's just begun!" He opened her door. "Turn in right away now, Allison, and get plenty of sleep." He found the light switch and glanced around quickly. Her blue nightgown was lying softly across the turned-down bed. "Shall I open a window for you?"

"No thanks, not just yet." Open a window? When he had kissed her and gone off, Allison stood in the cold overhead light of her bare room shivering. Later, after she had snapped off the electric switch and curled up under the blankets, she tried to bring some order out of what mixed and shifted in her mind. There was satisfaction that Mark did seem to be proud of her and might well ask her to marry him on Saturday night. There was guilt for her sneaky behavior that afternoon. If she had the courage she would be even worse tomorrow morning. There was also sharp regret over her furious meanness to Chi Hai so long ago yesterday. Her own dragon had really burst out! And there was always that tight anxiety over the terribly uncertain future for herself and the children.

But now it was all shot through with excitement over meeting Joe

Ruffin—thankful joy, whatever the consequences, that it was possible to be aware again with all her senses of a man. She thought of Joe's body, poised ready to run, his dark head set slightly forward on his shoulders, like an athlete or a fighter. Allison vividly remembered his enormous pleasure in every minute of the tennis.

She couldn't help sensing that the stagnant stream of her life might not be moving yet, but was already dangerously full. Mentally she tossed a few things on the dam. You promised Madeleine not to do anything foolish. Would you throw away Mark and a good life for sexual attraction, for romance? Lying there, Allison listened again to the light accents of the evening's conversation in which she had taken a creditable part, while orchids, like the yellow butterflies of the morning, fluttered across the surfaces of the dark. And yet, from somewhere, she could almost hear again that secret music.

Allison sat up and turned on the bedside light. It's just not sensible to decide anything tonight when I'm tired. Firmly she set her traveling alarm clock for 6:00 and put it too far away to reach easily. I will decide when I wake up, when my mind is fresh. Turning out the light again, she pulled the cocoon of sleep gratefully around her and curled up safely inside.

Man and Woman

In the case of man and woman "one is as necessary to the other as is that of any condition where there are two poles...even in the atom its polarization is necessary or the energy is soon expended...for the better, the bigger, the broader, the greater development of each other, these are necessary one to another."

The Cayce Readings: 5439-1

Shocked awake at dawn by the needling alarm, Allison hit the icy tiles with her bare feet and fumbled frantically to stop the sound. Silence. In the silver-gray light she stood, shivering with cold and misgivings. It would be unforgivable to sneak out on Mark again. And what if keen-eyed Mrs. St. John were an early riser? That would certainly be in character. Allison could stay perfectly safe so easily. She could just not go.

But the thought of returning righteously to a warm bed seemed to have little real power. Instead, thinking of Joe, she smiled slowly. Joe, so alive. Allison began to dress. In the thick quietness she pulled on a sweater over the goosebumps prickling her arms, left off make-up except for a little lipstick, tucked her racket under her arm, and feeling the cold tin of balls in her hand, hurried in silent sneakers down the back stairs. Thank heavens the children were asleep! Since she was usually so stern and selfish about being woken up, they would play in their room at least until seven-thirty.

With the pure air tingling her nostrils, catching at her throat, Allison went more and more slowly down the slippery, hard-needled path, afraid to see him. Suddenly there he was; tall and rangy, the thick-joined eyebrows above the searching eyes, the too-strong chin marked by a cleft. After the impact as they walked together toward the court, Allison could hardly look at him for pleasure.

"Did I keep you waiting?"

"A little," he admitted. In fact, Joe had no idea how long he had been sitting there on the hard bench given over to amazement. Angkor was only a short time ago, Angkor with Kate and Lam! In the chilly light of morning, Joe felt bewildered, saw himself as emotionally out of control, and determined to get a grip. But when he finally heard her footsteps, saw her slim figure really walking toward him, Allison looked so familiar, so perfectly right, that, jumping up, he only just managed not to take her in his arms.

They turned toward each other at the edge of the court, laughing like truant children. Joe said, "Let's play for half an hour or so, and then I want to show you the view above my place. It's even higher than the Ambassador's villa!"

Allison had to look away from his intent gaze. "I think half an hour is all I'm good for anyway." They played hard on the winged ease impossible down in Saigon's heat. He showed off for her, and she was properly dazzled. The early sun broke in bright splinters from the pine needles all about them.

"You're so much fun!" Joe said when they stopped and stood there looking at each other across the net. "Where on earth did you come from? Who are you?" He came nearer to see if he had made her dimple show.

Allison turned mock serious. "I come from the Ambassador's villa where a wicked fairy has cast a spell on me! I'm imprisoned for my sins until some day I perform all the 'oughts and shoulds' to gain my freedom."

"But no one can get their freedom through 'oughts and shoulds'!"

"Horrors! You may be right. Then I'm stuck!"

Not about to suggest the traditional prince, Joe found he was afraid of her frivolous, make-believe game. "Allison, really, tell me about you. When did you meet your husband?"

"When I was at college, I took my Junior year abroad in France." She was shrugging into her sweater. "So I met Max when we were both students at the Sorbonne."

"Why did you go way over there? Didn't you like your college?"

"Sweet Briar is all right. Just too near home for me."

"Did you like home better after you had been away for a while?"

Her smile was rueful. "I never did go back, not to stay, that is. I didn't even go home for my mother's funeral. Well, I wasn't happy as a child, and maybe I was afraid I'd never make it in the States. I guess I'm a coward."

Joe switched the long grass with his racket. They were moving together up the hill. "It seems brave to me to stay on alone with the children in Vietnam after your husband's death."

Allison thought about it. "No. You see, I fell in love with Vietnam. It was my first true home."

"I read once that some people have to leave their kin to find their kind." When he smiled his understanding into her eyes, Allison fell silent. Joe sensed her nervousness, hoped it was because of him, and just enjoyed the springtime of her company.

However, climbing past his own cottage under the pine trees, perched on the edge of space, he realized that Allison was not going to ask where he came from or what he was doing. So he began to tell her anyway, watching for her reaction.

"You know, I'm a Tarheel too, from near Greensboro. I'm a doctor, a medical missionary, up here for a holiday, and also to check out medical help for the tribespeople around Dalat. That little house back there is mine for the long weekend."

So it was true. Allison thought about all those drab, serious missionaries (the women probably without make-up), coming here from Laos or Cambodia or Vietnam for well-earned vacations and the relief of coolness. Well, Joe certainly wasn't drab. The life of him drew her like undertow. By the time they had walked up to the clearing on top of the hill where there were some bright, green-painted picnic tables, Allison still hadn't volunteered any comment on his work.

Separate, she leaned against a pine tree to look out at the mountains while Joe slouched on a picnic bench, his back to the view, his eyes on her. "You're much too thin. You don't have amoebic, do you?"

Allison could hear the doctor in his voice. "Of course not! And I like being thin." Her color rose because she really wanted to be more plump in the right places. "Anyway, this Dalat air is making me hungry—and fatter already."

"Maybe that's not the air. Maybe that's because you're falling in love with me."

Allison slid down the tree trunk and sat against it on the earth. "Joe Ruffin, anyone could tell you're a southerner by the outrageous things you say. Will you explain to me how a person as conceited as you are ever came to be a missionary?"

When he said, "I thought you'd never ask," Allison began to arrange pine cones in a defensive pattern around her on the ground. Joe frowned a little, watching her.

"Okay, Allison, I doubt if you want the story of my life, but I guess you'd

better have some of it. I'll make it as brief as I can." She said nothing. "My father is a physician, a GP. My mother died when I was three, and my father's sister helped him raise me. As a kid, of course, I played with the idea of being a doctor too. And then, at Chapel Hill, it even crossed my mind seriously. But the thing was, science interested me for the fun of it. I wasn't motivated toward any special career. Then I got drafted, right out of college. And get this, they trained me as a medical corpsman, one of those happy accidents that are never supposed to happen in the Army. We went to Korea fast."

With her back to the crusty tree trunk, Allison hugged her arms around her knees. When he was thinking hard, absorbed in how to tell her, she could get a good look at him. Joe's dark hair seemed to have a life of its own where it curled. His nose looked blunted, slightly off center. There was a tough solidity about him as though he was ready and willing to take on the world.

"That explains the medicine," Allison said, "but what about the religious part?"

His glance came up. "I never cared that much for church-going as a kid, did you?"

"Definitely not!"

"Well, I was lucky, because my dad never forced religion on me, though my godfather is a minister in the Episcopal church. But Allison, that was a powerful experience in Korea. Under fire as a medic, the only God I met was in people, and they weren't all Americans either. I've heard Him talking to His wounded buddies in language that wasn't so pretty, but it was real. And this God inside those other guys seemed to be inside me too. Dodging and running on those hillsides, my God knew all about it, without words. And sometimes we didn't have a four-letter word left. We were so beat, so totally gone in action, we were right out of our minds. Couple of times my life got saved, and each time by a ROK. Has anyone ever saved your life?"

Allison thought of Max, how he made her go back to safety, staying on to meet danger alone. "Once."

"Well, you know then, how you get this tremendous feeling of obligation. One time in that foul mess we called the Iron Triangle, some alert character knocked me out of the way of a mortar and then turned and got his, on the very next round. You've got to wonder, why me? It's kept me awake.

"By that time I was coming to know the Koreans; the wounded, the refugees, kids, women, old people. What got to me the most was their attitude toward the horrible conditions they were living under; starving, freezing,

wounded, uprooted from their homes. I wanted them to rebel, scream, curse. But they were silent and stoical—they were so used to suffering. Even the little kids. I couldn't get it out of my mind."

"It's here too," Allison said. "You feel helpless in the face of all that dumb suffering—and guilty too."

Seeing the trouble of it on Allison's face, Joe said quickly, "Well, eventually I got rotated out of there for good. Back home after my discharge I signed up for the Harvard Medical School."

She was surprised. "How come Harvard?"

"Some other Carolina guys I knew were going up there. We didn't say we wanted the best. We said we were curious about New England—skiing, blue-stocking women."

"You all were going to be God's gift to the frozen North." They laughed together.

Joe wrinkled his nose. "Well, it wasn't too easy. I had the GI Bill to help with the money, but those science courses I took at Chapel Hill weren't enough for the premed requirements, so I went and got what I needed in summer school."

"Did you like Boston?" It was Allison's imagined background for Mark.

"I didn't see much of it, spent most of my time in those cold stone buildings of the Medical School off Huntington Avenue. I was loaded with all this idealism and compassion for humanity (especially humanity in the Far East), and of course I was still having fun exploring the whole science of the human body.

"But every day I walked past some words from the Greek carved into one of those granite walls: 'Life is short and the art long; occasion instant, experiment perilous, decision difficult.' I wanted to get every bit of expertise I could, to be ready for those perilous instants."

"It sounds terribly serious...."

"Well, it was. Of course when I wasn't studying, I cut loose as wild as— anyone else. We figured we earned it. Are you getting bored, Allison?"

Although she shook her head, she didn't look up. Joe pulled on his earlobe. "Our last year the Dean's office got out this questionnaire to give them some idea how we would turn out as future doctors. One section was devoted to your motivation. There was a multiple choice of reasons you might have for being a doctor. We could check the most high-minded, altruistic motives. But tucked away in one of the last questions was, 'How much do you expect to be earning as a physician after ten years?' I guess the Dean ended

up with a pretty realistic idea of our motives. Actually, most of the students weren't kidding themselves about what they were expecting. Their aims were honestly mixed."

"Yours too?"

"Pretty much, but of course I had this urge to go back to the East, peculiar, if not unique. Or, if I stayed in the States, I wanted to practice in some distant rural area where doctors were scarce, to help people who're desperate, you know? I seem to have this urge to be really needed.

"Like there's this American doctor I've met in Saigon at the Seventh Day Adventist Hospital. I truly envy that man. He told me about one emergency case which he says is typical. There was a poor woman who had already delivered about eight children. Then, when she began to have lots of bleeding, some Vietnamese doctor had given her *twelve* D and Cs in less than a year, right in the office without anesthesia! The poor woman was just raw inside, and almost dead from loss of blood. This Adventist doctor had her transfused at once and said it was pitiful how grateful and renewed she felt after only the first transfusion.

"Of course, as you doubtless know, teaching contraception is illegal here because of the Catholic regime. So eventually my friend gave her a hysterectomy, which he says she had needed for years, and now she's beginning to live a little. This guy is so crazy about his work, it makes me jealous."

When Allison didn't raise her head, Joe doggedly went on. "Well, back in Boston, by the time I finished my internship and residency, I didn't have a whole lot of illusions left about American medicine. The politics, the hierarchy, the AMA reminded me of the military. I was more certain than ever that I wanted to go back to the East. To make a long story short, after searching around, I heard about the Christian and Missionary Alliance."

Allison stirred. "But aren't there lots of other organizations that sponsor doctors overseas?"

"You mean besides churches?" He grinned. "Yes. I looked into plenty of them. But, Allison, in those months when I was trying to understand what was pushing me, I thought it might be God. And in the end, it was only these CMA people who agreed to train me and give me a chance out here.

"So now I'm located down in Saigon at the Summer Institute, studying Vietnamese until I'm good enough at the language to practice medicine here." He gestured with his square hands. "It could be a big mistake. Since I got to Vietnam, I've been frustrated, trying to master the language and learn the customs. But then, you know Allison, just the other night down

in Saigon an old man, kind of a Buddhist sage, actually affirmed what I'm trying to do. He seemed to have been waiting for me to come, told me I had chosen well, and was going to be badly needed here." Joe looked up, eager to see if she understood.

Allison was understanding all right, more than she wanted to.

Joe rushed on. He had to risk it. "Last night I even began to see something of what Christianity has to offer. I've been feeling kind of guilty, as though I was using these people in the CMA in order to get out here and do my work, when all the time I decided long ago that missionaries are people who try to push their theology on to others so as to convince *themselves* they are right and find security."

Allison breathed more easily. "Like in Michener's *Hawaii*."

"The very ones." Joe's eyebrows met. "I don't know which I hate most, their self-righteousness or the 'miserable sinner' stuff!"

"There's little to choose...."

"Allison, what if some of them are not really like that? What if a missionary can be a person who tries to help other people stop hating themselves? So they can get started loving themselves and treating themselves kindly and getting well."

"But, Joe, what if the people really are guilty, truly have done awful things?"

"Maybe some of them only think they have! Maybe they've been taught to think they have. Allison, remember how Jesus said the Scribes and Pharisees had the keys of the kingdom, and not only wouldn't go in themselves, but kept ordinary people from going in?"

She looked uncomfortable. "Well, I remember he was pretty rough on the Pharisees."

"I think it was because they made everyone live by old, outmoded laws. Around here, witch doctors and sorcerers are like that. They profit when people think of themselves as sinners. So what about some priests and ministers in the States? Don't they get people to join up and contribute money by convincing them they are 'bad' and have to get forgiveness somehow? Like the tribespeople here, folks back home feel they have to get right with God no matter what it costs them. They might even have to sacrifice their *buffalo!*"

Allison couldn't help laughing.

"Okay. I guess I'm overworking this. Still...." He thought on. "Look, Allison, I see the buffalo sacrifice by the tribespeople as a kind of self-punishment. They murder their buffalo when the witch doctor tells them

it will get them right with the spirits and clear up whatever the problem is. But then see, they've already given up their best thing, their means of productivity, their way to survival!"

"Not to mention the poor buffalo—"

"That's just it!" Joe saw the thing even more clearly. "Let's say Jesus is the substitute buffalo. In the Christ, we killed our best thing, our true Self. But when Jesus allowed this to happen to him, *then* we could see it. We got the point, or we could have. No more self-torture, no more Christ-killing. That's over. From now on our Self can be loved and free. Our inner Christ never needs to be tortured and killed again. We need him for life." Joe stopped, embarrassed. "End of sermon."

Heavy discouragement flowed over Allison in a wave. Joe is a missionary all right. All this religious talk. We've wasted our whole time. Tennis and talking. Forget it. We should have gone right into that little cottage of his and made love! Why didn't we?

He was waiting.

What could she say to balance all this sharing of his? "Joe, to be honest, I'm not sure I get it. What you're talking about, I mean. The nearest thing to a religious feeling I've ever had was just those special times without words when everything seems to come together—like unbearable happiness. I used to call those my 'magic days' when I was young. Religion doesn't seem to me the right word for something that great."

Joe felt subdued, even envious. "That's beautiful, Allison. You want to hang on to feelings like that, no matter what you call them."

"But there's no way to hang on to them, I've tried."

Joe pondered. "I never had experiences like that. Some people would call it mysticism, I think." Seeing she didn't like that, he said, "Pastor Rau calls it 'having a delicious ear for God.' I don't have it, or I don't have it yet anyway. I seem to go more by thinking and ideas, or being with people."

Her impatience broke through. "But you're the missionary!"

"Did you think they were all mystics?"

"No, not all." She reviewed the preachers she had known in her mother's church. "But the really religious ones, holy...."

"Well, do you think religious people are all holy?"

Allison lifted her hands, and Joe quickly took them in his. "Look, how about this," he said, "what if people go into religious life not because they *are* holy, but because they wish they were? Because they realize they lack that very quality?"

Energy was flowing so urgently from his grip that she could hardly hear him. But he was still talking!

"Like nurses. Haven't you ever met tough, bitchy head nurses who must have gone into the field just so they could learn compassion and tenderness? I can tell you, I've met a few."

"But do they ever learn it?"

Joe was cheerful. "It's their best chance."

Allison pulled her hands away, frowning, laughing. "Joe…!"

"Heck, it's a paradox, of course. The best stuff always is."

Joe was a paradox himself. She could see him clearly as a concerned, intent man and physician, but she could also see exactly how he must have looked at thirteen, or younger. Joe's face was both dynamic and peaceful, conflicting, yet sure. People are drawn by a face like that. She began to re-arrange her semi-circle of pine cones.

"Don't let religion worry you, Allison," Joe said gently. "People like us who are dissatisfied, who are concerned enough to keep looking for answers, usually find something."

"That's exactly what's worrying me! I don't want to find anything, not anything religious, and I certainly don't want to commit myself to it, if I should find something." She looked up, exasperated. "And just imagine trying to convince someone else to commit themselves!"

"I bet no one is worried without good reason. Once you give yourself away, God alone knows where it will end! Would you get lots of your kind of magic days—or the Spanish inquisition? 'It's a fearful thing to fall into the hands of the living God'!"

Allison couldn't believe she was having such a crazy conversation. Could you talk with Joe about anything? "Are you married?" The question had popped right out, without permission. When Joe looked up with lighted eyes, she said weakly, "I thought missionaries had to be married."

"It's better, I guess. No, I'm not married yet, but I can be had! I don't think there's anything wrong with me, even though I am thirty-two. I was just waiting around for someone like you—afraid and brave, beautiful, and shy." Leaning back on his elbows, he went ahead unembarrassed. "The truth is, so far, you're the only 'just right' person I've ever seen."

There certainly wasn't a thing wrong with him!

"On the other hand, you don't want to think you're a bargain. You're skinny, a little conceited, and kind of peaked looking." Joe's teasing voice

changed. "But you've got courage, and a lot of other possibilities you don't seem to know about." The undertow between them filled the pause. Allison stood up. He did too, hastily. "Allison, wouldn't you like to go with me later on today to see a Moi tribal village in the hills? We could take the children too."

She moved back a step. "I'd like to, Joe, but you see, Mark Gardiner (he's the second Secretary at the Embassy) went to so much trouble to bring us up here, and I'm sure he's made plans. I ought to say no."

"Can't you make your own plans? How did you manage to get over here alone yesterday?"

"Mark had something to do for the Ambassador."

"Well...."

"But that's different."

"How is it different? He was doing his thing, and you were doing yours. You're a free agent, aren't you? Aren't you?" And he turned his back, furious that his anger was showing.

Her voice was strained. "Joe, be reasonable. You know I like being with you, but already the people at the villa think it's odd for me to be playing tennis over here with someone else."

" 'People will say we're in love'?" Joe wasn't smiling at all any more. "God, Allison, isn't it hard enough just being yourself, without caring so much what everyone else thinks?"

Stung, her answer came out hot. "That's exactly the trouble with me. I don't care enough! Didn't I come out this morning anyhow?"

"Yes, you did!" Encouraged, Joe seized her elbows hard. "Allison, does Mark Gardiner want to marry you?"

She was out beyond her depth. Her hands rested on the thick sleeves of his jacket, and she let them. "I think so."

"I do too, Allison; think about that." Joe gripped her arms even tighter.

"You can't!" She felt desperate. "You don't know me at all."

"I know you. I have for years. I made you up! And I love you, just the very way you are."

"Oh, Joe...."

When she dropped her head, he pulled it roughly against his neck. "I want to laugh with you, love you up, fight with you," his chin was hard against her head, "talk and talk with you, dance with you, eat and sleep with you. That's just the little beginning...." Pulling her chin up, he kissed her opening mouth.

In a daze Allison pushed him off a little, staring down at her hands. "Joe, you crazy, you're all over green paint!"

"Doggone that picnic table," he muttered, trying to look over his shoulder. "I thought that green was kind of fresh-looking."

She wiped her eyes, laughing. "Honestly, Joe, you don't seem like a missionary."

But he grabbed her again, hard. "I am though. Something about that is *me*. Now, when am I going to see you?"

"There's just no time when I can be by myself.…"

"I want to meet the others anyway, especially your children."

Allison looked away uncertainly, pushing back her fall of hair. "I guess you could come for a drink this evening. The Ambassador holds 'Open House' for Americans and their friends on Saturday evenings. Anyone can come." She turned back too late to catch his wry grin. "About quarter to seven?"

"Sure. That's fine. I'd like to. But don't look so worried. Do you think I'm going to use Tarheel dialect or preach them a sermon?" She stood there mute. His voice softened. "Don't look so guilty, Allison. I probably would do something like that, but for you I'll try not to." He frowned. "You are worried."

"Not worried so much.…" She began to gather up her things. "Joe, I'm an awfully mixed-up person! Not a bit good. You shouldn't like me; you are too—" Clutching his shoulders briefly, she kissed him, just a quick electric tasting of him, and ran off down the hill, not looking back. Oh God, she was thinking, what if he comes? If people see us together, they'll *know*, because we'll shine. We probably light up in the dark!

He let her go, yelling after her, "Quarter to seven!" Slowly, bitterly, he followed her down the hill. Damn. We wasted the whole time. Tennis and talk! We should have gone right into my place and made love! Why didn't we? What a horrible, wonderful morning! And Joe remembered the Professor who had wished him love.

As Allison started breathless up the back stairs, she looked at her watch. Unbelievably it was only five past eight. Upstairs, through her confusion, she noticed something white stuck on the children's door, a stiff sign: "Please KNOK. We would like it if you did." Feeling little stars of laughter spring up inside, Allison drummed on the door, burst in, and jumped on the children, who were playing crazy eights in James's bed. Letting go some of the

storm in her heart, she hugged and tickled them until Katrine's guarded expression changed to a half-laugh, to joyful surprise. They all ended up lying in the small box bed, one child's head on each of Allison's shoulders, the cards flung every which-a-way.

"Ummm," she murmured with pleasure, rubbing her cheek against their solid round heads. "I know someone nice for you to meet this evening!" By this she meant, children, it's true; a change can happen. Any day life can surprise you with love!

"It's your tennis man, isn't it, Mummie?" Katrine asked in her practical voice. "Is he coming here to the villa with Mr. Mark and all the other grown-ups?"

Allison rose at once and wandered off. "His name is Dr. Ruffin, and he's just coming over for a drink this evening. Let's all go down to breakfast now; we're late." From the bathroom she called, "Isn't anybody hungry?"

After she had changed hurriedly into navy slacks, shirt, and a green sweater, Allison stopped outside the dining room door to catch her breath, worried that her early outing might have been observed. However, everything seemed quite serene around the big oval table. Mark left his hand warmly on her shoulder for an extra moment as he seated her. All the greetings were friendly and casual. Disaster had not struck. It seemed she could still return to her pleasant role as a future member of the Embassy family.

But Allison's abstracted gaze wandered to the bright windows. And, passing the marmalade, her eye was caught by a red motorbike revving up in the back courtyard. The cook stood watching for a moment with pride as a young man (his son?) swooped off on a roar down the mountain. In my mood, she thought, I could ride one of those things myself.

Mark firmly captured the marmalade jar while asking her opinion of the sightseeing plans for the day, which were under discussion. Smiling radiantly, Allison said they all sounded fine.

Katherine laughed, but Jeff Gregory gave Mrs. Giraud a sharp look before going back to the map and their argument over which roads were safe from ambush. Lightly the finger of fear touched Allison's diaphragm. Ambush! Mark put before her a mimeographed page: "Suggested Tours Around Dalat," distributed by the Dalat Tourist Office. On the list were the Cam Ly and Prenn Waterfalls, the Zoo, Ankroet Lake and Dam, the mountaineer villages.

Mr. St. John wiped his mouth with his napkin, pushed back his chair, and announced with regret that any mountain climbing expeditions were out. He

knew of no security reason, however, why they shouldn't visit the Prenn Waterfall with its Zoo or the Ankroet Dam. "Tribal villages are best omitted just now."

"Damn the dam," Katherine declared cheerfully. "I was really looking forward to the bare-breasted ladies in the villages as well as that alcoholic rice beverage they serve."

"Next time." The Ambassador refused to be irritated. "After the recent sabotage of the airport, we are not going to take any foolish risks. Also, Mark, for extra security, we will not run a tour of the Nuclear Research Reactor that President Eisenhower is responsible for giving the Vietnamese."

Allison saw that the Gregorys, though bored, would not object to St. John's decisions. How comfortable and safe the sunshine and marmalade here with the Ambassador! How outlandish a life with Joe, outside somehow, with the tribespeople, missionaries, and Viet Cong! Somewhere, at any moment today, she might run into Joe. Even if she didn't set eyes on him any place in their touring, every hour brought nearer his entrance upon the scene, thanks to her crazy invitation. Which was more to be feared, the joy or the pain?

And of course there was Mark! The smile in his eyes as he reminded her of their own private plans for tonight made her just as nervous. Growing ever stronger was a terrible conviction that she would be incapable of decision. Like a child, Allison hoped that either Mark or Joe would do something so despicable or so marvelous, there would be no choice left.

Points of Interest

The mountain held the town as in a shadow...
Near me it seemed: I felt it like a wall
Behind which I was sheltered from a wind.
And yet between the town and it I found,
When I walked forth at dawn to see new things,
Were fields, a river, and beyond, more fields...
And there I met a man who moved so slow
With white-faced oxen in a heavy cart,
It seemed no harm to stop him altogether.

Robert Frost, "The Mountain"

Saturday morning the lonely hut clinging to the mountain was still safe in shadow when Kiem, leader of the three-man cell, feeling the sharp spur of excitement, put an end to the night. He had hardly slept anyway for rehearsing in his mind what he would say to Le Tuan Anh of the unreadable eyes, the one who was his only contact with the Lao Dong. At six, without regret, he rose from his mat and roused the old woman who also managed to live meagerly here in her own shack which he had made his hideaway. Now, anxiously, she heated his soup and tea, not well, but well enough for his impatience.

Holding the tea bowl to his mouth, Kiem thought about getting to the Prenn Waterfall, nine kilometers down the mountain from Dalat on the road to Saigon. If he went to the market, he could probably get a ride on a wagon returning to the lower plantations after disposing of its bananas, pineapples, or papayas. The walk was nothing to Kiem, but he would be less noticeable among others.

His sense of urgency was growing. Complicated preparations for tomorrow had to be made. After his meeting with Anh at 10:30, two meetings of

the cell on this one day might be necessary to plan for Sunday morning. Time was short, and the bicycle outside, his only transport, would be nothing but a hindrance on the steep way back up the mountain. It made him angry that Thom, that lazy southerner, could be right about the cell's need for a motorbicycle at least. And tomorrow they would even need a car! Kiem scowled so blackly that the old woman asked timidly if the soup had turned. He put down the bowls without answering and left for the town.

At the Dalat market Kiem put on a more pleasant face. In his neat dark clothes with his clear-cut features and winged brows, he made a very good appearance. A bent farmer who had only a small, though lively, grandson for helper was glad to accept a hand with the unloading of his cart. By eight o'clock the old man had sold all his pineapples. Lifting the boy onto the pile of empty crates behind, he invited Kiem to make the return journey with him on the high seat behind the oxen. Kiem then paid for his ride by seeming to listen to the garrulous old farmer, who clearly delighted in an audience. But "the people are the ocean, for us the fish!" Patient acceptance of the ancient one with his excruciating slowness and unending talk was a living lesson.

In spite of all this, when Kiem slipped down with a minimum of thanks at the gate of the Prenn compound, he found it was still only 10:00. The small grandson begged to go with him and see the waterfall and zoo animals. Kiem studied the bright-eyed little figure bouncing up and down on the crates.

"Just wait, small brother, one day I will come back for you—and not just to see the zoo!"

After they had gone he looked around for a place where his eagerness could subside, a place from which he could survey the scene and not be under observation. Le Tuan Anh had said 10:30. One must apply the discipline of further patience and the arrangement of thoughts during the waiting period. "Right thinking is the strength of the Party."

The space in front of the basin of the waterfall was open, its hard dirt already patterned with the shifting movement of Saturday tourists in various colors, sizes, and nationalities. Corrals for the zoo animals, hot and dusty, were at the far left of the clearing. The pen of the soft-pacing tiger seemed to be the most popular. Behind the zoo and the inquiring head of the giraffe, a green proliferation of brights and darks, creating jungleness, rose freely upward. Opposite the zoo and on the right, behind some kiosks for tickets and souvenirs, was a huge banyan tree. Kiem began his drift across the clearing toward the inky shadows among its great roots.

Suddenly out in the open, his foot was trampled by a backward-moving tourist with a camera fastened to his eye. Swallowing the cry of pain (he was wearing rubber sandals), Kiem swiftly gouged the man in the small of the back with the iron flat of his hand. The man did not swallow his pain. He turned, enraged, to face it, and so the Reverend Henry Tyson encountered the Viet Cong cadre, Trinh Le Kiem. One look was exchanged into which Kiem put the full energy of his hatred, saying nothing. Hank, thrown off balance, might have begun an apology until he met his victim's eyes. And over at the edge of the pool where the sheet of water fell, Charleen's bright smile for the camera faded. The cold fire of Kiem's glance took in the American's plump spouse in her flowery dress with her expression of happiness changing into anxiety. He felt his power. Knifing the unwelcome foreigners once more through with the icicle of his stare, Kiem moved away, a dark rod of righteousness and pride.

The steady sound of water drowned whatever spluttering protest Tyson made. It was frustrating not to be able to act. He had been in the wrong, of course, but had he deserved that blow, that searing hatred? It was just an accident, after all! Hank was completely innocent of any evil intent. And so Charleen attempted to convince him, frowning indignantly after the disappearing black figure of the Vietnamese. However, Hank's back hurt. He had met the enemy, and for the rest of the day would look for him over his shoulder.

Behind the temporary kiosks, Kiem let himself down between the massive roots of the old tree. Rubbing back circulation into the surface bruise on his foot, he grinned. General Giap said one must always embarrass and stalemate the enemy. Then, leaning against the living wood, Kiem directed his thoughts to the last few days. There was the information which he had received from Bui Tang about his meeting with Thanh in Saigon, added to that of the clerk in the Province Chief's office giving Thanh's plans for tomorrow morning's dedication of the new church near Dalat. These facts contributed to his confidence. Kiem was not so comfortable about his own visit to the bar where Le Tuan Anh had not been present on the previous evening. But he was always there at that hour! Had his disappearance something to do with the curious activity of the police in that place? And just how did Anh manage his own transportation? This question had bothered Kiem before. No doubt, at the exact moment of their rendezvous here, he would simply materialize.

A hand touched his shoulder, and the cool smile of Anh appeared above him. Shaken by his own prescience, Kiem was surprised into words without plan. "I went to the bar last night, looking for you!"

A slight frown of disappointment creased the smooth brow of Le Tuan Anh. This young man is terribly *active*. "It is always best to wait for my message, as I believe I have made clear." His flexible body dropped into the shadow beyond a large root.

"But I had something extremely important...."

"What is important is to move only as water moves. For example, and this can be a small lesson for you...."

Kiem's eagerness at the moment was not for lessons. He must tell about the chance to eliminate the Province Chief tomorrow!

Fixing the younger man with an unblinking eye, Anh continued firmly. "Do you remember the woman in the bar?"

Without much interest Kiem nodded. "The one they call 'the Tonkinese'?"

"Exactly. Yesterday afternoon that one attacked me with a knife."

Now Kiem was all attention. "What in the name of heaven for?"

"Oh, she had reason enough, a sound reason for revenge. Once, as a judge in our somewhat unfortunate Land Reform Program, I may have been instrumental in depriving her family of a large part of their holdings." Anh had placed himself behind a great root of banyan separating him from Kiem. Their heads were near, but deeply shaded.

"This woman's relatives may have starved. It is probable. However, that was part of my work for the Party and for the Nation. The destruction of many reactionaries was unavoidable and essentially creative. My mistake was stupidly to accept this dragon ring" (he placed before Kiem's eyes his cared-for hand) "which the woman and her husband offered me as a bribe. At the time I reasoned that anyone who attempts to bribe is open to having his corrupt suggestion accepted. Because of this faulty rationalization, and because I allowed myself to be fascinated by the jade and gold ring, so much like the dragon spirit of our united country, I endangered my life, and more importantly, the unification work of the Party!"

Stroking the ring gently, Anh rose to his feet in one motion and moved with seeming carelessness toward the basin of the waterfall, momentarily deserted by tourists. He tossed the ring into the place where the full weight of water descended and stood staring after it into the foam. Water sound drowned everything. Returning, he found Kiem sitting upright, visibly

stirred, but not, Anh saw, by the sacrifice of the ring. Such subtle, symbolic gestures were wasted on him.

"This woman attacked you?"

Le Tuan Anh leaned an elbow on one knee, his bare hand drooping. "Yesterday, with a knife, and quite without proper planning because of her intense and disorganized emotion toward me."

"What happened?"

"Fortunately for me, I had become aware of her hostility. And in the long mirror behind the bar I was watching her inept approach. So, when she flew at me, I simply pushed my chair over backwards. We rolled at once to the floor. This was acutely embarrassing and attention-drawing for me, although the knife merely grazed my shoulder."

Kiem stared. "What happened then?"

"The woman is not very fit, quite stout in fact, so she lay there dazed on the floor, while I myself disappeared at once, of course. Since there were many witnesses to this unprovoked attack, I feel reasonably sure that the woman has been taken into custody by the police."

Kiem felt a surge of admiration for this seemingly passive man. One should never be misled by appearances! From now on, it would be much easier to consult him, as in the vital matter at hand, and to abide by his orders if necessary. Respect for one's leader, Kiem felt, is essential.

But Anh had not quite finished. "This will be our last meeting, Comrade. Since the woman has by now undoubtedly told the police all she knows about my identity, it is necessary for me to remove to another place with another alias. First, of course, I must report back to headquarters. I was already preparing to do this, in any case, since my work here is complete."

"Complete?" Kiem moved his head slowly. He had received a dizzying blow. "But the work is just beginning; we are only now—tomorrow—able to arrange for the assassination of the new Province Chief!"

"So?"

Kiem actually thought he saw a twinkle of amusement in the eyes of the political officer. "Wait, Comrade, let me explain! We need the Party's endorsement for this most important and dangerous action."

Anh grew serious again. "Ah." What a shame that he must lose in the same moment the precious and symbolic dragon ring along with this impetuous and beautiful young man, the chosen leader of his special cell—North, South, and Center!

The relaxed lines of Tuan's balanced features tightened. "No. My

usefulness here is definitely ended, Comrade, as of this moment." Glancing around the clearing, he looked up at the waterfall with its rustic balustrade. A group of Cambodian girls were giggling fearfully at the very edge of the shining veil. One could slip behind it there through the dankness of a dark shallow cave into a tunnel.

"No. You will not see me again."

Kiem was desperate. "Comrade! It is vital that this man, the Province Chief, should be eliminated. He has already been interviewed by a reliable cadre, a member of our cell, down in Saigon; there is no possibility for drawing him into our Struggle!"

Anh listened to the urgency in the young voice. With Kiem's idealism he could wholeheartedly identify. "You are right, Comrade; I sympathize with your feeling that time is short. Indeed, it is running out. *We must unify Vietnam.* Unless people can go along with this aim, they are forfeit. You might of course consider kidnapping and ransom. Our revenues from this are growing. However, assassination is also encouraged by the Party. If some men die, it is better so. The important thing is that they must not be allowed to stand in the way of our national unity, our wholeness!"

Relieved, Kiem started to speak, but Anh went on. "Remember one important thing as to method, Comrade. Our people's struggle has been built along a correct and creative line, the line of organization, of right thinking. Try to realize that 'heaven, earth, human beings, and natural things,'" he quoted, caressing the ruggedness of the old tree, "'all have their dispositions and organizations.'"

That was just the point. "But, Comrade," Kiem said, "it is for this very reason that I want to explain our assassination plan; one further moment only, so you may approve it or not, or even suggest...." To his horror there seemed to be something already fading about his contact with the preoccupied agent.

Showing his profile only, staring elsewhere, Le Tuan Anh spoke without expression. "From now on it will be necessary for you to manage without me. Make your own decision, you three, and take the responsibility for it. Feel free to use the weapon of a gun if indicated. The armed struggle is now approved by the Party. Le Duan, a southern member of the Politburo, came back to Hanoi in '57 saying that political struggle was not enough. Since he became First Secretary of the Party in September of '60, there has been general agreement that armed force is needed, so you would have official approval. The timing is right; go ahead without me. My replacement

will contact you eventually, of course, so continue to check the assigned post office box at regular intervals." He was looking away because he wanted so much to rest his hand one more time on the strong and vital young shoulder. He resisted the desire.

Then, "It is curious," Anh gestured, "how many more Western tourists are recently polluting our national shrines and centers of pleasure."

Following the gesture, Kiem glanced distractedly toward a gleaming black limousine from which one of the indulged women of the foreigners was putting down long and slender legs, a cloud of soft hair half-obscuring the very feminine features of her pale oval face. Only an instant, but when he looked back again, determined to pursue his object, the political officer had dematerialized. Kiem rested his brow on the arch of his hands. Now he felt totally alone with his heavy responsibility.

Kiem may have seen Allison Giraud getting out of a car that morning at the Prenn Waterfall, but Joe did not run into her anywhere. This was not surprising. After visiting Prenn, the Embassy limousine took Tour Number 4 to the Ankroet Lake and Dams: "18 kms. from Dalat on the road to Ankroet (see map) passing through vegetable plantations, the Redemptorist Monastery, and scenic hills." A box lunch prepared by the villa cook was enjoyed beside one of the many lakes. Afterwards Mark Gardiner and Jeff Gregory took the kids out into a field to practice with softball and bat. Allison and Katherine Gregory half-reclined on the rug, lazily watching their driver gather up trash and leftovers.

"Peaceful, isn't it?" Allison said.

Katherine yawned. "More like boring. Those fields of artichokes were the only attractive things I've seen so far."

Allison looked at the other with interest and a half-smile for the charm of artichokes. "Haven't I seen you or met you somewhere before?"

"We must have been around a lot of the same places. I remember seeing you at a restaurant dinner party in Cholon with Dr. Thien and his wife."

"Oh yes, that was it!"

"But the last time was at the Cercle. You were playing tennis with Clay DeWitt." Kate took pleasure from the chance to say his name.

"Really?" Allison felt slightly embarrassed remembering.

Kate smiled. "As a matter of fact, you didn't see me. I was with this doctor, Joe Ruffin, who admired you considerably from the terrace restaurant."

"The missionary?" She sat up, startled.

"So he tells me." Kate paused. "Oh my God! Joe did mention that he might be coming up here this weekend. I bet he's the one you were playing tennis with yesterday."

"Early this morning too," Allison added ruefully.

Kate leaned back on her elbows laughing. "Fast work! Should I be feeling sorry for Mark?"

Allison's gray eyes sparked, her patience fraying. "What for?"

Kate patted the nearby arm. "Just my fun, old dear. Sorry. Of course you and Mark are not yoked up together. Not yet." Allison rose to her feet hastily.

"Wait!" Pushing off her inertia Kate got up too. "I like Joe. In fact, I think he's a very special guy. Please don't be cross."

"I'm not cross." Allison frowned a little. "Just embarrassed. I don't know what made me blurt all that out to you!"

"It's okay. Really. Your secret is safe with me." Kate still couldn't help smiling, but there was warmth in her look. "Joe's tremendously attractive. I wouldn't at all mind having his shoes under my bed."

"But missionaries are so...."

"They're weird all right. It could make plenty of problems."

Allison was searching for a handkerchief. "It's hopeless!"

Katherine felt touched. Suddenly the poised, elegant Madame Giraud, so well known in Saigon circles, seemed young and defenseless, driven to confide in a total stranger what she hardly realized herself.

"Well, nobody up here knows a thing about it. You can finish up a pleasant holiday here with Mark and the kids, and just wait to see how you feel back in Saigon. It may all seem different down there."

Allison blew her nose. "You haven't heard the worst yet—I invited him up to the villa tonight for a drink."

"No kidding." Kate wanted to laugh so badly. "That *is* awful. Not that I won't be delighted to see him again."

"Oh I know it's all a big joke to you. But somehow I seem to have lost my sense of humor!"

Looking into the honestly troubled eyes, Katherine really liked her. "Well, come on! We're not going to let a little thing like that throw us. What's done is done. For right now, we'll both disappear into the bushes, and when we come back, we'll put our heads together on how to handle the situation." Somewhat comforted, Allison at least felt no longer alone.

For Joe, the thought of Allison was not pain but pleasure. Still, that day as

he experienced a tribal village near Kankia for the first time and had his chance to work again, he was certainly not thinking of her every moment. Instead, knowing she was there, that he would see her later on, put a glow of excitement on all his activities. Beside him in the driver's seat of the Land Rover was a sturdy and sunburned nurse, a New Zealander with the World Health Organization. Eileen was taking him on her rounds among the afflicted members of the tribes.

It was all much as Joe had imagined. Thatched, gable-ended dwellings made up the villages. Each one was about thirty yards long and perched on legs of short thick logs. Every house sheltered a clan of around fifty people, young and old. In order to reach the open verandas Eileen and Joe climbed leaning poles with notches carved in them for steps. Inside, in the shadows, sometimes there were men squatting in a circle on the slatted floors, drinking rice alcohol through looping straws of reed from tall, green-glazed jars. The men smoked short-stemmed, silver-inlaid pipes. The women, who wore hand-woven skirts of black and blue and red cotton, cooked over fires that flamed up from a clay-bottomed box. The women were often smoking too, as they nursed their babies.

Outside on a veranda, Joe dodged a big snakeskin hanging from the eaves. The nurse explained that the tribesmen killed pythons for food or to trade at the market for medicine. Beneath the longhouses, undersized, tough-looking cocks and hens scratched at the beaten earth and ran with scrawny pigs, protesting, at the approach of strangers. The children, mostly naked, did not run, but remained shyly, hand to mouth, staring with glaucoma-clouded eyes, hoping, it seemed to Joe. And the mountains shouldered their way in everywhere, powerful, blocking the view.

When he and Eileen set up shop on a veranda or under a big tree, Joe remembered Pastor Rau. Because of their conversation the night before, these were people, not exotic black natives from some other dimension, foreign to him in language and thought, lesser perhaps. So he looked hard in their eyes, trying to feel their humanity, exactly like his own, across all the barriers of culture and condition and race. His heavy brows drew together in concern over their boils and fevers and infected gums. Dysentery was bad, but malaria was the worst and the most general. In fact, malaria was sapping the vitality of the race.

Eileen explained how the AID mission and the WHO had programs for spraying the villages against the *Anopheles* mosquito. There was need for haste to wipe them out before the mosquitoes should build up an immunity

to the pesticide. Firmly she wiped his face with a soft cloth to keep his sweat from dripping on the patients.

"Then why don't they hurry up with the eradication?" He paused and straightened. "Why don't they do it at once, quickly?"

"Well of course there's always the bureaucracy and the problem of funding for these programs." She stared at him curiously, wondering at his ignorance. "Not to mention the constant threat of the VC."

Joe seemed to have left her again, lost in the fibrillations of a small black chest, his clean blunt fingers holding with love the familiar stethoscope, named Simon, which his father had given him long ago.

But before the next patient he took up their conversation. "Up here in these mountains the Viet Cong are supposed to be busy. Have you ever met one? What are they like?"

"No, I haven't met one, and God willing, I won't. But I've heard a lot about them. One reason they aren't seen is that they are masters of camouflage. They put leaves and twigs through the net that covers their basketwork helmets and over their backpacks. If an aircraft goes over, they can blend right into the foliage by the road. I've heard that a VC cadre is trained to stay for hours with a bamboo breathing tube in a pond or under the flooded rice fields."

Joe had stopped working, letting the patient line of sick people wait. "Is there no way to catch them?"

"Well, I've heard they haven't yet found a way to conceal the smoke when they cook their rice. Americans are beginning to train Montagnard scouts to watch for camp fires, especially along the Laotian border."

The next patient seemed to have no complaint but severe headaches and great weakness. Joe pointed out to Eileen the frown of anxiety that seemed to have permanently creased the man's brow. She shook her head when the new doctor kept asking untranslatable questions about the conditions of the patients' lives, the state of their spirits! Had they been emotionally upset recently? Had they been in situations of stress?

"Dr. Ruffin, must we know all that in order to help these people?"

"Unless you just want to patch them up temporarily." Joe was peering down the throat of a young girl who kept trying to shrink away. So he stopped and waited, looking at her thoughtfully, until she came back timidly of her own accord.

Around noon, between villages, Eileen took him over to the shuffle of huts and tents behind the military training school, saying this was a part of her usual "beat."

"Camp followers?"

"Well," Eileen squinted out over the area, screwing up her freckled nose, "I guess you could call them that. But often they're the legal wives and children of ordinary soldiers in training. The families of the officers and noncoms have slightly better living conditions near the military barracks at Dalat."

"Wow. This army can't have many volunteers to the ranks." Joe was standing in the road staring with dismay at the sea of corrugated tin, canvas, and cardboard, when, out of the welter, a familiar figure came down the track toward him. Mrs. Thanh looked as composed as usual in her printed dress and black silk trousers, as concerned as ever while she bent slightly to hear the complaints of an exhausted-looking pregnant woman trailing three children and carrying one on her hip.

"Hey, that's Mrs. Thanh!"

"Makes you believe in angels, doesn't it?" When Joe glanced at her sharply, Eileen added, "I wouldn't kid you. I love that woman."

"Me too. Doesn't she ever get discouraged?"

"Not when I'm around. She never stops trying to get the government to do something more for the ordinary fighting man and his family." They looked at each other without illusions.

Joe thought this girl with her deliciously flat accent was having a rather depressing influence on him. He kicked at a rock. "Well, it's a good thing somebody is optimistic!"

Eileen was stubborn. "I think it's better to face facts. This President Diem expects loyal support from the populace no matter what their lot. He thinks it's his rightful due and the will of Heaven."

They watched Mrs. Thanh finish her talk with the woman, who went away, still muttering over her wrongs, shifting the baby to the other hip. When Yen Thanh saw them, her eyes lighted, and Joe felt his heart warm. Thank goodness there were Vietnamese like the Thanhs!

Invited into the waiting hospitality of Yen's official car, the three of them settled comfortably, talking shop. Eileen had brought a bag lunch for herself and Joe. Mrs. Thanh contributed tea in a thermos and cookies of some kind in a lacquered tin box. Having dismissed her chauffeur to scrounge his rice from someone he knew in the camp, she turned happily to the others.

"Now we can enjoy our lunch in peace! I am so curious to know about Dr. Joe's reaction to the tribespeople and their diseases."

"I'm curious too," Eileen said.

"Do not expect too much," Mrs. Thanh warned her. "It is more possible

we will get only questions from him."

"All right, all right! I do have a question." Joe was unblushing while they laughed. "Since you are kind enough to be interested, I'll even give you some background for the question." He received a fat sandwich with enthusiasm. "Back in the States I came to realize it's not enough to treat the disease, as most doctors do. You have to treat the patient too. I mean, an ulcer will take one course with one type of personality, and a totally different course with another type. This is true even with a disease like cholera. I'm sure you both can think of cases to illustrate this from your own experience. Two people exposed to the same virus, for instance, will be affected in different ways and degrees of intensity, or even one will be made ill and another will stay healthy. So much depends on the person.

"Back home I got used to trying to reach some kind of understanding of the patient, if possible, before attempting to treat or cure their disease. But how can I do that here? And that's my question. How can I understand the personalities, the problems of these people, their fears and superstitions, their tensions and pressures, when I don't know a word of their tribal language and can't even imagine one day in their lives?"

Eileen shook her head over this guy, clearly a madman. "Surely it's enough just to bring the vaccines and transfusions and medicines and pain killers unknown around here until we come? And since you've mentioned cholera, Joe, you must have heard of the U.S. Navy doctor, Captain Phillips, stationed in Taipei, who's got a team experimenting with these IVs of saline and sodium bicarbonate which act like magic to revive almost dead cholera victims if they're given in time. What's that got to do with personality problems?"

While Joe frowned over this, Mrs. Thanh smiled. "Of course you are both right. The medicines are a miracle to these people. And yet they will not truly be cured until the causes of their troubles are understood. Some are too much afraid of the VC or of evil spirits to eat or sleep properly. That woman I was speaking with is too angry with her husband over his other women to care wisely for her own health and the health of her children."

"That's it," Joe cried; "that's just what I mean!"

Eileen crossed her strong freckled arms and leaned back with finality. "We can only do so much."

As Joe began rubbing his hand fretfully through his hair, Yen said, "She's right, Joe. Just because we cannot do it all and do it properly, we must not be distracted from doing the little we can."

Joe sprang from the car. "Patience!" he shouted, raising his fists at the sky. "Patience!" he roared, so that interested children flocked around him laughing, and the chauffeur returned hurriedly, wiping his mouth on his sleeve.

The peaceful mealtime was ended. Eileen and Joe embraced Mrs. Thanh. They stood waving while the car pulled away until her laughing face disappeared.

Eileen sighed. "You're a wild man! Let's take some of that energy over to the dispensary, shall we?"

While an overly polite officer-of-the-day led them to a not overly sterile one-room dispensary, Joe was wishing that Eileen might sacrifice some of her skepticism without losing her concern. However, she did find somehow a skinny little man to act as interpreter for the afternoon's office hours. And she merely raised her sandy eyebrows at Joe's piercing questions, which seemed mostly to frighten the patients, Vietnamese and Montagnards, whose eyes slid away from his.

When Joe finally glanced out of the soil-dimmed window, the sun was dropping fast. Very cool shadows of the blue mountains were falling across the dirt clearing outside. He thought it had been quite a day, chaotic but with a lot accomplished. He had even treated two gun-shot wounds, said to have been inflicted by the VC.

"Doctor Ruffin," Eileen said, "we'd best go now. It's getting toward evening. We shouldn't be out on these roads after sundown."

Those waiting by the door seemed to understand her. They pressed closer. "But we aren't finished," he protested, meeting all the anxious eyes with difficulty.

She laughed shortly. "We never are."

On the return journey into Dalat, Joe had the strange sensation of returning into himself. His own sticky shirt. His hands on his medical bag, repository of a much-exercised Simon. His own slightly aching feet and calves. Where had he been? For that day he had somehow given himself away.

Eileen's blue eyes were smiling, perceptive. "You're pleased."

Joe only grinned. Impossible to describe the elation. He had come a long way for this. Relaxing, looking out on the shadowed fields, he remembered a poem of sorts he had written one night in Boston when he was feeling particularly frustrated:

> *I wanted to be a doctor*
> *to heal the sick*

to comfort the suffering
to minister to those in pain
So I went to a school of medicine
To learn what I needed to know.

"We've got a variety of interesting stuff in the house right now…a Cushing's syndrome, an insulin-resistant diabetic, a classic aortic stenosis—everyone should listen to her murmur before she gets transferred to surgery tomorrow—as well as the usual chronic renal failures and two strokes who are really gorbed out and a couple of crocks we don't know *what* to do with. We need to do two abdominal taps today so if there's anybody who hasn't done one, this will be a good chance. Divide up the patients, make sure you read their charts before rounds in the morning."

I wanted to be a doctor
 to heal
 to comfort
 to minister
 to care for
 to be with
but it wasn't in the curriculum
And I didn't know how to begin.

Joe leaned back in the seat of the Land Rover, clasping his hands around one knee, smiling to himself. He had come a long way all right, and today for the first time it looked as though he might have made the right choice. There's plenty to do here, and the missionaries are not half-bad. In fact, so far, they're okay.

Suddenly he sat up with such a jerk that Eileen gave him a quizzical glance. "Remember something?"

Allison! "Would you believe I'm invited to have a drink with the U.S. Ambassador tonight?"

"Coo! What time?"

What had Allison said? "Quarter to seven, I think."

Eileen looked at her watch. "No fuss. It's not even six yet."

Joe relaxed thankfully. There was even time for a shower. The shadows of the mountains had deceived him. In fact the clear boundaries of everything seemed to be growing more indefinite.

Open House

*In all my work I have been impressed by the paramount impor-
tance of bringing contrasting types, or contrasting conditions,
together and letting them interact. The focal point of interaction
is where the greatest interplay of energies occurs.*

Derald G. Langham, Ph.D., Circle Gardening

By five the Ambassador's guests were all back at the villa. Mark had asked
Allison not to be late coming downstairs. "We're expected to help with the
visitors, you know, and there's no telling who may turn up for a drink."
Thinking of Joe, she had a wild urge to run away.

Instead, high in her bare bright rooms, safely suspended, Allison took a
long bath, did her fingernails, put on a gray skirt and soft pink sweater. How
the swallows wheeled and dropped about the turrets of the villa, in curving,
lifting patterns between the white glare of the window glass and the distant
solidity of the mountains. After going to quite a lot of trouble to sweep her
brown hair up in a French twist, Allison decided it was affected-looking, but
by then it was too late to change. Herding the children ahead for their sup-
per, screwing in Maxim's pearl earrings, she followed on down the narrow
stair in the breath of her perfume, hands at her ear lobes icy on her warmly
flushed cheeks.

It was a shock to find him already there, kneeling, at work on the fire.

Joe looked up, delight waking in his eyes. They were alone in the big
formal room in the fast fading afternoon.

"Hello," she began nervously.

"Allison!" As he got up, brushing his hands off, his smile was wonder-
ful. "I'm early, too eager-beaver, I guess." Joe took her cold hand in his warm
ones against the rough tweed of his jacket. "Beautiful!" And there was an
extra gleam for the possible compliment to him.

Before all the life in him, everything else dimmed. Oh, Joe Ruffin, she thought with painful honesty, when I'm with you, I'm almost single-hearted like you. "Whatever did you have to be a missionary for?" Allison couldn't believe she had said the last part out loud, and thought he was going to shake her.

Instead, his jaw set, Joe turned her carefully toward the windows, as though to see her expression more clearly. "Allison, look. I'm a physician, a medical missionary, and it won't be long before I've learned enough Vietnamese to leave Saigon and get to work. There's a good chance it may be Nhatrang to help set up a clinic there, and maybe teach. The resettling of so many tribespeople in the lowlands is beginning to generate a lot of needs there."

She bowed her head. He was always thinking of other peoples' needs!

"But Allison; it's lovely there. I wish you could see the new Mission School, high on a bluff overlooking the sea and the islands. The faculty cottages have such a view. Actually," and he had the grace to grin, "I haven't seen it myself yet, but I heard a lot about it at breakfast this morning."

When she couldn't look back into his glowing eyes, Joe left her in two long strides. Allison thought he was going right away from the villa, but sudden footsteps sounded outside the door and Mark came in. She watched him trying to sort out the situation while she introduced Dr. Joe Ruffin. Then Mrs. St. John's voice could be heard approaching. For better or worse, Joe would have to stay now.

The Ambassador's wife had the kind of voice which has grown accustomed to something of an audience. "I always feel there *must* be a fireplace," they heard, coming from the hall. "I think that's what's wrong with these Saigon villas; you keep trying to do something central with a bookcase, when only a...well, good evening, everyone!" Pleasant with motherly charm she entered, hardly up-staged at all by the tall, broad-shouldered Ambassador.

Mark presented Joe, who explained he had taken the liberty of dropping in, since he was in the neighborhood.

Mr. St. John said these informal evenings had been planned for the pleasure of meeting people like Joe. "Dr. Ruffin," he went on easily, "may I introduce Mrs. Giraud...."

"We've already met, by chance, on the tennis court." Joe looked right into Allison's eyes.

She felt her rising blush and caught Mark's speculative stare. Neither did she miss the smile at the corner of Joe's mouth. All right, she thought, look-

ing down hotly, so Joe knew she loved him. How crazily she did. It was one thing to be in love, and quite another to throw away a sensible, relatively secure life, the one he could see here, for an outlandish future with a medical mission in some resort-fishing village that she heard was now a center for training commandos. How could this tornado that had hit her be a missionary?

Fumbling blindly for her cigarettes, she saw the Gregorys come in, minus children, and introducing some Australian friends of theirs who were staying down at the Sans Souci Inn. Clearly Joe had met Kate Gregory before. What had Kate said at lunch? She wouldn't mind having his shoes under her bed! While Mark steered Allison into a stiff Chinese armchair at the other end of the room near the lacquer-cabinet bar he was tending, she saw Joe and Kate fall at once into conversation down by the fireplace about something of intense interest to them both. About whom or what did they have so much in common? With her shining blonde hair and wearing the black knitted sheath, Kate Gregory looked lean and gorgeous.

To distract herself, Allison studied the Gregorys' Australian friends. John Barrister was tall, young, and so concerned over something that he frowned most of the time. He said he had been in Vietnam for quite a few years doing teacher training under the Colombo Plan. His slim wife, Jane, had brilliant red hair and used her lovely, absent-minded smile to show polite interest only.

Now the Vietnamese couple entered; stout Mr. Thinh, reminiscent of the President of his country in an immaculate white suit, Mrs. Thinh, bowing sweetly like a willow after rain in her jade silk and diamonds. Their daughter, Gabrielle, followed, standing slim and separate in dark red, a short, sleeveless Chinese dress instead of the more modest and traditional *ao dai*.

When Mark had served the St. Johns and given Allison a martini, he began mixing drinks for the rest of the group. Accepting a beer, Joe chatted in Vietnamese with the Thinh women. Looking from Joe to Mark, both usefully occupied and confident, Allison felt out of place, the only one in the firelit circle who was not having a most agreeable time. So she studied the room, which was like a stage set. Here, with its French windows facing west, was a place so well arranged that it might even be possible to hold a general conversation, excluding no one.

In the north wall under an Impressionist flower painting of universal appeal was the large fireplace. Graceful chairs on either side had cushions of the same gold brocade that curtained the windows. The seat of a low bench in front of the fire was elaborately worked in petit point with the

plumage of many birds. Allison could imagine Mrs. St. John doing that.

On the east wall under two misty Chinese scrolls was the long sofa, delicately covered in English flowered chintz. Rosewood end tables with brass handles, probably from Hong Kong, held tall brass temple candlesticks made into lamps with ivory shades, muting the light. Mr. St. John was sitting near the fireplace end of the sofa in a Chinese armchair opposite Allison's own. He smiled at her across the red lacquer coffee table before turning toward Jane Barrister who had slipped onto the sofa cushions nearest him.

At Allison's left against the south wall, the tall cabinet Mark was using as a bar ascended in black and gold and burgundy tiers of drawers and doors and other complications. Mark sat down in the chair near Allison whenever he paused. Jeff Gregory had negligently stretched his long legs out from a chair beyond and handy to the bar. A shining baby grand piano filled the far corner. Jeff's friend Barrister, the Australian, was sitting on the piano bench, his back to a splashy arrangement of speckled orange lilies and what looked to be a silver-framed photograph signed by Jack Kennedy on the closed piano top. Allison remembered his inaugural address only three months ago:

"Let every nation know, whether it wishes us well or ill, that we shall pay any price, bear any burden, meet any hardship, support any friend, oppose any foe, to assure the survival and the success of liberty." A note had been sounded to echo here.

The sun was about to set beyond the French windows. Allison took a deep sip of her drink—the bracing taste and smell of juniper should blur her acute awareness of Joe. Mrs. St. John pulled the cord and drew gold hangings across the evening behind the carved bench where Mr. and Mrs. Thinh were sitting. The Ambassador's wife then plumped herself down in a chair to the right of Mr. Thinh and to the left of Barrister on his piano stool. There was a really exquisite Chinese rug running in soft creams and old blues down the center of the room.

Allison saw that she was diagonally opposite Joe, as Mrs. St. John was opposite the Ambassador. We are on stage, Allison thought. Curtain going up. Everyone must play.

Just then the hall door opened, and the cook-butler admitted a dark, unruly-haired young man who might peer shortsightedly through his glasses, but whose hard body was clearly that of an athlete and an outdoor man.

"Jake Petrowitz," Mrs. St. John announced to the room, "is one of our IVS boys, International Voluntary Service. As you know, IVS is our Peace Corps out here in Vietnam. Jake and our son Jonathan were together in the Survival Training Camp in New Mexico!"

Jake ducked his head. Allison thought he would certainly survive more comfortably in the jungle than here in the Ambassador's drawing room. While Kate Gregory and Jane Barrister on the sofa looked him over with pleasure, Jake was seeking only the dark, uninterested glance of Gabrielle Thinh, poised as straight as a dancer on the fire bench to Joe's left. The newcomer sank down at once beside her but she did not turn away from her conversation with the doctor in Vietnamese.

Her father had noticed. Mr. Thinh, sitting solid and short-legged beside his pretty wife, staring through round lenses at Joe and Gabrielle, cleared his throat. In English he pronounced himself a Buddhist and asked the doctor what his religion or missionary work was—exactly?

Mark looked at Allison, raising a quizzical eyebrow as he handed Jeff his Scotch on the rocks. Jeff Gregory took a sip with relish, savoring the good whiskey and possibly the conversation here in the Ambassador's holiday residence. Through his eyes, Allison saw the Embassy well represented and the government of South Vietnam accounted for. Here also was a lively doctor-missionary, plus his own friend Johnny, pessimistic Australian educator, and himself, whose religion, skeptically held, was probably economics. There should be an American general present, but you can't have everything. Just as she was imagining Jeff's thoughts, he raised his glass to her with a wink.

Allison removed her glance carefully, allowing it to rest for only a second on Joe Ruffin, who leaned forward in that beat-up tweed jacket (still green at the elbows) and a clean shirt, his square strong hands linked easily between his knees. In response to Mr. Thinh's question about his religious work, Joe explained that he was a physician to the CMA and that intensive language study was his first job before he could be of any use.

"I'd like to learn something more about your religions, especially Buddhism, before long, but I guess everyone here would agree that getting fluent in Vietnamese is my first priority."

Allison saw Jake Petrowitz turn a look of sudden respect on Joe, but John Barrister said actually he thought studying Vietnamese was a waste of time. In his work as an educator, the only people you were ever likely to talk to at any length spoke French or English.

"It's simply not worth the trouble, especially as Vietnamese is an extremely difficult tonal language which you can never use anywhere else."

The Ambassador, fluent in French, pacifically declared that Vietnamese might be definitely worth the time, if you had the time.

Petrowitz then bent his serious gaze away from Gabrielle on to Mr. St. John. "Sir, I disagree. I honestly don't believe you can get involved in another country at all without understanding the language. And especially a country like Vietnam, with strong nationalist aspirations, just out from under Colonialism. It seems to me vitally important that their ancient language get some attention." With this he won Gabrielle Thinh's consideration for the first time.

But Katherine Gregory leaned forward to put the focus on Joe. "Dr. Ruffin, through your—uh—missionary contacts with the people here in the mountains today, did you happen to hear of any increase in Viet Cong activity?"

Allison swallowed a strong, resinous gulp of her drink. Joe answered that he had treated some gunshot wounds today which were said to have been inflicted by the Viet Cong.

Mark left the bar and brought his chair up behind Allison. "In fact," he told Katherine, "there is plenty of evidence recently that the highlands have become much more important in the guerrilla war. Communist agitators, trained in the north, both Vietnamese and Montagnard, have been coming down the mountain valleys to spread unrest, to disrupt control by the government. Like the arson at the airport last week. Also they are trying to interfere with economic progress. Would you agree, Jake?"

Cautiously Petrowitz nodded. "From our friends among the tribespeople we hear pretty much the same thing. These Communists are hard-working and dedicated. They move right in with the tribes and do everything they can to undermine any program planned to help the highlands, either by the government or the missionaries."

The Ambassador intervened. "But Jake, at present it is our understanding that the VC, in spite of their skill and devotion, still have only a loose hold on the peasants. The South Vietnamese government is making a real effort to conquer the hearts of the people."

Jake frowned. "Well, I can't help wondering, sir, if any Saigon bureaucrats are coming out in the countryside to do the job." He turned to Minister Thinh. "It seems to me your government needs to understand a few things, like the peoples' desire to own their land. You've got to come out and live

here to understand. You can't expect propaganda leaflets dropped from the sky to solve real problems."

If Mr. Thinh felt any emotional reaction, he did not allow it to show. "You perhaps identify yourself more with the Viet Cong cadres than with the government bureaucrats?"

Jake Petrowitz beamed his young grin around the room. "Well, it's true, I've got a lot in common with the Viet Cong. Like I happen to be living in a Koho village. Some Americans think I'm nuts, but I can't see it that way. I've got to learn their customs, eat their food, and share their smoky longhouses if I'm going to understand them and their needs. The Communists think this way too, but then I get seventy-seven dollars a month from IVS, so I'm a rich man compared to a VC cadre!"

Mrs. St. John said, "Jake here is known as a 'Montagnard freak,' but he probably won't tell you he received an award for his achievements in education and agriculture in the villages. Now, Jake, what you say is all very well, but these dedicated Viet Cong you speak of are trained in violence and terrorism, aren't they?"

The candid gaze seemed hidden suddenly behind the shiny spectacles as Jake spoke more slowly. "Well, so far I myself have only received a couple of lectures on the 'just cause of the National Liberation Front' from guys in black pajamas with floppy hats, but it's true, they can be dangerous. I would say the acts of terror seem carefully planned for their psychological value."

In fear Allison thought about violence.

"And political!" Minister Thinh began to be angry. "It is only necessary to look at the list of assassinations of government workers: teachers, public health officials, village chiefs, district chiefs, province...."

The Ambassador stirred. "Recently President Kennedy stated accurately that assassins have taken the lives of four thousand Vietnamese civil officers in the last twelve months. The victims are usually people of influence who refuse to submit to VC persuasion. Not only, of course, in the highlands. In recent years even the rubber plantations have been attacked, like Michelin in '58. By removing the leaders of South Vietnam, any country's basic resource and strength, they hope to create chaos and a power vacuum."

Very still, trying not to remember Max, Allison felt Mark lean his elbow on the back of her chair. He said it might be good sense for him to send her and the kids back to Saigon by air after the weekend.

If Joe noticed the exchange between Mark and Allison, he only said, "I

hope nothing happens to the Chief of this province, Colonel Thanh. I know him, and he's a great guy."

In a burst of gloom the Australian took the conversational ball. Perhaps he'd been out here too long—still, it looked to him as though the situation in this country was as good as lost.

Jeff Gregory got up to replenish Barrister's glass. Allison thought if alcohol is a depressant it certainly won't cheer the man. Katherine Gregory, she saw, was far from depressed. After all, everyone knows that a discussion which goes right to the roots of things should never be held in front of the Vietnamese, or for that matter, outside the Embassy, where the initiated see things with proper perspective. But Johnny Barrister, a bit red in the face, looked as though he had a few things to get off his chest after five years in Vietnam, before going home to Australia.

At Johnny's word "lost," the Ambassador had begun to look thoughtful, only the ghost of a polite smile lingering on his firm lips.

Minister Thinh bent forward. "Do I understand you to mean you have despaired about the military situation in Vietnam, Mr. Barrister?"

"If you like," Johnny said. "Actually, I'm concerned not only about the problems the government has in protecting the people in the provinces, but also the difficulty they have in even identifying with the people, as Petrowitz here says. It's the same problem the French had, if you think of it. Let's say you're a peasant with just a couple of hectares of land; your needs are the important thing, right? The people don't know anything about politics or democracy. They've nothing to lose by going over to Communism and perhaps everything to gain." With defensive truculence he looked around him. "So what are we doing out here? Perhaps we shouldn't be here at all, supporting and artificially developing a country that couldn't stand without our aid."

Allison could see Joe listening and watching with the keenest interest. He had quite forgotten her. And what about the Ambassador? He must be drunk to allow all this. Not drunk, she decided, his glass was still half-full in the big, quiet hand. The poor guy is relaxing for once and probably glad to get a genuine earful.

"Now in all honesty," and the Aussie headed gamely for the finish, "who knows whether the peasants would prefer a Communist regime or this tyrant President?" He took a draught of his fresh drink.

Several mouths opened, but Jake Petrowitz spoke first. "I can tell you some facts in answer to that, Barrister. Michigan State has a study under way,

not yet published but generally available in draft. Since there is so much talk about 'winning the hearts and minds of the people,' this study is being made to check out their real desires.

"And what do you suppose the people want most?" Jake looked around. "More bridges? Hardier crops? Control of malaria? Deep wells? Better housing? Flush toilets? Would you believe the study shows that what the majority of Vietnamese people want most of all is social justice? They're fed up with being forced to labor without pay on the strategic hamlets, fed up with the rape of their daughters by the National Guard. When this kind of thing happens, there's no place you can appeal to that you can trust, unless you have money for the big bribes. While the Reds are offering swift, if violent, justice, the people see their own government as corrupt and cheating."

"Social justice," a deep sigh came from Johnny Barrister. "Sounds very noble. And I'd like to have a look at your Michigan survey or study or whatever. But I'd be surprised if the Vietnamese came up with that term on their own in either language. That's a western ideal, isn't it? And who knows whether all these standards we inevitably use in our teaching and preaching are any good out here? We're always applying western measuring rods to a completely different culture!"

"'East is East, and West is West,' is that it, sir?" There was frost in Mr. Thinh's voice.

"I must say, I've begun to think so, Mr.—uh—Minister." Like an afterthought Barrister added, "But I'd be interested to know what you think." All the while Allison wondered what Joe was thinking, though not about Vietnam.

"Difficult. Very difficult." Mr. Thinh leaned back evasively. "In wartime, even in western democracies, the government is given extraordinary powers. This is war. Of first importance is to save the country. Then later we could more fully develop a people's government."

Mark's even voice came from behind Allison. "And, John, if you want a pragmatic reason for our being out here, you don't need to look any further than the military situation. The strategic reason is the most justifiable—from the point of view of Australia, even more than our own. You are so much nearer! Laos is already about gone to the Communists. In the cold war, can we afford to lose South Vietnam also, and then probably the whole peninsula to the Reds?" Mark had laid his arm casually over the back of Allison's chair.

"We have no one here to speak for the military," Jeff Gregory said. "But

a Colonel I work with among our advisers began a recent meeting with, 'Gentlemen, we are out here to kill Viet Cong.'"

Shaking off his friend's diversion, the Australian turned directly toward Mark Gardiner. "I've heard the Eisenhower 'domino theory.' Something like, 'You have this row of dominoes set up, you knock over the first one, and it's certain the last one will go down very quickly.' But the 'strategic real estate' reason was worth years of killing and dying to the French too, wasn't it? They killed masses of the Viet Minh, often with the latest weapons, and they lost out anyway! Even if you Americans should commit combat troops out here, you may well end up no more successful than the French."

Everyone looked stunned before such naked candor. Of course they had heard it all before, but not here! Glancing at her husband's growing stiffness of expression, the Ambassador's wife led them all off the track.

"You know, Mr. Barrister, I always feel when people comment on the French, they overlook the many advantages the French brought to this country. Dalat simply would not *be* here without the French." She was sending a special smile Allison's way. In deference to Maxim's nationality? Allison smiled back politely above her honest memory of Max putting business first in Vietnam. He would have been surprised to hear he should have done anything else. Oh Max, she told him, look at me and don't laugh; I am sick with love.

The Australian had been momentarily baffled. He tried then, in a mannerly way, to get back in the groove of his thought. "Well, ma'am, all I meant was, the French were out here to protect their own interests. And I'm wondering, if we're to be successful, shouldn't there be more to it than that for us? We're always sounding off, rather, about other reasons, like Jake here, aren't we? And isn't it somewhat hopeless? Your own Eisenhower, before Dien Bien Phu, when the U.S. was deciding whether to intervene to help the French, wrote that U.S. troops, unaccustomed to jungle warfare, would be swallowed up. He was convinced that no military victory is possible in this kind of theater, so isn't it somewhat hopeless? Perhaps we should just get out and let the Vietnamese choose for themselves. Communism's not too much worse than what we've got here, is it? After all, can you gain a military victory without any decent political basis?"

Allison saw that Kate was keenly enjoying the discussion from the sofa beside Mrs. Barrister, who looked very bored, clearly wishing to disassociate herself from her husband's passionate views.

"And frankly," Barrister went on devastatingly to Mr. Thinh, "your

government's a bit choosy, aren't you, about the kind of help or advice you will and won't accept? You don't always make us foreigners feel so welcome, if you see what I mean."

The cabinet minister managed a very tight smile. "I am wondering, Mr. Barrister, how you would like it, if a Vietnamese official person came to Australia (Canberra, is it?) and began to tell you how to run your country's government!"

The Ambassador cleared his throat. "Mr. Barrister, I'm sure you would agree that, as democracies, we want to respect South Vietnam's sovereignty even while we try to help them defeat Communist aggression." Mr. Thinh bowed gratefully. "Of course this interesting discussion has made clear that there is an important question to be decided by our newly elected President Kennedy. And that may well be whether to give top priority to the military battle against the Viet Cong or to the political reforms necessary for winning popular support."

There was a pause, but the discussion seemed unwilling to die. Jeff Gregory turned to his friend. "The truth is, Johnny, if we leave, they've got no choice. It's Communism or Communism eventually, as in Laos. Also, what you said about one method of government being as good as another doesn't wash economically. I can give you figures on North Korea and South Korea, as well as East and West Germany, which show very clearly which system benefits a country."

"Benefits who, Jeff? The rich people in Saigon, yes. Another Mercedes perhaps."

Allison found herself impressed by the gloomy weight of the Australian's point of view. He must have come out with very high ideals, to have become so disillusioned. Like her, Johnny Barrister might be discouraged, not so much in general, but specifically with himself, his own failures and defeats in Vietnam.

No one else spoke. They had come too far already. There was no retreat possible and no further advance.

But Mark thought he saw a way out. "Dr. Ruffin, what about you? Is it your opinion that we foreigners are justified in coming out to Vietnam? What does the church say about all this?" And he crossed his legs, taking care not to look at Allison.

"I can't speak for the church," Joe said, "but just as an individual doctor working for the CMA. Well, I have to agree with John Barrister that we are all out on a limb here in Vietnam. You call yourselves a 'mission' too, don't

you? An economic mission to fight poverty and ignorance. For whatever reasons we say it, I believe we are all saying we are somehow our brother's keeper. This is a risky involvement. Can anyone really help anyone else? Individually or nationally? Think of the problems as they show up everywhere: in South America, the Near East, India, Southeast Asia, Africa."

Mrs. St. John caught fire. "You know, Dr. Ruffin, for a long time I've had this wild notion that we should let the Communists have a try at Africa! Unopposed. My husband doesn't agree with me, of course, but I don't think democracy has a chance there, because so few people are literate. Africa would keep the Communists occupied! And I doubt very much that it's within the capability of the CIA and State to recruit enough high quality representatives to go overseas and accomplish all these impossible tasks throughout the whole world!"

"Oh my God," Mark muttered in Allison's ear.

The Ambassador, having doubtless heard it before, remained unperturbed. "Are we to understand, Dr. Ruffin, that you are a pessimist too?"

"Well, it's tough. You can't help being discouraged even back in the States, by the way so many human needs are not being met, either by government or science or religion. And though I haven't been out here very long, already I can see for myself what Johnny and Jake are telling us. A lot of Vietnamese people are demanding more. In fundamental ways they feel wronged and deprived. Our own people explained the same thing once, not very politely, to Great Britain. But of course we managed a complete revolution. Here in South Vietnam maybe a better analogy could be the growing pains and problems of our teenagers. Don't they defy us and at the same time count on our support and the family car?"

"Very apt, Dr. Ruffin!" Mrs. St. John was the mother of grown sons.

Allison watched Joe pull on his ear doubtfully. "Well, it's not all that apt, ma'am, since this country springs from a much older civilization than ours. However, I'm no authority on history or government or religion or the military. I was in the army in Korea, but I went as a paramedic. I never had to kill anybody, thank God. War is so fiendishly destructive, it forces you to decide that nothing whatever, anywhere, can possibly ever be worth it!" When he paused, no one had a thing to say.

So he went on, almost to himself. "However, there is violence, somehow always in us, no matter how much we try to repress it, and it will erupt now and again to keep the balance. We doctors have a word, 'homeostasis,' that has to do with the balance of extremes. Like the parasympathetic balanc-

ing the sympathetic system in the body. Or active versus passive. Yin versus yang. Rich versus poor. Whenever the opposites get out of balance, violence (or disease) seems to erupt.

"I've done some thinking about violence; like what's the good of it, and, if there is any good in it, how to put it to the best use. I've read some interesting ideas on the subject, but they are not exactly traditional." And Joe looked around the group with an uncertain grin. "One suggestion is that we are really all one in this universe, and all connected. If this is true, maybe the wild animals should be carefully preserved, because they carry our violence openly and help us keep balanced. I've even heard that volcanoes erupting can help the whole planet let off steam and avoid some of our outbreaks of war!"

Allison remembered the tiger her children were so eager to track down, before she came quickly back to the present. God, Joe is even worse than the usual missionary! He's crazy like an outlaw. He'll always be going against the system. He'll never be like everybody else. So how come he looks so much at home here? Maddening.

Ambassador St. John was not going to spend a whole lot of time thinking about the uses of tigers and volcanoes. "Speaking very practically, Dr. Ruffin, what would you say your business is out here?"

"Well, it's not changing governments. That's a chancy thing, since governments are always wrong in someone's opinion. I think changing people is the heart of everything. If we get new people, they will spread newness and change around. My aim is helping people help themselves to be well and whole.

"So what would you all say is standing in the way? People have thought that 'selfishness' in a person or nation is the cause of all our dis-ease. I'm beginning to wonder if it isn't self-hatred or the lack of self-esteem in people and countries that causes violence. When people like themselves, they stop making themselves sick and stop bothering other people. You have to love your fate and trust it, instead of doubting and fearing it."

Jeff frowned. "But Dr. Ruffin, it looks to me as though both Christianity and the medical world direct most of their attention to the miserable sinner or the pathology of the patient. I'm no expert on religion or medicine, but to the average guy they seem more locked in on dogma and tradition than working for change."

Joe nodded. "I've thought that way too. Still, there are exceptions. For example, in the coming of revolution to China, Christian missionaries (even

sometimes without knowing it) were the spearhead of evolution in places where tradition had become a paralysis. Like the treating of women as less than human. Back home we think of Christianity as stuck in a groove, but the essential message of the great religions has always brought change. With the Christ it's a sword, new wine that can't be put in old bottles. Missionaries have died as martyrs because people clung to the old and feared newness."

Oh, Joe, Allison thought, change is exactly what I'm most afraid of.

He began to look tired, and his words stumbled a little. "Well, that's it. I think I'm out here to see that some of these people get a chance to choose a new kind of life, a new spirit or attitude, a new body, something they might not have realized was possible before. Maybe, Mr. Ambassador, this is something like your own mission."

Mr. St. John looked thoughtful, but Mark was fed up. "In what way specifically?"

Joe turned. "Well, as I see it, you are also out here to offer other opportunities people have been denied. And not just material ones either. Maybe they'll choose to make a success of this fortified hamlet concept from Malaya. Maybe you'll convince this government to reform, as Jake suggests, before the people overthrow it. In the end, of course, it's up to the Vietnamese themselves. Our role isn't easy. We can only offer them the choices we think are good, out of our own experience, as honestly as we can, with as much respect and understanding as possible for their point of view."

He looked seriously across at Mr. Thinh. "There's nothing noble about it, but I don't think we should hate ourselves either. I believe we are impelled to be here. Not only because we have so much. But also because there's something important going on here, a learning process, and we are receiving as much as we are giving. Maybe more!"

Allison blushed for Joe, not minding what he said, or how much he cared.

The Ambassador smiled, "You put things very well. I'd like to hear one of your sermons, Dr. Ruffin." Allison thought he already had.

Glancing toward her, Joe wrinkled his nose apologetically. "Well, thank you, sir. If you're serious, come to church tomorrow at ten. I'm supposed to be one of the speakers at the dedication of the new Vietnamese/Tribal Protestant church. It should be quite an occasion. I heard that you and Mrs. St. John are invited as well as the Province Chief, Colonel Thanh."

"We are certainly planning to be there. So you'll be preaching will you, Dr. Ruffin?"

"My part won't be a sermon, just a short speech about health and healing. But anyway, I'm a lot more impressive in Vietnamese when you can't tell what I'm talking about."

Everyone laughed, and began to discuss the new church and the new Province Chief, Colonel Thanh. Except Allison. She had been amazed at how many ideas they all had about the situation here and how eager they were to express them. Looking around the charming room, Allison saw Mr. and Mrs. St. John like the King and the Queen of a Looking-Glass world. She exclaimed to herself like Alice, "Oh, you are all nothing but a pack of cards!" Except Joe. And she closed her eyes. But when she opened them again all the characters were still there, still talking.

And Allison remained silent. Shrinking from poverty, fearing violence, what could she say about Vietnam's crisis? How could she even meet Joe's eyes as she heard him telling about the Thanhs, how they were daily risking their lives for what they believe in. She wanted to cry out, care about *me* that much too! I'm disadvantaged! Can't you see how it is with me? Here I am like a china shepherdess under glass, and I like it here! If you really want me, do something forceful to break the world's spell. Joe, do something!

Their eyes did meet then, for a telling moment, but he only rose to say it was time for him to leave. The Ambassador got up, offering his hand, saying it was good of him to come, and thanking him for giving Mrs. Giraud some tennis.

"No trouble at all," Joe said generously. "May I borrow her for five minutes so I can meet her children? I don't know where she keeps them." The teasing glint was back in his eyes.

"Of course." After general handshaking, the door closed on them. Standing at Mark's elbow, Jeff murmured, "Why don't you go on out and join them? I'll keep bar."

Mark said tightly, "Thanks; if I need any help, I'll ask for it." He was a little red around the ears.

"Okay, okay." Jeff sauntered away. "No offense—"

Outside the drawing room door, Joe and Allison faced each other in the cold, dim passageway. "That was a surprise!" he said. "Somehow I never expected it would be so interesting."

They were standing close, in the power between them. "Oh, it was all just a lot of talk. Talk about Vietnam never gets anywhere."

Joe put out his hands. "Well, I apologize for my sermon. How right you

were!" And there he was kissing her, his lips oddly young and soft, his cheek roughly hard.

"Joe," Allison held on to his lapels. "You couldn't *marry* someone like me! I'm too—you can see I'm not your type. And this far along in life, how can I change?"

He managed to set her away from him. "If you could just stop hating yourself!" Then, more lightly, "You know, my grandmother, Sally Gray, was a minister's wife, and a pretty one, who loved nice things. She got very tired of people being surprised that my grandfather had married such a 'worldly woman,' a redhead too. She used to say that people ought to realize, a minister always marries his one wild oat!"

Allison smiled in spite of herself, thinking of red-headed children. She opened a door to the light. Children's heads around the table lifted in surprise at the invasion of their world with its own absorbing arguments. As Katrine and James put down their spoons to stare at Joe, Allison saw their wants so clearly; Katrine with her need for firmness and her constant hungry demand for appreciation, James with his quiet withdrawal from his mother's feminine ways, with his patient study of every man he met. Did her own wants show as clearly?

"Hi," Joe said to everyone. "Do they feed you pretty well around here?"

"Pre-e-tty well," Katrine admitted.

"Fork desserts?" Joe asked. "When I was a kid, a spoon always meant Jello or pudding, but I liked best the things they gave you a fork for, like pies and cakes."

"So far we've got mostly spoons. But there's a fork tonight!" James smiled eagerly. When Joe sat down in an empty seat, his arm across the back of Katrine's chair, all the children's faces turned to him at once. Allison stood watching, feeling tall and grown-up. She introduced the Gregory boys and her own children. Already she knew they would tell her later that Joe was keen.

"Well, being up here is a holiday, anyway," Joe said. "Where do you all go to school?"

"We go to the American School in Saigon," said Tommy Gregory with more pride than affection.

"Katrine and I go to Les Oiseaux." James had stopped eating entirely. "Boys only go through the second grade, so I won't be there much longer. But Katrine has to stay on for years!"

Katrine let her eyes close once. "I don't mind. I like Les Oiseaux, and I'd

like it a lot better without boys. *I'm* a good student. James is a dreamer—Soeur Raphaelle said so!"

"Good for you both." Joe smiled at them. "We've got to have both of those types around."

Katrine was forced to see the justice in this, but she went down fighting. "You sure have been playing a lot of tennis. Do you like tennis *that* much?"

"Not quite that much," Joe confessed, laughing.

"I thought not!" Katrine was triumphant, while Allison blushed. "Are you a real missionary?"

"I think I'm too chicken to be a real missionary. Sometimes awful things happen to them. Did you ever hear the jingle about missionaries? I think it comes from Gilbert and Sullivan, or maybe Edward Lear."

When they all said they hadn't heard it, Joe recited:

There once was a cassowary
Who lived in Timbuctu.
He ate up a missionary
And his hymn book too!

This went over very well indeed. Finally Allison and Joe went back to the front door and out into the dark. He spoke first. "I like Katrine and James. They're great."

In the sudden cold she shivered. "I never know whether I'm doing...."

"I know," he interrupted gently, "but you're doing all right."

"And in Nhatrang, or wherever," she nagged a little, "where would they even go to school? Who would teach them?"

"There are French and Vietnamese schools, until they're old enough to come up here to Dalat. But Allison, to be perfectly truthful, and I hope to God I'm wrong, with what I see looming ahead for this country, we would have to send our children home to the States anyway."

Our children. She was silent. And now what? Allison hugged her arms tightly under her breasts. How to part with him? In her heart she said, Oh Joe, you could help me if you would. You are strong. You could make me do the right thing. I'm so afraid. If only you would do something!

"Good night, Allison." His voice had all the vibrant strength of his hands, which didn't touch her. "It hasn't been nearly long enough. I wish we could plan something together, like tomorrow after church, maybe see a Montagnard village, you and the children and I. Hear some Koho music."

"I'd like to, Joe." Her teeth chattered. "It's just that Mark wouldn't understand. They would all think.... It wouldn't be polite."

"I know." In his heart he told her fiercely, there's only one thing I can give the special person I love, and that's freedom. You are you, and I love you. That's it.

But he only said, "Goodnight and thanks. Don't stand there shivering, Allison, go on back in." With a wave of his hand Joe was already gone, a long black shadow striding off the hill, head down, hands in his pockets. She went back into the villa again and leaned against the shut door.

Evening at the Savoisienne

*Violent passions, like summer thunder storms, are occasional
graces which sweep away stale tensions and clear the air for
action.*

Sam Keen, Beginning with the End

Thunder was tumbling down threats to echo back off the mountains. While
Allison ran upstairs to check on the children and get her coat, Mark stood
outside by the car smoking a patient cigarette but feeling uneasy. He had
been too damned patient! From somewhere a quote came into his head:
"Beware the fury of a patient man!" His thoughts simmered around Joe
Ruffin's obvious interest in Allison, as well as his irritating eloquence. The
rational process had been carried further than flesh and blood could bear
when you felt the power of a perfect stranger over your girl.

While he paced up and down waiting, a young couple ran out of the villa
toward a jeep parked on the circle. Hearing thunderous mutterings, they
paused to glance up over their shoulders at the darkening sky. Mark recog-
nized the Vietnamese girl, Gabrielle Thinh, and the IVS guy, Jake Petrowitz,
who waved a careless hand as they drove off. How had Petrowitz managed
to get that girl away, right from under her father's obvious disapproval?

Mark didn't bother to look up at the heavens, starless and grumbling.
There had been the same empty threats for weeks, and mid-April is not yet
time for the monsoon to break. When Allison appeared he dropped his ciga-
rette, crushing it firmly with his heel into the gravel. He would have her to
himself for the rest of the evening.

La Savoisienne Restaurant, as both Mark and Allison knew from other
weekends with other people, was a romantic old Swiss-French farmhouse.
Even in the dark you could sense the wild and shadowy profusion of grow-
ing things around it. Mark knew the gaunt Savoyarde who owned the inn

and ran it. Like an old aunt of his from Brewster, Massachusetts, she had the rough hands and penetrating eye of a dirt gardener. With her hands folded now on her dark silk skirt, Madame Bruard welcomed them formally, adding that aura of special attention which only regular customers received.

But as Mark was seating her at the candlelit table, Allison imagined the proprietress to be watching her severely, with dislike for her pretty face and general uselessness. Turning away from judgment, real or imagined, Allison saw another couple already settled at a far table in the corner.

"Look, Mark, that's Gabrielle Thinh and the IVS student who were with us at the villa!"

He frowned. "They would have to come here!"

She couldn't help smiling. "I don't think they'll bother us; they seem totally absorbed."

Jake Petrowitz was saying, "I had a little talk with your father about politics while you were upstairs."

"I don't believe it." Gabrielle leaned forward half-serious, half-laughing, her black hair hanging silken and straight over one narrow shoulder.

He grinned. "Well, maybe not quite. After that incredibly free political talk this evening right under the Ambassador's nose, I asked your father whether Vietnamese people like talking politics as much as Americans do. He said, 'No. Even within a Vietnamese family one does not.' I said, 'Maybe the sons don't argue with their father, but surely the boys would discuss politics among themselves.' He answered, 'Yes,' but he looked very doubtful. 'You see,' he said, 'Vietnamese are more reserved.'"

Gabrielle's eyes were merry while Jake went on seriously. "So then I asked, 'If you were against the present administration in South Vietnam, sir, would you feel free to say so anywhere?'"

And Gabrielle replied for her father, "It would be better not." Both young people laughed, that being exactly what Minister Thinh had said.

Mark and Allison turned to Madame, who came to present their menu cards, written in a pale lavender script. Allison was not bothered with decisions, however, since Mark had already ordered ahead, extravagantly: hot artichokes with Hollandaise, Poulet Flambé, Dalat salad, a Tavel rosé wine. Mark's confident pleasure returned as their dinner unfolded; well planned, well cooked, and well served.

Allison sighed happily. "This is the lap of luxury!" She dipped a succulent leaf in the yellow sauce.

After the artichoke plates were removed, Mark put his elbows on the table. "I've never seen you so beautiful, Allison. Is it the weather up here? You're blooming!"

She remembered Joe's, "That's not the climate; that's because you're falling in love with me!" Allison looked directly across at Mark. "If I do seem better, it's got to be because of this wonderful holiday that you arranged for us."

"Allison...."

But she was still speaking. "You know, Mark, tonight at the villa, I was surprised the Ambassador would let so much frank discussion go on."

"St. John is not your run-of-the-mill ambassador. He often surprises me."

"It wouldn't be easy to be in his spot," Allison said. "And you know, Mark, tonight I realized I hardly know anything about your work, or how you like it."

"I guess I should have shared more early on. But it was fun getting away from it all with you. Well, the truth is, I feel very fortunate to be out here in my job right now. The crisis situation makes this an important spot in the world picture, with tremendous challenges. And I'm learning something about just how much you can influence policy as you move up the ladder in the Foreign Service." He wrinkled his forehead. "I'm getting some occasional set-downs."

Allison smiled a question.

"I mean I'm learning about the limits we have to work under, from the Ambassador down. If 'challenge' is an operative word in this business, so is 'compromise.'"

Looking at his strong regular features, his straight blue gaze, she wondered what would have to bend in order for Mark to make it in such a setup. "Does it bother you when you have to 'compromise'?"

"It bothers me like hell. I seldom agree with the Department, and often not even with the Ambassador, about the way we use our leverage with this government in Saigon."

"Would it be okay to give me an example?"

Mark lifted his shoulders. "Well, take the South Vietnamese prisons. You wouldn't, I hope, have any reason to visit one, but I've seen several, most recently in the case of this Professor Minh, who was picked up by the government police a while back because of his views on the need for reform. Allison,

a medieval dungeon would be almost preferable to brother Nhu's jails. You'd better take my word for it, because I'd rather you didn't hear the details.

"You see, Allison, opposite a reactionary government like Diem's we're constantly trying to stay firm but friendly. In order to gain their cooperation in some very important area, we may have to close our eyes in another. These are the bare mechanics of what we are about. The higher you rise in rank, the more careful you have to be about the position you take on an issue. If you should take too hard a line one day, your own government can pull the rug out from under you by cable the next day. Eventually you might have nothing to do but resign, when the matter is important enough. Or you could even be investigated for 'unorthodox views.' It's happened."

Allison already knew something about the ways of diplomats. She listened with understanding, elbows on the table, chin in her hands. "Do you think you can stick it?"

"Allison, you may not believe this, but I have an aptitude for it! It's a game I like to play. And anyway, there're drawbacks to every job, compromises everywhere in the real world. In this job you're trying to gain all you can for our government in a touchy situation, while seeing it as clearly as possible from all angles and somehow managing to keep your objectivity."

"Thank goodness there are people like you in the world who go for this kind of work," Allison said.

Mark glowed. "One thing I like is how we Foreign Service people feel like members of a club, no matter what our nationality. We're all doing the same kind of thing, so we have a special understanding—Germans, French, Dutch, even Russians." He paused. "Allison, I'm really glad you're interested in all this. Does Foreign Service life appeal to you at all?"

She thought with a certain nostalgia about drawing rooms and white-coated servants, the various shapes of wine glasses at the tip of your knife, formal dress, and birthday garden parties for the Queen. "Rather," she smiled.

"It wouldn't bore you?"

"Only pleasantly!" And they both laughed.

But then her glance slipped away from his. Under their talk she felt possessed by the maddening, frustrated longing for Joe. And she drank more wine, setting free the brightness of her chatter. Still, it seemed to Allison, that her charming laugh didn't quite come off, perhaps because the couple across the room were being so serious.

• • •

Jake said, "Your dad is really okay, Gabrielle. Do you think you're fair to him? After all, he let you come out with me!"

Gabrielle pushed the dark-falling stream of her hair behind one small ivory ear. "But you don't understand Vietnamese men. How can you? It is not in your experience."

"All right!" Jake was pugnacious. "Explain to me; then I'll understand."

She blew out a dissatisfied breath, punching with her fork at the white cloth, leaning her cheek on her hand. "Okay. I'll try. My father is the northern male, very sensitive, a poet. He does not soil his hands with business or the budget. That is left to my mother, you see? He makes clever speeches, admirable pronouncements using aphorisms in beautiful words. Admiring the French culture, he allowed my older sister to study at Grenoble, but now he has learned something of her free life there. He feels my sister is greatly changed for the worse, so you can be sure this daughter will not go abroad!"

"But he let you come out with me!"

"Oh, Jake, he is very subtle. My father can easily allow this evening to please me, because we are away from home on holiday among strangers and foreigners. It will not affect in any way my standing as a possible bride back in Saigon."

This was sobering for the American. He certainly was not about to consider marriage with anyone, but he had hoped to see a lot of the intriguing Gabrielle. "Your father is always thinking in terms of marriage? You and I only met this afternoon!"

Gabrielle shrugged. Jake put his muscular forearms along the table beside the empty soup plates, and looked around. "What's *become* of that woman? Well, while we wait, tell me something about Vietnamese marriage customs and traditions." When she frowned, he said, "I mean, can't a person marry for love?"

"Okay." Gabrielle decided for education. "Marriage here is not based on love primarily. It's more of a contract between two families, see? Not always arranged, in Saigon at least, but always in villages in the countryside and in traditional families. I think the idea of marriage here is to provide a firm basis for producing a good family. It is arranged for boys to marry very young. The theory is, I believe, that in eating the appetite comes."

A little teen-aged maid in black finally took away their soup bowls and replaced them with steaming platters of beef, vegetables, and rice. Grinning across the food at each other, they started in eagerly.

Jake broke off a crusty piece of bread. "Can you ever have divorce?"

She shook her head. "And no separation either. If you are not happy, they say it is predestination. It is also said that God disposes, and human beings must obey." Gabrielle buttered her bread with small, neat fingers. "Of course there is polygamy, but not much any more."

"What you explained about marriage certainly provides a good enough reason for polygamy!" Jake was managing to do full justice to the meal and at the same time watch Gabrielle with interest over his busy fork.

"But you see, they make a real effort before the marriage to see that the two will be compatible."

"How do they achieve that?"

Her eyes gleamed. "By compatible horoscopes, of course. And also the age is considered. A girl must be at least fifteen, a boy eighteen. Then there may be a service period for the boy to prove to the girl's family that he is good. Like in country families, the boy helps the girl's relatives on the farm."

Jake had seen some of that through his work in the villages. "But look, Gabrielle, nowadays aren't things changing?"

She laughed merrily. "You mean, now they have 'love,' and with 'love' there is no need for horoscopes!"

Jake frowned. "You know, Gabrielle, I notice you're always saying, 'they,' not 'we' or 'I.' After all, you're a Vietnamese girl yourself, and with your conservative father, aren't you subject to the usual traditions?"

Gabrielle tossed her hair behind her shoulders, staring off at the foreign couple across the room. "I will never marry a Vietnamese!" Her chin went up. "To Vietnamese men, women may have some power, but only in the background, subtly, behind their men. No matter how capable they are, they must keep their place." Her eyes were on the western pair who appeared to be so romantically *intime*. "Look, Jake, over there. They were at the Ambassador's too. Perhaps they are planning marriage in the American style."

Jake followed her eyes with his own. "Mark Gardiner is American all right. She's…maybe French? I think I caught a French name, but I didn't talk with her."

"She is very attractive," Gabrielle pronounced judicially. "Elegant and chic, perhaps *Française.*"

Champagne was being served at Allison's elbow to accompany the sweet soufflé. Looking down into the seething gold in the wide glass, she felt the gaze of the young couple across the room. It was the kind of attention she

had grown used to, might always want. Butterflies and champagne, she thought, over against the powerful simplicity of Joe.

After dessert, Allison felt their conversation lagging while they sipped their coffee. The other guests were slowly leaving the room, that American boy with his Vietnamese girl too. But since Mark had already paid and tipped, they were left undisturbed.

And it was lovely, just what Madeleine and Georges back in Saigon would completely approve, what she herself always so easily enjoyed. Then what was wrong? What was that sudden unbearable pain? Or was it more like a sound, the tolling of a buoy submerged in heavy seas? A sorrowful toll, warning of some irreparable loss.

Touched by her downcast face in the candlelight, Mark reached out to take firm possession of the fingers she was pleating her napkin with on the table. "Allison, you are so lovely!" When she stirred uneasily, he went surely on. "No, I'm not the kind of person who pays compliments unless they are true. You are beautiful, and you should have just the kind of life that suits you. I want to help it happen. Allison, would you consider marrying me? I love you very much."

His eyes were seeking hers, but she couldn't seem to look up. "Darling Allison, you've been alone much too long with all your responsibilities. I want to take care of you and Katrine and James. Honestly, I believe I can make you happy, and the children too. Why don't we decide right now when to begin our life together?"

What an impetuous speech for Mark; how kind he was! "Oh Mark, I don't know if anyone can make another person happy. I'm afraid you can only be happy if you choose to be."

"Exactly!" Mark smiled into her worried face and opened his hands. "Choose me!"

Two tears suddenly left her lashes. She couldn't speak. Surprised, he reached automatically for the clean handkerchief folded in his breast pocket. Allison saw him blurred, swimming in tears. "Oh Mark!" and she buried her nose in his snowy linen.

"What's the matter?" he asked with real concern. She could only shake her head. Mark felt bewildered. Among the responses he had imagined, weeping had not occurred to him. With dignity he rose, took her soft coral coat from the back of her chair, and put it around her shoulders. "Allison, I think we should go."

She stood up at once, nodding and dabbing at her eyes. "Yes, of course. I'm terribly sorry, Mark. It's the stupidest...."

He took her arm firmly as she stumbled down the two steps to the hall. They would settle the whole thing properly in the car. The Frenchwoman, her eyes deliberately blank of curiosity, opened the heavy door for them. "*Bon soir, M'sieur, M'dame.*"

Mark began a mechanical response, breaking off when he saw the outside darkness stricken, falling heavily with wild rain. "Damnation!" he muttered. "The monsoon isn't due yet!" What a beautiful weekend, he thought. Missionaries who played expert tennis and argued politics. Allison herself in some kind of mysterious breakdown. Even the rains off schedule. He helped her in and dashed around the car, one foot splashing disagreeably into a puddle. Closing the door, Mark started the motor and shoved the gear into first. They plunged off with an angry rattle of gravel in the blowing stream of wet blackness.

Before closing her thick old wooden door on the last of her guests, Madame Bruard stayed to enjoy the sudden violent incursion of monsoon wind and rain. How she loved weather in all its moods! The dark explosion out there allowed something that struggled deep under her crusty self to feel for a time liberated. Sighing and shutting the door at last, she threw the bolts just as the lights went out.

While Madame groped her way back to the kitchen where the maids giggled and the cook complained, upstairs in his corner room the provident Tang was lighting candles for the NLF cell meeting. He placed one on the rickety round table and one on the bookcase under his picture of the Perfumed River at Hue.

Kiem watched, out of tired emptiness. Most of the important matters about tomorrow's key action in the Struggle had already been decided at their meeting earlier that afternoon. Since then each cadre had been busy with his special assignment. Now there was a feeling of nervous expectation in the room. None of the three had eaten all day because of the vital preparations. Although there was no rice here, at least they could drink the hot tea which Tang had prepared on a small brazier. Anyway, they were almost too excited to eat.

In the uncertain light, sipping from the warm, handle-less cups held close to their lips, Tang and Thom were studying the clear diagrams of the church which Kiem had drawn for them. He himself felt a sure confidence welling

up in his heart for the first time since Le Tuan Anh had deserted him by the Prenn Waterfall that morning. Kiem's old conviction of moral rightness had returned. Pinpoints of light in his eyes reflected the candle twice.

But when the candle began to flicker madly, Tang said, "The wind is rising!" and he closed the wooden blinds inside his windows, smiling. "'The prevailing wind signifies the Will of Heaven,'" he declared, "'and the people will bend as the grass.'" The three men, in a fever of excitement over what lay ahead, raised their heads to hear the wind.

Kiem tapped his fingers on the table. "To work! Comrades, remember, 'The basic principle of war is to preserve oneself and to annihilate the enemy.' Chairman Mao also said, 'Political power grows out of the barrel of a gun.' Comrade Tang, have you stolen the weapon as ordered?"

With a somewhat aggrieved, "Of course, Comrade," Tang produced a small automatic and a flat box of ammunition. Kiem examined the gun with great care. When the loading and firing were perfectly clear, he nodded sharply and turned to Thom.

"Comrade, have you also procured the necessary petrol and kindling for setting the church on fire as a diversionary tactic?"

Thom leaned back, tilting his chair. "I have."

"And where is it?"

"Hidden below in the Frenchwoman's garden shed." He nodded proudly.

Bui Tang was disturbed. "But Madame Bruard is working there almost everyday. She may discover it!"

"In this rain? And under a pile of old sacking which has not been moved for months?"

Kiem saw them squaring off for one more of their usual quarrels. Tang had already wasted the first five minutes before the lights went out accusing Thom of wearing the wrong clothes to the meeting.

"People should wear clothes proper to the meeting; good clothes for a ceremonial meeting, solemn clothes at a Struggle meeting, and old torn clothes at a misery-telling or denunciation meeting." Thom's old torn clothes, Tang said, were not solemn enough for this evening's purpose. Sincerity was exhibited by how well a cadre played his role.

Thom's chair had banged to the floor. His old torn clothes were suited to stealing petrol. How was he then supposed to go twelve kilometers home to his village and change for a "solemn" meeting? If his actions weren't sincere enough for the cell, they could....

And now they were arguing about where Thom had hidden the stuff for

the fire. He was being hooked again, the eternal victim. And Tang was the eternal sadist, manipulating others to break their spirits and gain self-satisfaction. Kiem listened to them against the formidable downpour of the rains. When the room flickered with lightning, he smiled. Hatred, the *élan vital* of the Movement, was not hard to encourage in this cell. Tang hated because he had never been given a place of respect and admiration. Thom hated because his precious land had been stolen, and he had lost his precious family. Kiem did not stop to wonder whether his own hatred was healthy, or even what its source might be. His problem was to direct all angry energy toward its proper object; otherwise they might self-destruct long before the final Uprising and the unification of Vietnam!

"Comrades," Kiem said, "let us conserve our violence for the enemy. We in this cell are a three-member collective. We are welded together with revolutionary and noble class spirit. This cell is our home, and we are like brothers.

"Remember our purpose—always to win the support of the people to unify Vietnam and defeat all foreign powers! Remember too our success in sabotaging the airport. General Giap told us to gather a thousand small victories like this and turn them into one large success.

"For tomorrow's action, Comrades, I myself have procured a vehicle, a rather old but well-functioning Renault which is hidden behind the shack of my old woman up on the mountain."

Thom crowed his pleasure. "Now you're talking, Comrade! With a gun, gasoline, and a motor car, our cell is in business at last!" He was not sleepy or bored tonight. Their action at the airport would soon be followed by the assassination of the Province Chief! "I volunteer to do the shooting!"

Kiem said, "Comrade, please wait for orders. Violent acts must be carefully conceived for their psychological value."

Thom turned sulky at once. "What's so complicated? So psychological? We move in, shoot the Province Chief, and move out. That's all there is to it. No further problem from Province Chief!" And he tilted back, smiling broadly.

Kiem left a deliberate pause under steady drumming from above. "Now, Comrades, you will listen to right explanations." Alert to their responses— Thom slumping wearily when ideology was the subject, Tang sitting straight enough but always looking critical—Kiem put strong encouragement into his voice. "Comrades, Chairman Mao has told us that 'all guerrilla units start from nothing and grow.' He has also taught: 'Man is the greatest factor in

the universe and can do everything!' Tomorrow, as one man, united in our fiery hatred for this traitor to the great future of Vietnam, this so-called Province Chief, this militarist, who is a stooge and lackey of the imperialist Diem-American clique, we three will courageously wipe out a powerful enemy of our nation's righteous cause!"

Kiem saw Thom lift his head eagerly while Tang nodded approval with narrowed eyes. "Think, Comrades, as I have been doing today, think about the people who will gather tomorrow at this church. See how this project fits in with our instructions always to let our work grow naturally out of the happenings and needs of the moment, like tomorrow's church dedication ceremony. This is part of the insidious propaganda of the Imperialist missionaries and the treacherous Diem government. Through the failure of this propaganda ceremony, the people will see that the cause of these foreigners is not in accordance with the will of Heaven.

"And furthermore, when we stand up and fight for our just cause tomorrow, our terror action will frighten the enemy and keep them from mingling freely among the peasants in the future. Through fear they will become paralyzed."

"Comrade, your words are true," Tang declared. "Seeing the enemy fall tomorrow, the people will be convinced that the future lies with us and not with this evil regime. Tomorrow they will see what happens when they listen to Yankee-Diem Imperialist propaganda. And in the end we will use the strength of the convinced people of South Vietnam to overthrow this feudal ruling clique and set up at last a People's Revolutionary Government!"

The young leader, on fire himself, saw his hate and devotion reflected back to him from his two cadres, who had totally forgotten their differences in the glory of their righteous cause and the chance to act heroically. Now there remained only the business of assigning roles in tomorrow's action.

It was not difficult. After the materials for a quick blaze had been carefully laid around the church foundations (the congregation being already inside), Thom would light the diversionary fires. Kiem himself, having slipped out of hiding into the doorway of the south transept, would take cautious aim and fire the gun accurately at the Province Chief on the podium. Kiem would then run immediately around the back of the church and into the woods on the north side, where the Renault would be hidden. Tang and Thom would be waiting in the car with Tang at the wheel. He would drive them all quickly away to their mountain hideout. The three men stud-

ied Kiem's diagram of the event as the rain slowed to peaceful dripping from the old farmhouse roof.

"Has the Ambassador no bodyguards?" Tang inquired. "And surely the Province Chief, a Colonel, will have soldiers with him?"

"Good point, Comrade," Kiem said. "I am informed by my agent that the American Ambassador and his wife will have only a chauffeur. Thanh and his wife will have a chauffeur and a bodyguard. It can be your first job, Comrade Tang, to get these three men into a dice game behind the cars, parked down on the road, while Comrade Thom is engaged in starting the fires. You, Tang, then go fast to our vehicle. When the drivers hear the shot, they will run first to that sound at the south side of the church. That will leave it clear for us to get back to the car."

Thom, the pessimist, growled, "And what if these rains keep me from coaxing fire out of my kindling, petrol, and paper?"

Kiem frowned. "If the diversion of the fire is not possible, we must risk shooting anyway." Thom looked unhappy. The lure of anarchy was one thing, martyrdom quite another.

Tang looked his scorn. "There will be no difficulty, Comrade Thom. Our materials, thanks to you, are now under cover. And, as anyone knows, especially a *farmer*, the rhythm of the monsoon repeats itself at its usual time daily, with only a slow advancement of the hour of rain. Therefore there will be no shower at 11:00 a.m. tomorrow."

Huffy, Thom reached for the teapot. "It is indeed thanks to me that our materials are under cover. But," he grumbled, pouring tepid tea for himself, "this monsoon is early, unexpected, maybe not reliable as in the past!"

"These early rains are a good omen for our action," Kiem said. "The beneficent dragon that controls the rains and the national fertility has given us a hopeful sign!"

And he stood up, excited as a boy. "Comrades, tomorrow we meet exactly as agreed, very early so as to load the car quietly before dawn. And tonight, in the remaining hours, we will sleep well in anticipation of our victory! Death to our enemy, and rapid advancement to our great and righteous cause!"

Night

Silently, within the sounding world of rain, Mark and Allison returned to the tall villa. Stopping just short of the blank garage door, he flung his arm along the back of the seat, and looked at her. Mark felt hurt and bewildered, but obviously she was very unhappy herself.

"Allison, what on earth is the matter?"

"Oh, Mark, I'm sorry...." Her voice came low and uneven. "I must be breaking up; I don't know—don't seem to have—control over this," and she hiccupped, "dreadful crying!"

Appalled, he saw that the car lights, reflected back from the garage door through the rain slipping down the windshield, were covering her—dress, coat, hands, hair—with a cinema of sliding tears. Mark looked away.

"Well," he began, on the defensive, "if the idea of marrying me is...."

Allison broke in with sudden firmness, wiping her nose. "No, no, Mark; it's not that at all. Somehow, some way, I seem to have reached such a low point that your wanting"—she seemed about to start crying again—"that your kindness—it was like the last straw."

She *was* crying again! Mark took her hand urgently. "But, that's just it; things have been so hard for you in the past. Now things will be different! Allison, I can see us suiting each other so well."

"Yes, yes," she sobbed. "We might have."

"Have you changed in some way?"

She shook her head. "That's the very thing I don't seem capable of!"

Mark drew a decisive breath, his passion quite drained away. "Allison, you

are simply exhausted. Let's go in. You'll be yourself in the morning." He switched off the headlights. Herself. Piloting her slim form through the beating rain, Mark wondered what had so suddenly become of his girl, with her poise and charm and fun that were going to make her the perfect Allison Gardiner of the future? All his doubts came crowding back while he struggled to make the big key turn in the stubborn lock. She was erratic, unreliable, unpredictable. Maybe she always had been.

As though agreeing, Allison preceded him mutely into the dim-lighted hall. How cold the house seemed. They started up at once, she turning her face back toward him. "Oh, Mark, you are wet and cold. I'm sorry."

"You are not responsible for the monsoon!" he exclaimed out of his irritation. "Besides, we are both soaking wet." When they reached the top of the staircase, Allison went ahead down the third floor hall and stopped at her closed door. They stood there looking at each other.

Moved by her sadness, Mark said, "Allison, I never meant to upset you," and he grinned a little. "I didn't realize that the thought of marriage with me would break you up like this."

She sighed, helpless to make things clear, while the rain on the roof kept on steadily drowning everything. The hand Allison put to his sleeve was as tentative as the sudden smile lighting her pale face. "Mark, did you really think I would make a good wife? Or did you just ask me to marry you because you—want me?"

At the end of his patience, the child-like question made him so angry that he missed the point. "I suppose you would have consented at once to our being lovers?"

Her lips parted; then she dropped her head in tiredness. "No. I don't suppose that would solve anything."

"You're damned right it wouldn't!"

"The thing is, we don't really love each other."

It was the kind of trite statement he would never have thought Allison could make. "You are perfectly entitled to speak for yourself."

"Please don't be angry, Mark. Try to forgive me. The thing is—something has come up."

Before he left, outraged and hurt, the sight of her was imprinted on his brain. Jewels in her ears winked out of the dimness, the light coat slipping back from her shoulders. She was like a Sargent portrait of a celebrated lady, somewhat spoiled by damp.

• • •

Allison had already begun to strip off her earrings as she went in and closed the heavy door. Chilled through, she hurriedly put on warm, dry flannel pajamas instead of her blue nightgown. But her already sore eyes were filling again with painful tears. Poor Mark. How awful. She had encouraged him by accepting his invitation to Dalat. And now when he had made himself vulnerable, told her he loved her, somehow she couldn't seem to marry him after all! Allison's hand went to her heart. How could she bear so much guilt? There was nothing to do but take a sleeping pill. She would take two. Surely after a deep sleep of unknowing the pain would be less. And then, in the morning.... Because Allison seldom took sleeping pills, oblivion dropped quickly.

But in an hour, or perhaps later, she started awake into fear. Someone or something had come down the hall. Her door was seized open! An alien presence stood there. The black cold silence lived, hung over her in judgment. Paralyzed, her throat constricted, Allison remembered the maid in Mr. St. John's ghost story. The murdered maid had become confused in her mind with Chi Hai, her own servant whom she had angrily slapped back in Saigon.

Allison was terrified, frozen, unable to move hand or foot. Over and over she told herself that this was the grip of a nightmare. There was no way to measure how long she lay there helpless in the hostile presence. At last, sweating, she found she could grope for the stark relief of electric light.

Nothing. No one at all was there, although the heavy door to the hall by her bed stood unlatched and ajar. Had she left it open? Allison thought not, but wasn't sure. After another timeless pause, she forced herself to get up and look through the two cold rooms and bath, and into the faintly lit hall of the old villa. No one was there, no maids, no Viet Cong, just the two sleeping children and, of course, her several selves reflected in the wardrobe mirrors, insubstantially.

Yet Allison was aware of some power of hate so strong it made the simple shapes created by electricity flat and unreal. She pressed her hands to her center, frantically telling herself that dreams can seem very real. At long last, becoming aware of her icy feet, she crawled back into bed, huddling for warmth under the blankets, holding tightly to her sanity. The gnawing ache did gradually recede, leaving her drained and empty. Then she turned off the hard light and conjured up all her treasures to her comfort. They blew away like tinsel on the dark at the end of the world.

Homecoming

The night comes on;
The river road grows dark.
The peasants come in slowly
From the fields.
In a hut hid deep
Amid the towering trees
Glows a tiny flame
To guide a husband home.

Hsiang Ssu, T'ang Dynasty, 618-906 A.D.,
Of All Things Most Yielding

In the house of the Province Chief, it was getting very late, almost eleven. Since five o'clock that afternoon, dressed in her prettiest *ao dai*, Yen had waited for her husband. At lunch they had discussed the possibility of dropping by the American Ambassador's villa for his Open House, but Thanh did not come home in time. Later on, Yen had waited dinner for him. Finally she ate alone and then dismissed the servants. Leaving a light in the hall, feeling depressed, she climbed the stairs. In their comfortable bed Yen piled his pillows behind hers and opened a paper-backed French novel left behind by the owner of the house, who had rented it to them complete with all furnishings when he returned to France. The book seemed clever and amusing and empty, but then she was not giving it her real attention. The tiny type danced on the yellow page. Mental words stood out more boldly than the print. "Our life now is too hard and dangerous and demanding. We can only bear to go on, if we go together, in sharing friendship, in honest communication, in love expressed." When she realized she was not reading but thinking, Yen put the book aside on the night table. With her elbows on her knees and her chin in her hands, 'What can I do,' she thought, 'to make our oneness happen again?'

394

At the same moment, Thanh was sitting outside in the car. He had driven himself home, having worked much too late to keep his driver on duty. He slumped at the wheel, feeling cold and oddly blank. There was a light on in the hall, shining dully through the glass on either side of the front door. More important, there was still a light in their bedroom upstairs. God, he was tired. How much longer could he hold out, keeping the terrible truth from that eager, loving, naive spirit that was his wife? He considered waiting there until the light upstairs should go out. Then he could quietly slip into his place on the other side of the bed and lie again as though dead until the morning and another day. What, another day of estrangement and civility? Stiffly the Colonel clambered out of the car. He unlocked the front door and turned out the hall light before tramping openly up the stairs. Yen was sitting up in bed, surprised, hope waking like stars in her midnight eyes.

"What in the name of all the demons," he asked gruffly, "are you doing still awake at this hour?" She did not answer in words, only looked at him tenderly, her breasts and arms rounded and golden in the shaded light.

Thanh ran his hands through his thick hair in desperation before he shucked off his clothes, ignoring the pajamas carefully laid out for him, and climbed into the bed. He crossed his arms behind his head, staring off into the shadows. Yen covered them both and nestled down near his shoulder, her elbow on the pillow, her head in her hand. And still she said nothing, only regarded him warmly with a half-smile.

If he was not to break down in unmanly tears he must tell her—at least a few of the things on his mind. Thanh cleared his throat roughly. Yen only looked at him gently, with love. So he stared off again into moody gloom.

"You made a big mistake to marry me; you should never have joined your fate to mine!"

Yen started to laugh a little at this awful phrase, but he turned on her furiously. "You have no idea. You have no understanding for the realities of our situation!"

She could have protested, either that he did not tell her anything, or that Vietnamese nurses and social workers have a pretty complete picture of life's realities, but she only said, "Please tell me, my husband." And now she was very serious too.

And so a dreadful thing happened. He began to tell her a little of all he had been holding back. One thing led to another as he had feared it might. "You know our last night in Saigon when I sent you to bed and stayed up

to do some work?" Yen nodded solemnly. "I met with a representative of the Viet Cong outside in the dark on our own terrace!" Her eyes widened. Thanh looked away. "He tried to persuade me to stop supporting the President and come over to the Communist side. He promised me power, and more than that, he promised me the unification of Vietnam, one Vietnam free of foreign occupation."

"Oh promises...." Yen's small mouth seemed to downgrade the whole thing.

Thanh held his head in his hands. When he looked up into her puzzled face, he saw there was no way out. "Yen, I must tell you everything. In case I should die, you need to understand. I want you to find somehow, somewhere, a new and different life for yourself and the children."

And, just as he had imagined, she was horrified. "Why should you die?"

"Because I can't go along with the Communists, either the northerners or the Viet Cong. I can't see Communism as the right way out for our country."

She leaned forward, her eyes more intensely black. "But of course not, Thanh. We have already aligned ourselves. We are on the side of freedom, with President Diem and the Americans!"

"My dearest," Thanh took her hands, "where is our freedom with the President and his family? This VC cadre who came to me by night, he accused our southern army of loss of morale because of the corruption of this present regime. I denied it, of course, but I was only pushing away what I know in great measure to be true. Everywhere there is a lack of strong young leadership. The strength of military forces are their second lieutenants and noncoms. In our army these are spread very thin. And you know very well, Yen, that lack of promotion, lack of leave, and favoritism have made many officers bitter. The only way to get ahead is to be loyal to Diem and his family. And that is not all. The secret members of Ngo Dinh Nhu's Can Lao Party watch and report on every officer. We are all written up in their secret files. This can only undermine our morale."

Yen started to speak, but he held up his hand. "You know, too, that if a position in this government is any good, it must be bought. All the way down through our system there is rottenness. You yourself are aware that a poor schoolteacher who makes only fourteen hundred piasters a month *must* have more to support a family. So he sells the questions and answers of the exams to his students and makes an extra eight thousand."

Pitifully, Yen wrinkled her brow. "But we are different...."

"Darling love, how are we different? Do you know why I was late this

evening? Why we could not attend the American Ambassador's Open House?"

Yen shook her head dumbly. Thanh's laugh was very strange. "The Corps Commander came to see me. The Corps Commander! At first I thought he came, as he said, only to suggest that I visit Nhatrang next week, since, with the hope of stepped-up military support by the U.S., there are plans afoot to designate the South Vietnamese Army's First Observation Group, stationed at Nhatrang, as the main unit for carrying on unconventional warfare in Laos, South Vietnam, and even North Vietnam!" Yen gave a little gasp. "And, since this is in my province, I am to have a part in these important planning discussions. Oh yes," Thanh nodded, "very proper. And I was properly pleased, until I learned the price."

"The price?"

"Yes. All the prerogatives of my position must be paid for, it seems. There is a big kickback due to the Corps Commander at the end of the month." He sighed. "No use to tell you how much, since we could in no way manage to raise it, even if we wanted to."

"But didn't you tell him—? Didn't you ask—?"

Thanh nodded. "I asked him where I was to get this amount of money. He said that was my problem. Later I noticed how, in the absence of strong assurances from me that he would be paid, he was not very friendly as he left. Oh, Yen, if you are not one of them, you become a threat to them, very dangerous!"

Her whole face grew sad with understanding. "They expect you to get this money by putting the same squeeze on those who owe their jobs to you in this province."

"That's it." He nodded again. "This province of Thuyen Duc, ironically called 'The Proclamation of all the Virtues,' is probably only ours because so far it has not proved to be very profitable for graft. And yet people here have offered me their buffalo and their rice crop for a place on my staff! The Corps Commanders and Province Chiefs are like new warlords; they buy and sell almost everything."

"But Thanh, remember also the great and powerful families of our country. Many are nationalists from both the South and the Center and those who have escaped from the North where they tell us that to own a bicycle now is like owning a Mercedes-Benz! They know what Communism means. We must appeal to them. Our hope lies in the pride and nationalism of our people!"

He did not lift his head. "You are right to emphasize regionalism because it is one of the forces that keeps us from achieving unity, like our class interests and our traditional, family-oriented outlook. Many of us were nationalists in the Viet Minh days in the sense of looking forward to the end of French rule, but not many really planned to subordinate ourselves in order to establish a strong nation-state. The Communists have created the only truly national force in their Viet Minh and with it they defeated the French. The Communists are the one group that have really tried to organize us on a national basis."

When Yen looked doubtful and ready to argue this point, her husband went on wearily. "Don't you remember back in our history how General Le Qui Ly was all ready to attack China itself, but the Mandarin families of Vietnam would not support him? Our great families are powerful, but irreconcilable. Their division in those days gave the Chinese a new opportunity to launch another invasion to occupy Vietnam once again. And still today we lack unity, are sick with corruption. But the Communists are wiping out corruption and forcing a unified stance even though they do it by violence. Oh, Yen, it is hard for me to have self-respect in these circumstances. Without self-respect, how can a leader go forward single-minded to win?"

"But, Thanh, you are forgetting the Americans. We have the great power of the United States on our side!"

He let out his breath. "I have always counted on that."

"But it's true, dearest, think of what they have invested here already!"

"Oh, Yen, if only President Diem and his family valued the Americans as we do! The Ngo family, especially Ngo Dinh Nhu and his wife, are too proud to make the necessary reforms the Americans recommend. They bite the hand that feeds us! How long will the Americans have patience with all this tyrannical nonsense?"

"But Thanh, the Ngos, they are our relatives, your kinfolk, no matter how distant."

"Exactly," and he let her see fully the bitterness of his heart in his eyes.

"Americans are patient, Thanh; I know what they are like, kind and patient."

He laughed out loud. "Like your so-patient Doctor Joe and your so-patient boss at Foster Parents Plan!" When she could only frown anxiously at the truth of this, Thanh went on. "No, Yen, I have myself been in the States at the military school. Our problem is very small compared to all the other

U.S. concerns, and the majority of American people know nothing about us."

"But Colonel Don...."

Thanh smoothed her forehead with his hand. "He is our friend."

"Well then," she said, relieved.

"Yen, he is a colonel, as I am. We must obey our superiors. But he does stand up for me. He even tells my own superiors how they should value the few good officers (like me) that they have! Once in a meeting of the Corps Commanders and Advisers, I actually heard him say something like this: 'Your government ought to value the few good officers you have, like my opposite number here, Colonel Thanh. Hell, the VC *values* good leaders. Sometimes,' Colonel Don said, 'I think I'd rather be adviser to the VC than the ARVN. With their kind of Vietnamese courage and discipline and dedication, we could win this war. As it is, with your lot, I doubt if we've got the chance of a snowball in Hades!'"

Yen smiled in spite of her trouble. "That sounds like him."

"But, Yen," Thanh pushed on, desperate for her to understand everything, "back in the States, in their Congress and in the higher military councils, they do not understand our problem as Colonel Don does. It is so far away. Sometimes it is presented to them as some kind of civil war, rather than a struggle against the Communists. And also I sensed while at the Command and General Staff School that their highest leaders might draw back from supporting our war to the full, if they thought Russia or China might come in on the side of North Vietnam. A limited war is one thing, but I do not believe the Americans would even contemplate a war involving the other great powers. Nowadays that means only extinction for everyone."

For a moment Thanh and Yen stared into nuclear holocaust. "But you and Colonel Don," she hurried to say, "you agree on limited war, as limited as possible."

He smiled. "And we agree on using a strategy which we hope will win, but also will help the most of our men to survive and come home."

"But Colonel Don and the Americans, they must know that to the Communists it doesn't matter how many men are killed!"

"Yen, I am proud of you. You are a good officer's wife. You understand some of the realities of our situation. But we must realize that the Americans do not grasp all aspects of our problem. There's a kind of simple extremism about Americans, maybe because they are so far removed on their separate continent from a problem like ours, so they only see black or white,

rather than all the grayness of detail. They see Bad Ho Chi Minh and Communist forces—or Good Ngo Dinh Diem, the only available opponent of evil. It is hard for them to see that Ho Chi Minh is a great nationalist also, and that Diem is also a repressive autocrat. Both men of course are cruel, as occasion demands."

In the silence Yen saw clearly the danger that loomed—the death of her husband, who was a threat to both sides! "What did you say to this agent of the VC who tried to persuade you that night in our own garden to come over to the Communists?" She asked this in terrible fear and found it hard to keep her teeth from chattering.

"I am not so proud of my answer. At the very end, I said I could not join their side, because I thought there was a little more freedom for the individual on our side, though I saw that he and I had a great deal in common."

"You admitted you would not join them—openly, frankly?"

"What else could I do?"

She was frantic. "You could have *pretended*; the lives of all of us are at stake...."

Thanh sat up. "Do not tempt me to be a coward, my wife! You, your father, you are people of peace. I am a soldier; that is my dharma. And it is your karma, or your mistake, to love a soldier! I am old-fashioned, dedicated to the fight for freedom and unity for my country, but weakened, weakened by the peaceful truths of your father, by respect for the freedom of others learned in the States, and weakened also by disrespect for my own government."

"And General Duong Van Minh, 'Big Minh,' whom you have admired and modeled yourself after?"

"Oh, Yen, I am sad to see these same weaknesses in him, as I see them now in me."

"Dearest, you are not weakened," she cried out. "You are made a stronger, finer man by these principles."

Thanh did not seem to hear her. "It is a terrible thing to lose self-esteem. Self-esteem is what Ho Chi Minh and General Giap have given the North. They see how creative it is to respect self and how destructive self-doubt and fear can be. I think this is true for both individuals and nations."

Yen searched anxiously to reassure him. "Well, self-respect is certainly something our American supporters have in plenty," and she managed a small chuckle. "They will never lose their self-esteem!"

"May that always be true!" Thanh said fervently. "Remember, just as the

Communists know how to value self-respect, they know clever ways to devalue the enemy in his own eyes with their propaganda and their brainwashings. I think their real victories lie in that area first, and only later are reflected in their battles. If we come to hate ourselves as a nation, we are bound to lose against a nation (no matter how small) which believes in its own moral righteousness."

In spite of the awfulness of this thought, Yen could not help finding it interesting. And she gazed with surprise at her stocky, solid husband. "Thanh, you are becoming a profound thinker!"

His mouth turned down with the humor of irony. "It is doubtless the influence of your father. Or the pressure of circumstance...." Once again he sobered, looking on desolation.

Seizing him by the upper arms, so strongly muscled, she stared straight into his eyes. "You are more virtuous than the enemy!"

"Virtuous enough for the sage perhaps, but not for the soldier. A soldier must be single-minded and ruthless, obsessed, in fact. With that Communist agent the other night, I felt he was like that, but my own single-minded strength had somehow slipped. He was more angry than me!"

When she looked bewildered, Thanh almost glared at her, his eyes full of the stark pain within. "Don't you see, Yen, we cannot allow weakness of opinion to creep in? We must be strong and merciless if we are to win and keep our nation from Communist domination. It is the only way now. There is no other. Don't you see?" He was almost pleading.

She moved into his arms, holding him close, pressing herself against his warm, real body. "Yes, yes, all right, Thanh, I see. Yes, it is the only thing we can do."

He nodded his head heavily. "And if I am killed, I am killed."

Even that she accepted now, sensing his hopeless desperation. At last she completely understood him. But she did not share her own last thought. If you go, Yen determined in her heart, I go too.

Thanh gave a deep sigh. And in their relief from alienation, both fell back onto the bed, passionately, hungrily, pulling, crushing each other into their precious oneness, restored at last.

Later on when Yen awakened, anxious, Thanh persuaded her to sleep again. "Tomorrow we will see your American doctor at the church affair. Don't be carried off!" he warned again in English.

She giggled. "Carried away!"

"That's what I said," he muttered sleepily into the hollow of her shoulder.

Dalat and Saigon

Perhaps then, if we listen attentively, we shall hear, amid the
uproar of empires and nations, a faint flutter of wings, the
gentle stirring of life and hope. Some will say this hope lies in
a nation; others, in a man. I believe rather that it is awakened,
revived, nourished by millions of solitary individuals whose
deeds and works every day negate frontiers and the crudest
implications of history. As a result, there shines forth fleetingly
the ever-threatened truth that each and every man, on the foun-
dation of his own sufferings and joys, builds for all.

"Create Dangerously"
from Resistance, Rebellion and Death, *A. Camus*

Terror on Sunday

It would appear that the chief use of terror by the NLF initially was to advertise itself, and its chief use at all times was a means of eliminating opposition. Terror was used to immobilize those forces, including the GVN official, standing between it and its domination of the rural areas.

Douglas Pike, Viet Cong

Sunday morning after the rain was fresh and beautiful. Katrine and James stood in the doorway of their mother's bedroom, where Allison lay looking ill. She seemed to want only one thing: they should go on down to breakfast without her. If anyone asked, they were to say she felt tired and would send for tea later. Still they hesitated, puzzled.

With exquisite restraint Allison said, "I'll be quite all right, Katrine; I just need to be left alone for a while." So they went away at last, and halfway down she heard them beginning to argue about whom to include in their newest game. Shakily lighting a cigarette, Allison hoped with passion that no one would come near her. Strangely enough, no one did. What a relief! She did not want to set eyes on a single overly active Gregory boy, or see bright interest quicken in the eyes of Mrs. St. John. Least of all could she face Mark, having refused his generously offered love. For what reason? And with all those tears! Allison remembered Chi Hai's fiercely prophetic warning: "*Madame beaucoup* cry: *Monsieur* no come back!"

With the added weight of her dream the night before, there seemed no escape from guilt and misery. Restlessly turning her head, seeing her wanness, flatness, and self-pity reflected in the mirror, Allison finally felt a prick of humor breaking through. Aren't you bored with hating yourself, Madame Giraud? So you are petty and inadequate and mixed-up, were you expecting perfection? Thank heaven you are not all there is to life!

Sitting up slowly in bed, hugging her knees, Allison considered what she might take from the fullness of life to put into her emptiness. The first thing that occurred to her was the sight of Joe, his entangling eyes, his teasing mouth, his stubbornness—crazy, motivated Joe Ruffin, who said he loved her, and included her in his future plans. This last worried her, but the cheering fact was that he did vigorously exist, here in Dalat, with his thick eyebrows and the green paint on his jacket sleeves—Joe.

Allison slid to the edge of the bed and stood up. Maybe, if she hurried off right now, begging a lift in the villa jeep, she could quietly visit that new church on the way down the mountain. She would only just look at Joe from a seat at the back. A little vitality stirred. He had said 10:00 a.m. It was already 9:15 by her alarm clock. Allison started to dress. She would be very careful not to have Joe notice her. All that was necessary for going on at the moment was to see him again.

A little later, drinking a cup of hot tea in the sunshine of the empty dining room, she turned to ask the boy, the cook's son, if he would drive her down to the church. Bao was very sorry. The Ambassador was using the car. Monsieur Gardeenair and some others, Madame's children also, had gone in the jeep to somewhere, maybe the market? Monsieur's Peugeot was still parked in the driveway. However, Bao shrugged, no keys.

Allison felt horribly disappointed. The bright day had played her false. "Surely there must be some way for me to get to the church! Could I walk?"

"It is five kilometers already, Madame." Bao was astonished that she wanted to go to church so badly. He had been studying her with admiration all weekend, and she didn't seem the type.

"Well," doubtfully, "if Madame wish...."

At once she was hopeful. "Yes?"

With a shy grin, showing several expensive gold teeth, Bao offered her a ride on his motor scooter. Allison got up from the table and followed him out into the back courtyard, still holding her napkin. His Vespa was red and speedy-looking. There was a small passenger seat behind, but not much to hold on to. So she went over and peered in at the dashboard of the Peugeot. Of course Mark had not left his keys in the ignition. There was a pause while Allison came back to circle the bike again on her two-inch heels, considering. She glanced up at the villa and the very blank windows of her own room in the tower. Then, to Bao's amazement, and somewhat to her own, she said she would try it.

So it happened that Bao and Madame Giraud swooped magnificently

down the mountainside, stopping with a flourish in front of a new frame building with "Tinh Lanh" painted in square black letters above the door. Although Madame of the beautiful legs paused only to thank him, and headed straight for the church door, it was a big moment for Bao, and he stayed to enjoy it. Rocking back in the saddle of his scooter, he saw the whole place had been made very festive. There was a giant archway in front of the church constructed of saplings, twined with evergreen, and topped with a bamboo cross. Woven throughout the arch were wild orchids from the forest in close company with the European window box flowers of Dalat, the kind his mother admired, geraniums and begonias. From within Bao could hear the gourd pipes, stringed instruments, and brass gongs of tribal celebrations. The sound was so joyful he was almost tempted to go in himself, before he saw the familiar gleam of the Ambassador's limousine parked only a little way down the road. There were other cars, but they had been parked even farther down in order to leave a welcoming space before the entrance. Bao saw the drivers beginning to gather sociably in groups, some squatting together in the dust behind their vehicles. He thought that Toan, the Ambassador's Chinese chauffeur from Saigon, was casting curious glances in his direction. So what? Bao clicked his tongue against his teeth.

It was only then, turning away, that he noticed the other faces, intent, almost threatening, peering from the underbrush around the edges of the churchyard clearing, serious faces, comically framed in bright purple blossoms of bougainvillaea. Now what could be so fascinating to such types there about what went on inside a plain wooden church? Somewhat uneasy, Bao turned away, and then gave them something important to look at as he roared off on his handsome Vespa.

On the homeward journey he was almost as puzzled by those strange men's curious interest as by Madame Giraud's sudden eagerness for attending church. But not quite. Who could understand a western woman's actions? Bao smiled dizzily, feeling again her light hands on his waist. Daydreaming about her, so much like the American and French movie stars whose photos were tacked up around his room, he only missed an oncoming bullock cart by a very masterful swerve.

Allison, trembling from the wild ride, smoothing down her wind-blown hair, did not take time to look around outside the church or notice any watchers. As she slipped through the door, a little black girl in a very short pink cotton dress handed her a mimeographed program. Receiving with it a

delighted grin of recognition, Allison smiled warmly back. Here was Joe's chatty little friend of the tennis court.

The service seemed to have begun, and the long backless benches of the rawly new interior were crowded end to end. A chair propping the door ajar was the only empty seat. As she dropped hurriedly into this, Allison felt many sideways glances of friendly curiosity. All the women seemed to be sitting on one side of the center aisle and all the men on the other, while the children were allowed to roam freely. By chance her chair was on the female side. At first she felt conspicuous and foreign. However, through small attentions, bows, and smiles, hymn numbers indicated, she was made welcome by the mixed crowd of Vietnamese and tribespeople, relaxed and happy, enjoying this celebration of their newly established unity.

Of necessity the program was in three languages. From it Allison understood that the merry music of gongs, pipes, and strings just ending was an American hymn which had been translated into a tribal setting. The opening prayer was given by a mountaineer pastor whose name, she read, was Rau. Even from such a distance, over so many heads, it was easy to feel the power of this small straight black man's delivery, first in Chil and then in Vietnamese. Although Allison's Vietnamese was quite good enough for her to understand when she concentrated, she didn't really try. She had only come to see Joe.

Straight down the aisle there was a clear view of the chancel, which contained little more than a central pulpit, decorated with palms and banana leaves, and benches on either side for dignitaries. Piled on the newly varnished steps leading up to the chancel were flowers, baskets of rice, eggs, green jungle bananas, plucked chickens. There were also many beads and bracelets which, Allison read, the tribesmen had surrendered in accepting Christ. The dish of uncooked rice with two eggs placed in the center represented the basic daily diet of the Montagnards. It was a semi-tropical Thanksgiving.

As the black pastor returned to his seat of importance, Allison saw Joe. He was on the right side of the platform, sitting beside a pleasant-looking Vietnamese couple, the man in the uniform of an Airborne officer. From the leaflet in her hand she read that these were the local Province Chief, Colonel Truong Vinh Thanh, and his wife. Joe looked to be very friendly with the lovely wife! Further along the same bench were a pair of youngish missionaries named Tyson from Nhatrang. On the opposite side sat the Pastor Rau with a couple of older missionaries, the Reverend and Mrs. Robert

Gordon, beside Ambassador and Mrs. St. John, who was gently moving her tortoiseshell fan. Beyond her sat a Vietnamese pastor named Kinh with his young wife, obviously expecting a child in the very near future.

All the congregation coughed, shifted about restlessly, and waved the palms they were holding. Allison felt the eagerness and excitement, like being in a theater just before the curtain goes up. The American missionary, Robert Gordon, who was next to take his place behind the lectern, had to wait, smiling, for all the shouts and the sea of palm wavings to subside. Then he explained the gifts crowding the steps at his feet, introduced the speakers and guests seated on the dais, and reminded everyone of the big picnic lunch after the service on the grounds of the CMA School. There would be everything from hot green tea to roasted chicken and pig, sweet potatoes, squash, and sweets of all kinds. Afterward, games would be played; races, rope-jumping, and a competition which involved the pushing by two sides of a long pole until it snapped in the middle. With a serious face Pastor Gordon added that, of course, after the feast, there might be some doubt whether anyone could participate in the games.

When a roar of ready laughter was his response, Gordon commented for Vietnamese and foreigners that it was great to know the tribespeople could laugh freely now. Before, as spirit-worshippers, their merriment had been forced, to cover up their anxiety. He spoke first in Vietnamese and then in English, while a Chil interpreter translated for the tribes. Allison thought the process itself was a vivid illustration of Gordon's closing theme—the oneness of God reflected in the unity of these differing groups coming together here today in their new church.

It was growing warm inside the building. Allison began to fan herself with her program while the Reverend Henry Tyson from Nhatrang, a thin gingery type with flashing glasses, told stirring tales of the tribal villages that had removed from their mountains in faith and courage to settle in a strange, hot lowland where they could freely worship the God of the skies without fear of the junglemen from the North. Impatient as she was to see Joe behind the lectern, Allison couldn't help being caught up in this intense drama recounted by the passionate missionary.

After he sat down again beside his plump and smiling wife, a hymn was sung in Vietnamese. Allison could hardly get a glimpse of Joe through the bobbing heads of the standing crowd. Still, eventually she would see him! He had said he was scheduled to speak, and his name was printed on the program. While waiting, she felt peacefully embraced in the warm

beat of indistinguishable, yet somehow familiar sound. Was it "Amazing Grace"?

To her right at the end of the row ahead, Allison could see the little girl in the pink dress leaning inside the arm of a stout woman wearing the black velvet turban of North Vietnam. Drim was the child's name. Allison remembered this, just as the little girl, obviously bored, slipped away and began to wander in the aisle. Her mother (or grandmother?) didn't notice; she never took her eyes from the platform where the Reverend Robert Gordon was introducing the doctor—Joe!

And Joe stood up, came forward. At the sight of him in a simple dark suit emphasizing the eagle-brightness of his gaze, the jutting prominence of his profile, Allison had to glance away, telling herself it had been a mistake to come, to see him again. And still she gazed.

Joe first looked out over the crowd to greet them in his easy, natural way before he began to read from the Bible. Allison gathered that the story in Vietnamese was the one about the the woman who had boldly made her way through a crowd to touch Jesus and be healed of some draining hemorrhage. While Joe read, Allison looked. In spite of the strength in his face, she saw clearly now the kindness there. His square-angled, masculine hands had relaxed their power, resting on the old book. This man had told her he loved her! In a special secret way he belonged to her, more than to all these others.

With acute tenderness Allison listened as Joe closed the Bible and began to speak slowly, in Vietnamese. Whenever he looked down at his notes, his face was severely concentrated, totally committed. But when he looked up and out on the people, it was full of light and trust. Sometimes when he pushed away his notes and leaned forward toward them over his crossed arms, the brightness of his enthusiasm was captivating.

After explaining that he was a doctor, not a minister, Joe began to talk about wholeness and health. He said you hear a lot about the need for a savior. What do we need to be saved from? In Joe's opinion we need to be saved from our mean judgments of ourselves. Guilty feelings take a heavy toll on the body. And fear is another enemy to wholeness.

Startled, Allison thought he was speaking directly to her own pain over deserting Max and her fears of what life can bring. But now he was urging happiness and self-appreciation, because we are all created by God and are greatly loved and valued by Him. In Joe's view, the spirit of Christ, once in Jesus, lives now in each of us. So, listening to this inner God, we can become

our own doctors, our own saviors, bringing to ourselves everything we hear from our inner Christ that we need for healing and wholeness—for life.

Allison thought it sounded pretty radical and would be afraid herself of taking so much responsibility, but she saw people around her intent and thoughtful. Joe ended with a story about La Yoan, the tribal sorcerer and witch doctor, who left the service of the spirits and came instead to serve the one God, because he saw the happiness of the God-followers, "and against happy people even my greatest charms fail." Fear hurts but joy heals.

Allison felt a wistful yearning. How could a person become happy? Could it possibly be that to love God and to love ourselves was one and the same thing? Her mind seemed to short-circuit.

Joe was seated now, and the older missionary, Robert Gordon, rose to lead the prayers. The people around her bowed their heads. Out of her heavy guilt and some surprising tingle of joy, Allison longed to say, "Sorry," and be forgiven, by someone, somehow. As simple as bread, she thought thankfully, until she remembered like a thunderclap God's terrible power to change people that Joe spoke of the day before. "Once you give yourself away," he had said, "God alone knows where it could end. Would you have your kind of 'magic days'—or the Spanish Inquisition?"

She stared at the bare wooden cross on the wall, now quite empty of a suffering body. Never mind the risks, she thought rashly, things can't get any worse for me than last night. And so, overriding her fears and stubbornness, Allison made an imaginary gesture. She took up the pretty little figurine which she thought of as herself, looked at it carefully—Allison Giraud, as is—and offered it firmly up in the presence of God, if there is a God. For whatever she was worth, and Joe seemed to believe she had worth, she gave herself away. That was all she could think of to do. Then she rested without thought.

His prayers over, the Reverend Gordon began to introduce the Province Chief, Colonel Truong Vinh Thanh. Allison glanced around, noticing almost with affection the people nearby who were drinking in Gordon's words of praise for a brave leader. One pock-marked woman, open-mouthed, her flowered nylon dress tight across her flat chest, forgot to fan herself with her big straw hat. Thin young men with tiny waists crossed their arms in identical white shirts studying the missionary and the Colonel, owl-eyed, through dark glasses. And looking idly backward out the open door, Allison watched with new-springing gentleness the little black girl in pink, playing with a long, green-leaved branch in the dust. This was Drim, the dark blithe

spirit she had met with Joe. Small wonder that the eloquent Pastor Rau was her father! Could the stout woman with the black velvet turban be her mother? That lady seemed unaware the child had escaped, being completely absorbed in her study of the Province Chief, the Airborne Colonel who was looking really splendid in full uniform, jumpboots, and ribbons.

Since Joe had finished his part in the program and only the top of his head was now visible, Allison peacefully let her mind and her eyes wander. Drim, she thought, was an odd, intelligent little thing. So, in the right circumstances, a black tribal child could be just as precocious as Katrine.

And, turning back toward the child outside, at first without fully registering, Allison thought she saw a *flame* licking up there in the courtyard close to the abbreviated pink dress! Turning all the way around she saw a tall, gloomy-looking man in greasy old black clothes deliberately setting fire to tidy little brush piles laid at regular intervals against the foundations of the church!

As the words "Viet Cong" streaked through Allison's brain, Drim came up behind the preoccupied man and poked curiously at a blazing branch. Faster than thought, Allison flew out the door, grabbed the fiery stem away from the child, and stamped on it. The man turned. She saw his amazed disbelief at her infuriating interference!

And just then a shot rang out from somewhere up at the far end of the church. As the second shot followed closely on the first, Allison saw all the drivers of the parked cars raise their heads and begin to run toward the sound of the firing at the far end of the church. It was like the slow motion of a nightmare. She opened her mouth to scream and draw their attention to herself and the child here by the front door. At the same time the terrorist, startled into dropping the burning stuff on his own feet, kicked it wildly away and clapped one horny palm over her mouth and the other over the face of Drim. Seized and dragged somehow to one side, struggling, choking, she saw only the little girl's round dark eyes, above the rough hand, welling full of horrified tears.

Allison pushed and shoved fiercely, with confidence. How could this one man overpower both her and the squirming child? But the first man was swiftly joined by another. Just as she heard his outraged exclamation, a heavy pain crashed against her skull, and light died.

Having silenced the woman with the butt of his handgun, Kiem grabbed her up, shoving Thom with the child toward the leafy bushes at the edge of the

clearing. Just in time! All the drivers and the Province Chief's bodyguard were racing for the side entrance to the church from which had come the sound of Kiem's two shots. At all costs, attention must be riveted up there so the escape would be successful. Kiem himself had run all the way around behind the church and back to the front where rage seized him over the stupidity of Thom. How had he managed to involve himself with this foreign woman and this child just when he should have finished his job of firing the church and already been seated in the getaway car, where Tang waited at the wheel? Grabbing the woman like a sack, shoving her with Thom and the child into the back, Kiem fell into the front seat and slammed the door.

"Mau di!" He gave the order breathlessly, glad of the already racing motor, noting with one backward glance the healthy blazes ravishing the foundations of the wooden church. But now he could see again the bright ribbons on the military chest that had made his aim so easy. Kiem looked ahead in frowning concentration holding to the door frame while the car slithered between tree trunks down toward the road. He had always planned to fire a second shot from the side door to be absolutely sure, before sprinting around the back to meet Thom and run for the Renault in the woods. But it was that woman, throwing herself right in front of the Colonel, who had caught the second shot. His wife? What a crazy thing to do! Impossible to plan for such illogical eventualities, and he growled bitterly over his shoulder at the crowded back seat. Women again! Kiem fought down a creeping sense of disaster.

"I couldn't think what else to do," Thom moaned in self-defense from behind. "I had to shut them up before someone noticed them. If those drivers had seen us, they would have run in our direction instead of toward the side of the church."

Kiem gritted his teeth. Now he was subjected to an analysis of the obvious by this offending cadre! "Go! Go faster, Tang!" He spat out the words. "We'll have too much time later to worry about the dangerous and imbecile stupidity of...." He was flung against the door by the sudden jolting down onto the paved road as the Renault was precipitated wildly out of the rough.

And they went on at top speed, constantly swerving to avoid settled areas, always climbing toward the ancient shack where they could take refuge and hide the tell-tale stolen car in the lavish generosity of the jungle. Although the child only whimpered in fear occasionally and the woman

seemed completely silenced, nothing stilled the wails and groans of Com-rade Thom, severely burned about the ankles and feet when he hastily dropped his firebrands at the surprise appearance of the woman and child.

But, "Did you get him? Did you actually *kill* the Province Chief?" Tang kept asking.

"Of course," Kiem was curt. He shared nothing more for the present, resolutely turning his razor-sharp mind toward making the most out of this unplanned-for situation which had resulted. One must create out of every happening, no matter how unexpected, in order to keep on advancing the Struggle.

Some minutes later when Allison came to, it was first to the exquisite agony of a big lump at the back of her head and then to the sound of steady moans from somewhere. She was jostling painfully on the floor of a car, and lifted her dizzy head with caution, breathing kerosene fumes and seeing, without really registering, the black grease that smudged her arms and her gray linen dress. Soon she located the nauseating kerosene or gasoline, slopping back and forth in a tin beside her. The groans of pain were coming from the man in black crouched in the far corner of the back seat nursing his feet. Sud-den wails from the child lying on her stomach on the rest of the seat inten-sified the sharp anguish in Allison's head. When both men in front shouted roughly to shut up, the little girl put a tiny hand over her mouth. The black eyes that met Allison's were brimming tears. Smiling hurriedly, weakly, Allison put her finger to her lips and began to stroke awkwardly the little shoulder in the pink cotton dress, patted the tightly braided black head. Some relief and hope began to replace fear in those dark eyes. Children were so ready to trust.

And Allison felt glad of the terrified little girl, whose need kept her from giving way in panic to the horror of their predicament. Still, there was no avoiding the fact that what she had always feared, what Katrine had even expected, finally happened. How? What had she done? Pretending for the benefit of the third man in back that she was still unconscious, through her nausea produced by the heavy smell of kerosene in the rocking car, with aching brain, Allison thought carefully. What had she done? She had sim-ply gone to church to see Joe. In a way she had prayed, and had genuinely tried to commit herself. But good gracious! Allison felt hysterical over how suddenly she was plunged into adventure the moment she tried Joe's sug-gestion. When he said that to commit yourself was dangerous, he certainly

used the right word! Would they ever have a chance to share the joke? But even here, the thought of Joe gave a lift to her heart like spring, and she determined that somehow they would laugh together again.

Allison began to pay close attention now to the men's argument in Vietnamese. Bracing herself against the jouncing floor, stretching her neck a little to ease the strain, she listened, at first translating with difficulty. It was clear that the leader, the young man in front on the right, must be from the North. She could hear in his pronunciation, Vs spoken as hard Vs, not slurred lazily into Ys in the southern way, and his Gs were pronounced "zhu" not "yuh." His leadership was easily inferred from the authoritative tones of his voice.

Trying hard to understand, Allison gathered that the handsome young leader with the shapely head and neat point of dark hair running down into his nape, was satisfied with the completion of their project (burning down the church? shooting who?), but he was criticizing her groaning companion of the back seat for burdening them afterward with a Frenchwoman and Moi child. The driver, whose neck looked much older, made his own unfeeling contribution. Their beautifully successful operation was now complicated, not only by these superfluous persons, but also by the further stupidity of Comrade Thom in having carelessly burned himself!

And yet the poor man seemed genuinely in pain. If he noticed that she was conscious, he was too self-absorbed to care or tell the others. Allison found she could not help thinking of him as "the poor man." Now he defended himself, crying that he couldn't help the sudden interference of these persons! How could it be his fault? Would he *desire* to cruelly burn his lower limbs or endanger their getaway? No. He had been rudely interrupted at a key moment in his vital part of the operation. The comrades should be thankful he had reacted with so much presence of mind, even in his intense pain, smothering the cries of these two who were dangerous threats to their mission of terror. What if the chauffeurs had heard these two yelling, and rushed to the front of the church rather than the rear? Also, the comrades should consider another important fact. With the woman and child removed, there was no one now who could describe any member of the cell to the police. In any case, it would not be difficult to get rid of these two witnesses quickly.

Horrifying as all this was from her own point of view, Allison felt that, for an injured person, it was pretty good thinking. And the older man, the driver of their careening vehicle, commended Thom's suggestion. He added, however, shifting down on the increasing upgrade, it might also be possible

to get a good ransom for the Frenchwoman, though of course the child was of little value.

Wondering why they thought she was French, but thankful, because Americans were now more and more recognized as the true enemies, Allison felt encouraged enough to look around for some way to help herself. The old car had been changed into a kind of van. There were no inside door handles in back. The rear windows were roughly curtained with sacking, nailed on. But the can of kerosene offered possibilities. Remembering her matches, feeling around distractedly, she found that her white purse was gone. They must have it. Maybe they had seen her French identity card, and would also know her name. She must keep them thinking that she was French and only French.

But the little girl was whispering tearfully in her ear in quite good English, "Please Mrs., please take me home to my Daddy!"

Allison responded with a stage whisper in French, "Wait a little," and smiled at Drim cheerfully with a sinking heart.

Leaning back on her elbow, and finding it bruised, Allison bit her lip. All this had started with prayer, she thought angrily, trying with shallow breathing not to take the fumes any deeper into her lungs. She had given herself away to God and found herself almost at once in a violent, grotesque situation, like nothing she had ever experienced before. She, Allison Giraud, and a teary little Montagnard child, were slammed into the rear of a dirty old car with three Viet Cong thugs, terrorists, kidnappers, and church burners! They could be killers too, she thought, sickened, remembering the shots. The whole thing might of course be accounted for by "accident" or "coincidence," but she found little comfort in the thought. If, on the other hand, she had fallen into the hands of God by her reckless commitment, then He was the one to ask for help. Closing her eyes, Allison prayed to be shown the best thing to do.

Slowly it came to her, that now, before they arrived wherever they were going, was the time to relax and think. She was lucky to be alive. Max, shot at once, had been given no chance to pray or plan. While she was living, she had a slim chance to escape. Other people in Vietnam had returned safely from experiences like this. Recently she had heard a lot of talk about those two Australians who had been ransomed from the VC for some drugs and a typewriter. She had even met them both briefly afterwards at a cocktail party! What could she think of to offer her own captors as ransom? Well, there was Mark's portable typewriter, but no drugs, beyond a little aspirin.

In her first-aid kit she did have a fat and unused tube of Vitamin E ointment for burns, which would be a great blessing to that poor fellow curled up and moaning in the corner. He would be glad of the aspirin too. But she doubted that the two in front would put a whole lot of effort into easing his pain.

Of course she could always just wait and hope that Joe or Mark or the Ambassador or the police would somehow save them. How long would that take? What might have happened to herself and Drim by that time? Terror alternately chilled and heated her bruises like a tropical fever. To stifle her fear she studied further what she could offer the men as ransom.

The man driving, the one with the thinner, older neck, had an ironical rasp in his voice that seemed to hint at sadism and cruelty. The man on the right was younger. There was a careless sureness and sense of power about the way he held his well-formed head. She sensed that now he had caught his breath again, he was pretty well satisfied with the way the whole adventure had gone, and that he was interested to discover how he could make some profit out of the mischance of the two prisoners. Turning her mind resolutely away from rape and torture, Allison wondered what kind of ransom might tempt him. He was probably not yet thirty. Could there possibly be "cowboys" like Bao among the Viet Cong? To the South Vietnamese, "cowboys" were somewhat wild, good-for-nothing young men who liked twist music and imitated beatniks. But when this man turned his head sharply, she saw the clean line of his chin, the clear features carved with character. Whatever he was, he was not a "cowboy."

He and the driver were talking about how to get rid of the lumbering Renault, speaking of what kind of vehicle would serve their terrorist purposes in the future. Never before had Allison so much appreciated her knack for the Vietnamese language! She even understood that they considered they had now graduated from an ordinary three man cell, *Tien To*, lowest group of the party organization, to a special action cell, needing to add lightning swiftness to their other remarkable capabilities.

As she heard the man in the back groan out that he had told them all along a fast vehicle was wanted, there flashed before Allison's inner eye the vision of Bao's glossy motorbike wafting her down the mountain like the wind. After that she lay back on her side, holding the child's tiny hand firmly in one of hers and bracing her body away from the bumps with the other. Keeping the Vespa scooter in her imagination like a talisman, Allison thanked God breathlessly and waited for further developments.

• • •

Although not on the program, violence had been part of the celebration of unity at the church. Robert and Amelia Gordon knelt with the doctor beside the fallen bodies of General Thanh and his lovable wife. Her back was against her husband's chest, her own breast uppermost to receive the final shot. With hope the Gordons kept their eyes on the doctor, whose head lay close to Yen's heart, his hand on her wrist. Then Joe moved her drooping body tenderly and put his ear beside the bullet hole in Thanh's chest. Slowly he stood up, with tears in his eyes, shaking his head. As one, these two were gone.

Joe cleared his throat. "Both are dead." My best new friends, he thought. How can I do without them?

At his announcement terrible wails began to fill the church, but they did not smother the voracious crackle of rising flames. With grief, but with haste, the Colonel's bodyguard and his driver began to remove the bodies of their Province Chief and his wife from this place that was suddenly becoming a hell. Cries of sorrow were turning to screams of panic.

Gordon stiffened. He saw smoke with fire filling the front entrance to the church and driving the people back. At once he and the Ambassador moved automatically to stand together on the platform, directing everyone quickly forward and out through the side doors. Mrs. St. John and other guests, Joe Ruffin and the Tysons, were swept out with the crowd of people pushing and shoving themselves toward the side exits. Gordon and St. John were the last to emerge, coughing and choking, from the building which was now occupied only by the roar of the fire.

Outside military police had already arrived, signaled by radio from the limousines of the Province Chief and the Ambassador. They were directing the stumbling, backward-staring crowd away from the church yard and into the road. Firefighters turned hoses on the brand-new building, now fully ablaze, and even onto the flowery arch in front, which had also caught fire and was rapidly blackening.

In the grip of shock, Joe stood watching the holocaust beside Pastor Rau and the Gordons. His thoughts were with his two friends, his elder sister and her much loved husband, now no longer in the world at all. Dazed, he thought too about the VC terrorists whom, until now, he had hardly believed real. He was numb. It was too soon for the sleeping tiger of anger to rouse.

Suddenly a stout older woman in the black turban of the North pushed by him and rushed up to Rau in a state of hysteria. The child Drim was

missing! Joe moved his head anxiously, distracted to a new worry. But surely Drim had been caught in the press of people and would soon show up among all those out on the road. No one was trapped inside. Mr. St. John and Robert Gordon had been the last to leave, and they were positive no one was left in the building.

"But that's just it," the frantic woman cried in Vietnamese, "Drim was not *in* the building! She had run out to play in front of the church. The last time I looked back, she was dancing around out there with a palm branch. Drim had no patience for sitting still! I was tired of her wiggling and so, to my shame, I just let her...." Overcome with sobs, Kieu would not be comforted, even by the sinewy arm of Drim's father, whose bright eyes of faith were now searching everywhere.

The Ambassador moved over by the Police Chief and undertook to explain about the lost child. Swift organization was already in place. The circle of police had not let a soul leave the scene. While everyone was lined up and questioned, the weeping Kieu quite forgot to be afraid of the police, who, in any case, now had only the Colonel's murderers on their minds. But they were also not much concerned about a missing child who was sure to turn up.

Who had seen the assassins? In the stress of questioning it seemed at first that no one had seen anything. But there was one woman, somewhat pockmarked, who had been seated near the back. She had seen the Moi child go outside to play and also saw a foreign woman in a gray dress running after her. This western lady was beautiful, very tall, with brown hair, a short plain dress, and white shoes with high heels. Everyone standing about frowned with the effort of trying to identify this unknown foreign lady whom others at the back had also noticed. Joe felt, in his already painful heart, a terrible foreboding.

The woman in the flowered dress was excited with importance. She pointed toward the now sagging, steaming door of the church. One last chair, she said, had propped that door open, and it was here the foreign lady sat down, having come in late. After Drim began to wander outside, this lady, looking back, seemed to notice something and followed the little girl very fast. And that was the last anyone had seen, either of the child or the foreign lady, just before the shooting of the Colonel and the great fire!

While a constable took notes, trying to show busy efficiency in the irritable presence of his Chief, Officer Le Ba Dinh, Joe told himself desperately that it could have been any western woman. Surely Allison would not have come to the church service alone. She had given him no indication that she

even wanted to come! And, by now it was clear that she had not been with the others from the villa in the Ambassador's limousine. Still his fears grew as the gesturing Vietnamese woman filled in details: shoulder-length brown hair, white shoes with dainty heels. Even before Bao, the Ambassador's houseboy, zoomed into the churchyard intending to pick up Madame Giraud after the service, Joe knew it had been Allison.

Then where was she? And where was the child? What had become of them? Neither Ambassador, police, firemen, nor missionaries had any answer. The two were simply missing. The Chief of Police offered his view, only a suggestion, mind, that they might have got in the way of the assassins and been carried off. Kidnapped. Such happenings were now everyday affairs in South Vietnam.

Mr. St. John looked stunned. This, on top of the murders! Mrs. St. John was feeling sick at the very thought of telling Mark, as well as Allison's children, who were off exploring the market stalls at that very moment. Her fatherless children!

Joe's pain was too great for speaking. His valued Vietnamese friends lay murdered, had ceased to be. And Allison, his newly discovered love, was in the hands of terrorists, along with his merry little friend Drim. Trying to grapple with all this, he stood there blindly, and both hands fell powerless to his sides. Then he felt a hand slip warmly into his. Charleen Tyson. Joe could not seem to hear what the Ambassador and Mrs. St. John were saying to Gordon and the other missionaries, but he felt the hand, and slowly came back into awareness.

The Chief of Police declared hopefully that, in tracking down the assassins of Colonel and Mrs. Thanh, it was very likely the child and the lady would also be found, dead or alive. Joe turned toward the Ambassador for some kind of help or reassurance in this terrible situation.

Mrs. St. John plucked at her husband's sleeve. "Dr. Ruffin," she murmured, and the Ambassador turned to take in Joe's appearance, much too distraught for the loss of a holiday tennis partner, or a casual pair of acquaintances who had given him a lift to Dalat.

St. John frowned. "I'm leaving now, Dr. Ruffin, to organize a thorough search for the killers and kidnappers!" The Ambassador turned and put his hand on the shoulder of the Montagnard pastor, father of the child Drim, who was staring off into the distance with his arm around the sobbing Ba Kieu. The pastor did not respond. St. John saw the same shattered surprise and disbelief written on the black face that was reflected on Joe's.

The Ambassador's helpless rage surged up. Did *anyone* realize how many village and province officials, good, bad, and indifferent, had been killed by the Viet Cong in recent years? But feeling the pressure of his wife's hand, seeing that people were looking to him for help, he swallowed his fury.

"I assure you, Joe, Pastor Rau, and everyone here, that we shall at once bring all our influence to bear in order to locate and, if necessary, ransom Allison Giraud and the child Drim, and bring the killers to justice. I have just spoken to the Gordons, and I hope you," he nodded to Joe and Pastor Rau with the woman, "will join them and all interested parties in a meeting at the school later this afternoon to pool our information and report whatever actions we all have been able to take." He gave a rough pat to the doctor's shoulder. It was obvious the poor fellow was just about as cut up as the couple whose child was missing.

The St. Johns were helped into their limousine by Toan, their chauffeur, who got quickly and guiltily into the front seat and started the motor. Who knew what he, Toan, might have observed and warded off, if he had not been gambling with the other drivers behind the cars?

Bao, the houseboy, was about to follow the limousine on his red Vespa, slowly and sadly, when the American doctor broke away from his missionary friends and came right up to him. "Excuse me. Did I understand rightly that you brought Mrs. Giraud to church on your motorbike?"

"Yessir. Every car go out already. Madame very want to go church."

So it was confirmed. Nodding absently, Joe waved him on. He had not thought Allison would be interested in the church celebration. He wondered if he had understood her at all. Though she had dared to come out early to see him yesterday, and though she played a mean game of tennis, Joe had thought of her, with her dreamy preoccupation, her "magic days," as a person more involved in being than doing. Now she was thrust into action, while he was left helpless.

Yen Thanh had been like him, very busy and active with people. Happy that way. Oh God. Dear Yen. And suddenly he remembered her Buddhist father, who had called to a different side of Joe, the side that might learn how to know and to be. With tears in his eyes he realized there was nothing he could do here in this strange town in the mountains. His rage could go no place in action. And yet how could he just be, thinking of Allison? One thing he reaffirmed was her courage. Somehow in his thoughts, in his prayers, he must be trusting and hopeful, must have confidence in Allison and faith in God.

So, as Bao's red Vespa disappeared up the mountain, Joe came back to the circle of missionaries. Everyone was trying to offer encouragement to Pastor Rau and the woman, Kieu, where they stood together, openly mourning their loss. Bob Gordon gave one backward look at the gutted, smutty, stinking ruin which had been their new church. The firemen had about finished the work the blaze had begun. Amelia put her arm around her husband's drooping shoulders and turned toward their car.

But Gordon stopped, looking around at those who were left. "We must all go back to the school now and form searching parties to cover the woods and the vacant houses. The Ambassador suggests that those of us most nearly concerned meet with him later this afternoon to share the reports that come in and pool our information. I offered the school cafeteria, where we will meet at three. In the meantime, anyone who has any knowledge of places where the Viet Cong are used to meet or hide, please come to me at once. There will be no questions asked. People who know anything at all about VC hideouts or habits will be welcomed as true helpers. Of course, we will follow up all such tips most discreetly and no names will be used. These are the things we can do to help find the lost ones. And at the same time we will pray for them and for those who have died. If we can, we will pray for the killers, that the God in them will soften their hearts. Now let's all return home to make up search parties and recruit our faith! Remember, 'All things work together for good for those who love God!'"

Assassination? Kidnapping? Destruction? But somewhere inside Joe's head he seemed to hear firmly, *All things*.

On Trial

The getaway car was slowing down. Terrible to think they had reached their destination! Now with her ordeal close upon her, Allison remembered the warning of a U.S. briefing officer she talked with once in Saigon. "I'll tell you this," the blunt-faced Captain had said soberly, "if they ever capture you, don't use the term Viet Cong or VC in addressing them. They don't like it!" Mark had said the same thing on the way up to Dalat.

This appeared to be her only instruction, and the ransom of the two Australians her only positive precedent. There was, of course, the possible existence of Joe's God. However, if He, with a capital H, had not actually landed her in this spot, He had certainly not helped her avoid it. In the sudden stillness as the car came to a complete halt, Allison felt totally on her own.

The back door was jerked open from the outside. It was humiliating to lie on the car floor like a sack while the burned man clambered painfully out over her legs. On her elbows with her head raised, she could see over her shoulder that the driver had opened the far door and was grabbing for Drim. The child shrank away, but was hauled off easily. The third man, the one Allison thought of as the leader, now stood by the near door looking down. The contempt in his eyes was as real as wind or fire.

"*En dehors,*" he said coldly, and she scrambled out, glad not to be touched, and drawing in eager breaths of mountain freshness after the suffocation of the kerosene fumes. She had been so afraid of vomiting.

Out in the light and air, standing in grass to her knees, being shoved from behind toward an ancient shack within the forest, Allison realized she had no idea of their location from the town of Dalat. Ahead of her Drim was struggling and kicking, being carried into the house over the shoulder of the driver, who might look somewhat old, but was not in the least weak or gentle. The man behind Allison held her left arm behind her cruelly hard, driving her forward. They were slowed down, however, by the limping progress of the burned man. His every step seemed to bring on acute pain.

Allison squinted hastily up at the sun, remembering how it always went down behind the mountains which she had watched from her balcony at the Ambassador's villa in some other world. But the sun was now high overhead, telling nothing.

Before she could look around any further, they were already inside the smothering dimness of the little house. She and the child were tied up roughly in heavy wooden chairs with their arms behind them. Allison had feared being gagged. When this did not happen, it was sadly clear that they were too far away from any other habitation for screams to be of use. As her mistreated body began to adjust to its awkward position and physical protests lessened, Allison saw a dark, dirt-floored hut with a high ancestral altar holding faded photographs of deceased relatives. In the center of the room was a low wooden table on which stood a lone vase of dusty-looking plastic flowers. A frightened woman had just come in, fussing nervously, and set down bowls of steaming rice or manioc with greens on top. Evidently only the three bears were to eat. Drim began to cry now, angrily and in earnest, either because of her bound hands or for hunger at the mouth-watering smell.

The poor burned man showed no interest in food. He crept carefully into the corner on a mat, and, closing his eyes, continued to moan. His black trousers were rolled up above the knee, and Allison could see that his shins, ankles and the tops of his thin feet were badly burned. She looked away hurriedly. Now the man she thought of as the leader was digging into a pocket of his black tunic. He brought out crumpled piasters and counted them onto the table top for the woman. Allison remembered hearing that the Viet Cong were more careful to pay for their support from the populace than the South Vietnamese army. As the two men squatted down and began rapidly to poke food into their mouths with chopsticks, also produced out of their pockets, they stared curiously over lifted bowls at their victims while Drim cried all the more for something to eat.

At this Allison felt a certain spine-stiffening scorn for her captors, and, clearing her throat, said severely in French, "Are you grown men going to eat your fill while the child goes hungry?" Unmoved, the two went right on eating. Then, casually, under her affronted gaze, the handsome young leader gestured with a flick of his hand to the old woman to give the child the food of the injured man. Drim's tears dried on her cheeks while she eagerly ate everything the woman, clucking sympathetically, put into her mouth. Allison looked on amazed. Her own stomach felt so hard with tension and fear that she could not imagine digesting anything solid.

Desperate now, on the edge of panic, she thought how Max had once said, in difficult situations, it helps to play the role of spectator. After all, her eyes were free. There might be a certain refuge in detached observation. So, to let go her terrible fears, Allison tried to record what she saw about her in an objective way. This helped—it really was helping!

Of course it was hard to observe the burned man with detachment because of his acute suffering. Allison could hardly bear to glance at his legs, attracting flies, or watch the anguished rocking motion of his body, without feeling his pain in her own nerve endings. She turned her attention to the other two men. The older one, the driver, resembled her idea of a Vietnamese scholar. Even though he was wearing only the black tunic, trousers, and sandals of any street coolie, there was something about his graying hair growing from a point at the center of his forehead, about his stringy goatee, about the long fingernail of his right little finger and the metal-rimmed reading glasses in his breast pocket that indicated the scholar or intellectual. And his eyes are keen, she thought, though hooded. He knows a great deal, but is not giving away much. There was no moustache to hide his rather cruel, thin mouth. Here objectivity broke down. She felt very glad that this person did not seem to be the one in charge.

Allison only studied the man she thought of as the leader when his head was down, his attention on eating, for, when his eyes met hers, she found that her own fell away at once before the direct black gaze. This was the one with the Northern accent. He appeared to be about her own height, five feet, seven inches, and surprisingly attractive. His olive face was a squared oval with well-cut features and wide cheekbones. There was a straight firm nose, somewhat broad at the nostrils. He had a strongly rounded chin and nicely shaped ears close to his head. When he turned to regard the condition of his group's ailing member, Allison saw how the lustrous black hair grew smoothly from the crown of his head in a cap to the shape of his skull,

ending in a point at the nape of his neck. Suddenly he turned, and their eyes met. She couldn't help recording intelligence, controlled power, and hate because he meant them to be seen. The Communist leader confused her by being attractive. But her angry resentment against him was increased by his obvious assurance that he would always command respect.

Having finished their meal, the two men took her own Bastos cigarettes from her limp, white leather purse, which had been dropped on the table. They each lighted one. Then, continuing to ignore their suffering companion, they began to pace about the dim room, asking Allison questions in French. Although fear ran like ice water through her veins, she was too proud to let this show in her voice and answered haughtily in the same language. She was marshaling all her forces. Two things seemed especially important: one, that they continue to think of her as a Frenchwoman rather than an American, much more interesting nowadays to the VC, and two, not to show by any flicker of expression that she understood what they said to each other in Vietnamese.

"It is strange," said the leader in his harsh French, studying her through the blue blur of cigarette smoke curling deliciously upward, "it is strange that a healthy French lady like yourself should be here in a foreign country alone. Where is your husband?"

The surge of bitter rage was decidedly helpful, and she was able to match his coldness with her own reply. "Your friends in the Viet Minh murdered him in 1954."

"So?" The heavy level eyebrows rose. "A pity then that your husband was not intelligent enough to choose the right way."

Allison forgot all about her situation, her bound hands, the frightened child, the moaning man with his terrible burns. "*Your* way, then," and she barely managed to avoid saying "the Viet Cong way," "is the only right one?"

He shrugged. "The right, which is nationalism through the organized Communist way, will not fail to annihilate the wrong, which is colonialism and greedy imperialism."

While Allison digested this dumbly with blazing eyes, the scholarly older man drew a satisfying breath of smoke and put up his chin to blow it out again in a delicate wreath. "All people must realize, Madame," he said, "that there is no further doubt as to which side may be considered right. In mobilizing the Vietnamese population to defeat a modern European army, such as you French, the Viet Minh have *already* proved themselves in a test which few Nationalist movements have undergone, and even fewer have survived."

At this impressive speech by his comrade, the injured man in the corner expelled a contemptuous snort before returning to the cradle of his pain. Now Allison dared to bend upon the hurting man her regard. It was easy to perceive that this person, a southerner by his accent, was brimming with sullen hatred and bitterness. Of course she could not know the cause. She could only imagine his frustrated dreams and hopes, now turned to despair. For whatever reason, this man thought of himself as a victim. And now that he alone had been burned in the recent adventure, he was once again confirmed in his victim role. There was a possible remedy, a tube of vitamin E ointment, lying in her first-aid kit back in the quiet white bathroom at the top of the Ambassador's villa. In her sudden feeling of kinship with a fellow victim, Allison knew that if she had the salve here in her hands, she would gladly donate it to her enemy for his relief from pain. Again she felt mild surprise.

The handsome leader was going ahead with his argument about the Right and who was righteous. "You see," he continued in his carelessly accented French, rich, nevertheless, with vocabulary, "we are more intelligent and we have a brilliant plan for the whole. You are always looking back. You cling to old moral principles without value for the future, and you keep on trying to patch up a reactionary establishment for only one part of our country. Your day is over. You are immoral, useless, decadent, and also wrong. We are virtuous and upright."

How did he manage to strike so near the bone? Still, while pushing down the return of her own guilt feelings, Allison was able to click her tongue against her teeth indignantly. "How can you say you are virtuous when you hate so fiercely and even kill without care? Can you deny you are all obsessed with hatred?"

He gave her then a thoughtfully appraising look. "Why should I deny it? Hate and hostility, these are very important to the power of the Movement. They must be kept alive. But we do not hate the right, only the evil and the wrong."

The older man supported his leader in Vietnamese with what sounded like a quote from some Communist document: "Promotion of hatred must be permanent, continuous, and directly related to the Struggle movement as closely as a man is to his shadow."

This was ignored by the leader, who continued to look at Allison with some curiosity. "Why should I not hate you, Madame? Are you good? What are you good *for*?"

Allison could not answer, thinking sadly, what indeed? How are they so able to discern your guilt and weaken you with it? It was a relief when they devoted their next questions to why she was living in Vietnam and why she was here in Dalat. Eventually, as her bound arms began to itch and tremble, they seemed fairly well satisfied and totally uninterested in the fact that she was, as she said, on holiday, visiting at the villa of a friend.

Only then the older man suddenly hinted at ransom. As casually as possible, with a prayer in her heart and telling her shoulders and arms to relax, Allison started into the bargaining by offering them Mark's portable typewriter. She was thankful for basic lessons learned in the noise and smells of the Saigon market—start low, remain cheerful, never show you care very much. Under present circumstances some of the conditions were not too easy to maintain, and at first there was no response at all. Allison was not surprised, since she had also thrown the child's release into the deal lightly but definitely.

There was a frowning silence. She lost patience and added, "Well, whatever you decide about me and my ransom, you should simply let the child go!"

"No!" The level brows of the young leader met above the bridge of his nose. "She is young and can learn to follow the Revolution."

Allison sighed. "Surely such a little girl would be better off at home with her parents!" And indeed Drim reinforced this with wails for her Daddy. The burned man in the corner joined in, groaning and cursing.

"Silence!" The force and tone of the young man's voice brought immediate quiet.

The older man, it seemed, had never lost track of the bargaining process. "For two persons? Even for one, a typewriter is nothing, especially as the machine probably writes only in French." He spat.

Allison said she thought she could get one which typed in English. The leader looked faintly interested. Perhaps such a machine might have its uses at VC headquarters in propaganda for the enemy. The older man grumbled something undecipherable in Vietnamese. Allison, so helplessly tied up and trying not to be thirsty, found it difficult to look as though she didn't care. It was pretty clear that arguing for the typewriter much longer would only irritate them. Nodding her head toward the hurt person, she offered to bring with the typewriter "some very excellent medicine to heal the bad burns of your friend."

The leader, whom by now she had heard was Comrade Kiem, turned his

detached gaze upon the fallen Comrade Thom. "These burns will heal, eventually, by nature."

Allison frowned. "But the pain! It would be a great easement to your friend to stop the acute pain. And also, such dirty kerosene burns are easily infected. If you leave the burns untended and if infection sets in, this man might die!" Comrade Thom also seemed to understand French, for his groans increased.

"Let him die," the leader said. "If he does not heal, he is of no value to us. We have already lost many brave fighting men of the Revolution. When one dies, there is more rice for the rest."

While Allison stared in disbelief, the older man, Comrade Tang, enlarged upon this moving theme. "And if this man does not die, through his suffering he will have gained a rich struggling experience. General Giap has said that all our people as they go through many ordeals become always increasingly mature."

The injured man fell back against the wall in his corner and stared ahead of him with cloudy brooding eyes. Allison bit her lip. "Along with the excellent typing machine and the large tube of very healing salve, I *might* also be able to bring a very fast *motorbicyclette*, though this may not be the kind of vehicle you would have any use for."

Allison was resolutely suppressing her knowledge of Bao's total devotion to his beautiful machine when she caught a gleam of interest in the older man's disdainful eyes. "Would that be the Vespa we saw you riding on when you came down to the church?"

Kiem was not impressed. "And what could we do with a red motorbike? A typewriter is not as good as a gun, but at least it is better than an Imperialist toy!"

Allison hid her disappointment by murmuring consoling things in French to Drim who, not understanding a word, was looking more and more belligerent and angry. Feverishly Allison turned over other possibilities for ransom in her mind. She could only lay her hands on a few thousand piasters. There wasn't a single gun at the villa as far as she knew. (That place was certainly removed from reality!) Don't panic, she told herself sharply.

Well aware that she must not press them about the Vespa, or anything else, she gave up and rested a little, trying to overlook the pain of her wrists. It was annoying, too, to be totally at the mercy of insects. Suddenly a childhood memory was superimposed upon the present. She and her friends had been playing early settlers in "the little woods." The boys as Indians, one of

whom was Allison's ideal at the age of seven, had tied the girls up in wicker chairs taken from someone's back yard. She could remember her feelings of distress and humiliation, but nothing at all about how they were eventually released. They must have been! Tears of helplessness tried to well up for the first time. This was not a game, and the outcome was far from sure. In desperation Allison angrily turned everything over to God, since she was unable to think of anything else to try at the moment.

There was some comfort in talking with Drim, even though the child could only understand the tone of voice and not the French words. It was while Allison was explaining, ironically, to Drim that they must wait just a little longer before going home, when, with a thrill of hope and without turning her head, she heard the older person start to argue in his own language for the Vespa. They could paint it an inconspicuous color. In the background Comrade Thom was making a strong plea for medicine to soothe his fiery injuries. Ignoring this, Comrade Tang went into what they could use the bike for too rapidly for Allison.

Comrade Kiem seemed to admit their need of a vehicle, though reluctantly. (Clearly he felt that a righteous cadre could win the whole Revolution barehanded and on foot.) Still, a bike might well be of assistance, but—and there was a very large but—Kiem would not risk the continued safe and successful existence of the cell for anything at all that they could manage to do without.

He turned on her fiercely, suddenly, the thick brows leveled, the eyes burning. "And how would such a female as you manage to obtain and bring back to us in double quick time the typewriter, the medicine, and this Vespa? Can you even drive such a machine yourself?"

Good God. She had never even thought of that. She had been imagining they would send out a ransom note, and her friends would come to her rescue with the required items. So Allison was silent while they went on arguing with each other in Vietnamese. The whole unexplored area of how to manage the exchange loomed impossibly ahead. It was clear to her they would never risk the approach of anyone else, anyone who might be carrying a hidden weapon. The child, Kiem said, should of course await the woman's return. And obviously, he asserted, they would only meet the woman with the ransom items at a chosen place where they could see all approaches and know she was returning alone.

"You are able to drive this machine yourself?" Kiem asked again frowning his disbelief.

Allison managed to lift her constricted shoulders. "But there is nothing to it!" In that moment she liked herself very well, though she was not very sanguine about the plan. It seemed incredibly naive and ingenuous; the prisoner, once free, returns like a lamb with her own ransom!

Comrade Tang at once made this very point in Vietnamese. It was extremely doubtful that such a spoiled and soft white woman would ever return for the Moi child. Once free, she would certainly not be either stupid or brave enough to come back.

But Kiem was studying Allison again. "I do not think she is stupid. However, she is quite weak and soft. Everyone knows how sentimental these westerners are about children, of whatever race." Kiem and Allison met each other then, eye to eye. She felt him taking her measure as she was taking his.

In the end Kiem stated, "This woman is weak, but she has self-control, perhaps even some courage." He said it grudgingly in his clearly incised Northern dialect.

Then, as Allison translated and absorbed the extraordinary, somewhat left-handed affirmation, he turned away again, with indifference. "In any case, we have already accomplished greatly our important mission. If, in addition, this woman returns, we may gain a good motor bike, and a typewriter, which could be useful. On the other hand, if she deserts the child and does not return, what have we lost? One useless white woman who would either have to be fed or killed."

"She might provide some pleasure," Comrade Tang leered.

Before Allison could repress her shudder, Kiem had whirled on him angrily. "We will in no way debase the integrity of this cell! We are disciplined and controlled, not self-indulgent rapists like our enemies in the army of the South."

Again Allison felt surprise. And yet, everything fitted into the Puritan character of the man. Even as her spirit of hope leaped like a deer, still another weary hour seemed to pass before a plan for the possible exchange had been evolved. Perspiration dripped down her legs from the backs of her knees. Flies settled unmolested on her bound ankles, wrists, nose, and twitching eyelids. When she had explained the location of the villa near the mission school on the top of the mountain, she hoped to God they wouldn't know this was U.S. property. The only sign she had ever seen was the faded one at the gate to the rutted drive, and there were no security guards.

The two comrades spread out a creased and worn road map on the table

for thorough examination. These men were undeniably patient and careful where their own interests were concerned. The interests of the Struggle, Allison amended in fairness, since it seemed unlikely that anyone here was going to get much personal pleasure out of the dashing Vespa. They would probably paint it black or brown and make it into a utilitarian tool for the Revolution. She sighed.

Kiem raised one eyebrow. "You are impatient, Madame?"

"I am a prisoner, Monsieur. I am not free to hurry. Of course, if I had any choice, I would not waste time here in this way."

She saw that when she was bold she interested him. He considered, his eyes on her body, then her face. "You were present at the church," Kiem said suddenly. "If you are a true God-follower you might be expected to use this 'wasted' time in prayer."

"I have been praying." When she said it, she realized it was true.

Kiem exulted at this admission as though he had in some way caught her out. "To God? Ha, ha! You are stupid to say there *is* a god. Where is he? Why doesn't he set you free? Madame, there is no god. Revolution is power. Man forms his own destiny. We are the supreme being."

Wrinkling her nose, Allison managed momentarily to dislodge the fly. "You have been misled, Monsieur. There *is* a God, even though His ways are very hard to understand." And she hoped God was listening.

Clearing his throat Comrade Tang interrupted the theological discussion, tapping the map. "Here is a track, Comrade, which looks to be seldom used, at the lower back side of this small peak where she says the villa of her friends is located. Could we not put the woman out in this wilderness area and force her to climb up to the villa from behind and unobserved in order to procure the ransom items?"

Kiem went back to the table and leaned on his hands above the map. "It might do, but only if we leave immediately after we drop her."

Allison felt such an overwhelming need for a toilet, a drink of water, a chance to move! By all means, take me there, and leave immediately, she thought. And yet.... "If you drive away from that place where you have left me, how can I bring the things to you and claim the child again?"

Kiem showed his amazement at this audacity. "You will be kind enough to leave the planning to us, Madame."

"Oh all right," she agreed, as if to a tiresomely arrogant husband, "have it your own way."

"We thank you." The light in his eye, which almost showed a humorous

appreciation of the situation, bothered her. She didn't want to like him or share with him any private joke.

"Now." He turned seriously to the job in hand. "Before we take Madame to the spot below the villa from which she begins her climb, we will first show her the meeting place where she will afterwards rejoin us in no less than one hour." The two men argued for some minutes about the safety of the final meeting place.

Allison tuned out, numbly giving up to the silence within, not praying—nothing. She discovered an odd refreshment in this. However, she procured only a few moments of peace, soon realizing that Comrade Kiem, well aware of all the possible dangers, might yet decide against trying for the ransom. If the woman should alert the police or the military, he said to Tang, they could cordon off the whole area of the meeting, and so, even though outside the range of the cell's lookout, could easily block from a distance all paths of escape.

Comrade Tang must not have considered this dangerous possibility. At once he was ready to give up the whole thing. There was absolutely no need to jeopardize their most successful special activity cell (*Tu To Dac Cong*), not to mention their lives, for a motorbike and a typewriter! At this point Allison lost hope. Their arguments began to fade. The protests of her own body were drowning out Drim's whimpers and the moans of the burned man. Her own aching head, her anguished wrists and shoulders spoke too loudly for any more careful translation of the men's plotting. For a few moments it was blessed to sink into non-being and give up the mental struggle to stay one clever step ahead of them. Oblivion was the only peace. Allison fainted.

And so she did not see Kiem toying with a new solution, revealed at first by the gleam in his eyes. She did not hear him say to Tang in Vietnamese, "It happens that I have recently discovered a very secret escape route, a tunnel leading off of the cavern behind the Prenn Waterfall. My contact used it successfully yesterday, and I believe, after receiving the ransom, we could withdraw through this tunnel into the jungle on foot. By then we will have abandoned the Renault and will slip away through the tunnel in our plain black clothes to mingle with the countryside and its people."

"And how will we look in our peasant clothes pushing a new red Vespa?"

Kiem slapped his forehead lightly with impatience. "If I were as stupid as you seem to imagine, Comrade Tang, I would not be the leader of this cell. Of course we will hide the motorbike carefully in the underbrush and return for it on some more convenient night, when we will re-paint it. Now

let us locate on the map a trail near the waterfall to which this woman will return with the ransom."

Coming to, Allison felt numb in all her parts, including her brain. Anyway, what more could she do? Allowing herself to drift off again into a kind of coma, she was suddenly jerked awake by the child's fierce cries. By the time she got a grip on consciousness, Allison was being shoved toward the door, her ropes untied, her knees buckling beneath her body, and Drim was being left! Allison stopped. She shook her head, cleared her very dry throat and reiterated firmly that she would not go for the ransom at all unless they brought the child with them in the car for the eventual trade-off.

"You can just keep us!" She heard herself say on a tired exhalation.

The young man looked at her coldly, measuring. Allison returned his stare in kind, finding that she meant it, which was strange since she had no special affection for Drim. While they glared at each other, Tang, sighing loudly, went off and returned, bringing Drim like a small sack. For a moment Allison felt dizzy with the pride of success. But then Tang seized the child's arms while Kiem thrust a rag into her mouth as a gag, tying it firmly into place with an old handkerchief. Drim's screams turned to mumbles, and tears flowed from her outraged eyes.

Before she could make any further protest, Allison was given exactly the same treatment. And even as she and the child were carried out and tossed again into the rear of the smelly old car, cries could still be heard faintly from the injured man left behind helpless in the hut. Allison found herself choking on the abominable gag. The only thing was to relax and breathe strongly through her nose. Trying to advise Drim to do the same, she choked the more. So once again she breathed deeply and stretched her legs out as far as they would go against the opposite door.

Coaxingly started, the old car floundered over the rough ground and back onto some kind of road again. Closing her eyes wearily Allison felt amazed at her brief arrogance. What she had feared for years had happened, and, mysteriously, had not yet completely overcome her. Dear God, she thought in English, something is moving at last. Help it to be good!

Reactions

Sometimes in Vietnam, if I am to tell you the truth, it was as if we were watching movies of ourselves in which we were the stars; it had that kind of unreal intoxicating feeling. For in those days we lived on the very edge of life and death, and that heightened every experience.

David Halberstam, *"A Letter to My Daughter,"*
Parade, *May 2, 1982*

From the car window Douglas St. John surveyed the Swiss-like charms of Dalat with a tightened jaw. Unreal! He glanced at the opposite side of the limousine where Mark Gardiner sat, looking terrible. The young man showed a lot of outer self-control, but his fear for Allison must be even more painful repressed. With his own aide another victim of the attack, it was clear to St. John that it was up to him to bring help. Events had put him directly on the spot.

So far he had not been idle. First, he had informed Washington by coded cable through the Embassy in Saigon. Then he had notified the Country Team through General Joshua Godwin, the MAAG Chief. Josh had put him in touch with the Vietnamese Corps Commander of this district at Nhatrang. Although Josh had already paved the way for him, St. John had to explain the situation again, emphasizing the murder of the Province Chief and the kidnapping of an American citizen.

Even while expressing proper dismay, the Corps Commander remained suave and detached, almost aloof! Of course, he had said, first it was necessary to gain permission from the Palace for any action. Also, one must make allowance for the many difficulties.

"Difficulties?" St. John had roared.

Very difficult, was the quick response, to deploy all the men required for a thorough sweep in the very mountainous terrain around Dalat.

With that fine young couple lying dead—Allison in the hands of their murderers! After an explosion from the Ambassador's end, the General attempted reassurance. Of course, as soon as he was able to contact the Palace, then, with the President's permission, he would at once put in hand the necessary organization for a sweep, although, one must realize that the day being Sunday....

However, he added hastily, as formidable curses came clearly along the wire, of course everything possible would be done in the very *difficult* circumstances. It was not too hard to gather that the Americans might be one of the chief difficulties. Into the silence of St. John's angry frustration, the Corps Commander then carefully dropped his regrets for the death of the Province Chief and his wife, regrets also for the loss of the American lady. Most sad occasion. It had not helped matters that the Corps Commander's English was so very good.

After that the Ambassador had begun trying to contact Diem himself through the Officer of the Day at the Embassy in Saigon. He had done all this from Thanh's office at his big desk where he saw a framed photograph of Mrs. Thanh with her arms around their two laughing daughters. What would become of those little girls now?

Leaning on Thanh's desk and gazing without focus at some kind of tree outside the window, St. John kept on doggedly trying to reach Diem. When the President's rather high voice came through at last, he almost sounded pleased for the American Ambassador to experience at first hand the true character of the Communist enemy. Ngo Dinh Diem, however, did register all the appropriate rage and offered every possible assistance of the Vietnamese government and military in tracking down the terrorists.

Eventually, after the Sunday staff down in Saigon had helped him make other calls to other understaffed offices, St. John replaced the receiver and stood there for a few moments recovering. At least Thanh's counterpart, Colonel Don Altbacher, was on his way up, would arrive by the afternoon plane. The Ambassador remembered this man as sensible and adequate, though he was certainly no dynamic leader. All the better, probably.

On the phone Altbacher had expressed his sincere admiration for the Thanhs and his own personal sense of loss. He also seemed to have been acquainted with Allison Giraud. It would be damn good to have him aboard. St. John advised the Colonel to avoid talking with reporters who might be on the plane, and to come directly to the Mission School. He should certainly arrive for at least part of the scheduled meeting.

At this point Mark Gardiner had entered the former Province Chief's office to report on the actions of the local police. It seemed that Thanh's elderly male secretary had confided to Police Chief Dinh his strong suspicions that one among the clerks in the outer office had been in contact with the enemy and might well have reported the scheduled movements of the Province Chief to the Viet Cong. Mark said that this old secretary, almost hysterical with grief, had easily convinced Dinh, who then had all the office clerks rounded up and taken in for questioning. It wasn't very long before one of them broke under pressure (torture, let's face it, St. John said to himself) and told of his contact in the café across the street with an agent of the NLF.

The police now had the description of a tall, young northern man to go on with, but both ARVN and police action still awaited orders from the Palace. Here in Dalat, with the Province Chief dead, general paralysis prevailed. Mark looked stony, adding that Cabinet Minister Thinh, the Ambassador's guest at the villa, had already left with his family in haste, recalled, he said, by his government to report on the event in person down in Saigon.

And finally now, being driven over to the Mission School, where he had scheduled the meeting to brief everyone concerned on "progress," Douglas St. John was feeling the unreality of a world out of control. It was his world; he was exactly where the American Ambassador was supposed to be on a holiday weekend, but a seismic shift had occurred. Even his driver, Toan, always the cool Chinese functionary, was actually snuffling, wiping his nose periodically on his sleeve. Mark Gardiner, the dependable, was distraught and could hardly be expected to play the steady right-hand man of his Ambassador. I must carry this burden pretty much alone, St. John told himself again. At least *I* wasn't assassinated. He had carefully reassured the Department on this point in his cable.

But I must think clearly about every aspect of the happening. There is more to the problem of Communist activity here in this unlikely spot than the safety of Allison Giraud and a tribal child, more than a new unifying church being burned out at its first service, more even than the murder of the Province Chief. Here in Dalat is the Nuclear Research Reactor given to South Vietnam under Eisenhower, plus the Commissioned Officers Training School and the Da Nhim Dam being constructed nearby with the help of our unlikely allies, the Japanese. Not to mention the airport, already sabotaged. But most important of all, the Ambassador thought, somehow we

must try to counter the devastating effect of terror; the demoralization, fear, and even eventual sheep-like resignation to our fate. This meeting at the school could offer a place to start rallying the right kind of morale.

Just then Mark, sweating a little, turned to him. "Have you ever thought, sir, how crazy this whole situation is? What are we *doing* here in Vietnam, besides making things worse? If we Americans weren't here on some quixotic mission, would the Thanhs be dead this morning? Would a girl like Allison be off in the jungle somewhere, helpless in the hands of kidnappers and murderers?"

Terror was already accomplishing its purpose. Sadly St. John remembered the firm and sturdy figure of Col. Truong Vinh Thanh, the jump officer of courage, the Province Chief of honesty and character.

"Of course the ones they kill are always the ones we could work with best. That leaves us trying to create something worthwhile with their corrupt Corps Commanders and their self-centered politicians and businessmen who don't give a damn for their nation or its people. It's their own Province Chief, after all." But of course Mark was completely deaf to everything except his anxiety for Allison.

Quickly the Ambassador put his ruddy hands on the younger man's cold one, lying forgotten on his knee. "Mark, listen to me! We are doing our damnedest to catch those devils and get Allison safely back. And remember, too, there are other people here in Dalat feeling exactly the way you and I do. They are all doing some scouting on their own. We are on our way to help those folks, to report on our actions, and maybe give them a little hope. They may even have some news for us!

"The press will probably be in on our meeting too. One thing we certainly can do is give them accurate facts and figures on other systematic VC killings. At least we can let the world know what's happening here in Vietnam, a kind of genocide. Informed public opinion has got to mean something! So I need you, Mark, to get hold of yourself and look up the figures on VC assassinations in the last year. *Mark*, get out your briefcase and find those figures for me!" As Gardiner turned blindly, fumbling with the catch on his case, the Ambassador thought, this is what terror is about. They'll beat us every time unless we can get a grip. And what does it mean, to get a grip? It means to know who we are, to accept it, and have the courage to be it in the world. *They* know, and *they* do.

Arriving at the Mission School, they were met by Robert Gordon, looking even grayer and more serious than before. With his head a little down

and on one side, while leading them toward the cafeteria, Gordon apologized to the Ambassador.

"I was unable to keep the press out—don't know how they managed to get here so soon." He smiled, then, raising his hands. "They're curious and intrusive, but, after all, this is important news." And he lifted one shoulder with regret.

St. John paused in the doorway to the school cafeteria, feeling the press of people, their group smell and excited vibrations as a physical wall. He glanced around. It was only a little after 2:00 p.m., and already every chair was filled. Hadn't he limited the meeting to those immediately concerned? People stood against the walls or sat on the edges of tables swinging their legs. Feelings of outrage, violation, helplessness were reflected in a kind of restlessness that vibrated throughout the big, windowed cafeteria of the Mission School.

Standing between Mark and the Reverend Gordon, Douglas St. John continued to look around in some surprise at the heterogeneous crowd, eager for any word of the assassins and their captured victims. He saw Moi tribespeople, dusky, short, and fierce, ready to avenge Drim with machetes or poisoned arrows. He saw Americans from his own villa, and missionaries from the school, with anxious faces, fearful for Allison and the child. St. John assumed that most of these were Christians of all colors who would find it hard not to hate the enemies who had destroyed their new place of worship, killed their capable young leaders, and kidnapped the unfortunate bystanders, an American woman and a tribal child. There were also reporters, avid for information, unsentimental, though not always truly objective.

"I don't see that young man, the doctor...."

Gordon said, "You mean Joe Ruffin. No, he's still out, I think, joining in the sweep and contacting any of our people who might know where the Viet Cong have their hiding places. Frankly, there's not a lot of hope he will learn anything important, but Joe seems to have gotten himself thoroughly involved in this thing, and badly needs to take some kind of action."

When St. John, ready to begin, turned to the side and met a bleak stare from the empty blue eyes of his aide, he found his rage resurfacing, and knew he could offer these angry people no glib palliative for the acute problem. What *was* it about this country where East met West in a collision that constantly produced spin-off problems for which there seemed to be no solution? But we are like them, he thought, and they are like us!

As ready as he would ever be, the Ambassador turned to the quiet

missionary at his elbow. Robert Gordon cleared his throat, lifted up his softly worn Bible, and read aloud the difficult passage from the very difficult Sermon on the Mount about loving your enemies and blessing them that curse you. Then he looked out with troubled understanding on the shocked, hurt, and affronted human beings crowding the school lunchroom. Closing his eyes, bowing his gray head, Gordon prayed for those who had died and for those who had killed and ended by entrusting to God those who are absent from us, "knowing that Thou art doing for them better things than we can desire or pray for."

While everyone joined him in the Lord's Prayer, the stout woman beside the tribal preacher Rau, she who had been living with him and caring for the child Drim, gazed about her on all sides, trying to understand from the slightly more resigned faces what the Head Man had said. When Rau seemed unable to explain, Kieu remained furiously bewildered and frustrated.

For a moment the Ambassador's gaze rested on Kieu's face so near the front. There was an enraged strength in her which stood out from the crowd. And he found himself telling this particular woman what had been done so far. When he had finished his report on the actions of himself, the military, and the police, St. John still saw his own fury and dissatisfaction reflected in the woman's face. Probably didn't understand a word of English. Aware of the newsmen, pushing eagerly from the back, hands already shooting up, the Ambassador ignored them and asked Mark Gardiner to put everyone into the overall picture with a quick summary of recent actions by the northern infiltrators and the Viet Cong.

Standing there, nervous as he was about Allison's fate, Mark was glad of the angry impatience communicated like support from these people. Knowing personally some of the journalists, he raised a saluting hand to their group before he began.

"Friends," and Mark wrinkled his high forehead, "I know it doesn't seem natural to deviate into past history when terror now, in the moment, is what we are concerned with."

The Ambassador leaned back in his chair; Mark was not going off his rocker yet. The flat Boston syllables revealed a level head and were somehow calming in themselves.

"But there is much we need to learn about violence and terror to help us in counteracting its power. For instance, before 1959 our Province Chief might have been knifed on the sly. But today Colonel Thanh and his wife

were shot, assassinated in public openly. Behind this action lies a decision of the Central Committee of the Communist Party in Hanoi to change from a 'political struggle' to one of 'armed action.' By October of '59 this new kind of struggle was well launched. In that year one South Vietnamese government or pro-government official was killed every day. This includes school teachers and public health nurses. While there were 193 assassinations in all of 1958, there were 119 assassinations in the last four months of 1959 alone."

Mark looked around, stilling the tremble of his hands by gripping the lectern. Only a few journalists looked interested. People sat there dazed, probably wondering if there was any point. For Mark the point was to talk and not feel.

"So you see that now in Dalat in April '61, we're part of a much larger campaign of terror. If you are asking why this is going on, why a fine man like Colonel Thanh was deliberately destroyed, I can only say individual leaders, like the Province Chief, with strength and integrity are likely to stand up to the Communist insurgents. Good opposition leadership is the greatest threat to the National Liberation Front. Silently and systematically the NLF is gradually wiping out an entire group of Vietnamese leaders. They represent a terrible loss for South Vietnam. A country's natural leaders are a resource that cannot be over-valued or replaced. We have to ask ourselves, can this country stand up for freedom against the northern Communists without its best leaders?"

When Mark paused, hands waved urgently from the back, penetrating voices of the press broke in. Mark gave the nod to a large black-haired American.

"Can we get down to cases, Mark? Ambassador St. John has outlined what efforts are so far being made to track down the terrorists and reclaim the woman and child. Would you mind telling us what or who you are looking for? What kind of a team does this terrorist work? What information have you got on them?"

Gardiner seemed to sway, just slightly. The Ambassador rose at once, putting his bulk at Mark's elbow. "I think I'll field that one, Mr. Hendricks. I've recently been fully briefed on the types we believe are responsible for this morning's attack. Your word 'team' is an accurate one for the *tu to dac cong*, or special activity cell, the most dangerous small element in the Communist structure here in Vietnam so far. The cell is made up of only three men, but they are highly motivated and eager to take risks. Members of the spe-

cial activity cell work in areas they know intimately. Such cells can strike anywhere at any time, and they are responsible for most of the spectacular acts of sabotage which have been committed, such as the assassination of leaders, dynamiting a bridge, or the burning of our airport here last week."

"Are the members of such a cell northerners, sir, I mean, from North Vietnam?"

"Some are northerners and others have been trained in the North. It's pretty much the same thing." He pointed to one of the missionaries near the front.

The man who rose identified himself as Reverend Henry Tyson. "Mr. Ambassador, why would they kidnap a woman and child who are not in your category of leaders at all?" Other people were nodding eagerly at this.

"Good question. At this moment all information seems to show that the woman and child simply got in the way of the assassins' escape, and were carried off to facilitate their getaway. It was also a smart move since the only two witnesses who might have identified the terrorists have been removed!"

"Would they be likely to ask for a ransom for the return of the two?"

"It could happen and has happened elsewhere, but not in this case so far." The Ambassador paused as he saw a sober-looking American Colonel enter at the back and take his place standing along the wall. This must be Don Altbacher, counterpart and friend of Colonel Thanh and his wife.

"Of course," he went on, "we are ready to meet any demand which will ensure the safe return of Mrs. Giraud and little Drim." Deciding to ignore the rest of the frantically waving hands, St. John bulldozed ahead. "And now, since there are no more questions"—there were groans—"I would like to make a final statement." He gazed fiercely about the room, quelling any signs of mutiny.

"It is very important to understand what the purposes of terrorists are if we are to keep them from succeeding. We have learned through studies by the USIS that terror builds morale within the revolutionary movement, and it advertises the movement among the general population. Terror disorients the people while it eliminates opposing forces. The Communists aim to whip up our fear and our emotions and keep them at fever pitch. I want you to think about this. If the Communists achieve these aims, they win and we lose. So what can we do?" Leaning his elbows on the lectern he bent, glowering, toward the audience.

"First of all, we can understand what they're about. And we can refuse to be railroaded into a helpless state of fear and loss of control. We can

decide to stay calm no matter what they do, because we are clear in our minds and hearts about our aims here in South Vietnam. President Kennedy has promised that we will make every sacrifice, bear any burden, to help all of us stay free. Knowing our goals are good and with our self-esteem high, we will stay disciplined in the face of the worst the enemy can do. In the war of terror every man, woman, and child is on the front line. I call on every person here to bring up his or her own courage and fortitude to the defeat of our common enemy!" Nodding briskly, St. John began to move himself and Mark toward the door.

Amid calls of "Mr. Ambassador! Mr. Ambassador!" he and Gardiner disappeared.

Bob Gordon went out to see them off. When he returned, the waiting group was considerably smaller. All the reporters had gone, to file whatever story they could make out of the Ambassador's briefing. They would be back, to the Mission School and the Ambassador's villa, but there was a respite from their importunity for the moment.

Gordon felt very tired. It was somewhat relaxing to see that the people who remained in the cafeteria were those of his own flock except for an American Colonel at the back. Joe Ruffin had just entered. Bob's eyes met Joe's across the room. So he had found nothing.

Gordon cleared his throat. "Here we are, gathered like one family. Why don't we draw in closer to each other and share our fears, our questions, our information, and our constructive ideas?" The people eagerly pulled chairs into a circle around their pastor.

Joe had come up to Pastor Rau and the woman who sat so heavily beside him. "I'm sorry," he said in Vietnamese, "so far I've found no news of your child or Mrs. Giraud or their captors. No one I've been able to contact has seen them. But men well acquainted with this area are searching carefully. Before long we will hear some news."

Bowing his thanks, Pastor Rau turned and spoke encouragement to the woman beside him, who held onto her granite attitude of despair. Charleen Tyson, sitting behind Kieu, wanted very much to say something about the power of prayer, but she felt timid in the face of the other woman's stoic hardness.

Pastor Rau stood up. "Reverend Gordon, do you believe that the death of the Thanhs and the kidnapping of this lady and my child are the will of God?" Charleen felt as though he had been reading her mind; it was her very own question.

Bob sat up a little straighter. Most people in the room understood some Vietnamese so he answered in that language. "No. I believe it was the will of man, not the will of God. But still I believe there can be a creative use of all this—even of death. 'Except a grain of wheat fall into the ground and die, it abides alone; but if it dies, it brings forth much fruit.'"

A mighty grunt of disapproval came from the Tonkinese woman.

Gordon inclined his head toward her. "Ba Kieu, please speak out and share your feelings with us."

Troubled, she gazed at the faces around her, then looked to Rau for help. He said, "These people love and accept us; they are our friends. You can say what is in your heart without fear."

Kieu drew a long breath. "The men who deal in death are evil. They should be destroyed, as they destroy innocent people. Why are we sitting here doing nothing? If your God of the skies is powerful, he will help us find them and destroy them so they can kill no more!"

The Reverend Hank Tyson was fighting in himself a strong feeling of emotional kinship with this non-Christian, immoral woman! His favorite hymn seemed echoed in her words: "Henceforth in fields of conquest, Thy tents shall be our home. Through days of preparation, Thy grace has made us strong, and now, Oh King Eternal, we lift our battle song!"

But Charleen, reaching out, touched Kieu's shoulder. "Oh no, dear lady, we have to love our enemies and pray for them; we mustn't fight back!"

A gray-haired Vietnamese pastor behind her spoke to Charleen in French. *"Madame, vous etes tres naive!"* When she looked bewildered, he went on in Vietnamese. "I can only imagine that your knowledge of the enemy is limited. Have you never heard of Christians like Tranh My Be, the pastor at Choudoc, near Saigon? He was taken by the Viet Minh and buried alive standing up. This horror was so shocking to his wife that she died, leaving two children. Can you really feel love and affection toward such evil ones?"

Seeing Charleen was helpless to respond, her eyes filling at once with tears, Joe Ruffin turned toward the old and bitter pastor. "But don't you find, sir, there are terrible cruelties perpetrated by the other side too? I've even heard it said that the VC are the scourge of God upon the corrupt South Vietnamese government and the atrocities of their secret police."

The older man's mouth tightened in a thin line, but Robert Gordon held up his hands. "We have to be very careful. It's so easy to be angry at either side. In the stress of suffering, we want to strike out at someone or something...."

While he paused before the imponderables of human existence, Charleen Tyson's voice was heard. "But Reverend Gordon, don't we have to learn to accept suffering and death? I mean, not denying it's a terrible sorrow, but don't we have to take up our cross…?"

Suddenly the tribal Pastor Rau stood up, his eyes flashing. "I do not believe we are meant to *choose* to be martyrs! If we must die, our God will help us die bravely, but I believe we serve him best by life. Life!"

And Gordon, seeing Rau, Joe, Charleen, indeed the whole group looking toward him said, "I think you are each giving us some kind of insight into this problem of pain. Maybe we have to be willing to suffer so we can learn to hear. Suffering can drive us to God for help!"

Joe was edging to the end of the row, drifting away, wandering off back to the search which seemed so hopeless. If only he could find her, and if only she would marry him, he thought he might even give up the whole Vietnam thing and go home with her to the States. If she wanted to. Anything was possible for love of Allison.

So he went doggedly on with the search for a while, but he felt himself giving up, surrendering, not because it was good to do nothing but because nothing could be done. And a certain stillness descends.…

A man climbing into a jeep saw Joe Ruffin going off down the mountain through the tall trees and remembered he had met the doctor at the Thanhs. Beside his driver, the U.S. Colonel leaned forward and pointed out the half-hidden driveway to the Ambassador's villa. The jeep turned in. When Don Altbacher walked into the front hall, the Ambassador and Mark were there, having just returned from the school. Both men had met the Colonel before. They thought he looked suddenly old.

"You have no further word about Allison?"

They shook their heads. "That sweetheart—" He stared down at the parquet. There were actual tears on his reddened, congested face.

"You are her friend," Mark said, "and a friend of the Thanhs. He was your counterpart."

"I don't know if you can understand." Altbacher looked around him, baffled, helpless. "It's bad enough about Allison and the kid, but this whole church thing should never have been allowed!"

As Mark began a gentle protest, the Colonel plowed right on. "Should never have been allowed with Thanh present, not to mention yourself, Mr. Ambassador, with all due respect. Not without maximum security!"

The Ambassador coughed. "Of course now, with hindsight—"

Don Altbacher turned on him. "You don't understand! *We can't do without them.*" Now he had their total silence. "The value of those two, of their kind, here in Vietnam cannot be measured." The Colonel looked desperately around the hall. His voice fell. "They cannot be replaced. There are so few. There's just no way...."

Action

*Be who you are, and become all you were meant to be...is the
only winning game in the world.*

Sydney Harris, Winners and Losers

The jouncing Renault with its blinded back windows had come to a stop.
In the complete silence Allison's choking gag was removed and she was
shoved out onto the ground. Kneeling, and then standing up, dazzled, swal-
lowing, rubbing her sore mouth, she saw nothing familiar at all in the sur-
rounding forest glade. But Comrade Kiem was already drawing a map with
swift lines in the dirt, explaining their situation in short impatient French
phrases, mostly infinitives and nouns.

Slowly Allison took in from his diagram that they were in a deserted spot
on a side fork well off the main road up the mountain to Dalat, the same
road she and Mark and the children had climbed excitedly in the Peugeot
only the day before yesterday. She and her captors must have come all the
way around the city on a seldom used track. Now they looked to be in wil-
derness not far above the Prenn Waterfall and Zoo. Little Drim was cling-
ing desperately to her waist. Patting the small shoulders, Allison shook her
head to clear away heavy discouragement and tried to get the men to remove
Drim's gag. They refused.

Comrade Kiem now made it absolutely clear that this was the exact spot
to which she should return after her visit to the villa of her friend for the
ransom items. She should return, that is, if she kept her side of the bargain,
and if she was capable of driving the Vespa, *and* if she did it all within an
hour of their leaving her off somewhere below the villa.

Allison was impatient with his "ifs." "All right. I know the road out of
Dalat and down to the zoo."

Rising from his sketch, brushing off his trousers, Kiem said he assumed

anyone would. On that road, and well out of Dalat, one kilometer below the first Prenn Waterfall sign, she was to make a left turn onto this unused trail. A kilometer more through the forest would bring her to this deserted open place where they could make the exchange. Looking around under the tall hemlocks, holding the mute Drim close, Allison saw that the narrow overgrown track branched here in two directions. If one path went back to the main road, she thought the other must lead downward in the general direction of the Prenn Zoo.

Sharply her elbow was grasped again. Kiem pointed to the tallest tree from which they would observe her approach. He looked at her keenly to see if she understood. And she understood. Even if she returned with an army, the men could still grab up Drim and escape. When Kiem shook her bruised elbow in a peremptory way again, Allison had to nod with reluctant admiration, feeling for a moment like a fellow conspirator. He would go far, she thought, whether upwards in the Communist hierarchy or away on the red scooter to other adventures.

Standing there in the tight circle of Drim's desperate arms, wondering if she could possibly bring this thing off, Allison heard the skeptic, Comrade Tang, begin to raise more objections. Pushing down her fear that it was all off, that everything was lost, she made herself listen.

Tang's worry was about the timing. And Kiem was furious with him for bringing it up—probably because he was worried over the same thing. If they were not completely gone from this area within a few hours, their situation would become dangerous, Tang said. Kiem was counting on the ineptitude of the South Vietnamese government and their lack of efficient organization to prevent any immediate military sweep, but the time of comparative safety would soon be running out.

"Get in the car!" Kiem ordered his confederate, eyes blazing. "The sooner we leave her off, the sooner she will return here, and we can disappear."

Allison wholeheartedly agreed. The sooner they got on with the whole wild project, the sooner it would all be over, one way or another. Looking down at the sketch once more, she had to be satisfied. At least it would be pretty much downhill from the villa. Maybe she could just coast back here, since she had little idea how to work a motorbike. That, however, was a problem for the distant future, some minutes away.

Tang was seated in the driver's seat again, and their argument had ceased. Each time she overheard their talk in Vietnamese, she had to remind herself to look uninterested, to respond only to French and in French. Kiem

now demanded if she understood and would comply. He checked to see if their watches agreed at 3:00 p.m.

"I will do my best to get back in the time, but if I am late...."

"We shall be gone," said Kiem, "and the child with us!"

"But there are so many difficulties; I may not...."

"You will suffice!" he said. So she and Drim were thrust back into the suffocating car which lurched onward toward the drop-off place.

And it happened. They actually left her off, blessedly free and mobile, in the lonely valley! But she did not pause to savor the moment. There were plenty of things to worry over and plan, trying to climb in heels and great haste up the back of the precipitous hill. High above, like an illusion, the turrets of the villa glimmered through the pines. It was the memory of Drim that worried her most. When the child had realized that Allison was leaving, Drim had sobbed into her gag. Tears had poured down her cheeks while Comrade Tang held her cruelly fast. That had given Allison courage to look at both men with the full power of what she felt for them in her eyes.

"When I return, if this child is not waiting for me, safe and well," her French was vehement, "I will speed away on my very fast scooter and you will get nothing!"

Comrade Kiem seemed unaffected by bourgeois emotion. "You had better be back in an hour then. The People's Front for the Liberation of South Vietnam has no time to waste on liars who do not keep promises."

Promises, she thought, were only important from the Communist point of view when they were expedient. However, she felt quite sure that Kiem was deadly serious about the time limit, so, struggling stiffly up through the thick underbrush, Allison took off her best white pumps, carried them a few yards, and tossed them away, needing both hands to pull herself up. The gray sheath dress was by now conveniently torn, allowing her bare legs to move freely after hours of bound mobility. It was a dear temptation, as she climbed higher, to turn left toward the school and the gray cottages. What a relief to hand everything over to Joe! But her inexorable brain reminded her that if Joe were gone, she would only have lost precious time and strength, might even bring the whole school about her ears.

And as she wiped her upper lip with the back of her hand, Allison surprised in her heart another motive, the instinct to protect Joe. She pushed on. What was one Frenchwoman? Nothing. But an American missionary might be more of a trophy. Missionaries had been killed already.

Her torn dress snagged suddenly on a weird spiny plant. Allison stopped

feverishly to disentangle it and also got hung up mentally for a moment. Wasn't this plant an aloe? Wouldn't it be a help to the burned man? Forget that, how was she ever going to bring this whole complicated adventure off?

Oh Max! Pulling at her skirt, sinking luxuriously into self-pity, Allison seemed to hear his gravelly voice exclaim, "Will you please to glance, Madame Giraud, at the heroine you are? *Mais formidable!* Perhaps at last you will admit that what you did about us, back then, was the only sensible human thing you could have done!"

The snagged dress came loose, and some inner band snapped too. Lightly, more eagerly, Allison went over the top. And there stood the villa, completely unchanged! She could hardly believe it. Across the courtyard at the back door, breathing rapidly with a hard pain knotted below her throat, she stopped to look at her watch. Three-twenty. A priceless twenty minutes had been devoured just in getting up the mountainside. It was again a strong temptation to find the Ambassador and Mark, turn the whole terrifying project over to them. But Allison knew the tight time limit made this impossible, so she prayed that Mark and the Ambassador would be gone, out searching for her, anything. Mrs. St. John too! She had no time or breath for explanations, no strength to fight back, if they should reasonably oppose the weird plan of action she had worked out with the VC. With God? Her bare feet slipped through the pantry and up the service stairs, *just* behind the stolidly turned back of the chambermaid who was putting away silver.

Regretting every single stair, Allison drove herself upwards. At the top, stunned, she heard James and Katrine having their usual argument next door. The clean beauty of her high room, the spread peace of the broad white bed, were like a mirage. She gave it all one incredulous glance and rushed into the bathroom. With the flushing of the toilet the children were on top of her at once. But when they saw her standing there gulping water at the basin, they fell back for a moment, shocked. Allison took advantage of the pause. First she grabbed up the large tube of E ointment from her first-aid kit and then ran back into the bedroom to fumble through her small jewelry box. The children followed, round-eyed.

"Mummie, we've been so worried! What happened to you?" Katrine was horrified. "Just look at your dress and your poor feet. Why, you look perfectly dreadful! And they said you were kidnapped!"

"Ummmm." Allison's eyes narrowed as she plucked from its velvet nest the emerald ring Max had brought her from Singapore, the most beautiful and blatantly valuable thing she owned.

Katrine drew close. "Mummie, I was right after all, wasn't I, Mum? There really *were* VC, and they really *were* after you!"

Allison pushed the great ring down on her finger. "Katrine, *ma chère,* you were absolutely right. How right you were!" Turning, she felt two arms in a clutching rush around her waist, a teary face against her breast reminding her of Drim.

"Oh, Mummie, we thought you were gone! We were so afraid...." Allison's body was shaken by Katrine's sobs—brave, tough, independent Katrine!

And a wail started up from James. "We were so *afraid,* Mummie; we thought you would never come back!"

"Well, I'm not gone, you two. You're not going to get rid of your Mum so easily!" and she arranged them both in front of her, lovingly, sending up a quick prayer.

"Now, Katrine, there is something important and exciting to do. You and James can help me; it's a real life game against the Viet Cong." She had their complete attention. How perfectly dear they looked, open to anything she might suggest. Had she ever fully realized how unique her children were? "You see," she hurried on, "the Communists kidnapped me along with a little mountain girl named Drim...." It sounded too wild to believe, but not, apparently, to the children.

"We know! Bao and Monsieur Bep told us everything!"

"Good," she said, relieved. "Now listen, if you will help me, I'm going to trade them Bao's red motor scooter for the little girl, and I'll be back again in no time."

Katrine was nodding. "For a ransom. But Bao will never let us have his new scooter! And anyway, he isn't here. He drove Mark and the Ambassador away somewhere to try to find you."

Just as well, Allison thought. "Now, Katrine, you run down to Mark's room. I think his typewriter is on the desk. Put it in its case and bring it down to the back yard *quickly.* James, you run as fast as you can and tell the cook I'm coming right down to talk with him."

Gazing for one last time into the green deeps of her emerald, Allison added more slowly, absently, "I'll be right there...." But her henchmen had disappeared down the stairs. What time was it? She was afraid to look at her watch, and the little traveling clock had run down. Alone for a moment, as she twisted the great ring on her finger, Allison noticed sharply how much her feet were hurting. Automatically then, getting out her tennis shoes, she

shook powder inside them and tied them on over her sorely cut feet, but she was moving more and more thoughtfully.

It was only when she stood up and glanced in the mirror that Allison came to a full stop. She saw a stranger. There was almost nothing familiar about the tangled hair, the dress, stained with kerosene, dirt and sweat, the pale, anxious face bare of everything except smudges. And in that same moment she glimpsed her ruffled yellow negligee swaying lightly from its hook on the back of the door behind her, like a daffodil in spring.

"Are you out of your mind?" Her old pretty self seemed to survey the forlorn type in the mirror and couldn't help laughing a little. "What in the world do you think you are doing, Allison Giraud? Why don't you just—stop?" It was a smiling question. There had to be a lot of humor in the situation.

But another Allison stood there, shocked and vulnerable, taking in the sane comforts around her; her firm white bed, her own consoling bottles and jars, the serene view from the windows, the actual possibility of a hot bath! Numbly she reminded herself, "There's Drim! I must get her back...."

"What, *you*, old dear? On a red scooter you don't even know how to drive—in that outfit?" The tiny laugh struck home like a splinter of glass. Allison winced. It was pretty corny. "Now really! Don't you give Mark and the Ambassador credit for having at least a better plan than that?" The so-feminine voice seemed to hint at over-emotionalism and even aggression! "Haven't you already done your bit? Surely now the sensible thing is to turn it all over to the experts—and relax."

Trembling, Allison sat down on the edge of the bed. It certainly was a wild goose chase. In a flash of imagination she did stop, drank all the water she thirsted for, took a deep hot bath, and stretched out full length in the lovely linen sheets. After all, she really could...just...stay. With a weary sigh of sensible relaxation, Allison let herself slip back, completely blanking out God, Joe, and the sobs of Drim, along with the moans of the man with the hideous burns. She was just plain exhausted.

There was one drawback. As Allison slid once more into her old consciousness, she felt again the familiar pain. There she was again, the same flat person of that very morning, aching and empty, guilty, fretfully thirsting for meaning, for selfhood. She frowned with surprise. Suffering. Apparently that was not to be avoided either way.

"All the time I thought you could escape it, somehow." And Allison stood up.

Then, hurriedly, urgently, came the voice of her other self with the clincher. "But aren't you afraid?"

For a few almost fatal seconds she fought this one off. After all she had been through today, she had certainly proved her courage.

"In that case," said the devil's advocate, "why don't you move right on with your adventure? What are you waiting for?"

Oh God, Allison thought, I am absolutely terrified. How did I manage to avoid realizing that until now? I'm not only afraid to go back to Comrade Kiem and Comrade Tang, I'm even afraid of the cook! She sighed. So what? Afraid or brave my time is running out. Decisively she looked at her watch. Amazing how much could happen in a few seconds.

Allison gave one last wry glance at her yellow negligee, now hanging limp on the door. She drew a deep breath for action. When you try this crazy abandoned way, you get right outside of yourself—for hours! And once you have tasted the difference, what you dread most is going back. Having looked squarely at her fear, she felt somewhat better. For just one more split second, she regarded the possibles. And it swiftly emerged that the only way to feel real was to keep right on with the business in hand.

Out in the courtyard behind the villa, Allison faced the approaching cook, searched those opaque black eyes under his slightly raised brows. Pushing down her old mistrust and pushing away his polite protestations of relief at her return, she asked a few questions. It was good to find out that everyone was over at the Mission School working on the problem of catching the terrorists and getting her and the child back. It was bad to learn that Kiem, Tang, and Thom were undoubtedly assassins, having murdered the Province Chief and his wife. But she reeled for only a moment, thinking of how those very killers would be growing nervously, sharply irritable with little Drim.

Allison launched her appeal as a cool statement of fact in French. "I am going to ransom the kidnapped child with Bao's motor scooter. I regret this, but it's the only thing they want, except Monsieur Gardiner's portable typewriter."

The cook's face went blank. "My son is not here; I cannot allow...."

Allison did not attempt humanitarian pleas. She held out the magnificent jewel on her palm. "I know this emerald is probably more valuable than the motorbike, but I have no time to bargain. You and Bao may decide afterwards either to keep the ring or ask me to replace the Vespa. It will be up to you." She could not read a certain light that appeared in his eyes. "The

children here, and your wife," she pointed to the open-mouthed woman who had just joined them, "are my witnesses." Allison put the ring into his nerveless hand. "And now if you will please quickly teach me how to work the bike."

"But, Madame," genuine admiration had sprung up in his voice, "surely Madame will not return to the Viet Cong terrorists alone and in this fashion. *Monsieur l'Ambassadeur....*"

She looked him in the eye. "If I don't return alone and with the scooter in fifteen or twenty more minutes, they may kill little Drim, or carry her off to where we can never find her again." Katrine and James were excitedly pulling the red Vespa out from the wall of the garage, tying the typewriter onto the carrier with Bao's green and white elastic. While the cook ran his hand nervously over his hair, Allison thrust the vitamin E ointment under the band.

And she changed urgently to Vietnamese. "Please, hurry, Mister Cook, show me!"

The childish plea did it. "I will do my best, Madame," he said, returning to French. "This will not be necessary," and he handed the ring to his wife, "but we will keep it until your return." Her return! In spite of his dignity, Allison wanted to embrace him. And to think she had figured him as a spy for the VC!

Madame Giraud was so unmechanical that the cook had grave problems. All she wanted was to learn how to start and stop. However, as he anxiously tried to explain, gears were vital. Allison decided she was ready before the cook was nearly satisfied. Her minutes were running out.

Katrine and James danced wildly about the sunny courtyard as their mother stood astride the machine in her sneakers and torn dress. Ruefully noticing the children, Allison felt cold with a terrible fear that broke out in perspiration.

"Come here and kiss me, you crazy dopes!" The first tears of the day stung her eyes. "Now," her voice trembled and she steadied it. "Watch what Mummie can do!" Thrusting down hard three times with her heel, she powerfully felt and powerfully heard the motor's roaring answer. Then, shoving in the gear with hand and foot under the cook's worried eye, Allison was off, much too fast, careening around the house and down the drive.

There was no time or balance for looking back, but she could hear faintly behind her the children's cheers. That cook turned out to be a really nice man, Allison thought warmly, thankfully, as she bumped down the rutty hill

and out onto the road along the lakeside. Appearances certainly can be deceiving. At a sudden perilous wobble she realized she was actually *on* the thing and away! With vibrating hands she held hard to the road edge beside the fleeing landscape while the wind stung more tears into her eyes and a strange elation woke in her heart. Joe, look, I'm flying! A terrible jolt from a pothole brought her back to the matter in hand. Rehearsing her landmarks, she began to watch carefully for the turn-off, and the machine steadied. It was all downhill.

Lifting her head so the wind could blow the hair from her eyes, Allison didn't look beyond the rendezvous. At every point in this wild adventure, her ridiculous efforts had been met by something more. Something extra had somehow always been added to her slim resources, and her faith was growing.

"Don't worry, Drim, don't cry," Allison murmured, "I'm almost there!" And tearing into the wind and the intersections, bouncing violently over rough spots, bending dangerously into the turns, she went on. You will suffice, Kiem had said.

Unconventional Warfare

But somewhere in infinity opposites meet.

Madeleine L'Engle, Camilla

Kiem looked at his watch. He did not wish to be waiting for this Madame Giraud. Women had spoiled his aim all day, blocking the path of correct strategy. The Vietnamese woman, wife of the Province Chief, who placed herself between her husband and the second bullet, had destroyed the purity of his action! Kiem had never wanted to kill her; never planned or intended to. And now this foreign woman had inserted herself outside the church at exactly the wrong moment so that they were forced to kidnap her, forced to burden themselves with a female and a female child. All of this was wrong, maddening. How often was woman unpredictable, the enemy to logical action and thought, enemy to calm tranquility, stirrer-up of self-doubt and all the unreliable emotions! She, the Yin, was very well in her place, but a burden to herself and others anywhere else.

Striding up and down in the clearing which he had designated as the meeting place with the Frenchwoman, Kiem stopped suddenly to gaze down the track by which she would come, if she came. He could imagine her slim form, her pale, delicate features, soft hair blowing, gray-green eyes blazing, light fingers tightening. One must concede in one's secret heart that this woman was dangerously attractive. French, after all! Had not Uncle Ho himself once said, "Moscow is heroic. Paris is the joy of living"?

Meanwhile Comrade Tang leaned stiffly against a tree, too tense to sit or even squat on this occasion. He watched their leader fiercely striding, then stopping suddenly in dreamy abstraction. Tang's perceptions were acute. What he sensed now made him very uneasy. He and Kiem had returned to the agreed-upon meeting place in the car with the little girl. They had driven the vehicle well into hiding in the undergrowth, locking the troublesome,

but gagged child away inside with Comrade Thom, who had been picked up at the hut. Now they were here, waiting for the return of the woman, dangerously waiting. He cleared his throat and frowned. When Kiem looked up, Tang let the leader see both his anxiety and his criticism.

But Kiem spoke calmly. "Eleven minutes are now remaining, Comrade Tang, before the return of the woman with the ransom. There is just time for you to climb that tall tree over there to observe the area carefully and be absolutely sure she is unaccompanied. If there is the slightest sign of support, military or otherwise, you will at once descend and we will disappear by my secret route, deserting Thom and the child."

As they looked up into the tree, Kiem was aware they had come to a hurdle. Tang could easily manage to climb the hemlock; its boughs reached out handily at comfortable intervals all the way up. But the matter of dignity, of face, was more difficult. And at the thought of a hurried descent, the possibility of the dangerous, as well as the ridiculous, loomed.

Tang studied the tree, his chin lifting sharply. "For a man of my maturity," and he shook his head with decision, "this action is not appropriate."

The eyes of the younger man narrowed. "It is necessary for me, as leader, to handle the ransom and trade-off. I quite agree that Comrade Thom was the appropriate cadre for the observation assignment. However," and he paused for emphasis, "I can only call to your attention, Comrade Tang, that the life of our special action cell is at this moment seriously endangered. Our successful sabotage of the airport has already drawn government attention to Dalat. The assassination of the Province Chief plus the complete frustration of the enemy's propaganda in the form of their new united church has shown us to be altogether too successful. The sooner we get rid of the woman and child the better. Our cell must immediately disappear and regroup later." He did not express his further thought: Have we bitten off too much? Will we die for it?

Tang's voice had an edge. "Exactly. I am perfectly of your opinion, Comrade Kiem. Let us therefore disappear on the instant and forget the climbing of trees for the benefit of a Frenchwoman who is of no value to us. Of course," and his eyes glittered, "if the possibility of seduction or rape is of more importance...."

"Chutt!" Kiem cut him off, his stare icy. "You forget yourself, Comrade, and you are also forgetting essentials. The burned cadre, Thom, creates a serious problem. If we leave him behind, he may be tortured for information. He doesn't know much, but what he does know is too much.

"We also cannot return him to his village. The burns themselves reveal his part in the church affair. They would be most difficult for him to explain. Of course I could simply eliminate him, as I can eliminate any cell member who becomes a burden or impediment. In Thom's case, we would be wasting the years of his indoctrination and training at Xuan Mai.

"Therefore my plan, *the* plan," he continued with force, "is to take Thom north with me on the Vespa, which will sometime tonight or early tomorrow be repainted and disguised in our hiding place beyond the waterfall. You may then take the car if you wish, or the bus if you feel the car is now too dangerous, and remove your family back to Hue until you hear from the Party again. The Vespa offered by this woman in exchange for herself and the child is a stroke of luck for us. And so, in this way as I have outlined, we shall be able to dissolve our too-successful cell and remove ourselves to await in safety the fading of our notoriety."

A gloomy Tang studied the ground at his feet. But these northerners really love notoriety, he thought. They thirst for fame. *He* will return to the North. *He* will report to Headquarters and gain much face in his own person for the dangerous efforts which all three of us have exerted.

"And how am I to maintain life for myself and my family as poor refugees?"

Kiem glanced again at his watch. "Hue is your own family home. You have important relatives there, as you have often stressed. Also, as Treasurer of our cell, Comrade Tang, you will allot to Thom and myself only a few hundred piasters for our northward journey, keeping for yourself the remainder of our savings to continue life for you and your wife and children in Hue until you are able to find work again in the Struggle. You are of value to the Party and the General Uprising. The Party does not forget its obligations."

When Tang's nod was only grudging, Kiem then responded with anger, all the more hot since he himself was becoming impatiently aware of the peculiar importance to him of this foreign woman's coming. "As for your insinuations about the possible misuse of the Frenchwoman by myself, I can only remind you of the four virtues instilled in us by our leader, Comrade Ho Chi Minh: industriousness, frugality, justice, and integrity. Rape is not in any way the correct behavior for myself as your leader, nor for any member of this cell. Now it only remains to point out to you, Comrade, that it will be suitably industrious for you to climb at once to the top of the tree for immediate observation!" Kiem turned his back so as not to submit Comrade Tang to undue embarrassment as he obeyed orders.

This of course he did, leaving Kiem alone below. When the climbing sounds had ceased, it became very quiet. Waiting there, it occurred to the cell leader that his isolation in this forest was what distinguished the guerrilla from the regular soldier. For a guerrilla the home front was always far away. The enemy, more numerous and more powerful than he, could be anywhere. Here at any moment, the ARVN might institute a thoroughgoing sweep. Kiem's sense of being a hunted animal was never far below his thoughts. And yet he knew what the daring of just one individual guerrilla could accomplish. He had only to remember a story like that of Ba Bua, the heroic peasant who had entered an entire army post of the enemy, shot the commander, and successfully got away! Comrade Ba Bua, of course, had had no woman problems.

Still, one was forced to admit that in the national history there had also been heroic females. Perhaps because of Mrs. Truong Vinh Thanh's sacrificial death with her husband, the Province Chief, Kiem began to think, as he waited, about brave Vietnamese women. There were the Trung sisters, who had captured sixty-five cities and founded a kingdom. That was in the first century. How shameful this is for us, he thought! In spite of the example of two mere women, we have remained slaves to occupying powers from the Trieu to the Ngo dynasties!

Just at this moment, incredibly, he heard the sound of a motorbike approaching, vibrating unevenly with the bumps, but coming rapidly nearer. Kiem looked up until he could see Tang's head peering through the branches. High, high above, clinging to one of the topmost boughs, Tang gazed out all around. Then he gave the agreed signal with the flat of his hand. She was alone.

Watching along the shade-dappled narrowness of the track, Kiem saw the woman on the Vespa veer uncertainly toward him. He looked at his watch. She was actually one minute before the time limit. There were very strange feelings within the mind and heart of Kiem as he watched her bring the vehicle to a shaky halt, turn off the ignition, and tumble from the saddle onto the ground. She rose, dusting her hands on her ragged skirt, straightening her thin shoulders, tossing back her brown silk hair. There was a light in her eyes as she came up to him. She gestured toward the Vespa with the typewriter strapped onto the carrier, and then reached back for a large tube tucked under the elastic.

This she held out, saying in French, "Your friend's burns should be cleaned, treated with this ointment at once, and covered. The aloe plant,

which I think grows in this country, would be even better, but I had no time to get any." Kiem stood staring. She had actually done it. She had returned.

"If you do not attend to it immediately, your friend will be much more difficult to save!" Kiem accepted the tube automatically, but frowned his seeming disapproval. It had not occurred to Allison that he might hate her all the more if she made it back.

So what? She drew a deep breath. "And now I have kept my part of the bargain. Where is the child Drim?" Allison turned about in every direction, searching the glade with her eyes.

Meanwhile, what Kiem felt with horror was not hatred but the contrary! She had disarmed him of his anger by being brave, by being worthy of his trust. He struggled to retrieve the proper hatred.

"The child is hidden nearby in the car, but she will not come with you, a foreigner. She will remain here with Comrade Tang and his family in order to be properly trained for our nation's Struggle!" He was rather pleased with himself for having come up with the whole thing complete and right in a second.

There was, however, very little time for self-congratulation. The woman rushed at him like a demon, kicking and striking at every place on his body she could reach, and screaming with rage the while about his false promise and his lying tricks and his evil, murderous....

With his arms up to defend himself, Kiem heard Tang, high above, crashing down the tree to his aid. While fending off the female wildcat, Kiem managed to shout to Tang that he should *stay there and keep watch*; he, Kiem, could take care of one crazy woman!

And, after quite a struggle, he did get hold of her arms, forcing them behind her, gripping her against him. They were breast to breast, eyes blazing, the very furies panting out of them both. Kiem started to crow with triumph just before he realized she had been cursing him in French and *English* and *Vietnamese*! He saw in her suddenly faltering gaze that she realized her mistake. She had given herself away. This woman had understood everything from the start! Again commanding Tang to stay where he was and keep watch, Kiem dragged her unceremoniously off into the forest.

Allison stumbled weakly after, like a victim. There was a certain justice in it. They were equals after all in deception. Like a victim! Fiercely then she shook free, and he let her go. They stood there facing each other under the tall silent trees. The two humans were small in size, but very large in vibration. Allison rubbed her wrists, glaring at Kiem's imperious good looks,

remembering what her children had said about the death of the Province Chief.

"You are a murderer," she told him, "a killer of innocent people!"

He was astounded. "Not so! A Province Chief has been purposely and rightfully removed, a Province Chief who himself chose to stand in the way of one Vietnam, unified and free of foreigners. As for his wife, she took her own life by getting in the way. That is not our responsibility; we cannot control such erratic behavior."

But he looked away, and Allison thought she saw his hand move slightly toward his hip. There seemed to be something heavy there. Was it a knife, or the gun, the same gun he had used at the church? Allison was so angry about the murders and about his refusal to produce little Drim, after all her efforts, that she could hardly breathe. In any case there was nothing else to say. As angry as she had ever been in her life, Allison determined to kill him.

They were standing close, and like a flash, she reached into his pocket. There *was* a gun, but it went off just as she drew it out and found the trigger! When the impact of the shot was past, they both saw she had fired into the ground near Kiem's left foot. Allison still held the gun, not believing she had actually fired it.

"And now who is a murderer?" His nostrils flared. Before she could lift the gun again he had thrown her to the ground and they were fighting for it. Kiem held her down with his body and wrenched the pistol from her fingers, tossing it away to a safe distance, but calculated, so that the weapon would not be lost to him.

That was his very last logical thought for quite a while. Beneath him he felt her thighs shifting, the round breasts taut with tension against his chest, her breath coming in warm gasps against his cheek and neck, her fists pounding his shoulder blades. When Allison began to scream, Kiem stopped her mouth with his own. Was the clash a kiss? He did not feel the blood of his cut lip; she could not tell when their fierce hatred became another passion. The driving pulse of it overwhelmed them, strung him into rigid power, unstrung her into sudden yielding. She wore only a pair of pants below the torn dress. What he did about their clothes, he did with one hand unconsciously, curving the other about her breast, his thumb light on the rising nipple.

Kiem and Allison saw nothing and heard nothing but the rhythmic tide rising inevitably in their bodies, intensifying the life of every cell. As his movements drove in and out, she felt the uncontrollable onset of her orgasm which seemed to follow his release in seconds. The electrical exchange set

both their bodies alight from the lowest centers to the very highest. For some moments afterward they lay as though fainted, before they hungered impatiently and seized each other again.

But after this, each paused to look at the other. The faces so different reflected the same shocked astonishment. And suddenly Allison heard her own hysterical laugh. She couldn't help it. Kiem looked exactly as she felt. Their situation was fantastic, funny! Hadn't she been about to kill the man? The bewilderment in his black eyes turned to sparks of light and he laughed too, his shoulders and his whole body shaking with it. They both laughed helplessly, before they came close again, gazing into each other's eyes. Kiem's hands closed gently on her waist, and he felt her hands clasping the back of his neck. So they made love again, this time more consciously, with meaning and intention. It was very beautiful.

Afterwards they lay together on the ground looking up through the tall trees. He knew the wonder was over when finally he heard Tang's furious catcalls from the top of the pine. Aware that nothing short of an oncoming enemy force would take Tang from his post as guard, Kiem looked at his watch. She knew it was over when she heard the muffled bumps and unintelligible noises of the suffering child locked in the car.

Allison sat up. Tears filled her eyes. Here was a man like Max. Here in this strange enemy was a passion to match her own, something she must have been unconsciously looking for, something so hard to find behind all the masks, among the men she knew, so afraid to love, afraid to hate. Here was an enemy, a man of pride and grace and courage, what James would probably call a "cool dude." He was a very tiger, and yet for just this moment, now, he was her own.

Kiem sat up too, and kneeling opposite touched the corner of one of her brimming eyes. If his own eyes were not full of tears, there was a new shining softness in their dark depths. Here was a woman of courage and grace and pride, a very tiger of a female, and for just these moments she had given herself to him in wild and willing passion. He sighed. She was not only a foreign woman, but even his enemy, doubtless English or American.

And yet Kiem could not help saying, "What an addition you would make to the Peoples' Struggle!"

Allison smiled with delight at the strange compliment. Then her face fell. "I guess there is no way...?"

"No way." His beautifully carved mouth became a line. His eyes were quickly dead. "We are enemies."

"But perhaps we can part friends, and somehow stay in touch—until all this is over...."

"*No.*" Kiem stiffened. "You weaken my hatred for your kind."

At last they had to pay attention to the annoying bird whistles coming impatiently from somewhere up high in the trees. Kiem rose, reaching down to take her hand. He pulled her up close then, and looked very seriously into her eyes. "There is nothing further for us."

Allison's brows drew together like a child's, her mouth starting to protest. His strong hard hand covered her lips, and he shook his head slowly. "There is nothing." She saw the pain in his eyes over this extraordinary experience, their oneness. "But there is something I can do for you which will not weaken my principles or my cause, at least not very much."

She laid her hand then against his lean cheek. Kiem took her wrist, and gently drawing down the hand, put her away from him. "I can give you the child, and send you both back to wherever you came from."

When he turned at once, Allison followed, pulling at her skirt, smoothing down her hair. For this moment she really did not know who she was. But she seemed to know who he was, and said eagerly, "I can be silent, so they can't follow you and find you."

Kiem paused. "You think so now. But later, would you betray your country?" And he remembered that this woman, who was only his for now, knew Vietnamese and had probably understood his escape plans for the cell. At once he became sharply objective. By the time she and the child can walk to anywhere, he thought, we will be far away with our two vehicles. However, we can no longer use the tunnel behind the waterfall as I planned. Swiftly we must take both scooter and car up to our furthest mountain hideout and spend this night repainting the Vespa for my run north with Thom. The automobile shall be destroyed. Comrade Tang will have to take his family back to Hue on the bus. Kiem moved directly toward the hiding place of the car in order to release the child.

The woman followed. Her hand touched his arm. "But, we are friends...."

"No." He turned back for a moment. "I have told you. You weaken my hatred for your kind. We cannot ever be friends. But we are already lovers, and that must be for us something."

Following again as he strode ahead in his supple grace, Allison thought, it is something.

When they passed the tree, the sentinel comrade whistled several times

furiously. Kiem looked up, shading his eyes. "Someone comes?" he called softly.

Tang replied, "No," but began at once to remonstrate hoarsely. Kiem stopped him. "Keep on watching! Only a few seconds more, Comrade." A snort was heard from above.

Even Drim's tearful joy at her release and reunion with her American lady did not lift Allison's feeling of emptiness. Kiem did not kiss or embrace her. In one sober look exchanged, they shared their acute sense of separation, of lost completeness. He pointed the way back along the trail.

She glanced in that direction before turning again toward Kiem, unable to leave. Then, ceremoniously, Kiem bowed to her, his hands in the Eastern prayer position. Allison placed her hands together too, and bowed to him. They looked at each other one more time.

She gripped the child's hand. "We are going home." It was okay now to speak in English. Drim was still able to bounce a little, pulling Allison away along the trail to freedom, while looking back anxiously for fear of pursuit.

"Maybe they will chase after us!"

Allison did not look back. She couldn't see ahead very well either. "No, Drim, they will not chase us. So let's get started. It's a long way home."

Aftermath

And after the flood of tears...there is joy, the simple, matter-of-fact joy of existence.... For beyond the pain, beyond all the man-made walls, there is always the elemental vibrancy.... It is the sheerest, most miraculous ecstasy. It is nothing special.

G.B. Leonard, The Transformation

It was over. At first while Allison, her hand on Drim's shoulder, plodded numbly along the forest trail toward the main road, this was her only thought. It was over. But as tears dried and vision cleared, she did not know herself any longer. Totally involved for the past hours, now letting go, Allison sensed that her inner landscape was somehow changed. As after a hurricane or a typhoon, the air is cleared. Still, it was best not to look too closely, not yet; best to keep putting one sore foot in front of the other inside her ponderous tennis shoes.

But Drim dragged behind, begging to be carried, entirely changed, too, from her former saucy, independent self. Now she was cowed and whimpering. "We had a terrible time, didn't we?"

Allison stopped to focus on Drim's need. "Well, it's over now," she said, "we are quite...safe." Pressing her lips tight on each other with resolution, she picked the child up and adjusted her on one hip as Vietnamese mothers do. Drim was too old and much too big for this, but she had been through a lot. While Allison paused to catch her breath, she heard no sound behind her and resisted looking back. It was over.

Changing the now relaxed and heavy child's body from hip to hip occasionally, Allison drove herself on until they reached the two-lane highway that climbed toward Dalat. She looked up and down the road. Nothing was coming. Somehow it was not surprising that the gradual softness beginning to fall around them was rain.

This came at first as part of her relief, a gentle blessing. So she hitched Drim a little higher and started on up toward the town. But very soon the rain was coming down in earnest, dimming sight and discouraging progress. Striking her calf against a huge, shelf-like rock at the edge of the road, Allison stopped. She removed the tight little arms and slipped down onto the handy ledge of solid stone, shifting Drim into her lap. The rock was cold. She would probably grow numb sitting there, but it was good to feel strongly supported. And later Allison found the stone had taken on a little of her own warmth.

Perhaps a car would stop for them. None did. Although the few cars passing spewed out muddy water, Allison felt too shaky to rise, and her frantic signals were ineffective. Kicking off the tennis shoes, she cooled her burning feet in a chilly puddle. And with Drim's head pressed lovingly against her shoulder, any desire for further action slowly ebbed away. Allison rested on the rock in the merciful rain. I couldn't possibly do another thing, she thought peacefully. And there's really no need. It's all over.

Yet, in her body, she could still feel the deep central glow of her union with Kiem—my enemy, my Viet Cong, "my only love, sprung from my only hate." How could this possibly have happened? Men like Kiem had murdered her husband. Kiem himself had shot and killed Colonel Thanh and his wife. And yet the shudder over his violence seemed to be one with the shudder of tenderness at the dark smudge of his lashes, the joy-producing strength of his powerful youth. How terrible; how strange!

Encounter with the enemy. It happened, she thought in amazement. The thing I most dreaded finally happened to me, and it's.... How can something so bad turn out to be so—lightening? Maybe kissing the dragon had changed him into a prince. No. Kiem might be as proud as a prince, but he remained a real dragon. This was no fairy tale. Nor was it a rape. How to bear thinking of that?

Think instead of what I accomplished! What I did in an hour to ransom myself and Drim. And yet I would have killed him. I tried my best to kill him. I was so enraged when he refused to free Drim as he promised, I am almost a murderer too.

Wait, she thought anxiously, wiping the rain from her eyes. I must try to grasp something. There's some important meaning here. After I tried to kill him, and missed, then what happened? All our hate and passion somehow ended in letting go. We, my enemy and I, in spite of ourselves, in the moment of our clash, came to be one.

But we are totally different. At once afterwards we have to go our separate ways, though possibly neither of us will ever be the same again. Can there be oneness and difference at the same time? That's the hope.

Thinking of Kiem, feeling Kiem, Allison's eyes stared right through the tall tree shapes, leading deeper and deeper into infinite, odd dimensions. And nearby, only just across the road, she saw one of her tree ferns uncurling its quaint fronds to the delicious shower. She didn't know whether she was looking through the lens of rain or of tears. They had let go, she and Kiem. Tears are for letting go. Or does letting go always end in tears?

There certainly was a strange shimmer about the fern frond she happened to be watching. It appeared to flicker with vibrating life. Surprised, Allison moved her focus to the hairy trunk. And that too seemed to dance with a flame-like energy, just as its drooping wands of wet green lace appeared to be lifting. Allison caught her breath. Something was happening. Something was being shared with her!

Tentatively she moved her lens to the right. A neighboring vine sprang into the same quivering light. All very well for nature, Allison thought, spellbound, but it won't be the same for man-made things. Deliberately she directed her lens to the asphalt of the road. At once it came alive with that peculiar shimmering life! Astounded, she discovered that anything within range, the crystalline mineral of the supporting rock, the line of a roof in the far distance—everything, like and unlike, was alive and dancing, fast or slow, with the same electric energy.

There were no words for it, but there was sound. Staring at the tree fern she seemed to hear its music, if not with her ears. The primitive fern tree and the neighboring giant hemlock were singing, were part of an unheard symphony. The air quivers. There are bells blowing on the rain-swept wind. Newness is tumbling through the air, flaming through the forest. Every different thing is alive with the bliss of one energy. Sitting stunned on her rock, Allison listened.

And the whole sudden awareness glowed with the presence of love, a passion of oneness expressed with Kiem, but not ending there. Why, God, whatever you are, Allison thought, staring in wonder through the silently singing life-shapes of leaf and tree and rock and road, I never dreamed you cared so much! Hugging the heavy child to her like a secret, she gave herself up to delight. Joy not known since her girlhood blazed and bloomed and sang around her rock in the rain. Maybe later she could tell Joe. Maybe he

would believe it. But for now she would just be still and wait and watch and listen. If she even moved, the magic joy might slip away.

It was Drim who moved. "I'm hungry!" She sat up angrily, and her elbow dug into Allison's ribs. "What are we doing just sitting here in the pouring rain? I'll catch cold! I could even catch pneumonia. I want to go home to my Daddy right now. I want my supper! I'm wet, I'm cold!"

Allison straightened up. She was a mother, after all. "Yes, okay, Drim, we'll get up and go on home." Looking down for her soggy tennis shoes, she lost sight of the vision at once. When she glanced up and down the road now, it had become dark rain-shiny asphalt again, nothing more. Well, there was something more. A police jeep chugged past in low gear, a man peering out of it on either side.

Through the foggy dusk, the two figures on the rock were so much a part of the landscape that the jeep almost passed them. But Mark, turning, straining his eyes, waved the driver to halt, got out, and ran back. With a shout of triumph he lifted the two, helping Allison to her feet.

"My God, *Allison!* Are you all right?"

She smiled at him. "Yes, we're both okay. But Mark, it's wonderful you happened to come by just now! We were starting to get really tired."

"And cold, and *hungry!*" Drim bounced with outrage on Allison's hip.

When Mark tried to take the child from her, Allison didn't let go, so he led them both carefully toward the jeep. "Where are your shoes?" he asked, looking down, horrified.

"Oh," she said vaguely, "I may have left them by the rock," but she didn't look back. She knew she couldn't regain the wonder. Now and in the future she could only try to remember what it had been like.

The policeman was sent for the shoes while Mark settled Allison and the little black girl in the back of the jeep. Allison sighed happily and continued to smile at Mark, shivering a little, her teeth chattering. He wrapped both of them in his jacket, since Allison never relaxed her hold on the child. Like a prize she has won, Mark thought.

"Don't worry," he urged. "I'll get you right back to the villa in five minutes flat, and later, when you're warm and dry, you can tell us all about your experience. Allison, you've been magnificent! The children told us—"

But she interrupted. "I think we'd better take Drim home first." She glanced down at the very familiar black braided head. "Her parents must be

frantic." The man in uniform had handed Mark the dripping, dirty shoes and was starting the jeep's motor again.

"Magnificent," Mark had said. Had she done something as special as that? It was more like something had been done to her, or for her. No! Allison thought in triumph, it was not done for me, it was done with me; the whole thing needed my cooperation.

"But the child is already almost sound asleep," Mark protested, "and you can't go wandering around like this any longer...." A sudden constraint fell between them as it seemed to occur to Allison for the first time what she looked like. Her hand went up to her hair.

Mark frowned impatiently. "I'm not talking about your appearance! Wet and cold as you are, Allison, you could easily catch pneumonia."

She put her hand on his arm. "Honestly, it's okay, Mark. I'm just tired, and my feet hurt. Otherwise I feel grand. But I can't relax completely until I know Drim is safe home. Look, I'll wake her up and she can show us where she lives." Gently Allison began to shake the inert little body.

"No, let her sleep." Mark resigned himself. "It's somewhere on the grounds of the Mission School. We'll go directly there." He gave the order to the driver in Vietnamese. The message that they were found could go out from any telephone.

After that Allison was content to be silent. As they drove back to Dalat she gazed out through the dark at the small lights beginning to shine around the lake within the many homes.

Mark watched her anxiously. "Allison, we were desperately worried about you! The Ambassador and I were trying everything to get you back. Dear Allison, I'm so glad you're safe! Was it very—horrible?"

He had reached back for her hand, and she clasped his firmly across the child's body while she seemed to be thinking back. "No," she sounded surprised, but her voice came warmly through the dark. "On the whole, it was wild, and scary, but it ended up—all right. Sorry about your typewriter though." Her smile was mischievous.

"That's okay." Mark felt confused. "It's just that I wish I could have done something! When you came back to the villa, why didn't you wait for me? Why didn't you let us take care of the rest of it for you?"

Allison frowned for the first time, thinking how to explain. "It didn't work out that way, Mark, the timing I mean. He only gave me an hour to get the ransom things, and he wouldn't have waited with Drim if there had been *any* sign that I was not coming back alone."

"The bastard! That's about their brand of courage, threatening an unprotected woman."

She thought about it. "Well, the three of them had enough courage to attack that crowded church. No, they are brave, however wrong they are. But you can see, Mark, after the successful strike, they had to think about covering their escape."

God knows they did! Her reasoning took his breath away. "The successful strike," Allison had said. Dumbfounded, he waited for more, until he saw that she was satisfied with her explanation.

"Allison," Mark turned around then to look at her directly, "our first concern is to get you and Drim taken care of, but on the way, before we get back to the villa, is there anything you can tell me to help us go after those men? There's a good possibility, if we move quickly, we can still catch the criminals. The red Vespa shouldn't be difficult to spot. Do you have any idea in which direction they may be traveling?"

After a pause Allison said, "I've no idea at all, Mark. And anyway, it was hours ago, or it seems that long. They must be already gone—far away."

He didn't think she was trying very hard to help, but the jeep had slowed, turning into the drive leading up to the school. Allison leaned forward, excitement filling her heart.

On the veranda of the school's main building a group still waited in the dusk: Bob and Amelia Gordon, Pastor Rau and Kieu, Hank and Charleen Tyson, along with Joe Ruffin. He had come back to join them while they all made a real effort to eat supper. When that was over, they had come out on the porch again in the semi-dark to sit on the steps or in the wooden rocking chairs, too weary to say cheerful things to each other any longer. Even Charleen was silent. Not knowing how to prepare themselves for either good news or bad, they just sat.

At first when the jeep drew up no one moved. Then, with a sudden shout, Rau jumped the steps and fell against the jeep. Mark quickly got out of the way so Rau could receive from Allison his heavily sleeping child. Tears coursed boldly down the hard, dark cheeks of the mountaineer pastor. Holding Drim against his chest, he checked to see that she was merely asleep and breathing regularly. Then, with a sharp word, he called to Kieu and handed the child into her waiting arms. Allison watched her own joy flood the faces of Rau and Kieu.

The whole group crowded down the steps, cheering. In the headlights

of the jeep Allison saw tired faces brighten with relief and welcome, with love and admiration. Joe Ruffin was a part of this circle, where she felt herself being made the center of praise.

Rau began to speak. "Madame Giraud, may God bless you and your family for the rest of your lives for your brave act in returning, yourself, alone, into the hands of the enemy to save our child!"

It was too much. Allison drew a breath, tears rising in her own eyes. Seeing this, Mark quietly offered Madame's thanks and suggested they meet again in the morning. For the moment, he said, food and rest for Drim and Allison were in order. Mark got back into the jeep, and the driver shifted into first gear while Rau stood away from the vehicle, bowing with infinite feeling. Then, as they moved off, Allison searched for and found Joe's affirming eyes. He winked!

The reception at the Ambassador's villa was as overwhelming as that at the Mission School. Mr. and Mrs. St. John were in the front hall, she holding out her arms in affectionate relief. Don Altbacher was beside them, beaming. Allison couldn't imagine how Don could be here so suddenly. Kate and Jeff Gregory both smiled warmly, not trying to restrain their youngsters, bouncing with enthusiasm. In the background the four servants grinned, nodding and bowing. At Allison's anxiously questioning look in Bao's direction, he saluted her, showing the gleam of his gold tooth. Then it was okay about the Vespa!

And piling down the banister were her own two tigers screaming, "We're awake, we stayed up! We knew you could do it!" Opening her arms, Allison capsized under their onslaught. Everyone rushed to help her up in the midst of great laughter.

Feeling her tremble, Mark at once organized a retreat for Allison, with Katrine and James, up the stairs. A supper tray was brought to her bedside by the moon-faced chambermaid after the hot bath Allison had dreamed of all that day. The fat maid could not help giggling in a most human way as James and Katrine started in to "help" their mother with her supper.

"You're not eating, Mummie," Katrine accused, her own mouth full.

"You need to get up your strength," James said seriously, attacking a drumstick. Allison kept her arms around them. Seeing that she was thus handicapped, the children took turns putting delicious morsels into her laughing mouth.

She was glad, though, when the plates were empty, the tray removed, and she could slide down into bed at last, a child on each side and a hard round

head in the hollow of each shoulder. As the chatter died and the two dropped off into relaxed and trusting sleep, Allison sent up heartfelt thanks for everything and drifted away in sheer exhaustion.

She woke soon, however, kicked in the knee and stabbed in the stomach. Getting up, she carried first Katrine and then James back into the other room, tucking them carefully into the small blue beds. Straightening up, rubbing her lower back, she glanced at the photograph of the Matterhorn. The Swiss mountain was still gleaming there through the dimness. Everything is still here, Allison thought.

But something really had happened. And she felt satisfaction over the whole experience on a deep level of her being. It was astonishing to realize that one of the memorable things, one of the things that stood out, was Joe Ruffin's wink at the end. He understood a little, somehow. One day she might be able to share the incredible adventure with him. Well, perhaps not all of it.

Kiem. Allison went back and got into her bed that was still there. As she reached over her same little alarm clock to put out the light, Maxim's emerald ring glittered. The cook had returned it to Mark, who had slipped it back on her finger. They would find a way to replace Bao's Vespa, Mark said. In the dark Allison turned the ring. Max! She hadn't even thought of him for hours and hours. Was that because of Kiem? And she began to re-live their very brief tempestuous time under the tall trees. Stretching out as far as possible across the great bed into profound amazement, Allison let go again. No angry maid would disturb her tonight. She was at home now, in Dalat, or anywhere.

Late the next morning Allison got up, dressed, and began the day in a mood of surprise and gratitude. Without argument, she had allowed herself to be persuaded to stay over another day in order to "rest up." At first she felt numbly in limbo, but later when they talked to her about the murders and the search for the Viet Cong agents, she was shocked into awareness.

Don Altbacher arrived to ask her questions. He suggested they take a walk together around the villa grounds. When they were sitting on a bench overlooking the tennis courts of the Mission School, the Colonel felt puzzled by Allison's vague replies and her abstraction.

"I don't like to distress you, Allison," he sounded troubled himself, "but it would help us to have some description of the vehicle you were carried off in and also what the men looked like."

Allison frowned. "They looked...." Each one—Kiem, Tang, and Thom —appeared on the screen of her memory with painful clarity. "They were not—unusual. They were—Vietnamese...."

Altbacher put his hands firmly on his knees. "Tall, short, old, young?" She nodded.

He was careful to hold on to his patience. Allison had been greatly stressed.

"You can see, Allison, that you are our best witness. Two fine outstanding people have been killed, and the new church razed to the ground. You yourself and the little girl were kidnapped! If you can help us with the identification of these criminals, they may well be brought to justice."

A great tremor ran through her body. She looked around desperately so as not to meet his eyes. Just then, to Altbacher's dismay, the missionary doctor, Joe Ruffin, appeared, strolling up from below on the school grounds.

"Colonel!" he called out. And then as he drew near, "Good morning. Do you think you could wait a while about any questioning? Allison has been through a lot and really ought to be resting. You know, thinking of something else."

And what business is it of yours? the Colonel thought. What are you to Allison Giraud?

But with the interruption she had pulled herself together and now turned directly to him. "Don, I'm sorry. I guess I can't help you at all. I—I'm sorry."

He rose then. "Well, maybe later on." But she only looked doubtful and went away with the missionary across the clipped grass toward the tall white villa.

In the afternoon Don talked to Mark Gardiner, hopeful that Mark might have Allison's confidence. Mark shook his head.

"No, she doesn't seem prepared to give any information about them, Colonel. The Ambassador and I have both tried as tactfully as possible. Allison seems to have pulled down a curtain over the experience. I don't know, maybe it's just too painful. It's not clear exactly what happened, but we certainly don't want her mind affected by forcing her to dwell on it." Mark began to move Altbacher toward the hall. "If the situation changes in a week or so, I'll let you know down in Saigon."

Altbacher turned back as he found himself leaving by the front door. "Well, Gardiner, I'm sure you know this makes it almost hopeless for us to catch these characters!"

Mark looked rueful. "There's no help for it, old man. It's damned

difficult. However, for the moment the Ambassador's view is that Allison should not be grilled about it. We are just thankful that she and the child are safely returned."

Don agreed, but, thinking of the Thanhs, he sighed heavily. They shook hands and he walked out to his jeep and driver waiting on the sweep of gravel. Of course he was glad Allison was safe, though somehow she was no longer the Allison he knew. She had become so reticent. It was as if she was cutting off their friendship cold, for obscure reasons of her own. And in a way, that was sort of like killing, too.

That night, the St. Johns and Gregorys having left for Saigon, Mark, Allison, and the kids, hovered over by the caring servants, had supper together in the dusky, too large dining room. And afterwards, when the children had been stowed away upstairs, Mark and Allison found themselves sitting once again on the chintz-covered sofa in the firelit drawing-room.

Allison stirred. "You may be wondering if I...." She paused. "I'm sorry, Mark, I still...."

He patted her hand. "Never mind, old dear. You made it quite clear that you couldn't marry me before the attack ever happened." Absentmindedly he poked the fire. "I *am* curious about what happened. I have to admit it."

She sighed.

"You seem to be protecting them, Allison. Do you feel you owe them something?"

She thought about Kiem and the crash of their hate/love and what she had somehow experienced through the whole adventure. "That's close, Mark. I guess what I owe them is gratitude, you know?"

"Gratitude?"

"Well, I was all to pieces Saturday night. You remember. And then on Sunday, through the terrible happening, through the VC attack, I found myself! I don't know if I would go on growing or become what I'm meant to be without that, without what happened to me because of them."

Mark thought it over. "Now you know what you can do. You've got confidence; you're independent."

"Maybe it's more like inter-dependent," and she flashed him a smile.

But he was on another wave length. "Allison, no matter what kind of deal you made with them, or what favors they did for you that make you want to protect them, you must know that unless they are caught, they will continue to murder again and again. Unless, that is," and he paused on the

sudden thought, "unless something happened during the experience to totally change *them!*"

Allison felt besieged. Her experience had become for her like a secret treasure that could be exposed and devalued. Her new insights seemed to have no place in the fragmented world of Vietnam to which she had been restored. The old insecurity was poised to return and overwhelm her. So, for the second time in twenty hours, the courage to act, to speak, rose up from within her.

"I haven't got it all figured out yet, Mark, but I think I learned a little about how we create our enemies."

Looking at his earnest and puzzled face, Allison saw Mark enfolded in the same unity that held Kiem and Joe and the Thanhs and all the villa people along with the tree ferns and strangler figs! She felt her heart brim with love for him, for them all!

"We don't need to make those enemies, Mark, we really don't." And with her treasure shining safe again, she reached for his hand.

Mark's grin was sadly crooked. "I don't understand much, Allison, but I *can* see it's all over for us." And he thought, I lost her before I really saw her possibilities. So now it's too late. He cut their evening short, having had about all he could take.

But down in Saigon, and after a few days back at work, Mark faced the fact that while losing Allison was pain, something of the feeling was relief!

Down from the Mountain

And what the dead had no speech for, when living,
They can tell you, being dead; the communication
Of the dead is tongued with fire beyond the
language of the living.

T.S. Eliot

Joe Ruffin left Dalat on the bus. The crowded, uncomfortable trip Tuesday took hours more than the swift flight up on Friday with the Thanhs, whose bodies had now been flown to Saigon for a Buddhist ceremony. Joe thought about the tumultuous weekend, while the increasingly loaded bus descended with many jerky stops from the high cool into the lowland heat.

He remembered that Christmas Eve feeling on the Vietnamese Air Force plane just before the three of them came down at the stinking, sabotaged airport of Dalat. Even there it was good to be with the Thanhs!

And he saw again his final picture of those two, with their clear faces of peace, lying together in the embrace of death, the woman's head against the man's neck, his own head turned toward her. Joe felt he must carry the rightness of this picture to her father, the old Buddhist wise man. It was something he could still do for Yen and Thanh.

When the bus ground to a halt at Blao, he watched while people trying to get off fought with people trying to get on. It was pretty noisy and beginning to be very warm, but Joe didn't mind. He leaned back, closing his eyes, absorbing all the smells and sounds, not to mention the nudges and pokes of two stout women squeezing in beside him. When they were finally settled, he was just able to turn his head and smile at them. They both smiled back, fearfully excited to be going somewhere.

People are great. Joe thought about the missionaries, especially Rau and Bob Gordon. Not to mention the dizzy joy of meeting Allison, but almost

at once he had come up against her fears and guilt, the little obstacles she kept hurrying to put in their way. He had told Allison how much he loved her, shared something of his background and hopes, even on a crazy rush asked her to marry him! He had tried little things, too, like suggesting she bring her children and come out in the countryside with him. But Allison was too worried about what people would think. And already tied up with that Mark Gardiner.

While Joe watched the tea plantations dropping past the window as the bus left Blao behind, he remembered the rougher, mountainous terrain where he had spent his wonderful working day among the sick tribespeople with that New Zealand nurse. Over lunch that day was the last time he talked with Yen Thanh, would ever talk with her again. He could see her still, bending to speak with the importunate pregnant woman, one child on her hip, a toddler trailing at her skirt. Who would take Yen's place now? Who would shine her steady light? What could he do here in Vietnam for the Thanhs?

That same night he had joined all the folks at the Ambassador's villa for cocktails. As interesting as the people were with their political talk, what he felt most strongly was Allison's anxiety. And yet he had walked away!

Next morning was the Festival Service, his own simplistic talk in rote Vietnamese, before the swift assassination of his friends and the kidnapping of his love.

On the way to Bien Hoa, passing through the lush garden of South Vietnam, Joe thought only of Allison. The song of hungry love at Angkor still sounded in his heart, but deeper, on other levels of his being. He had no regrets about Angkor. That had been warmly physical, and this was earthy too. But Allison was even more. She was the lost side of himself.

And yet when the weekend had exploded with everything—joy, love, friendship, and hope; terror, hate, fear, and despair—Joe had hardly even played a supporting role! He frowned with pain. Maybe if I could return to my peaceful cottage on the edge of the high place, I would get the message, some word about the meaning of it all and my place in it. No good. I had the sanctuary of the cottage all to myself the whole time and all I did was sleep in it. I'm not the meditative type.

And he thought of the worst moment of the weekend, when Charleen's hand stole into his and kept him sane. What heals me is people. I feel at home with the Vietnamese, their language, their friendliness, their laughter. Through Dr. Thien and Phuong and Mrs. Thanh and the old sage he had come to love Vietnam. And always, back in Saigon, when lonely,

homesick, frustrated, tired, depressed, Joe went out in the streets. The people of Saigon were like the ones jammed into this bus. Even without knowing them, their very aliveness, their keeping-on-ness in spite of everything, comforted, restored, and nourished him. That's me, he thought with some satisfaction; and then, but where does that leave me?

Especially, where does it leave me with Allison? It's great to hear music every time I think of her, but I've hardly had a chance to learn what she wants. Even before the kidnapping, even though he knew she was attracted to him, she never committed herself. And now he had no idea how she might be changed by events. After the past murder of her husband and her own recent kidnapping, you might well think Allison would want nothing more to do with Vietnam! Would take off at once for the States. If she didn't marry Mark.

Joe had seen little of Allison after her safe return. So far she wasn't giving anybody information about her captors or what had taken place. But he felt she was different. Now that she had proved herself a capable heroine, he wondered whether Joe Ruffin would have any place in her view of the future at all. Maybe he shouldn't assail her with his love as he once had. He could try being patient, watch, and wait, see what was going on with Allison. At least that would involve seeing her!

And so, as they pulled out of Bien Hoa, and the bus began to devour emphatically the last thirty kilometers of the deep green gardens outside of Saigon, Joe decided that his first act when he got home to the hostel would be to look up Allison's number in the Saigon phone book. And, after this decision, squeezed against the bus window by the two stout ladies who were sleeping soundly, bolt upright, Joe nodded off himself. The jerks of the bus, when his head knocked against the edge of the raised window, punctuated cruelly his dreams of Allison. What if he had to give up his new love, Vietnam, for his new love, Allison?

Allison was so glad to get home she was ready to cry with profound relief. Never had she so truly appreciated her faithful Nam. Since the angry maid, Chi Hai, had not returned to work, Nam had substituted her own niece, Chi Sau, who was a bit overzealous. A blouse you left momentarily on a chair appeared less than two hours later, washed, ironed, and hanging in your wardrobe! Never mind. Here was order and beauty and home. The children were overjoyed to melt at once into their old routine—baths, supper, squabbles, homework, bedtime. Their world was once again blessedly secure,

could be a little separate from hers, pleasantly mysterious again. And every small material thing in the apartment seemed to make Allison welcome, to radiate welcoming love! Her porcelain cockatoos on the bookcase, were they smiling? How amazing, she thought, things that are loved, love back!

So Nam found her Madame with tears on her face, leaning against the door to her bathroom, where the pale tiles gleamed and the fresh blue-and-white towels hung in a fat and docile row. The Saigon grapevine had already informed Nam that her fears for her little family had been amply justified.

But, seeing the tears, Nam did not reach out to touch her mistress, only coughed apologetically. *"Madame très fatiguée. Nam beaucoup contente Madame pas revenir morte."*

"Moi aussi, Nam! I also am content to return—not dead," and Allison, half-laughing, took the small stiff figure into her arms. It was only a moment, and each one drew quickly away, but the thing that was permanent and deep between them had, for a second, taken on outer form.

Once in bed at last, behind her own blessed mosquito net, with her own windows open to the Saigon night and the Saigon River, Allison still found she could not sleep. Instead she wondered carefully over the whole stunning weekend in Dalat. I went up, she thought, in all my fears and guilt, hoping to make it with Mark, a fine man and a strong one. Meeting Joe Ruffin was an infusion of new life along with a terrible threat to my plans for a safe future. Mark's generous offer of marriage (she still thought of it as "kindness" and "affection," not perhaps fair to Mark) had pushed her over the edge of truth. Thereafter, Allison thought, she must have had a small nervous breakdown. Certainly she had fallen apart. Didn't she want, after all, to depend on Mark, on someone?

The whole dreadful experience at the church and her own kidnapping, her mad return to the villa and wild ride back to her captors, passed across her inner vision like a movie. But she saw it in the strangest way. It looked bright! Allison marveled over her terrible clashing embrace with Kiem, and how everything peaked afterwards in the high magic of her sudden brief grasp of the unity of life on that solid rock in the rain. Life is weird! Maybe Joe's wink afterward had been the only possible comment.

So what about Joe? He was here in Saigon somewhere, wherever missionaries live. He loved her. He had said that. Maybe now, after her successful escapade, when she had lived through fear, now that she almost liked herself, maybe she could dare to love him back. Dependence would certainly not be the main part of a relationship with Joe. Allison stretched out, reach-

ing far down with her toes. In the open, soft dark, in the re-found Saigon night, there was a beginning glow of freedom from the old fears, a freedom that promised wild possibilities—even the fulfillment of desire?

There was no chance to sleep in the next morning. The phone rang constantly. Friends like Madeleine came to offer horrified sympathy and stayed to lunch. Allison let it all happen, but she observed the excitement from a distance and studied her old friends with mild surprise. They were not really satisfied as they left, just before the sacrosanct hour of siesta. They still seemed to feel she wasn't sharing everything. And, when she had closed the heavy door on her privacy, Allison was shocked to think how they would have relished what she did not share! Seeing through their eyes, suddenly she felt the first strong guilt over her lovemaking with a murderer. Why was she only now facing what she and Kiem had done?

Nam, having finished the washing up, went out to her room down by the back stairs. The children had returned to school. Allison, already shrugging into her yellow robe, thinking about a nap, looking around for a book, heard the doorbell ring again. Horrors! She was about to ignore it, when, with the second persistent buzz, it came to her clearly who was there. He probably ignored siesta!

She went at once to open the door for Joe. With a glance, he took in her light robe, seemed to take all of her in with the charisma of his remembered smile. "I did call you," he explained. "The line was always busy."

Allison's dimple escaped. "You'd better come in." She had never dreamed how fun it would be to see him standing there in her own living room, looking around; his dark curly head, his sturdy shoulders, his rather militant jaw with the cleft in it. Joe turned slowly, seeing the blaze of bougainvillaea out on the roof beyond the glass sliding doors, her jade sofa under her own big watercolor sketch of Nha Trang harbor with its "Bali Hai" islands and, across the room, the actual view of the wide Saigon River.

Joe whistled. "Nice," he said.

It was not as hard as before to meet those bright hazel eyes. "Well, it's not big, but I love it up here, looking out on the river."

"How are you, Allison?"

Always direct, always probing. No small talk. "I'm fine; I really am, Joe. Hey, why don't you sit down, and I'll get us some coffee." But he followed her into Nam's immaculate little kitchen with its surfaces all glossy brown tile and its big tan water filter and small Buta gas stove.

When they were both sitting side by side on the sofa sipping the French

coffee spiked with chicory, Joe did not stare out at the wide flat river or its sluggish traffic.

"Allison, I was terribly worried when you were kidnapped!" She looked down at her hands. "But I couldn't help being glad you wanted to come to our church on that wild day." He took her hands. "I was surprised you got yourself free so quickly, but I wasn't a bit surprised that you went back to rescue Drim."

Allison laughed. "Well, I was! When I look back on the whole thing, I don't know what possessed me!" It was especially odd since she had never developed any real attachment for Drim.

"There are three people, Rau and Kieu and Drim, who will never forget you."

"I'm glad it all worked out." She withdrew her hands and looked away, embarrassed by her memories.

Joe got up to roam around, picking up an ash tray on a bookcase under the yellow eye of a white china parrot and putting it hastily back. "After all you've been through, I can't help wondering how you feel now about us."

It was hardly a proposal or declaration of love, but it felt more comfortable than either. Allison looked right in his eyes. "I'm not sure yet, Joe. I need more time to get to know you, but—I'm not as much afraid as before."

"Afraid of me?" He was ready to laugh.

"Well, afraid of our kind of life together here in Vietnam." In her newly brave honesty, she had to tell him that.

Joe's dark brows came together. "You just said you weren't as much afraid now."

She smiled. "Not as much."

He wandered around digesting that. "After all this experience with the VC, you still think it would be worse being married to me?"

Then Allison's chuckling laugh rippled out. "Joe, you dope!"

"Maybe I'm just not as attractive as they are." He turned his chin up.

She sobered so quickly that Joe became suddenly aware there might be something important here, some part of what she had not shared about her adventure. He felt all the more convinced of this when he saw how hurriedly she managed to get herself in hand.

"Joe, I need some time, okay?"

He thought about it, and somewhat to her disappointment, agreed at once. "Right. Maybe we both need time. Well, while we're waiting, we should be together often—I mean, so we can get to know each other."

She rubbed her nose with the back of her hand. "Like what were you thinking of?"

"I was thinking of asking you to go with me tomorrow to visit this old Buddhist sage. He's the father of Yen Thanh, my friend who was murdered with her husband, the Province Chief."

Murdered by Kiem. Why couldn't he be asking her out for a lovely dinner? Allison drew a deep breath. "Well, I don't know if I would be any help...."

Joe looked bleak. "I don't know if anyone could be a real help to the family, but I've got to go, and it would be a help to me to have your company."

"I don't think I can get away until Saturday."

"Good, I'll come for you around three Saturday afternoon. Thanks, Allison!" He put his hands on her shoulders and kissed her lightly.

It was almost worse than no kiss. And when she had seen him out, closing the heavy door, she could hear him *running* down the stairs. Joe hadn't asked any questions about her experience. He was the only person, except Nam, who hadn't questioned her about what happened. Didn't he care? Allison wandered back into the bedroom and lay down on her bed, staring up at the slowly revolving ceiling fan. Was Joe the kind of man you could share anything with, even her encounter with Kiem? Even the indescribable aftermath on the rock? What a relief if you could! But, he's weird, she thought, with tremendous pleasure and fearful doubt before she let go into sleep.

Then suddenly, in a little more than half an hour, Allison startled awake and sat right up, snapping the gossamer threads of unconsciousness. There was a painful lump in her chest near her heart, a big lump that she could neither swallow down nor absorb. She pressed her hands to the place, and in her new courage Allison began searching for the roots of the pain. Some part of this day had upset her. Thinking how Madeleine and the others would view her encounter with Kiem stirred up guilt. That couple had been Joe's friends. To think of visiting the father of the murdered ones! Once she had felt guilty about slapping Chi Hai. And behind everything else was the way she had failed Max.

But this time across the wall of guilt she had placed between herself and Max, she saw his troubled face! He was shaking his head with that quizzical look of love she knew so well.

"Must we have regrets, *ma chère?* If you will forgive me for arrogantly ordering you away as I did, I will forgive you for obeying!"

"Oh my God, Max, don't make me laugh when I'm crying!" And she held her arms out wide to the bright shadow of his spirit, once more close to her at last.

Allison blew her nose. "Now I see what I've been doing, Maxim. My guilt was keeping us apart!" Her relief blossomed like a soft cloud. Here again she and Max were one, his embrace like feathers surrounding her lightly.

"I thought you'd never get rid of the thing, old dear," and Allison felt he had tried his best from over there to call her attention to the horrid block.

"Oh Max, darling, I'm sorry!"

"No regrets, *chérie*, above all no regrets—they ruin everything."

"I see that now, I mean about us, and perhaps the silly maid too."

"It's humorous, after all!"

"But Max, wait, this thing with Kiem...."

"You feel regret that it happened, he and you?"

"Oh...no. No!"

"*Alors*, all is well, *n'est-ce pas?*" His smile was a tease. Did he know everything?

"*Tu*, Maxim, look, what about this American I find myself in love with?"

He gave a mock sigh. "Your missionary?"

Allison sat up straight, fully vulnerable, truly honest. "Don't laugh, I'm really beginning to love him!"

Max was serious. "*Bon*, he is not a bad egg, that one. I think I will like him. Is there a problem?"

"You know there is! How can I go to him and tell him nothing about what happened?"

"But you will tell him. I can hear in your voice how much you want to share the whole thing. Silly girl, you are desperate to share it all with him."

"But, Max, surely he will be offended! It was not a rape, you understand."

"I understand, and I believe he will too eventually—if he is worth his salt at least."

Allison stared.

"You must try it, dearest. You must. We had our good times and our bad times, didn't we? But when did we ever hide the truth from each other?"

It was strange that just in this moment Allison saw again Joe's wink as the jeep pulled away from the mission school at the end of that very long day. And suddenly, here again she felt the feathery lightness of an unseen embrace.

"No regrets!" echoed faintly on the soft siesta air.

Reality

The soul should always stand ajar, ready to welcome the ecstatic experience.

Emily Dickinson

On Saturday Joe came for Allison in one of the small Renault taxis of Saigon. As the little car scurried through the traffic toward Cholon, they were acutely aware of being close and not touching. Clearing his throat Joe explained he had talked to the old gentleman briefly the day before to arrange for their visit today. Since the two little girls were staying at their grandparents' home and should not be further upset, Dr. Duc would meet them at the Thanhs' house.

On the way to the bungalow where he had spent such a pleasant evening with the family little more than a week before, Joe told Allison some of the things he remembered about that dinner, even his uneasy suspicions of the wandering barber. Neither of them could imagine how the barber in Saigon might have any connection with what happened to Yen and Thanh up in Dalat.

It was heavy on Allison's mind that she must find some way to share with Joe her part in the whole terrible adventure. The sooner the better. But Joe was speaking of her friend Colonel Don, who had also been a guest of the Thanhs that evening. Allison couldn't smile when Joe repeated some of the strong opinions the Colonel had expressed.

"He's pretty dedicated to his job of trying to save South Vietnam from Communism," she said.

Joe agreed, but rejoined, "He couldn't save Thanh, his own counterpart." In the weighty pause, Allison thought again how very close she had been to the murderer of Joe's dear friends. And she was going to tell him that?

"We talked about other things, too, that night. The old gentleman told

485

us how Buddhists feel about war—and there was one weird thing. Dr. Duc seemed to think I have some kind of role or mission here in Vietnam. He welcomed me in a funny special way as though he had known I was coming! And behind it all I got the decided feeling that, in his view, what lies ahead for this country will be very rough."

Allison didn't much like the sound of the old gentleman. "So he said they would need you here?"

"Something like that."

She lifted her chin and turned away from him toward the window. Joe thought, she doesn't say, "There's a sucker born every minute," but that's what she's thinking.

Allison was really thinking, lots of people are always going to need you. I'd have to learn how to share you with all the other needy types. Maybe after everything that has happened, I can do that now. I went up to Dalat to find a man, and God knows there were men, but I believe what I found was my own self. And so, if I'm to stay faithful to me, I need the courage to share it all honestly with you!

In the back seat of the taxi Joe had taken her hand. Holding his strong, good-feeling hand, Allison realized she was saying good-bye to Mark, to Kiem, even to dear Max. But what if Joe were shocked away from her after he knew the truth? Could she still be adequate, just as Allison? Kiem had said, "You will suffice."

While Joe held her smaller, strong, good-feeling hand, he was thinking with pain of the Thanhs and their love for each other. What kind of destiny would his love for Allison, and hopefully hers for him, commit them to? Would she come around to sharing his kind of life? Or could he give up all this for her? North Carolina seemed very far away.

There was no longer any hostile barber by the guard post of the Colonel's house, nor was the same Corporal there. He must have been Thanh's personal aide. The new guard was indifferent; Joe and Allison were expected. He motioned them toward the gate. When they went down the path where Yen once had run to meet Joe, the door was opened by the old gentleman himself. He had seen them approaching, hand in hand. There was a breathless quality about them, as though they were blown to him on the crest of their excitement at being together.

Dr. Duc bowed them into the quiet living room, warmly lit by the afternoon sun. Everything was the same. Joe saw the scroll with its willow tree bending before a storm. He saw the elaborate lacquer painting of warlike

Chinese soldiers at the far end of the room. The Colonel's desk was closed, the teak dining table shone, polished and bare. Joe felt Allison waiting at his elbow and introduced her to Yen's father, Dr. Nguyen Trung Duc, who looked at her steadily for a few heightened moments, bowed graciously, and invited them to sit down. The Thanhs' maid, with averted eyes, brought in a tray of tea things and set it on a table near the father's hand.

Joe's dear interpreter of that night being gone, he plunged into Vietnamese anyway, knowing Allison grasped the language much better than he, and would surely understand his simple renderings.

"Sir, I know you've already been notified of the deaths of your daughter and her husband, but, since we were there when it happened, we wanted to come and tell you anything further you may wish to hear about this tragedy." Something shot into his mind: "They were lovely and pleasant in their lives, and in their death they were not divided." It must be from Shakespeare or the Bible, nothing he could translate. Somehow he must get that feeling across to the father in his own words. The old man was waiting quietly, his serious eyes fixed on Joe's face; his expression, though grave, was patient and polite.

Joe said, "I feel great pain for the loss of these wonderful people. They were my friends, but valuable to many more as brave leaders of your country."

Dr. Duc said, "They will be missed, and, as you say, not only by us, the family members. But they are not the only ones, Dr. Joe. So many like them have already been killed."

Allison felt herself shrinking. It could not be that she was sitting here politely sympathetic beside the father of the woman Kiem had murdered!

Joe was saying, "Everything possible is being done to bring the killers to justice."

The old man shrugged. "These people are killing or driving away all the brave souls, leaving our poor nation to be governed only by a terrible mediocrity." Arranging the handleless cups, he began to pour the pale, flower-fragrant tea.

Joe said again, "Both our governments are making every effort to see that these attacks are not only stopped, but punished."

With careful grace Dr. Duc passed a cup to Allison and one to Joe. Then he said, "Assassins—no matter for what cause their crimes—destroy themselves and their own characters because of their use of evil means." Allison thought this more terrible than anything said so far.

Joe paused. "Well, I want to share with you my picture of the Thanhs as they lay there in the church, violently killed, but somehow peaceful and in love and together."

Yen's father was nodding. "They had faced this possibility, I think, and had come a long way toward accepting their destiny. So, I believe at the end, with all that's good and evil, they were at home together in the house of life. And we ourselves must try to remember that dark powers may be creative forces in disguise."

Joe frowned. "I certainly hope something creative can come out of their life and death. Still, I wish it could be published somewhere, so the world will know about courageous Vietnamese like Yen and Thanh."

The father smiled faintly. "Already a reporter from the *New York Times* has been here. There may be a small paragraph about the Colonel's death on an inside page. No, Doctor Sir, few will hear of their deaths or understand. The French have a name for them, *Les Inconnus Illustrieux*."

Allison translated for Joe, "'The Great Unknown Ones.'" Then she leaned forward. "Please, sir, I would like to offer you my sympathy too."

The old gentleman waited, as if knowing she would say more.

"My husband, Maxim Giraud, also died by violence at the hands of the Viet Minh. Our children and I have been without him for several years now." She stopped.

"Ah, you have experienced a great loss too. I can feel, Madame, your understanding for ours and I am grateful. Perhaps by now, through the passing of time, you are learning some of the compensations for catastrophe which as yet we are unable to see."

The compensations of catastrophe. Was there a familiar ring? She thought about it and felt surprise. "It may be, *Monsieur le Docteur*, that in the last days, I have learned something of these compensations."

He looked at her with warmth. "Your husband too was perhaps one of 'the eminent unknown ones.'"

"It's possible!" she agreed with joy.

"And another of these," the old man said, turning to Joe, "is my friend Professor Minh, whose arrest you witnessed."

"I was planning to ask you about him before we leave. Is he now free?"

Dr. Duc shook his head. "Not in the sense you mean."

Allison loved Joe then, as he put his hands on his knees and asked, "In what sense *is* he free, if he's still in jail?"

The old man got up and went away into another room. When he re-

turned he held out a letter. Joe took it from the slightly trembling hand.

Yen's father said quickly, "First you must understand that my friend Minh is an idealist. He is not a Communist, but in his opposition to government tyranny, he was useful to the Communists. Yet radical behavior like Minh's can be creative and constructive."

"How do you mean?" Allison asked.

"If you go to an extreme, strong opposition is created. And out of the struggle between the opposites, something new may be born. This is one movement in life.

"But there is another—the movement of harmony and unity. In life these two movements are always in tension, you see. Within Buddhism, for instance, both movements are present. There are extremists in my religion, monks, who are making secret plans for self-immolation to draw attention to the wrongs of this regime. They prepare even now to die by fire in protest."

Allison was horrified.

"Oh yes, Madame, we too have our idealists willing to become martyrs. So I think it is a mistake for this Catholic regime to make enemies of the Buddhists, who have about four million firm adherents in Vietnam. Some of us work more in the direction of harmony and reconciliation. But both paths are necessary to our revolution, our evolution, one might say. My friend, Professor Duong Quang Minh, took a militant stand against tyranny and brought upon himself the anger and revenge of this tyrant government, which, being desperately afraid, colors all opposition Red."

Joe said, "I think I see what you mean. A guy named Stephen in the Bible was stoned to death and became a martyr, maybe because he was constantly provoking opposition."

"And your Christ also? His was a creative work, bringing great change, but painfully. And painful tortures have been inflicted on my friend, Professor Minh."

"What kind of tortures would be used?" Joe asked. Dr. Duc raised his hands and let them fall. "We should not distress Madame Giraud."

Allison shook her head. "Please go ahead, sir. I guess I've already imagined worse things than the truth."

"There is that." The old man sighed. "I receive information on these matters from those who have returned from the cages of the Diem government and also from the cages of the Communists, enough to understand that my Yen and her husband Thanh were fortunate to die a clean death

together." He pondered deeply for a moment before raising his head. "Please know that in addition to the terrible suffering of the tortured victims, I myself believe the suffering of the torturers must be very great. Their pain, being unbearable, they inflict outward on others. Part of the 'perks,' if you will, of a prison guard is to do with the prisoners what he likes."

The eyes of Joe and Allison were fixed on him darkly.

"A catalog of tortures." He sighed. "Well, aside from living in a cage where one can neither stretch out nor stand up, one may be beaten with a rubber hose, or forced to sit at attention some sixteen hours a day. One must perhaps bow to ninety degrees whenever a guard looks into the cell, or else great pain may at once be inflicted. One may be forced to kneel with hands up for painful hours. One may be put into solitary confinement in leg irons. One may be beaten on the soles of the feet with sticks of bamboo. There have been those who were hung upside down in the air while water was poured into their nostrils to make them talk. The imagination of man is infinite in its variety."

Allison was very still, reminded of Thom's searing burns, hearing the primal scream out into the universe of all the agony humans inflict on each other. Humiliation, indignity, was an essential part of the pain. Joe took her cold hand in his.

"If they can stand the pain," she said, "I guess we can stand to hear about it."

"But oh, my good friends," Dr. Duc went on sadly, "in thinking about the unity of all life, I believe the hardest part is to be one, not only with the suffering victims, but with the suffering torturers. There are many sides to oneness, so we cannot, must not, put anyone outside the pale."

While they both stared at him, it seemed to Duc that the woman was more able to accept his meaning than the man. He pointed to the letter, forgotten in Joe's hands. "I am talking too much. Let my friend Minh speak for himself. This is the one letter he has managed to smuggle out to me from prison."

And so they began to read:

To Dr. Nguyen Trung Duc from Professor Duong Quang Minh:
Dear Friend,
 I am happy at last to have found an opportunity for sending you my greetings from this place of my detention. In honesty

I have suffered a great deal. Terrified, beaten, in great pain thereafter, panicked, lonely, self-hating, hating of others, despairing—all. It was much through my own fault, as I now begin to see. Duc, you know I came here angry, set against everyone and everything, even against myself for ineffective stupidity and conceit. An agony of protest had me always in its grip.

But, as you might guess, prison offers one thing difficult to procure in the world outside. There has been much time to meditate. And to observe carefully whatever small events punctuate the long monotony of hours. Often I was surprised to notice and recognize a terror like my own springing up in the eyes of my sullen guard, when his superior officer could be heard above, shouting for him to come at once! Thus began my slow realization that we are all afraid, all self-hating, all in prison!

When I have managed to escape in sleep, my dream life has been as rich in violence and stress as my real existence. One dream was significant. I am a student in a classroom of some university and feel much annoyed by an extremely obese woman student sitting next to me. When no one is looking I feel an overpowering temptation to pinch her fatness painfully. I do it! The glee which I felt was so acute that it woke me. I saw with horror that I too can take pleasure from the pain of another! In the dream my feeling was even akin to sexual pleasure. How close I must be to the torturer!

My dear old friend, now, with tears in my eyes, I thought of you and your simple philosophy; don't fight *against*, align yourself *with*. Not in cowardly agreement. One cannot agree with much that is said and done. But to align yourself with those by whom it is done, align yourself in your secret heart with their humanity. My prisoner-jailer and I have our fears, and even our pleasures, in common!

And so, late one evening, perhaps through constant hunger, a strange thing happened to my cell, which is extremely small. Suddenly when I looked, everything seemed to come alive. I am referring to the solid matter as well as the usual creatures. The bars of the door quivered with an inner light. My dulled rice

bowl began to glow, to send out widening rounds of light, ha-loed. Every atom around me flickered, seemed to dance, seemed to live as I do. We—the walls, the floor, the mat, the bowl—we were all one and alive with this power of light. I was filled with unbearable love for everything within my sight and beyond, as though love and light are one.

It was the most extraordinary experience of my life so far. There actually is a living union below the surface of things! How often have I theorized there might be. But what a differ-ence to *experience* all things lit and quivering with one and the same life energy. My vision faded, not to be recaptured, of course, although the sense of wonder stubbornly remains.

Since then, as you will guess, though not more comfortable, I am at last at peace. No longer am I angry and impatient with myself. I even see my growing contentment reflected in the ten-tative glances my prisoner-jailer-comrade and I exchange. There have been no recent beatings.

Duc, my thankfulness and joy over this strange freedom made it essential that I discover a means of smuggling this letter out to you. (The man who puts in my rice is a new friend.) I have been troubled for you, knowing it is also hard to be on the out-side, worried over the unknown sufferings of friends within. Please do not feel great anxiety for me anymore. On the con-trary, accept my gratitude for your help, for the seed of truth that you planted: "To fight is not to win." And Duc, it is only a matter of time, I believe, until constantly changing events bring us physically together again.

What a happiness that will be! In the meantime, I hold you always in the highest esteem and affection.

Yours,
Minh
Duong Quang Minh

Dr. Duc watched the Americans working at the letter in three languages, she translating for herself and for him into English. But the man often found the right English word when she could find only a French one. The older man listened to her with special intentness, because of his surprise that she had an easier time with the thought behind the words.

What had this woman survived of loss and the gain therefrom? What peak experience had she known, if somehow she could relate so well to Minh's mystical visitation? It was not possible in one so young. And yet, when the awareness in those gray-green eyes met his own gaze, Duc knew that she did understand. And so, he thought, while the doctor has the will and energy to help us, the woman has an intuitive understanding. This foreign woman is therefore not foreign to me.

As they gave back the pages of Minh's letter, neither Joe nor Allison could find words for any comment. But Dr. Duc held out his hands to Allison, and bowed deeply over hers. Once again, he thought, on the heights of gratitude, I am blessed in this world with a daughter of the spirit! Then Duc turned to offer his right hand to Joe. The three stood there together. The old gentleman felt their eyes on him in serious wonder. It was enough. It was appropriate.

"Thank you both very much for your visit of sympathy, and for your healing presence here in our troubled country." With his hands in prayer, Dr. Duc bowed to the God spirit in each of them, and they returned the same gesture.

So, holding hands, Joe and Allison left the Thanhs' home. They nodded to the sentry and walked over to the main avenue to watch for a cab. Allison said only, "Maybe we should have asked him to let his little granddaughters come over to play with Katrine and James."

She had said "we." Joe wanted so much from Allison, this sensuous and dreamy woman. But he felt he must satisfy himself for the time being with her "we." Exerting will power, he stifled his impatience and put his mind on hailing a taxi.

"I've been thinking," Allison went on, and Joe forgot about the cab. "I've been thinking of what you said about the Thanhs, and how peaceful they looked in their death. I agree that after the worst happens, and you somehow don't snap, then you find you are reconciled to everything, to things as they are."

Joe didn't quite understand, and waited, but there was nothing more. So he said, "Well, I was thinking too, about prison, and how life is like a prison to so many people. Maybe the belief in reincarnation can be a kind of liberation—I mean from the chance of more than just this one life."

Now Allison felt confused. She had been lifted up by Dr. Minh's written affirmation of her own intuitive experience that all life really is one energy. But here was Joe talking of differences again.

She looked troubled. He looked bewildered and frustrated. They stood there by the curb, very small, very separate, under the hot white sky with its fortressed clouds holding the eventual rain.

Anxiously she put her hand on his arm. "Joe?"

"Allison?"

"But I want us to understand each other!" It was like a protest.

And while they stood there, close, questioning, a taxi pulled up. "To where, Mister, lady, to where?"

Once in the cab, disturbed as they were, they didn't know where to tell the driver to go, even though he was frowning at them rather savagely over the back of the seat.

"We could go to the hostel," Joe suggested, wondering at the same time how they would manage to talk as they needed to there, just before dinner, when everyone would be coming home.

Allison frowned nervously. She pictured the hostel as some kind of religious barracks. "No, no," and she gave the cabbie her own address. As the taxi rushed through the evening streets, turning left along the river, the two in the back seat were silent, smothered in pent-up emotion.

By the time they stopped in front of Allison's little apartment building, neither one had said a word. Joe got out and reached through the window to pay the driver. Allison stood waiting on the pavement for him.

"Well," she said desperately, "you can come upstairs, but the kids are bound to be home by now, and Nam will be fixing supper."

Joe had to smile. What poor lovers they were, with no corner of the whole wide city to call their own! He looked around. Providentially a bench materialized under the trees on the other side of the street facing the river. So he led Allison to it, and they sat down together, looking out over the water with their backs to the rest of the world. In the pregnant silence Joe laid his arm along the bench behind her and began to talk as casually as he could.

"That was quite an experience with the old gentleman and the incredible letter from his friend, Professor Minh. Thanks a whole lot for coming! You know, Allison, with the business of the man in prison and the vision he had, I felt as though it all meant something special to you. You were trembling and your hands were cold." Allison looked away. "And I couldn't help noticing," Joe plugged on, "that even though he had never met you before, Dr. Duc addressed himself to you most of the time." He let out his breath. "You two seemed to be sharing some experience that completely left me out."

Allison turned to him with a rush. "Not left out, Joe! You are his friend and the friend of his daughter. It was just that suddenly we knew we had an understanding, because something like what happened to Professor Minh in prison happened to me on the mountain." She took hold of his sleeve and out of her trouble searched him with her eyes. "I want to tell you about it all, Joe, so you will understand too!"

He smoothed out the frown between her brows with his hand. "So tell me, Love."

Allison let her tale begin to pour out like a brook, rushing, tumbling over obstacles. She kept her eyes on her hands which he held in his warm grip. At top speed she hurried through the whole story, arriving too soon at the surprising attractiveness of Kiem, even hard and cold though he was. Allison held nothing back; her terrible anger when he tried to deny her the child after all she had been through, her attempt to kill him, their furious fight and their fierce lovemaking under the trees. And she said to Joe as she had said to Max, "It was not a rape, you understand!"

Joe was shaken with anger and jealousy. Allison had made love with the murderer of Yen and Thanh! He couldn't speak. She got up to walk back and forth while he sat there frozen.

Still, through his own shock and pain, Joe saw that Allison was greatly troubled with serious guilt. It was possible that his response now could make or break their future. She was moving away from him. Frantically Joe realized, no matter what, he must have her for his life.

In the turmoil of his mind, he remembered the Professor, not any special words of his, but just his accepting attitude toward life. Thinking of Angkor, he saw a way, took her hand, and pulled her back down beside him.

"Allison, not long ago in Angkor Wat, I made love with a young woman I didn't even know." Joe knew in his heart that his lovemaking with Lam was not comparable, but it might help move his Allison from guilt into their shared humanness. Joe looked straight into her eyes. "Somehow at that time and in that place, it felt right. Maybe if I had been you, and your Kiem had been some kind of dragon lady, I might have tangled with her in the same way."

Allison stared. He was never what she expected. She didn't know whether to feel relieved or not. There was nothing to do but finish.

"That's not all," and she managed, however inadequately, to tell him about her peak experience on the rock. When she was through, he surprised her again. There were tears in his eyes.

"Allison, you are really blessed!"

She leaned back, feeling limp. "But Joe, I don't understand it at all yet. It was so wild and crazy!"

She had to wait again while he turned the whole thing over deliberately in his mind. "What was your *feeling* at the time; do you remember?"

Allison considered. "Yes, with Kiem—and later on the rock—it was the feeling of letting go."

Joe nodded slowly. "That's got to be it. See, from our human point of view these extreme happenings are wild and crazy. But since you were so totally involved, you let everything go. Kiem did too. All your former rules and strict behavior went—everything! I guess it's only when we stop controlling our life, there's a chance for a breakthrough."

"Well, but Joe, I was so afraid you would think it was terrible, to make *love* with the enemy, with a murderer like that!"

"And you were going to use your guilt to keep us apart."

Allison was silent, remembering her separation from Max until she gave away guilt at last. "Guilt is a terrible block."

Joe rested both arms along the bench. "I wonder what the key is to getting free of it."

"Maybe it's not judging, ourselves or anybody, not deciding what's bad or good, since it's all a mystery and we just don't *know*."

Joe thanked God for the tolerant Professor at Angkor who had wished him love. "But you know one thing, Allison. After letting go, you did actually experience, like Professor Minh in prison, that everything is one. Most of the rest of us are ignorant, Allison. Maybe that's why Jesus said, 'Father, forgive them, for they know not what they do.'"

Allison felt insightful tears springing up. "You mean, he meant that what they don't know is: we are all really one. They think they're separate from the person they are torturing. So as long as we think we're separate, we'll go on hurting each other and need forgiveness. But oneness is!"

Joe drew her down against his shoulder. She rested her head against the pulse in his neck. There was a smile in his voice when he said, "Allison, you are the missionary!"

At once she sat up straight to confront him and saw the laughter lines crinkling up his eyes. "Yes, you are," he said. "That's you! And right now I'm trying to figure out how I can get to be your enemy!"

Allison saw the joke, but without enthusiasm. Joe pulled her down

against him again. His hand gentled her head, the curve of her cheek, while he gazed out across the river. "Are you okay now?"

She sighed. "Maybe," and she examined the planes of his face close to her own. She really liked Joe's face. It was just right. "How about you?" Rising, Allison drew him up beside her. "Thanks, Joe."

"What for?" He dropped his head to kiss her with tender appetite. They clung to each other in the fast-falling darkness.

She took his hand. "It's late already! Why don't you come and have supper with us? Nam always has plenty."

Katrine and James welcomed Joe with lots of chatter and a hundred questions. Chi Nam looked him over carefully, discreetly, as she served their shrimps and rice. Allison was quiet, eating little, her head in her hand, watching them, listening to them, at peace. Without being asked, Nam took over the children's baths and like an expert little sheep dog cornered them into their rooms and beds.

At last they heard her footsteps descending the outside stairs. When Allison and Joe were finally alone in the shaded lamplight, he could see her face sharpened with tiredness. But he simply couldn't wait any longer. "Will it be all right for us, Allison? Do you think you can marry me?"

Her smile came on. "I'm getting there."

"Well, I just wanted you to know, if we have to leave Vietnam, go home to the States to live, that's okay. I can work there too. The important thing is for us to be together."

Allison wiped her eyes. "Joe, before I was afraid to go back, *and* afraid to stay here. But now, I believe I can be at home either place, especially with you. The truth is, I love Vietnam, and it looks as though you do too. We would miss the people. We'd miss their faces. We're hooked. So why don't we just stay on here, like in Nhatrang, or wherever is the best place for you to practice medicine?"

Joe still hesitated. "Allison, it's not going to be very—comfortable. Almost everyone sees nothing but stormy times ahead."

"I know. But somehow it's our place and they are our friends. You relate with the people so well. Let's do our best for them just as long as we can."

A great weight lifted from his heart and he took Allison right up in his arms and bent his mouth to hers.

Epilogue

Picnic

The happiness mentality maintains that one must organize one's own life toward the absence of discomfort. Even if a person manages to accomplish this for a brief period of time, the terrible pain in the rest of the world still exists.... The fact remains: private happiness can exist as a permanent condition in the midst of public suffering only if it is based on delusion.

Gerald May, Will and Spirit

Just before dawn the morning after their visit to Yen's father, Joe slipped out of Allison's apartment and down the stairs. Outside he found himself in the midst of the first rain of the monsoon for the Saigon area. Laughing, celebrating, he walked all the way home in the downpour. Tossing wet clothes on the floor, Joe fell on his bed into a deep sleep of relief and thanksgiving. But when the phone rang early at the hostel, Marian Banks managed to wake him and bring him down in his shorts to the one phone in the kitchen.

"Did I wake you?" It was Kate Gregory's unmistakable voice.

"Well, as a matter of fact...." He fought his way out of the drowsy glow.

"Joe, it's eight-thirty. You should be up already. Haven't you recovered from our wild Dalat weekend? I thought you'd be gone to your Vietnamese lesson."

He got a grip. "I should be. I can't get into any kind of health partnership with these people until I'm pretty fluent in their language."

"Tribal or otherwise?" she asked meanly.

There was silence.

Hastily Kate went on. "Joe, I seem to be your nemesis this morning, but the fact is, Phuong has 'saved himself' again. He deserted that nice family I managed to place him with."

Joe groaned. "Katherine, do you think maybe we should give up on Phuong? Just let him live on as a wild street urchin?"

"It's tempting. Anyhow, we have to give up until we hear from him again. Who knows where he is at this point?" Wearily, Joe thought of searching in the usual haunts of the Saigon market where the tough street boys, with their horny feet and elbows, hung out, on the watch for easy gain and challenging fights.

Katherine didn't wait for an answer. "But Joe, I also called about something pleasant."

"Great." His feelings after last night were very very pleasant.

"Our two older boys have their birthdays soon, and we were thinking about a joint picnic celebration for them and their friends. Jeff and I are also having a few friends of our own so we parents can enjoy ourselves too. Make the thing bearable, I mean. Would you and Allison consider coming? Of course the boys want James and Katrine, too."

"Hmmmmm. I'll ask Allison, but I don't see why not. What's the date?"

"Next Saturday around four in the afternoon. What a relief you are, old dear! All the kids' parents so far have asked at once exactly *where* we're having our picnic, and don't we think a picnic is dangerous right now, outside of our own back yard?"

"Is it dangerous?"

"God, Joe, I don't know. But we can't live our entire lives in cotton wool, can we? Jeff made me call Security and 'they' said it was okay, if we don't go any further out than the airport. That's not very far into the country, but I do remember an old rubber plantation that should do pretty well. There's room enough for a cookout and some games. Honestly, things have really escalated if there's no place safe in this country beyond Tan Son Nhut! I'll be glad if you and Allison have the guts to come!" They both thought at once that there was no problem about Allison's guts, but she might easily have another engagement.

"I'll find out and call you back. Thanks a lot, Katherine!" Joe couldn't very well say, thanks for thinking of Allison and me as a couple, the parents of Katrine and James!

But Kate, hearing the appreciation, knew very well how she had caused it. "See you," she said with an affectionate sound in her voice.

"Oh, Katherine, let me know if you hear anything at all from Phuong."

She sighed. "Don't hold your breath."

"No." He stared out of the kitchen window into the busy street, crowded

with rush-hour bicycles. "It sure is difficult to figure out how to help him."

"Impossible, don't you mean?"

She had hung up. Joe put the receiver back while he thought some more.

His friend, Marian Banks, passing through the kitchen, stopped. "Is anything wrong, Joe?"

"Well, I've been having a lot of trouble trying to get a roof over a certain street boy's head, and it looks as though he's allergic to roofs. Marian, do you discover that every time you try to quote 'help' somebody, you come up against all these problems?"

She considered. "I guess the trick is to find a way to help them help them-selves—along the lines they have in mind. Otherwise they come to lean on you, and then resent you."

"But you still think it's something we have to do, don't you?"

"What, help people? Well, at least we have to try, since it seems as though we're all bound together." She gave his shoulder a pat, pocketed a banana out of the blue bowl, and went through the back door into the hot street.

Joe remembered the first time he had seen Phuong, lying wounded on the pavement outside the Embassy. And he saw him again, incongruous in the white hospital bed, clutching the box of Joe's gifts. Mysteriously he was bound to Phuong of the spiky hair and the gamin grin.

Katherine Gregory's cook was not too happy about the birthday picnic for the boys. He said it was because it was likely to rain now that the monsoon had started.

"Oh, Monsieur Bep, please let's try it! The rains usually come at night at first, or even very early in the morning. And the boys have got their hearts set on a real American cookout, with our barbecue and the borrowed one from Colonel Thompson. "

"But Madame," he interrupted with a hectic flush on his thin face, "the transportation, the 'hot dogs,' the salads, the ice cream and two cakes, the...."

"Now Bep, I'm borrowing the Hendricks' Chevy station wagon for Monsieur and you and Bao and all the food and most of the kids. I can bring the grown-up guests in our Fiat. I'll get the charcoal and everything else we need from the PX. Once we're out there, you and Bao will have plenty of time to get the fires started while the kids play games, run races, win prizes. Then when they're all tired out, we can have a grand picnic, ending with the

two lighted cakes! There'll be nothing but trash to clean up, and all over before nightfall."

At first nothing erased the worried frowns creasing Monsieur Bep's high brow. But gradually, with An putting in an eager word (he was putty in the hands of little Hal), the thing was settled. Monsieur Bep went very carefully down the back steps to his kitchen, having given in at last, but without joy.

Jeff Gregory was not much more sanguine about the picnic birthday party than his cook, but a strong sense of humor always helped him to enjoy his wife's projects. Whether things succeeded or failed, he usually found himself highly entertained.

And so, on a Saturday not long after their return from Dalat, Jeff was driving his friend Tom Hendricks' station wagon out Cong Ly Boulevard toward the airport. He drove slowly because the back was open and the wagon was packed to the tailgate with picnic stuff plus his noisy sons and their noisy friends. Kate was leading in their own Fiat with Joe Ruffin, Allison and Katrine Giraud, and some of the picnic. In the end it had been necessary for the Bennetts to bring their station wagon, too, to accommodate the servants, the barbecues, the games, etc. etc.! Keeping his eye on Kate ahead and, through the rearview mirror over the kids' heads, the Bennetts, Jeff thought, Saigon Safari!

When they finally found it, the old rubber plantation on a disused road not far from the airport did not look all that inviting. The gray, twisted trees were past use and the underbrush had long been allowed to creep in plentifully, turning most of the once-clear aisles to jungle-like thickets. When they had parked, all the children bounded out into the nearer wilds, shouting. Gingerly, the cook got down from the Bennetts' wagon and looked about him in extreme doubt.

Kate, however, on a high of her own enthusiasm, showed everyone what a great spot this was, pointing to an area that was almost clear for the games and the cookout. This not-large space was ringed about with encroaching bushes and small trees. Little paths opening off the clearing seemed to be swallowed up suddenly in brambles and weeds as high as a man's chest in the shadows of the old rubber trees.

While the children ran about exploring, An and Monsieur Bep unloaded the picnic and the barbecues from the Bennetts' station wagon with its imitation wood sides. Jeff and Sam Bennett, having lifted down the PX ice

chest, began to open some of the beers. Kate and Joe rallied the kids around for games of darts (with rubber tips) and volleyball. Allison got Katrine to help Sara Bennett and herself with spreading out the picnic lunch on rugs. Katrine seemed to think herself above playing with the rowdy boys.

It would be a fabulous picnic. After the hamburgers and hot dogs, the potato salad and soft drinks, especially Coke, there would even be ice cream cones (cones from the PX and ice cream from a hand-turned freezer). There would be two birthday cakes with lights blossoming in the thick frosting. Chocolate chip cookies and candy bars were mounded up in plastic plates for afterwards. Allison was amazed over all this American splendor which she and Kat and James had completely forgotten could exist.

She was stunned too by the powerful pull between herself and Joe. Allison felt lazy, lethargic, putting out the napkins slowly, leaning into the spell of Joe's energy, calling to him silently with her yielding willingness. Every now and then he sent a direct look toward her, so that this slumbering thing between them sparked into flame. But once, as she was looking away, Allison thought she saw someone—a Vietnamese child?—scuttle off into the underbrush.

There were many shiny prizes for the races and the darts competition. James won a bright blue sailboat and could hardly contain himself. As the smoke from the charcoal fires rose into the still air, so did the aroma of sizzling meat, along with the merry whoops and shouts of the boys. Then suddenly, when Joe looked up from a toss of the volleyball into grabbing, reaching hands, he glimpsed stealthy movements in the wild, overgrown stretches just beyond the clearing. Turning quickly, he saw dark little faces retreat back into the shadows.

"Hey," Joe said, "I think there're some kids out there in the woods!"

The adults turned to look. Sam Bennett sharply told all the party children to stay close in the clearing and not wander off in the bushes. Jeff Gregory sauntered over to the edge and peered around.

"You're right, Joe. There're quite a few kids in there." He looked perplexed. "I don't guess we can exactly invite them all to join us...."

It was a problem. The grownups felt uncomfortable. At first the children were too busy playing to notice, but Joe kept Hal from rushing into the woods after the ball. He went for it himself and picked it up under the eyes of a very thin boy about ten or twelve years old. There were many other eyes watching.

Joe said, "Hello everybody!" in Vietnamese. No one answered. Someone

laughed loudly; others tittered. With the ball, Joe returned to the clearing, feeling somehow in retreat. Retreat from what?

The games petered out. Some hands from the thickets had appropriated several of the rubber darts and didn't give them back. Kate decided it was about time to call everyone to take a plate for their meal. The smell of cooking was tantalizing. Looking around, Kate saw their small clearing was surrounded on three sides by watching faces. (The road and the parked cars were on the fourth side.) She turned toward the woods. Could that be Phuong, the one with squinting eyes?

"Phuong?" she called. No one answered. Kate sent a worried look in Jeff's direction. He shrugged. She drew a deep breath. "Come and get it everybody!"

Then the first stone fell. They all whirled in that direction. There was a rustle followed by total silence.

Kate said sharply, "Well, go on Monsieur Bep, serve up, won't you?"

He bowed doubtfully just as the second rock fell near Sara Bennett's foot.

"Hey," Sam Bennett stood up angrily, "we'd better get the kids out of here, Gregory!"

"But we haven't even started the party," Kate protested. "Maybe we can...."

As a third rock fell, the American children began to scream excitedly. Joe was staring into the surrounding woods. "Maybe we can talk to them and give them some...."

A shower of rocks hit the picnic group. Jeff Gregory was on his feet. "Ong Bep, An, get the stuff in the cars! We'll put the kids in first. Let's clear right out of here—fast!"

"Come back to our house," cried Kate, hustling kids away, protecting them with her body from the falling stones. "We'll have the picnic at home!"

Under the scattering of rocks the adults rushed the children and themselves into any car. Joe, the cook, and the boy were dumping hot coals, tossing food and equipment into a station wagon. The people, the party, with cakes, paper cups, thermoses, hot dogs, toys, were scrambled together and barely shut into vehicles before the pattering rain of stones became a solid hail storm.

Inside as the cars drove away, there were sighs of relief along with intense feelings of anger, defeat, and humiliation. They had been rocked out, driven off by a pack of alien kids!

Joe found himself in the Fiat with Kate. They were last. As she put on

speed, the falling stones stopped bounding off the little car. They were out of it. The children were safe. No windows were broken.

When Kate turned to Joe, he saw tears in her eyes. "I guess all the prudes were right. I shouldn't have tried to do anything outside our compound."

Joe felt his heart tighten. "Katherine, please don't blame yourself. The truth is, nowadays something like this can happen anywhere." He was thinking about what Yen's father had said, "When things get out of kilter, then violence erupts to right the balance.'"

"Katherine, there's a terrible gap between us and them, the haves and the have-nots. It's maybe impossible, this late, for us to bring things into balance, try as we will."

She drove steadily after the Hendricks' wagon, looking through a blur of tears. "Joe, did you think you saw Phuong in with those rock-throwing kids?"

"Well, it did cross my mind that one boy was very like him."

Stopping for a red light on Cong Ly she put her head down on the wheel.

Joe rested his hand on her shoulder. "Maybe it wasn't him. Lots of Vietnamese kids have eye trouble." He offered his handkerchief and she blew her nose.

At the Gregorys' house the gates were wide open. Joe noticed that the barber was not there. His equipment had all been removed. But Ong Coolie was bowing and smiling by the gate as they drove in behind the other two cars. The bicycle repair man and his family were working away in the dirt outside the compound walls under the over-arching branches of the monkey-pod tree and the threatening monsoon clouds. Ong Coolie attended cheerfully to the closing of the gates.

Inside the walls the birthday celebration was held anyway, but things were not quite the same. "Those little demons!" Sara Bennett exclaimed. "Someone could have been badly hurt."

As the children devoted themselves soberly to their ice cream, Jeff turned his back, muttering to Joe. "There's just no way you can picnic on the edge of the third world!" Joe nodded mutely, glad that a U.S. official saw things in that light.

But everyone was depressed. As soon as they could, Joe and Allison led Katrine and James over to say their thanks and goodbyes. Outside the gate by the curb Joe hailed two cyclos for the four of them. He was not really surprised, then, to see that the barber had materialized, was once again sitting in his chair with his legs negligently crossed, awarding them just a passing glance of cool hostility—of one-upsmanship?

"Look out for your mother, now," Joe said, putting James and Allison in together, while he took Katrine beside him, held her firmly in the circle of his arm.

Joe and Allison and the children were pedaled quietly home through the wide, tree-lined streets where, with graceful complication, Saigon was pursuing life as usual. An oasis, sheltered by her exposed provinces, the city somehow still preserved a hothouse peace. For a little longer she was like a city under glass.

References

The following are books used in research to make factually authentic the background of the story.

Agency for International Development. *Principles of Foreign Economic Assistance.* Washington: United States Department of State, 1965.

Anon. *Report on Vietnamese Refugees and Displaced Persons.* New York: American Council of Voluntary Agencies for Foreign Service, 1965.

Brown, Robert McAfee, Abraham J. Heschel, and Michael Novak. *Vietnam: Crisis of Conscience.* New York: Herder and Herder, 1967.

Crawford, Ann Caddell. *Customs and Culture of Vietnam.* Rutland, VT and Tokyo: Charles E. Tuttle, 1966.

Dooley, Thomas A., M.D. *Deliver Us from Evil: The Story of Vietnamese Flight to Freedom.* New York: Farrar, Straus and Cudahy, 1956.

_____. *The Edge of Tomorrow.* New York: Farrar, Straus and Cudahy, 1958.

Dowdy, H.E. *The Bamboo Cross: The Witness of Christian Martyrs in the Communist-ridden Jungles of Viet Nam.* Harrisburg, PA: Christian Publications, Inc., 1968.

Doyle, Edward, Samuel Lipsman, Stephen Weiss, and the editors of The Boston Publishing Company. *The Vietnam Experience: Setting the Stage* (Volume I). Boston: The Boston Publishing Company, 1981.

_____. *The Vietnam Experience: Passing the Torch* (Volume II). Boston: The Boston Publishing Company, 1981.

Eisenhower, D.D. *Eisenhower Papers, 1954-1960: Papers of Dwight David Eisenhower.* Edited by Daniel Holt. Baltimore, MD: Johns Hopkins University Press, 1998.

Fitzgerald, Frances. *Fire in the Lake: The Vietnamese and the Americans in Vietnam.* New York: Vintage Books, 1973.

Gettleman, Marvin E., ed. *Viet Nam: History, Documents, and Opinions on a Major World Crisis.* New York: Fawcett Publications, Inc., 1965.

Goddard, Dwight, ed. *A Buddhist Bible.* Boston: Beacon Press, 1966.

Graham, Andrew. *Interval in Indo-China.* New York: St. Martin's Press, 1956.

Green, Graham. *The Quiet American.* New York: Viking, 1956.

Grey, Anthony. *Saigon.* Boston: Little, Brown and Company, 1982.

Grolier, B.P. *The Art of Indochina.* New York: Crown, 1962.

Halberstam, David. *The Best and the Brightest.* New York: Random House, 1972.

_____. *The Making of a Quagmire: America and Vietnam During the Kennedy Era.* New York: McGraw-Hill, 1987.

Hefley, James C. *By Life or By Death: Violence and Martyrdom in This Turbulent Age.* Grand Rapids, MI: Zondervon Publishing House, 1969.

Hefley, James C. and Marti. *No Time for Tombstones: Life and Death in the Vietnamese Jungle.* Harrisburg, PA: Christian Publications, Inc., 1974.

Hickey, Gerald Cannon. *Village in Vietnam.* New Haven, CT: Yale University Press, 1964.

Karnow, Stanley. *Vietnam: A History.* New York: Viking, 1983.

Karnow, Stanley and the editors of *Life.* *Southeast Asia.* New York: Time, Inc., 1962.

Larteguy, Jean. *L'Adieu A Saigon.* Paris: Presses de la Cite, 1975.

La Tourette, Kenneth Scott. *Introducing Buddhism.* New York: Friendship Press, 1956.

Liska, George. *The New Statecraft: Foreign Aid in American Foreign Policy.* Chicago: The University of Chicago Press, 1960.

New York Times, The. *The Pentagon Papers.* New York: Quadrangle Books, 1971.

Nguyen Khac Vien. *Tradition and Revolution in Vietnam.* Berkeley, CA: The Indochina Resource Center, 1974.

Nguyen-Van-Thai and Nguyen-Van-Mung. *A Short History of Viet-Nam.* Saigon: The Times Publishing Company, 1958.

O'Daniel, John W., Lt. Gen. U.S.A., Ret. *The Nation That Refused to Starve: The Challenge of the New Vietnam.* New York: Coward-McCann, Inc., 1960.

Palmer, General Bruce, Jr. *The 25-Year War: America's Role in Vietnam.* Lexington, KY: The University Press of Kentucky, 1984.

Pike, Douglas. *Viet Cong: The Organization and Techniques of the National Liberation Front of South Vietnam.* Cambridge, MA: M.I.T. Press, 1966.

Podhoretz, Norman. *Why We Were in Vietnam.* New York: Simon & Schuster, 1982.

Raskin, Marcus G. and Bernard B. Fall, eds. *The Viet-Nam Reader: Articles and Documents on American Foreign Policy and the Viet-Nam Crisis.* New York: Random House, Inc., 1965, 1967.

Rust, William and the editors of U.S. News Books. *Kennedy in Vietnam.* New York: U.S. News Books, 1985.

Santoli, Al. *To Bear Any Burden: The Vietnam War and Its Aftermath in the Words of Americans and Southeast Asians.* New York: E.P. Dutton, Inc., 1985.

Shaplen, Robert. *A Forest of Tigers.* New York: Alfred A. Knopf, 1956.

Sheehan, Neil. *A Bright Shining Lie: John Paul Vann and America in Vietnam.* New York: Random House, 1988.

Stavins, Ralph L. *Washington Plans an Agressive War: A Documented Account of the United States Adventure in Indochina.* New York: Random House, 1971.

Tuchman, Barbara W. *Stilwell and the American Experience in China, 1911-45.* New York: Macmillan, 1970.

Warner, Denis. *The Last Confucian.* New York: Macmillan, 1963.